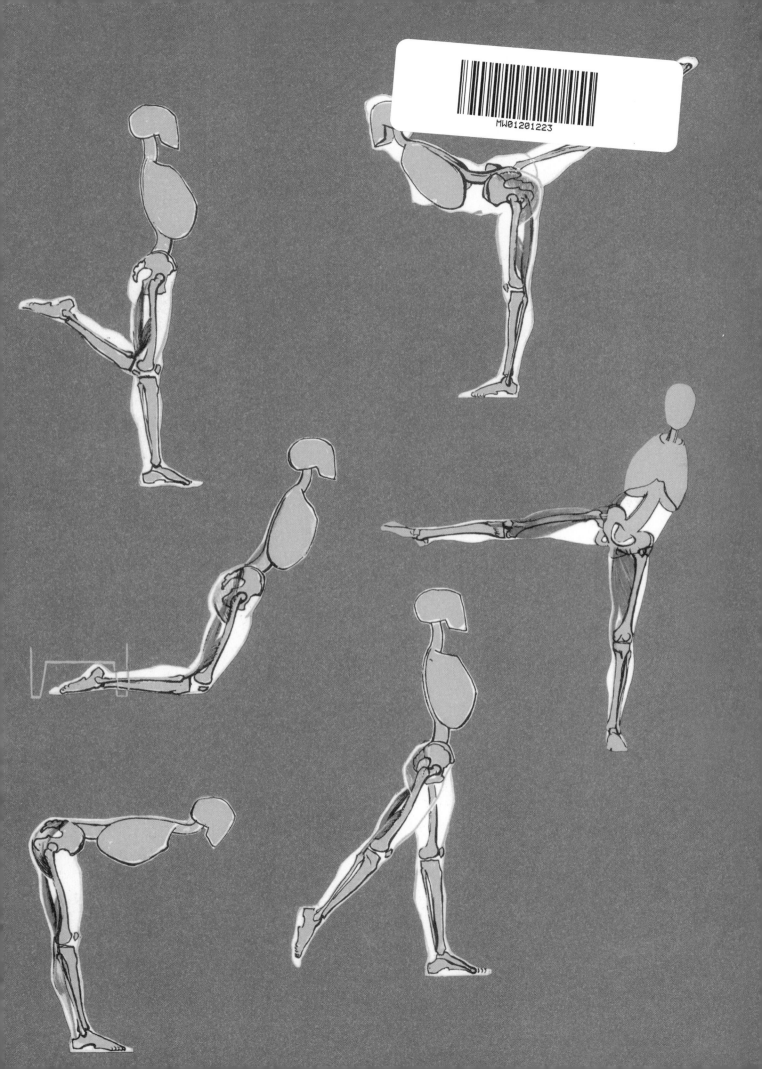

The Complete Guide to
Anatomy
for Artists
& Illustrators

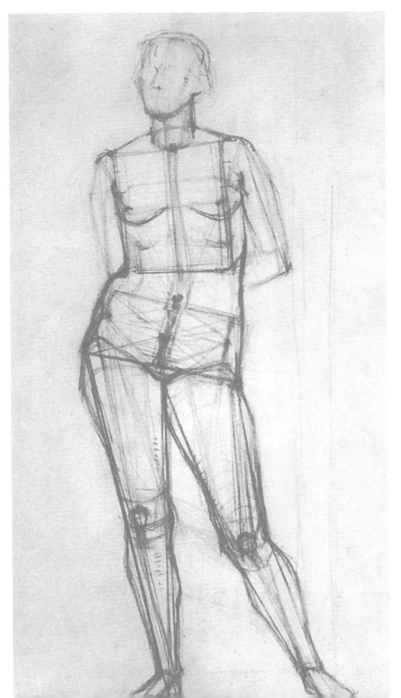

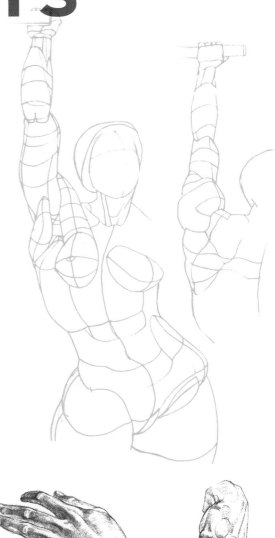

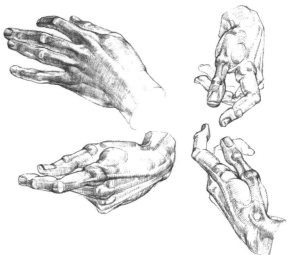

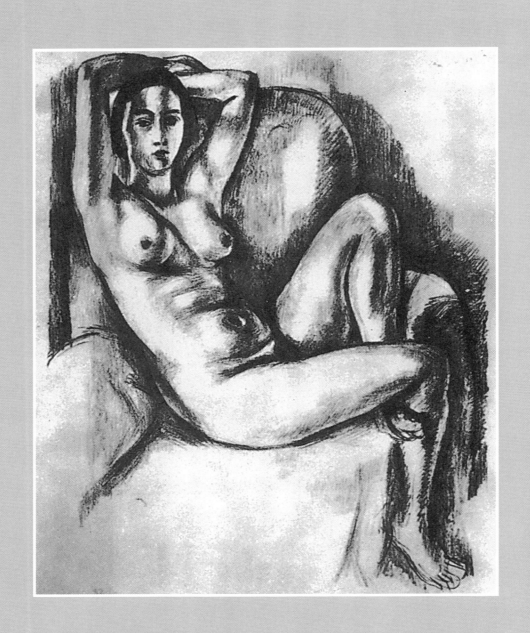

The Complete Guide to
Anatomy
for Artists
& Illustrators

GOTTFRIED BAMMES

SEARCH PRESS

First published in 2017

Search Press Limited,
Wellwood, North Farm Road,
Tunbridge Wells, Kent TN2 3DR

Reprinted 2018, 2020

First edition published in 1964.
© 2009 Christophorus Verlagt GmbH & Co. KG, Freiburg.
World rights reserved by Christophorus Verlag GmbH,
Freiburg, Germany

Original German title: *Die Gestalt des Menschen:
Lehr- und Handbuch der Künstleranatomie*
English translation by Burravoe Translation Services

ISBN: 978-1-78221-358-1

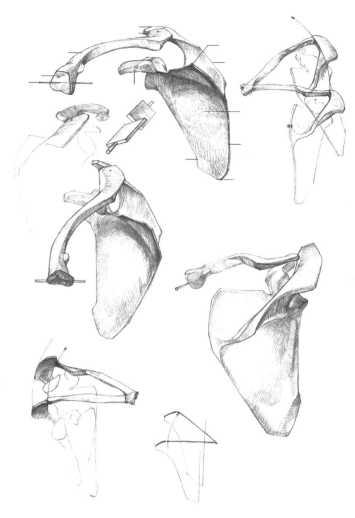

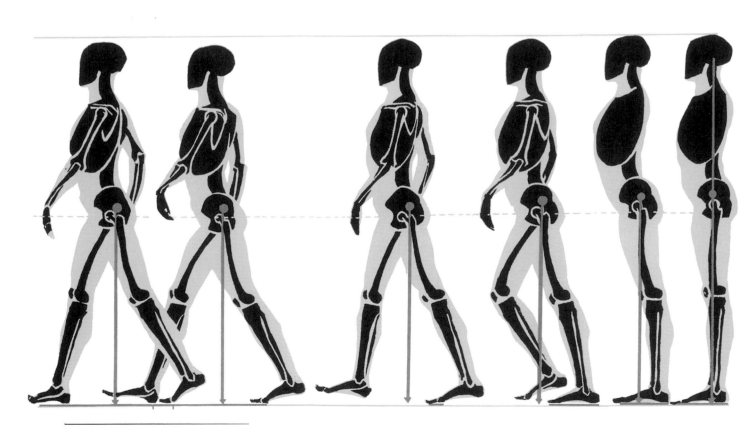

Foreword

The naked human body is, and has always been, the most important subject of artistic life drawing. To become familiar with the forms of the body is to better understand nature's greatest achievement. The bare structure of our own bodies – with its proportions, relationships, qualities of form, norms and systems of rules – is seemingly so familiar to us. And yet it has such power to amaze us. The body stands for everything that is natural and intimate: our outward and inward lives, every aspect of the way we are. In images of human beings (all with their own peculiar social aura), we always want to find something that we can identify with, something that we can connect with our own feeling for our own bodies, our physical and mental energies and our social and ethical views – we even see echoes of ourselves in these images. This makes the exploration of the human form more than just a tradition that has survived from the Renaissance. Instead, it is an ongoing process of humanity encountering itself, a kind of monologue through which we learn to understand ourselves. This book on anatomy for artists is intended as a textbook and handbook on the naked human form. It is far more than just a book about the anatomy of bones and muscles, or a list of facts that recapitulates the details of the human organism. Crucially, it is about the underlying reasons behind the way human life is expressed – it is about the body's 'what' and 'how', 'action' and 'form' relationships, and how they impact on one another. Essentially, all of these factors mean that anatomy for artists is about the study of natural forms: artistic anatomy relates to aesthetics, but is not one of the fields of the study of art.

The author aims to do more than just take useful insights from the natural sciences and 'apply' them to art (the works of Leonardo and Vesalius alone would provide almost enough information for this purpose). Instead, the author's chief goal is to make it clear where artistic and scientific thought differ, and where they are the same; to liberate these twin poles from a dualistic way of thinking. But this can only be done if the explanation of scientific subject matter links it to the essentials of artistic thought, with plenty of practical guidance. And this is why the author has defined the goals and subject matter of the new artistic anatomy with the specific character of art in mind. The tremendous response and approval that greeted *Die Gestalt des Menschen*'s first edition – leading to a call for translation into multiple languages, and a need for wider distribution within Germany – has confirmed that he was right, and the publisher VEB Verlag der Kunst Dresden has now responded by offering a new modified edition of the book to the wider public – not to update the content, but to better meet the increasingly widespread need for an affordable book that covers the modern factual and methodical principles of figure study for a wider circle: artists, young students of art, art teachers and tutors of amateur art groups, individual amateur artists and all of those interested in art.

Only in one area did the publisher abridge the encyclopaedic scope of the first edition, simply by cutting the contents: the material on the form-types characteristic of taller races (the least indispensable part of the book) was cut out. Elsewhere, the book was condensed and made more concise. This, however, meant practically rewriting it entirely, leaving only a few lines intact from the original, more lengthy edition.

These are not the only alterations to the book. Where the original book's insights on a certain problem – on how the different forms interrelate, for instance – had turned out to be particularly useful in teaching practical anatomy, a number of aspects of the issue are now explored in more detail, and so the information presented has actually expanded in this respect, supplemented by the author's own drawings and by examples from among the masterpieces of the visual arts. The same applies to the interrelated issues of proportions, static properties and dynamic properties, with all their methodical aspects – this particular group of issues offers unequalled opportunities for building bridges between artistic and scientific thought. This section provides plenty of advice about figure studies, both for self-taught artists just starting out and for art educators; the points that should be considered and the resources that can be used to implement your ideas. In these pages, artists can find defined and delimited goals, with self-contained solutions, but no fixed formulae. Plenty of space continues to be dedicated to illustrative examples for students: in some cases, the old examples have been replaced by new examples, and in others, they have been supplemented and improved by the addition of new material. It is important that anyone involved with practical art work should learn to recognise not only the consummate mastery of the perfected artworks, but what is achievable for a student. Readers will discover that the ultimate objective of studying anatomy from an artist's perspective is not to correctly portray the 'muscle-man' figure – which does not truly represent the aims of anatomy. Taught imaginatively, this branch of artistic instruction can inspire a harmonious understanding of human beings' appearance, can nurture the whole of the artistic experience, and is ideal for introducing beginner artists to very diverse working materials (chalk and lead pencil, pen and paintbrush, adhesive techniques and the simpler printing techniques, and modelling materials). Everything is tackled with the view to achieving full mastery of a specific study goal, using any specified material or medium for producing an artwork.

The author has reworked the first chapter, 'Anatomy for artists past and present', with particular care, emphasising even more strongly the fluid character of anatomy for artists' history and its ongoing continuity, and demonstrating the historical origins of all of the anatomy problems faced by artists today – and all of the arguments for and against artists learning anatomy. The whole purpose of looking at the history of anatomy is to explain the direction that the challenges we have

encountered as we study the naked human form have taken us in, and how they ought to be resolved in this day and age. Our new aims, our chosen teaching methods, the methodology of anatomy for artists: all of these are inseparably linked with the changing forms that anatomy for artists has taken throughout history. All aspects – art, science, teaching – therefore need a fully detailed historical background.

The expression and physiognomy section – largely concerned with the mechanics of changes of expression, with particular reference to research by Lersch, Peiper and Rubinstein – has also been extensively reworked. Regrettably, only fragments of the material could be included in this revised subsection.

This book has found its way to the reader in its current form thanks to all those who have contributed directly or indirectly to its success. Firstly, the publisher, VEB Verlag der Kunst Dresden, which set aside all difficulties and doubts to publish the first edition. The publisher's courage was rewarded with a great success: additionally, the book's meticulous typographical design earned it the 1964 Schönstes Buch des Jahres [Most Beautiful Book of the Year] award. For this edition, the publisher again showed great sympathy with the author's ideals, and a willingness to make them practicable. Thanks to Horst Schuster, this edition too does full justice to the aesthetic demands of such a complex book design project. I also wish to thank Mr Wilhelm Burmeier, the actor of the Staatstheater Dresden, who was kind enough to serve as the model for the photographs of different facial expressions. The author also wishes to thank the numerous museums (in Germany and elsewhere) that provided material on the art masterpieces from their collections; Professor Herbert Schmidt-Walter, the director of the department for art education at the Hochschule für Bildende Künste Dresden, for many enlightening conversations on artistic and scientific thought; Mr Peter Schmidt, for his sympathetic aid in producing purely practical, high-quality reproductions of the naked human body and, not least, the people who provided the photographic images for the book.

This book's well-rounded content is the result of long but very rewarding work with the next generation of artists, with art teachers and with the tutors of amateur art groups, encompassing over ten years' work in training and education with amateur artists and students of artistic dance. Identifying with the interests of students – and of art – is the source of all truly imaginative art teaching. As an artist, a subject-teacher and an anatomist, the author knows exactly 'where the shoe pinches' from the point of view of the student. If the hints, ideas and material contained in this book inspire the reader to participate with enthusiasm, then it will have truly served a useful purpose.

FOREWORD TO THE SECOND EDITION

Since the encyclopaedic first edition of *Die Gestalt des Menschen* was published by VEB Verlag der Kunst Dresden in 1964, this is the second time that the author and publisher have presented this book to a worldwide readership extending from the USSR to the USA. The first edition prompted plenty of appreciative letters and favourable reviews from scientific and artistic specialists – and plenty of enquiries as to when a new edition of this textbook and handbook of anatomy for artists would appear.

Encouraged by international recognition and success, the author and publisher have now responded to these requests by providing a suitably improved new edition. First and foremost, the visual teaching aids have been supplemented; the second edition contains over 70 new illustrations. Apart from a number of clarifications, the text itself is unchanged, and is the same length.

In the images showing the different body types of the two sexes, the physical changes are now depicted continuously up until the 50th year of life for women and the 60th year of life for men. Of particular interest are the images of the young people who had previously appeared in *Die Gestalt des Menschen*: twelve years on, the new images show a significant degree of change. The number of model images has been increased, to reinforce the impression of a unified language of forms across all the different body types. Also entirely new are the life-drawing images detailing major features in the functional behaviour of the pelvis, the spinal column and the rib cage in seated or recumbent human figures.

Some of the examples of pieces of work by students have been replaced with fresh work produced during classes. The author himself has produced a number of additional drawings of the musculature of the torso, the neck and the skeleton, drawn from models, demonstrating how these body parts function. The biggest improvement, however, is that now all the book's discussions of problems in anatomy, including the section on the psychology of facial expressions in artistic images of human beings, are illustrated with artistic masterpieces.

The author is deeply obliged to all of the people who have contributed – directly or indirectly – to creating a new and even more rounded book. First, he would like to thank all of the staff at VEB Verlag der Kunst Dresden, who, as always, have done everything possible to ensure the success of the book. He would also like to thank the artists who have kindly permitted their artworks to be reproduced in this publication. He thanks the director and staff of the Scientific Archive for Photographic Reproduction of the USSR Academy of the Arts in Leningrad, where, on the occasion of a guest lecture that he gave at the Repin Institute, he was given the opportunity to view examples of Russian pre-and post-Revolution nude art and to select some images, and where he met with a great deal of friendly support. A small selection of these images has been included in this edition. Last but not least, the author would like to thank all of the people, in Germany and in other nations, who have expressed their approval of his work in personal conversations and letters.

It is hoped that this book will, once again, make a valuable contribution to providing well-grounded answers to the practical questions that arise in connection with the artistic study of the naked human body's form – and of its natural beauty.

FOREWORD TO THE EIGHTH EDITION

The book *Die Gestalt des Menschen*, which appeared in 1964 in Dresden, has received consistent acclaim and interest ever since. In 1982, a third edition was published, with a number of clarifications based on new insights on methodology and the optimal presentation of the facts: changes were made to the book's contents, the exercises that have been included, and its direction. Over the comparatively long period of time that has elapsed since, no changes have been made to the book's subsequent editions.

My teaching activities, however, have continued to move forward since that first major reworking. My practical work continues to lead to new knowledge, and to confirm the usefulness of the old. The rethinking of what can and should be achieved in teaching is constantly in flux, bringing with it new material which provided a reason to bring out this new edition.

The book's basic concept remains unchanged, but 32 additional full-page plates have been added, featuring numerous individual images and additional illustrations and texts, plus detailed captions.

I hope that these new resources, combined with the pre-existing resources, will even more readily provide 'aha' moments of insight for the reader. I am very grateful to the publisher, Ravensburger Buchverlag, for their understanding and accommodating handling of this long-overdue revision.

In the foreword to the third edition, I explained to readers my theory that artistic anatomy studies greatly depend on and are enriched by studying historic conventions in understanding and representing anatomy for artists. This theory has lost none of its relevance, but the traditional, familiar skeleton and muscle figures have, then as now, certain drawbacks in terms of the psychology of learning, in terms of revealing the relationship between art and anatomy, and in terms of effectively assimilating the subject matter. My thoughts, then as now, revolve around the following key points:

First: if a form as important as the human body is to be effectively taught, then its most important aspects, in terms of their consequences, must be made memorable by visually highlighting and simplifying the constructive elements of the human form to aid comprehension. In particular, this is the best way of portraying the forms and structures of the skeleton and joints. I was also determined that, in addition to the individual analyses – vital if the reader is to understand the essential features of each individual step that contributes to the whole – the book should show how all of these individual stages fit together to make a whole by training an understanding of the architecture of the body's form that grants the student an overview of the arrangement and context of the forms.

Second: there was a need to add new perspectives. Anatomical subjects are usually shown only in front, side and rear views. The book had to include perspectival, three-dimensional views, recognising the improvement in clarity produced by varying the viewing angle of any given object as much as possible. In other words, viewing the body from as many different standpoints and perspectives as possible reveals more and more of its aspects. By varying one's view of the subject, practical drawing exercises in which one 'walks around' the subject reveal what is always the same about its form: its essential, unvarying qualities.

Third: students of the many different aspects of anatomy must acquire enduring knowledge and, especially, must acquire skills through practical activities. As I have already said, I believe that encouraging students to understand and design the body as an architectonic structure is the best method and objective for fully realising the potential of anatomy. These ideas become crystallised during the teaching process, because when teaching, it is important to make sure that the insights and knowledge gained by the students stick, and are not simply lost again.

Fourth: with this aim in mind, I have included a number of examples of students' finished work, but also examples of my corrections to work produced during classes. These offered plenty of opportunities to put right misconceived, insufficiently sensitive, untidy or disunified drawing work, helping students to experience life drawing study 'at close quarters' – as long as they were willing to understand and recognise aspects and issues beyond the narrow confines of their own artistic perspective.

Fifth: it goes without saying that a book of this kind contains examples of masterpieces depicting the human figure as reference material for the reader. These also help to provide standards and benchmarks. These artworks demonstrate the synthesis of good comprehension of the subject matter and good research with observation, feeling, sensitivity, personal experience and unrestricted imagination.

I have also written a linked series of supplementary manuals on aspects of drawing and figure composition: the history and theory of the human form in art and anatomy are discussed in the large volume entitled *Akt: das Menschenbild in Kunst und Anatomie* (Belser Verlag 1992).

I have placed particular emphasis on the visualising of the anthropological and anatomical subject matter – on making the information on the different body shapes of young people and adults of both sexes easy to read, generally by using lines of comparable or similar lengths to mark the figures' proportions.

Alongside the more generic visually striking and memorable forms, the reader will find anthropometric figures that give more exact measurements. This is a good way of illuminating the relationship between the 'norm' and the 'individual' within the wide range of different forms allowed by nature: the different individual cases may show certain aspects of the general rule, but they cannot be reduced or 'distilled' into a set of general rules.

The process of understanding proportions is now more closely linked with static issues, and these have therefore been incorporated into the new figures intended to demonstrate proportions, thereby allowing proportions, static and dynamic issues to be interconnected in a more immediate way.

As ever, it is important to simplify the human form, to make it more accessible: not to make the work easier by 'dumbing down' the essential scientific content

– in fact, the reverse is true. There are two different ways of simplifying body forms (which can be done to differing degrees and in different ways). First, one can remove all the incidental natural elements that do not contribute to understanding the essentials of the form. Another, and equally important, method of simplifying body forms is to allow the several different elements or components of the form in question to be seen all together, to bring them together in a configuration that helps the student to understand the form. Both types of simplified form are potentially useful in ensuring that the essential facts are understood, recognised and comprehended, so that they can help one to truly picture the subject, instead of the subject becoming lost in a mass of excessive sensory detail.

Additionally, to aid reader comprehension, complex issues relating to form are introduced cumulatively, in a graduated series of individual images. These learning sequences are an integral part of the 'genetic method': starting with elementary building blocks, then moving through limited differentiations of forms (the many individual structures that make up the skeletal structure of the foot, for instance, which make it difficult to bring the individual parts together to create a whole). At the end of the book, further artistic nude drawings are included, to demonstrate how knowledge of the subject matter and actual experience combine and coexist.

For the new edition of *Die Gestalt des Menschen*, I was largely able to use the graphics I had created for my book *Wir zeichnen den Menschen* (1989). In order to avoid disruption to the existing book design concept, the additional panels that have been added to the new edition have been given numbers within the existing illustration numbering system, but with an oblique stroke (e.g. 89/1, 89/2, etc.).

Space was available between the previous texts and illustrations; this meant that new text could be added without packing too much text into the book.

In order to make it even easier for the reader to make useful connections between the text and the book's plentiful illustrations, the main text was modified to reference the illustrations wherever possible.

Given the increasing lack of good foundation knowledge and the increasing use of superficial practical tools that are not fit for purpose in the field of anatomy for artists, it is hoped that any student of the human form who reads this book will discover it to be a reliable and inspiring adviser and friend.

FOREWORD TO THE TENTH EDITION

As always, *Die Gestalt des Menschen* [now in this English edition, *The Complete Guide to Anatomy for Artists & Illustrators*] reproduced in its tenth edition, offers answers to all of its readers' wide-ranging questions.

This book has been helpful in any number of ways, especially to younger readers looking for the essentials of image-making. It has proven invaluable as a standard work, and has sold well for many years.

As the author of this book – my first book, originally published in the year 1964, and since sold and welcomed all over the world – it will give me great pleasure if readers are able to gain useful information and artistic success from this new edition.

Professor emeritus Dr Gottfried Bammes (Pedagogy)
Professor emeritus for Artistic Anatomy at
Dresden Academy for Fine Arts

Dresden, August 2002

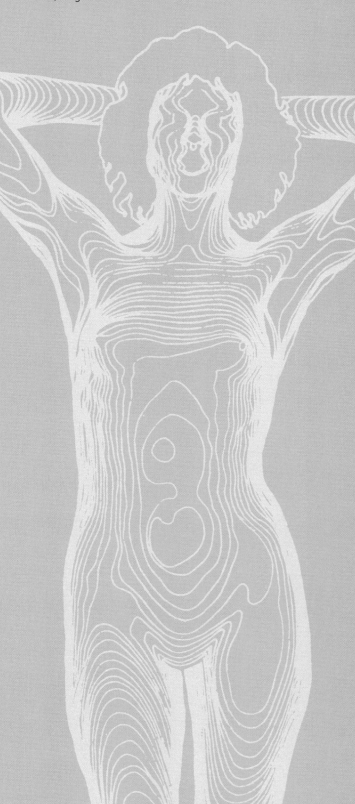

Contents

4 | THE BODY'S PLASTIC BUILDING BLOCKS 186

5 | THE LOWER EXTREMITIES 202

9 | THE NECK 418

10| THE HEAD 434

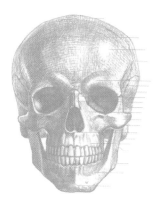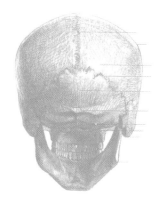

FINAL COMMENTS: ANATOMY FOR ARTISTS AND ARTISTIC FREEDOM 473

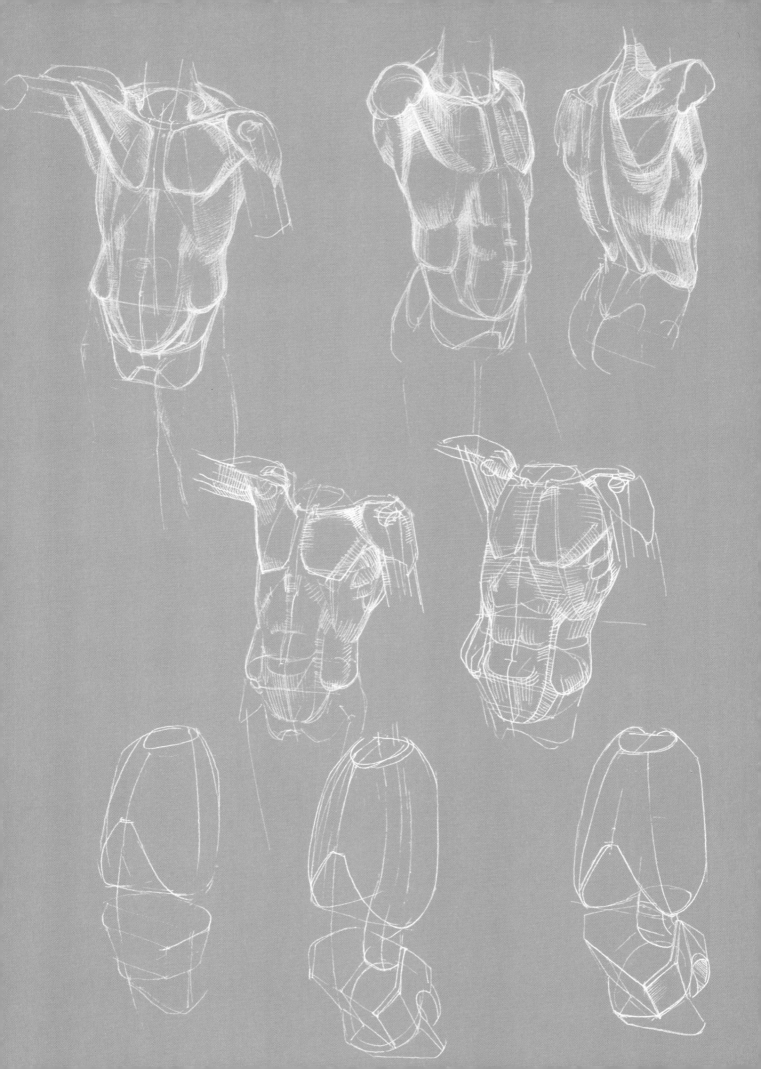

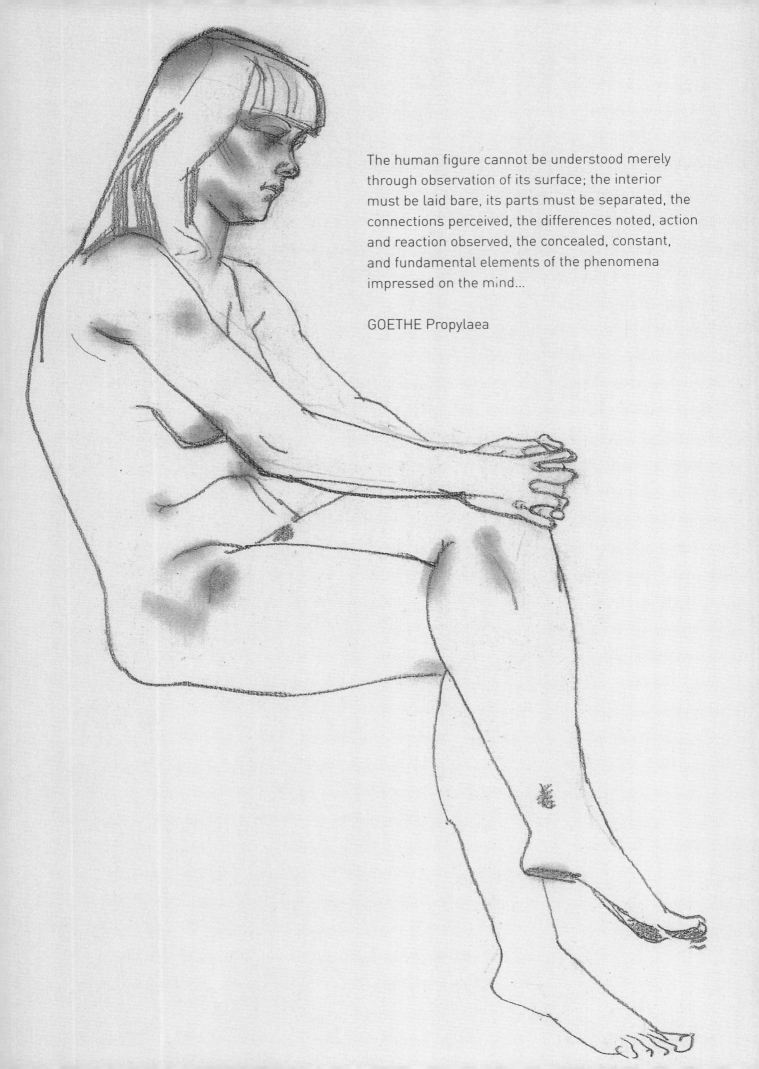

The human figure cannot be understood merely through observation of its surface; the interior must be laid bare, its parts must be separated, the connections perceived, the differences noted, action and reaction observed, the concealed, constant, and fundamental elements of the phenomena impressed on the mind...

GOETHE Propylaea

1 Anatomy for artists: past and present

1.1. THE FRIENDSHIP OF SCIENCE AND ART

The late 19th century, with its revolutions in artistic thought, attributed every aspect of artistic creativity to an autonomous, self-sufficient artist subject – thus replacing the dialogue between the artist, the depicted object, and the art's beholders with a one-sided, subjective, self-exhibiting monologue. This drastic spiritual change meant that the whole vast field of appearances was now distrusted and questionable. Half-measures, combined with a dualistic concept of artistic creation, have promulgated a concept of 'modernism' that requires artists to know and wish to know and understand as little as possible about objects and human beings. This attitude is summed up by Gustaf Britsch's comment about physical science becoming a destroyer of the unified visual experience: to think in such a dualistic way is to lose sight of a real visual understanding of phenomena, to cause them to lose their identity with their core forces. Inevitably, this leads to a levelling in how we experience objects. As a result, even the depiction of the human being in art becomes questionable, insignificant and indifferent, and this is only natural if the subject areas and resources that were once the allies of artistic education are to help artists to interpret the appearance of the human being in their own, scientific way.

On the other hand, we also have to discard the numerous manifestations of anatomy for artists that have appeared in history when their simple, isolated, scientific descriptions of the attributes of human beings do not offer any new insights, and cannot form an integral part of the interpretation of the human form in art education – particularly those restricted to a selection of material 'suited' to artists.

A more detailed discussion of how prejudices against historic ways of teaching anatomy to artists have become widespread and entrenched can be found in my book *Akt: das Menschenbild in Kunst und Anatomie* (Belser Verlag 1992). My attempt to provide a serviceable artistic manual, one springing from the immediate needs of an approach to artistic life study that has not lost sight of the fundamental laws of forms and their structures, aims to achieve far more than the 'anatomy for artists' works of the past – because it is an artist anatomy system that retains a connection to the practical business of depiction. Learning, getting

to know and, indeed, recognising the laws that govern the structures of natural forms when one sees them is an appropriate study for any modern human being, and for anyone willing to devote the whole of their subjective and artistic powers to the appearances of all living things. There can, therefore, be no enmity between a philosophy of total artistic experience, and a scientific branch of study that provides the means to a rounded and well-founded artistic spirit of enquiry and capacity for interpreting art subject matter: they are natural friends. By the same token, there is no danger of artistic anatomy study merely providing formulas for the creation and evaluation of art.

1.1.1. Preconceived notions about anatomy for artists: the rights and wrongs

Questions relating to this issue are very pressing for young artists, and for all people with an interest in art. Embarrassingly enough, artists of standing and reputation also fail to understand, instead interpreting scientific study as a corrosive threat, to rob their artistic plans and impressions of power and lustre! The form of artistic anatomy that I teach does not try to pass over prejudices, or to dismiss them as merely preconceived notions. Instead, I see it as my duty to seek out the causes of these prejudices, in order to understand why these misunderstandings and disharmonies have so inevitably arisen between art and science. After all, there must be reasons why cross-fertilisation between these two fields became so dubious. This situation of scientific methods and artistic methods of experiencing and revealing our world being treated as mutually exclusive studies with no business in each other's territory, of two once friendly fields becoming enemies, cannot have simply come about by accident.

There are plenty of obvious reasons why artistic thought – with its personal and emotional view of the world – might feel threatened by science and by the scientific mentality. There are also plenty of obvious reasons why art imagery, with its philosophy of unity between the human being and the world, might seek to exclude the fundamentally different method of understanding the world through dissection and analysis. After all, at some point in the past, anatomy began to focus on close observation, making dismemberment its ultimate goal and thereby losing sight of the objective of truly understanding the whole form.

Surely the dismembering, dissecting aspect of anatomy cannot help but be an obstacle in cultivating the skills of depiction? And yet no one can deny that the process of dissection can, in the wider sense, reveal the characteristic features of objects and of factual issues. The severance of art from science, and the gulf between the two, is a historic legacy, and the prejudices against anatomy for artists are the result of a historical process. All of the thorny issues are really rooted in a dark background created by dualisms and parallel existences, by the unconnected and oppositional attitudes to art and science, artists and their fellows, subject and object, content and form, the rational and emotional spheres, the body and the soul, the soul and the intellect, science and art. The cause of this lack of coming together, this oppositional attitude and hostile refusal to interconnect, is a matter for sociology, philosophy and the physical sciences; it cannot be addressed in this work on anatomy for artists.

1.1.2. Art anatomy's special relationship with science and with art

The problems with the relationship between anatomy and art can only be solved if anatomy for artists truly identifies with art positions, but without simply shifting its emphasis erratically between art and science. We must bear in mind that anatomy for artists touches on many other fields of knowledge, and that the transitions between these fields are very fluid, with no fixed signposting. Art anatomy exists at the meeting point of the two different forms of human world-understanding: at the intersection of science and art, where the two fields mesh with neither obscuring the other.

Art assimilates its world by thinking in pictures; this belief was first expounded by Aristotle, and was acknowledged by Lessing and Goethe. The same belief was popularised by Belinski in the 19th century, and was perpetuated by Lenin in the theory of reflection. The term 'reflection' is readily misunderstood; reflection is not repetition or reproduction. In a far more important sense, reflection is a form of universalising that is foreign to scientific logic, but which has a logic of its own (Schmidt-Walter). The universalising character of artistic depiction is not illogical, even though it does differ from the scientific view. An artist's understanding of the world is founded on the unified, holistic world of experience: what artists create, they conceive of as a whole, and this wholeness is expressed, not in multiplicity, but in unity. When anatomy interferes with this sense of wholeness by showing and describing human beings and their environment only in terms of their peculiarities and specific traits, then the wholeness is replaced by an illusory realism that shows us only the sum of the parts, and nothing more. To this extent, we might agree with Britsch's warnings against art becoming dominated by methodologies foreign to it, a falsely understood system of life study, 'descriptive measuring' – but only to this extent. Art aims to recognise particular and characteristic aspects that would remain unrecognised without art's own generalising, universal view. Through art, we learn to recognise and understand these aspects of reality.

We can see that there are two different sides to the thinking of image-makers: image-making is the reflection of objective reality by the observing subject. Art anatomy is primarily concerned with the objective aspect. It can teach observation to artists, but only by helping them to grasp the characteristic aspects and those governed by rules, thereby endowing them with a full intellectual understanding and with practical skills, and showing them how to express the essence of the studied object in abstract terms: this is the only possible basis for a communion of content and form. We are not trying to deny that art anatomy must start by providing an understanding of the facts: on the contrary, we stress that facts are the best starting point for a sequence of study that ultimately ripens into intelligent observation and investigation and real insight. Without a doubt, anatomy for artists has been amply doing its duty in transmitting facts ever since Leonardo da Vinci. Today, however, facts are not enough – in fact, they have never been enough. After all, in Leonardo's day, art was at its height, with all the resources of its own rich traditions and the culture that had fostered it to draw on: had this not been the case, an increased emphasis on anatomical instruction and research – which, in Leonardo's own case, went far beyond the real requirements of art – would probably have created problems for those engaged in producing art similar to those that we see in the modern age.

1.2. THE METHODS AND GOALS OF ANATOMY FOR ARTISTS: A HISTORICAL PERSPECTIVE

1.2.1. Anatomy's role during the Renaissance

There is no space here to fully discuss the Renaissance, which is a convenient conventional term for a vast number of dramatic economic, social, political and cultural events.

To depict a religious canon of sacred history, medieval art required only simple renderings of the human form – but this was not adequate to the needs of the new age. As a result, anatomy became a vital ally to the new art taking over the world; it paved the way for a new human image and a new humanism.

Not that the path to success was easy! Progress was obstructed not only by a dense barrier of ignorance, but also by opposition from the ecclesiastical authorities. The church vigorously opposed the new questioning of the formerly prevailing system of medical knowledge propounded by the Greco-Roman physician Galen (AD 129–211). Increasingly, art called for the dissection of corpses. Standard anatomy did not offer much useful information to artists, as it was concerned only with the internal organs, the lower body, the neck and throat area and the brain. No anatomist offered anything that was useful to artists, not even Mondino dei Luzzi of Bologna (1270–1325), whose compendium of anatomy had no illustrations. The work of the physician Jacopo Berengaria da Carpi (a physician of Leonardo's era who died in 1530) was similarly unsuited to the

specialised needs of artists, as was the vernacular book by Laurentius Phrysen in 1518, in spite of the increased scientific and visual clarity of his woodcut illustrations. What artists really needed was more precise information on the mechanisms of movement in the human body, its bone structure and musculature. Realistically, this could not be achieved by borrowing from the medical profession, and artists were therefore forced to perform this task themselves. We know that men of Leonardo's tutors' generation would have busied themselves with the dead behind closed doors and in morgues, exposing the muscles and the skeleton piece by piece with a knife. Amid the sickly smell of human flesh, opened corpses and the stink of corruption, a hitherto unseen new world was revealed to them: the world of the human being.

'For Mantegna and Signorelli, anatomical knowledge had the same significance as religion in the Gothic age. For the humanists, anatomical insights provide the atmosphere within which the breathing artistic life perfects itself, just as religion did for the artists of the Gothic era.'[1] Signorelli, however, did not see depicting figures based on an accurate understanding of anatomy as an end in itself: the gestures of his male nudes are the external sign of an inner state. The sharp lines and hard modelling reveal the clarity of his understanding, and his dedicated and effective observations [1].

These artists' achievements in advancing research are remarkable! By taking the science of the human body into their own hands, they inspired medical anatomists to think about how to visualise anatomy – a development that culminated in the triumphs of Leonardo, which, in terms of both objectives and method, far surpassed those of the medical profession.

1 Wilhelm Hausenstein, *Der nackte Mensch in der Kunst aller Zeiten und Völker*, Munich 1913, p. 47.

Fig. 1 Luca Signorelli (1441?–1523)
Reclining male nudes. Kupferstich-Kabinett, Dresden.
Signorelli's keen observation of the anatomy of the naked human body reveals the Renaissance artists' increased interest in naturalistic realism.

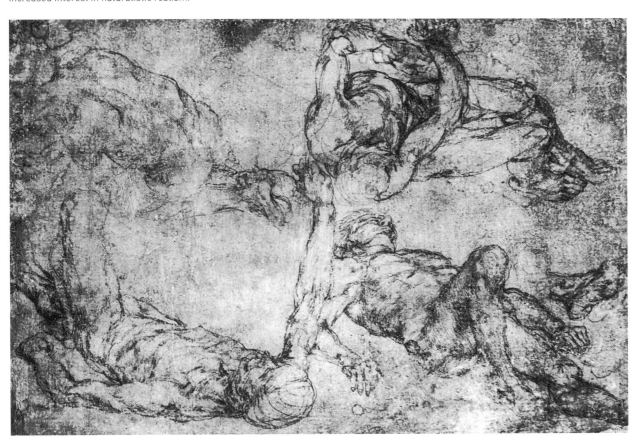

1.2.2. Leonardo: anatomist and teacher

Marcantonio della Torre, the anatomist of Pavia, initially engaged Leonardo to draw for his lectures. Their collaboration may have given rise to the ambitious idea of creating a 120-volume work on anatomy (in the event, only 799 drawings were created). In terms of teaching value, these drawings are as fresh as they were 400 years ago.

Leonardo speaks passionately about the vital necessity of observation. 'If you believe that the form of a human being, with all its members and in all of its different positions can be reproduced in words, then you must put this thought out of your head: the more precisely you describe them, the more you will confuse the mind of the reader … One must therefore depict as well as described.'[2]

2 *Leonardo da Vinci: Tagebücher und Aufzeichnungen*, Leipzig 1952, p. 35.

Leonardo also argued tirelessly for the dissemination of natural science's insights and for their harnessing for artistic purposes. He dissected over 30 corpses. Filled with humility, he would bend over the bodies of the destitute or condemned, undeterred by accusations: 'And you, O Man, who will discern in this work of mine the wonderful works of Nature, if you think it would be a criminal thing to destroy it, reflect how much more criminal it is to take the life of a man … and let not your rage or malice destroy a life, for indeed, he who does not value it, does not himself deserve it.' The message is clear, and this is also the essence of the Renaissance spirit.

No insight is possible without a concept of the objective facts [2]. Leonardo duly creates a clear picture of the armpit: he removes the covering skin in order to expose the muscle, and draws the armpit's major

Fig. 2 Leonardo da Vinci (1452–1519).
An anatomical representation of the armpit: a semi-schematic representation. This image was created circa 1510. The reduction of the muscle volume to thin strands allows a more precise insight into the processes, functions and intersections of the muscles.

Fig. 3 Leonardo da Vinci (1452–1519).
A representation of the principles of the throat and neck muscles. This image was created circa 1510.

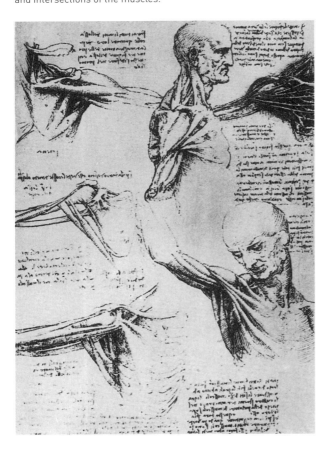

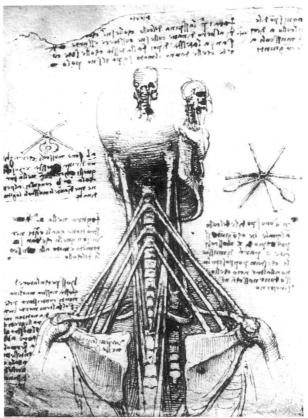

views, registering the condition of muscle definition and simplifying extensively to demonstrate the problem for instruction purposes.

His drawing has an abstract element: the muscles are shrunk down to thin threads. The result is a thread representation of muscle conduction that provides clear information on the origin, conduction and insertion of surface and deep structures, with all overlaps and functional interactions shown. He portrays the neck and throat muscles in the same way [3]. Without compromising the scientific content, he opts for a clear and simple teaching style: we can see the same penetrating simplicity today in the anatomical work of Kollmann, Braus, Benninghoff and Tank (and also within this book). Leonardo has consciously chosen this method of representation: he recommends it, and is evidently proud of what he has achieved: 'you will never get anything but confusion in demonstrating the muscles and their positions, origin and termination, unless you first make a demonstration of thin muscles after the manner of linen threads; and thus you can represent them, one over another as nature has placed them; and thus, too, you can name them according to the limb they serve.'[3]

His studies of legs [4] show the same removal of skin, muscle definition and thread conduction method; once again, he has checked the facts against examples taken from life [5]. We see the knee extensor muscle, with its curve emphasised on the thigh and modelled with deep darkness at its outer boundaries, and the flexor sinews positioned precisely in the popliteal fossa. On the lower leg, we see the tensed calf muscles: all of these are intimately tied to the leg's function. This is the ultimate aim of all art anatomy from this period: observation and

3 *Tagebücher und Aufzeichnungen*, pp. 31–33, 37, 41.

Fig. 4 Leonardo da Vinci (1452–1519).
A representation of the leg muscles as a thread image.
The artist's methods reveal the origins, insertions and three-dimensional layers of the muscles.

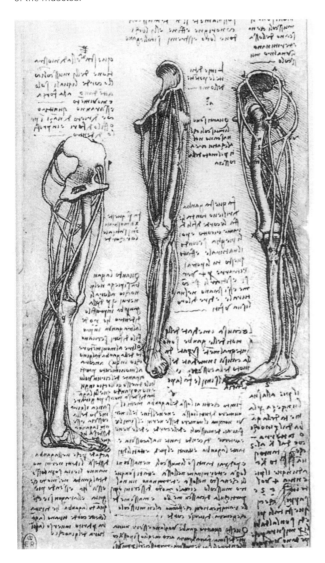

Fig. 5 Leonardo da Vinci (1452–1519).
A representation of the functioning of the leg.
To heighten the realism of their artistic representations, artists were urged to emphasise the functional movements and energies of the body.

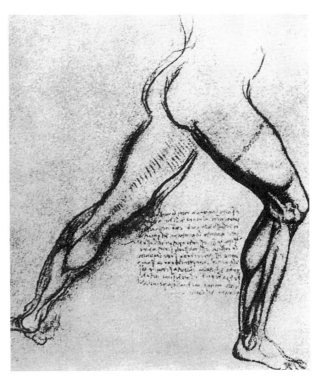

the learning of it through knowledge and science, in order to succeed in understanding how bodies function in movement even when a life model is unable to oblige.

In contrast to the unsparing detail of the close-up view, however, there is also the male nude that is consistently seen from the back [6]. Leonardo's sfumato reintegrated visual aspects to create a whole. 'Beware', he warned, 'of becoming a wooden painter'. 'The limbs that are not under strain should have no such display of musculature.'

We see Leonardo's greatness in the fact that, in making anatomical phenomena clearly visible, he also creates new scientific ways of demonstrating these phenomena, which would still be entirely valid today [5]. He elevated drawing to the status of a fully valid scientific demonstration or teaching aid (Heydenreich).

His achievements in the teaching of anatomy still stand up well today: his clear way of conveying an idea, his method of representing the course of the muscle from its origin to its insertion using threads, in order to reveal the results of the muscle's action, to create an overview of the intricately interwoven individual elements and his use of the cross-section to reveal the reason for the specific three-dimensional plastic features of the body's surface. The gains were enormous in terms of creating the ideal overview and three-dimensional view, and of creating systematic and comprehensible illustrations. Even more importantly, however, we have him to thank for the principle that research and depiction should proceed from one another. He fused together artistic praxis and its theoretical basis in the natural sciences to create artistic mastery, in which science and art were the offspring of the same spirit.

1.2.3. The muscleman figure: a dubious model for art anatomy

At this point in history artwork and craft work, artistic rules and aesthetic considerations alike were the preserve of the master artists, who would teach their students everything they needed to know during day-to-day work in the workshop. No textbooks were needed – that is, unless some highborn patron chose to 'study' with a master artist. This kind of situation provided the background to the book of anatomical drawings created

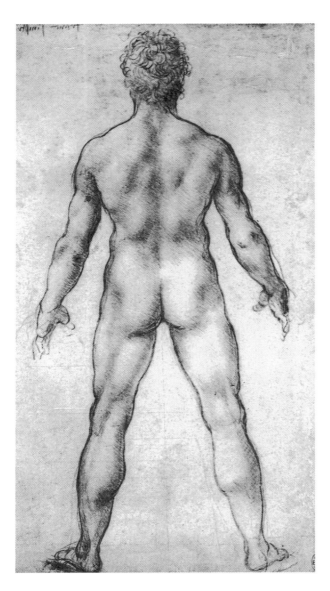

Fig. 6 Leonardo da Vinci (1452–1519).
Male Nude in Rear View.
In spite of the artist's outstanding anatomical knowledge, his nude studies run no risk of dissipating the overall artistic unity into additively recorded individual details.

by Rosso Fiorentino (1494–1540) for King Francis I of France. Fiorentino's arrangements of juxtaposed skeleton and muscle figures are intelligently judged [7]; the intention is to reveal how the bones affect the forms of the body's surface in a living human being, and the method would still have teaching value today.

One thing, however, is impossible to overlook: the muscleman figure has become the definitive method for looking at nature, and, indeed, the ideal perception of nature. Euphoria over the new achievements in research and a new adherence to natural correctness have begun to crowd out truly artistic concerns: the muscleman is becoming the ideal model. This has stubbornly persisted: it has become symbolic of the subject matter and methods of art anatomy. Insofar as we can infer a whole attitude from these ecstatically lit images of various muscle parts, with their crude emphasis and addition upon addition, they tell of the advent of the age of mannerism. Artistic form has been converted into an academic formula, and the mastering of the natural form through direct and intensive observation and research has been replaced by attempts to dazzle with erudition and intellectualism.

There is nothing new about objecting to a dry manner:[4] Michelangelo had to face the same accusation.

In any case, Tortebat (a 17th-century figure who will be discussed at a later stage) had to defend himself against the Paris academy students' opposition to the study of anatomy, which they believed could only lead to 'a raw and dry style, like Michelangelo's'.

1.2.4. Michelangelo: his influence on anatomy for artists

As Renaissance art replaced medieval art – the movement and principle rejecting two-dimensionality, along with the old imagery system in which human beings stood for symbolic notions, and which negated the body's physicality – anatomy for artists incorporated the new rounded view of human beings, the fleshy and corporeal aspect, into its researches and teaching.

4 Compare with Gottfried Bammes, *Das zeichnerisches Aktstudium in Werkstatt und Schule: Theorie und Praxis*, Leipzig, 1968.

Fig. 7 Rosso Fiorentino (1494–1540).
A page from the book of anatomical drawings, showing skeletons and muscle figures. The drawing of skeletons and muscle figures in similar postures was an attempt to convey information about the different parts of the body, and their effects on its form.

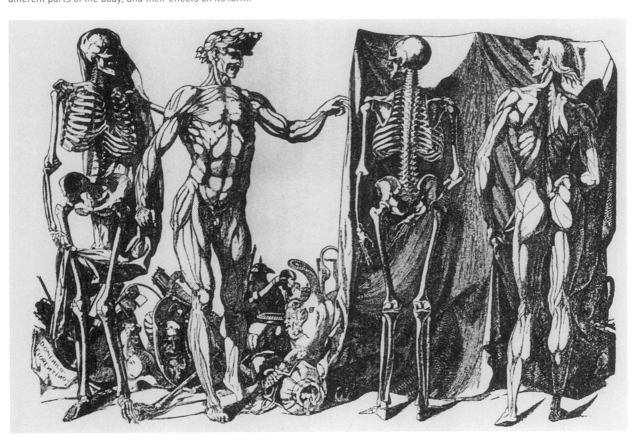

Given that Italy, the home of the Renaissance and the most progressive nation in Europe, could look back on a Roman heritage, is it any wonder that a Roman awareness of bodily qualities continued to resonate?

Michelangelo elevated the rounded and corporeal into a hymn of praise [8]. Like Leonardo, he looked to anatomy for scientific insights, dissecting until he became sick to the stomach. We do have anatomical drawings created by him, but his major project of producing a work on anatomy covering 'all types of human movements and postures' came to nothing. Michelangelo successfully acquired an extraordinary wealth of ideas of form that gave him the liberty he needed to impose postures and movements of unprecedented dynamic power upon his heroic figures: these postures, with their dramatically bold tensions, would be impossible for a model to even approximate to. In fact, he dismembered figures and put them together after his own fashion (Nebbia). The great insights available to him allowed him to overcome the imitation of nature and to cause the viewer to forget about anatomy – because it was always, for the artist, an immanent presence.

The seated male muscle figure attributed to Michelangelo by art historians of the 19th century [9] shows anatomy's remit very clearly: to define plausible positions and movements, and the body's three-dimensionality and physicality. This plastic seated figure has the same inexhaustible inventiveness of motion as the figures of youths in the Sistine Chapel paintings.

The elevation of the left arm, initiated by the rotation of the shoulder blade, the deep embedding of the lumbar spine into the back's extensor muscles, the pushing together of the muscle mass in the outer, inclined stomach muscle as the figure's torso leans sideways, the extreme tightening of the soft parts on the other side, the powerful outward arching movement of an immense rib cage compressed on the one side and extended on the other: all of these show a consummate knowledge of and mastery of sequences

Fig. 8 Michelangelo (1475–1564)
A study of a nude seated slave.
To design a heroic image of the human body, the artist made use of abundant experience of anatomical forms.

Fig. 9 Anatomical seated figure in motion (skinned or 'échorché').
The skinned, male body model (the muscleman, or the male muscle figure) was frequently used in academic art instruction and used to teach the features of the skeleton, the muscle volumes and sinews.

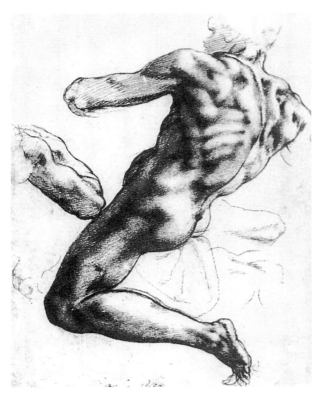

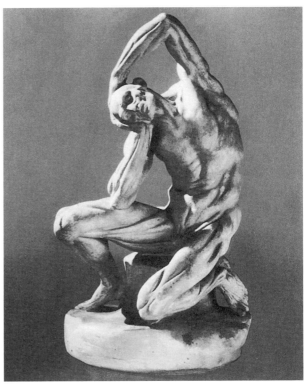

of movement, and also show what can be done through the ordering and arrangement of the primary and secondary forms.

Modern Italian anatomy had become a true anatomy for working artists, a practical resource for realistic expression. It was not a doctrine of art in its own right – nor does it aspire to be one today. Leonardo's art, for instance, never sprang solely from his researches.

1.2.5. The North: not a natural home for anatomy

Italy had never entirely lost touch with the nude figure. Art from Italy's past remained, and, under Italy's southern sun, the poorer people were often scantily dressed. One could still see bronze statues in the ruins of Rome: the Idolino, the Ilioneus (the torso of a kneeling young man), and the Apollo of Capo d'Anzio, which, as 'the highest expression of the ideals of art out of all the works of the classical age' (Winckelmann), was accorded a place in the Belvedere in the Vatican.

The torso of Heracles had been excavated near the ancient Theatre of Pompeii, and the Laocoön Group was dug out of the rubble at the Baths of Titus, inspiring a new passion for the glory of the human form.

Many artists were prompted to emulate, to fully explore this glory – and how better to acquire an insight into the human body as a living and whole entity than through a system of anatomy developed by the artists themselves?

Nudity was, of course, encountered less often in northerly climes. Dürer knew little of anatomy, in spite of a burning desire to share the knowledge that underpinned the work of his great artist contemporaries from beyond the Alps. He felt they freed his works from the narrow confines of the workshop: 'But how can one have knowledge of how parts of the body are designed to interact perfectly, if not by studying anatomy?'

He responded by copying Italian anatomy studies, and anatomy-based nudes [10]. This German artist did,

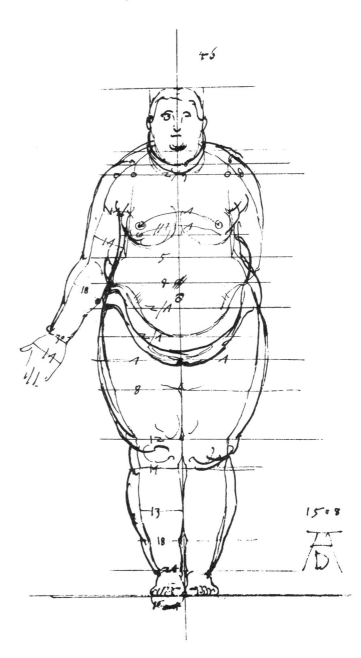

Fig. 10 Albrecht Dürer (1471–1528).
A schematic representation of a typical obese woman, from Dürer's major work on proportions. Drawing, produced circa 1505, taken from Dürer's Dresden Sketchbook.
With his discovery/construction of human types, characterised by a coherent formal language, Dürer significantly advanced art theory.

however, make a significant contribution to one field with multifarious connections to the study of anatomy: the study of proportions. In his work on proportions, he studied this issue and came up with the idea of human types with a shared language of body shapes.

1.2.6. Vesalius' anatomy replaces Leonardo's

Leonardo's anatomical teachings failed to achieve proper acceptance for decades after his own era. Marcantonio della Torre died of a fever in 1506, bringing to an end Leonardo's close partnership with this significant figure in the teaching of anatomy, and the era in which they had produced anatomical drawings together on the estate of Leonardo's favourite student, Francesco Melzi. For a time, Leonardo kept these drawings himself. In 1515, he went to France, in response to a call from the king, where he died four years later. Melzi saved his master's drawings, preserving them to be studied by men of art and science. Vesalius, the world-renowned professor of anatomy at Padua, would have heard of and perhaps even seen the drawings, and they may have spurred

him on to complete Torre's work himself. After his death, Melzi's papers were sold to the sculptor Leoni, who took this invaluable body of material with him on a journey to Spain – where two volumes of Leonardo's drawings and notes were recently rediscovered. It is probable that the Earl of Arundel indirectly acquired one of the three further volumes of studies in Leonardo's style for King Charles I of England, which remained hidden among old papers in a cupboard in Kensington Palace in England until the 18th century.

It was Vesalius (1514–1564) who discredited Galen, by conducting dissections and comparing what he found in reality with the old book-knowledge. He raised objections to false representations and incorrect views, assembled the first complete skeleton in Europe, lectured at Padua, and, jointly with his fellow countryman, Titian's pupil Stephan von Calcar, produced a new work on anatomy. Published in the year 1543 in Basel and featuring many excellent woodcut illustrations, *De humani corporis fabrica libri septem* was a worldwide success [12]. Its illustrations of the mechanics of movement were so forcefully convincing that they can also be found in art anatomy books

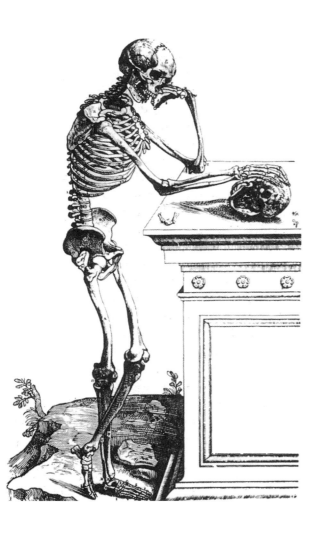

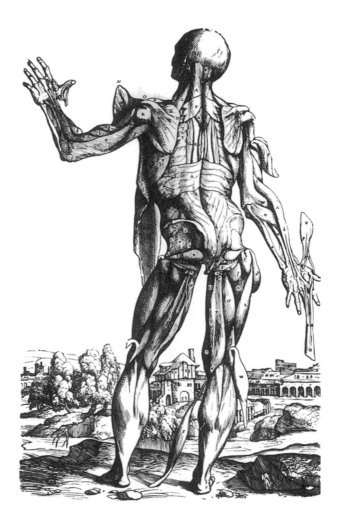

published many years later, as they were still the most visually clear, eloquent and artistically excellent illustrations available. The *De humani corporis fabrica libri septem* remains a shining example of science unified with art.

Never before had anyone represented a skeleton with such clarity – not even Leonardo. Of course, a complete, rigidly mounted skeleton had not previously been available for study [11]. But what an achievement for an artist to so swiftly translate this into living movement! The upper body is leant slightly forward, and the rib cage telescopes toward the floating ribs. All of the different parts fit together organically. The head of the weight-bearing hip joint fits firmly into its socket.

The mechanics of the bent knee, the ankle, the shoulder girdle, the elbows or wrists – in every case, the skeletal forms accurately demonstrate the governing principles, and the typical features, in accordance with their purpose. This is more than merely an imitation of nature: Vesalius' work comprehends and reconstructs intellectually. This approach was lamentably absent in later times.

Fig. 11 Andreas Vesalius (1514–1564). A skeleton in dynamic contrapposto pose from Vesalius' 1543 work on anatomy, *De humani corporis fabrica libri septem*. This anatomical work was a high point in anatomical representation (artistic and scientific), and continued to benefit academic studies for many years to come.

Fig. 12 Andreas Vesalius (1514–1564) Rear view of a male muscle figure. One peculiarity of this visualisation is that individual muscles are detached at their origins, in order to gradually reveal the different levels of musculature.

Vesalius and his artists deliberately set out to teach anatomy, and later efforts in the field would find it impossible to evade the sheer power of their work, which remains a high point in the history of art and of medicine.

1.2.7. Improvements to anatomy for artists in the 17th and 18th centuries, and the first textbooks

Artists in the 16th century had to fight for social and intellectual emancipation, and for emancipation from guild-related restrictions and constraints. Previously, students would train in a master's workshop, and 'would learn nothing of which the how and the why were not comprehended simultaneously' (Ludwig). All the theoretical knowledge they might require would be quite literally passed on hand-in-hand with their practical lessons, as part and parcel of the praxis of art. Breaking free of the social and intellectual strictures of the so-called 'mechanical arts' (artes mechanicae) espoused by the guilds and conquering the 'liberal arts' (artes liberales), however, called for a special emphasis on the theoretical aspects of the art lesson. From Leonardo's text on painting I/53: 'Practice must always be founded on good theory... those who are engaged in practice without theory are like sailors who board a ship without rudder and compass.' Dürer also broke with convention and with mediaeval craft-based traditions and practices in favour of 'art' as elevated to the status of a science by the new theories of the Renaissance (Waetzoldt). The guild's monopoly on the teaching of art had now been successfully broken. The Baroque era, with its new philosophy of art, created its own training institutions: the art academies.

The great Renaissance flowering of art had already passed away when the art schools – which began as free artist associations – first came into being: the Accademia e Compagnia delle Arti del Disegno in Florence (1562); the Accademia di San Luca in Rome (1593); the Accademia degli Incamminati in Bologna (circa 1583); the Académie Royale de Peinture et de Sculpture in Paris (1648); the Rome branch of the Paris academy, the Académie de France (1666); the Akademie der Bildenden Künste in Nuremberg (1662); Akademie der Künste in Berlin (1696) and many more. The master–pupil relationship was gradually giving way to a teacher–student relationship. Lessons became a distinct and independent form of teaching, resulting in a need for teaching books. In the Baroque era, improved education was furthered by absolute monarchs who wanted to enhance the quality of their 'children's' artwork and craft work to increase national revenue.

The Academy of Antwerp opened in 1643, three years after the great Flemish painter Ruben's death. He left a guide to drawing featuring twenty engravings by Pontius, published in Antwerp [15]. The eight anatomical depictions show the Baroque quest for expression, but convulsively intensified. They completely disregard the actual facts of nature. We see swelling muscles that do not exist, put there only to make the surface more dramatic, with plenty of inaccuracies and distortion in the muscle origins and insertions. Drawing

lessons amounted to copying sample material – as is revealed by Abraham Bloemaert's manual on drawing, published in 1655 [13]. Today, this philosophy of copying is criticised for offering no worthwhile knowledge, and for promoting a smooth, facile and artificial style – although, in fairness, copying does have some real value. In his *Anweisung zu der Praktik oder Handwerk der allgemeinen Malerkunst* published in 1669, Wilhelm Goeree outlines a methodical step-by-step process: first, one must acquire the basics by becoming acquainted with perspective, in order to master the right forms and proportions – with the assistance of copying exercises, for which plenty of copper-engraved studies of heads, hands and feet are available.

In order to better understand the turnings of the body during the copying process, one would have a wood-turner make an egg-shaped form, and then depict the axes of the mouth, the nose, the eyes, etc. on it. 'In this way, one can teach the student about all kinds of transformations of the cross-axes ... Otherwise, he will simply learn as a parrot learns to talk: without sense.' It should be said that this was not new: Holbein and others had given hints on the spatial perception of bodily volumes [14].

Goeree goes on to say that the first phase – the copying of well-executed sketches – is also the time when students should gain a sense of how things fit together, 'a judicious certitude of the features'. Anatomy does, of course, figure prominently in Goeree's wide-ranging theorising. 'The human being is the greatest masterwork of divine creation. Of all objects, it deserves the greatest care and effort, as is unanimously attested by dissectionists or Anatomici, that the revelation of the human image, both due to its movement and the harmony of the members is an amenable object or template for art, through which one can rightly recognise the miraculous works of God and nature...'[5]

Movement and dynamism are the supreme principles of the Baroque era [15]. Expressive gestures also featured as teaching objects in drawing lessons, which always included their basis in anatomy. Physical movement was equated with being moved in spirit. For the first time, the models used in drawing incorporated 'pantomime', or whole-body gestures (expressing states such as desperation, shock or horror) which feature in all drawing instruction materials and teaching books of the Baroque era. 'Mimic' studies (studies of facial expression) inevitably followed.

5 Wilhelm Goeree, *Anweisung zu der Praktik oder Handlung der allgemeinen Malerkunst*, Hamburg 1678, p. 42.

Fig. 13 Abraham Bloemaert (1564–1651). Drawings of arms and legs set as copying exercises.
A Dutch mannerist and co-founder of the academy of Utrecht, Bloemaert regarded the old-fashioned copying method as a valuable teaching exercise.

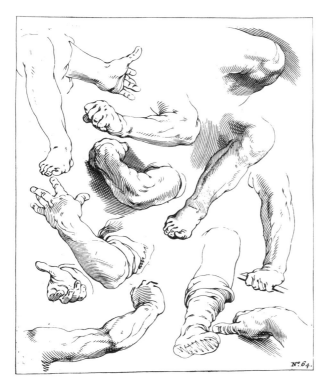

Fig. 14 Hans Holbein the Younger (1497–1543). Perspective studies of heads and hands. Reducing complicated forms to create maximum simplicity in body structures is a proven method used in drawing classes, and by individuals studying drawing.

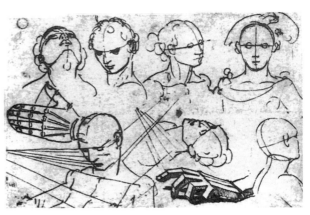

In his *Gründliche Anleitung zur Zeichenkunst,* Gerard de Lairesse (1641–1711) demanded that artists should interpret their models with 'passion and expression' [16]. Joachim Sandrart (1606–1688), one-time head of the academy at Nuremberg, speaks of 'affects or stirrings of mood' in his work *Teutsche Akademie* (1675), claiming that 'the mimic' (facial expression) must move the heart like eloquence.

The more successful and refined a thing or a piece of art is, the more effective it is in moving us.'[6] Henri Testelin, first secretary of the academy at Paris, made enough notes on painting and drawing to fill a small book with his rules and formulas. Chapter III, 'Of expression and strong presentation of actions' states: 'That which creates a stirring in the soul also drives a body to action. The muscles expand or contract according to the quantity and strength of the spirits of life contained within them'. He goes on to make a number of remarks about the expressive attitudes appropriate to the highborn, to common people, and to angels!

Daniel Preissler's *Gründlicher Anleitung zur Zeichenkunst* (published for the seventh time in 1750), similarly contains a set of general rules for capturing movement when copying model drawings, or for creating drawings based on classical works of art. For instance, one should mark out the relative positions of the joints and connect them in stick-figure fashion, thus obtaining the basic expressive character of the figure's movement; these angled lines will also help to give the figure the right proportions. This is a technique still useful to teachers and students today [18].

Le Brun, the quintessential patriarch of art – who, having succeeded in his fight against the guilds (or *maîtrise*) in the name of free art, founded the Académie Royale in Paris – produced the most exhaustive work on emotions that has ever existed. His semi-schematic representations of facial expressions present entirely valid observations based on experience, with great simplicity [19].

However, we are getting somewhat ahead of ourselves in terms of history. The first real art anatomy teaching book (dating from 1668) was written by Tortebat, a member of the Paris Academy. In 1706, a translation entitled *Kurtze Verfassung der Anatomie* was published (Rüdiger, Berlin) for the pupils of the Akademie der Künste (founded in 1696).

Tortebat's primary conviction was that his book would bring anatomy and art closer together, by excluding all

6 Sandrart, *Teutsche Academie*, Frankfurt 1675, p. 78.

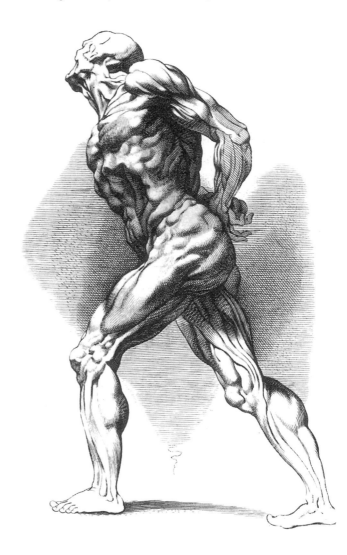

Fig. 15 Peter Paul Rubens (1577–1640).
A muscle figure taking a step forward,
from Rubens' drawing lessons.
The artist was not averse to
compromising scientific reality by
adding invented muscles to his
anatomical figures.

superfluous medical details and covering only bones, muscles and the mechanisms of movement. In other words, his book represented too little of a good thing. He used Vesalius' illustrations, arguing that they were the best available. It appears that he was writing during a period of decline in anatomy, as this would explain his defensive position, his barbs and polemical sideswipes against anatomical ignorance: 'I seem to hear a number of people objecting, saying: "What is the use of taking so much trouble over anatomy?"', thereby risking developing a dry manner – like Michelangelo's. The view that one can learn from life alone how the muscles should be outlined is false, he tells the naysayers: 'neither spending your whole life drawing from nature nor imitating old models can help you'. He calls for the restoration of the vital image-making skills, saying that the state of the anatomical drawing gave plenty of indications of the current state of artists' understanding of anatomy. Drawing would give a proper account of how the understanding of things had advanced. Truly, progress was being obstructed by prejudice!

Things are not much different today: many artists still feel that anatomical studies are a waste of time, are deterred by the obscurity of medical anatomy and its vast mess of useless information, or insist that they can depend on their own senses. 'You think that you have strong legs, and that you will go far. But you are like the blind, stumbling from one ditch into the next...' Tortebat insists that anyone who wishes to do so can get a grounding in the sciences, as long as practical work is alternated with theory. 'Thought must provide the basis for exercises, just as exercises fix and ground thought.'

However, Tortebat (who, incidentally, was not motivated by any need to make a living from anatomy) also warned, quite intelligently, against overrating anatomy: 'Alone, it can achieve little in terms of creating something truly beautiful. Again and again, the gaze must be turned on well-formed life.' In other words, one should never simply think about anatomy in the abstract – the artist must always return to looking at the living.

Fig. 16 Gerard de Lairesse (1641–1711). Gestures expressive of emotion, from *Het Groot Schilderboek*, which was published by the author's son.
The capturing of disturbances of the mind through gestures, with their different features, is characteristic of artistic training during the Baroque era.

Fig. 17 Johann Daniel Preissler (1666–1737). Figures from the drawing manual *Gründlich verfasste Regel* (published for the seventh time in 1750). The locations of the joints are marked by dots.
This way of marking the joint positions and connective lines makes the rendering of movement more elementary, making it easier to copy set drawings.

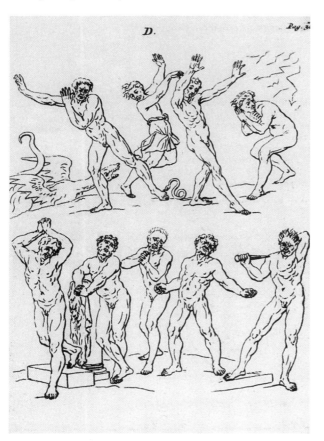

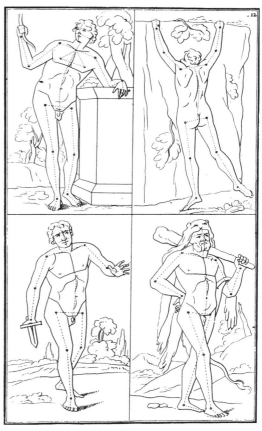

1.2.8. Anatomy for artists becomes a study in its own right

A hundred years after the publication of the French edition of Tortebat's book, anatomy was no longer the domain of art tutors. In the 18th century, theory and praxis began to diverge. Anatomy ultimately became a separate subject of study at the academies, disassociated as far as was practicable from medical science. A specific body of teaching content was defined and systematised. It is a testament to the subject's new independence, that the first teaching and drawing books completely dedicated to the subject were produced at around this time. This separating of anatomy from the unified body of artistic study was due partly to the increased autonomy of theoretical anatomy lessons, but also to anatomy's increased significance as a supplementary science. This was an asset in some ways – but in other ways, it became a liability. In the Renaissance, when artwork and craft work first began to separate, the crafts were nonetheless still artistic, and the arts lost none of their craft skills, because all of the elementary disciplines were united in the person of the master artist; this comprehensive knowledge prevented the gulf between artistic praxis and theory from becoming any deeper. Baroque-era artistic training, on the other hand, divided its curriculum into different subjects. The Baroque academies turned increasingly to the 'science' of art, over-emphasising teaching. Their halls began to be overshadowed by taught ideals of the 'right' way of depicting a human body.

The anatomical instruction available to artists in the late 18th century is not impressive or inspiring. Pierre Thomas Le Clerc's *Principes des dessins d'après nature* of 1780 is symptomatic of this; it passes smoothly over the surface of art and science alike. It is not fit for purpose even within the sphere of teaching; it reflects the era of Fragonard and Boucher, of fragrant and charming nude feminine compositions whose

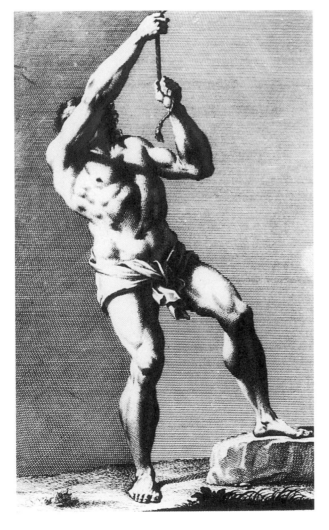

Fig. 18 Johann Daniel Preissler (1666–1737). Set drawing showing the characteristic movements of a nude male figure pulling on a rope, from the 1750 drawing manual, engraved by Georg Martin Preissler.
The detailed rendering of the body, and the mastery of depicting of emphatic movement, spring partly from learned elementary skills (see Figure **17**).

Fig. 19 Charles le Brun (1619–1690). Facial expressions, from a small teaching book on emotional expression.
The artist renders the characteristic features of facial expressions in a very simplified form, based on empirical observation.

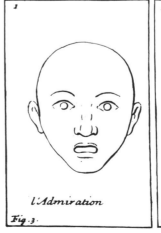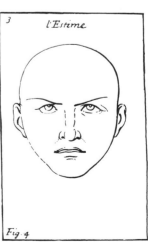

charm cannot hide the era's dilution of real anatomical understanding. [20]. Careless teaching had given rise to an anatomy that was increasingly out of the hands of artists, who ultimately left it to official medical men such as the polymath Petrus Camper of Groningen (1722–1789) and the court physician Dr Seiler in Dresden.

When Ludwig Christian Hagedorn (1763) presented proposals for the structure of a prospective new academy to his lord, the ruler of Saxony, he excluded anatomy as an autonomous subject of study from the curriculum of elementary artistic instruction, and recommended it be entrusted to a non-artist, 'as the study of bones and muscles is a matter for a skilled surgeon'. His recommendation was followed. Seiler was a natural choice. After all, he had produced a *Naturlehre des Menschen für Künstler und Kunstfreunde*, which he now intended to adapt for the needs of artists. The Königliche Akademie hoped to

unite theory and praxis by having students draw freshly surgically prepared cadavers.

Exercising and applying the knowledge rather than simply offering theoretical information represented a great stride forward, and was a suitable approach to an important subject of study. But in spite of everything, the major question remained unresolved: how to bridge the gap between objective representations derived from the physical sciences and the world of art. If we move forward in time to our own era, this problem is still evident in works on anatomy. The authors themselves are very much aware of it, but do not know how to solve it – and this is what the author of this work is setting out to rectify.

It is interesting to note Seiler's era's intellectual parameters for anatomy in artistic activity: 'Any representation of any particular object calls above all for the art of representation, as its purely artistic aspect, followed by a scientific acquaintance with the

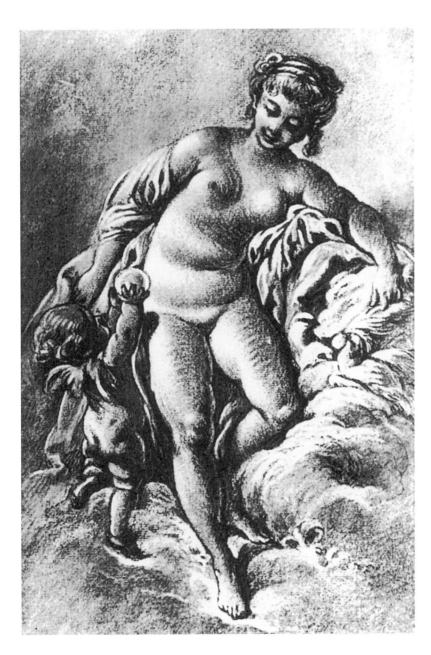

Fig. 20 François Boucher (1703–1770).
Venus with the Doves.
Albertina, Vienna.
A superficiality in the study of body forms is also reflected in the anatomies, which are ultimately interested solely in externals.

represented objects. The more multifaceted the artist's scientific education, the wider the scope of his art; one therefore cannot define the boundaries of an artist's scientific education, but only generally distinguish those [areas of artistic study] that are indispensable for art and are needed by all artists, such as a knowledge of anatomy and perspective ... The indispensable supplementary sciences such as anatomy and perspective, which are most easily learned when an artist applies them regularly, can be combined with the academy's other classes' (Prof. Matthäi to Count Vittzthum, 1816). The Dresden academy professor goes on to say that public lectures on the supplementary sciences rarely achieve their purpose, especially when artists do not make use of the knowledge they impart on a regular basis. 'Holding these lectures will bring no benefit to the majority of the students, unless they readily have occasion, not only to be convinced of the usefulness of the lesson by applying it, but also to consolidate their understanding of it through practical exercises'. (Academy files number 12, Landeshauptarchiv, Dresden).

Fig. 21 Dr. Wilhelm Burkhard Seiler. Classical artworks with skeletons drawn in, from his *Handbuch der Anatomie des Menschen* (1850).
The painstakingly drawn-in skeletons are a 'posthumous' scholarly artwork analysis to aid in understanding the shaping effect of the bone structure on the body's form.

1.2.9. Intellectual narrowness and new factors in anatomy for artists in the 19th and 20th centuries

Seiler was appointed to his post in 1822. The first lessons based on his anatomy textbook took place in 1850. Its anatomical figures were of unparalleled accuracy, and there were even a few drawings contributed by his friend Carl Gustav Carus. The new textbook marked the return of morphological studies and representations of the proportions for both sexes and for non-adults, addressing features of the different forms outside the constraints of any fixed canon of proportions. In a similar morphological vein, Seiler elaborates on depictions of classical statues, using clear analysis of the skeleton to reinforce analysis of the plastic forms [21]. He was a judicious and purposeful teacher. However, interest in his lectures gradually declined. Surely this remarkable man was not unsuited to helping the young artists with their uncertainties and dilemmas? Perhaps his own lack of artistic talents meant that he was unable to fulfil the

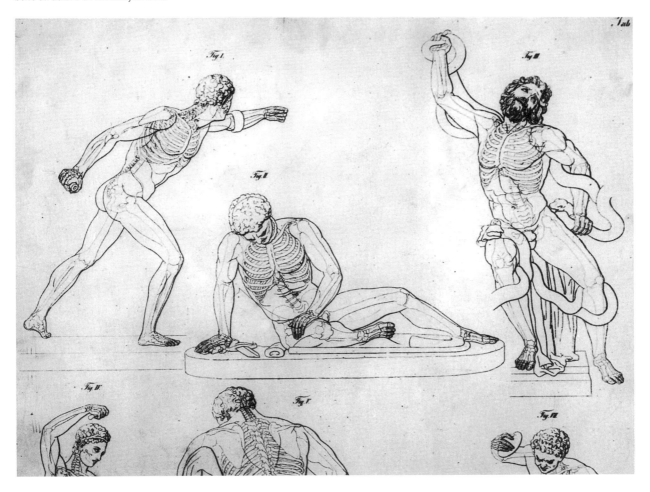

basic requirement of helping students to consolidate what had been learned through practical exercises? Or perhaps, then as it is now, the split between actual art training and the supplementary sciences created problems? In any case, around one hundred years went by before another significant, fresh development in art anatomy occurred. Precise factual drawing had by now become well-established in European works on anatomy, which now covered the living skeleton and analyses of the muscular systems of figures and artworks. Major works on art anatomy had been produced by the French author Paul Richer (1890), by the English author John Marshall (1888), and by Brisbane (1769) [22], plus *Die Gestalt des Menschen* by Fritsch, Harless and Schmidt (1899), with its chapters on facial expressions and moving bodies, its anthropological tables and cinematograph images of different gaits. Kollmann's comprehensive work (Basel) was published four times between 1885 and 1928; it included photographic nudes as a replacement for specimen drawings, and as a demonstration tool.

The rigid adherence of all anatomy teaching to painstakingly describing details, interpreting the features of the body's surface and accurately capturing the appearance of human bodies in single fleeting moments up to this date was only partly due to an impressionist/naturalistic artistic philosophy: art anatomy was affected by the prevailing teaching and learning principles as well as prevailing artistic attitudes. A modern realist abstract art philosophy seeks to capture the crystallised essence of its subject, and depends upon the direct experience method, on observing from life and gaining a precise and comprehensive knowledge of objects. Without this knowledge, an artistic depiction cannot be universal enough to depict the sensory totality of the depicted object. Anatomy for artists should always impart the facts, but these must be a starting point only. Next, the facts have to be pared down in order to highlight the true essence: in other words, analysis should be followed by synthesis. Art anatomy, today as in the past, has never provided enough information about the

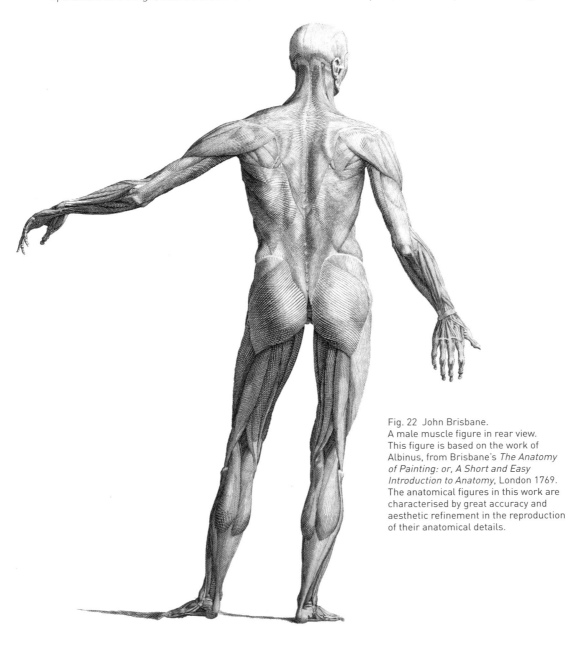

Fig. 22 John Brisbane.
A male muscle figure in rear view.
This figure is based on the work of Albinus, from Brisbane's *The Anatomy of Painting: or, A Short and Easy Introduction to Anatomy*, London 1769. The anatomical figures in this work are characterised by great accuracy and aesthetic refinement in the reproduction of their anatomical details.

different stages and objectives for bringing together the natural sciences and art, and how best to implement them; hitherto, the discipline has been insufficiently aware of the necessity.

This is partly because of the separation between science and art, and the different views of art that prevailed before and after the turn of the 20th century; at the dawn of the 20th century, the artist's own subjective vision began to be considered the defining essence of art. Corinth's handbook *Von Erlernen der Malerei* only goes to prove this – he includes ten pages on the characteristics of nudes in art, with very bad anatomical drawings. Both scientifically and as teaching aids, they could hardly be any worse. Notwithstanding this, Corinth, as a teacher, tries to find teachable material to rely on. He tries to explain the facts, and, ultimately, is trapped by his era's most quintessential contradiction:

'I hope that these descriptions of [anatomical] details will allow the creation of knowledgeable nude drawings. If anyone were to ask me "To study drawing, is a knowledge of anatomy absolutely necessary?" I would answer: "No, it isn't."

Just as a person with the right sense can tell us at once that something is wrong in a drawing, even if he had never seen a naked human body, so too a talented beginner will instinctively know what is right, based upon artistic feeling. This is one of the signs of ability ... Knowledge is for making it plausible, to yourself and to others, that objects are drawn in the way that they are, and not in a different way.'

And yet institutions of artistic education are lucky if they encounter such a genius who 'instinctively knows what is right' once in a decade!

Individual part views and close-up views, rightly distrusted by artists, had to be discarded if art anatomy was to move forward. Medical anatomy had long since realised how these failed to meet its own needs (Benninghoff). Additionally, there was an ideal tool available for re-establishing interconnection: to produce a unity of form and function. Now that the right conditions had been created, this decisive step was ultimately taken by Siegfried Mollier. In his book *Plastische Anatomie*, this German anatomist, who taught in Munich, presented anatomy's interconnections for students of the visual arts. Unfortunately, in spite of his awareness of the needs of artists, he confined himself to the natural sciences, thereby excluding many important matters: proportions, static and dynamic properties, and the head, along with facial expression. His approach was too one-sided, restricted to the functional arrangement of the mechanisms of human movement. In achieving the goals he had set himself, he bypassed any discussion of how to understand the human form as a bodily, corporeal structure engaged in spatial interrelationships, or the function of individual details of anatomy in creating the human form's three-dimensional shape. He also, understandably, did not see the need to discuss contextualised interrelationships of form.

In spite of this, he will forever be remembered for his insights into the mechanics of the joints, into the unity between their physical construction and their effect, into the interactions between this construction and our body's motive forces, and because he laid the foundations for a new way of thinking about our body's form. He detailed the needs and requirements of each body part, thereby finding the key to a solution in the essence of each body part's form, its constructive character, and forcing a move away from describing inessential details. The artist who drew the illustrations understood how to simplify and streamline the body's real features [23]. Taken as a whole, Mollier's book contributed to a new understanding of body forms as architectonic forms, and to a move away from mere imitation – thus marking the beginning of a new and productive approach.

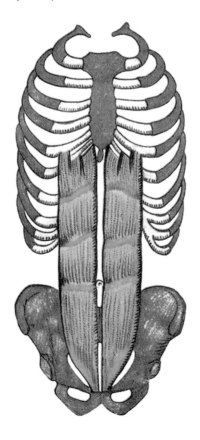

Fig. 23 Siegfried Mollier (1866–1954).
An illustration from *Plastische Anatomie: Die Konstruktive Form Des Menschlichen Körpers*, Munich 1924.
This representation of the straight abdominal muscle is one of many examples of Mollier's simplification of anatomical forms and avoidance of a purely descriptive treatment.

He replaced vague notions of the body's structure taught within the confines of the artist's studio only with compelling observations of the very essence of the organic form, based upon its constructive properties. A student of the physical sciences had broken the dominance of static and purely descriptive images in works on anatomy for artists. Mollier's simplified constructive forms – of skeletons at rest and in motion – had put an end to the notion of the human body as a series of isolated 'points'. So, was this a real breakthrough?

Some ambitious artists did embrace Mollier in the 1920s and 1930s. However, much of the artwork produced during their era and the times that followed remained scientifically and artistically unsound – and this is still true today.

Tank, who was inspired by Mollier, produced a work on anatomy for artists entitled *Form und Funktion* (1953). As a work on the anatomy of the bones and muscles intended to communicate pure anatomical fact, one is forced to acknowledge its clarity, its scientific correctness and good presentation [24]. Tank dreamed of an 'eternal' art anatomy: for this, the physical sciences must be the basis, particularly given the unlikelihood of further advances in scientific

understanding of the mechanics of human movement. He argued that the human form had to be interpreted from this standpoint, and not according to the demands of art – because these change constantly. Now, certainly, we do not think that art anatomy should be based upon any specific fashion in art, or a particular attitude to art. But we do think that it should be based upon an understanding of the nature of artistic creation. And it is an essential characteristic of art and the way art treats images not to simply depict and reproduce its object, but to create from that object something universal. Art anatomy lessons can therefore never be about the human body solely viewed as the sum of its parts.

Tank, however (along with many others) put all his efforts into promoting the 'sum-of-the-parts' view. Why else would they want their nude drawings to consistently include the events of skin removal – findings extracted piece by piece from dead bodies, demonstrated on images of living bodies? Supposing Tank's nudes were intended purely to help the reader to understand anatomy; the fact that he adds individual physiognomy features to these inventories of the facts relating to the outer surface of the human body leaves the student no choice but to assume that the

Fig. 24 Wilhelm Tank (1888–1967).
A nude study from his 1953 work on anatomy *Form und Funktion*. Tank made a muscle figure, resurrected and given a skin and the appearance of a life drawing, the basis for a naturalistic life drawing method.

Fig. 25 An illustration from a Chinese-language edition of a French art anatomy book. This image is typical of the book's method in that only the external properties of the nude forms are described.

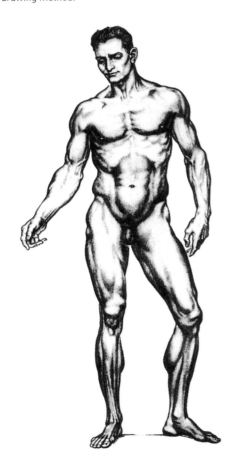

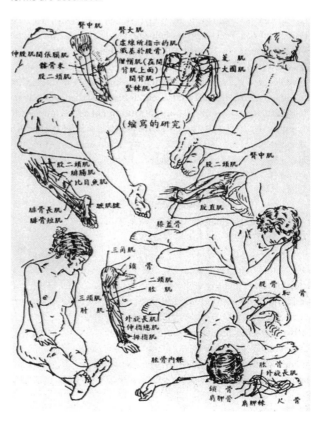

muscle figure is intended as an aesthetic norm, and as the embodiment of an achievable study goal. The muscle figure – in this case, the 'living' muscle figure – has, once again, become the symbol for the whole curriculum of study. Non-artistic interests have invaded artistic thought, have invaded what we described at the beginning of this book as the business of experiencing the relationship of the human being to the world holistically. Now we can see why the art world is so dismissive of, hostile to and prejudiced against art anatomy books!

The work on anatomy for artists by the Russian expert Nahum Mechanic[7] is an effort to explain the appearance of heads depicted in a painting (Repin's *Cossacks of Saporog* picture) using medical facts: by means of muscle and skull analysis. The concept behind this idea is hopelessly naturalistic, as are the book's actual illustrations of bones and muscles, which provide no information on their action, construction or physical properties. The extensive and well illustrated book on anatomy for artists by the Romanian intellectual G. H. Ghitescu (1963) is similar, and fails to break away from this fundamental attitude – as does Meyner's book on anatomy (third ed., 1956).

Equally, however, the science/art relationship is lost when key scientific information is abandoned, and the student is simply handed formulas to make up. In our present day, a Chinese-language edition of a French anatomy book shows how to 'do' bodies lying on their bellies, on their backs, on their sides and in a twisting position [25]. Beyond some minimal interpretation of the bones and muscles, this book offers no insight and no concept of the physicality of the body as it exists in three-dimensional space, just bald statements of the body's shape. It is, without a doubt, right to present the skeleton as key to the human form; purely abstract representations used as a teaching aid, however great the degree of abstraction, must always retain a factual, scientific core.

1.2.10. Some critical remarks on Anglophone anatomy for artists

The availability of art anatomy books, and other aids to figure drawing that extensively reference basic anatomy, in the English-speaking world is astonishing. Previously, the irresistible rise of non-figural art banished all artistic aids, and even the learning of drawing skills in general, from the training and educational resources used in art classes, but this has now declined, leaving the way clear for a rethink of the value of technical skills in the arts and crafts.

Keen to remedy or even reverse this loss of basic skills, publishers and authors have addressed themselves once again to the teaching and learning of the fundamental artistic curriculum. This urgent need to make up for the shortcomings of the past may well have been what prompted British and North American publishing companies to reprint older works on anatomy, a trend that continues to this day.

7 *Osnovy plasticheskoj anatomii*, Moscow 1958.

Foremost among these is the book *Art Anatomy* by the Englishman William Rimmer (1816–1879), a sculptor, painter and art anatomist who lived in the USA, and was invited to lecture on art anatomy in Boston, where he embraced his role as educator with enthusiasm, and, by his own account, opposed the decline in human anatomy knowledge among artists. He believed in the benefits of artistic instruction and painstaking practice; significantly, he claimed that no one had truly mastered the figure until he could draw it from the imagination, as it were, 'in the act of falling' – according to Ingres, the true test of draughtmanship. Rimmer enjoyed a considerable reputation in the USA, where his anatomy studies were likened to Leonardo's in that they were works of art in their own right. The foreword to the 1962 edition of this book dating from 1877, published by Dover Publications Inc. (1972), declares that: 'We want more objective information now, truth without beauty.' The question is: if it is to be really worthwhile, what should the goals of a revival of anatomy for artists be? This vital ability of drawing a figure, as it were, 'in the act of falling', requires that the artist internalise certain organic structures and forms, and this internalising process requires images of real value to the internalising mind: memorable images. I see the same semantic content – that is, the nature of a representational form being equated with the correct fulfilment of a task – in the dialectic of the unity of form and of function. This question of the right methods and goals for learning to internalise the human image is one that Rimmer – in spite of his own brilliant mastery of the human form, and all of the variation in its physiognomy, its prominent features and expressions – never found an answer to.

Later publications shared this deficiency. In his 1904 book *Figure Drawing* (reissued in 1965 by Dover Publications Inc.) Richard G. Hatton tried to do away with painstakingly exact renderings of anatomical details useless to artists. The simplified images in this book, however, are more like visual impressions, and are individually optical in character: the construction of body forms is, once again, stifled by plain description. Rendering even the body's structure and skeletal shapes as impressions based on no practical proof, with no distinctions drawn between the important and unimportant, essential and inessential details, forces artists to depict nature from scratch each time. This approach therefore offers no way of advancing. When anatomy does not offer real insights and knowledge – when the essential anatomical facts are refined out based upon somebody's personal notions, rather than highlighted and simplified for clarity's sake – then artists really are better off without it. When things are not explained 'beginning with the inside', as it were, one is stuck with watered-down 'surface' information, and a formulaic approach that endangers real artistic skill.

A real 'Constructive Anatomy' was required to redeem this, and a book on anatomy by George Bridgeman appeared in 1920 under that title (reissued by Dover Publications Inc. in 1973). Most disappointingly it featured no constructions, only purely subjective visual simplifications that offered the graphic artist neither notions of, or insight into, actual constructive forms,

things that can and must be derived from any living structure – nothing to help escape optical imitation or to develop the kinds of skills that can be freely applied. The abbreviations and signs that we use to check the facts when working with models are only made possible and real by our precise and comprehensive acquaintance with the facts: their orderly arrangement, the way they interconnect, and the simplicity that is made possible by a knowledge and understanding of complex anatomical structures. Bridgeman's book, however, completely fails to support, in any respect, his absolutely correct thesis that architectural principles are articulated in the bones of the body (the dome of the head, the arches of the feet, the pillar-like structure of the legs, etc.) and that mechanical laws apply to the hinges of the elbow, the leverage principle of the limbs and so on.

The methods used for the practical teaching of anatomy at a USA art academy are revealed to us by a book entitled *Art Students' Anatomy* (published in 1935 and reprinted in 1961 for Canada and Great Britain) by Edmond J. Farris, a professor of anatomy (not himself an artist) at the Pennsylvania Academy of Fine Arts. It is a typical example of a 'simple' anatomy textbook for art students: 'In the study of anatomy it is advisable for the student to master: first, the skeleton and its surface projections; second, the muscles and their surface projections; and third, the surface form as affected by various actions.' The foreword to the second edition (from 1961) describes the instruction process:

Suggestions to the teacher and student

Various methods are used in art schools for the study of anatomy. In the lectures and work at the Pennsylvania Academy of the Fine Arts, I have endeavoured to teach students to develop primarily keener powers of observation, and thus create a clearer insight in understanding the nature of the figures which the artist represents.

We follow closely the order of chapters in the book. We consider the landmarks and proportions very early in the course, for the student is constantly referring to landmarks and proportions in practically all of his work. The skeleton as a whole, the skull, bones and joints are studied in detail. Every student has a set of bones available for drawing purposes and to refer to during the lectures. The lecture is preceded and followed, as a rule, with approximately ten minutes of demonstration and sketching from the model, to emphasise the anatomy considered in the lecture. In the study of the muscular system, not only are the origin, insertion and action of each muscle stated, but the individual shapes of their fleshy and tendinous portions, and their effect on the surface forms, are carefully demonstrated, when possible, on the living model.

Besides such visual aids as lantern slides and motion pictures, frequent visits are made to the galleries, to discuss the anatomy in all types of art. At the close of each semester, the students compete for three different prizes; one for the most complete and accurate set of bone drawings, two for the most accurate drawing a skeleton which is posed, and three for the drawing of the most accurate muscle surface anatomy representation.

A number of reproductions of students' work are included in this book, and these reveal what is meant by 'precise drawing': the taking on board, word by word, of seen-but-not-understood images of areas of the body and individual bones in isolation. They are exercises in descriptive natural measurement-taking, as Gustaf Britsch would have put it, with no relationship between effort expended and insight gained. Bridgeman's book narrows down psychological processes of learning that need a really deep understanding of the study of nature led by the meaning of forms and their relative values to plain detailed observation, which cannot help young artists to develop a perspective, a mental concept or philosophy. Precise observation will of course always be a primary requirement in anatomy for artists, as with all figurative nature study. But to stop at observation is to treat seeing as a purely mechanical and optical process, when seeing is, in actual fact, a selective action that relates to insight.

English-language art anatomy books show almost uniform ignorance of the need to cultivate the imagination of students, for clearly interpreted forms, to foster the ability to reconstruct complex physical details in three dimensions with the governing principles of construction as the basis, or to develop the ability to give a depicted form veracity.

Of course, this is not altered by trusting in the 'visual principle', as is the case with the book *Anatomy for Artists* by Reginald Marsh (first published in 1945, and reissued in 1970 by Dover Publications Inc.). The problems can only be solved through real visual intelligence: intelligent seeing. Marsh's book offers only quick imitations of hundreds of artworks by great masters and anatomists; it makes no attempt to answer any questions about the laws by which a sequence of movements arises, functionally and plastically, from architectural principles and from the mechanisms of movement. Marsh arranged the drawings in a way that, through the turning of the individual pages, the use of body cross-sections form a continuous image, so that 'the reader can look up the desired or approximate view' of what they require, with hands, heads, feet, etc. available as needed. 'These drawings consist of free adaptations, combinations, abbreviations and copies of works of the old masters, chiefly from the Italian and Flemish schools before the advent of academicism.' If his book really did preserve the thoroughly grounded figure studies by the old masters, instead of watering down their achievements in such a seductively facile way, then at least Marsh could have claimed to have truly represented one factor of art education: the real hard work demanded by life drawing, and in the creation of anatomical studies.

All of this scientifically unfounded content culminated in the book *Figure Drawing for All It's Worth* (1946) by the American author Loomis [26] – who, unfortunately, was not alone in his attitude to life sciences, as is attested by the instructions for movement studies, hand studies and figure studies by a number of his American countrymen that were published in the German language in Switzerland recently. It is typical of Loomis' approach that he offers different standards of proportions: a plebeian figure who is apparently worn out by labour and who is only seven-and-a-half head lengths in height; the average member of the population; the ideal male figure type of a man, elevated above the previous two figures at eight head lengths in height; the comfortably situated citizen or incarnation of the elite class, who is eight-and-a-half head lengths in height and equipped with a neat beard and a tobacco pipe; and, finally, a heroic figure of nine head lengths in height with a very small forehead and a massive bull neck, equipped with sandals, a fig leaf and a discus: he is a charmer, a superman or a magazine idol.

Essentially – and quite indefensibly, even from the point of view of providing usefully simplified teaching materials – these are formulas for skeleton and musculature studies, intended to allow figures of all kinds to be drawn easily and quickly, for all occasions:

a quick glance at this 'cookbook' of formulas is all that is needed to find recipes for how the seams and folds of jackets and trousers arrange themselves, for how to deploy light and dark areas, how to use chalk and pen, and how to 'do' sitting, lying, standing and erotic images of undressed girls in high heels stretching, or sprawled out on, or sliding off, divans. The net gain? Facile execution, a slick routine – and money! How clear and hard-fought, by comparison, Leonardo's, Vesalius', and Mollier's educational principles were: in addition to being artists and scientists of the first rank, these men were well aware of their responsibilities as teachers.

I could continue, but it would do little to change the picture we have gained of anatomy for artists in the English-speaking world. I, the author, am aware of only one exception: *Dynamic Anatomy* by Burne Hogarth, first published in 1958 by Watson-Guptill Publications New York (the seventh edition was published in 1975). This artist, who founded the School of Visual Arts in New York City and continues to give his famous lectures and demonstrations of anatomy and drawing, made his reputation in the field of illustrations for magazines, newspaper arts and art education, and was the creator of the illustrations for *Tarzan*. In contrast to the conventional anatomy books – especially those of the USA – his anatomy book gives the artist's perspective.

Fig. 27 An example of an illustration from *Dynamic Anatomy* by the American, Burne Hogarth, first published in 1958. In this book, also, the muscle figure in powerful motion is treated as the ultimate goal of anatomy teaching, becoming an end in itself.

Fig. 26 An example of an illustration from the drawing instruction manual by the American author Andrew Loomis, *Figure Drawing For All It's Worth*, 1946. These proportion study figures are based on ideologically-motivated aesthetic norms, rather than the real organic relationships and structures of the body.

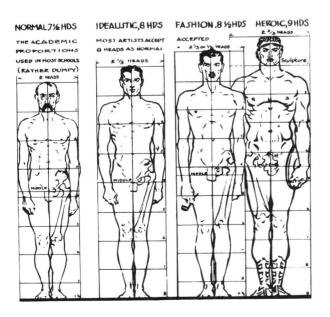

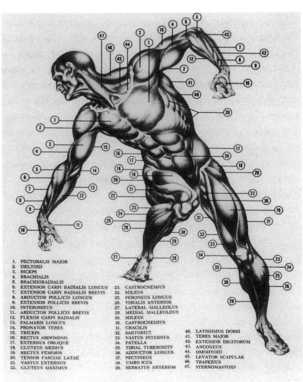

In *Dynamic Anatomy* he presents the living, expressive structure of the human form. He leaves us in no doubt about his sharp and understanding eye for the dualism of art and science, impressed upon him by the situation in the Western world, when he says that:

'The 20th century artist appears to be in a state of conflict and disorder. He has a world of art to explore, yet he shows no purpose, no goals. He seems to have lost his sense of direction as he ranges across the uncharted art frontiers. He has rejected the compass; he has thrust aside standards, criteria, definitions; he has renounced science as a tool in the discovery and development of art. He has rejected the human need to relate, to communicate the results of discovery ... If we recognise it is the mission of science to define with clarity and precision the workings of the universe, to relate with order and harmony the new concepts of time, space, and energy into new and better ways of life, we reach the conclusion that science is the most powerful instrumentality in the progress of man. To the artist, however, science is considered an invasion, a hindrance, a stricture upon his free and personal interpretation of the world. He sees the scientist as an intellectual instrument – precise, logical, mathematical, mechanical. He sees himself as a sensitive organ of feeling, emotion, inspiration, and intuition. As a result, the artist rejects science and scientific thinking in the projection of art. Art to be pure, he reasons, must be devoid of science; feeling is not precise; emotion is not mechanical; inspiration is not logical; intuition is not measurable – the artist is no scientist.'

Aside from a chapter covering anatomy's history, in which Hogarth traces the development of the human figure in art, the book's major focus is on individual anatomical facts, and on the nine principles of foreshortening. There can be no doubt that – quite apart from the book's outstanding artistic portrait studies, drawn by Hogarth himself – Hogarth has made the most momentous contribution of any author in the English-speaking world to constructive figurative drawing, including the arrangement of the body's masses. His efforts to find architectonic solutions deserve our full attention. This tendency is purest and most coherent in his built-up anatomical drawings of the head, whilst the rest of his figures – muscle figures in furious motion and individual body parts that are titanic in form – are superhuman-like, going beyond the factual to lay claim to an aesthetic guideline or ideal image [27]. The violence of these exaggerations, the enormous knottings of the soft parts, and the homogeneous way that more and more of these are added to the figures, are really a pity. Hogarth pushes the figures back into the era of history when the muscle figure was the ultimate objective and formula of all anatomical instruction, and the aesthetic norm – not least because of his completely incomprehensible

failure to include the structure of the skeleton, the plastic centres, and non-complex views. In this respect, Tank and Hogarth are strikingly similar. If you really wish to rebuild the structural unity of the body's architecture, with all its tensions and balancing factors, then a precise knowledge of the properties of its constructive scaffold is an unavoidable necessity.

1.2.11. Permanent and changing features of anatomy for artists

All of the great eras of anatomical achievement have contributed to the firm foundations of anatomical research today – and have enabled us to recognise the crucial unity that exists within such a great variety of anatomical detail. There is something else, however, that may have struck us. Art anatomy depends absolutely upon painstaking research of the human body – in other words, research is anatomy's unchanging aspect. But art anatomy is also a teaching subject: if it is to help artists to create better art, it needs to choose its subject matter well, and to set its goals and learning paths intelligently. Its role in communicating essential facts gives it a permanent place in the teaching system; it expresses a spiritual affinity between the physical sciences and art. Anatomy may not put in an appearance until the era, and the era's art, has to call upon it to meet a need, but when it is permitted to do so, it illuminates a wealth of new views for artists, enabling them, when they focus purposefully on their subject matter, to recognise those all-important qualities that are at once particular and universal; the qualities that are indispensable to, and are the very essence of, artistic perspective, and are identical with the key characteristics of artistic creativity. In all of this, we see the constantly changing aspect of anatomy; of its nature, and of its practical function.

1.3. IDEAS ON ANATOMY FOR ARTISTS TODAY

Whilst we have naturally included a brief outline of changes and ongoing processes throughout the history of artistic anatomy, with their implications, our retrospective of the origins and metamorphoses of anatomy for artists is intended as a critical look at its legacy, rather than an attempt to write its definitive history. The crucial point is that the demands of this branch of art instruction do not stand still; they change constantly. The demands of the subject today spring from its past manifestations.

Every era brings with it a new image of the human being, and seeks its own distinct human ideal. Now that art no longer springs from a humanist foundation, however, we are in danger of losing sight of the human image. Worse, the human being is becoming discredited as a subject for art. It is not this book's purpose to trace all the different causes of this trend, but I will go so far as to say that this kind of art is founded on the same attitudes as the version of modern science

that denigrates external appearances – such as the human form – as essentially meaningless, justifying the devaluing of sensory data by arguing that the essential character of the human being lies within, and that the crucial essence of nature has nothing to do with externals.

In his own time, Goethe foresaw this dramatic advance of the natural sciences. It is certainly true that the sciences have vastly advanced our knowledge of internal worlds – and especially of the world within the atom. But we must not forget that the origins of an expanded and deepened knowledge – a knowledge that should serve human beings and human existence – lie in the living whole. We should not confuse the methodology of research into the 'ultimate' structures with 'discovering the real thing', or confuse the methods of science with its ultimate goals. The results of atomic research do not contradict the results of morphological understanding. What we can see reveals the essential nature of something just as much as the non-visual, mathematical language that reveals minute structures invisible to the eye. To go along with Goethe: the outside has an inside, and the inside has an outside.

Of course, from our own perspective of realist, humanist art, we reject the principle of imitating nature. As Goethe said (replying to Diderot): 'The most scrupulous imitation of nature will not create an artwork.'

If it is to be of any use to artists, artist anatomy should always be aware of this; to be effective, it must reveal the human being with the human shape. Its philosophy must be humanism. It cannot respond to artists' needs by simply selecting suitable facts from the sciences – this would lead only to more confrontation and dualism. It must spring from the roots of artistic creation itself, and build its goals, measures and means on this foundation. Otherwise, it will remain on the periphery, an extraneous addition to arts education. At the risk of repetition, the author would also like to stress that anatomy for artists has to become a part of art teaching from within: it must arise from the real goals of artistic creativity. This book had to be written to show how this can be done, and to demonstrate the ways and means.

1.3.1. How our goals depend on the character of artistic creativity

Based on our retrospective, we will now explore some of the foundations (theoretical and practical) of anatomy for artists. The author never grows tired of emphasising that the problems of anatomy for artists cannot be solved while people persist in believing that they can halt the swing of the pendulum between art and science on one side or the other. Artist anatomy must wake up, set aside old traditions, and gain a foothold in the present day – but not the latest fashions of the day, the noisy fuss of a vocal marketplace of sensations. The curriculum and objectives, the methods and strategies of artist anatomy should be drawn from the peculiarities of the artistic creation process itself, not from some particular style or trend. The methods offered here are not described for the sake of vanity,

but because the methods themselves are a part of effective education through real engagement with reality. Crucially, they also demonstrate the emergence of students' creative powers. The old-fashioned procedure of a tutor simply imparting knowledge orally is of no use to us, because students need to consolidate their knowledge: to hear it is not enough. In an artistic education, this consolidation of knowledge also involves properly acquiring certain skills – something that can only be done through practical activities. We do not wish to present tutors with a set of instructions. Instead, the author is trying, for the first time in the history of anatomy for artists, to impart to readers the theoretical and practical principles of teaching and learning this subject: all its whys and wherefores. This means that the results of the teaching and learning process cannot be ignored, which means including the voices of real students – through their work. The examples of students' work will prompt any reader involved in or interested in teaching art to rethink the structure of figure drawing classes with the student's requirements in mind – and also to discover new ideas and to make improvements. This material will also help those who are learning art by providing hints on how they might tackle set tasks. These examples of work by students are also intended to help to visualise all the objectives, choices, methods and resources involved in anatomy for artists, as well as what can be achieved and what has to be learned in terms of the necessary armoury of skills.

Let us remind ourselves, once again, that there are two sides to any artwork: the objective side (the Object) and the subjective side (the way the Object is evaluated and clarified by the artist). Truly great art can never be solely 'eye art': the artist has to 'work on' and mentally process what he or she sees, because an artist is looking for what is hidden under the surface; the inner and relatively stable aspect of the real object. There will always be something of this interior, this core, to be found even in the random features of the real object's outward appearance.

1.3.2. The teacher–student relationship in artist anatomy

Artist anatomy's useful qualities emerge from a foundation of scientific knowledge, but within these boundaries, it has the capacity to train the student to use the medium of drawing to clarify the really significant features, the elements that have to be captured in order to epitomise the real object's qualities. It encourages the student to notice characteristics, and directs this cultivated awareness toward the typical features of, for instance, the real organic form. Using special teaching exercises to aid comprehension of the facts is an ideal way of preparing a student to thoroughly penetrate into the subject. Drawing – even plain factual drawing – can never simply be a matter of repeating and reproducing the real object's appearance: it must be founded on an act of mental understanding.

Even factual drawing involves concentrating and harmonising the drawing's factual content. Otherwise,

the relationship of the artist to nature would be purely passive. At best, a purely factual drawing evokes a learned mental image that is only a small part of the real overall impression. Memory images break down when one has to apply them under different conditions; overall concepts, on the other hand, reflect true understanding. To express constructive principles linked to functions, the student must adopt a dialectical method. The student learns to recognise and acknowledge the rules governing the relationships of form and action, and the requirements and constructive needs of the drawing process.

A meticulously constructed system that imparts a sensible structure to the subject matter and offers real knowledge, plus well-considered, well-organised and well-planned teaching, with well-chosen and well-linked teaching elements, and the right selection of resources and materials, can make a significant contribution to educating students to take an actively creative attitude to nature.

Once one has recognised the essential rules, one can apply them even under completely changed conditions. In this way, a student can learn to face any study task involving naked human figures, by understanding the specific body's appearance as a variation on a greater system of fundamental rules. Setting goals in this way helps to shake off a lecturing style in which the tutor is the only active participant. The activities undertaken by the student become an important element of art teaching: the aim is to cultivate a creative attitude in students. Thus, we replace the one-sided teaching process with a teaching method involving a particular sequence of actions that allows both teacher and student to be active.

Summary:

1. The artist anatomy of today provides an 'armoury' of scientific resources appropriate to the content, objectives and methods of a modern, realistic study of naked human figures; the content, objectives and methods of an education in anatomy for artists are derived from the unique needs associated with artistic creation.
2. Artist anatomy is concerned with realities, and is therefore, in the first instance, an objective science that imparts knowledge of real features. This is crucial to the artistic skill of applying knowledge generally.
3. Artist anatomy, which is a science, is thus different from art, which reflects reality in a unified, total and synthetic way.
4. As an academic subject, anatomy for artists exists in the boundary between science and art.
5. A shift of emphasis in one direction or the other is fatal, without necessarily reducing the complexity of the subject matter.
6. Anatomy doctrine in the recent past and the present day is restricted primarily to imparting pure scientific facts, founded upon a dualist ideal that regards science and art as two separate and autonomous areas. Thus, it fails to recognise the interpenetration and unity of real object forms and image forms, content and configuration, subject and object.

7. Crucially, artist anatomy helps us to overcome idealistic conceptions in art, because it explores the factual reasons for the body's appearance, cultivates insights and concepts of form, and creates the right preconditions for a fusion of the real object's form and the images formed. It is therefore right that artist anatomy should be a part of art education.

1.3.3. The specific goals and tasks of anatomy for artists

Tasks and set goals in artist anatomy training and education are highly specific. In this area, as in others, 'education' is understood to refer to a process that contributes to the end result of equipping students with a body of expertise, skills, competencies and the right habits. The examples of students' work incorporated into this book serve to demonstrate what this approach means in practice. This programme of education has two distinct branches: on the one hand, the imparting of a body of expertise (or knowledge); on the other hand, the imparting of skills, competencies and good habits. The last of these refers primarily to how a student should go about tackling practical activities, especially when creating artwork.

The form of the system for imparting knowledge

The table of contents offers the best overview of this book's concept of the system for imparting the anatomical knowledge needed by artists. It offers an abundance of information, but with an internally coherent structure. If all this knowledge were simply put down in a book as a sequence of facts, the student would be forced to do a great deal of planning in order to assimilate it. The aim of the layout is to offer a comprehensible structure, with the intention of logically interconnecting this inventory of facts.

To ensure the best, most rational structure, the programme begins with the science of proportions. In drawing naked and clothed human figures, it is important to start by ensuring a harmony between the seen figure and the drawn figure. This study of proportions deals with the proportions of all the body's component parts and of the body as a whole in terms of length, breadth and depth. It also covers how these measurements are affected by posture and by expressions of emotion. At this stage, the intention is that tutors should restrict themselves to the handling of proportions in the drawing of naked human figures only, in order to avoid overwhelming the beginner with all the other factors of bodily form, such as the fine details of the bones and muscles, architectonic factors, and the body's three-dimensionality. This delimitation inevitably means that the images are 'flat' at this stage. The student should be able to recognise the real relationships and relative proportions as rendered in simple sketches, and to determine the main directions of movement (this will be elaborated on in more detail at a later stage). The study of proportions, in this sense, is of practical use to working artists, allowing them to recognise real configurations, and the typical aspects of proportions in individual cases. We have no wish to

create an 'ideal' that is distinct from the 'real': we want to approach nature in an unprejudiced way – that is, to dispense with a perfect, preconceived Platonic canon of beauty.

The study of proportions offers a way of cataloguing the great abundance of body phenomena, in terms of grouping identical or similar features of the human form together: the gender-determined typical features of men and women, the typical features of human beings at different stages of development, of human beings of different ethnicities, physical constitutions, and so on.

The static and dynamic properties of the human body cannot be reduced to schematics. The anatomy books of authors such as Tank, Meyner and Barcsay used schemas in a way that made the student's task harder rather than easier: for instance, as an aid to depicting the functional actions of the contrapposto pose, students were presented with structures of converging or diverging lines and curves taken entirely from the external lines of the body. There can be no real insight unless the laws governing these static positions are clarified. A linear structure like this would be of no use in a different circumstance – in depicting a figure carrying a load, for instance. The structure of lines in a diagram like this becomes a scaffold or skeleton in which no real thought is involved, offering no explanation of causes or effects, and no explanation of the rules governing the transformation in the character of the contrapposto form. A scientist can use a linear schematic of this kind to teach, to impart an idea. Such a rigid pattern is of no use as a visualisation of the essence of a thing for the purposes of art, however, because it does not connect with the displaced body masses, the special qualities of the proportions, contractions or extensions, the tensions and relaxations within the form.

From the systematic standpoint, it is necessary to present the proportions in connection with the rules governing sequences of movement, or function.

The mechanisms of movement are described in terms of the interactions of the joints and muscles; this makes the best sense given the nature of the subject matter, and the teaching strategy. This subject matter is therefore covered in connection with the functional systems (as with Mollier, Benninghoff, Braus). This system of organisation teaches students to think of the different elements in their proper context, and to avoid teaching the sum of all the individual parts without teaching their significance as part of a unified whole.

1.3.4. The system for imparting knowledge and skills: its structure

Imparting knowledge is only one aspect of the education process. Next, one must address the question of the abilities and competencies that artist anatomy should aim to develop. Here, we will concentrate on only a few of these skills: what is said can be taken to apply to other skills as well.

Being active as an artist – in the most literal sense – demands that we 'put ourselves in the picture' by absorbing knowledge of the world, by collecting experiences, before subjecting them to a mental process (judgement formation) and, finally, by taking them and using them to develop a unified image. Without this ability, there can be no art.

The word 'skill', as used by the art teacher, has a complex meaning, covering two individual terms: 'abilities' and 'competencies'. In point of fact, these two concepts overlap, and are both fundamental to mastering art. Skill can only be developed by undertaking any specific activity, as a gradual process.

It is down to us to determine which aspects of artistic skill are enhanced by artist anatomy, and in what way. When one considers that in many places the subject is still taught theoretically, without any nude model, without even a single pencil or brushstroke(!), without anyone asking how the knowledge is to be applied and consolidated, one realises that it is no waste of effort to devote plenty of energy to formulating and putting into practice this particular goal of artist anatomy: the goal of equipping students with a system of competencies and skills. This is primarily a matter of allowing students to cultivate their practical and intellectual abilities: the ability to draw a body, and to understand its rendering in three-dimensional materials (modelling), to cultivate a gift for observation, good visual memory, a gift for 'picturing', a good feeling for shape and space, and the ability to think and to properly exercise abstraction, founded upon a comprehensive insight into the essential nature of things. We must not forget that it is part of a teacher's duty to shape abilities – these are not a priori, biologically determined. Practical artistic activities call for knowledge and competencies, but neither knowledge nor competencies are of any use unless they are properly combined with the aforementioned activities: one presupposes the other. '[There can be] no acquisition of knowledge without the presence of a certain measure of abilities and competencies, and, likewise, there can be no development of skills without a certain store of expertise.'[8] As any art teacher knows, artistic skill varies widely. After all, many art students and amateur artists are still unable to make the connection between image concept and picture structure, the perceived object and the drawn object.

These are abilities that must be acquired. What use is all the knowledge in the world of the laws of proportion, static properties and dynamic properties etc. if the student has few or no opportunities to apply his or her knowledge to practical drawing activities: to explore, to enhance, to deepen and to consolidate? The ability to accurately draw objects – a practical ability that is constantly employed in artist anatomy – involves, in its turn, a large number of individual skills; along with the need to master perspective, one must also learn to judge the main directions of movement, and its limitations.

Along with the ability to judge directions of movement, students must also develop the competency to check the correctness of the judgement itself.

8 *Didaktik*, Berlin 1958, p. 41.

What is competency? Competency is defined as: 'A maximally perfected, easy and automatic execution of the same operation, which constitutes the technique of the activities concerned.'[9]

Let us apply this to our own case. The student begins by checking the direction of movement of the whole figure, initially using a true plumb line and the horizontal and angular functions (as recommended by Preissler: cf. Figure 17). Having gained these basic competencies, students can eventually dispense with these aids entirely, and simply judge by eye, judging the perceived object and their own drawing of it 'automatically'.

This exercise also gradually fosters the vital ability to correct one's own work. This is an example of what we mean by saying that abilities and competencies are inseparably linked.

They are the preconditions for a subsequent partial or complete abandoning of the need for a nude model.

One must be sure of these initial skills before one attempts to master new subject matter. Otherwise, to impart any further knowledge is to build on sand. It is this knowledge – the knowledge of, for instance, the rules of the body's static and dynamic properties, and the interrelationships of the centre of gravity and support in the maintaining of balance, and how these interrelationships change during movement – that permits artist anatomy to develop students' further ability to judge a typical movement in its substance, its interrelationships and its expression (e.g. figures in contrapposto pose, seated, stepping forward, moving forward, hauling, straining, carrying, lifting a load).

The veracity of natural laws must repeatedly be checked and confirmed by observing a model; this is the only way to acquire the ability to draw certain movements from one's own mental imagery, even without the need for a model (which is more than simply a matter of paying attention to the various different points, such as body volumes and the rendering of surfaces). As long as this is borne in mind, one does not have to wait until the figure in its totality has been mastered before drawing from one's own impressions. In fact, in making anatomical knowledge available to students, the important thing is to make them aware of possibilities and to foster the powers of the imagination, to open things up and to encourage them to engage independently with the essential features of movement. One can begin to do this as soon as students have attained competency in confidently drawing the basic constructive skeletal forms from imagination. The author himself has used this method with university students, and the experience has always been a positive one. Students always approached these particular exercises with enthusiasm, and invariably produced very satisfactory results. It is, of course, important to avoid simply 'inventing' some movement or other; instead, these drawings from the imagination must be of very concrete and specific activities – executed in the individual student's own manner. Past experience has confirmed that, if the progressive levels of difficulty can be tackled systematically, then there will be no risk of

9 Teplow, *Psychologie*, Berlin 1953, p. 202.

gross errors occurring at this stage. Gradually, the tutor cultivates the student's ability to draw an impression of a moving figure that is completely correct in terms of proportions, and is a convincingly rendered, functioning body. The student has now acquired a limited amount of skill.

These practical abilities and competencies will later be joined by others, such as a capacity to capture the body as a structure in three-dimensional space, and, ultimately, a mastery of the most difficult foreshortenings, even when working without a model.

An artist relies upon sight and upon sharp-eyed observation, assisted and supported by visual imagination.

Artistic anatomy favours the teaching of observation skills. The subject combines observation – as a purposeful activity – with the intellectual process of recognising the essentials of a real object's form. For instance, it makes no sense to have students learn the full topography of the complex shape of the pelvis by heart – with all its elevations, crests, ridges, projections, bumps and openings. To an artist, descriptions only have meaning and validity when their relationship with the whole, the totality, makes them a necessary part of it, and if the overall totality cannot be sufficiently precisely defined and understood without such a description.

The essential thing about the pelvis is its construction, its composition as a space-enclosing container. Descriptions of its individual details are only useful if they relate to the task of capturing the greater whole.

Our method allows students to develop a gift for observation and an interest in every aspect whilst ensuring that they do not miss out on the ability of purposeful concentrated observation and focus upon the main points of emphasis, so that their attention is attracted primarily by the most essential plastic and constructive features. This process serves as a bridge; it is intertwined with thinking ability. After all, the concentration of one's powers of observation on the way the body is constructed is vital when considering the ways and means in which nature fulfils the demands made on it, and the resulting form of the 'instrument'. Drawing activities are helpful because they reveal any remaining gaps in the student's visual concept – especially when the real object itself is inaccessible. The ability of acquiring as perfect a visual concept of a subject as possible can be learned through modelling exercises far more completely than one could learn it from drawing individual views of one's subjects. Two factors are of key importance here: on the one hand, tackling the subject in three dimensions has the advantage of literally showing the object in question from all sides, and there is therefore no risk of some areas of the likeness being 'dead': insufficiently considered or crafted. On the other hand – and this may be even more vital to the reader's success – modelling is a very 'activating' process, thanks to its cumulative stages of adding, reducing, smoothing, moulding, pressing, bending and rounding the material. One feels a sense of vitality as soon as one begins to pass the clay through one's hands.

By properly combining the acquisition of knowledge with manual activities, one can school a feeling for space and form, thereby cultivating the intellectual ability of visual memory.

Laying the groundwork for a system of knowledge and competencies using the methods described here should avoid the risk of students misguidedly pursuing an interesting style, superficial competency, slickness, routine or a falsely 'artistic' approach.

Artistic anatomy has a further, and no less important, goal: to foster in the student a truly creative approach toward the object.

This task relates closely to the question of which method of cultivating insight and knowledge is most favourable to the specific needs of an anatomy for artists. For the moment I will simply lay a foundation (cf. the section on the constituents, structure and constructive forms of the knee) [219]. To take the example of the knee, this book does not deal with the peculiarities of the form additively, but in their logical connections to the functions of the knee. Verbal exchanges during art classes may be very useful for teaching this kind of insight. Meanwhile, one might draw an image on the board, illustrating the subject matter in gradual, successive phases. The introduction to the lesson must start out by giving information such as: the knee bears the body's weight both at rest and in motion, shortens the length of stride, helps in surmounting obstacles on the ground, and can move the centre of gravity closer to the ground or away from it (by pushing away or jumping).

The second stage: What are the constructive elements developed by nature to meet this task? (A wire model or natural skeleton might be used here.)

The answer: 'rollers' are necessary, to enable turning on a base (the head of the tibia).

The conclusion: the action of the joint is reflected in its form. Any specific form must correspond to a specific action.

From this one can generalise: the diverse appearance of all the different items has an internal order. The idea is to test the validity of this insight for every joint. Furthermore, this means that the easiest way for artists to find their way through the great diversity of the body's organic forms is to investigate their functional and constructive essentials – that is, to investigate the essential features of the organic form in question, and to express it in abstract form through drawing exercises.

The more rounded an artist's understanding of the fundamental facts, the more easily he or she can understand the 'variations' and 'ornamentations', the more readily he or she will retain the essential features of objects, and the more effortless his or her reproductions of functional processes from his or her own impressions – and recognition of these processes when observing the natural object – will be.

The aim of artistic anatomy is to achieve a creative attitude. This means that, in life studies, the object should not be reproduced by rote: instead, it should be permeated and thoroughly understood. Life drawing is not a matter of copying things down, but of building an analogous structure, by consciously making creative

decisions! Students should be constantly reminded of this. This will gradually give rise to dependable habits that will shape their future actions. 'Scientific and artistic insights into reality are never irreconcilably separated. These two forms [of insight] increasingly interpenetrate and complement each other, enriching one another without ever becoming identical.'[10]

Artistic and scientific insight draw ever closer, increasingly enriching and interpenetrating one another – in other words, their closeness increases as one's understanding of the subject matter intensifies. This is the ground in which we plant the pillars of a bridge between understanding of the object and understanding of the image. The traversable bridge spans the methods. The aim is to cultivate a creative attitude to the real object. Structuring a student's classes to include the possibilities of arrangements provide the most valuable assistance in this. (The reader can find a more detailed version of the system for imparting knowledge and skills in the author's *Die Gestalt des Menschen*, Dresden 1964, pages 511–516.)

Summary:

1. Artist anatomy has its own role to play in the educational system; it serves to train and cultivate ability. We describe the purposeful and conscious influencing of behaviour as cultivation. The imparting or acquisition of knowledge and skills is described as forming or education.
2. Cultivation and education are a single unified process; educational content also has a cultivating function. This cultivation is linked to specific educational content.
3. The purposeful, formative, conscious influencing of the student comprises three chief tasks:
 a) the imparting of knowledge
 b) the fostering of skills (abilities and competencies)
 c) the cultivating of attitudes and behaviours (habits, feelings, the directing of the will, traits of character).
4. The general tasks of education and cultivation are given subject-specific aspects by the peculiar requirements of the subject in question. This means that certain goals of cultivation and education are brought to the fore, whilst others are of lesser importance. There may also be overlaps with art teaching.
5. The tasks and objectives of artist anatomy are:
 a) to impart scientific knowledge, through an appropriate system of organisation (see the table of contents in this book)
 b) to develop skills in practical, intellectual abilities and competencies such as:
 those of drawing and three-dimensional forms
 cultivation of powers of observation
 cultivation of visual memory
 cultivation of the imagination
 cultivation of a feeling for form and space

10 Schmidt-Walter, 'Gegenstand und Bild beim Studium der Wirklichkeit', *Zeitschrift für Kunsterziehung*, Heft 7/8, 1959.

cultivation of the capacity for thought, including thinking in abstract terms

c) to interconnect scientific and artistic thinking
d) to train students in the dialectic mode of thinking

to train a creative attitude

to cultivate independence and a self-critical attitude to one's work

to inculcate thoroughness and the ability to be truthful with oneself (without any sliding into mere effect)

to inculcate a sense of respect for life

to inculcate a realistic view of art.

6. Training a creative attitude extends to training students in dialectic thinking. Analysing and explaining the body's surface should never be the final stage of anatomical instruction; it is merely the platform that provides a starting point.

7. A dialectical understanding essentially consists of an understanding of the rules governing the interaction of function and construction.

8. Making the right selection of educational elements and structuring them correctly when planning the elementary teaching structure is critical to success. The content plays an essential educational role, but so do the ways and means of how the content is made accessible.

9. In life-drawing study, capturing the real subject does not mean merely reproducing it, but thoroughly understanding it intellectually.

10. Understanding the essential constructive and plastic facts of an organic object's structure encourages the student to refine and intensify appearances, and to treat appearances in an abstract way – to behave creatively.

11. This is a favourable precondition for fusing the object form with the image form. Scientific thought and artistic thought are not mutually exclusive: they interpenetrate.

12. Skill is developed by undertaking any specific, practical activity step by step (in drawing or in manually rendering a likeness in some other way).

13. Competencies are the automatic components of a conscious activity, and have nothing to do with 'the artistic', or with routine.

14. The abilities and competencies developed by artist anatomy are an inalienable part of artistic mastery.

1.3.5. Developing the creative powers of the student

Every science and every subject has its own specific contribution to make towards generating a whole picture of the world, through its own specific methods of investigation. It is only through their own special methods and potential that they can get to the heart of appearances.

To achieve one's goal in artist anatomy – to get beyond simple perception, to consciously consider and to research, to penetrate into the significant issues, to bring together the individual facts to create a picture of the overall context, and to look at the overall context and be able to understand the individual facts – requires, more than ever, a carefully considered method. For this reason, we will take a few

problems from the subject's various problem areas, using these as examples to show how one can master such problems by working in sensible stages. The author has tested every single one of the tips offered here in practical work with pupils, students, amateur artists, and art educators, and would ask that, when considering the examples of 'student work' included here, readers should take account of time expenditure: the author himself had a total of three hours a week at his disposal, each semester, to lecture and to lead his students in exercises.

1.3.6. Issues of proportions, statics and dynamics

Artist anatomy is founded upon artistic practice. It begins by considering the laws of proportions, static and dynamic properties for every instance, for every application and every kind of life-figure drawing. Everything else is founded on this.

In the primary areas for presentation, problems of artistic arrangement are of key concern to the content and methods of artist anatomy. On this basis, a practical series of working phases can be proposed:

Fig. 28 Study in proportions.
An exercise task concerned with the problems of proportions. First step: developing a proportioned figure based on a model on the basis of the simultaneous process, constructed from simple, geometrical forms.
Free student work, first year of study.
Time: 30 minutes.

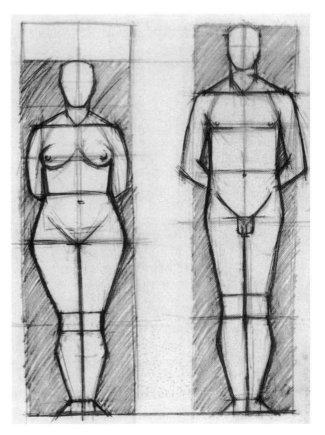

First step: Inspired by the simultaneous process of classical times, also used by Leonardo (see section 2.1.2), the height and width dimensions of the male and female body are determined. Working in terms of the whole is taken as a given: the drawing in of the axes of symmetry of the body, terminating at the crown of the head and the sole of the foot, the laying out of lines of equal length, based on the model (halving, quartering, dividing into eighths, etc.) [28, 89].

These lines are marked onto the central axis as horizontal axes, initially of random breadth (vertical division). This is followed by investigation of the dimensions of width, also by comparison – by dividing the whole or by taking the head as the basic unit of measurement. The widths are then marked on the horizontal axes. This produces a proportioned scaffolding structure; the outer points only have to be joined with straight lines to produce a proportioned figure made of simple geometric forms. All of these actions should be performed conscientiously (making careful measurements with a compass and ruler, etc.).

The first-stage task can be modified, and the difficulty level increased [29]. For instance, one might work with covering paint (gouache) and a broad brush, producing a proportioned rectangle as described above (preliminary brush drawing). In such a case, however, the proportions of the model should be worked from the inside outward with broad strokes of the brush, with no preliminary drawing, judging the extension of the characteristic forms of the head, the rectangle of the upper body, the trapezoid form of the hips etc. based on one's judgement of the form of the 'patch' [29a]. This method saves the student from becoming fixated on individual details. An 'object figure' is produced: that is, a figure defined in relation to the 'rest' (the background area). The object figure is like a silhouette, with no internal detailing.

Further increase in the level of difficulty: the materials are the same, and the proportioned rectangle is created as before. Next, however, one develops the proportions out of the surrounding space (the basic figure). In other words, one works across the area with the covering paint, beginning at the edge of the rectangle, allowing the object figure, as an un-painted area, to rise out of the negative. This is done without any preliminary drawing, or subsequent 'painting in' [29b]. This is a very difficult task for beginners, and teaches an exceptional degree of concentrated observation. Generally, it takes several tries to achieve moderate success.

Fig. 29a, b Study in proportions.
A modification of the first step: development of vertical and horizontal dimensions on the model, with the object figure (patch) and ground figure (rest of the field) differentiated. Executed as a brush exercise.
Free work by an amateur artist.
Time: around 60 minutes.

Fig. 30 Study in proportions.
The second step based on the model, serving to consolidate the knowledge and competencies acquired by differentiating the body's proportional divisions.

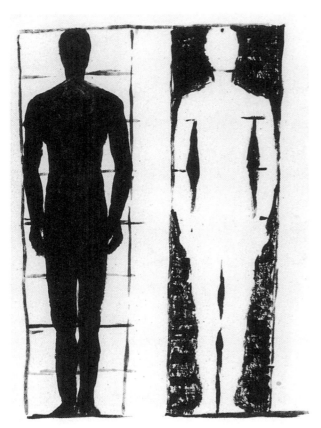

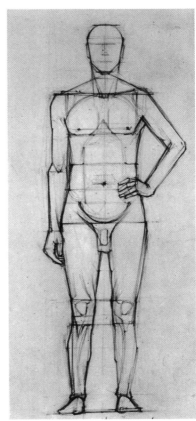

Second step [30]: This phase is concerned with consolidating knowledge, becoming more relaxed, and acquiring a feeling for proportion competency in putting down a drawing of a proportioned figure of eight head lengths (HL) in height, drawn freely and based on a model.

Large paper sizes (e.g. wrapping paper) are useful in making the drawing more relaxed, encouraging one to draw the broad curves of the whole body. Larger formats also make it easier to spot mistakes. For drawing materials, one might use graphite, bistre, red chalk, charcoal, chalk or gouache.

Once again, the student takes the whole figure as the starting point, this time by loosely drawing a rectangle of 2 HL in breadth and 8 HL in height. The location of the pubic bone is marked at the halfway point on the line between the crown of the head and the sole of the foot and then it is divided it into quarters and eighths. An eighth-width is then applied to the left and right of the axis of symmetry, thereby completing the narrow, upright rectangle. Then, one visualises the model and draws in the measurements, inscribing the relevant lengths into the rectangle, whilst its centre, half, quarter and eighth marks and widths allow one to check one's work. By doing this, one learns to gauge

measurements. The students should gradually learn to use their eyes like a compass, for measurement: they should learn to dispense with this aid and checking tool, initially drawing everything as simple geometric forms. Importantly: the figure should not be created by multiplying or adding to the 8 HL; it must be generated as a whole. Right from the start, students should get used to determining the paper format to match the figure.

In the first phase, the teacher and student work together (through instruction, followed by board drawing, followed by the student's own drawing). In the second phase, the students tackle the exercise in a more active, independent way. The teacher checks the student's work and corrects it, pointing out the major forms and proportioned features of the model. The teacher will show students how to check their own work (the figure rectangle with the centre marked in, and the most important dimensions in terms of width, etc.). As far as possible, students should learn to discover their own mistakes.

Third step [31]: This stage provides a more rigorous test of students' confidence in plotting a well-proportioned figure. The student must cut out a properly proportioned figure of a piece of coloured paper without any preliminary drawing and as a coherent whole.

Fig. 31 Proportion study: the paper cut-out exercise. The cutting out of the object figure from the figure-enclosing rectangle (= the basic figure) teaches a more complex understanding and certainty in creating the form.

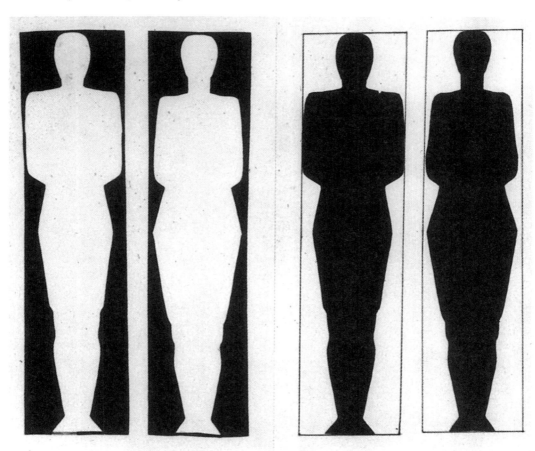

This can be done using the following guiding principles: mark out an 8 HL height and a 2 HL width on the paper. Fold this upright rectangle together so that the point of the crown of the head and the point of the sole of the foot are brought together (the crease line, which marks a division through the centre of the body, is the sole orientation point for structuring the figure's height). Then, one unfolds the piece of paper, and folds it along the axis of symmetry. Now, the student must cut out the figure free-form, without any further preliminary drawing to provide guidance. This obliges the student to keep the whole form of the figure in mind when directing the line of the cut.

The result is a folded/cut shape that tests the student's confidence for proportions. Placing the dark-coloured cut-out figure (the object figure) and the background from which it was cut (the ground figure) side by side on a light coloured background harnesses the light–dark contrast values to make the form clearer. This phase also prompts students to participate actively, teaching them to 'play' with the effects of decorative value whilst learning to check their own knowledge and skills.

As a substitute for the paper cut-out exercise, one might also create a printable proportion figure as a kind of template [33]: the figure is drawn on a rubber undersheet, linoleum, a potato or wood, and deconstructed into individual sections: the upper body, the stomach, the trapeze form of the hips, etc. (simple geometric forms). The body parts can then be printed individually – allowing the student to compose expressive motifs of figures in motion. Above all, this strategy permits study of the behaviour of intermediary forms (muscles in extension or contraction) [34]. In the hands of individuals running art circles, amateur artists and art educators in particular, this step can offer an excellent way to couple tackling the problems of proportion with decorative work [35]. (Compare with the lively, stencilled skeleton figures at work in the third chapter, page 146 onwards.)

Small, poseable proportion models are always useful for consolidating and deepening the amateur artist's knowledge of proportions [32]. They can be produced from all kinds of different materials (paper, cardboard, thin films of all kinds, plywood, metal and so on). Foil or film materials are particularly durable and easy to work (using pins as pivots). The pivot points for the joints can be found using the simple skeleton proportion drawings from the previous stage. The manual work of creating these objects also fosters intellectual engagement. The ability to adjust motion posture in frontal and profile view allows changes in the model figure's proportions to be seen clearly during any adjustment in the small model. The behaviour of the intermediate forms in relation to the main forms (extensions, stretches, contractions, overlaps) can be carefully studied,

Fig. 32 Movable proportion models made from various thin materials. These proportion figures also demonstrate function; they illustrate the behaviour of the different sections of the body in relation to one another. Created by amateur artists.

Fig. 33 A print created with the movable proportion template. Naturalistic attitudes of figures can be simulated in this way, like the movable proportion models. Created by an amateur artist.

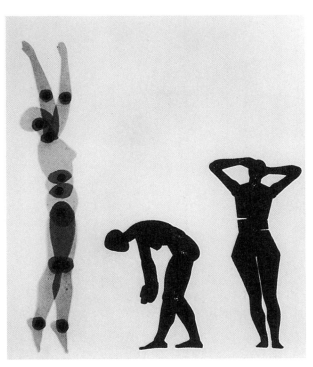

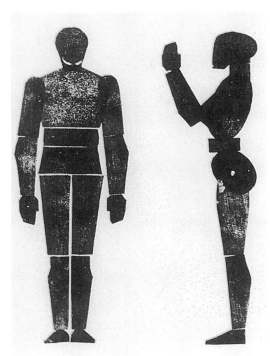

Anatomy for artists: past and present **47**

allowing the less obvious movements to be properly considered, pinpointed and explored. This stage offers a practical aid in checking one's own work, which permits a certain degree of freedom from the living model.

It is always a question of combining the theoretical scaffolding with the pictorial scaffolding. The proportions must not be investigated in a dry way! Naturally, we are nowhere near exhausting the study of proportion: working from the nude figure itself is, of course, of key importance.

Fourth step [36, 37]: The knowledge that the student has gained should be constantly checked by comparing it with the real, living thing. The recognition of the individually typical features is an essential part of this. Nature should never be looked at through the lens of fixed, schematic concepts. In this phase, the parameters of the nude are investigated, and any deviations from previous experience are determined. If it turns out that the nude figure in question has a height parameter of 7½ HL rather than 8 HL, then the

proportions of the figure rectangle must be altered (if one wishes to continue using it as an aid) in order to correctly match the specific body type.

The student should make careful measurements, using the fixed points provided by the bone structure to construct his measurement lines. There is no compelling reason to record all interrelationships using a fixed unit. The positions of the individual measuring points in relation to one another should also be clarified with the aid of connective lines, which helps in checking their angles. Once again, easily understood simple geometrical two-dimensional forms may be useful.

The numerous actions involved – using a plumb line, mapping out, measuring, estimating and checking – help the students to acquire manual competencies. In this way of working, students approach nature flexibly, consolidating their self-confidence by dealing with larger volumes of material. Because this task prompts checking of previous knowledge, they also learn to be critical. All of this, however, is unthinkable without a transition from the didactic element (lectures given by

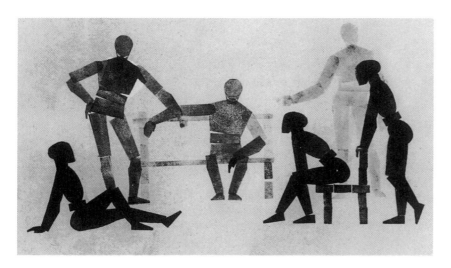

Fig. 34 A proportion stencil print, showing the motions of resting figures.
This is a playful way of combining acquired knowledge of static issues with the behaviour of the body's different sections, in their right proportions.
Created by an amateur artist.

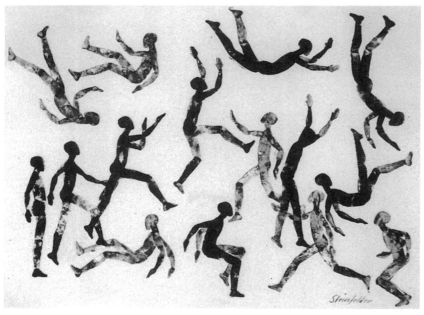

Fig. 35 Proportion stencil print of dynamically moving figures. Working with the poseable proportion stencil encourages students to explore dynamic movement.
Created by an amateur artist.

the teacher) to autonomous, non-verbal student work.

The interconnection of proportions with static functioning are described on page 44 onwards. Without handworking competencies in mastering proportions, however, static problems relating to the figure can only be identified in an insufficient and unsatisfactory way. This is another area in which it is important to bridge the gap between image-making theory and image-making practice.

The exploration of proportions can be further modified by giving students the task of independently developing proportioned figures of 'types' with a unified, coherent language of forms [38]. Variations include very tall, thin body types and shorter, broader body types. The important thing is that this exploration of proportions should be properly extended to all body parts (cf. also the body types as invented by Albrecht Dürer).

Exercises of this kind [39] are especially valuable to future illustrators, for example. One should learn to give the imagination free rein. However exaggerated – or even grotesque – an image might be, one must still

bear in mind that it must be felt to be right in an organic sense.

Fifth step: In the third step, one can overlay and simultaneously cut out two pieces of paper of different colours (an ochre-coloured object figure against a blue-grey background, for instance). This anticipates the fifth stage. During this stage, the student learns to understand the essentials of the contrapposto pose through exploratory shifting and rearranging of the body masses [41]. This is done by cutting up a proportion figure to obtain separate body masses. The student marks the centre of gravity and line of gravity (a straight-drawn line) on to the white object figure [31]. From previous explanations, students will know about the reduction in the body's support and the necessary shift of the centre of gravity from its original position (drawn from the plumb line on the white object figure). De facto, the student shifts the paper cut-out representing the trapezoid form of the hips toward the centre of the standing leg side. This basic operation is followed by further rearrangement of the body masses

Fig. 36 Study in proportions.
The typical features in the individual are developed with a heavier emphasis, and the flatness of the figure's treatment is gradually relieved by suggesting a three-dimensional body.
Student work, first semester.

Fig. 37 Study in proportions.
The individual proportions of the model and the differences in physical forms are brought more to the fore, without neglecting the original purpose of the exercise.
Free student work, first semester.
Time: around three hours.

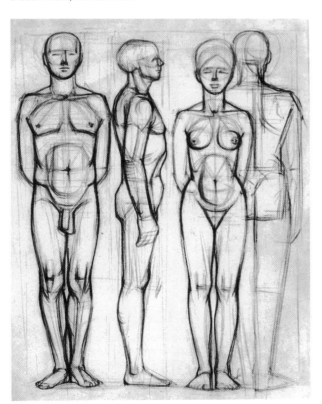

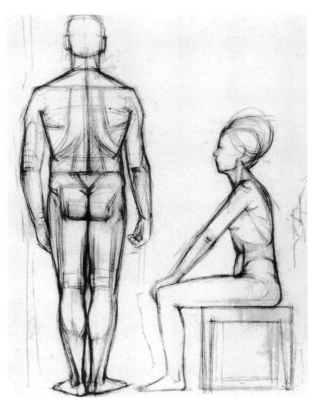

(in the fitting together of the paper pieces). This is an interesting exercise, both because it forces one to recognise the laws of nature, and because it prompts one to move the figure freely as a whole. The ready way in which the figure can be quickly changed, shifted and moved around also offers scope for the imagination. Once again, the students must check everything, and consider, perceive and be active in the way they relate to the model.

Sixth step [40]: A more specific choice of method – the genetic method – is ideal as an aid in recognising how the character of the form, from sole to crown, changes in the contrapposto pose. In an educational context, this method has the added advantage of getting away from reproducing the externals of the nude form in favour of addressing the functional essentials.

The figure's size is once again treated as a constant, with a fixed sole-to-crown distance.

The individual stages of creating a drawing (cf. also sections 3.2.2):
a) The upright body position can be determined using the plumb line. The body's midpoint and centre of gravity can be marked on the plumb line. Next, one marks the standing surface beneath.
b) The pelvic mass is grouped in a trapezoid form centred on the centre of gravity.
c) An oblique standing leg and a simple rib cage form are added. The rib cage bends from the base of the equilibrium position over to the side of the standing leg. There is a relationship between the clavicle and the course of the spinal column. Identify and draw in the head size for the further determination of the differentiated proportions.
d) The figure is developed in simple geometrical forms that are placed together.
e) Any further differentiation of the form is created by emphasising its functional essentials.

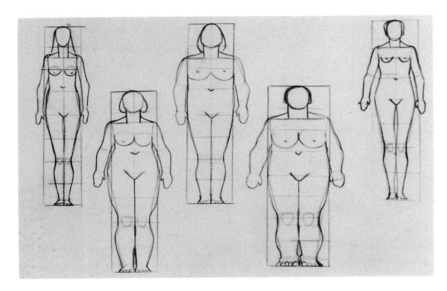

Fig. 38 Freely invented proportion types. The invention of body types is based on impressions of coherent proportion values.
Created by an amateur artist.

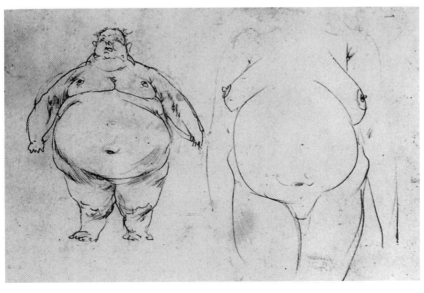

Fig. 39 Invented grotesque figures. In spite of all the exaggerations, the connections to what is organically possible are preserved.
Created by a prospective illustrator, first semester.

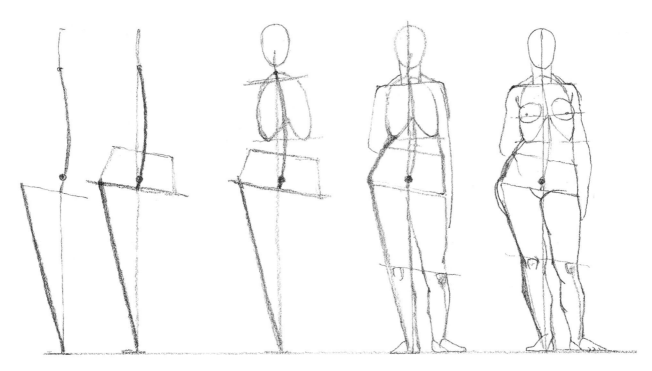

Fig. 40 The stages of drawing a contrapposto figure. Before students can master the problem of a figure standing with all the weight on one side, the rules governing the relationship between the centre of gravity and support at rest must be clarified, step by step.

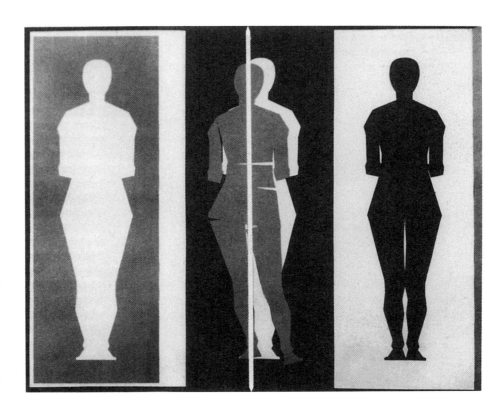

Fig. 41 Proportioned figures in contrapposto pose.
Here, the contrapposto structure is produced from proportioned figures broken down into sections.
Cut-outs in paper of different colours.
Created during an art teaching advanced training course.

The proportion specifications and functional content arise from reciprocal interrelationships.

This step is above all characterised by an active role for the tutor, who draws an image on the board, and must develop an understanding of the form's character through a consciously planned genetic method, and teach students to construct a figure on the basis of rules rather than external appearances.

The individual cumulative stages of the board drawing are followed, analogously, on the nude model. Both act as teaching aids, interacting with one another.

Seventh step [42]: In order to check the knowledge and competencies gained thus far, students are given a short space of time in which to draw an impression of a contrapposto figure – that is, without having a model to draw from. The figure that they draw must incorporate the typical features in terms of the proportions of the sexes in adulthood, the functional rules for a figure standing with the weight on one side, and the displacement of body masses, their extensions, contractions, tension and relaxation. The body and its relation to space is not dealt with yet.

To avoid an excess of rigid construction, brush, pencil, pen and other tools and materials may be used to complete this phase [43–45]. One can use soft lead to record the forms that are especially expressive of a standing posture, putting the major body masses down on paper in dotted lines (the upper body mass, the gluteal muscle group, and the masses of the upper and lower leg). The figures should be no more than 10–15cm (2–4in) in size. This task has the advantage of allowing one to omit certain anatomical details, for example the joints, feet and hands. The drawing has only to record the correct proportions for the type of figure concerned, the strength of the functional expression (e.g. a relaxed contrapposto standing pose) and the rhythm of the body masses. The task is deliberately restricted to successfully implementing these three components of the figure: the advantage of this is that the solutions are defined and self-contained in terms of the key points that must be achieved and the means by which they are to be achieved. The model should change positions every five minutes, so that the students have to capture the postures quickly (this will also prevent the nude figure being reproduced without real understanding).

Above all, however, this task prompts students to unify their own feeling for the body with the overall gesture of the pose, and to experience the human being from the inside working outwards.

Understanding of proportions, function and three-dimensionality can be addressed in more detail in extended tasks at a later stage, once all the preconditions are in place.

Art students have to learn 'with something kept in reserve'. As they progress through the stages of their education, they will not always know whether, how and in what way they will be able to apply to the image-making process the knowledge gained through understanding their observations. Art students need the patience to endure a long haul, and anatomy for artists is no exception. This lengthy educational path should

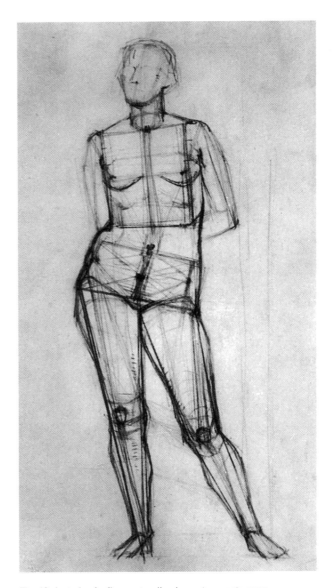

Fig. 42 A study of a figure standing in contrapposto pose.
The student must be in a position to create a sketch that expresses the rules governing the 'standing leg–free leg' posture, from their own impressions.
Student work, first semester.
Time: around 45 minutes.

Fig. 44 (bottom left) Images recording figures standing in contrapposto pose.
Using a brush for rapid model poses is a good way of committing them to paper quickly and avoids a purely technical constructive representation of the investigation into the figure.

Fig. 45 (bottom right) Functional rendering of standing figures.
The deployment of the body masses correlates with whether the figure's stance is relaxed or erect.
Work by an amateur artist, in soft pencil.
Time: around one hour.

Fig. 43 Standing, relaxed nude figures.
This task is restricted to capturing the proportions, functions and rhythms.
The suggestions of three-dimensionality are based on simplified volumes.
Student work, first semester.

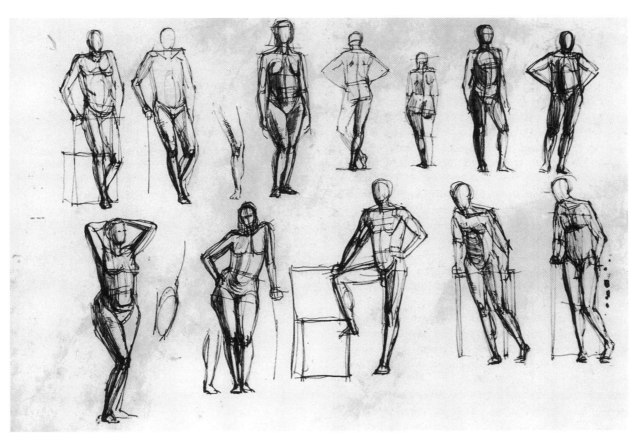

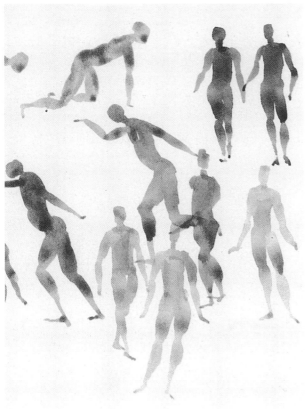

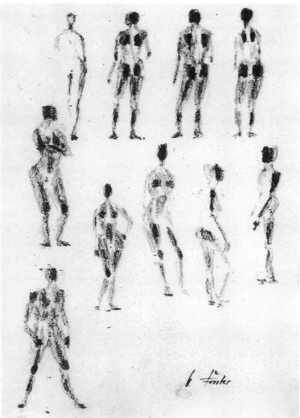

offer way stations that allow students to realise the usefulness of their active learning, and which also serve to highlight the successful completion and conclusion of each stage of that learning. One of these points is reached once students have gained an understanding of the issues of proportions and of static and dynamic properties. Students' independent work offers the quickest way to reveal how much of the intellectual knowledge and manual skills taught have been retained – as long as students' creative powers are given the opportunity to develop, in artist anatomy as in other branches of art.

As we have seen, the problem area of proportions, static properties and dynamic properties occupies a key position in the context of imparting a system of knowledge and competencies. Once the student has mastered these basics of rendering figures, they provide the foundation for all further learning. Additionally, it is essential that exercises to train drawing competencies be included for each individual module of content, even though one will often have very

little time to expend on these exercises. There can be no real gain in knowledge unless it is rounded out by practical application! Good advice is often expensive.

An intelligent choice of materials for implementing one's drawings can prove invaluable in this respect. The tutor will give recommendations and provide reasons for the choice of materials, and for how they can best be used.

The materials themselves also possess their own powers of inspiration, which may aid the artist in finding the best form of expression for the subject matter. Artist anatomy must pay as much attention to developing the student's capacity for expression as it does to imparting facts and subject content.

What does one aim to achieve when one studies, for instance, a seated figure [46]? The answer: a better understanding of changes in the proportions and of the functional behaviour of the limbs and body parts in relation to one another, a sense for the rhythm of the body masses, and for intensity of expression (of the inner state of the model: serene, attentive, nonchalant,

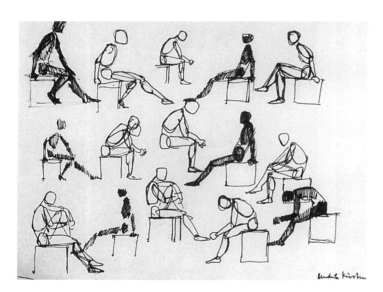

Fig. 46 Figures in a seated pose.
The main purpose of these studies is to clarify the changes of position of the main masses of the body in relation to one another.
Work by a student using a felt-tip pen, first semester.
Time: approximately one hour.

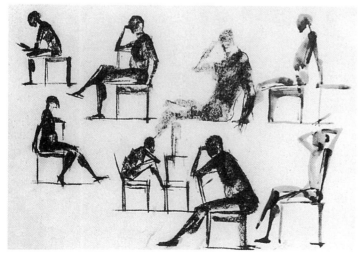

Fig. 47 Renderings of various different seated poses.
This is an investigation of the mechanical and psychological components of the seated pose.
Work by a student, using chalks, first semester.
Time: about one-and-a-half hours.

negligent, tensely rigid). In order to be whole and self-contained, any solution to the task must contain all four of these components; to add any further demands at this stage, on the other hand, would overtax students.

How can these clearly defined goals be achieved?

By choosing and deploying the right means of implementation!

The relationships of the volumes of the skull, rib cage and pelvis are securely put in place using a stiff flat brush and gouache paint, and the main masses (the front of the thigh, the rear of the calf) are similarly laid out [47]. Sharper lines are then used to mark in the harder forms of the joints, feet and hands atop these soft, rounded forms (although these do not have to be executed in detail). Creating an image in this way, through contrasting methods (sharp–soft, round–pointed, large–small, firm–loose) breathes life, intellectually, into the study, contributing significantly to its richness of contrast, and thus to its strength of expression. It is particularly important to bear this in mind if you are using art materials that have a tendency to produce indistinct, blurred, hazy images (soft materials such as chalk or red chalk, for instance).

What is the reason for using the specified art materials? The answer: they force their users to perceive the greater whole. Art tools and materials that permit one to lay down the body masses in broad strokes produce a picture quickly, and this approach promotes intuitive understanding and rendering of the model's pose. They also prevent students becoming enmeshed in details that they are as yet unable to master.

Why keep the figures small? This makes it easier to retain an overview of the figure, helps to keep the figure compact, avoids the expectation of accuracy in every detail, and saves time. For the reasons already given, it is helpful if the model changes pose rapidly (this prevents copying!)

An exercise in creating the object figure out of the ground figure may be added at this stage [48] in order to teach a focus on the greater whole whilst avoiding incidental details. Before one can do this, one must

Fig. 48 Seated figures shown in relation to different formats.
This piece examines the expressive values for various seated poses (based on observations of complex outline forms) with regard to the proper proportions for the format.
Freely drawn by an amateur artist in soft pencil.

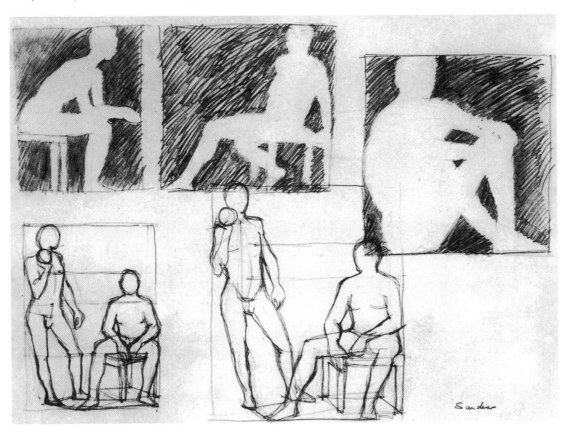

look at the model's pose and expressive body language (expressive of rest, relaxation, attentiveness, etc.) and determine the format's proportions. The format is laid out, and is then filled in with the significant content. Contrast values can be used to delineate the form in a number of ways, from the black and white paper cut-out method to woodcut surfaces.

All these statements on art materials and their relationship to the static properties and expressive issues of seated figures are even more true of the realm of dynamic movement: stepping figures, figures in motion, figures performing work and expressive movements [49, 50]. This is because studying figures in rapid, fluid motion demands materials that allow one to work quickly.

In Figure 49, a student has humorously coupled the phases of stepping forward with the movements of doing work. The skeleton figures were printed using a movable stamp figure.

Round brush exercises are excellent for learning to understand the nature of expression, proportions and movement sequences. When setting these exercises, a tutor must be very careful that they make sense in the context of the brush technique [50]. This method allows students to put feelings, ideas and learning into practice readily and swiftly. For that very reason, however, teachers must set clear goals in order to prevent lapses into boundless excesses, or into mere effect.

The body's masses – the head, the rib cage, the pelvis and buttocks, the front side of the thigh, and the rear side of the calf – should be drawn with a single brushstroke. This means that the size of the figure depends upon the size of the brush (one wouldn't want to paint large figures with a small brush!). The simply rendered joint shapes are developed out of the brushstroke, rather than copied in. The brushstroke must breathe: imprinting and simultaneously forming – loosening and dying away – swelling out, etc. The task should on no account be tackled in a manner alien to the brush (such as by filling in a silhouette). Equally, the marks of the brush should not be placed one after the other in a mechanical fashion.

Why is this? Because otherwise, there can be no whole figure, only the sum of the individual areas. Additionally, each individual area must be given its proper shape. In all of these exercises, one must ensure that the model's pose is a clear and expressive profile or frontal view. This is because semi-profile views introduce a new set of spatial problems.

The figures must be uniformly compact in size. The models must be inventive, and must change their poses rapidly: this promotes greater concentration on capturing the form, and a readiness to recognise the essentials. The task itself and a sensibly planned wide range of materials represent two halves of the same whole in dealing with the problems of proportions, statics and dynamic properties. This is where the really

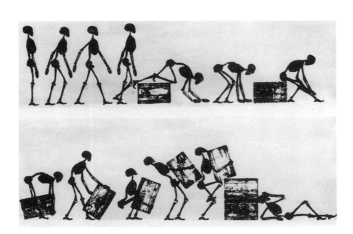

Fig. 49 Phases of stepping forward, and movements of figures at work. The skeletons are printed using movable stamps; the artist clearly wished to visualise dynamic movement in a humorous way.
Free student work, first semester.

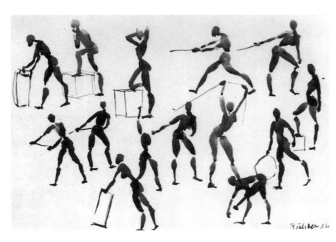

Fig. 50 Studies of the movements of figures doing work. With the model in constant motion, one has to develop an economic way of committing what one sees to paper (a kind of 'brush shorthand').
Student work with a round brush.
Time: around two hours.

fruitful and liberating quality of artist anatomy is to be found: an anatomy for artists that speaks to both the heart and the intellect of the student [51].

One can encourage this harmony through a task involving placing several figures in a relationship to one another (without necessarily having a specific solution to an image problem in mind). Naturally, the figures should have a reason for being together: the theme of the picture might be 'a ball game', for instance. Again, the task has to be clearly defined. As the stage at which body–space problems should be addressed has not yet been reached, the relationships between the figures should avoid half-measures, confusion, obscuring of the intention and complications. To start with, only frontal views and profile views of the figures are permitted, although this does not mean that the inner details of the figure should be drawn two-dimensionally. Layering the space, or using a single or double vanishing point perspective, however, is out of the question. The figures' actions should be taking place within a space that is only a few steps deep. If the figures overlap each other, then it is important not to hide the parts that are critical to their sequence of action, or to the functions of movement. The sequence of movement will break down if it loses its essential features and interconnections.

As for developing the features of the figures themselves, precedence must be given to the complex business of bringing elements together and perceiving them in relation to each other. In other words, the sequence and expression of the movements are of key importance. This exercise will help to refresh and to deepen students' learning of the laws of statics and dynamics. Finally, knowledge of proportions will become another integral part of the learning and exercise phases achieved thus far. When students engage with movement, their own energetic feeling should be expressed: students should allow their own working style to become more animated. This can be done in several ways. Students might put down the movement as fast as lightning using a single line, or, alternatively, might try to clarify the relationship of the main body masses to one another by weakening and strengthening a structure of several energetically drawn temporary approximate lines (as shown in the illustration reproduced here). The overall objective and the challenges constituted by the passion for discovering and inventing ways of expressing movement itself, and learning how to implement these by trying out specific suitable media helps us work more freely. Just because this kind of freedom has no place in the metier of artist anatomy teaching itself is no reason to treat it with indifference. The key to versatility and a readiness to be inspired is not solely to be found in the material itself; it is also a matter of learning how to consistently add a new spice.

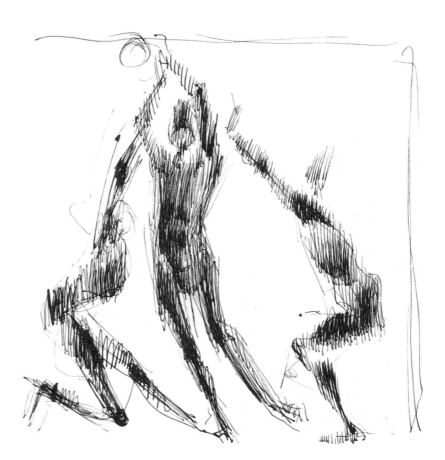

Fig. 51 Experimentation with functionally moving figures. The loose, free rendering of the figures is in the interests of conceiving the movements based on knowledge of static laws, and the motor skills of applying the lines.
Work of a student.
Time: 15 minutes.

1.3.7. The problem area of constructive forms

As we constantly widen our horizons, there is a self-evident need to unite the individual issues within the context of a greater complex. We are becoming ever more precise, complete and wide-ranging in our treatment of dimensions and space; this applies both to the macroscopic and microscopic world view of the scientist, and to the human body as an object in art.

Surely we must seek out and develop easier and better planned instruction methods? In this way, learning about the individual details of the human body's construction will lead us to the most important sets of issues, incorporating the understanding of volume as an expression of the essentials of construction, and paving the way to a real understanding of the plastic form! The ideal preconditions for this can be created by means of two (consecutive) methods:

1. Working with the constructive form
2. Working with the elementary or simplified basic form.

The term 'constructive form' is defined as follows. Essentially, it is a methodical working aid. As such, it promotes a thought process, and a 'thought result'. It represents a thought process directed towards seeking unity amid diversity, and abstracts essential functional features from the seemingly accidental features of the object's appearance. It also represents the 'thought result' of reifying the dialectical unity of function and construction in terms of material and manual implementation.

An explanatory note: work with constructive forms is based on the action of a section of the body, and the interdependence of processes and anatomical facts. As we have already reiterated several times, the performing of an action (a function) and the structure that implements it (construction) exist in a state of mutual entanglement, and mutual indebtedness. The process for abstracting out the essential features from what we see is by no means obvious from the beginning. When one is understanding laws and rules in artistic terms, however, it is very much an allied operation; after all, working as an artist involves a kind of research into nature (Adolf von Hildebrand in his book, *Das Problem der Form in der bildenden Kunst*). In working with constructive forms, artistic and scientific thinking come together. The author feels that this key principle should be reiterated again and again – but, equally, he does not neglect to warn the reader against anatomy for artists becoming purely a sterile doctrine of the constructive form.

As soon as students reach a significant stage in their path of ongoing understanding, and feel aware of this dialectic in the nature of what they are doing, having 'found' the constructive form through the process of material and manual implementation, it can only signify the attaining of a new stage in thought.

To see nature only through the lens of construction would impoverish art unthinkably. If we wished to understand the essence of what we see through anatomical perspectives, we would come up against an anatomy that, regardless of changes in external appearance, remains relatively constant, and changes far less readily than outward appearances do. What resides in law is relatively constant (Hegel). Anyone who looks at the essential features of the joints from the perspective of how they function and the principles of their construction will soon realise this.

It follows that working with the constructive form must always mean being able to comprehend the fundamental dialectical principles of nature more quickly and more easily, or, indeed, even being able to comprehend them at all. We can grasp the nature of the body's being as the basis for appearance only in terms of the chief and most necessary characteristics; it is only in this sense that working with the constructive form can be seen as a 'result', and even then it is only a preliminary result. It is not an end in itself. It is a purposefully deployed method for thought and practical exercises. It embodies a step on the road to full understanding, because it allows one to produce phenomena with visual clarity whilst showing a consciousness of 'the structural context of a diversity, the structures that inwardly connect and support the individual parts' (Max Müller and Alois Halder). In this sense, artist anatomy, as a theoretical branch of art instruction, may claim to be ahead of artistic practice, rather than merely following its lead. The eye should always be open to the wealth offered by nature, and it must also be trained to see what is really essential. Pictures created at this stage should reflect this new level of understanding: they should endeavour to synthesise, by unifying a natural wealth of variations with the essential facts.

Surely, these thoughts are not irreconcilably distant from Albrecht Dürer's famous statement? 'But life in nature leads us to recognise the truth in these things. You should therefore look at it attentively, pattern yourself after it, and do not depart from nature on a whim because you believe that you can find a better way yourself; you will be misled. For, truly, art resides in nature; he who can tear it out shall have it'. One must materially and manually express one's insight into the essence of the living being during the drawing and modelling process because, for an artist, it is practical intellectual work that leads to greater intellectual clarity. The success of the artist's insight into the essence of the being is proven only by the product of this process, and whether the successful achieving of this stage of thought has penetrated into the artist's actions can only be confirmed on the basis of how it is applied when working from nature. Working with the constructive form has particular significance in two main directions in acquiring and in consolidating the essential content. (The author points to his postdoctoral thesis, 'Neue Grundlage einer Methode des Lehrfaches Plastische Anatomie', 1958, section 3.3, and his book *Die Gestalt des Menschen*, pages 531–540.)

1. Thus, students find it easier to orient themselves in the great 'spectrum of variation' seen in the plastic transformation of the joints during different movements. The peculiar external plastic form of each joint can be illuminated and 'reconstructed' by

introducing students to the building block forms in relation to the action performed by the joint.

2. Students also achieve an understanding of transformations in the relative positions and forms of the major bony spaces of our bodies. An understanding of these transformations in relative position and form is a precondition for precise knowledge and spatial comprehension of the peculiarities of the bony cavities themselves.

Joints

Some examples have been included here to show how tutors and students can work together on understanding the plastic peculiarities of the joints, whose constructive skeletal forms and movements provide the basis for the joint's external appearance. Practical experience has shown the correctness of this sequence: first, the clarifying of the task, followed by the facts of the relationships between the component parts, the construction of a joint and its mechanical properties, the modelling of the constructive form, and, finally, free-form drawing from the model, and from the imagination. The reader should be able to trace this tried-and-tested sequence in the end result: the student's work. In every case, we have taken care that the subject matter is introduced in the same identical manner demonstrated by the author in the introductory section. This is why we leap right into the midst of the stage of instruction primarily dedicated to developing the abilities and competencies of students, and explain the procedure based entirely on the examples of the knee and the wrist joints.

To begin with, the tutor has described the role played by the knee, its component parts and its construction with the aid of appropriate samples, and, using the genetic method, has shown how the joint is constructed from the individual components by drawing them successively on a blackboard [219] (cf. section 5.3.3).

First working stage [52]: Prompted by the image on the board, students should undertake a plastic exercise in rendering the joint's construction as a three-dimensional body, learning to literally build it. In learning terms, it makes sense for students to create the elements individually, one after the other, relating each to its function. This avoids any possibility of simple imitation:

Creating the trochlea
Creating the cube-shaped frontal structure
 (facies patellaris)
Creating the flat surface (the head of the tibia)
Creating the four-edged shaft of the femur
Creating the three-edged shaft of the tibia
Creating the convex shape of the kneecap

This is followed by putting together the component parts (represented by the structural model) to form a single structure. It is the manual aspect of the exercises that is so instructive – in other words, producing things by hand causes the facts to stick much better than a purely mental exercise would.

Not until the basic principles of the three-dimensional body's construction have been clarified can the student undertake greater differentiations, such as rounding the cube-shaped frontal structure, dividing the trochlea into a double roller form, forming the structure of the intercondylar eminence, and applying the condyles and epicondyles to the basic surface of the trochlea.

Second working stage [53]: At this stage, we are concerned with transferring the three-dimensional concept to the two-dimensional drawing surface. Students will draw the natural shapes of the knee bones, bearing in mind the principles of construction dealt with in the first working stage. All of the lines and edges that are in reality hidden from view should be drawn (like a transparent three-dimensional wire model). One advantage of this is that it obliges students, as they draw from their own specific vantage point, to thoroughly consider the position of the three-dimensional body in space, and to draw the whole of the structure. When drawing from nature, students readily succumb to the temptation to draw the external features without being able to show how they relate to the whole. The important thing is that students should learn to apply the insights gained from the real construction approach in the first working stage to this second stage. The difficulty level can be increased by drawing the constructive form, in its function, without a model.

Third working stage [54]: The main purpose of this stage is to understand the living plastic appearance of the model, to penetrate into its full complexity based on the knowledge of the special qualities of the three-dimensional structure gained from the first and second working stages.

One can prompt students to gain an understanding for themselves through a repeat analysis (through drawing exercises) of external appearances, going right down to the skeleton, or by delicately underlaying the drawings from life with the constructive forms, and then reconstructing them three-dimensionally.

In any case, it is advisable to give precedence to one single form of understanding through drawing: either skeleton analysis, or external construction. Trying to draw both at once with equal emphasis creates confusion, and makes it harder to investigate the structures with the degree of definition that is essential at this stage.

Fourth working stage [55]: In order to check their own work and to thereby discover gaps in their concept of the form, students try to draw studies of the knee from a wide range of perspectives, and with all the different foreshortenings, without a model. This will quickly lead them to recognise the gaps in their ability.

A precise knowledge of the constructive form and its composition – and the resulting mechanical processes – is the basis for understanding the plastic transformations associated with movement.

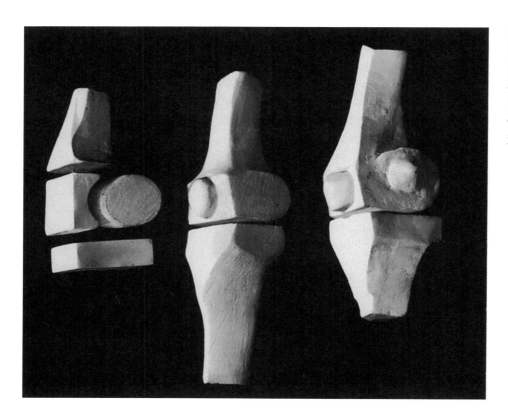

Fig. 52 The constructive
forms of the knee bones.
The individual elements
are modelled in the form
of a structural model (first
working stage), and are fitted
together during the next steps
in the working process.
Work by a student, second
semester.
Time: approximately six hours.

Fig. 53 The constructive forms of the
knee bones, based upon their function.
Constructively drawing striking and
memorable forms, whilst simultaneously
simplifying the form, is psychologically
essential to internalising the unity of
form and function in the object (second
working stage).
Work by a student, second semester,
drawn purely from the imagination.

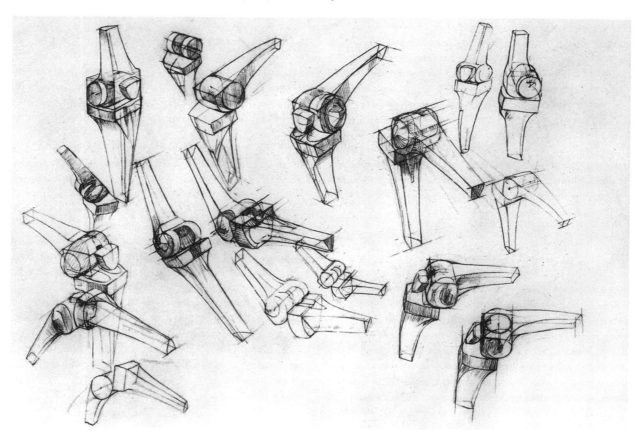

The aim is to present the fundamentals in relation to the additional plastic 'attachments', such as the soft tissue forms. It is a good idea to constantly check that students are bearing these fundamentals in mind. Our illustration is therefore specifically concerned with the functional behaviour of the leg joints, which the model demonstrates in action for a brief period, so that the impression from living appearances can be subjected to a constructive and mechanical analysis, with the purpose of creating a clearly articulated plastic form.

The hand and hand joints

Once one has clarified issues such as subdivision, component parts and structure, and the construction of the hand, one should begin with the modelling exercises.

First working stage: The goal is to initially get to know the component parts of an ellipsoid joint, in a simple architectonic form: in isolation, and in combination.

The individual stages might look like this (cf. also section 8.12.3.):

a) The first step is producing a four-edged shape with the same length and breadth as the natural skeleton of the hand with a distal penetration, ulna and radius firmly united together as a whole. The form is now differentiated to the extent that both bones can be seen on the flat stretched-out convex curve of the back of the hand, and the shallow concavity of the palm of the hand: the club-like end of the radius and the wheel-like end of the ulna.

b) We fit the arch of the first carpal row (the sickle form) into the hollow form of the distal joint surface of both bones of the forearm, taking care that this harmonises with the transverse curve of the bones of the underarm. A small cube shape can later be placed on the palmar, ulnar side to represent the pisiform bone.

c) The next step is to construct the metacarpus, firmly connected to the second carpal row. There are many factors to consider that affect the plastic shape: the

Fig. 54 An investigative life drawing. The constructive forms are linked with the forms of the soft parts by means of a constructive drawing strategy (third working stage).
Work by a student, second semester.

Fig. 55 Studies of the knee, drawn without a model.
In order to determine whether – and in what way – one has understood the unity of form and function, one must try it out in drawing exercises, in order to check one's ability to draw from memory (fourth working stage).
Free work by a student, drawn purely from the imagination, second semester.

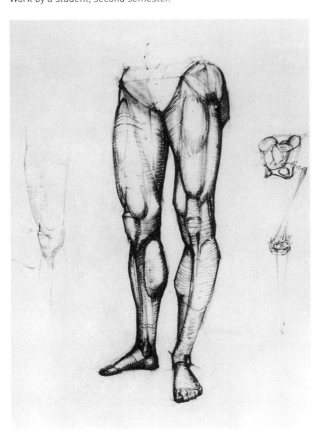

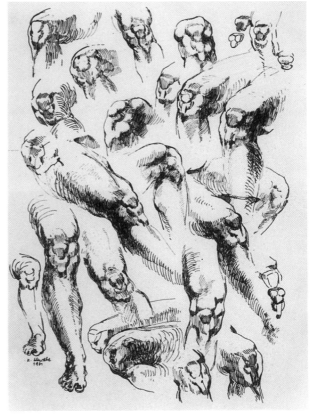

relationship between the greatest breadth and the greatest length (both should be about the same), the trapezoid form of the metacarpus without the thumb metacarpal bone (which is modelled separately), the particularly pronounced convex transverse curve of the metacarpus trapezoid in connection with the distal carpal row, and the flat transverse curve on the distal head row, and the low convexity of the longitudinal curving on the rear side, plus the more pronounced concavity of the longitudinal and transverse curving of the palm.

d) The capitate of the distal carpal row fits into the proximal, in the manner of a hinge joint [431].

All of the processes of movement can be imitated faithfully and naturally, allowing the plastic transformations to be studied to advantage.

Again, importance should only be ascribed to the details in so far as they play a role in the functioning of the whole system.

Second working stage (not illustrated here): It is very hard for the student to see the many individual forms within the hand skeleton all together, as part of a larger whole unit. Just as with the foot, it is easy to become lost in detail. When drawing the hand, the student should always take care to bring together the individual units dealt with in the first working stages to create a constructive complex. In the case of the moving hand joint, this is made even more difficult by problems of spatial arrangement; it is therefore advisable to start by drawing from a modelling clay model that you have made yourself before moving on to the natural skeleton of the hand.

Third working stage (not illustrated here): When looking at the living hand, the beginner sees the individual features without properly being able to fit them together as a whole, or to clarify their three-dimensional, spatial relationships.

Fig. 57 Arm and hand studies with an expressive character.
One of the ultimate goals of anatomy for artists is to be able to use knowledge of the construction and function of the body as the basis for artistic expression (fourth and fifth working stages).
Student work, done partly from imagination. Fourth semester.

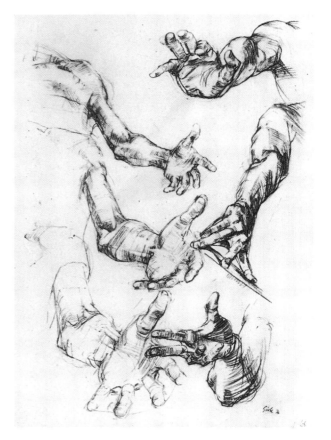

Fig. 56 Assembled model representing constructive hand skeleton forms.
The individual assembly elements are fitted together without connections, thus allowing them to be used to simulate and to demonstrate movements. Joint forms are also manufactured manually by the students (first working stage).
Created by a colleague of the author.
Larger-than-life size.

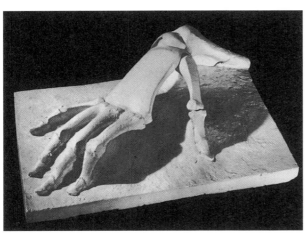

Students should therefore construct their drawn studies in the same way, creating clear three-dimensional bodies, working in the same way as with the first working stage. From the point of view of capturing the body in space, it is advantageous for the student to treat the fingers as consisting of connected tetragonal pieces. This helps to develop a reliable and free method of rendering the connective joints. Expressively drawn studies of the arm and hand can only be undertaken on the basis of precise anatomical functional concepts, which should be accompanied by spatial investigations that emphasise three-dimensionality [57, 58].

Bony spaces

In order to shed light on the various transformations undergone by joints during movement, it is important to understand their constructive form. Aside from the scaffolding forms of the joints and their variations of movement, there are a number of other 'constant'

constructive forms in the frame of the human trunk: pelvis, rib cage, skull. These form the main bony spaces in the skeleton; these volumes are so important to the constructive structure that, compared with them, the soft tissues – the muscles and fat – are of only secondary importance. In this explanatory chapter, I will keep to the examples of the pelvis and the skull.

The pelvis (cf. section 5.5.)

The tutor has explained the role of the pelvis: it connects the trunk to the lower extremities, takes the weight of the upper body when at rest (standing, sitting or recumbent) and moves, protects and carries the intestines and internal reproductive organs (and, in women, the birth canal). It is also the centre where many muscles originate. From all this, a constructive form is derived. To start with, this constructive form is drawn on the board [59].

The pelvis's hemispherical body offers stability and large capacity. It combines the advantages of the ring

Fig. 58 Three-dimensional, spatial studies of the hand.
Being able to draw these is an important precondition for being able to create expressive hand studies. We investigate the hand's spatial configuration by opening up or condensing the structure of strokes, based upon the layers of spatial depth (top right, bottom left). The hand's three-dimensional configuration is imitated by giving the spatial directions of the surface's gradient, with no boundary at the object-space transition.
Student work using a pen on a dark background. Fourth semester.

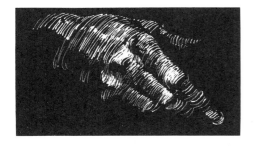
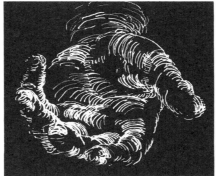
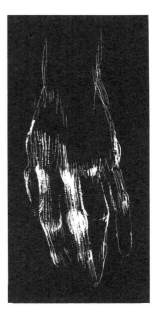

construction (ability to withstand a great degree of demand) with an abundance of space. If one compares the pelvis with a hemisphere, then its upper limit can be treated as analogous to the equator, whilst the South Pole would be represented by the pelvic floor. The latitude equidistant between the equator and the South Pole divides the upper and wider pelvic region from the lower and narrower pelvic region. The pelvis–thigh connections, the hip joints, are found at the same height as this 'latitude' (which, in terms of similarity to the natural pelvis, can best be represented by a ring construction). This basic construction is modified: the hemisphere is drawn in at 'hip joint latitude' height (at the linea terminalis). Thus, the greater pelvis region is set some distance from the smaller pelvis region, creating a crater form. The rough outline of the crater shape is differentiated by a wider flattened area to the rear, and by the way the pelvis comes to an obtuse-angled point (like a prow) toward the stomach area [60a–a_1, b–b_1]. What we are trying to do here is to gain a concept of the pelvis as a 'block', an enclosed three-dimensional body [60a, 61].

In order to avoid compression of the soft tissues due to the coming together of the rib cage and the pelvis, the closed form of the pelvic ring is interrupted by a stepped opening in its upper region, toward the stomach [60a, b, c]. This graduated opening exposes the anterior superior iliac spine and the front part of the narrower pelvic region to view when seen from above (the superior ramus of the pubic bone) [60c]. Beneath the pubic symphysis, toward the ischial tuberosities, the lesser pelvis comes to a point with a small triangular surface at the ischial tuberosity (the pubic bone arch). We can easily transform the block form into a hollow form, the floor of which (the lower opening of the lesser pelvis) we can remove [60a_1, b, c, c2, d3].

This example shows how we can determine the main forms from the secondary forms, and give meaning to the details in terms of their relationship to the whole (on this, cf. pages 226–227).

The 'explaining' of the pelvis by means of an image on the board can take us thus far, working genetically, as a thought-operation-type abstraction. This alone, however, is not enough. For an artist, the abstract needs to acquire a sensory element!

Once the picture on the board is fully complete, a question remains: is there now a fully spatial view – from every angle – and can students put it down on paper from every perspective, with every possible foreshortening? This makes the modelling exercises particularly indispensable.

Fig. 59 From the introductory orientation to pelvic pliability, showing its progressive development. Excerpt from a blackboard illustration by the author in *Sehen und Verstehen*.

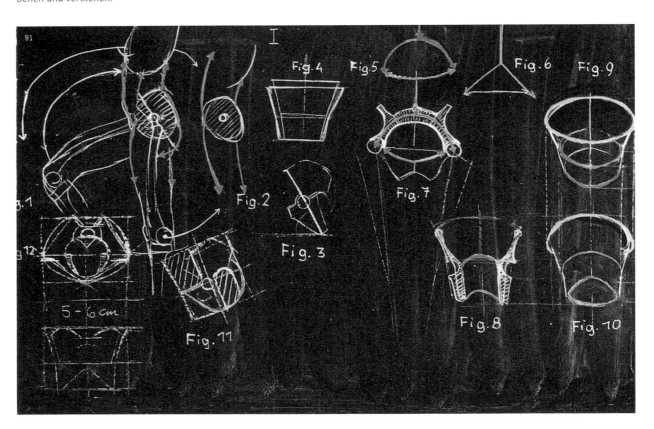

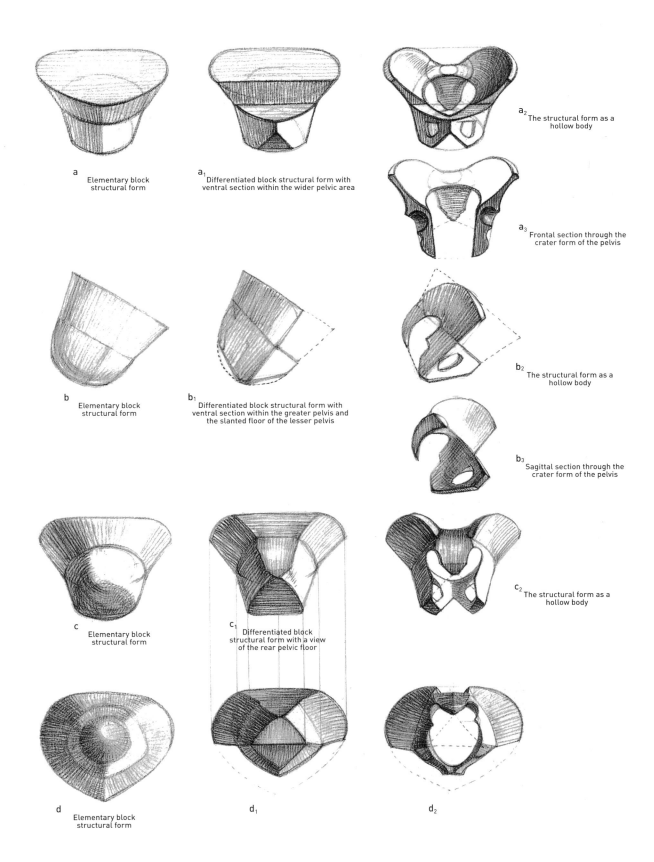

a Elementary block structural form

a₁ Differentiated block structural form with ventral section within the wider pelvic area

a₂ The structural form as a hollow body

a₃ Frontal section through the crater form of the pelvis

b Elementary block structural form

b₁ Differentiated block structural form with ventral section within the greater pelvis and the slanted floor of the lesser pelvis

b₂ The structural form as a hollow body

b₃ Sagittal section through the crater form of the pelvis

c Elementary block structural form

c₁ Differentiated block structural form with a view of the rear pelvic floor

c₂ The structural form as a hollow body

d Elementary block structural form

d₁

d₂

Fig. 60 Sequence showing the constructive development of the form of the pelvis, from a number of different perspectives. The differentiated hollow body is developed step by step out of the heavily simplified bodies, conceived as 'blocks'.

First working stage [61]: This involves modelling the form of the pelvis with the aim of working out and consolidating a fully rounded spatial image. The sequence of individual tasks is the same as for the board image: the student starts with the solid shape, leaves out the secondary, incidental forms, and creates a block. Another possibility is to model the hollow form of a crater with a piece of rod, and to add the apertures in the back and stomach sides at a later stage.

Second working stage [62]: The aim of drawing the pelvic bone (under the headings discussed above) is to be able to check understanding of its spatial shape.

Once students understand how to lay out the outline of the whole shape, and how to clarify their standpoint with an eye to its axes, they will succeed in portraying the angle of inclination of the pelvis, and in arranging the secondary and individual single forms in such a way as to create the proper bowl form, which encloses the space. Subsequent working stages will require the pelvis to be drawn from impression, without a model. Applying a knowledge of the pelvis as a three-dimensional construct to artwork becomes very necessary when the hip and thigh muscles must be represented, showing their origins and insertions [244/1].

The head: the skull

The objectives of studies of the head – capturing large masses of the cranial and facial skull regions and their architectonic features, assigning the secondary forms to the main forms – are discussed in section **10.3.**, 'The constructional form and plastic appearance of the skull' (page 437 onwards).

Like the shape of the pelvis, the specific three-dimensional form of the head can be worked and developed piece by piece using the modelling method, with appropriate simplifications [63]. Instructions for students are the same as for the pelvis: in other words, the idea is not to simply reproduce the skull's external form. Exercises in modelling the skull should produce self-contained structural constructions: the protective housing of the braincase and supporting scaffold of the facial skeleton. To proceed in the fashion of a master builder, it is useful, for example, to develop

Fig. 61 A plastic development sequence for the constructive form of the pelvis. The three-dimensional capturing of the basic composition begins with the modelling of an elementary block-like form, followed by the making of hollows and incisions in this volume (first working stage.)
A plaster model by a colleague of the author, used for demonstration for third-semester work.

Fig. 62 A study of the pelvis in a perspectival view.
The aim is to bring out the constructive functional content of this complex natural shape, along with the striking qualities and simplicity of the form (second working stage).
Student work, third semester.

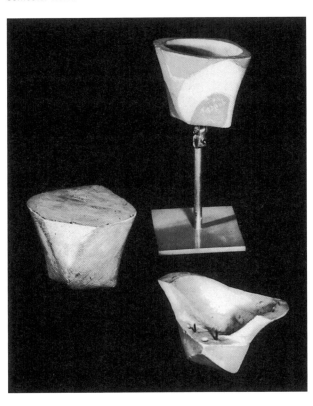

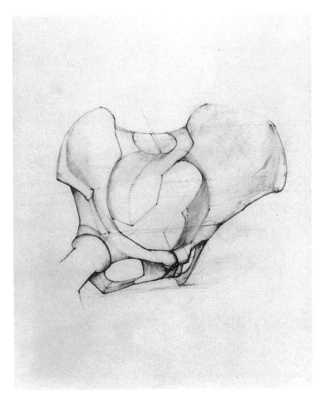

the braincase plastically from the ground plan up, to erect the sides, front and back walls and roof. This develops a feeling for structure. Greater clarity can be achieved with the two main masses of the skull if they are first modelled separately, and are brought together at a later stage [64]. This understanding of build, of structure, should also be incorporated into the two-dimensional skull studies. The continued emphasis on detail on the one hand and the whole form on the other ultimately derives from an insight into the dialectic: an insight into the way in which the individual elements and the overall whole exist and interrelate.

In this case, the purpose of modelling the sections of the skull individually, and then placing them together carefully and correctly, is to get to know and to handle practically the two distinct functions (containment and protection) of a round, enclosing shell structure such as the cranium and the support from within provided by the pillars of the facial part of the skull as a self-contained unit, but also as a construct with a highly specific structure [63].

Correct handling, however, also means understanding the whole, in order to precisely determine and adequately render the significance of the individual details whilst taking into account the highly differentiated structure. This also means being able to call to mind the rules of the configuration at any time, regardless of whether one is dealing with three-dimensional plastic constructed forms, or with two-dimensional drawn constructed forms [64]. Once the character of the pillar structures in the facial skull have been understood, it makes sense to allow the embedded and absorbed horizontal structures and the various surface modifications to become a part of the picture.

Furthermore, the supportive scaffold is covered by soft tissue forms; these, however, do not conceal the essential features that determine the character of its external appearance [65, 66]. For studies of the head (and of other parts of the body), students must therefore employ a construction process in which hard forms and soft forms come together, interacting

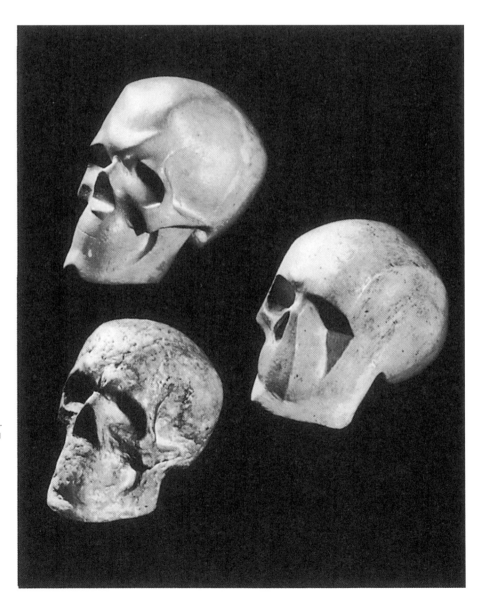

Fig. 63 Models showing the architectonic structure of the skull. The preliminary stage of modelling (first working stage) is concerned with the basic plastic forms of the cranium and facial skull sections, the constructive interconnections (with particular reference to the transference of the pressure caused by mastication), and balancing the forms with each other.
Student work, plus a demonstration model by a colleague of the author.
Plaster, life-size.

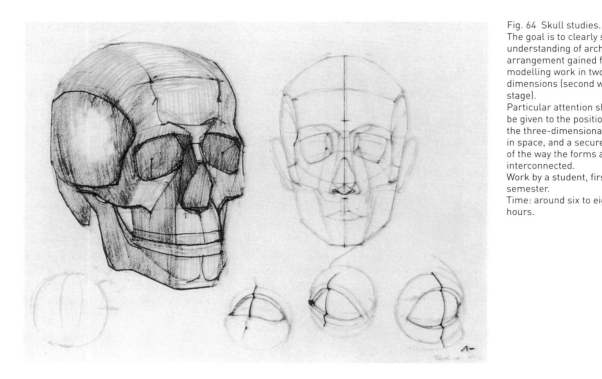

Fig. 64 Skull studies.
The goal is to clearly show the understanding of architectonic arrangement gained from modelling work in two dimensions (second working stage).
Particular attention should be given to the positioning of the three-dimensional form in space, and a secure sense of the way the forms are interconnected.
Work by a student, first semester.
Time: around six to eight hours.

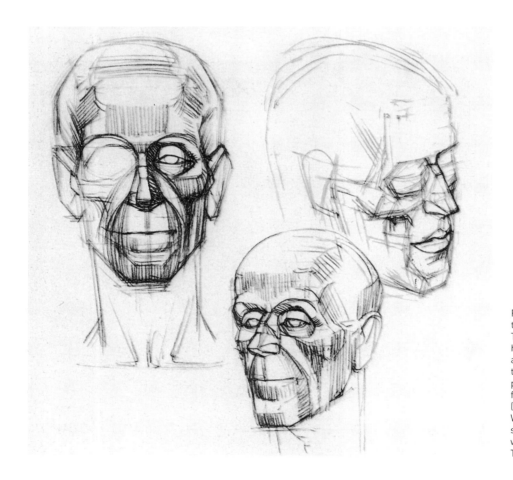

Fig. 65 Analytical studies of the head.
The student projects his or her understanding of the architecture of the skull into the living model, in order to provide stabilising structures for the head's surface form (third working stage).
Work by a student, second semester, drawn partly without a model.
Time: around two hours.

and complementing one another, forming peaks and hollows: on the head itself, at the transitions between the head, the throat and the upper body and so on.

We need to promote competency in mastering the trunk and its skeletal forms [67] because it provides the foundation for the next stages in terms of portraying the torso muscles, and of a further understanding of the architectonic plastic qualities of the torso. Before students can enter into this new area of subject matter and the new problem areas, however, they must, once again, be given the opportunity to test all their knowledge and skills relating to the constructive form. For both students and tutors, this represents a good opportunity to check what has really been learned.

This is decided by means of an exercise, the title of which being laconically short and to the point: draw the skeleton in motion! Students should have very specific activities in mind: an acrobat's handstand or somersault, a juggler on a unicycle, a straining heavyweight, a figure squatting on the ground – the range of activities offered by sport and by professional occupations is inexhaustible! The criteria for solving this problem are: typical proportions, functional expression and movement relationships, successful foreshortenings, and constructive forms which are clearly readable in their function.

Imagination is permitted. It is therefore not surprising that, with this task in particular – which, you will remember, is completed without any visual reference material – students will constantly surprise the tutor [68]. In terms of results, this represents a high point in the complex business of working with the constructive form, and in the total course of anatomical instruction. Thus prepared, ascending step by step, building on each stage in order to reach the next, and with all of the stages interpenetrating and complementing each

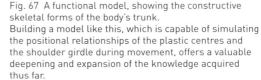

Fig. 66 A three-dimensional, spatial study of the relationship between the head and throat.
This study conforms to the fundamentals of constructive drawing based on the knowledge and skills acquired thus far, including the specific knowledge relating to the individual forms within the head (fourth working stage).
Work by a student, second semester.
Time: approximately two hours.

Fig. 67 A functional model, showing the constructive skeletal forms of the body's trunk.
Building a model like this, which is capable of simulating the positional relationships of the plastic centres and the shoulder girdle during movement, offers a valuable deepening and expansion of the knowledge acquired thus far.
Created by a foreign guest student. Plastic, 30cm (11¾in) in height.

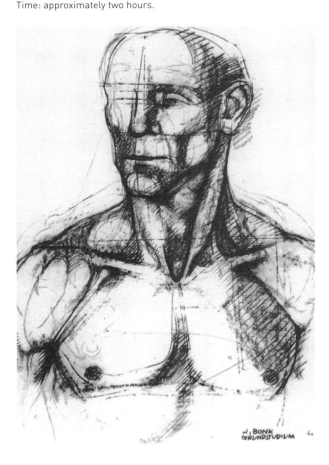

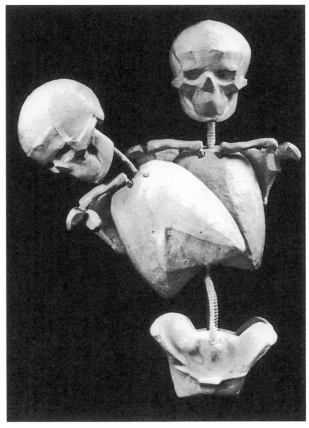

other, with learning and practical application, exercises and new insights, the creative powers of the student develop.

Our educational activities for artist anatomy have now acquired a rhythmic structure. The individual working stages are planned phases and teaching elements in a proven sequence; combined with other lesson elements, they impact decisively on the overall structure.

The advantages offered by working with the constructive form in studies of nudes are self-evident [69, 70]. One only has to picture the task of drawing a reposing nude figure, with the back of the rib cage resting on the surface, and twisted in relation to the pelvis, which stands vertically on one side. What an abundance of foreshortenings and intersections! The construction of the volumes, their position in space, the primary masses and the secondary forms must be understood, and the interconnections that make up the whole must be reliably produced. Confident understanding – the ability to reproduce, in thought or on paper, the supportive structure that, in a living person, would be concealed – is extremely helpful in revealing the answers.

Summary:

1. The ways in which working stage sequences for artist anatomy elements can be structured are primarily based on the study goals, the overall structure, and the educational principles that apply to each unit of subject matter, each tutor and the age of the student. They also apply to the special area of anatomy for artists, and guarantee a lesson structure that is conducive to the process of understanding.
2. Artist anatomy begins with the individual facts of the structure of the human body and the fundamental principles of its construction, followed by the wider complexes, which comprise the understanding of volumes as an expression of the subject matter of construction. This helps to create a secure route to an understanding of the essential features of the plastic form.

Fig. 68 The skeleton: its function
In this illustration, the static and dynamic movement concepts, working motion and expressive motion processes, constructive form and mechanical joint processes are combined, shown in their mutual dependence and interpenetration.
Work by a student, third semester.

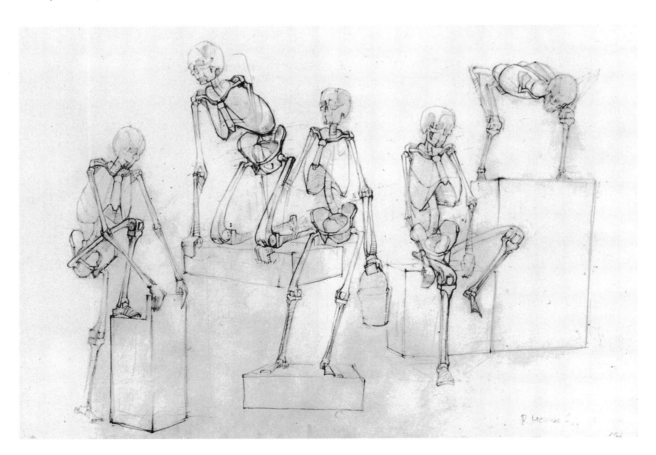

3. In order to further develop students' creative powers, two particular methodologies – one following the other – can be used to create favourable preconditions:
 a) working with the constructive form
 b) working with the elementary or simplified basic form.
 In working with the constructive form, one should try to think dialectically.
4. In the material and manual implementation of an artwork (through modelling or on paper), the constructive form embodies a stage in thought, which is derived from phenomena governed by laws.
5. In ongoing life studies, this mental stage should lead onto an endeavour of synthesis: to unite natural diversity with the essential nature of the subject.
6. Implementing the constructive form furthers the endeavour to make an abstract thought visualisable for the artist, and to understand detail from the functional whole.
7. Working with the constructive form is particularly useful in understanding the bony cavities (pelvis, rib cage, skull), and the plastic transformations of the joints.

8. Working with the constructive form is primarily important because it helps to appropriate and consolidate the material, the acquisition of form concepts, drawing competencies, and clarification when working with nude models.

1.3.8. The problem of the three-dimensional body and space

When working with elementary or simplified basic forms, we use the second of the two possible methods for streamlining, honing and heightening learned material, and for creating an order and arrangement of individual elements that allow the essential plastic qualities of the form of the object as a whole to be seen.

The reasons for using the second method are as follows: the constructive form comprises only certain areas of the body: the supportive scaffold form, or the bones. The body has other components that are critical in determining its form: muscles, skin and fat, which, taken together, compose the spatial form of our body. The nude image, however, should not present anatomical facts like a cross-section image. Instead, the soft tissue forms should be viewed in relation to the

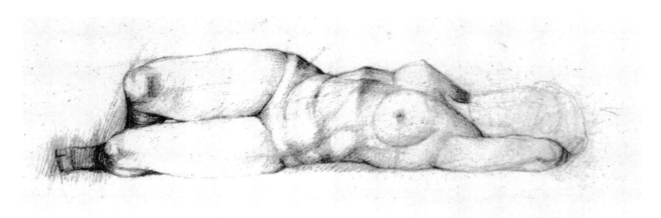

Fig. 69/70 Three-dimensional spatial investigations, drawn based on nudes.
The ability to reconstruct the plastic centres in the right form and position and in terms of the points of construction, and to properly connect them with the soft tissue forms, makes it significantly easier to create the plastic building blocks of the body in a clearly intelligible form – particularly for difficult perspectival views.
Work of a Burmese guest student.
Time: two hours each.

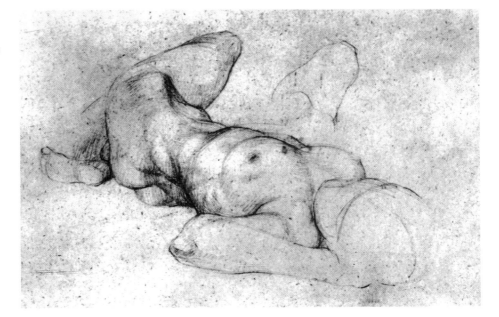

supportive structure so that they are united with it as a total, whole form whose volumes are optimally clear and simple [69, 70].

This process helps to pave the way to attaining a stage of thought (and responding to the associated dangers).

At this stage, three-dimensional concepts are supported by mathematical abstractions: simple cubic, pillar and spherical forms. 'Box men' have become a blight. Any simplification for educational purposes is justified as long as the heart of the matter is retained: in our case, the specific features of the spatial form. Simplifying forms into spherical and box shapes is unscientific because they refer to mathematical bodies that lie outside of nature, and because they exclude the key essence of the plastic form. One cannot reduce the head to a sphere, or the upper body to a rectangular block. The dangers of schematics are self-evident. The endpoint of anatomical instruction should not be the muscleman figure, which is the embodiment of ostentatious knowledge. Instead, one should attain an insight into the architectonic structure of the body, accessed via a process of formulating characteristic statements on the specific three-dimensional spatial features of natural bodies by means of simplifications.

We will call this the 'elementary', or the simplified, basic form.

The definition of 'simplified basic form': the simplified basic form is, by its nature, a methodical aid. It is a stage of thought based on the concepts of the scaffolding forms. Incorporating the soft tissue forms, it abstracts from it to create a whole form with great clarity of volume. In this way, the simplified basic form creates further favourable preconditions for the assimilation of the object form into the image form. As a result of thought, it embodies the material and manual implementation of the architectonic content of a whole form, and gives an unambiguous meaning for its occurrence. The simplified basic form contains cubic components. However, it has nothing in common with the schematic figures known as 'box men'.

Explanation: The artistic mode of thought can only elevate individual anatomical details into the sphere of consciousness and the conscious assimilation of knowledge if 'dissection' is complemented by intellectual reconstruction. After all, the whole is just as necessary to the artist as its parts. In terms of a process of gaining insight, an analysis without synthesis is unthinkable: there must also be a unifying

Fig. 71 Life-size cross-section model in wire. In educational terms, a model like this is helpful because it prompts students to regard the appearance of the living person as a three-dimensional composition. The well-thought-out cross-sections are very effective in aiding comprehension of specific shapes.
Work by the author.

Fig. 72 Nude study, with a 'surface net' design. Here, the figure's three-dimensional and spatial properties are clarified with the aid of a 'surface net' that the student can mentally overlay on the model, helping to check the lines of cross-sections and height.
Work by a student, fourth semester, subject area: plastic. Time: two hours.

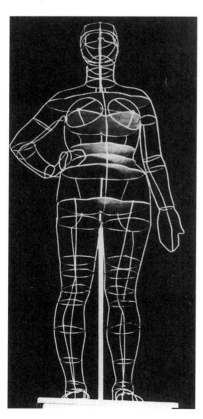

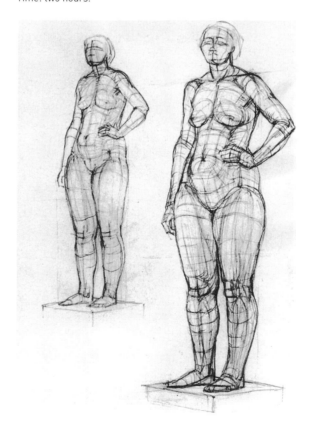

and harmonising of the many individual elements into a new whole whose components interpenetrate and influence one another. Anatomy for artists helps to pave the way for an artistic, visual way of thought and insight that endeavours to capture the appearance of things as a totality, and is more than the sum of its parts, by offering defined stages and learning operations that lead to this holistic view.

The purpose of working with the simplified basic form in teaching is to improve understanding of the essentials of the corporeal spatial form through analysis/synthesis, with the synthetic aspect predominating. The aim of the work, with the simplified basic form, is to cultivate the order and clarity of the architectonic whole – including individual parts, such as the supportive scaffold and soft tissues – in the way they create volume and merge to create the whole form. In this sense, working with the simplified basic form trains students to draw constructively. The individual facts acquired thus far serve to form an objective understanding of the essentials of the plastic form. The anatomical individual facts are fused into a spatial, streamlined, simplified basic form. To summarise:

- The simplified basic form serves to teach the spatial movement and the positioning of the volumes [70]
- The drawing exercises provide an introduction to the body in space.
- Simplified basic form work is an educational simplification of the highly differentiated, complex forms of the human body.

The most basic endeavours behind this simplification are as follows:

1. An understanding of the individual spatial form. We understand the individual spatial form to mean the peculiar demarcation of a particular section of the body, as reflected in the body's surfaces.
2. Making the individual spatial form more memorable by using a clear surface arrangement to delineate the volumes.
3. The ability to reproduce the individual spatial form, with particular reference to the shifting of perspectives (perspectival foreshortening).

Certain procedures are required to support this approach. The tutor provides visualisations and overviews of the three-dimensional body. Wire cross-section models of the type developed by the author are useful because one can see through them; they allow one to see cross-section lines that would otherwise be hidden. They also emphasise the distribution and intensity of the accents of curvature [71]. The pieces of transparent plastic film fitted in between the cross-sections can be taken out of the model in order to be compared with each other (cf. section 8.7. 'The architectural form of the trunk...'). Where the surfaces extend across sharp cross-section accents, they come together to create raised 'edges' (cf. Holbein, Hand study, illustration14). This provides a possible means of clarification, by using a system of surfaces to render the most important 'spatial gradients' of the body's surface [72].

An essential precondition for understanding a simplified basic form is to have previously addressed the constructive form and, founded on this, the

muscles. Fundamentally, the aim of any kind of work with simplified forms is to consolidate the spatial rhythms through exercises, and to make them available for correction by the tutor. All the previous steps in working with the constructive forms and with the representation of muscles must be considered to be preliminary stages for this final stage of concept formation. Here are a number of examples.

The plastic qualities of the torso

The student has at his or her disposal the constructive forms of the pelvis and rib cage (plaster cast copies of students' work), with appropriately matched proportions [73]. The tutor explains how the two large bone volumes are surrounded by the soft tissue forms, and how these also create elastic bridges between the two sections (cf. section 8.7. 'The architectural form of the trunk...').

Students incorporate the constructive forms of the skeleton when working with the simplified basic form; after all, they are a precondition for understanding the plastic situation.

First working stage: This comprises modelling a plastic torso which is divided into clearly defined separate stages:

a) Guided by the nude model and the cross-section model, the student recreates the constructive pelvis form by adding its soft tissue masses. It makes sense to base one's work on an outline drawing (at trochanter-pubic bone level), by laying this drawing out on the surface beneath the model.
b) This should be followed by the connective section between the pelvis and the rib cage. During this stage, the main intention is to clarify the plastic function of the oblique abdominal muscles, whose spatial 'gradient' is a consequence of their attachment to the sides of the pelvic brim and the borders of the rib cage. As a volume, the straight abdominal muscle is ignored for the time being.
c) The constructive rib cage [323] is placed atop the connective section. The front-lying volume of the straight abdominal muscle, which is to be modelled separately, can now be properly understood as a bridge between the pelvis and the rib cage, in a significantly forward position.
d) The students can then fill up these basic form volumes with the secondary forms, such as the large chest muscles (pectoralis major), the breast area and the shoulder girdle.

The students create their own assembled models that teach greater familiarity with the individual architectural elements and their peculiarities; fitting them together to create a whole through a process of building. The purpose of modelling the simplified basic form is to understand volumes by handling them, to merge the simple three-dimensional body structures of the individual secondary forms together like a master architect. This helps to cultivate students' ability to envision three-dimensional, spatial forms: an indispensable precondition for free creative work.

This level of thinking and mental picturing also extends into drawing activities, although the natural

form should not be constrained by any kind of 'box man' template. In this way, one very gradually gains a feeling for three-dimensional forms in space, cultivating a creative mode of action that, when drawing nude studies, shapes the process of observation, and determines one's actions.

It should, however, be acknowledged that there will not always be sufficient time to develop the simplified spatial basic form through modelling.

Second working stage [75]: Now that drawing can exercise a deeper influence on forms that have been prefigured in modelling, it is desirable to switch from modelling to drawing: the idea is to construct the primary masses and their secondary forms – without slavish imitation.

Students' new-found confidence in thinking spatially will allow them to work more freely in rendering nudes from life [74]. More attention can now be paid to the peculiar features of different attitudes, and to the features of different body types. Appearances can

be given greater liveliness. Secondary drawings can be created before or after the main study, as an aid to understanding how the body's masses fit together. Sometimes these come at the beginning, as a way of feeling out the problem, but they can also be done by way of a conclusion, as a means of reflecting an understanding of the whole form that is more condensed and substantial than the main study.

The sequence of steps given here may be altered by practice and, of course, students' degree of talent will affect the educational decisions that must be taken.

The subsequent working stages are concerned with developing a further understanding of the figure as a single, whole entity. This can be done by studying the nude figure under the headings already dealt with [76]: it might be done by extending a fine-lined surface net across the whole figure, or by using contrast to reinforce the simple plastic basic form. The spatial dimension can be investigated by varying the density of an accumulation of lines and strokes. How the masses are displaced in relation to one another and

Fig. 73 An assembled model of the female torso.
A model fitted together like this has the advantage of providing a practical way of creating the plastic centres (pelvis–rib cage) so that one can then create the soft tissue forms as a secondary layer atop these structures, thereby learning an architectonic method of working (first working stage). Anatomy graduation piece by a student of plastic studies. Fourth semester. Plaster. Height: around 40cm (15¾in).

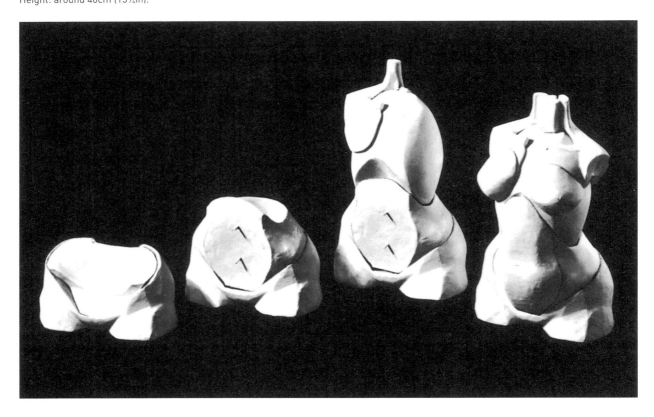

pushed together in the contrapposto pose, how the square block of the upper body angles against the hip region, how the front, side and rear surfaces of the body masses present from a diagonal perspective; these are among the most important things to consider when tackling the problems of how to portray a nude.

This working stage, also, can be subdivided into individual stages [78]:

a) First, determine the standing surface occupied by the figure and its directional parameters in space, marking in the crown height, the relationship of the upper body length to the lower body length, and movement sequences as determined by function.
b) Trace the axes of the corresponding points in space.
c) This helps to determine the primary masses within the space.
d) Next, construct the secondary forms on the simplified basic forms correspondingly, assigning them spatially to the primary masses. Clarify the overlapped areas and interpenetrating bodies. When rendering a significant area of a nude figure,

it is particularly important that the corresponding 'opposing' part can be seen along with it, even when it is removed from the other optically.

The ability to see the body spatially permits one to portray it in a freer way whilst allowing one to cut down on the means and materials [77]. The body's axis of symmetry, which runs from the hollow of the throat through the breast bone, the navel and the pubic bone, determines the overall movement of the upper body: it characterises the degree of lateral turn, and the arrangement of the extended and contracted areas.

The corresponding points are located on faintly drawn axes, showing a clear spatial relationship. They indicate the perspective from which the artwork is drawn. The surfaces that enclose the clear volumes show clear directions in space. Tectonically, the secondary forms are placed atop the primary masses – the shield shape of the chest muscles and the hemispherical breast shape on the rib cage, for instance. This requires a sparing use of one's tools, and much sensitive observation of areas of overlapping. Using the constructs representing the constructive

Fig. 74 Using lighting to emphasise the three-dimensional quality of the body and the individuality of the model.
Here, light, as a formative factor, is used to produce the clear arrangement of the body's masses, and to render the particular qualities of the pose and of the individual (third working stage). Work by a student, subject area: Painting, third semester.
Time: around two hours.

Fig. 75 The architectonic form of the torso. This drawing task is an investigation into the values of the different forms, their spatial and functional relationships. On this basis, a rendering of the body's architecture is created (second working stage). Free student work subject area: Plastic, third semester.
Time: around two hours.

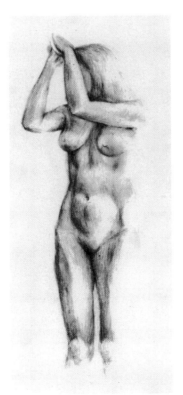

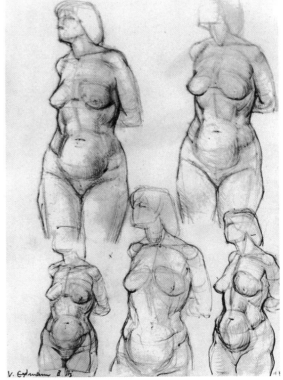

shapes of the bony cavities makes it easier to perceive foreshortenings and turnings, to properly understand these and to build a proper depiction of integrated body masses – in the reclining nude form, for instance.

Finally, out of the simple and striking constructive and constructible forms, we develop the ability to project these forms on to the actual figure of a living person, with its interplay of skeleton and soft tissue forms. This puts us in a position to foresee, predict and apply imagination to three-dimensional, spatial features according to the proper rules [79, 80]. If, for instance, students are familiar with two plastic centres such as the rib cage and pelvis as concepts, they will have no trouble developing a concept of the inevitable results of these two plastic centres shifting in relation to one another through bending, stretching or turning, given their relationship to the abdominal wall, the skin, and the breasts. The same applies to the behaviour of the bones of the arm, and the muscles attached to them. The importance of this ability cannot be overemphasised; it plays a crucial role in preparing the way for artistic inspiration. By their very nature, artistic inspiration and intuition do not come out of nothingness. They are the fruits of unceasing work (often with a very small return), and a result that suddenly begins to shed light in a very specific direction. It emerges suddenly and undeniably from

the knowledge of the essentials of the subject that has been gained through abstractions. What Albrecht Dürer described as the 'intrinsic/internalised full form' can then appear in the artistic imagination, representing that essence in a condensed form. However, anyone who is always solely dependent on 'copying from' the physical reality of a model will become a slave to this method, and will be prevented from making the crucial leap of artistic imagination through a lack of accumulated material.

Summary:

1. Working with the simplified basic form allows one to reach a stage of thought at which one can use individual anatomical facts and their function in space to generate optimal clarity of the whole form.
2. The simplified basic form represents a further step on the road in assimilating the real object form into the pictorial form.
3. The function of working with the simplified basic form is to form an understanding of the nature of the three-dimensional spatial form, by means of analysis and synthesis.
4. Working with the simplified basic form serves to simplify and clarify the body-space concept for educational purposes.

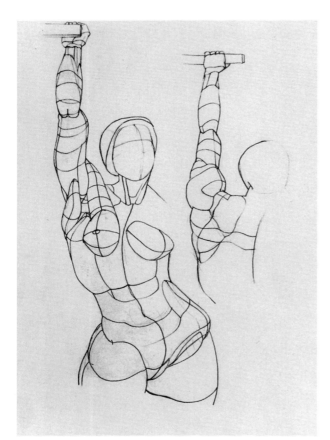

Fig. 76 Three-dimensional functional constructed figure.
A 'surface net' concept consisting of cross-sections and elevations provides the basis for this investigation. This helps to fix the spatial movements of the body's volumes. In this piece of work, the emphasis is on the development of the arms out of the torso, and the formation of the armpits.
Student work, fourth semester.

5. This clarification process can be assisted by supportive teaching and visualisation aids such as cross-section models and plastic exercises.
6. This kind of educational simplification has nothing to do with schematism or with 'box men'.
7. The work with the simplified basic form is based upon the anatomical knowledge gained thus far, and is primarily founded on developing a concept of the constructive skeleton forms as the basis for the body's architectonic structure.
8. Plastic exercises in the context of working with the simplified basic form are steps to pave the way to a 'constructed' drawing style.
9. Working with body cross-sections should only be seen as a single stage in the process, as an aid in making the main spatial directions of the surfaces that delimit the body easier to understand.
10. Methods should be used in a manner that contributes to achieving the goal. They should not be applied in a dogmatic or rigid way. They should be uncompromising in achieving the goal, but elastic in terms of the route they travel to reach it, and should be stimulating for learners – these are the qualities of a methodology that is well-rounded and fit for purpose.
11. The methods should enable students to use their understanding of the rules governing the interaction of constructive skeleton forms and soft tissue forms to predict plastic and functional states.

1.3.9. Issues of form and spatial context

Because of their objective character, the two problem areas that have just been discussed (proportions, static properties and dynamic properties; and three-dimensionality and spatiality) can be taught as relatively autonomous areas. The constructive forms of the joints and bone spaces (pelvis, rib cage, skull) can initially be presented on an objective level, independently of students' own subjective factors.

The next teaching stage introduces the connection between formative soft tissue masses and the fundamental support structures, and the possibilities for viewing them in combination, and bringing them together to create greater complex units.

However, there is a factor that connects with all of these goals, tasks and operations that has not yet been sufficiently dealt with. In their intellectual and dialectical aspects, the transitions from the individual details to the larger complex units are still somewhat 'fragile'. This is not because of a lack of clarity about the functional interactions, or of information on the three-dimensional relationships of the individual sections. Instead, what is needed is a synopsis of all the parts, viewed within the whole. It is in this area that the reciprocal interaction between the object itself and the gaze of the subject, the viewer, is most revealed. The whole figure must be visually presented from all educational perspectives – artistic and scientific. If

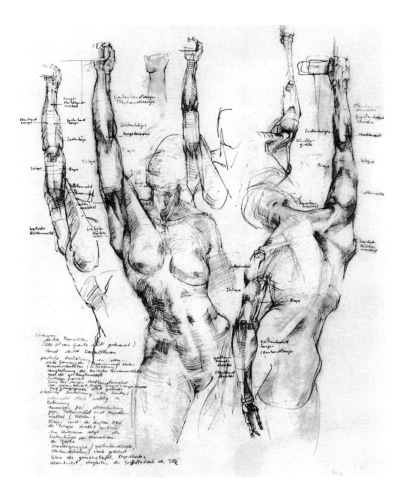

Fig. 77 Expressive intensifying of functional actions.
The differing forces of extending, elongating and stretching (pulling), and the weight loads incurred by standing on one leg (pressure) reveal themselves in the behaviour of the joints, the body's different sections, and their connective soft tissue forms. The forms with the opposite character (the contracted forms) also need anatomical and graphical representation.
Free student work, fourth semester.
Time: around two to three hours.

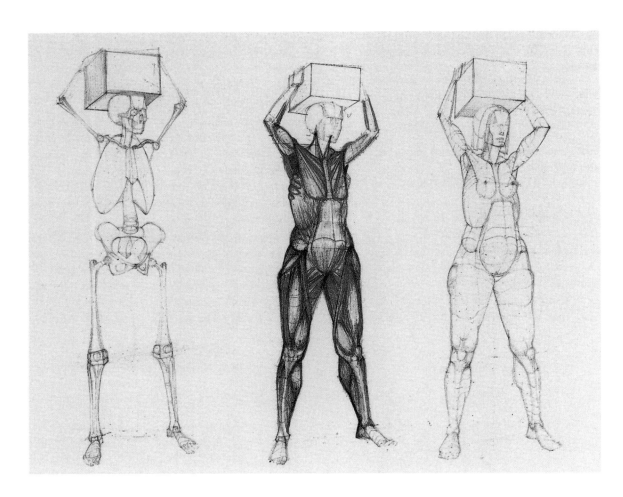

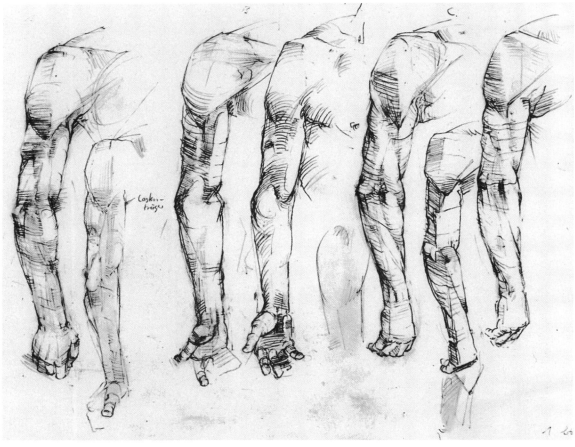

artistic anatomy is excluded from this, the result is a non-dialectic – and therefore unsuitable – separation of subject and object.

Different accents will of course be carried by the artistic and anatomical aspects of teaching. Both serve to clarify the overall context of the form, which is revealed partly through a linked sequence of objective relationships, and partly by developing sympathy, experience and identification with, and achieving a harmony in, the whole human being with all the content of the object. The primary business of artist anatomy is to make students aware of the sequences of objective connections, whereas developing the subjective aspects is a matter for the artistic fields of study.

The idea of the overall form context presupposes the existence of parts, in the same way that the chain requires individual links. The crucial difference is that, instead of being a row of equal elements, there is a strict hierarchy. Recognising this hierarchy, however, is impossible without synopsis. Artist anatomy, like other fields, should therefore promote synopsis as much as possible [84]. The synoptic view creates bridges and correspondences between outward and inward forms among all the various parts and sections: correspondences based on more than just a feeling.

Synopsis creates a hierarchical structure by evaluating and adjudging the main forms based on examining their alignments and volumes. This recognition of the main forms includes the silent dialogue with the secondary and interstitial forms. Synopsis is a complex intellectual process, which extends into the depths of the viewing subject, with all their experiences and previous life, their temperament and feeling: this fund of resources opens the way for the refinement and greatness, beauty and balance, form qualities, significance and abundance of meaning of the composition of the organic form. An openness to experience opens our eyes, in intellectual terms, to the nature of things, and allows us to better consider what we have before us. Understanding through viewing, and viewing through understanding, is an important goal in observing the individual details, as well as only a means of gaining a better understanding of the whole form: just as the observation of the whole, in its turn, can only be a means of gaining a deeper understanding of the individual facts.

Thus, synthesis extends deep into our intellectual ability to reflect on our experiences, and to apply a coherent system of order and internal coherence to the way things are. Just as the goals and paths of artist

Fig. 78 (top left) Figure construction through analysis/synthesis.
In this three-part task, each individual observation plays an integral part in constructing the body's architecture. Conversely, one could also start with the synthesis (the body's architecture), and finish by analysing the skeleton.
A graduation exam task, based upon a briefly standing model, drawn partly from mental images. Fourth semester.
Time: four hours.

Fig. 79 (bottom left) Arm studies: the results of a functional plastic projection. A knowledge of the functional processes of the skeleton and the relationship of the positions of the muscles to the axes of the joints enables students to predict the inevitable character of the functional plastic operations.
Student work, fourth semester, drawn largely from mental images.
Time: two to three hours.

Fig. 80 A free conception of a figure study. One of the ultimate aims of anatomy for artists is to enable students to create figures from their own imagination through their acquired anatomical knowledge and skills, independently and without a model.
Work by a student, subject area: Plastic. Fourth semester.
Time: approximately one hour.

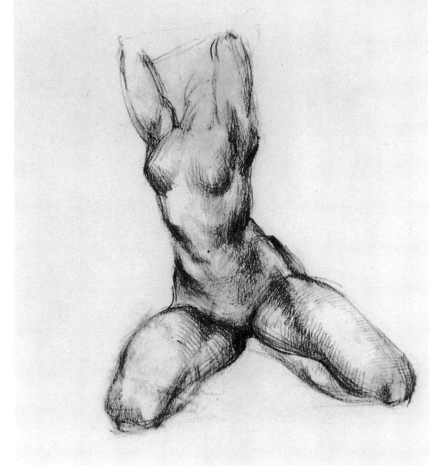

anatomy are not intended to be distant from actual artistic activity in the sense of being isolated, but are instead tailored to the nature of artistic activity; even so, whilst it works on this objective level, it aims to address the subject, the nascent artist. This endeavour is at the very outermost limits of art anatomy's capacity, and its competency. If the work of students and tutors is to be a success, the discipline must aim to have a secure grasp of the term 'form context'. Where the form context expresses the understanding gained, it reflects the dialectical unity of object and subject. The form context creates the interrelationship of the parts to the whole. How this is done, how the evaluation is carried out, the degree of sympathy and identification, the recognition of something of oneself, the extent to which the ego expands itself into the rendering of the content, the manner in which and the extent to which it arises from identification, the source of a passionate intelligence and intelligent passion – all of this is down to the subject.

The 'what' and the 'how' are inseparably intertwined. The form context objectivises itself in this unity, in the

unity of the 'what' and the 'how'. To concern itself with the 'how' is not the task of artist anatomy. Where it comes to the 'what', however, anatomy for artists can aid the synoptic view within its own area. It can do this on an objective basis, on the basis of the relationships and correlations of an internally related chain of facts.

Let us take the example of a proportioned study of a standing nude figure in profile view [81]. First, we adjust the vertical alignment. Taking this most universal factor of all human postures, we fill it with our own feeling for the body. These adjustments represent a very simple identification of the self with the other, and are therefore a very elementary experience. Points on the body such as the openings of the ears, and the shoulder, hip, knee and ankle joints form a shared perpendicular.

This takes place through a sense of the soles of the feet and the crown of the head as opposing poles, which every human being develops as a child. The directionality of the figure one sees is one's own directionality, as a human being.

Fig. 81 The rhythm of the body in profile view and its form interactions. The concentration of the main masses of the body and their positional relationships to the axes of the joints create the form structures in the profile view. Emphasising the form interactions applies a sense of order to the form values.
Student work, first semester.
Time: two to three hours.

Fig. 82 Photo-mechanical representation in which areas of similar spatial depth are marked, based on a female nude model. The 'grain' on the body – like the height level lines on a topographical map – reveals zones with a shared spatial depth. (From Dieter Lübeck, *Das Bild der Exakten: Objekt der Mensch, zur Kultur der maschinellen Abbildungstechnik*, Moos Verlag, Munich 1974).

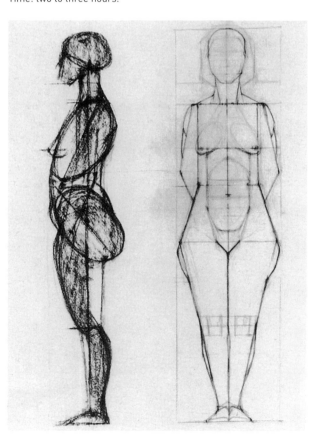

These verticals impose a state of balance upon the body's masses, throughout its whole structure. Any forward extension will have a corresponding rearward extension. To plainly state the facts: in profile view, the body is asymmetrical. The experienced gaze, however, will recognise that the body's structure is in fact symmetrical in a higher sense. In other words, it is balanced.

The bulges of the body also have their own alignments. The volumes and alignment of the upper body are governed by the rib cage: an oval form, the polar axis of which descends at a forward slant from its uppermost point on the spinal column. On the other hand, the polar axis of the oval form of the pelvis/ buttock mass inclines from front to rear, and is located to the rear of the straight vertical plane. The interstitial forms extend between the two masses: on the rear side, the short and tight interstitial form of the lumbar area, and, on the stomach side, the long, convex shape of the abdominal wall. This structure is covered with a layer of secondary forms: the breasts, the shoulder

blades and the pad of fat below the navel. These create apparent indentations, or 'deep points'. The leg has its own rhythmic structure: the significant projection of the knee extensor mass on the front thigh. Its main part, where the clear accent lies, is grouped around the hip joint (peripheral relief). It has its corresponding counterbalance in the back of the thigh, located behind the vertical axis. This simple description of the facts, which leads to the conclusion that everything is 'fit for purpose', 'according to the rules' and 'in proportion' has nothing to do with aesthetic values. Observation does not make the composition of the arrangement immediately evident. Further thought is needed to enable us to penetrate into the depths of nature's work. The content and the essence of the body's three-dimensional composition does not as yet have any aesthetic value. However, as we penetrate into the inner causes of external appearances, a question arises: how does nature respond to challenges through this composition of forms? Thus, the natural form is related to its internal content. At this point, the

Fig. 83 Modelling the body based on its spatial layers.
Recognising the spatial layer zones of the body is part of understanding its spatial interactions. In this drawing, zero space value is represented by the areas with the thickest structure of lines.
Free student work, third semester.
Time: two to three hours.

Fig. 84 Rendering the body–space interaction.
The reduced, sparing use of materials to render this image is characterised by the lack of a boundary between the body and the space. The eye is prompted to complete the image.
Free student work based on a model, fourth semester.
Time: three hours.

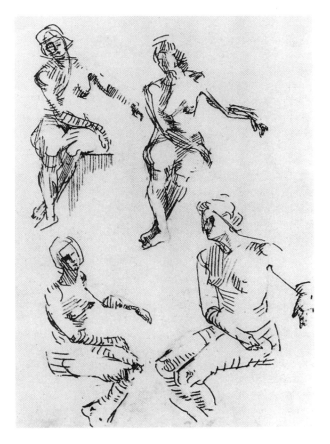

Anatomy for artists: past and present **81**

problems of artist anatomy begin to cross over into the realm of aesthetics. We experience the interplay of the construction of the forms – with its main forms, interstitial forms and secondary forms, its drawn-out fluctuations and sharper, more energetic bends – as possessing a musical beauty.

Artist anatomy introduces one to experiencing the construction of the human form and its hierarchies. This hierarchical sequence becomes the form interaction, as the external movement of the model's form becomes an inherent inner movement. Artist anatomy leads us to the overall form context on an objective basis; based on the relationship and sequencing of corresponding points. For instance, one could solely reproduce the relationships of the deep points (the deepest 'indentations' in an outline) to each other. None of these deep points lies deep enough to endanger the safety of the whole form. The recess of the neck is not deeper than the recess of the lumbar area, which, in turn, is not deeper than the contour of the rear thigh, which is not deeper than the Achilles tendon, above the heel (this gives stability, and also emphasises our verticality). Intellectually, one connects these deep points together. One can treat them like the pillars supporting a bridge, drawing a line between them: a regular, rhythmical structure. These deep points reveal the extreme tolerance limit of the connections. Always pay attention to the deep points! They are more consistent than the high points. The continuation of the whole structure is bound to the deep points. No one knew this better than Michelangelo. These deep points reveal how nature fulfils requirements in a brilliantly economical way. At the ankle, for example, our whole body weight rests on a structure only two to three centimetres [¾ to 1in] thick! One can extend or exaggerate the height as much as one wishes. Michelangelo, Rubens and Tintoretto often did this. The sequence of the deep points, however, must be respected. Otherwise, one destroys the whole structure of the form context that exists around them.

However, we do not regard the problem entirely from the point of view of securing the interrelationships of the body in its external outline forms: the ups and downs of its projections and recesses. We also have to be concerned with the spatial context, or spatial interrelationships. First and foremost, we think about the relationships between areas of the same spatial depth. We dissect the body, as it were – this can be done from any viewing angle – into vertical 'slices', at right angles to our line of sight. This visual operation teaches us which areas of the body are united by sharing the same zone of depth [82]. Finding areas of similar depth (something that has previously been completely disregarded by artist anatomy) is also a process of correlating and manufacturing contexts – spatially, and by means of creating a continuous representation of the body's spatial movement by comparing all the body's areas and assigning them to their own appropriate depth level [84]. Furthermore, it follows that:

Marking in the correlations between regions at similar and different depths offers a practical possibility for allowing the volumes of the body to emerge out of spatial depth. The curves of the body and their 'peaks' are simply generated by the modelling of space: the spaces that comprise the furrows, wrinkles, valleys and hollows of the body's surface [83, 397c, 400]. This means that we can approach the three-dimensional figure, and the three-dimensional representation of spaces, as a firm, concrete entity – which, in turn, is the reason why one can produce the whole figure plastically, solely by marking out the space. Having previously dealt only with the body itself, and with representing it three-dimensionally, anatomy for artists now extends to include space, which is the complementary partner of the body. From this point on, our artist anatomy investigations will take an equal interest in the spaces that are defined by the body. Anatomy for artists is, by necessity, an anatomy of both body and space.

Tutors' corrections of students work – and students' corrections of their own work – are enormously improved by a simultaneously rational and emotional view of the living subject's nature. This can help us to avoid simply looking at the individual areas of the body in isolation by encouraging us to experience and to understand the totality and the laws of the body in space. Assertions on 'correct' proportions apply only in quantitative terms. The conceptual bridges between the corresponding points operate in the objective realm, but appeal to an emotional understanding: to the subjective side of the dialectical unity of object and subject. When the external movements of the subject become identified with the inner motions of the subject's spirit, a new quality is born. For artist anatomy, this represents the outer limit. Beyond this, it has no more to offer to the subjective powers, because its real main area is the object, not the image. Generating correlation sequences is a handy way of teaching students to understand that if one fails to satisfy the logical sequence of deep points, then the whole structure will be potentially under threat. This poses a question for the 'what' and the 'how', the natural laws and the aesthetic laws. The rules governing the contexts and interactions that are found in any organic form are simultaneously internal and external. The dialectical unity of the subject–object relationship, with the emphasis placed on the subject, calls for an evaluation of how best to express the overall context, the whole entity. To implement this lies outside anatomy for artists – it belongs to the realm of art. The ability to profit from experience cannot be taken for granted, a priori: it needs to be constantly expanded and deepened. Artist anatomy is not, and should never be allowed to become, a school of art. It does not impose aesthetic norms, instead maintaining a sensitive closeness to aesthetics, and it does not make evaluations – even though, without a judgement of how perfectly nature has accomplished its task, its ultimate aims can only ever be half achieved. Anyone who can create forms in the right interrelationships intuitively and with authoritative knowledge will master the figure, having experienced and truly understood the hierarchical structure of its elements.

Summary:

1. Understanding and objectivising interrelationships of form is a complex intellectual operation, founded on the dialectical unity of the object–subject relationship. It takes place in the rational and the emotional context.
2. Synopsis – an overview of all the parts as they exist within the whole – is necessary in order to create the spatial context.
3. Artist anatomy emphasises the objective aspect.
4. The context of form interrelates the parts to the whole, preventing them from being viewed in isolation; the context of form expresses an understanding, with the emphasis on the objective aspect. It is for the subjective individual to evaluate how the overall context should be expressed.
5. The objective principles of artist anatomy can prompt a synoptic view by expressing the inner coherence of individual details through linked sequences of relationships and correlations, by clarifying the primary forms, secondary forms and interstitial forms, and thereby revealing the inner hierarchy of the different elements and their regular, rhythmic arrangement.
6. A visual understanding of the form context can be aided, on an objective basis, by the inner context provided by so-called deep points, which are in many cases the points of maximum load in the body's construction as a whole (at the joints, for instance).
7. Creating visualisations of these correlating sequences is a practical way of learning that if these relationship sequences are insufficiently served, then the 'what' and the 'how' and the natural and aesthetic rules are undermined.
8. Coherence of form, as a new quality, is fostered by the artist treating the body's external movements as inner motions of the spirit – in other words, by bringing his or her whole person into harmony with the inner content of the figure of the subject. The implementation of this lies beyond the remit of artist anatomy.
9. The form contexts relate not only to the elevations and depressions of the outline forms, but also to the investigation of areas of the same and of differing spatial depth. This means that anatomy for artists is an anatomy of the body and of space.

1.3.10. Multiple aspects and boundaries

Nothing should be allowed to become set in stone or dogmatic. Arguments against rigidly pursuing a goal are provided by the need for varied tasks, varied tools and methods, a well-planned and varied round of activities, and the need to maintain fresh eyes for the subject and to relieve stresses whilst stimulating new centres of the brain, and to ensure an open mind. Certainly we want to pursue our goals persistently and consistently – but beyond this, we must be under no constraints. The freedom to achieve the goal in different ways should be inviolate.

Perhaps, on a particular occasion, for instance, the functional structure of the nude is not to be subjected to a strict one-sided muscle analysis, from impressions, without the use of any visual aids, but is to be subjected to investigation as a body-space problem instead? The important thing is that the task should always contain an element of purposefully planned research.

Or, alternatively, can't students' understanding of three-dimensionality also be checked by means of a nude study created by working with flat surface combinations?

An anatomy for artists that understands the needs of art can provide inexhaustible inspiration. It offers so many different facets that call out to be addressed! There are so many different ways to achieve all the different individual goals! Compared with everything that is still waiting to be represented, explained and investigated, what is presented here represents only a fraction of the author's theoretical and practical investigations. Anyone wishing to research the matter more fully is directed to the scientific and practical resource material he has produced on the problems within the field, which has been studied in these works in minute detail: 'Didaktische Hilfsmittel im Lehrfach Plastische Anatomie' [dissertation], 'Neue Grundlagen einer Methodik des Lehrfaches Plastische Anatomie' [habilitation] and his work, *Die Gestalt des Menschen*. Sometimes, the distant, ultimate goal tends to be eclipsed by the superficially more immediate concerns: proportions, static properties, the plastic building blocks of the body, specialised movement structures, the constructive and simplified basic forms – an immeasurably large workload. In any case, anyone who enjoys in-depth study of the subject has their whole lifetime in which to devote themselves to studying it.

Above and beyond all the individual goals, and in spite of a sometimes oppressive restriction of vision, tutors and students engaged in artist anatomy, as they tackle the individual goals, inevitably draw closer and closer to the distant goal – within the boundaries of the subject. Essentially, the object of their efforts is to accumulate sufficient ideas of the human form to ensure their free creative work will never suffer from a lack of knowledge and skills in this area.

One part of this is being able to draw the movements and three-dimensionality of the body – and, by extension, the spatial relationships and contexts of form – without reference to a model.

A student who has reached the final stage of tutoring and learning in anatomy for artists should be able to complete a specified task entirely from impression. A successful rendering of the body's functions, clear body volumes and an accurate understanding of spatial positions should be sufficient to solve any problem without the assistance of aids such as the model, or the skeleton. The illustration shown here [80] is a drawing by a sculptor, without any links to any particular theme. This drawing was created spontaneously out of a need to test understanding and to check the concept, in order to gain a more certain knowledge of the body and its relationship to the surrounding space, and a concern for the clarity of the advanced and recessed areas, the front and rear, and the spaces enclosed within the arms, the legs, the torso and the floor area.

The task ultimately culminates in placing two figures in a spatial relationship to one another, clarifying them so that they stand out from the base of the standing surface, and – based on a capacity for imaginative ideas – giving the bodies organic-functional movements, configuring the individual structural context of manifold different elements, composing the connective and supportive structure, and making the form of the human being really present in terms of the whole organism [85].

Beyond this, however, the teachable and learnable principles of artist anatomy cannot go. From this point on, it is the artistic disciplines that must lead the way in providing knowledge and skills. It is their responsibility to teach students to understand the appearance of the living being above and beyond its objective aspect, in its totality. When it is related to the principles of the artwork, the objective form undergoes a fusion and condensing process. From this transformation, the new quality called 'art' emerges.

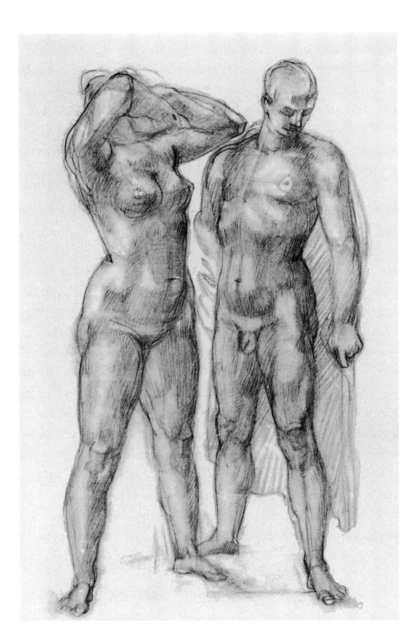

Fig. 85 A freely-conceived study of the body's architecture.
In this study, the spatial relationships of two figures have been fixed, and the plastic centres, together with the soft tissue masses that cover them, have been employed in a varied interplay of surface structures.
Work by a student, fourth semester, created without models; subject area: plastic.

2 The proportions of the human body

2.1. GENERAL REMARKS

2.1.1. Preliminary remarks on defining the purpose of studying proportions

Today, we understand the doctrine of proportions to be the study of proportions. This indicates a wish to avoid any form of restrictive dogma. The study of proportions helps artists in their practical work. Its purpose is to help in recognising and bringing out the typical form 'content' and characteristic peculiarities of the model. The study of proportions is essentially concerned with objective factors. It does not prescribe any mathematical or Platonic pattern or fixed canon that we should acknowledge as 'beautiful'.

The study of proportions provides direct practical instructions for how to create artistic studies from life, how and wherein we recognise the rules governing the proportions of the body's length, width and depth measurements, the typical features of both sexes, the different stages of development seen in young people, and the different constitutional types, sports person types, and ethnic types. The study of proportions, by this definition, also includes the identifying of generalities in form features. The form features that characterise adult men or adult women, for instance, recur in an identical or similar form in a large number of people, depending upon the organisational principles according to which they are compiled. Thus, we can group people according to their characteristics, defining these groups as the different body types. Such a system provides us with a compass to help us to navigate the vast variety of different shapes found in the naked human form, and helps us to maintain the idea of unity within this great multiplicity of forms.

This brings us into direct alignment with Albrecht Dürer, whose doctrine of proportions was founded on the concept of the different body types. His observations of real human figures left him uncertain as to which body form he should call 'most beautiful': 'However, a pleasing appearance is also composed within human beings, and in this our judgement is so doubtful that we might, for instance, find two human beings, both quite beautiful and endearing, and yet neither one is like the other in any part or portion, either in measurements or in manner, and such is the blindness of our understanding that we are uncertain as to which is the more beautiful.'[11] Proportions in the strict sense – that is, the relationships of the components of a body to each other, excluding their relationship to the substance of the forms – have, in and of themselves, no aesthetic value. Childlike forms in an adult, or girl-like proportions in a male youth, do not, a priori, carry an aesthetic message. If we consciously initiate an interplay between these objective qualities and the biological meaning, however, then a sense of beauty or ugliness arises within us. 'It is only through the substance that a form receives one or another aesthetic value, and this is the objective basis of beauty, both in reality and in artworks' (M. Kagan). The 'beautiful or not beautiful' question also depends on another factor: on the judgment of the subject, a person with a life behind them and a wealth of experiences, a capacity for forming new experiences, an intuitive capacity to make connections, and an individual temperament. We readily understand why Albrecht Dürer would find himself experiencing beauty as relative, because beauty depends upon the opinions of human beings. Our wish is to be as flexible as possible in how we view nature. This is why the author has intentionally kept his proportioned figures two-dimensional, with no remodelling of forms: this approach excludes aesthetic norms. This, however, is not to overlook the fact that only a full shaping of the natural form does full justice to it, or to fail to acknowledge that our judgement should not exclude the aesthetic perspective.

The idea is not to supplement old systems of proportions with a new version. Where we do make reference to the old systems, it is in order to better reveal our own way of working, or to harness useful ideas from history to meet today's needs. If we use the 'eight heads' rule of proportion as a basis, it is simply because it is useful – this, without making any sort of aesthetic imposition, is the measure of what is 'pleasing'.

2.1.2. Terminology: proportions, module, canon

We can use a base measure or standard benchmark, referred to as the module (Lat. modulus = unit of measurement) to register the body's various length, width and depth measurements. Proportion is taken to refer to the relationship of elements, in a pure sense, to each other and to the body as a whole. The relationships differ by size, width, value and effect.

11 Albrect Dürer, *Vier Bücher von menschlicher Proportion,* Buch III fol. T3v (1528)

A system of proportioning rules arrived at by making comparisons is referred to as a canon. The smaller the module, the easier it is to precisely define the positions of the important measurement points. As a general rule, the depiction process itself dictates which basic measurement is used.

2.1.3. The measuring process: historical and current ideas

For practical purposes, there are two different measurement methods that can be used:
a) Starting with the whole figure, and then subdividing it [88]. One can then compare the resulting subdivisions with each other, and with the whole. For instance, one can find the centre of the body – the halfway point between the upper and lower half of the body – and then follow this with a further subdivision (quartering the body). The distances between the division points can then be compared

with each other, and their equivalence determined (this process is therefore known as the analogue or simultaneous process). This process was used in the classical era, and by Leonardo.
b) Treating the part as a fixed measurement and multiplying it to determine the whole [86].
For instance, the size of the figure might be arrived at by adding or multiplying the basic unit taken from the sole-to-ankle measurement (the additive or summative process). This method of constructively determining the objective overall length was the method used in ancient Egypt.

We prefer to use the same process used by Leonardo and the artists of classical antiquity, for the reasons given on page 44 in the section dealing with the problem area of proportions, statics and dynamics. That is, we start with the whole as a given value and, on that basis, we discover the possible (and inevitable) ways of assigning and subdividing its parts to create a hierarchical structure. In any case, a student

Fig. 86 Egyptian proportion figure in net grid. The rigidly set body proportions result from the multiplication of a base unit, such as the sole–ankle distance, which also provides the size of the squares in the grid, allowing for many fixed measurement points. This is referred to as the additive or summative process.

Fig. 87 Polykleitos.
The Spear Bearer (second half of 5th century BCE).
This statue is very significant in the emergence of the study of proportions because its construction is based on the organically constructed body as a whole, followed by the finding of similar or identical measurement lengths (the simultaneous or analogue method).

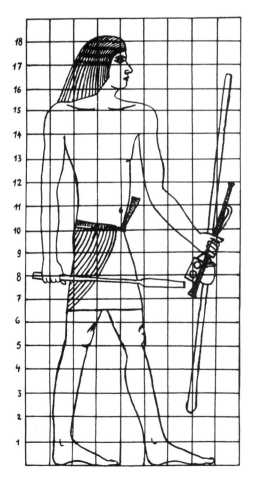

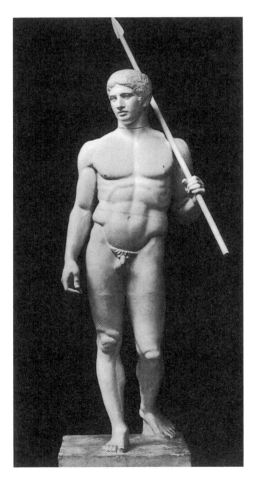

should learn to automatically determine the size and proportions of the drawing format, in order to lay out the picture correctly. Additionally, rather than being divided up at random, the composition should be divided up in relation to its contexts of function and form. Beginning with the whole form and progressively dividing is a favourable method for artistic creativity. This approach provides good support to the artistic perspective, and shows that the appearance of the whole should not be equated with the sum of the parts.

These are the right reference points to use if we wish to pay homage to the endeavours of the classical era and the Renaissance [88]. In these eras, art's function was different from that of ancient Egyptian art, and that of the art of the Middle Ages.

Classical art calculated the measurements of artworks with reference to the viewer, and displaced the body masses to reflect the consequences of movement, understood organically – in this, it was very unlike Egyptian art, with its rigid quadratic net proportioning. This approach gives rise to the problem of foreshortening (which is the product of visual perception). The Greeks created space, or an illusion of space, in their artworks, using compensated ratios in order to improve an artwork's effect: the Egyptian proportioning schema would have been completely unsuitable. When setting the measurements for a colossal statue, for instance, they took into account the worm's-eye-view of the viewer. This can be seen, for instance, in the elongated upper body of Phidias' statue of Athena.

The Greeks, then, were aware that a relativity existed in the doctrine of proportions, and altered their ratios based on free measurement. In his *Spear Bearer* sculpture, Polykleitos created a canon that allowed the jointed structure of the body to express organic movement and a dynamic psychic state [87]. On the figure taken as a whole, the upper and lower body are

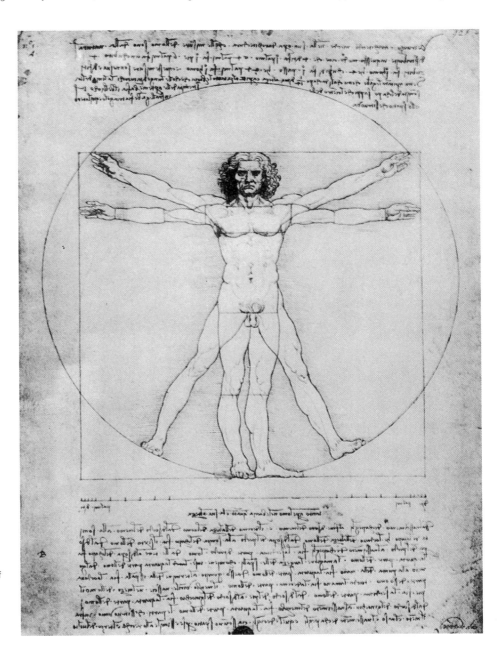

Fig. 88 Leonardo's proportion figure. The structural arrangement of this proportion figure, which references the Augustan architect Vitruvius Pollio, is a visual rendering of Leonardo's system of height and width relationships, which was based on anatomically determined measurement points.

clearly distinct, along with the torso and extremities, and their subdivisions.

The individual elements of the body permit comparison, with each other and with the whole form:

Face (from hairline to end of chin) = $^1/_{10}$ of overall length
Hand (from carpal to tip of middle finger) = $^1/_{10}$ of overall length
Head (from crown to chin) = $^1/_8$ of overall length
Hollow of the throat to crown = $^1/_6$ of overall length
Foot (heel to tip of toe) = $^1/_6$ of overall length
Fingertips to crook of elbow = $^1/_4$ of overall length
Shoulder width = $^1/_4$ of overall length
Span of the arms = equal to the body's full height

The continuity that runs from the classical era to the Renaissance is interrupted by the Middle Ages, which saw a return to two-dimensional art. We take our reference points from Leonardo and Leone Battista Alberti, who based the study of proportions on experience, and took an anthropometric approach.

From our point of view, Leonardo's way of working is particularly worthy of attention. It is eminently practical. He connected with the classical era through the proportion figure of a man with outspread arms, provided by the Augustan architect Vitruvius as a 'middleman' between Polykleitos and the Renaissance. Leonardo taught the analogue process [88]. The horizontal span of the arms encompasses a distance equal to the total height of the figure, from sole to crown (in reality, the span of the arms is greater than the figure height). Based on this experience-derived fact, Leonardo draws the figure within a square. Beyond the body's sole-to-crown central axis, he looks for the organic structure, locating the body's centre line at pubic bone/trochanter level (which, for men, is actually generally slightly above the geometric centre). This creates a harmony between the upper body and the lower body. The process of finding equal distances continues with the halving of the upper body at nipple height (the first body quarter) and at the height of the tibial tuberosity (a projection on the tibia beneath the kneecap, which marks the fourth body quarter).

Fig. 89/1 Using historical ideas to investigate the proportions of the male body.
The emphasis visually is on bodily dimensions of equal or similar length, which allow subdivisions of the figure's height. The value for half the body's height, for instance (shown by the vertical grey strip on the right), corresponds to half of the body's width if one arm is raised horizontally (the horizontal grey strip). In a man, the upper body length (pubic bone–crown) is generally somewhat shorter than the lower body length.

Figs. 89/1–89/4 are taken from Bammes, *Wir zeichnen den Menschen.*

Fig. 89 Relationships of dimensions in sitting, kneeling and crouching figures in relation to the standing figure.
With special emphasis on the comparison lines corresponding to one quarter of the body's height.

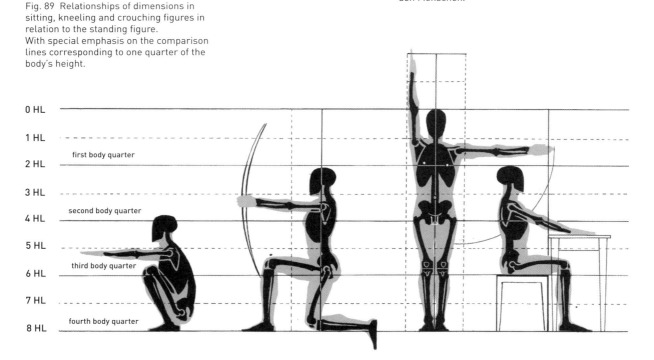

0 HL
1 HL
2 HL — first body quarter
3 HL
4 HL — second body quarter
5 HL
6 HL — third body quarter
7 HL
8 HL — fourth body quarter

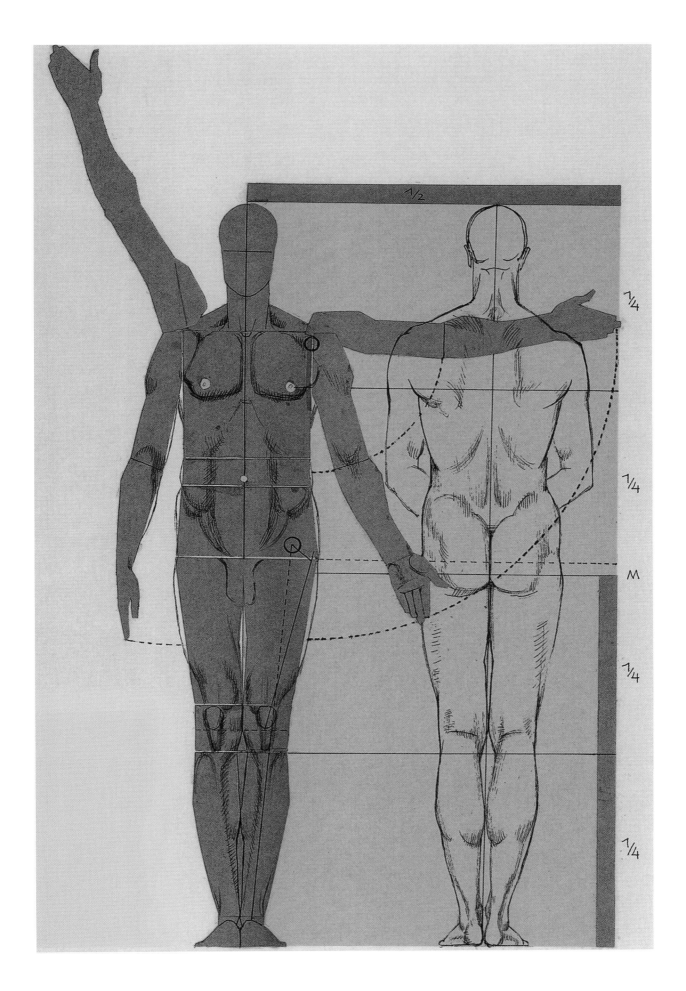

Fig. 89/2 A preliminary look at the body's proportions in relation to its statics. Straddling the legs reduces the body's height, and increases the size of its support structure. The centre of gravity is lowered from S_1 to S_2, thereby increasing stability of stance. In the proportioned figure on the right-hand side, the line of gravity is drawn in vertically through point S_1. The body's major pivot points (such as the head–neck joint, the shoulder, hip, knee and upper ankle joints) are arranged on this line.

When the body is seen in profile, the masses of the rib cage and pelvis form a dorsally open obtuse angle in relation to the body's overall vertical posture.

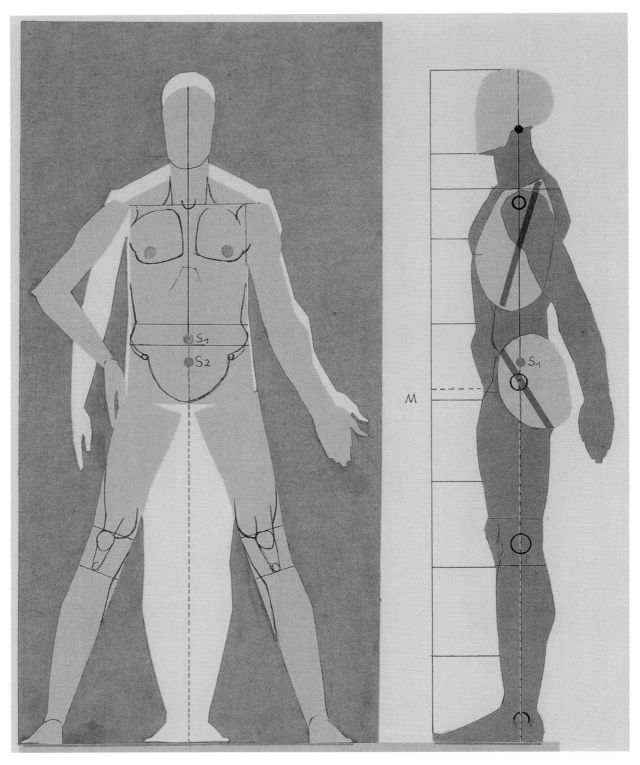

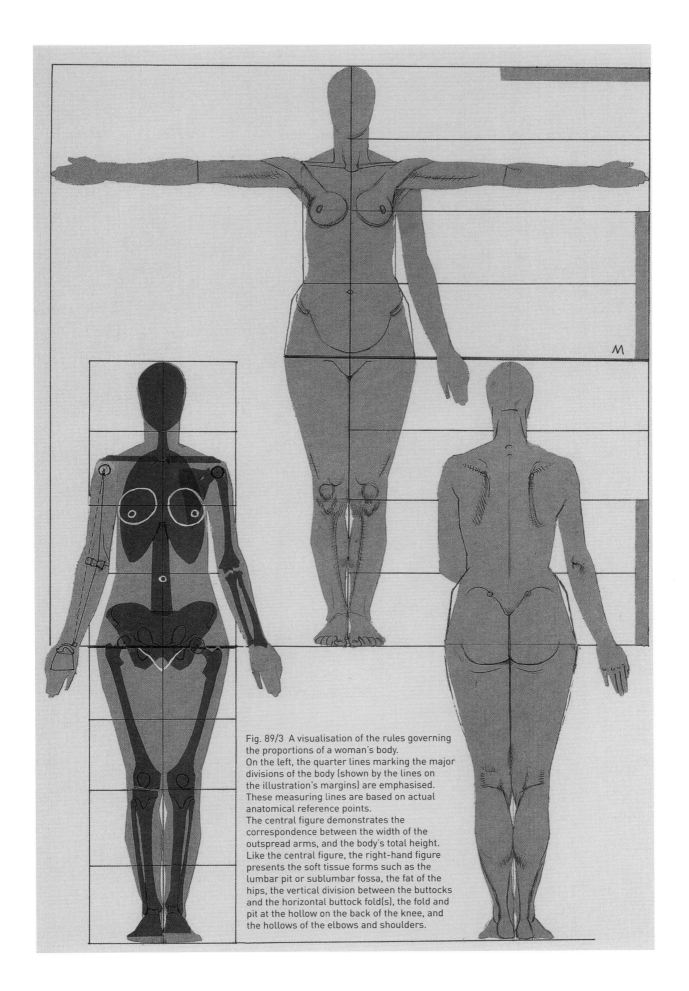

Fig. 89/3 A visualisation of the rules governing the proportions of a woman's body.
On the left, the quarter lines marking the major divisions of the body (shown by the lines on the illustration's margins) are emphasised. These measuring lines are based on actual anatomical reference points.
The central figure demonstrates the correspondence between the width of the outspread arms, and the body's total height. Like the central figure, the right-hand figure presents the soft tissue forms such as the lumbar pit or sublumbar fossa, the fat of the hips, the vertical division between the buttocks and the horizontal buttock fold(s), the fold and pit at the hollow on the back of the knee, and the hollows of the elbows and shoulders.

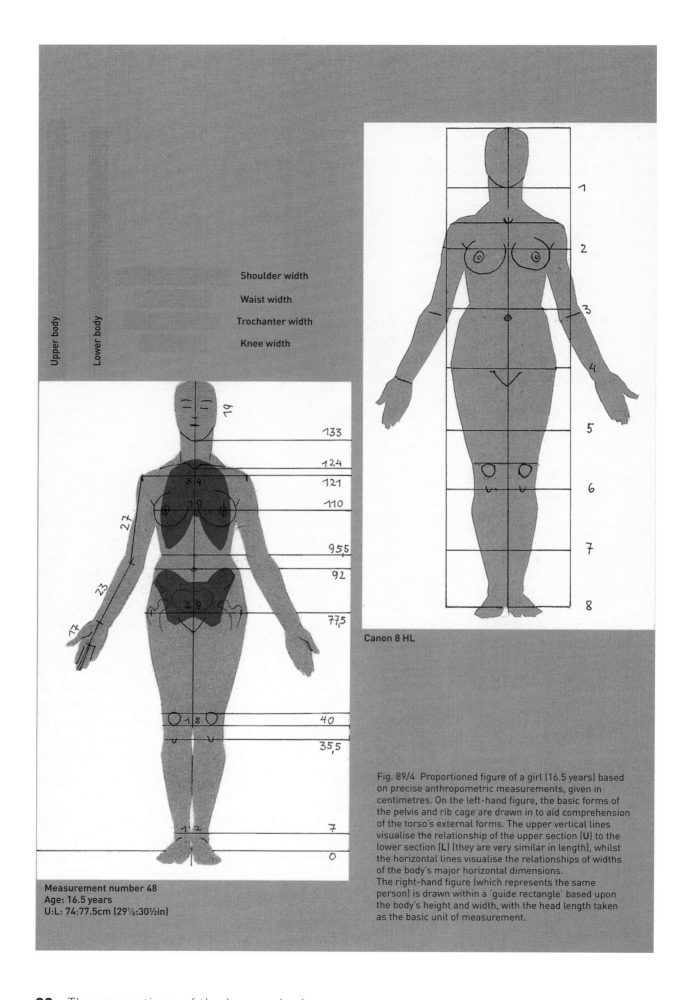

Shoulder width

Waist width

Trochanter width

Knee width

Upper body

Lower body

Measurement number 48
Age: 16.5 years
U:L: 74:77.5cm (29⅛:30½in)

Canon 8 HL

Fig. 89/4 Proportioned figure of a girl (16.5 years) based on precise anthropometric measurements, given in centimetres. On the left-hand figure, the basic forms of the pelvis and rib cage are drawn in to aid comprehension of the torso's external forms. The upper vertical lines visualise the relationship of the upper section (U) to the lower section (L) (they are very similar in length), whilst the horizontal lines visualise the relationships of widths of the body's major horizontal dimensions.

The right-hand figure (which represents the same person) is drawn within a 'guide rectangle' based upon the body's height and width, with the head length taken as the basic unit of measurement.

These horizontally divided quartering zones also recur quite clearly in seated, crouching or kneeling figures, and are therefore useful for teaching purposes for demonstrating how height measurements are reduced by different movements and postures [89]. Additionally, the quarters of the body's height have corresponding equivalents in the body's horizontal dimensions: the shoulder width, for instance, with the fingertip–elbow length. The nipple–crown distance is divided at the level of the end of the chin. According to this schema, the head length (HL) represents an eighth of the total length of the body.

This is the character of Leonardo's process: he relates the different parts to each other and to the figure as a whole in terms of their size values, treating the body as an inherently subdivided structure whose natural divisions should be taken as the reference points.

The principal methodology adopted by Leonardo and his intellectual forebears is essentially still fit for use today, but with certain modifications. In the case of a man of 170 to 180cm (5ft 7in to 5ft 11in) in height, for instance, the lower body will be longer, and the upper body shorter [89/1]. This also means

that the pubic bone is located higher, and therefore does not correspond to the body's geometric centre, or fit Leonardo's precise division of the body into four quarters. I have taken the concept further by applying it to a rear view of the plastic male form [89/1, on the right], and to the changes in the body's proportions seen in a straddling figure, additionally combining this with the first references to the statics of the body [89/2]. This requires a visual rendering of the body's static factors in profile view (seen in the right-hand figure, which shows the vertical arrangement of the major pivot points).

Unlike Albrecht Dürer, Leonardo paid little or no attention to the proportions of the female body [89/3]. Our illustration shows the outline of the female forms, with the skeleton forms inserted to show the reason for the proportions seen in their heights and widths. Anthropometrically precise investigations of the proportions of young female bodies [89/4] rendered with measurements in centimetres and with the established canon, can certainly be regarded as compatible with the analogue process.

Summary (first part):

1. The study of proportions teaches us to recognise the rules governing height, depth and width relationships in the form of a specific individual body.
2. The study of proportions does not involve the invention of so-called beautiful figures, or a Platonic canon of beauty.
3. Similarly, in the study of proportions, one does not use averaged anthropometric data from the biological canon.
4. The study of proportions primarily begins with the whole figure. The preferred measurement method involves comparison of length, width and depth relationships (the simultaneous process).
5. The study of proportions primarily makes use of the traditions best suited to the creation of realistic works of art: i.e. those that reveal the 'typical'.
6. Leonardo's proportioned figure (the Vitruvian Man) demonstrates the comparison of body measurements with each other and with the whole figure for the purposes of figure drawing.
7. The measurement points correspond to the organic divisions of the body. The head measurement (crown–point of chin) represents an eighth of the body's total height, the length of the face (hairline–point of chin) represents one-tenth of total height. The head length corresponds to the point of chin–nipple distance, and the elbow–shoulder distance. The length of the face corresponds to the length of the hand.

Dürer's investigation of proportions verged on fanaticism. He devoted 28 years of hard work to the proportions of the human body, addressing the subject with profound sincerity and with an unparalleled thoroughness. Beauty had to be provable. He tried to solve the problem using mathematics, and so began by constructing figures using compass-drawn circles. The great change came after his second journey to Venice (1505/1506), which brought him into contact

Fig. 90 Albrecht Dürer (1471–1528). Dürer's greatest contribution to proportion theory was his conceiving of consistent types, e.g. figures with extremely thin or extremely low and compact body development.

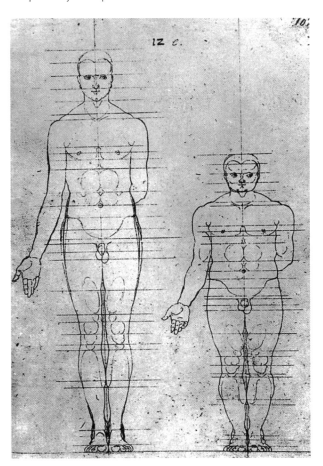

with the Italian theory of art. He felt that this was the right approach, believing that a good theory offered the only way to escape from the restrictions of practising art in the manner of a craft. He appealed to natural diversity, deciding that beauty was not in fact absolute: 'For it is possible that two different likenesses may be made, neither conforming to the other, one fat and one thin, and yet we cannot judge which is the more beautiful'.[12] This thought had preoccupied him for some time, and almost caused him to abandon his efforts. His findings, after three decades, included no schema or system of proportions, and no 'beautiful' figures. His investigations extended from very fat figures to very thin figures [90]. So, what do his researches tell us? They offer a very important insight: Dürer recognised a harmony in the unity and consistent qualities of the form's character. He created body types. In doing this, he entirely avoided discovering an ideal or even an average canon of beauty. He dedicated himself to an endless effort to define different characteristic types 'which – in its own way – had only to avoid being coarse and ill formed'.[13] In the type, the variable element meets a common element (Waetzoldt). It is the unity of the language of form that is critical to the character of a figure. Dürer therefore posited only a single law of proportions, which he himself followed all his life: that everything, including the proportions of the human body, should have a 'rhyming' likeness (Waetzoldt).

Summary (second part):

1. In 1528, Albrecht Dürer published his study of proportions as *Vier Bücher von menschlicher Proportion.*
2. These studies had brought him to the realisation that beauty was not absolute and unchangeable, but was instead subjective
3. Following his second journey to Italy, he distanced himself from the construction of any ideal canon of beauty.
4. He recognised the endless diversity of human appearances, and endeavoured to define characteristic types 'which – in its own way – had only to avoid being coarse and ill formed'.
5. Dürer discovered a unity of the language of form in natural features, and a coherent form character in individual beings. This was the only rule of proportions that this master artist followed.

12 From draft manuscript for *Vier Bücher von menschlicher Proportion*, written 1512.

13 Erwin Panofsky, 'Die Entwicklung der Proportionslehre als Abbild der Stilentwicklung', *Monatshefte für Kunstwissenschaft*, Jahrgang 14 Heft 2, Leipzig 1921: 188-219.

2.2. THE TYPOLOGY OF PROPORTIONS

We do not want to impose any kind of restrictive template on the rich diversity of nature. On the other hand, for educational reasons, it is necessary to impose certain boundaries on the range of individual appearances. We have therefore used the general rules and parameters seen in whole groups of human beings with similar or identical form features to structure this diversity into types.

2.2.1. The generalised morphology of both sexes

When we, as human beings, look at a human being, we find ourselves faced with a polar entity. The crown of the head and the soles of the feet constitute the poles, with the whole vertical organisation of the body extending between them [91, 92]. The free-standing head is raised high. The face is adapted to its vertical dimensions, but is carried horizontally, like the head of an animal. The sole supports the head, and the significant sections are oriented on a shared vertical line. The long legs – which make up half of the body – are the supports that compliantly serve and constantly resist the body's weight. The eyes are positioned high up, and the gaze extends in a wide circle. The wide front is fully presented to view. The unstable balance, the recessed shoulder blades and the unhindered, loose-swinging arms extend far out to the sides, with the width of the chest. The pelvis and rib cage are set at an angle to each other in the lumbar curve. The buttocks are developed, holding the vertical arrangement in constant balance. The legs are as firm as pillars. They brace against the weight of the upper body, with the knees fully extended. The mass of the thigh prevents any buckling in the knees. The clenched thigh muscles ensure a stable stance, and also push us away from the ground by means of our uniquely arched feet, working against our weight.

Within this polarity, a further polarity is contained: the polarity of the male body and the female body, which have clearly distinct form features. Unlike animals, we develop these features gradually, achieving sexual maturity only after a long delay. In men, maturity brings a larger, sturdy bone construction, with a wide rib cage and narrow pelvis and with a covering of muscles. Women have a more delicate skeleton, with a wide pelvis and narrow rib cage, a more pronounced bending in the exterior angle of the leg (see relevant section), and a different arrangement of fat deposits, some of which are only found in women (these occur in the breasts, the mons pubis, the inner thigh, and the hips). A man's torso is shorter than his legs, whilst a woman's torso is, relatively speaking, longer than a man's.

Whilst female features in the male body and male features in the female body are known to occur, this is rare. The list of differing features in the sexes also includes differences in hair growth. All of these features are summed up under the term 'secondary sexual characteristics' (sexual dimorphism).

A general morphology of secondary sexual characteristics

Man	Woman
Skull and head Larger, more angular. A sharp crown shape. The forehead has a receding shape, with a more gradual transition into the top of the skull. The brows are high, the masticatory apparatus is more massive, and the cheekbone (the partial origin of the masticator muscles) is pronounced. The angle of the chin (on the ascending part of the lower jaw) is highly developed. The angle of the jaw is protruding, and the point of the chin is directed forward. Facial hair is present. The contours of the face are sharp.	Smaller, softer forms. A flatter crown. The forehead is steeper, giving the face a more childlike appearance. The transition from the forehead to the top of the skull is more distinct. The brows are gentle, the masticatory apparatus less massive, and the cheekbones more delicate. The angle of the jaw is flatter. The chin is levelled out. No facial hair is present. The contours of the face are soft.
Neck A pronounced larynx. The neck has a powerful, muscular form.	The larynx remains undeveloped, as in a child. The neck has a generally slender form.
Shoulder girdle Wide. The distance from the high point of one shoulder (or acromion) to the other is just about a quarter of the body's height, or just about two head lengths.	Narrow. The distance from the acromion of one shoulder to the other is somewhat over 1½ head lengths.
Rib cage Wide, expanding downward, with a larger volume. The chest muscles are large, and form a distinct transverse bulge. The costal arch (or last rib) sits deeper.	Narrow. The lateral spread of the rib cage sides is minimal. The major chest muscles are covered by the semicircular forms of the breasts. The costal arch (or last rib) sits higher.
Spinal column The lumbar lordosis is less pronounced.	The lumbar lordosis is more pronounced.
Abdomen The straight abdominal muscles stand out clearly to the sides. The pit of the stomach sits lower. Navel located at the height of the iliac crest. Clear separation of the bulge of the outer oblique abdominal muscles and the iliac crest. Sharply defined inguinal crease.	The pit of the stomach sits higher. This produces an apparent lengthening of the torso. The mons pubis stands out from the lower abdominal wall. Navel somewhat higher. Smooth transition of the outer oblique abdominal muscles to the iliac crest. Shallower transition from the abdominal wall to the upper leg.
Pubic hair Rising towards the stomach in a pyramid-form.	Finishes horizontally towards the stomach.
Pelvis Narrow and high. The distance between the two trochanters is somewhat over 1½ head lengths. The trochanters are set further back, giving the male body the appearance of a pyramid standing on its point. The posterior superior iliac spine is often positioned closer together. The lumbar pit forms an isosceles triangle with the sacral apex.	Low and wide. The width from trochanter to trochanter is just about equal to one quarter of the body length (= just about 2 head lengths). The trochanters are set further back, giving the female body the appearance of a spindle. The lumbar pit forms an equilateral triangle with the sacral apex.
Legs The alignment of the femur is steeper. The shape of the leg is angular and muscular. The leg length is a little greater than the upper body length.	The alignment of the femur is more oblique (because the width of the pelvis is greater). The shape of the leg is firm and rounded (with a particularly massive adductor muscle group). The leg length is often a little less than the upper body length.
Arms The arms are sometimes longer than a woman's arms. The exterior angle of the arm is not very pronounced.	The arms are sometimes shorter than a man's arms. The exterior angle of the arm is very pronounced (bending arm).

2.2.2. The proportions in both sexes

We find the proportions peculiar to the two sexes using Leonardo's process. We look for relationships of similarity in the body's width, height and depth measurements. Seen in frontal view, the body's axis of symmetry terminates at the crown and at the soles of the feet. We then mark the horizontal axes that match the position of important orientation and measurement points at intervals, like the marks on a yardstick, thus creating the subdivisions in the figure's height. The

parameters of the horizontal axes are set based on this (width subdivision).

With the exception of the proportions for the skull and head, we do not use a set of compasses to lay out our proportion schema.

When handling all the readings for the height and width subdivisions, one should always have a large 'maybe' in mind; the height subdivisions are most frequently subject to variations.

The author's proportioned figures are primarily intended to impart a method for finding a model's

Fig. 91 A proportion study of an 18 year old girl
She is at the beginning of the maturation phase, with a body height of 164.5cm (5ft 4¾in), a canon of 7.7 HL, and a head height of 21.3cm (8⅜in).

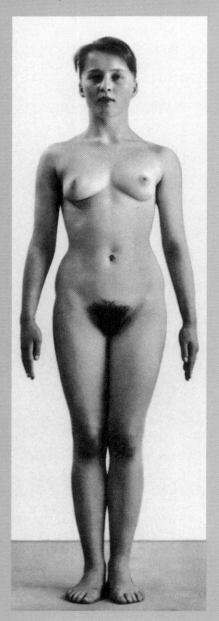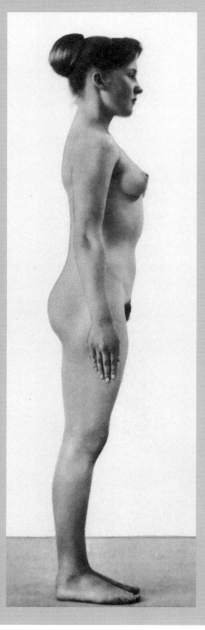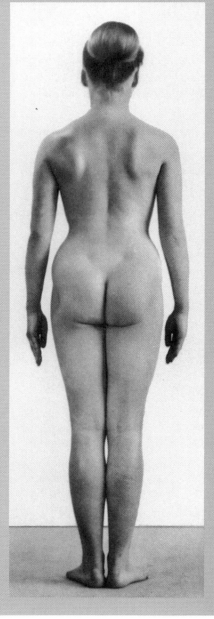

characteristic measurement points, and for constructing the proportionate relationships between them. The measurements given are not intended to be slavishly restrictive. Interconnecting the height and width subdivision measurement points creates simple two-dimensional geometric basic shapes, which can be further differentiated to create further shapes [95]. The reasons for using the eight heads canon are partly practical, because it makes the division process easier. Additionally, the well-developed 8 HL body type is very common [89/1, 89/2, 89/3, 95–97].

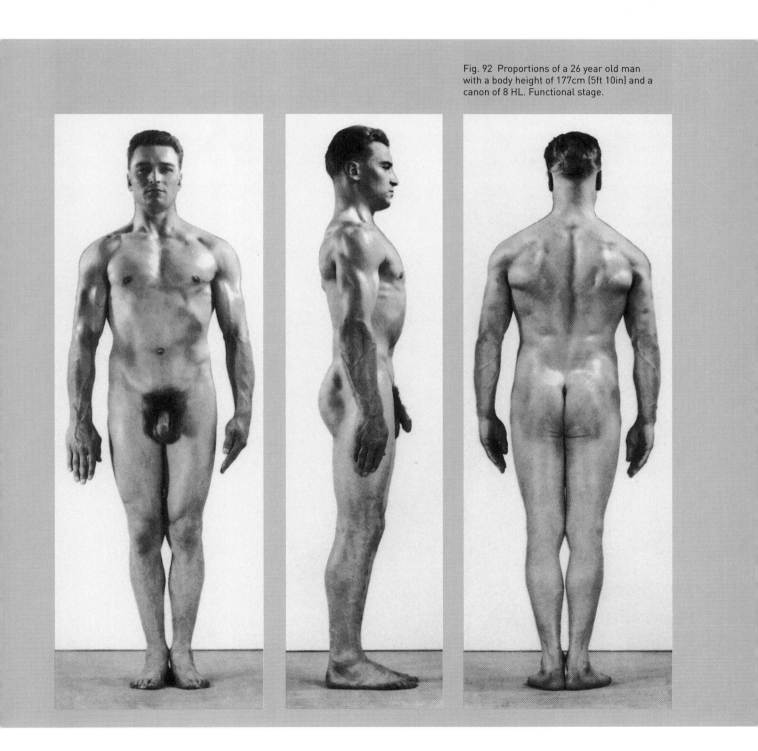

Fig. 92 Proportions of a 26 year old man with a body height of 177cm (5ft 10in) and a canon of 8 HL. Functional stage.

The proportions of the human body **97**

The skull and head proportions of an adult in frontal view [93]

The proportions of the head should be determined in advance, as an aid to relating the different body parts precisely to each other – and to the head itself – in the depiction of the figure.

The skull (= the basic bone structure) and the head (= the totality of all the formative elements, including bone, cartilage, muscles, skin, fat and hair) comprise the volumes of the cranium and of the facial skull. The cranium is composed of the enclosed cranium space, and of the surfaces of the forehead, temples, crown, and the back of the head, and the base of the skull, whilst the facial skull is given a richly varied structure by the openings for the sense organs, and for the masticatory apparatus. There are correspondences in the length and width measurements of the skull, as with the rest of the body: these are found by halving the skull's longest distance measurement, the crown–chin distance. In adults, this C–Ch vertical axis is bisected in the centre, at point E, by the horizontal eye axis (a horizontal line passing through the outer corners of the eyes).

The size of the facial skull can be found by describing a circle whose radius is one third of the C–Ch length around point M. The circle intersects the C–Ch length at the nasal spine, at ⅔ HL length from the crown.

The relative size of the facial skull can be found by halving the E–Ch distance at W (this represents a quarter of the overall length). From here, one draws a circle whose radius is one quarter of the head's length (E–W). These two circles, the first with a radius of ⅓ HL and the second with a radius of ¼ HL, intersect each other. Connecting them with tangent lines creates the oval form of the face.

The hairline is at the halfway point of C–M in H – in other words, it is ⅙ HL from the crown. The distance from the hairline to the point of the chin is referred to as the facial length. The bridge of the nose opens out into the brows and eyebrows, thereby extending

Fig. 93 The unit of the head proportions and skull construction (frontal).
The basic shape of the cranium (reddish-shaded) equates approximately to a circle whose radius is ⅓ of the head length (the crown–point of chin length), whilst the facial skull (shade of brown) equates to a circle with a radius of ¼ of the head length. The eye axis forms the precise midpoint between the crown and the point of the chin, as is emphasised by the strip on the left-hand side. The strip on the right-hand side marks the ⅓ subdivisions of the overall height – ⅔ on the crown–nasal spine line, and ⅓ on the nose spine–point of chin line.

From Bammes, *Wir zeichnen den Menschen.*

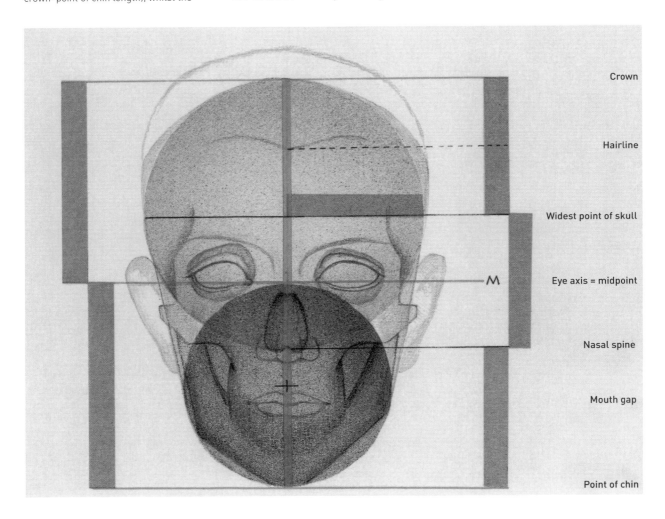

Crown

Hairline

Widest point of skull

M — Eye axis = midpoint

Nasal spine

Mouth gap

Point of chin

to above the eye axis. The soft tissue of the nose is secured to the nasal spine and beneath it, taking up around a third of the face's length. The mouth is (approximately) halfway between the nose and the point of the chin. The lower lip and chin section is larger than the upper lip section. The height and length of the ear are the same as for the nose.

The skull and head proportions of an adult in profile view [94]

Many of the values that apply to the frontal view are, of course, repeated in the profile view. Figure 94 begins with the relationship between the cranium and the facial skull, whose boundary is approximately identical to the line that runs from the brows downward towards the ear canal opening. The ear canal opening marks the midpoint of the depth measurement extending from the forehead to the back of the head, and is on approximately the same level as the nasal spine (or ⅔ HL below the crown). One can determine the depth

measurement of the cranium by marking out ⅔ HL on the horizontal line from the nasal spine to the posterior (horizontal) base of the skull.

This ⅔ HL distance (see the horizontal strip below the illustration) is then divided into two equal stretches, with an additional third extending to the rear. Thus, the cranium is enclosed by a transverse rectangle of height and depth measurement lines, which provides the basis for the drawing of the ovoid form. This form recedes at the rear of the head, being blunt at the rear and 'pointed' in the forehead area.

The proportions of the body of an adult male in frontal view [95a, b], and the process for finding them

This proportioned figure is based upon an adult man 180cm (5ft 10½in) in size, and a canon of 8 HL. Rather than evaluating the body's full development in terms of height in centimetres, Stratz primarily judges it based on the canon: 'I consider the relationship between head height and body height to be more important, and

Fig. 94 The unit of the head proportions and skull construction (profile).
In its depth extension, the cranium (reddish-shaded) corresponds to an ovoid, with its 'blunt' end (= the rear of the head) inclined downward at the back. The ear canal opening lies approximately on the midpoint of the line from the forehead to the rear of the head. The facial skull (green-shaded) connects to the cranium at the anterior base of the skull (= runs roughly from the upper brow to the ear canal).

The strips visualise equal lengths of ½ and ⅓ HL.

From Bammes, *Wir zeichnen den Menschen.*

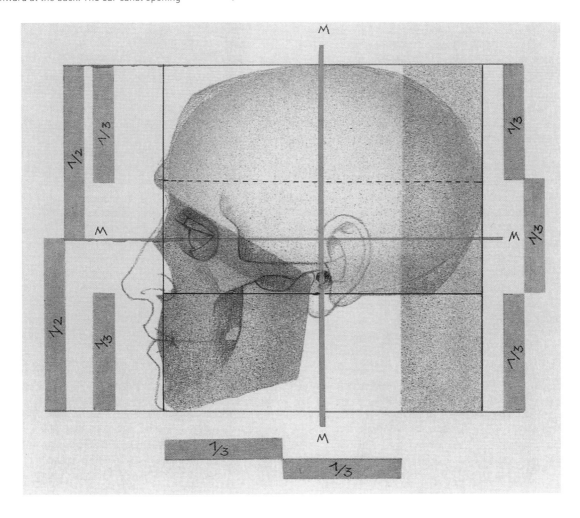

regard the development of an 8 HL person as more normal than 7¾, even if the latter has a greater body length in absolute terms.'[14]

Figure 95 is free of secondary forms. The margin contains a visualisation of the height subdivisions, derived by analogy, and based on the head lengths. The major horizontal axes are located at the height of the shoulders, nipples, waist, hips and the hollows of the knees and ankles. The line at hip level, which is a little above the body's geometric centre, gives us the upper and lower body lengths. The shoulder line – the connective line between the bony tops (the acromia) of both shoulders – is the most prominent horizontal axis. It intersects the vertical symmetrical axis at ⅓ HL from the nipple axis, which is at 1 HL below the chin (that is, at 2 HL below the crown = the uppermost body quarter). At 3 HL, the body narrows to form the waist. At 1 HL below this point, one finds the lower end of the pubic symphysis. It is on the same level as the wide point of the hips, the trochanter major level. It follows from this that a man's legs are longer than his trunk (which equals the torso plus the head).

The knee represents an intermediate form between the cone of the upper and lower leg. The distance from the upper boundary of the kneecap to the tibial tuberosity is ½ HL. The medial tibial plateau is ¼ head length above the tibial tuberosity. It marks the upper boundary of the lowermost body quarter. This is subdivided at the level of the inner side of the lower leg, at ⅓ HL above the soles. The elbow joint aligns fairly exactly with the level of the waist, whilst the wrist hangs a little below trochanter level, with the fingertips level with or below the midpoint of the upper leg. Total arm length is 3½ HL, ½ HL shorter than the leg length (which is somewhat over 4 HL).

The pelvis measures 1 HL, from its upper boundary at the iliac crest to its low points at the ischial tuberosities. The span of the arms (taken as the distance between the middle fingertips) is slightly greater than the total body height, especially in individuals with a slender build (in contradiction of Leonardo's Vitruvian Man). The shoulder width, from acromion to acromion, measures just about 2 HL. As one descends from this point, the widths consistently decrease. The loosely typical male waist draws in only slightly (width = the hollow of the throat to the crown). The width of the narrow hips, above trochanter level, measures 1½ HL, both knees together measure 1 HL, a single knee measures ½ HL, and both malleoli) taken together measure ⅔ HL. The standing surface occupied by both soles equals 1 HL.

The greater width at the shoulders, the narrowing at the hips and the very narrow base at the thin part of the ankle give the male figure the appearance of a wedge shape standing on its point.

14 Stratz, *Der Körper des Kindes*, Stuttgart 1923, p. 281.

The lines of the dimension of depth can be found in the same way as the lines of the dimension of width [95c, d]. This will not be discussed further at this stage, as the key points can be read from the illustration [95].

The proportions of the adult female body in frontal view [96a, b] and the process for investigating them

The axes of height division are the same as for the male figure. Compared with the male figure, however, there are a number of displacements: the pubic bone is located at the body's midpoint (as a result, women's legs are shorter than men's, both proportionally and in absolute terms). The nipples are at the level of the uppermost body quarter, although they may frequently be lower due to the weight of the breasts. The level of the shoulder girdle is ½ to ⅓ HL from the point of the chin, whilst the waist is a little above, and the navel a little below, the third HL point (this causes the female body to appear longer than the male body). Owing to the shorter length of the legs, the medial tibial plateau lies almost within the lowermost body quarter, with the tibial tuberosity located beneath. As with the man, the length of the interstitial form of the knee measures ½ HL (from the upper edge of the kneecap to the tibial tuberosity). Ankle level is ⅓ HL above the sole, and elbow level is identical with waist level. The wrist is at hip height or below, and the fingertips are at or close to the midpoint of the upper leg.

The width dimensions

In men, the most conspicuously wide area of the figure is in the shoulders. In women, it is the hip region (measured from trochanter to trochanter), with a measurement of just about 2 HL. The waist width measures just about 1⅓ HL. The upper body, rising from the broad trapezoid form of the hips, is like a narrow vertical rectangle in shape. The shoulder width is only 1½ HL. Below the wide point of the hips, transverse extension steadily declines: the two knees taken together have a width of 1 HL, whilst the two ankle joints have a width of ⅔ HL. The region of the exterior of the calves between the accented points is somewhat wider than the knees are when pressed together. The sole width is 1 HL, as with the male figure. The resulting basic form is a spindle shape, widest at the midpoint of the body and tapering at both ends.

The extension measurements of the profile view are described pictorially only, not in words [96c, d].

Figure 97 summarises the peculiarities of the male and female bodies, in terms of the typology of proportions. Here, they are seen together. The man and woman were drawn at the same size in order to make the absolute height and width differences readily apparent through comparison using the proportioned rectangle (which is 2 HL wide and 8 HL high). Both body outlines are discordant.

This is followed by an overview (pages 108–109) that again encapsulates the peculiar proportions of both sexes, based on the process of constructing the correspondences and similarities of the elements to each other and to the whole.

Fig. 95 Process for finding the proportions of a mature man with a body height of 180cm (5ft 11in), and a canon of 8 HL.

a) The wedge shape – the basic shape of the male body.
The vertical central axis is subdivided by horizontal transverse axes, based upon the model's proportions (height subdivision).

b) The same figure, rendered in simplified skeletal forms (see page 102).
This allows the accents of form and measurement points to be more precisely located.
The two vertical strips indicate the unequal lengths of a man's upper and lower body. In addition to showing the process for investigating proportions, this illustration provides information on the static factors in the alignment of the limbs. Centre of gravity CG is supported by the soles, with a line extending from the midpoint of the head of the hip joint through the centre of the medial tibial plateau and converging as it approaches the upper ankle joint (this is known as the support line). The alignment of the femoral shaft deviates from this support line because of the presence of the cantilever arm of the neck of the hip joint between the head of the hip joint and the socket. This creates an obtuse, outward-opening angle in the knee region (= the exterior angle of the leg), which is more pronounced in women (owing to the greater width of the female pelvis). There is a similar angle between the humeral shaft and the ulna (= the exterior angle of the arm).

c) The same figure in profile view
The two vertical strips repeat the information on the unequal upper and lower body lengths in the male body (see page 103, left).
The red vertical line (= line of gravity) is a static line running through the joints responsible for maintaining balance in a person standing upright.

d) The same figure in profile view, with the dimensions of depth given in HL (see page 103, right).

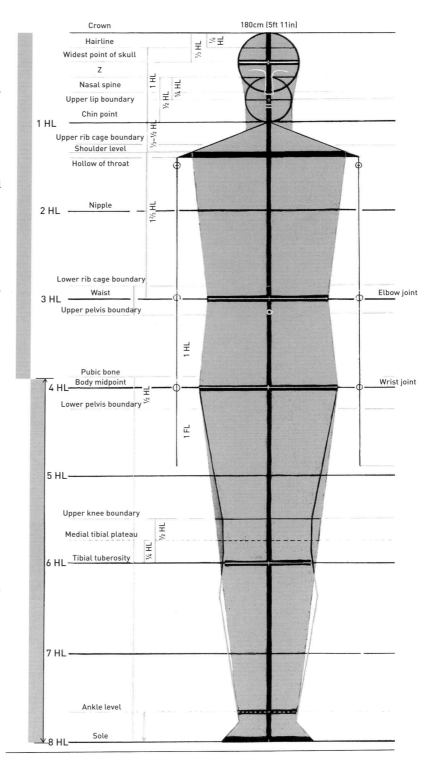

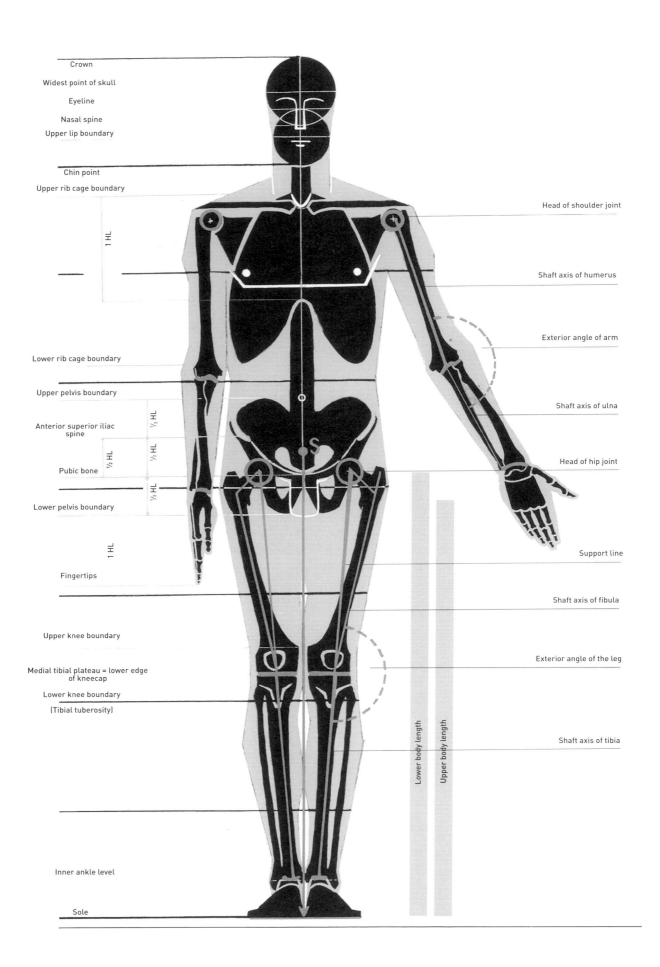

Crown
Widest point of skull
Eyeline
Nasal spine
Upper lip boundary

Chin point
Upper rib cage boundary

1 HL

Head of shoulder joint

Shaft axis of humerus

Exterior angle of arm

Lower rib cage boundary

Shaft axis of ulna

Upper pelvis boundary

Anterior superior iliac spine

⅓ HL

½ HL

⅔ HL

Pubic bone

⅔ HL

Head of hip joint

Lower pelvis boundary

1 HL

Support line

Fingertips

Shaft axis of fibula

Upper knee boundary

Exterior angle of the leg

Medial tibial plateau = lower edge of kneecap

Lower knee boundary
(Tibial tuberosity)

Lower body length

Upper body length

Shaft axis of tibia

Inner ankle level

Sole

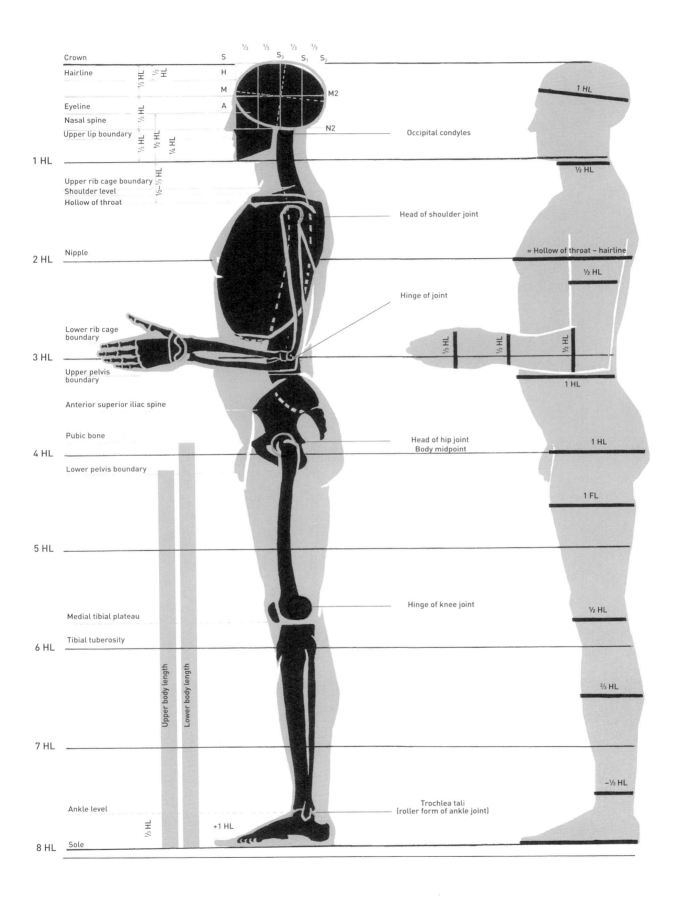

Crown

Hairline

⅓ HL ⅓ HL

S ⅓ ⅓ ⅓ ⅓ S₃ S₁ S₂

H

M

Eyeline

A

⅓ HL ⅓ HL

M2

Nasal spine

Upper lip boundary

⅓ HL ½ HL ¼ HL

N2

Occipital condyles

1 HL

Upper rib cage boundary

½–⅓ HL

Shoulder level

Hollow of throat

Head of shoulder joint

2 HL Nipple

Hinge of joint

Lower rib cage boundary

3 HL

Upper pelvis boundary

Anterior superior iliac spine

Pubic bone

Head of hip joint

4 HL

Body midpoint

Lower pelvis boundary

Upper body length Lower body length

5 HL

Hinge of knee joint

Medial tibial plateau

Tibial tuberosity

6 HL

7 HL

Ankle level

Trochlea tali
(roller form of ankle joint)

⅓ HL +1 HL

8 HL Sole

1 HL

½ HL

= Hollow of throat – hairline

½ HL

⅓ HL ⅓ HL ½ HL

1 HL

1 HL

1 FL

½ HL

⅔ HL

–⅓ HL

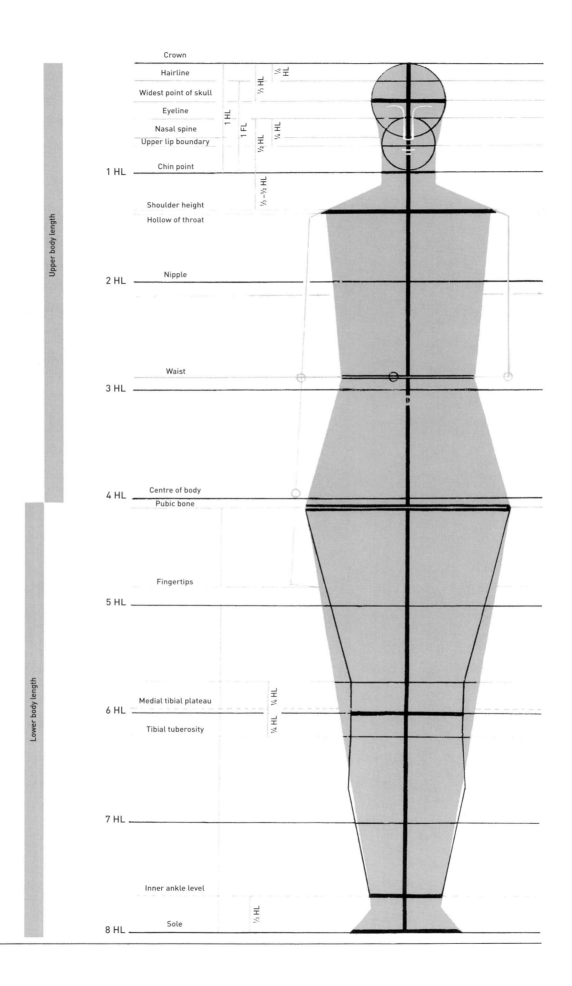

Crown

Hairline

⅙ HL

Widest point of skull

⅓ HL

Eyeline

Nasal spine

1 HL

1 FL

¼ HL

Upper lip boundary

½ HL

1 HL — Chin point

⅓ – ½ HL

Shoulder height

Hollow of throat

2 HL — Nipple

Waist

3 HL

4 HL — Centre of body

Pubic bone

Fingertips

5 HL

Medial tibial plateau

¼ HL ¼ HL

6 HL

Tibial tuberosity

¼ HL

7 HL

Inner ankle level

⅓ HL

8 HL — Sole

Upper body length

Lower body length

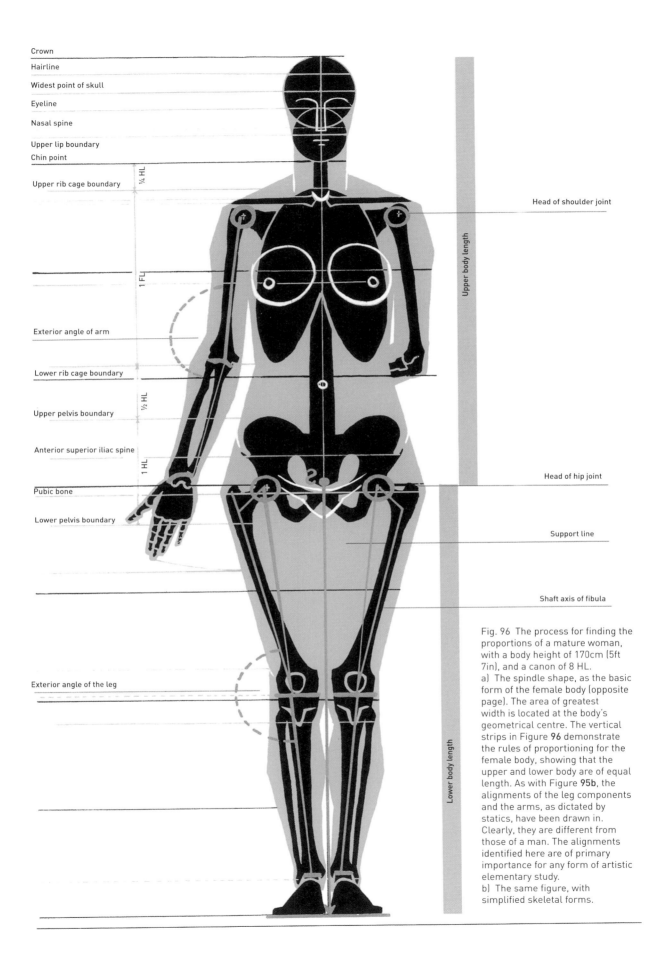

Crown
Hairline
Widest point of skull
Eyeline
Nasal spine
Upper lip boundary
Chin point
¼ HL
Upper rib cage boundary

1 FL

Exterior angle of arm

Lower rib cage boundary
½ HL
Upper pelvis boundary

Anterior superior iliac spine
1 HL
Pubic bone

Lower pelvis boundary

Exterior angle of the leg

Head of shoulder joint

Upper body length

Head of hip joint

Support line

Shaft axis of fibula

Lower body length

Fig. 96 The process for finding the proportions of a mature woman, with a body height of 170cm (5ft 7in), and a canon of 8 HL.
a) The spindle shape, as the basic form of the female body (opposite page). The area of greatest width is located at the body's geometrical centre. The vertical strips in Figure **96** demonstrate the rules of proportioning for the female body, showing that the upper and lower body are of equal length. As with Figure **95b**, the alignments of the leg components and the arms, as dictated by statics, have been drawn in. Clearly, they are different from those of a man. The alignments identified here are of primary importance for any form of artistic elementary study.
b) The same figure, with simplified skeletal forms.

The proportions of the human body **105**

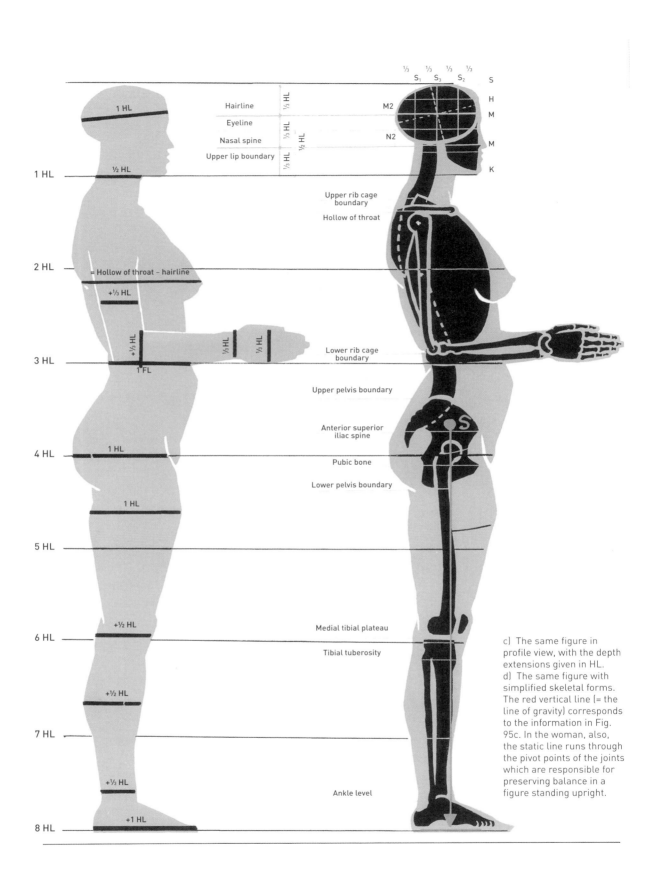

		⅓	½	⅓	⅓	
		S₁	S₃	S₂		S
						H
Hairline	⅓ HL				M2	M
Eyeline	⅓ HL					
Nasal spine	½ HL				N2	M
Upper lip boundary	⅓ HL					K

1 HL

½ HL

1 HL

Upper rib cage boundary

Hollow of throat

2 HL

= Hollow of throat – hairline

+⅓ HL

+⅓ HL ⅓ HL ⅓ HL

3 HL

1 FL

Lower rib cage boundary

Upper pelvis boundary

Anterior superior iliac spine

4 HL 1 HL

Pubic bone

Lower pelvis boundary

1 HL

5 HL

+½ HL

6 HL

Medial tibial plateau

Tibial tuberosity

+½ HL

7 HL

+⅓ HL

Ankle level

+1 HL

8 HL

c) The same figure in profile view, with the depth extensions given in HL.
d) The same figure with simplified skeletal forms. The red vertical line (= the line of gravity) corresponds to the information in Fig. 95c. In the woman, also, the static line runs through the pivot points of the joints which are responsible for preserving balance in a figure standing upright.

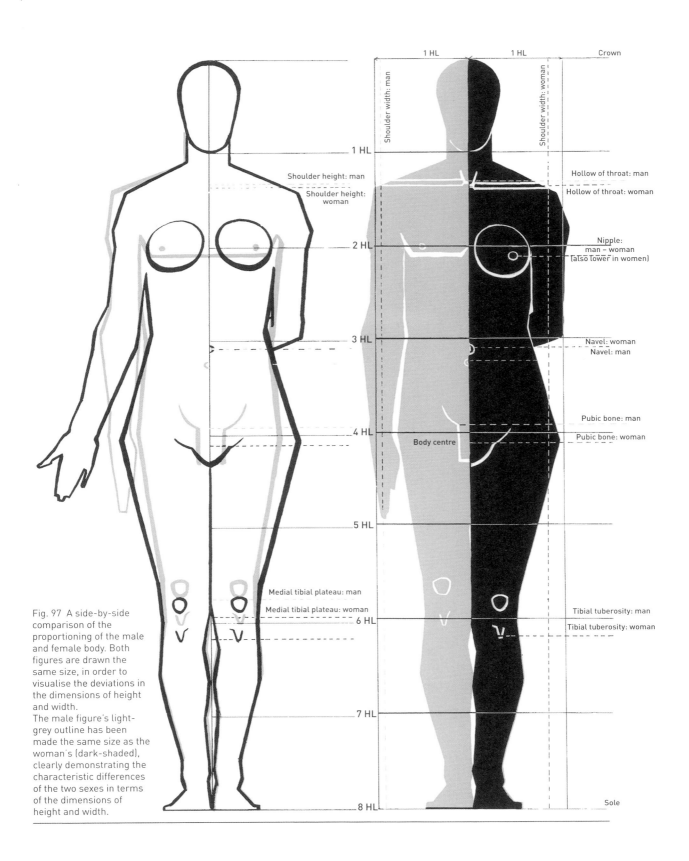

1 HL

Shoulder width: man

Shoulder width: woman

Shoulder height: man

Shoulder height: woman

Hollow of throat: man

Hollow of throat: woman

2 HL

Nipple:
man – woman
(also lower in women)

3 HL

Navel: woman

Navel: man

4 HL

Body centre

Pubic bone: man

Pubic bone: woman

5 HL

Medial tibial plateau: man

Medial tibial plateau: woman

6 HL

Tibial tuberosity: man

Tibial tuberosity: woman

7 HL

8 HL

Sole

Fig. 97 A side-by-side comparison of the proportioning of the male and female body. Both figures are drawn the same size, in order to visualise the deviations in the dimensions of height and width.
The male figure's light-grey outline has been made the same size as the woman's (dark-shaded), clearly demonstrating the characteristic differences of the two sexes in terms of the dimensions of height and width.

The proportions of the human body **107**

Summary: Man

Body quarter	Height division	Width dimension	Depth dimension
1st body quarter	Crown height = 0 HL Height of chin point = 1 HL Shoulder height = $\frac{1}{3}$ HL below the chin point Hollow of throat = $\frac{1}{3}$ HL below the chin point Nipple height = at 2 HL	Widest part of skull = $\frac{2}{3}$ HL Neck width = $\frac{1}{2}$ HL Shoulder width (bone) = −2 HL Shoulder width (with deltoid muscle) = 2 HL Space between nipples = 1 HL	Neck thickness = $\frac{1}{2}$ HL Nipple–shoulder blade = hollow of the throat–hairline
2nd body quarter	Waist height Navel height below 3 HL, at the same height as the upper pelvis boundary Pubic bone = hip height, a little above the body's geometric midpoint	Waist width = shoulder height to crown Hip width = 1$\frac{1}{2}$ HL	Stomach – loin = 1 HL Pubic bone – buttocks = 1 HL
3rd body quarter	Medial tibial plateau = $\frac{1}{4}$ HL above 6th HL Tibial tuberosity at 6 HL = lower body quarter	1 knee width = $\frac{1}{2}$ HL	Thigh thickness = 1 FL Knee thickness = $\frac{1}{2}$ HL
4th body quarter	Inner ankle height = $\frac{1}{3}$ HL, above 8th HL Sole = 8 HL	1 ankle width = $\frac{1}{3}$ HL 1 foot width = $\frac{1}{2}$ HL	Calf thickness = $\frac{2}{3}$ HL Thickness of lower leg above ankle = −$\frac{1}{3}$ HL Foot length = hollow of throat – hairline = nipple – shoulder blade
Additional notes	Elbow height is just above waist height Wrist height is at hip height or below Finger tip height is at the midpoint of the thigh or just above	Wrist width = $\frac{1}{3}$ HL Hand width = +$\frac{1}{3}$ HL	Upper arm thickness = $\frac{1}{2}$ HL Lower arm thickness (radius and ulna in a parallel position) close to the elbow = $\frac{1}{2}$ HL

Abbreviations: HL = head length
FL = facial length
+ = over
− = just about

Summary: Woman

Body quarter	Height division	Width dimension	Depth dimension
1st body quarter	Crown height = 0 HL Height of chin point = 1 HL Shoulder height = ⅓–½ HL below the chin point Hollow of throat = +⅓ HL below the chin point Nipple height = 2 HL or lower	Widest part of skull = ⅔ HL Neck width = ½ HL Shoulder width (bone) = +1½HL Space between nipples = 1 HL	Neck thickness = –½ HL Nipple–shoulder blade = hollow of the throat–hairline
2nd body quarter	Waist height = 3 HL Navel height just below 3rd HL above the upper pelvis boundary Pubic bone = hip height, a little below the body's geometric midpoint	Waist width = shoulder height to hairline Hip width = 2 HL	Stomach–loin = 1 FL Pubic bone–buttocks = 1 to +1 HL
3rd body quarter	Medial tibial plateau = just below 6th HL Tibial tuberosity below 6 HL = lower body quarter	1 knee width = ½ HL	Thigh thickness = 1 HL Knee thickness = +½ HL
4th body quarter	Inner ankle height = ⅓ HL, above 8th HL Sole = 8 HL	1 ankle width = ⅓ HL 1 foot width = ½ HL	Calf thickness = +½ HL Thickness of lower leg above ankle = +⅓ HL Foot length = + 1 HL
Additional notes	Elbow height is just above waist height	Wrist width = ⅓ to –⅓ Hand width = ⅓ to –⅓	Upper arm thickness = +⅓ HL Lower arm thickness (radius and ulna in a parallel position) close to the elbow = +⅓ HL

2.2.3. Additional remarks on the typology of proportion

The fundamentals of the physical features of both sexes can be modified, in their range of visual manifestations, by the individual's constitution, but, essentially, cannot be undone. The harmony within a constitution type, such as the leptosome type (slender build), the pyknic type (compact and rounded build) and the athletic type (sturdy skeleton and musculature) appears to be primarily established by the way the different physical build characteristics occur in combination with each other, with the individual parts repeating the characteristics peculiar to the whole form.

Modern physical constitution research (Kretschmer, Lenz, Zeller, Sheldon) shares the same idea of a totality founded on qualities of form found in Dürer's enquiries and in the morphological efforts of Goethe's era [98–102]. It recognises unity and uniformity in the way that nature has equipped each individual organism with its own language of form.

An artist may deviate from his model as much as he likes, but it is important that everything should be subordinate to an overall quality, so that the character of physique – stocky, slender, rounded – runs through the whole body type like an echo, continually evoking the relationships of the physical characteristics to each other. Dürer likened this to rhyme. Artists often draw inspiration from coherent body types (e.g. Renoir, Maillol, Rodin, Marcks and many others).

The significance to artists of knowing the constitutional type of the model is self-evident. However, the danger that goes hand-in-hand with looking for typical features must not be overlooked.

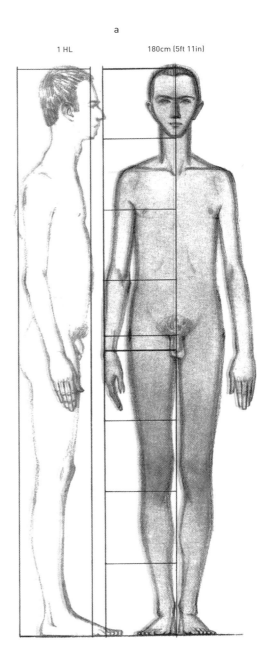

a

1 HL 180cm (5ft 11in)

Fig. 98 Constitution types (semi-schematic).
a) Leptosome type, normal size 180cm (5ft 11in), with an average size of 168.4cm (5ft 6¼in). Canon: 8 HL. Note the unequal lengths of the upper and lower body, and the parallel contours of the torso.
b) Athletic type, normal size 170cm (5ft 7in), with an average size of 170cm (5ft 7in). Canon: 8 HL.
c) Pyknic type, normal size 168cm ((5ft 6in), with an average size of 167.8cm (5ft 5¾in). Canon: approx. 7¾ HL. The position of the pubic bone is almost identical with the body's midpoint.
When considering different constitution types, one should always bear in mind that these are rarely found in a completely pure form.

Artists must not allow their full experience of the wealth of natural variety to be narrowed down, or forget that finding any body type in a pure, exaggerated form is extremely rare. On the other hand, it is the 'alloyed' types that produce both physically and intellectually interesting individuals. The transitions between one type and another take place in incredibly fine graduations. Also to be avoided is the notion that the mixed types are in any way 'hybrid'. On the contrary, it is among these types that one finds complementary physical and intellectual elements that contribute to a fortuitous overall whole. All of this poses a lifelong challenge to the eye of the artist, who must be ready for every individual appearance, must keep alive and constantly refresh an eye for individual detail, and must discover uniqueness, beauty and greatness within the individual.

Peculiar qualities of physical constitution are also associated with the major sporting abilities. One thing one can be sure of is that any specific sporting activity will have its own optimally suited, typically proportioned body type. Javelin throwers and shot-putters, vaulters and swimmers or gymnasts, sprinters and long-distance runners are significantly different from one another. Painters and sculptors creating artwork for stadiums or sport clubs must bear in mind that there is no one single sports person body type, instead any body will be, to a greater or lesser degree, representative of a specific sport discipline.

Instead of the different constitutional types being further discussed here, a concluding overview of peculiarities of physical build follows [99, 100, 101, 102].

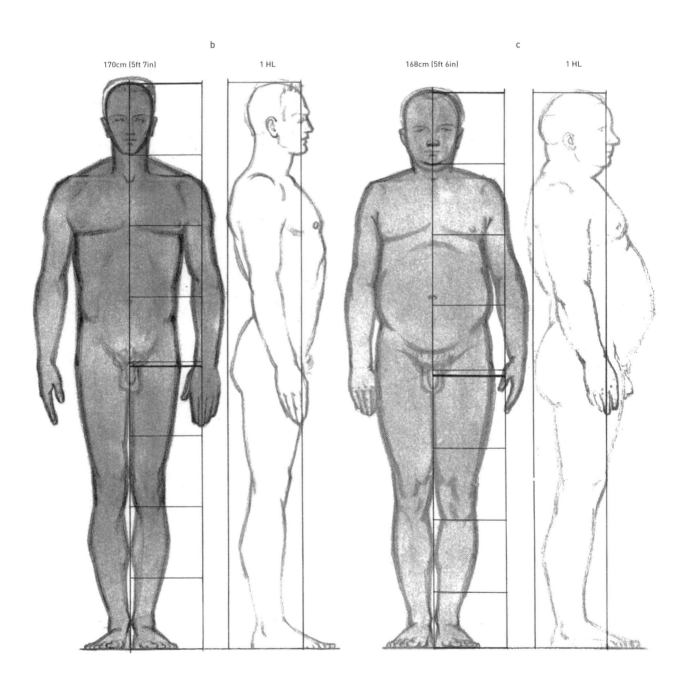

b

170cm (5ft 7in) 1 HL

c

168cm (5ft 6in) 1 HL

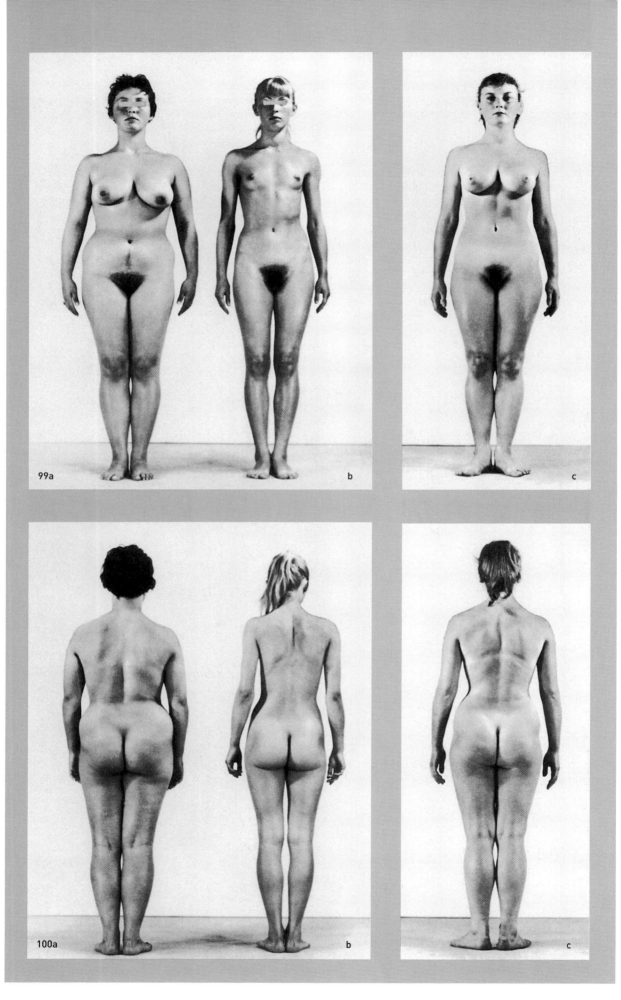

99a

b

c

100a

b

c

112 The proportions of the human body

Fig. 99 Three female constitution types.
All are of equal age (19 years old) and
equal body height (160cm/5ft 3in).
a) Predominantly pyknomorph (rounded).
Canon: 7½ HL.
b) Primarily leptomorph (slender).
Canon: 8 HL.
c) Primarily athletomorph (muscular).
Canon: 8 HL.

Fig. 100a–c The same three female
constitution types of the same age and
same size, seen in Figure **99**.

Fig. 101 A youth of 17 years old, with a
body height of 170cm (5ft 7in).
A student with predominantly
athletomorph physical characteristics,
alloyed with pyknomorph characteristics.

Fig. 102 A youth of 18 years old, with a body
height of 183cm (6ft).
A student with predominantly leptomorphic
characteristics.
a) Note the length of the legs, and the
gracile bones and muscles.
b) Note the flat and slightly sunken rib cage.

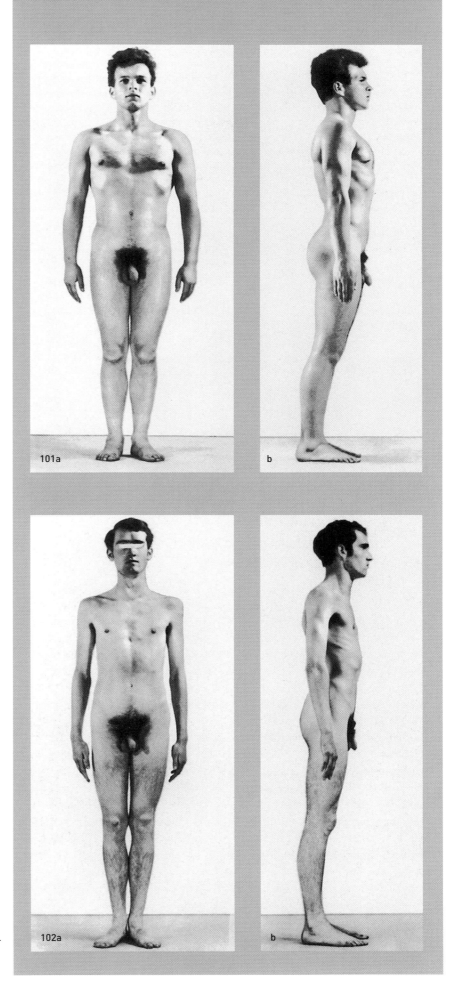

The proportions of the human body **113**

Summary overview: physical characteristics of the three constitutional types,
collected by Grimm and Kretzschmer

Type	Torso proportions	Surface relief	Extremities	Head and neck	Face	Hair growth
Pyknic	Short, deep vaulted rib cage, obtuse rib angle	Round, soft forms owing to well-developed fatty tissue	Soft, relatively short extremities. Fine boned, short and broad hands and feet.	Relatively large, rounded head. Flat crown-of-head contour, short, massive neck	Softly plastic, ruddy face. Weak profile curvature	Fine scalp hair, with a tendency towards baldness. Medium to heavy final-stage hair growth
Athletic	Wide, strong shoulders, a trapezoidal torso with a relatively narrow pelvis	Powerful, plastic muscle relief on a sturdy bone structure	Powerful, sturdy arms and legs, large hands and feet, possible acrocyanosis	Sturdy high head. Free, powerful neck with an oblique, tautly stretched trapezius muscle	Sturdy face with plastic bone structure, emphasised acra. A vertiginous egg form	Heavy scalp hair. Indifferent final-stage hair growth
Leptosome	Flat, long, rib cage. Acute rib angle. Relatively wide pelvis	Lean or sinewy, with a lack of subcutaneous fatty tissue	Long, thin extremities with long, narrow hands and feet	Relatively small head. Long, thin neck	Pale, narrow face, abbreviated, ovoid, pointed, narrow nose, possibly an angular profile	Coarse scalp hair. Possible fur-cap hair. Weak final stage hair growth

2.3. THE TREATMENT OF CONSTITUTION: TYPICAL CHARACTERISTICS OF FORM IN ART

We can define the concept of the characteristics of somatic types in a wider sense, or in a narrower sense. In the first of these two cases the term refers, generally, to the overall anatomical constitution of an individual. Within the framework of genetically determined features, these show a disposition to variation. For instance, there are the typical sex-determined characteristics of the adult man and the adult woman in terms of their proportions, and the features of so-called constitution types in the narrower sense, as presented in section 2.2.3. In their sum total, and in the special features and qualities of the language of form in which they are expressed, these constitute a coherent unity. These bodily states play a significant role in helping artists to 'grasp' the quality of the form in its visual manifestations, providing artists with material for impressions that serve to stimulate their formative experiences. The formative impression values and experiences attached to proportions, combined with the secondary characteristics (in the narrower sense) are an agency that enters into artistic expressive shaping, as a strong inspiring force.

The sculptor Vera Mukhina creates an artwork composed of long-flowing lines, with the lean forms of the slender model type, with long limbs and flat breasts, narrow pelvis, and small rib cage volume, as the subject [103]. Kustodijew, on the other hand, is drawn to the soft, silky roundness and plastic fullness of the female pyknomorph type, a form inclined to an impressive simplicity whose shimmering, expanses of skin are modelled by the artist in a restrained silver tone [104].

Artists possess a lively sensitivity for interpreting ideas through the choice of a specific type, outside of formal design, aside from gesture and attributes – and, conversely, for allowing the visual and sensory experience of a body type to inspire an idea. To picture Maillol's L'Action enchaînée as a soft pyknic female figure, like his Pomona, would appear to be simply impossible [105, 106]. Unlike the shackled female figure, the latter figure's habitus would prevent her from bursting the chains, from straining to break free, because her body lacks the more athletic woman's masculine lineaments of hardness and power. In the case of L'Action enchaînée, there is barely any difference between the width of the pelvis, which is almost masculine in its narrowness, and the width of the shoulders. The fleshy skin covers powerful muscles, strong bones; in her, nature has been sparing with the soft rounded forms with which the pyknic type seen in Renoir's Venus and Maillol's Pomona are generously endowed.

Maillol's sculpture Le Cycliste, also called L'Éphèbe, is on the opposite side of the spectrum from the pyknic type, showing a fine-limbed, slender, lean and lank athlete [107].

Here, we see Maillol – an artist who created earthy, weighty female forms with uncomplicated and worldly connotations that unite the body masses in a clear simplicity – allowing himself to be inspired by a youthfully delicate athlete. There is not a scrap of fat

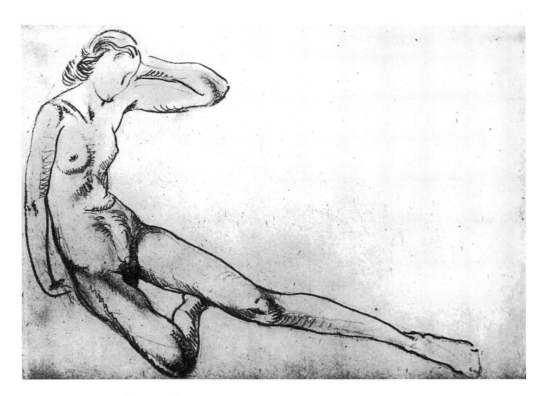

Fig. 103 Vera Mukhina (1889–1953).
Nude study (1951). Lead, 35 x 25.8cm
(13¾ x 10⅛in).

Fig. 104 Boris M. Kustodijew (1878–1927).
Nude study (1915). Lead, 51.4 x 62.2cm
(20¼ x 24½in).

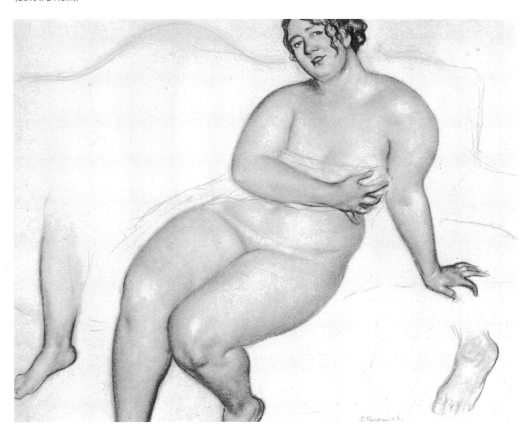

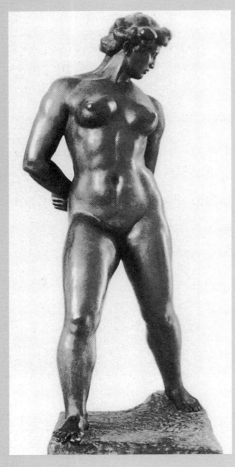

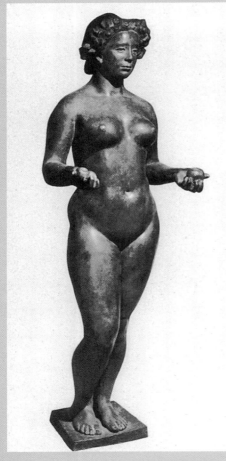

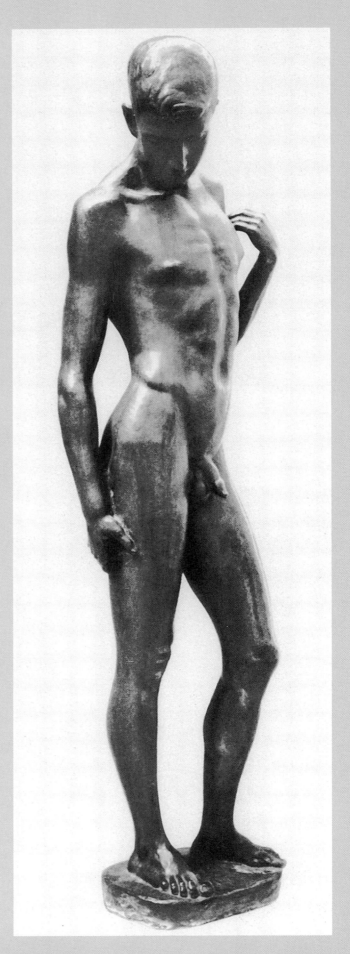

padding out this well-exercised, 'dry' form. Equally, there are no athletically heavy torso muscles laid around the pelvis and rib cage to fill them out. What there is of the tensely bulging quality usually bestowed so richly by Maillol on his creations is focused on the legs, which provide a runner or cyclist's driving force. High up, at the centre of the body and the centre of movement, the leg musculature – not to any degree compact – is laid around a lightly-built bone structure. The ankle is of a gazelle-like slenderness, and the muscles have the elasticity of sprung steel.

What a tremendous contrast there is between Bammes' *Ringer* and Geibel's *Boxer* [109]! This heavy athlete is weighing his invisible opponent, who is present in the form of his incipient attack [110]. Soon, the two giant bodies will be pressed together, moving dynamically through the air, each with the object of throwing the other.

It will be Herculean labour, performed by athletes with a gigantic bone structure and heavy muscles, to enable the heightened development of strength, with air packed deeply into the swelling rib cage, with chest muscles standing out on the thorax like shields, the tensed body like a structure of steel plates, armed against the opponent's impact. With his powerful legs, the wrestler will lift his partner's weight, and strain against it. His crouched posture and his arms, which are held in readiness for the grasping action, show how he is anticipating the weight. It is this – the relationship of the individual to the whole sequence of events – that provides the motivation for the vibrating muscles.

In Fritz Cremer's sculpture *Schwimmerin* [108] the artist has given form to a calm and attentive gaze over those tumbling in the water, rather than to the tension of the first leap into the water, with its associated sensation of movement. The coolness of the wet

Fig. 105 Aristide Maillol (1861–1944).
L'Action enchaînée.
The artist has chosen a muscular body type, to match the artwork's message.

Fig. 106 Aristide Maillol (1861–1944).
Pomona.
The voluminous pyknomorph body type is best suited to a goddess of fruits.

Fig. 107 Aristide Maillol (1861–1944).
Le Cycliste, also called *L'Éphèbe*.
Maillol's creation shows a fine-boned youth with slender musculature, quite different from the modern cyclist type.

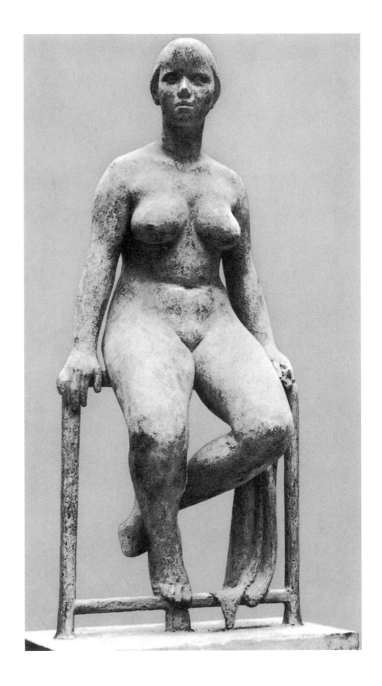

Fig. 108 Fritz Cremer (1906–1993).
Schwimmerin.
The balanced, rounded forms of the female swimmer have a particular attraction for the sculptor.

The proportions of the human body **117**

element has created her rounded forms, whilst the legs drive the spindle-shaped body through the waters like a seal-shaped skittle, in quick, short movements. The well-formed rib cage similarly fills in the form with ample volume. All in all, it is a beautiful body springing from a sporting background.

The very slender *Boxer* portrayed by Hermann Geibel (1889–1972) would appear to be a long-range fighter, nervous and 'wiry', covering himself by drawing in his elbows [109]. The excessively long legs, which have a spring-like quality, have a quick, light tripping step. Above the slender centre of the pelvis, the figure has

drawn his right shoulder back a little in order to lend the straight strike of his right hand further impetus by bringing the shoulder girdle sharply forward. The crouch for the attack, seen lurking in the neck, the concentrated fixed gaze behind the fists; the narrow front, with its parallel contours, is turned slightly, to evade the opponent's blows. The body's whole structure is tall and lightly built, not heavily muscular, with sharply defined sinews and projecting bones, built for endurance. This figure is predominantly of the leptosome type, and could equally well be that of a medium-distance runner or vaulter.

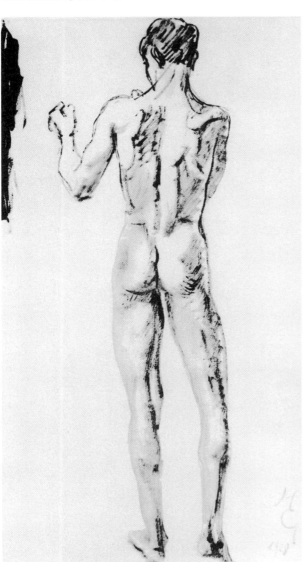

Fig. 109 Hermann Geibel (1889–1972). *Boxer* (1928). Kupferstich-Kabinett, Dresden. The constitution of this sportsman type is characterised by a tall and slender build.

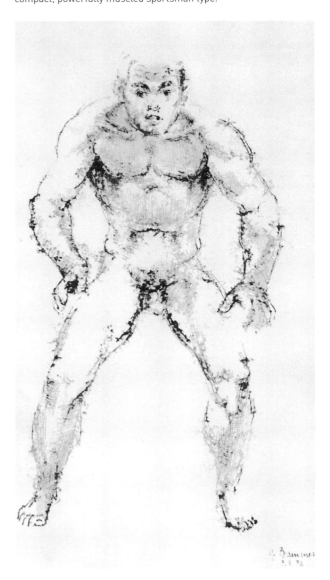

Fig. 110 Gottfried Bammes (1920–2007). *Angreifender Ringer* (1972). Pen and ink, 35.5 x 37.5cm (14 x 14¾in). Factually and artistically, the theme is represented by a compact, powerfully muscled sportsman type.

2.4. THE PROPORTIONS OF DIFFERENT DEVELOPMENT STAGE TYPES

Between birth and the attaining of full adult growth – that is, within a span of around a quarter of a century – a process of physical and intellectual development takes place that reveals itself in the rhythms of the emerging form. A young human being does not simply steadily develop into an adult. Instead, we do so in stages, with distinct stagnation and acceleration stages. Additionally, the relative percentages of the whole figure taken up by the head, the torso, and the arms and legs do not remain constant throughout an individual's development as the young individual develops from a newborn to a mature man [111–113] or mature woman. In relation to body length at birth (about 50cm/19¾in):

the head grows to double birth size
the torso grows to three times birth length
the arms grow to four times birth length
the legs grow to five times birth length.

Our presentation of proportion typology puts recognising the canon first, because the growth of the head in relation to the rest of a young body determines the specifics of how the individual's appearance is influenced by age and development [112, 113, 114, 116].

The most significant body differences between the infant and the adult are not based solely on the generally recognised size differences, but also on a complete readjustment of the relationship of body length, and the proportion of the whole body taken up by the torso and extremities.

In its first year of life, nature equips the tiny and infinitely helpless human being with a very large brain and an underdeveloped masticatory apparatus (sustenance at this stage is soft or liquid) [115, 116, 121, 122]. Therefore, even if one looks at the growth of the head alone, there is a shift in the relative proportions of the cranium and facial skull. The brain initially predominates.

In an adult, the eye axis represents the centre of the head (shown by the strongly drawn horizontal line [114]). In an infant or small child, however, this lies below the centre of the head (faintly drawn line [114a–f]). The shift in the proportions of the head in favour of the facial part of the skull occurs with the replacement of the first set of teeth, as the jaw structure develops. This causes the face to extend downward. The first stage of facial development concludes with the milk teeth stage. The growth of the skull in terms of depth (the extension from the forehead to the back of the head) remains approximately constant in relation to its point of greatest width (outline of skull [114g–i]). The distance from the thinly drawn-in greatest skull-width to the strong halving line on the depth axis remains a proportional constant from birth to adulthood [114a–c]. The thicker vertical line marks the centre of the brow–back of the head distance measurement, and almost invariably coincides with the ear canal opening.

Fig. 111 A side-by-side comparison of the proportions of an adult and an infant, both drawn at the same size (based on a line drawing by Stratz).

1 HL for the adult = ½ HL for the infant

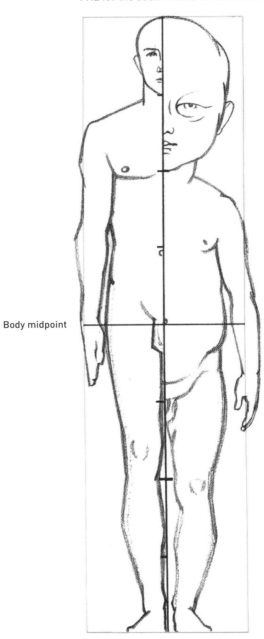

Body midpoint

The height and position of the forehead are of particular significance [113] in expressing age. In infants and small children, it overhangs; later, it gradually becomes more sheer, and then more fluid in its shape. A steep forehead shape is more commonly retained by women, maintaining the impression of girlish, youthful features.

When creating a likeness of a child, some modern-day artists press the crown far down toward the eyebrows in the mistaken impression that this will heighten the impression of 'childlikeness' – and, instead, merely produce a botched version of an adult face. These shrewd speculators in artistic deformation merely project an animal quality into the face of the human child, once more betraying their inhumanity.

There is no one single shape for a child! A child always represents a very specific stage of development, with its own clear typological features [115]. We read rhythms in the nascent forms, all of which have their own developmental types. One can distinguish two large sections: a neutral and sexually dimorphic age.

The neutral stage begins at birth [116], and transitions into the dimorphic stage at around six years old. In the first major span of time, there is no sign of the development of the secondary sexual characteristics in the two sexes. If one were to look at a boy and girl standing naked side-by-side from the back, it would be almost impossible to tell their respective genders [119/1] (hence the term 'neutral'). In the second span, which lasts until death, the two sexes show distinct form features (sexual dimorphism) [115/1–115/4, 118/2, 118/3, 124, 124–128].

Fig. 112 Two children in the first year of life (infant age).
The eye axis, which is still well below the centre of the head, emphasises the heavy dominance of the cranium and the dome of the forehead in relation to the facial skull, which has not yet extended (because the teeth have not yet developed).

Fig. 113 The head of a small child.
The face forms are soft and gentle (a flat nose bridge, wide nostrils, broad cheeks). The development of teeth has led to the first extension of the lower part of the face.

Fig. 114 The head proportions of an infant, a six year old, and an adult.
a) Infant skull in profile.
b) The skull of a six year old in profile (second dentition period).
c) The adult skull in profile.
Note the growth and elongation of the facial skull, shown in the comparison of the halfway line of the skull (the thick horizontal line) and the eye line (the thinner horizontal line) in b.
d) The infant skull in frontal view.
e) The skull of a six year old in frontal view (second dentition period).
f) An adult skull in frontal view.
Note the increase in the facial skull, as in a–c.
g) An infant skull in top view.
h) The skull of a six year old in top view.
i) The skull of an adult in top view.
Note the positions of the points of greatest width (thin horizontal line) in comparison to the halfway line between the temple and the back of the head (thick horizontal line).

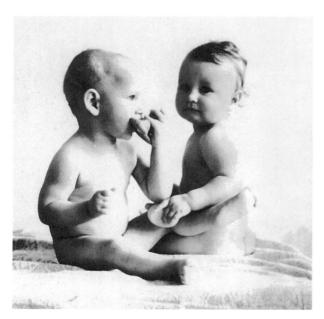

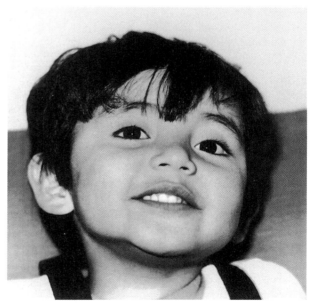

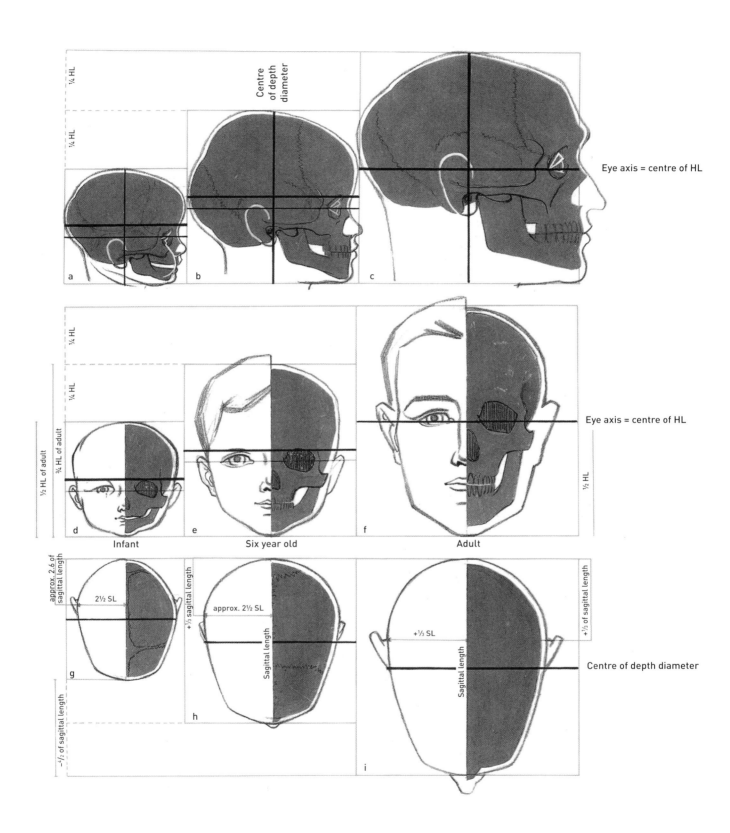

¼ HL

¼ HL

Centre of depth diameter

a

b

c

Eye axis = centre of HL

¼ HL

¼ HL

½ HL of adult

¾ HL of adult

d

Infant

e

Six year old

f

Adult

Eye axis = centre of HL

½ HL

approx. 2.6 of sagittal length

2½ SL

g

approx. 2½ SL

+⅓ of sagittal length

Sagittal length

h

+⅓ SL

Sagittal length

i

+⅓ of sagittal length

+⅓ of sagittal length

Centre of depth diameter

–⁴⁄₂ of sagittal length

Fig. 115 The development of the
proportions, from neonate form to
fully grown man or woman, in terms of
absolute size relationships to one other
(presented using reworkings of line
drawings by Stratz).
The intersections of the figures with their
neighbouring figures indicate the growth
differential between the two sexes.

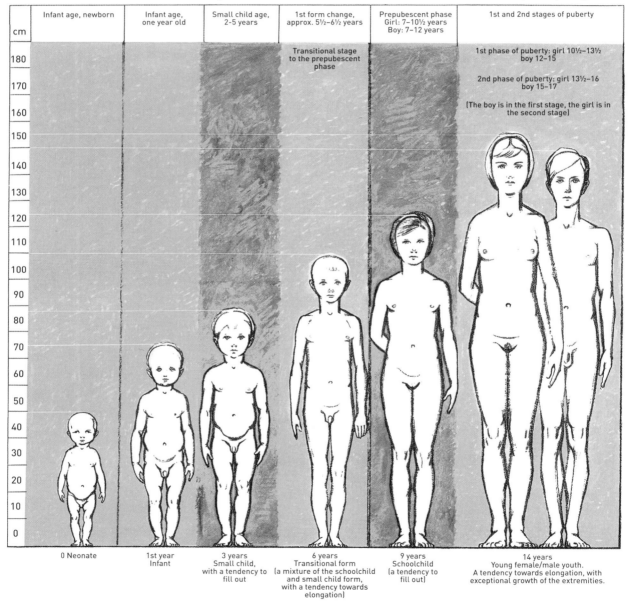

Neutral age

Sexually dimorphic age

| cm | Infant age, newborn | Infant age, one year old | Small child age, 2–5 years | 1st form change, approx. 5½–6½ years | Prepubescent phase Girl: 7–10½ years Boy: 7–12 years | 1st and 2nd stages of puberty |

Transitional stage
to the prepubescent
phase

1st phase of puberty: girl 10½–13½
boy 12–15

2nd phase of puberty: girl 13½–16
boy 15–17

(The boy is in the first stage, the girl is in
the second stage)

| 180 |
| 170 |
| 160 |
| 150 |
| 140 |
| 130 |
| 120 |
| 110 |
| 100 |
| 90 |
| 80 |
| 70 |
| 60 |
| 50 |
| 40 |
| 30 |
| 20 |
| 10 |
| 0 |

0 Neonate

1st year
Infant

3 years
Small child,
with a tendency to
fill out

6 years
Transitional form
(a mixture of the schoolchild
and small child form,
with a tendency towards
elongation)

9 years
Schoolchild
(a tendency to
fill out)

14 years
Young female/male youth.
A tendency towards elongation, with
exceptional growth of the extremities.

122 The proportions of the human body

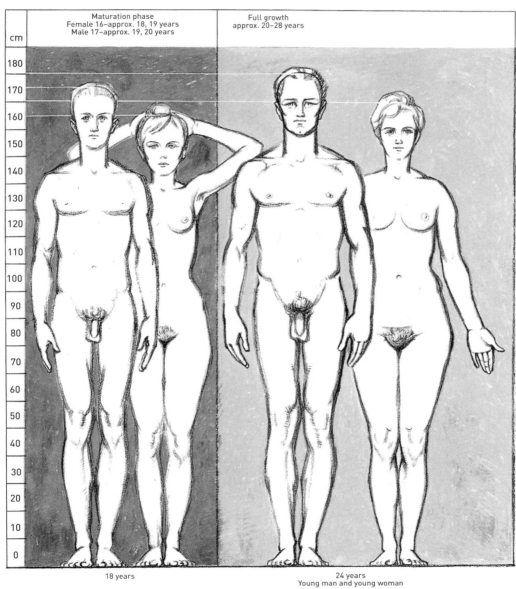

Maturation phase
Female 16–approx. 18, 19 years
Male 17–approx. 19, 20 years

Full growth
approx. 20–28 years

cm

180
170
160
150
140
130
120
110
100
90
80
70
60
50
40
30
20
10
0

18 years

24 years
Young man and young woman

In spite of all our efforts to capture typical body forms in words, tables, schematics and photographic reproductions, we have no desire to overlook the great variety seen in nature – the great realm of 'what can be' within the framework of the 'norms' produced by abstraction. When we look at youth, age or sex-linked appearances, these are always diverse: we are always dealing with individual cases [e.g. 115/3, 115/4]. There are certain general features, certain striking visual qualities, but they do not provide 'laws'. Figures 115/1 and 115/2 show two girls of virtually the same age, with their anthropometric measurements given in centimetres. They are of unequal body height, but show virtually the same canon in terms of their height subdivision. These illustrations use these factors to make a statement about unlikeness in likeness, and likeness in unlikeness. Ultimately, all a work on anatomy for artists can do is to refine the reader's sensitivity for forms, and the reader's eye for harmonious wholeness. The eager vision of the artist's eye prioritises an organically grown, sensitively felt-out experience of – and a sharing in the life of – the unrepeatable character of the personal without divisible particulars, and its inherent completeness – the way that many parts come together to form a well-ordered unity. After this, anatomical analysis can move onto the individual details of the physical structure.

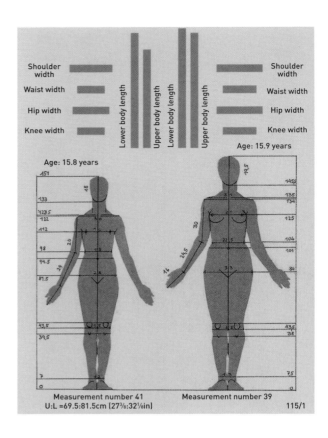

Fig. 115/1 Proportioned figures of two girls of almost the same age (15.8 and 15.9 years) based on precise anthropometric measurements. The outlines of the different youthful forms of the two figures indicate two different development types. The left-hand figure has not yet reached the second stage of puberty, in which the characteristic feminine pads of fat develop (as seen in the right-hand figure).

Fig. 115/2 The outlines of the forms of the two figures seen above, repeated. The figure rectangle derived from the head lengths (8 HL in height and 2 HL in width) makes it easier to judge the differences in heights, and also the laws of proportioning as expressed in the canon. The 'grid net' with the head length as the basic unit, makes both the height division and the relationships of the dimensions of width clearly readable. In a mature female body, the hip width will generally approximate to the width of the rectangle. In exceptional cases, it may even exceed it.

From Bammes, *Wir zeichnen den Menschen.*

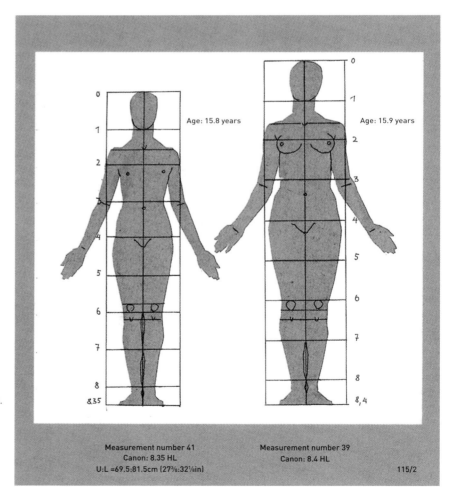

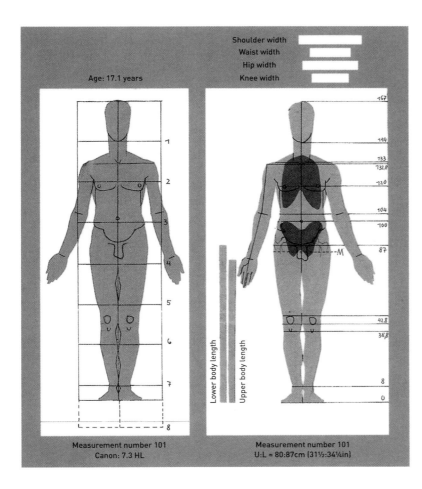

Fig. 115/3 Proportions of a male youth figure (17.1 years) with a body height of 167cm (5ft 5¾in). Early in the phase of maturation into a young man, the male youth overtakes the growth and elongation acquired by girls in the second phase of puberty, whilst the musculature of the youth is still undeveloped and his figure gives an impression of leanness, owing to an elongation in height. In particular, this impression is produced by the greater length of the lower part of the body. The width is still contracted at the waist.

On the left, the figure's canon of 7.3 HL is recorded in the frame of the rectangle surrounding the figure. The measurements in centimetres and inches are given on the right, as established through anthropometric measurement.

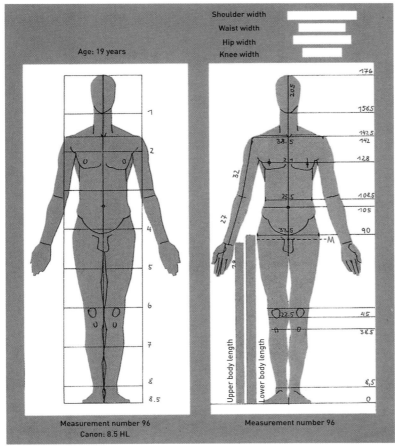

Fig. 115/4 The proportions of a young man figure (19 years) with a body height of 176cm (5ft 9in).

With a canon of 8.5 HL, the figure gives the general impression of being tall and elongated. The relatively small size of the head gives the impression of gigantism, whilst a comparatively large head (see, for instance Figure **118/3** on page 131, and Figure **121** on page 134) causes the form to appear childlike and boyish. The waist, which is still slightly drawn in, giving the figure an hourglass shape, will fill in as the musculature increases, creating the wedge-shaped basic form of an athletic man.

From Bammes, *Wir zeichnen den Menschen.*

Looking at the table on pages 122–123, we can see that the neutral age includes the infant, small child and transitional stages, with the corresponding development types of the infant form, the small child form, and the transitional form (from the small child to schoolchild form). The sexually dimorphic age follows the transitional stage and continues until death, and contains the following sections: the prepubescent phase, the first and second puberty stages of the young male and young female forms, and the maturity phase of the young man/young woman form. The prepubescent phase is a preparation for sexual maturity: an extended pause for breath. At the end of this period of preparation for the actual sexual reshaping, a second change in form occurs, with the departure of the schoolchild form. From the changes of the pubescent phase, the youth or the young woman emerges. The maturation phase continues this progression, until, ultimately, the gender-specific masculine and feminine forms are attained. The whole temporal continuum of becoming and growing is visualised in Figure 115, and in the overview on the page opposite.

Small child age (two to five years) and small child form:

The neonate period lasts until the fifteenth month of life. It manifests in the disproportionate relationship between the very large head (one quarter of body size) and torso, and the underdeveloped extremities, still unsuited to their function, which have the appearance of appendages [111, 115, 116]. Above the genitals, the torso is separated from the legs by a deep furrow: the stomach line. The pubic bone is located at 1½ HL beneath the body's midpoint.

Proportions of an infant [116, 121, 122]:
body size	50cm/19¾in
canon	4 HL
torso length	1⅔ HL
leg length	1⅓ HL
arm length	1½ HL

Proportions of a one year old child [112, 113]:
body size	around 75cm/29½in
canon	4–4½ HL
torso length	1¾ HL
leg length	1¾ HL
arm length	1¾ HL

Between the third and fifth year of life, the small child acquires a charm that will never return again. The features of the emergent small child type are: a body height of about 5–5½ HL (i.e. the figure is still dominated by the head), a round, cylindrical body, a low level of curvature in the spine, relatively small, rounded and soft extremities with little emphasis on the joints, a thin neck, equal pelvis and shoulder widths, no distinct waist, and parallel side contours. The abdomen terminates in a fold at its lower edge (the abdominal line). There is a lack of differentiated relief, plenty of subcutaneous fat tissue and, consequently, folds and small dimples at the joints (this is partially taken from the *Fischer Lexikon* – 'Anatomie').

Proportions of a two year old child:
body size at approx.	75–85cm/29½–33½in	
canon	5 HL	
torso length	2 HL	
leg length	2 HL	
arm length	2 HL	
position of the navel = body midpoint		2½ HL

Proportions of a four year old child [117, 118/1]:
body size at approx.	100cm/39⅜in	
canon	5½ HL	
torso length	2 HL	
leg length	2½ HL	
arm length	2½–2¾ HL	
position of the navel = body midpoint		2½ HL

The navel is located above the body's midpoint

First form change and schoolchild form (five to six-and-a-half years):

In approximately the sixth year of life, qualitative changes begin [115, 118]. The form changes from that of a small child to that of a schoolchild: the motor apparatus develops rapidly, a general elongation takes place, a reduction in subcutaneous fat tissue, leading to a sharper body profile, and a reduction of the body and torso percentage (canon 5½–6¼ HL).

The abdomen becomes flattened, the waist becomes more distinct, the shoulders gain mass by comparison with the pelvis, the curvature of the spine becomes more pronounced, musculature increases, the central and lower parts of the face increase in size (in connection with the transition from the first to the second set of teeth). The body's midpoint is almost on the abdominal line.

Proportions of a schoolchild:
body size at approx.	120–125cm/47¼– 49¼in
canon	5½–6¼ HL
torso length	2¼ HL
leg length	3 HL
arm length	2½ HL

The prepubescent phase and the schoolchild form (for a boy, 7 to 12 years; for a girl, 7 to 10½ years):

The critical form change is completed in the short space of a year: the seventh year of life [115, 118]. This results in the schoolchild form, which is dimensionally larger (three-and-a-half to five years). The peculiar features of the form (the canon of around 6 to around 7 HL) do not undergo a qualitative change. Growth occurs, weight increases, and there is a renewed filling-out of the figure [118/1, 118/2].

Proportions of a seven year old child:
body size at approx.	115–120cm/45¼–47¼in
canon	6–6¼ HL
torso length	2¼ HL
leg length	3 HL
arm length	2½–2¾ HL
position of the navel:	2½ HL (from the crown)

Summary overview: development phases

	Year of life	Stage	Development period	Developmental type	Canon
Neutral age	1 year old	Infant stage	Infant stage	Infant stage	4 HL
	2–5 years old	Small child stage	Small child stage	Small child stage	5–5½ HL
	6 years old	Transitional stage	First form change	Transitional stage	5½–6¼ HL
Sexually dimorphic age	7–12 years old = boy 7–10½ years old = girl	Youth stage	Prepubescent phase	Transitional (for mixture of small child and schoolchild form)	6½–7 HL 6–6½ HL
	12–15 years old = boy 10½–13½ years old = girl		First phase of puberty	Schoolchild form	7 HL
	15–17 years old = boy 13½–16 years old = girl		Second phase of puberty		7 HL
	18–20 years old = man 16–19 years old = woman	Functional stage	Maturation stage	Form of the young man Form of the young woman	7¾–8 HL 7¾–8 HL
	After 20 years old	Full growth			8 HL

Fig. 116 A newborn infant
Characteristic proportions: a very large head (= one quarter of the body's length), a large torso, and short extremities.

With the exception of a girl's hips, which are slightly fuller, no really significant, discernible sexual differences emerge during this period. The body retains its childlike character. As children grow, their width measurements increase: in boys, the chest circumference and shoulders widen; in girls, the hips, buttocks and thighs fill out. A 10 year old boy and a girl will still share the same proportions.

Proportions of a 10 year old girl [118]:
body size at approx.	125cm/49¼in
canon	6½ HL
torso length	3¼ HL
leg length	2¾ HL
arm length	2¾ HL
position of the navel:	2¾ HL
position of the pubic bone = body midpoint	

The second form change, with the first pubescent phase, and the form of the young boy and young girl (for a boy 12 to 15 years; for a girl 10½ to 13½ years):

The developmental pause of the prepubescent phase is over. New hormones have a dramatic effect on the sex-related reconstruction of the body's form: the secondary sexual characteristics are distinctly expressed. At the midpoint of puberty, proportions are displaced to the greatest degree. Elongation accelerates, the figure extends. In girls, there is an increase in the glandular and fatty tissue of the breasts, a rounding out of the hips, and the emergence of pubic and underarm hair. In boys, there is heavy muscle and bone development, pubic hair growth, and light beard growth. In both sexes, the face, hands, and feet become more awkward; the form becomes leaner.

Proportions of a 12 year old girl [119]:
body size at approx.	147cm/58in
canon	7 HL
torso length	3½ HL
leg length	3½ HL
arm length	2¾ HL
position of the navel:	2¾ HL
position of the pubic bone = body midpoint	

Proportions of a 14 year old boy [115]:
By the fifteenth year of life, boys will have caught up with girls in growth.
body size at approx.	150cm/59in
canon	7 HL
torso length	3½ HL
leg length	3½ HL
arm length	3 HL
position of the navel at just about:	3 HL
position of the pubic bone = body midpoint	

The second form change, coupled with the second phase of puberty (for a boy, 15 to 17 years, for a girl 13½ to 16 years):

In girls the tempo of growth slows, finally stopping completely. The secondary sexual characteristics develop further: the breasts become fully developed, taking on a hemispherical form and distinct nipples. The volume of the hips is increased in terms of the skeleton and soft tissue forms. The pubic hair extends into the groin. The awkwardness seen in the head, the hands and feet during the first maturation phase gives way to fine, harmonious forms. In particular, the head (in both sexes) undergoes a reharmonising process.

At around the fifteenth year of life, boys overtake girls in growth. In a boy,, shoulder width increases, and the pelvis becomes relatively smaller (with a wedge shape); the musculature becomes more powerful and the bones more sturdy. The pubic hair rises toward the navel in a pyramidal shape. A form with masculine features is attained.

Proportions of a 16 year old boy:
body size at approx.	170–175cm/67–69in
canon	7½ HL
torso length	3¾ HL
leg length	3¾ HL
arm length	3¼ HL

Proportions of a 14 year old girl [115]:
body size at approx.	156cm/61½in
canon	7–7½ HL
torso length	3½ HL
leg length	3½ HL
arm length	3½ HL

Maturation phase and form of the young man and the young woman [115, 123, 125]:

It takes some time (two to three years) for both sexes to achieve harmony. At this stage, growth comes to an end. Both men and women are now in possession of their full development. At 19 years, a girl's form has fully matured, and develops into full femininity. A boy will have the full motor muscle power of a man. The form attained during this maturation phase shows constitution in its purest form, and bestows on the body what, from this point on, will be its typical features (Zeller).

Proportions of a 23 year old woman:
body size at approx.	163cm/64⅛in
canon	8 HL
torso length	4 HL
leg length	4 HL
arm length	3½ HL
pubic bone = body midpoint	

Now that we have dealt with the proportions of

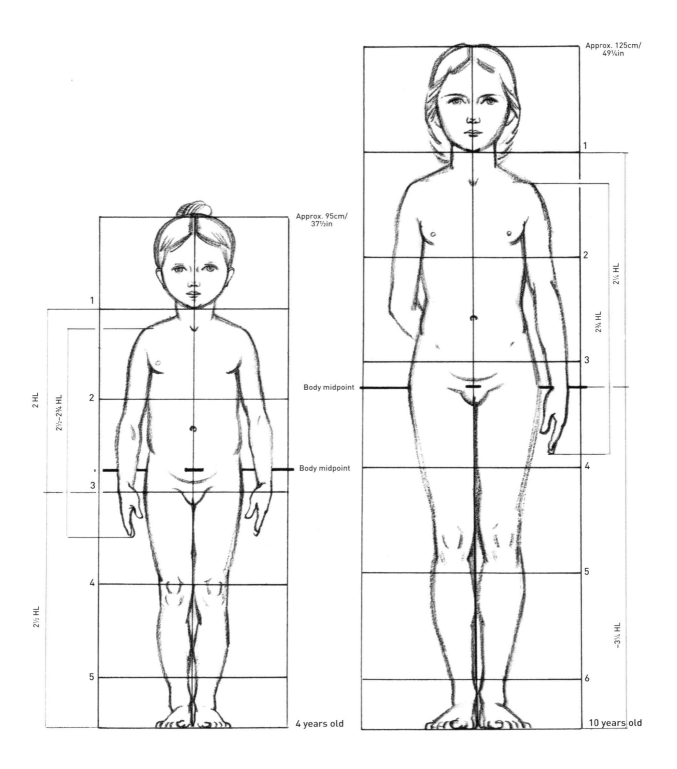

Fig. 117 Proportions of a four year old girl, body height 95cm (37½in), canon 4½ HL. These features show that the development type is that of a small child.

Fig. 118 Proportions of a girl of approximately 10 years old. Body height 125cm (49¼in), canon 6½ HL. These features show that the development type is that of the prepubescent phase.

Approx. 95cm/ 37½in

Approx. 125cm/ 49¼in

2 HL

2½–2¾ HL

2½ HL

Body midpoint

2¼ HL

2¾ HL

Body midpoint

–3¼ HL

4 years old

10 years old

Fig. 118/1 Form types: the small child form (at four years old) and the schoolchild form (prepubescent phase).
The form types correspond to Figures **117** and **118**. The elementary form characteristics are visually emphasised. In the small child, the torso dominates over the leg length. In the 10 year old girl, the lower and upper body have achieved the typical equality of length.

From Bammes, *Wir zeichnen den Menschen*.

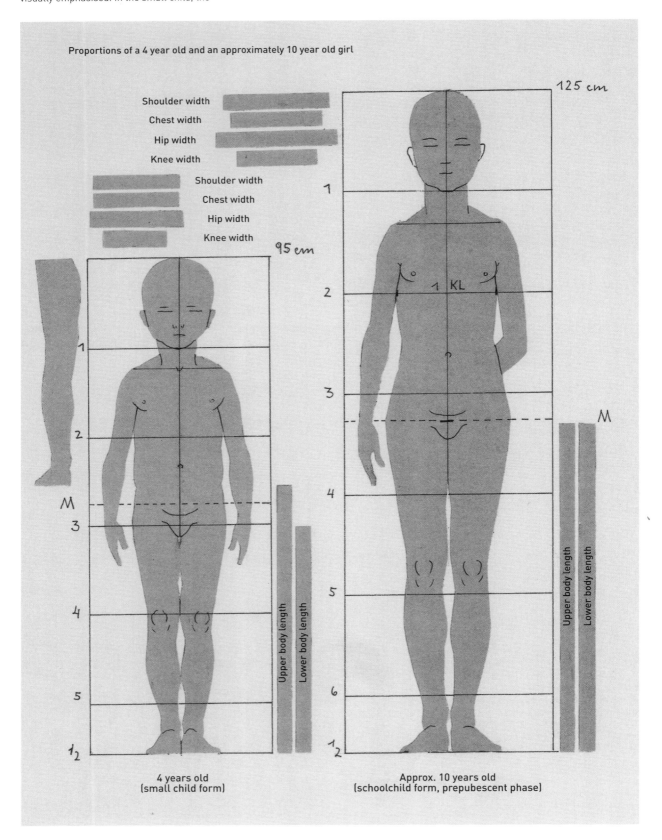

Proportions of a 4 year old and an approximately 10 year old girl

4 years old
(small child form)

Approx. 10 years old
(schoolchild form, prepubescent phase)

different developmental types in a normative manner, the listed form characteristics will be documented in a series of images of models. The following recommendations for making judgements in this area have been compiled in order to provide certain key emphasised criteria that can be applied when observing the appearances of living people – to provide, as it were, a compass for orientation [118/1, 118/2 118/3]:

- The relationship of the lower body length to the upper body length. How strong is the dominance of the lower body length in relation to the upper body length [118/1, left]? Conversely, when and in which developmental stages does it dominate?
- The relationship of the limbs to the torso. Are the limbs still weak, or are they already strongly developed in relation to the torso [118/1, 118/3]? When, and in which developmental type?
- In which instances are lengths equal for boys and girls [118/1 right, 118/2, 120]?
- The leanness or fullness of the parts of the leg [118/2, 118/3]
- The relationship of the shoulder, waist and hip widths. Does the waist draw in to create an hourglass shape, dominating the three areas of width?
- Fat deposits in the torso: the formation of the chest and breasts. Fat pads in the navel and pubic area, and in the buttocks.

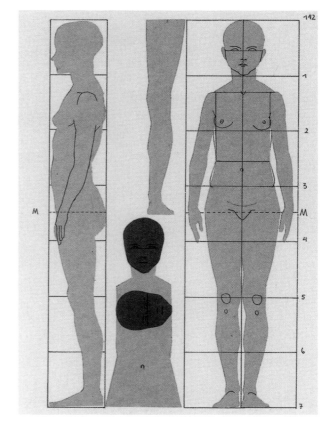

Fig. 118/2 (above) As the form and appearance of a young girl of this age continues to develop, the upper and lower body lengths become equal (see the accompanying isolated comparative length measurements of the legs and torso). The hips begin to widen, and the waist and the feminine rounded forms of the breasts, thighs and buttocks become distinctly formed.

Fig. 118/3 (below) In terms of the elementary relationships of the sections of the body, a boy of the same age as the girl in the upper illustration has the same proportions, with a canon of 7 HL and equal upper and lower body lengths. The forms of the individual body parts are still sharp and angular. In future, they will be rounded out by increased muscle, rather than by fat deposits.

From Bammes, *Wir zeichnen den Menschen*.

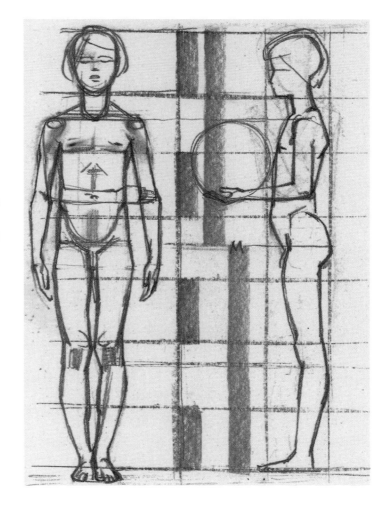

Approx. 142cm/4ft 8in

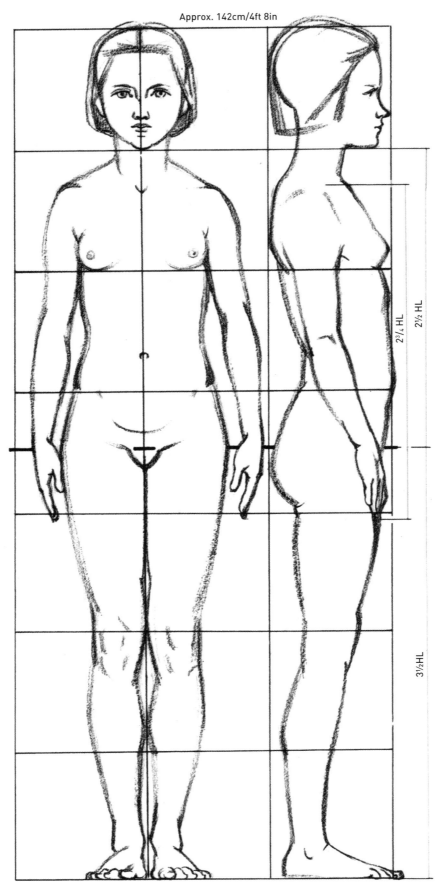

2¾ HL

2½ HL

3½ HL

12 years old

Fig. 119 Proportions of a 12 year old girl. Body height around 142cm (4ft 8in), canon 7 HL (the form of a young girl in the first phase of puberty). The length of her legs is now the same as the length of her upper body.

Figure 120 presents, once again, the major growth rhythms, beginning with the newborn stage and including the two year old stage, the seven year old stage, and the 14 year old stage, concluding with the 21 year old stage. It shows the absolute size relationships of these ages of life to each other. From the two year old stage to the adulthood stage, there is a consistent difference of a head length. From birth to two years old, the pubic bone is located considerably beneath the geometric midpoint of the body (represented by a white triangle). From seven years of age onwards, it is identical with the body's midpoint; for males, it then gradually rises above the midpoint. The positions of other height subdivision points, such as the knee, the navel, nipples, the hollow of the throat, stay constant in relation to each other – with the exception of the head.

The thick vertical lines drawn inside the figures are marked in head lengths (canon) whilst the thin horizontal lines outside of the figures give the lengths of torso, arm and leg, expressed in head lengths.

The reproductions of the model in Figure 91 shows a young woman with a more mature figure for her age group. Figure 125 shows a common, mature female body at the functional stage.

Fig. 120 Proportions of human beings at different ages. The body's geometric midpoint is marked by a ◁ sign.

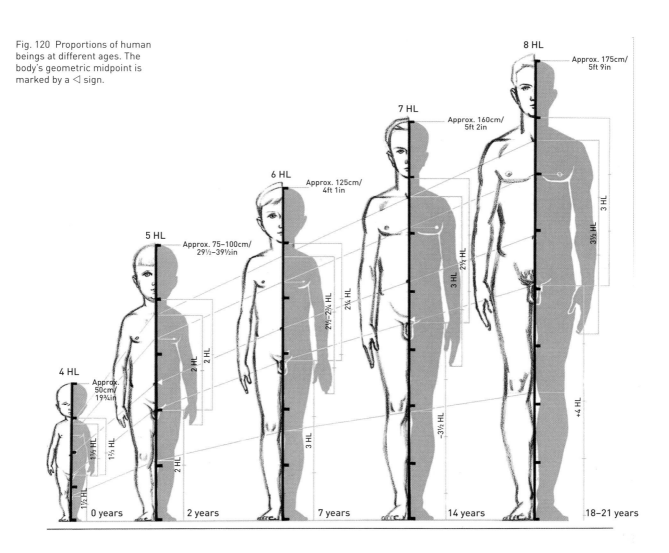

Fig. 121 The head of a four month old infant.
a) In frontal view (picture taken with infant in
horizontal position, rotated 90°).
b) The head of the same infant in profile view.

Fig. 122 The body of a four month old infant.

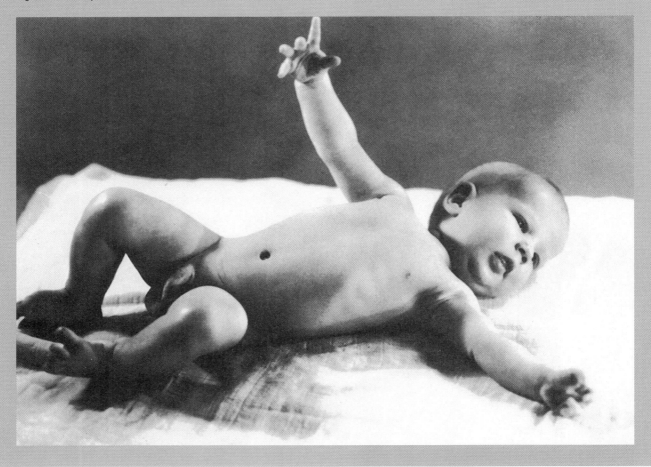

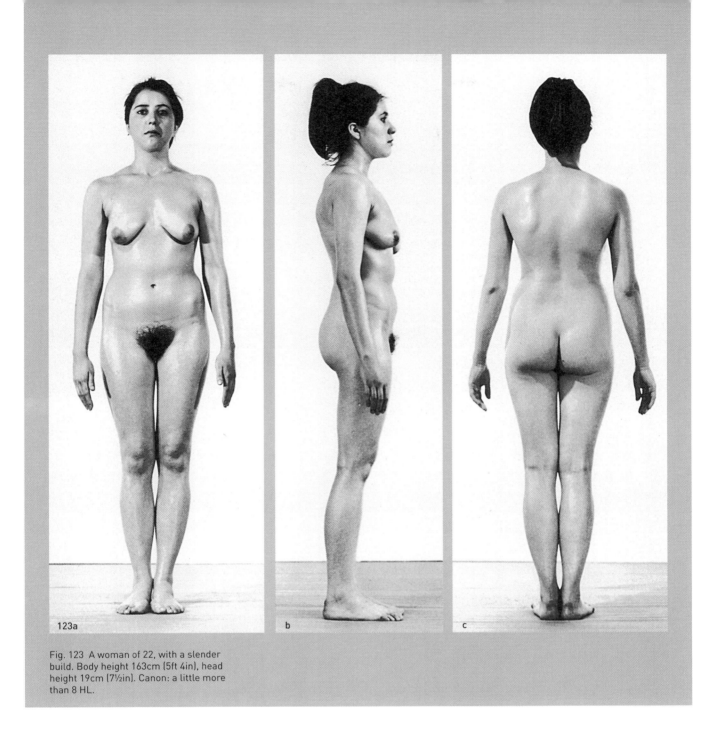

123a b c

Fig. 123 A woman of 22, with a slender build. Body height 163cm (5ft 4in), head height 19cm (7½in). Canon: a little more than 8 HL.

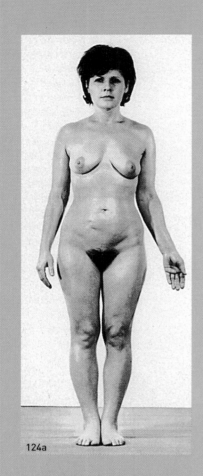
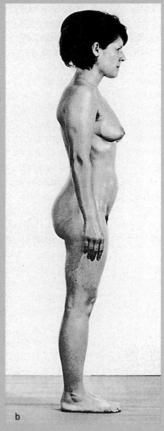
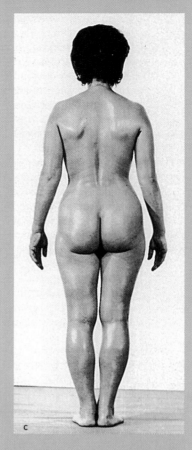

124a

b

c

Fig. 124 (above) The mature female body.
A woman aged 34.2 years, mother of four
children, body height 157cm (5ft 2in),
head height 20cm (8in). Canon: 7.8 HL.

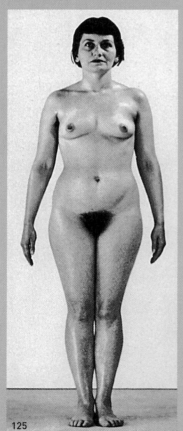

125

Fig. 125 The mature female body.
A woman aged 35 years, mother of two
children, body height 156cm (5ft 1½in).
Canon: just about 8 HL.
The point of greatest breadth, at the hips,
is just about equal to a quarter of the body
(functional stage, full growth).

Fig. 126 A heavily built female body type.
Age 50.11 years, mother of three children,
body height 158cm (5ft 2¼in), head height
20.5cm (8⅛in). Canon: 8.1 HL.
The hip width is almost a quarter of the body.
Note the pronounced upper and lower
abdominal lines.

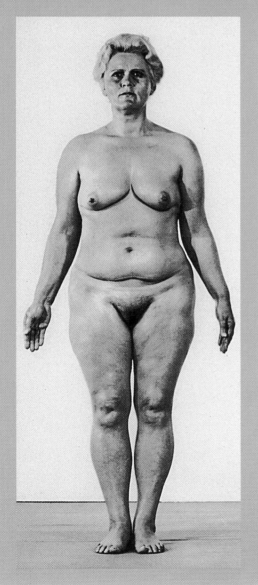
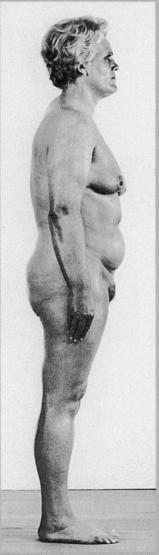
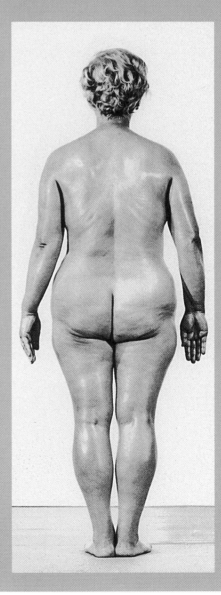

Fig. 127 A heavily built, primarily athletomorph man. Age 53.10 years, body height 169cm (5ft 6½in), head height 19cm (7½in). Canon: around 8.5 HL. The shoulder width is almost a quarter of the body, the hip width easily 1½ HL; the lower body length exceeds the upper body length a little.

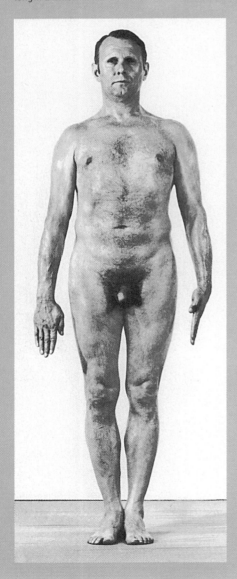
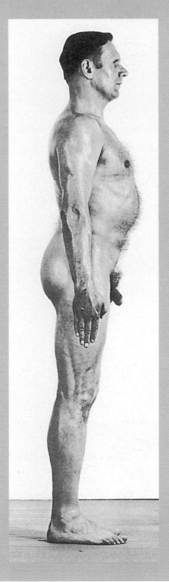
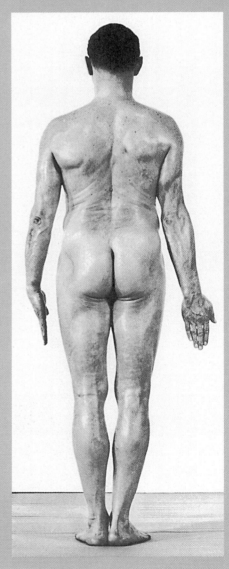

Fig. 128 An average-sized man of slender build (a former artist). Age 61.8 years, body height 161cm (5ft 3¼in), head height 19cm (7½in). Canon: 8 HL.
The shoulder width is just about 2HL, the hip width easily 1½ HL; the lower body length is a little shorter than the upper body length.

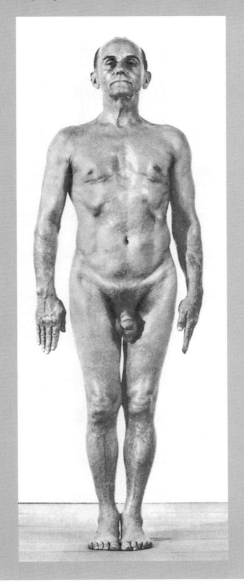
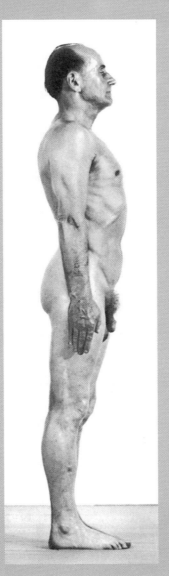
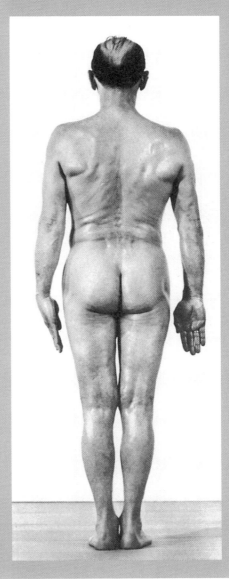

2.5. THE TREATMENT OF THE CHARACTERISTICS OF DEVELOPMENTAL TYPE IN WORKS OF ART

As we have seen from sections 2.2. and 2.3., the regular recurrence of form properties or characteristics observable in many individuals allows human beings to be grouped into types. The charm of the overall physical 'physiognomy', with the idiosyncrasies of its language of form, has a great attraction for artists. This can be applied, for instance, to the young human being, in the stages between the first days of childhood and the ultimate entry into adulthood. The period of around 20 years during which growing up and maturation takes place has multiple facets, all of which are fascinating for artists; this is because, in the whole sequence of stages of ongoing development of the young human being, each stage has its own age-typical compositions and features of form. These features characteristically belong together, constituting the body's typical

developmental features of form, both in terms of the body's proportions, and in terms of other aspects of its morphological appearance. From the perspective of experience and impressions, the development stages attained are fascinating, as are the periods of upheavals and transition in which the youthful form sheds the features it has attained and strikes a new note in terms of the human form.

In his factual work *Studie von einem etwa einjährigen Kind* [129], Hans Holbein the Younger is motivated by several different aspects of the child's age: its need for help in standing, the way the knees cannot yet fully extend, and, above all, the child's proportions. The assignment of the child figure to this age group would appear to be justified: the canon is around 4½ HL.

The large head agrees with the length and the weak division of the torso, whose volume is still dominated by the child form. Above all, the short, weak little legs which dangle from the rest of the body, almost like the legs of an insect, are clearly barely serviceable supports for the extremely long and heavy upper part of the body. At the same time, however, this infant form shows the emerging features of a small child. It is the small child

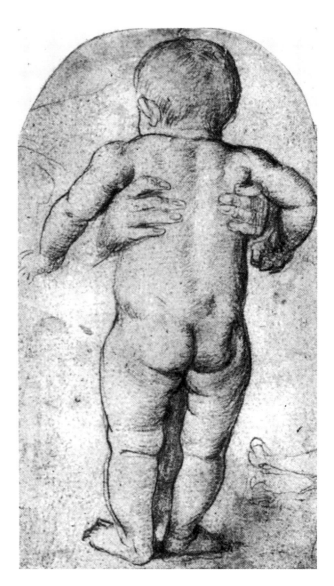

Fig. 129 Hans Holbein the Younger
(1497–1543).
Studie von einem etwa einjährigen Kind.
Kupferstich-Kabinett, Dresden.

type that provides the theme for Bammes' artwork *Mutter mit Kind* [131]. Here, the fully attained form of a small child is shown in relation to the mature body of the mother.

In his *Kinderakten* of 1885 (which he created as studies for his *Kinderständchen*, painted the same year) Anselm Feuerbach chose the charming form of the 'bambino' as his model, giving a very detailed rendering of how a child appears at four years of age [130]. The canon comprises 5½ HL, the torso, legs and arms measure 3, 2½ and just about 2 HL respectively. The rules of proportioning that apply at this age are in harmony with the four year old body's other formal features: the little barrel-shaped abdomen, the deeply indented abdominal line and groin, which create a clear separation of torso and legs, and the dimples in the legs, which are already beginning to disappear. The folds and bulges of the inner surface of the upper leg also begin to even out. The material quality of the widely distributed rounded subcutaneous fat tissue is used by the artist to create an image of this particular stage of childhood that captures the initial filled-out period. This phase, in which extravagant plenitude can be seen in

the naturalness of the child, infected the Baroque era with an insatiable desire to glorify the small child to an ever greater degree. For the artists of the Baroque era, the carefree existence of a child, intoxicated by the all-powerful present moment and with a quality of embedded innocence in a seeming eternity, took on a metaphorical significance, thus allowing the artists to equate the sensual visual manifestation of the small child with their own personal feeling for life.

The three artworks that follow show forms dramatically different from that of the small child, and owe their existence to a very different set of experiences of form.

Adolf von Hildebrand's *Trinkender Knabe* [132] and the childlike *Mädchenakte* by Gerhard Marcks [134] do remind us of the schoolchild form, but we also see that the prepubescent phase has concluded. The boy, with his 6½ HL canon, is clearly more than 10 years old. The girl's waist is beginning to narrow, and her body's forms are becoming more angular, indicating that she is entering the first phase of puberty. Whilst the boy's body still shows girlishly soft and smooth rounded forms, the girl already has angular forms like the boy: she is in the

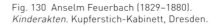
Fig. 130 Anselm Feuerbach (1829–1880).
Kinderakten. Kupferstich-Kabinett, Dresden.

Fig. 131 Gottfried Bammes (1920–2007).
Mutter mit Kind (1970). Red chalk.

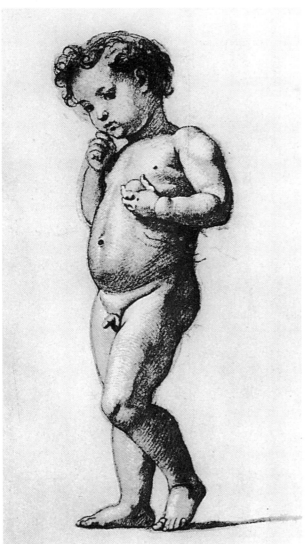

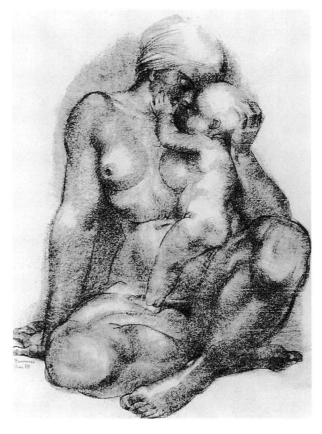

midst of her puberty. In spite of this, the brittle forms of the girl's body show the first indications of femininity. Far beyond the small child form, the tensions revealed in these new contrasting forms, seen in both sexes, have contributed significantly to inspiring artists in the creation of form.

In the sculpture *Giulietta* [133], Karl Albiker is in pursuit of the stage of the childhood developmental type at which the sexually dimorphic stage of childhood has been attained (11 to 14 years).

The lengthening of the limbs has resulted in a canon of 7 HL, corresponding to an age of 11 years. The hips and thighs of this delicately slender girl are beginning to fill out, providing the first indications of the

secondary sexual characteristics, still at the beginning of their development. The treatment of the impression values that provide the artist with factual material enable a sensitive balancing of all the characteristics that mark the great distance, in terms of forms, between that of the small child and the second stage of maturation – and also mark a distance in terms of forms from von Hildebrand and Gerhard Marcks' nude child artworks.

In his sculptural group entitled *Geschwister*, Richard Scheibe touches on the poetic theme of a young boy and young girl growing up together [136]. For Scheibe, there is always more to the nude than the optical perception level. *Geschwister* shows two young people heading

Fig. 132 Adolf von Hildebrand (1847–1921).
Trinkende Knabe (1870–1872).
The rounded character of the boy's physical build, and the canon of 6½ HL, place the body's form at the end of the prepubescent phase in the tenth year of life.

Fig. 133 Karl Albiker (1878–1961).
Giulietta.
The trailing, undulating forms, combined with the seven-head canon, are typical of the age-related features seen in the first phase of puberty.

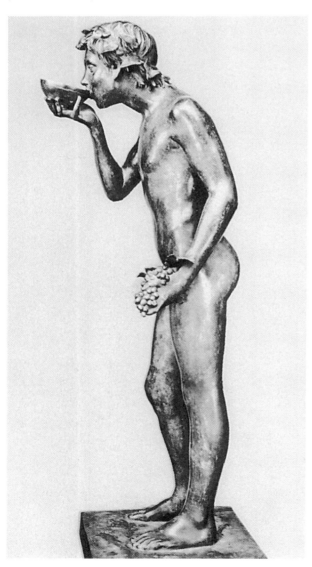

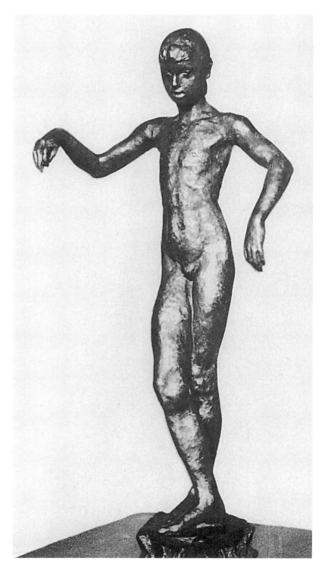

142 The proportions of the human body

toward the prime of their lives, with a well-measured inward and outward clarity. All of the physical signs of the transition from childhood to future adulthood are present to indicate the dramatic transformation process: the charms of the emerging woman are, tentatively, beginning to develop. At 15 to 16 years old, the girl is at the end of the second phase of puberty (see page 122), and will soon enter into maturity. Her limbs are acquiring a delicate rounded quality. There is just a suggestion of a wider, more feminine pelvis, and her breasts have not yet entirely filled out, but her body proportions – a canon of 7½–8 HL – approximate to those of an adult. Scheibe's motif – a motif that has tremendous resonance – is the as-yet and the not-

yet, as certain things fade away, they mingle with the promise of other things to come. The brother would appear to be the younger of the two, owing to his smaller body size. This assumption, however, proves to be unjustified: his proportions are 7½ HL, suggesting that he is at the outset of the second half of puberty – in other words, he is in his sixteenth year of life, and should have just caught up with the growth spurt of his sister of the same age. The artist has not expressed his theme of the two figures' charming age-specific qualities coherently to its logical conclusion.

Why do our feelings undergo such lively fluctuations when we contemplate Gerhard Marck's *Stehender Jüngling* statue [135]? It is because we are capable of

Fig. 134 Gerhard Marcks (1889–1981). *Mädchenakte*. Kupferstich-Kabinett, Dresden.
The 7 HL canon and the angular forms of the shoulders and the joints suggest the form of a young girl in the first phase of puberty.

Fig. 135 Gerhard Marcks (1889–1981). *Stehender Jüngling* (1937). 2m (78¾in) high, since destroyed by bombs.
The length of the legs, the narrow pelvis and not yet fully developed muscles are among the admired and attractive features of the nascent man.

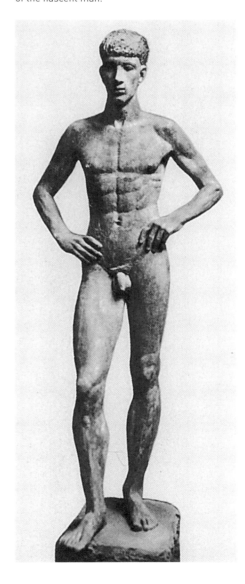

aligning ourselves with its humanity; we experience something of that period in our own growth, our own emergence. We experience a humanity that is a threshold and a transition. In this likeness of Marck's son Herbert, who fell in the Second World War (the sculpture itself was destroyed by bombing), the emergent man comes into being. The pillar of the standing leg bears the narrow pelvis up high. Above this base, the rib cage gains in width and fullness, in accent and profile. On this architectonic structure, strongly-built muscles are beginning to form which give an idea of the health and vigour of the maturing man. In spite of the temptations inherent in the theme, the artist has refrained from infusing passion into the figure's gestures and attitude. Collected in himself, at peace through his harmony with the rules

of physical formation, and through both the promise and certainty of a capacity for vigorous intellectual and physical striving embodied in the architectonic severity of the form and in the rejection of any hint of a slavish superficiality, the youth, the young Marcks, becomes the epitome of an unceasingly repeated event: a boy maturing into a man. Transcending individuality and acquiring a heightened significance, the statue of the artist's son has a universal message. It is elevated into a sphere that speaks of human dignity and of something admirable, even of an ideal. As long as art retains a humanitarian perspective, it can never afford to be without this quality – because art can only preserve the human centre through a full consciousness of human existence as contained within the human form.

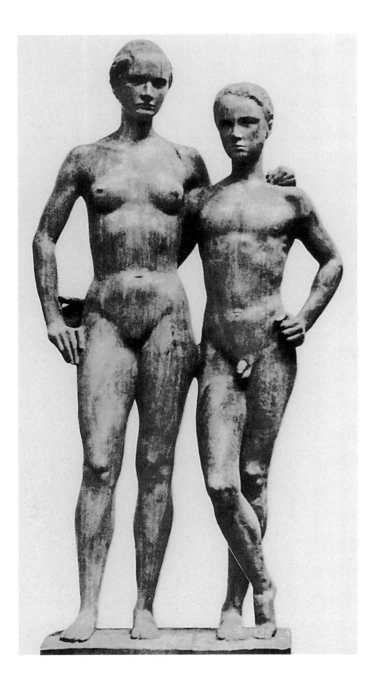

Fig. 136 Richard Scheibe (1879–1964). *Geschwister* (1943). Birnbaum. All form features indicate the end of childhood, and an entry into the prime of life.

Summary overview: stages of growth

Neutral age

Sections of progressive growth	Year of life	Developmental section	Developmental type	Body size	Canon	Upper body length	Leg length	Arm length
Infant stage	0–1	Infant age	Infant form	50–75cm (19¾–29½in)	4–4½	2½	1½	1½
Small child stage	2 3 4 5	Small child stage	Small child form	75cm (29½in) Approx. 93cm (36½in) 100cm (39½in)	5 5½	Approx. 3 Approx. 3	2 2½	2 2½–2¾
Transitional stage	5.6–6.5	First form change	Transitional form between small child and schoolchild	115–120cm (45¼–47¼in)	5½–6¼	Approx. 3¼	Approx. 3	Approx. 2½

Sexually dimorphic age — Male

Period of growth	Year of life	Developmental period	Developmental type	Body size	Canon	Upper body	Leg length	Arm length
Youth stage	7 8 9 10 11 12	Prepubescent phase	Schoolchild form	125cm (49¼in)	6–6¼ 7	3¼ 3½	–3 3½	2½ –2¾ –3
Beginning of second form change	13 14 15	First pubescent phase	Young boy form	150cm (59in)	7	3½	–3½	3
	16 17	Second pubescent phase		175cm (69in)	7½	3¾	3¾	3½
Functional stage	18 19 20	Maturation phase	Young man form	180cm (71in)	7–8⅓	–4	+4	–3½
	21 22 23 24 25	In full force	Man		8			

Sexually dimorphic age — Female

Period of growth	Year of life	Developmental period	Developmental type	Body size	Canon	Upper body	Leg length	Arm length
Youth stage Beginning of second form change	7 8 9 10	Prepubescent phase	Schoolchild form	125cm (4ft 1in) 125–130cm (4ft 1in–4ft 3in)	6–6¼ +6 6½	–3¼ 3½ 3¾	3 +3 –3¾	2¾ +2½ 2¾
	11 12 13½	First pubescent phase	Young girl form	140–150cm (4ft 7in–4ft 11)	7	3½	3½	2¾
	14 15 16	Second pubescent phase		156cm (5ft 1in) 160cm (5ft 3in)	7–7½	Approx. 3½	+3½	3½
Functional stage	17 18 19	Maturation phase	Young woman form	165–170cm (5ft 5in–5ft 7in)	7¾–8	4	4	+3
	20 21 22 23 24 25	In full force	Woman		8			

Abbreviations: HL = head length + = over
FL = facial length – = just about

3 The bearing and movements of the human body: the basics of statics and dynamics

Inconsistencies in the functional statics and dynamics of a figure create unease in the viewer. A major part of an artwork's success therefore depends on the artist understanding their parameters, and understanding what is possible. In the way we stand, we obey the laws of gravity: the human being is a pillar, aligned with the vertical. Any representation of a figure that deviates from the erect body position by more than a specified degree compels us, imperatively, to feel that the figure is falling over, overbalancing, or flying – in short, that it is unstable – because this is what our own experience of our bodies tells us. Artists can therefore not afford to ignore the rules that apply in this area.

3.1. THE RULES GOVERNING STATICS AND DYNAMICS

3.1.1. Terminology: centre of gravity, line of gravity, support area and stability, and the laws governing their interrelationships

We must explain the conditions that remain when the body is at rest: the forces that balance each other (statics), and the forces that disrupt balance and thereby initiate movement (dynamics). Dynamics apply, for instance, to the process of taking a step. An erect body position is possible if the centre of gravity has a support surface. The centre of gravity is the hypothetical mass centre. In order for the body to maintain its balance in any position – that is, so that it does not turn, fall or otherwise change position – only the centre of gravity must be supported. The centre of gravity is the point of attack; that is, one must imagine the whole mass of the relevant body as united at the centre of gravity. The base area above which the centre of gravity is positioned is called the standing or support area. The gravity line is the perpendicular line that descends from the centre of gravity to the support area, giving the direction in which the force of gravity acts. For a human body standing erect [137], the centre of

gravity is located at the intersection point of three right-angled planes: on the perpendicular plane through the body's axis of symmetry, on the perpendicular plane through the points of the ear opening, hip, knee and ankle joints, and on the horizontal level at the level of the first and second sacral vertebrae. The human centre of gravity is therefore located approximately in the centre of the lesser pelvis, high above the small support area provided by the soles of our two feet (resulting in a state of unstable balance).

As long as the centre of gravity is located above the support base, then a body is in a state of rest or

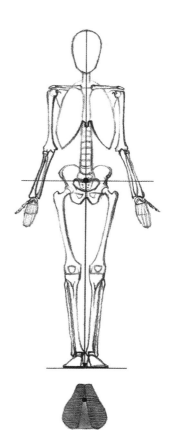

balance. Otherwise, the body will fall towards the side on which the centre of gravity is located. The position of the body's centre of gravity, the size of the support base, and the body's specific weight contribute to its stability: that body's resistance, when positioned on a horizontal surface, to overturning (falling). The lower the centre of gravity, the greater the body's support, and the greater its specific weight – and therefore the greater its stability (as seen in animals).

3.1.2. The upright stance on both legs with no displacement of the centre of gravity

The conditions mentioned above also hold true for the human body [138]. Its stability can be increased or reduced (by adopting an attacking stance with the legs placed wide, or by resting the body on the toes of one foot, as with classical dance) [146]. In the first case, the expressiveness of the stance relates to a sense of firmness, readiness, courage, defiance, earthliness, affirmation of life and decisiveness. In the second case,

it rests on a sense of lightness: a weightless, fleeting, inconstant quality.

The upright stance on both legs (where no extra weight is being carried) will typically be accompanied by a spine that is straight when seen from the front, from the rear and from the side (including its double S-form curvature), and by horizontal axes – such as the foot, knee and hip joints, the nipples and the shoulder joints – that are parallel at right angles to the spine.

3.1.3. Displacements of the centre of gravity in the standing position

Owing to the high lubrication of our joints and to our state of unstable balance, even the smallest change in position of any part of our bodies (lifting the arms to the sides, for instance, or inclining the torso to one side) causes our whole figure to alter its posture. When thus endangered, our state of balance must be preserved through displacements of the centre of gravity [249, 252, 311, 313]. A forward or backward

Fig. 137 (left) The position of the centre of gravity in the human body, and its relationship to the standing or support area (the outline of the soles of the feet beneath the skeletal figure). Coupled with the small support area, the high position of the centre of gravity (which is approximately at the body's midpoint) gives the human being an unstable balancing position.

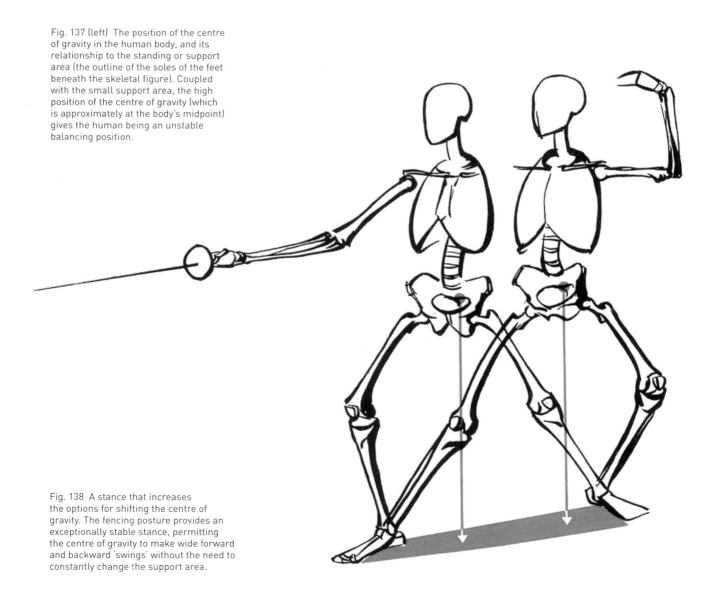

Fig. 138 A stance that increases the options for shifting the centre of gravity. The fencing posture provides an exceptionally stable stance, permitting the centre of gravity to make wide forward and backward 'swings' without the need to constantly change the support area.

The bearing and movements of the human body: the basics of statics and dynamics **147**

bend or inclination of the torso occasions a relocation of the centre of gravity (in the case of a forward bend, the centre of gravity is displaced in the direction of the stomach, with compensating balance movements: the buttocks are drawn back until the centre of gravity, in the stomach region, comes into communication with the support of the feet).

3.1.4. Displacements of the centre of gravity in the standing position caused by the carrying of an extra load

The carrying of an extra load (on the head, in front of the abdomen, on the back, or to one side) means that the body's own centre of gravity is joined by that of the load. The two unite to create a shared centre of mass that alters the body's position. The degree of displacement depends on the magnitude of the load, and its distance from the body. The further away from the abdomen the load is, the more we have to lean back to prevent the weight point moving beyond the support area of the soles. The heavier the load, the more the body's axis will incline away from it, to the opposite side [138, 139, 144, 145].

3.2. THE FREE-LEG/STANDING-LEG POSITION (CONTRAPPOSTO)

The contrapposto derives from the need to reduce the tensions that arise when one leg takes on the whole of the body's weight, in order to relieve the other. The problem of free and load-bearing limbs has preoccupied the fine arts since the era of Polykleitos; the polarity of imposing and relieving weight has become an inexhaustible art motif, especially since it also permits the expression of an inner state, a release of the psyche.

3.2.1. Reduction in support

On the factual level, the facts are as follows: a well-balanced contrapposto distributes the body's weight unambiguously onto the sole of one foot (the standing side). The loose-hanging leg (the free leg) bears only its own weight. The support base is reduced by one half, or by the width of one sole. This should mean that the gravity line lies outside of the remaining support

Fig. 139 The economical shifting of the centre of gravity in fencing.
This strobochromatography-based movement analysis demonstrates this particularly well in the five movement phases (from white to pink) seen in the fencer on the right-hand side of the picture: his centre of gravity undergoes a very significant forward shift, without the size of his support area changing significantly.

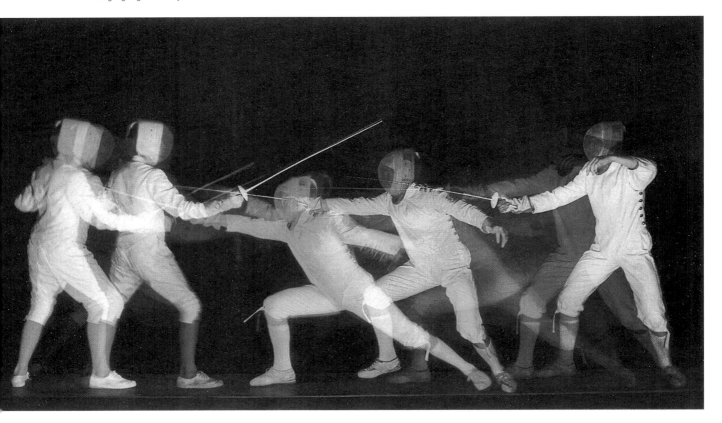

base. How can a state of balance be preserved? Only by shifting the centre of gravity over the centre of the sole of the supporting foot! Otherwise, we would fall over. To stand with one hip against a wall and raise the leg furthest from the wall, as seen in Figure 140a inevitably results in falling over, because of the impossibility of shifting the hip to displace the centre of gravity [140b].

3.2.2. The rules governing the typical alteration of the character of form in contrapposto

The displacement of the centre of gravity in contrapposto affects the whole figure, significantly changing its character of form.

The position of the pelvis shifts by half a sole's width to rest over the remaining support area. The supporting leg assumes a special oblique angled position. The pelvis lowers on the free leg side, and the outward pressure on the trochanter major creates a characteristic accent on the supporting side [141a, b]. As a consequence of the reduced distance between the pelvis and the ground on the free leg side, the free leg assumes the position needed to retain balance (it bends, and is placed on the lateral, rear or forward side of the standing leg).

The following transformations take place in the upper body. The lowest section of the spinal column inclines in the direction of the free leg side. This is followed by the re-curving of the spinal column towards the standing leg side [141c]. These changes make it easier to maintain balance. If this did not happen, the upper body would be at a pronounced angle. The hollow of the throat is positioned above the middle of the sole. The wide part of the shoulders and the nipples both incline to the free leg side; their movement is analogous to the position of the spinal column in the shoulder girdle area [141d]. The head balances best in the vertical position, hence the slight bending of the cervical spine towards the free leg side. On the side bearing no load, the lines flow loosely, smoothly and softly from the shoulder joint over the rib cage and the side of the abdomen, which is tautly extended, and finally terminate at the loosely placed foot (with no great emphasis on the hip).

What a difference there is on the side bearing the weight! On this side, the rib cage and the pelvis are pushed together at the waist. From this point, the line moves outward over the accent of the ala ossis ilium to its high point at the trochanter major. This area is at the heart of the function and of the rhythmic/dynamic action of the pose, because it is here that the firm, taut

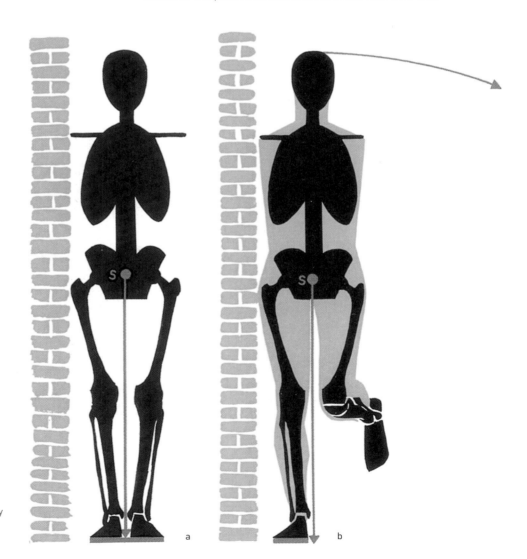

Fig. 140 The reduction in the support base seen when a body's weight is shifted solely to one side.
a) The weight is on both feet. The fact that a resisting element is in place against one hip would not result in displacement of the centre of gravity.
b) One leg is raised (and thereby relieved of weight). The centre of gravity lies outside the tipping edge for falling over, making falling over toward the unsupported side inevitable.

pillar of the leg props up the body's weight. The foot, also, is broad, spreading out in response to the weight placed on it [142, 143].

Summary:

1. In contrapposto, the reduction in support forces the body to shift its centre of gravity to rest over the remaining support.
2. This means that the standing leg is at an angle.
3. Because of an absence of support, the pelvis is lowered on the free leg side.
4. The reduction of the distance between the pelvis and the floor forces the free leg to assume one of a variety of positions. Its knee is located lower than the knee of the standing leg.
5. In order to maintain balance, the spinal column curves between the pelvis and the shoulder girdle to create a C-shape, which is concavely open on the standing leg side.

6. The effortless carriage of the head occasions a compensating curvature of the cervical vertebrae.
7. The nipple and shoulder girdle axes slant downward on the standing leg side, countering the inclination of the belly.

3.2.3. The contrapposto as influenced by an extra load

When the load is carried on one side, the contrapposto form becomes still more pronounced. The extra load and the body's own weight point form a new, shared centre of mass [144, 145]. It deviates from the old weight line in the direction of the laden side. The upper body bends away from the load to compensate, causing the trochanter major to become a sharp accent. One would preferably carry the weight on the standing leg side, thereby allowing the weight to be directly supported. The spinal column tends toward an oblique position, but does not, for reasons of balance, re-curve in the opposite direction in its upper section. Due to this, one does not see the same pushing together of the pelvis and rib cage.

Fig. 141 The rules governing the alteration of the figure's character of form when it rests its weight on one leg.
a), b) Because of the body's need to reduce tension, one leg is relieved of weight (reducing support by the width of one sole). This results in a need to shift the centre of gravity from S to S₁ (½ sole width).
c) Forced reversed bend of the upper body on the weightbearing side (the area shaded in grey shows the balance-disrupting position of the upper body that goes with the extension in the line of the spinal column).
d) The counter-bend of the cervical and thoracic spine (the grey-shaded area shows the balance-disrupting position of the head that goes with the continuation of the curve of the thoracic spine.

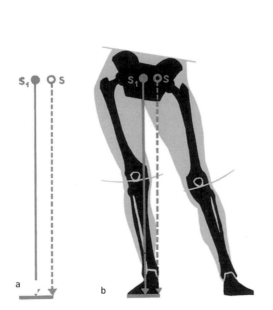
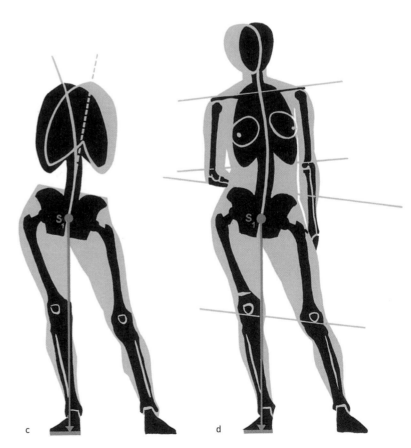

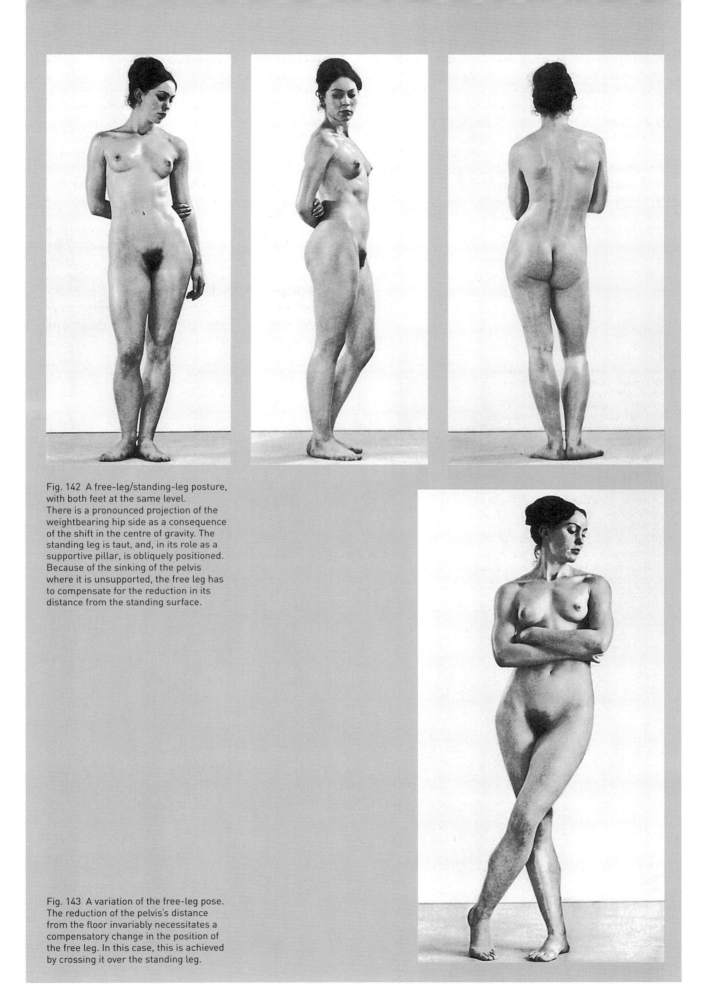

Fig. 142 A free-leg/standing-leg posture, with both feet at the same level. There is a pronounced projection of the weightbearing hip side as a consequence of the shift in the centre of gravity. The standing leg is taut, and, in its role as a supportive pillar, is obliquely positioned. Because of the sinking of the pelvis where it is unsupported, the free leg has to compensate for the reduction in its distance from the standing surface.

Fig. 143 A variation of the free-leg pose. The reduction of the pelvis's distance from the floor invariably necessitates a compensatory change in the position of the free leg. In this case, this is achieved by crossing it over the standing leg.

3.2.4. Expressive balanced movements

'Expressive movements', in this case, refers to movements that, in essence, signal a state of mind. We have previously stressed that standing, sitting or lying should never be understood as purely functional mechanical procedures, as a mood is expressed within them and through them. This, of course, also applies to all movements that, unlike working movements and locomotion, are without specific purpose, but signal a person's mood through the sympathetic movement of the body and the limbs. We know that joy increases motor movement, that depression reduces it, and that horror freezes it. Of course, locomotion and working movements are always important components of expression. After all, both tempo and the sympathetic agitations of the limbs that accompany expression play an important role.

A person's step may be firm, edged, angular, jagged or soft, flowing, erect, tired, slack, lame or many other things. The same is true of the movement qualities seen in the performing of work. Balanced, expressive movements that have no actual purpose – or their heightened versions, which exceed the measure of the required effect and therefore contain excessive innervatory sympathetic tension – are close to the

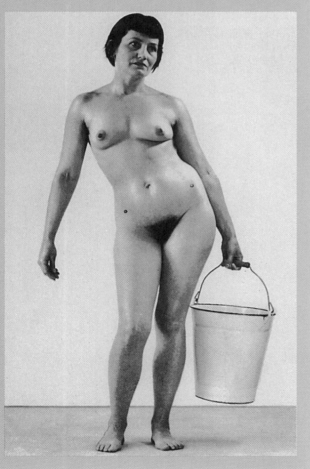

Fig. 144 The contrapposto as influenced by an extra load.
The extra load (the bucket) and the body itself form a shared centre of mass, which deviates from the original position of the body's own centre of mass in the direction of the weightbearing side. This causes the standing leg to adopt a less oblique position. The marking of the two anterior superior iliac spines of the pelvis shows just how pronounced the sinking action of the pelvis is.

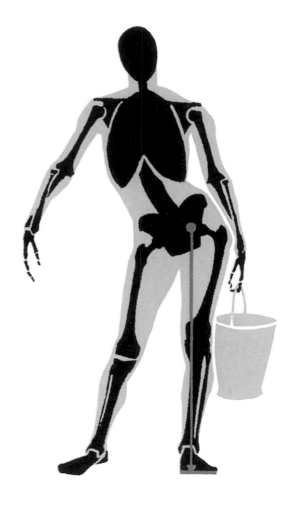

Fig. 145 The contrapposto as influenced by an extra load.
The shared centre of gravity of the extra load and the body lies outside the central zone of the pelvis.

realm of pantomime, or whole-body expression. These heightened forms of movement are found particularly in the movements of artistic dance, such as standing on the toes – a balancing action with a minimal support base, which serves no purpose – and the arabesque action [146], during which the whole body, along with the pelvis, inclines forward around the head of the hip joint on the standing leg, in a movement that similarly serves no purpose. Balance is approximately maintained by the upper body and arms on one side of the balanced form, and by the raised and outward-rotated 'free leg' on the other side. The centre of gravity rests above the sole. Such a difficult balanced pose – unnecessary to any useful action, but necessary as a possible form of human self-portrayal – can only be achieved through a perfect mastery of one's musculature: a goal whose achievement lies within the realm of the performer's attitude to life, their self-discipline, their feeling of life, and the whole composition of their life.

These assertions do not apply only to balanced, expressive movements; they also apply to those movements we have already mentioned that relate to changes of location, or to purposeful working actions.

Fig. 146 The arabesque pose from classical dance: a difficult posture balanced upon a single leg. The forward inclination of the upper body must be compensated for by raising the non-weightbearing leg. The pelvis participates fully in the forward inclination.

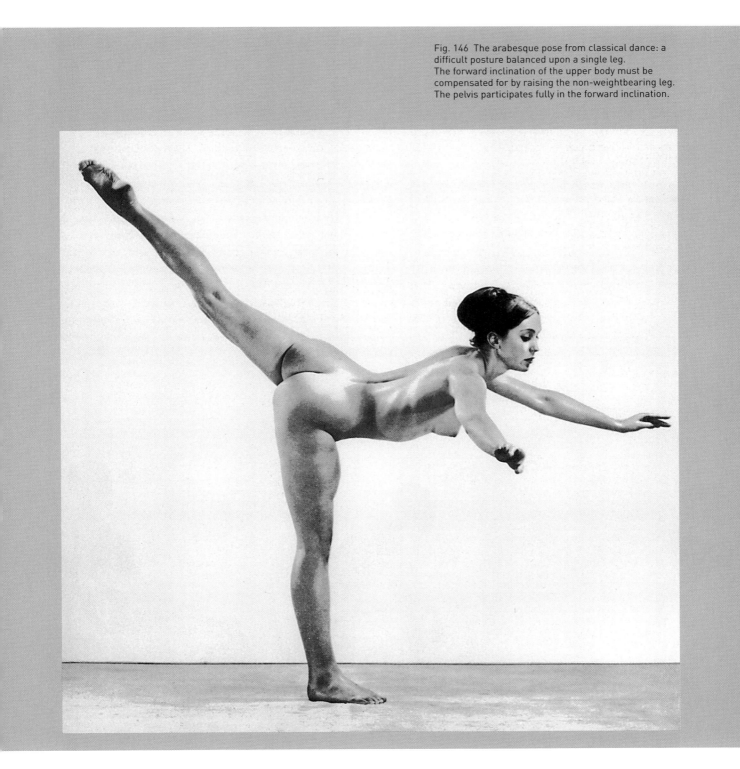

3.3. SITTING AND SEATED POSES

Aside from lying down, sitting is the body's most relaxed pose. It produces transformations in three different respects: proportional, static and anatomical/functional. The three main forms of sitting are: free or central sitting, forward sitting, and backward sitting. In terms of changes of proportion, sitting reduces the height of our body by the length of the upper leg: that is, by a quarter of the body's size. A seated person's height will extend to the nipple level of a standing person [89].

Because the lower body is no longer involved in forming the centre of gravity (instead, it merely supports its own weight), the centre of gravity moves out of the pelvis, to a point close to the ninth thoracic vertebra. The gravity line falls between the two ischial tuberosities, which provide the support. The main weight is removed from the two large gluteal muscles in the buttocks.

The anatomical/functional changes take place in the context of the position of the pelvis and the spinal column. This will be further discussed for each of the seated positions.

The upright seated position: The contour of the back differs from its contour in the upright standing position [147a, b]. The curvature of the spinal column changes its shape, becoming flattened [150]. What causes this? In the upright pose, the pelvis maintains an oblique forward tilt. This causes the spine to bend sharply back (the lumbar lordosis, which serves to balance the upper body), accompanied by a counter-curve in the thoracic spine section [247, 306]. When the body is in a seated position, the ischial tuberosities become the fulcrum for the 'weighing scales' of the pelvis: the upper body mass presses on the rearward arm of the balance beam (the sacrum) and causes it to sink, accompanied by the rising of the forward arm of the balance beam (the pubic bone).

This puts the pelvis in a vertical position. As a consequence, the lumbar lordosis is flattened out,

and the thoracic spine flattens out in response. This stretches the contour of the back. Maintaining this position involves a large number of muscles, which explains why we do not remain in a free sitting position for long if we can help it.

The forward seated position: In this position, we incline our upper body forwards, supporting it by resting the elbows on the knees. The arms, the upper legs, and the upper body become a reposed constructive triangle. The centre of gravity is in the stomach area. The back follows the forward inclination; and the lumbar lordosis actually becomes a flat convex shape (lumbar kyphosis).

The backward seated position: In this position, we either lean or support ourselves, in an effort to relieve the strain on the musculature. This puts the centre of gravity behind the ischial tuberosities. If we support ourselves with our arms, the upper body sinks down between them. This causes the shoulder girdle to be pressed outwards (important for the depiction of nudes, in which the artist must make plain the functional differences between a hanging load and a support). The pelvis also tips backwards. As with the forward position, the back is rounded.

For a figure sitting on the floor with the knees drawn up [148], the centre of gravity – which is formed largely by the masses of the torso and upper legs – is located over the two ischial tuberosities. The pelvis tips backwards; this leads to a forward-curving motion in the thoracic and lumbar spine, with a pronounced rounding of the whole spine, and a heavy contraction of the abdominal region.

A free backward-leaning seated position on the floor [149] is statically maintained through the anchoring of the arms on the knees. The pronounced rearward slant of the pelvis leads to the flattening out of the lumbar spine, whose rearward slant is similarly continued by the thoracic spine. The upper legs, the torso and arms form an approximately equilateral triangle, whose 'apex' bears the weight at the ischial tuberosities.

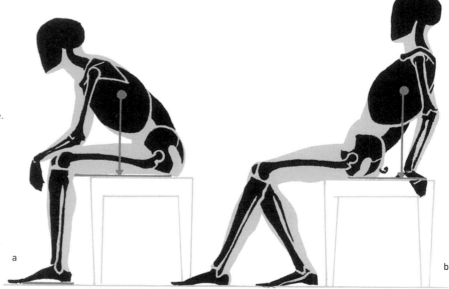

Fig. 147 Centre of gravity position and support area in a seated figure.
a) Leaning forward.
b) Leaning back.

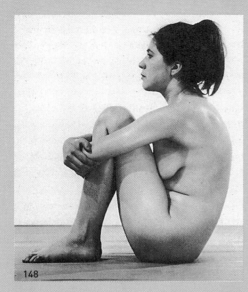

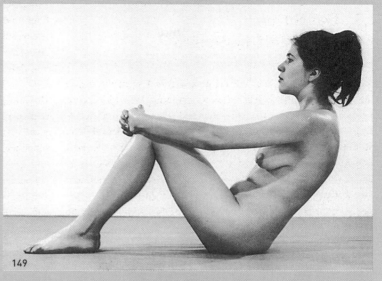

Fig. 148 A seated pose, on the floor with the knees drawn up.
The pelvis is tipped slightly backwards, causing the lumbar spine to abandon the lordosis it exhibits when at rest in the standing position and to assume a slight compensatory kyphosis instead. This leads to a rounding of the back as a whole.
Note that, in this seated posture, the knees are level with the shoulder girdle.

Fig. 149 A person seated on the floor in a backward-leaning posture. The backward-leaning position is checked by the arms grasping the knees, forming one side of a closed stable equilateral triangle.

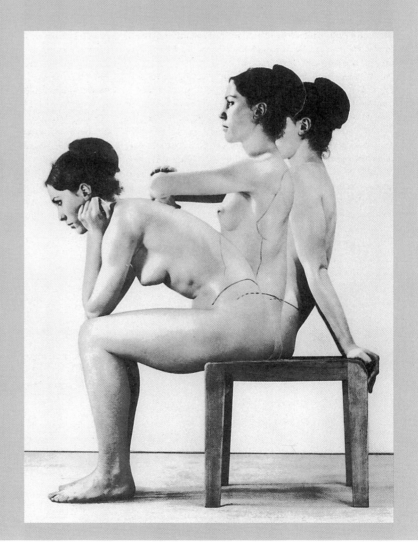

Fig. 150 Different forms of sitting (a phase photograph). Forward-leaning, upright and backward-leaning seated postures.
Note the different position of the pelvis that is inevitably caused by the extension in the line of the spinal column in an upright seated figure. The lines on the model trace the line of the iliac crest.

The bearing and movements of the human body: the basics of statics and dynamics **155**

3.4. THE TREATMENT OF THE RULES GOVERNING RESTING POSES IN WORKS OF ART

It is ultimately impossible to create an overview of the various different forms in which the body is able to maintain its balance, and to therefore maintain a resting position. The previous chapters merely discuss some of the basic forms. In relation to our particular subject matter, we should not overlook the fact that, whilst rest positions do of course exclude locomotion (which represent their opposite), they do not exclude functional actions. When standing, sitting or lying, the body exerts itself to maintain balance; it is not in a completely passive state, without function, or completely without action.

An at-rest standing pose with the legs together reveals an even distribution of the body's weight onto both soles and an unstable state of balance, with a high centre of gravity, whilst standing with the legs wider apart increases the support area, lowers the centre of gravity, and increases stability. Standing with all of one's weight resting on one leg in order to reduce tensions initiates a whole chain of transformations occasioned by static properties (cf. sections 3.1., 3.2., and 3.3.). With the body and its component parts constantly producing ever new and surprising combinations of acting forces and relationships between body masses and plastic centres, and weight being applied or transferred, the interactions and configurations of forces in the body's at-rest positions are unfailingly startling. Movement in rest, rest in movement – these are motivations that are compelling to the artist, in terms of their physical processes, but also in terms of their equivalent psychic processes. After all, the rest positions, like other body positions, are external expressions of inner states: they are a form of whole-body gesture.

It therefore makes sense that artists should make use of these naturally expressive forms by integrating them into expressive artwork; artists may even use them exclusively, preferring them to many other possible expressive values. Since the resting poses

Fig. 151 Luca Signorelli (1441?–1523). *Loadbearers.* Chalk. Kupferstich-Kabinett, Berlin. The expression of these functional events is primarily reached through the bent leg columns, the oblique positioning of the pelvis and the consequent spinal curvature.

Fig. 152 Hans von Marées (1837–1887). A study for *Die Hesperiden* (1885). Red chalk. The expressive form conception of this study has as its functional theme a double weightbearing situation, in which the weight is borne by the single standing leg and by the supporting arm.

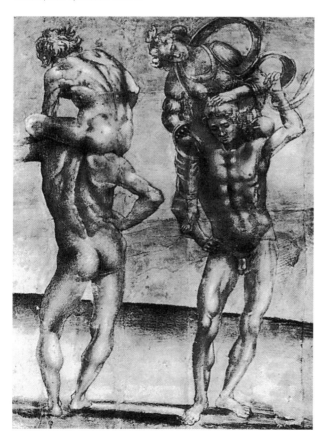

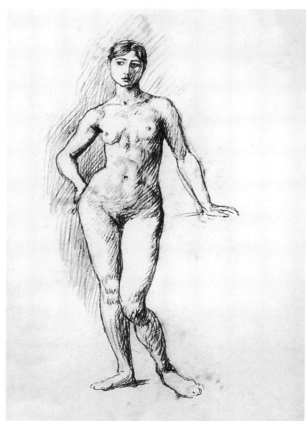

are governed by the rules discussed in the previous sections, we are not asking whether artists follow them. Instead, we are asking how they deploy their knowledge and discernment to implement the intended message of their artwork to the highest degree. The reader will understand that a selection of works of visual art that feature this vast field of artistic motifs is, like others, inevitably subject to certain constraints. It was not until the era of Polykleitos that the richly varied contrapposto figure, whose external relaxed state is the outward clothing of a corresponding inward state, first emerged. This predominance of a well-measured physical and psychic balance can be seen in Figure 87 (see page 86). This sturdy hero's posture is somewhere between a striding posture – devoid of haste or excitement – and an observing stance. There can be no doubt that he is engaged in making a slight movement; if he were not, the centre of gravity would clearly be displaced to a location above the weightbearing sole. The artist has also adjusted the accent of the weightbearing trochanter, and the standing leg is a solid, whole entity, subordinated to its function.

The thigh of the left leg – the leg that is free of weight – is separated from the hip region by the fold of the groin. The back-placed foot, as it touches the ground, is not wholly free from weight, since the centre of gravity is only slightly shifted toward the other side.

Signorelli's *Load Bearers* reveals how the portrayal of figures in action benefits from the insights of artist anatomy [151]. Without these, its motif of a figure standing firm under a heavy earthly burden, in such an earthly and human manner, could hardly have been expressed! The weight presses down on the spinal column with such force that there is a sharp bend at the transition from the oblique line of the thoracic section to the countermovement of the lumbar region. The pelvis sinks down very low on the free leg side; the spinal column must compensate for the imbalance in the figure's substructure and support. All of this means that the trochanter is pressed outward, showing an ominously sharp angle; the standing leg bends like a support bowing under its load, its countering line checking the heightened slant in the line of the spinal column.

Fig. 153 Gottfried Bammes (1920–2007). *Mädchen, Hemd überstreifend* (1970). Red chalk.
The picture's central motif is the weight carried by the hip, and the body's spatial movements resulting from it.

Fig. 154 Colin Saxton (1927–2013). *Standing Female Nude* (1977). Black chalk. The sharp, angular projections of the pelvis and hips contrast with the pliable character of the belly's soft tissue forms.

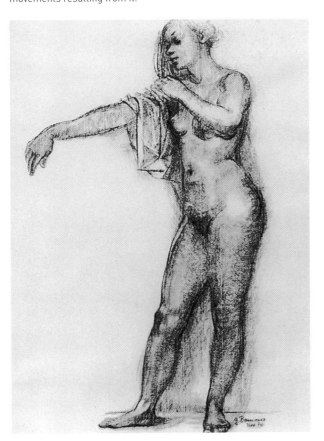

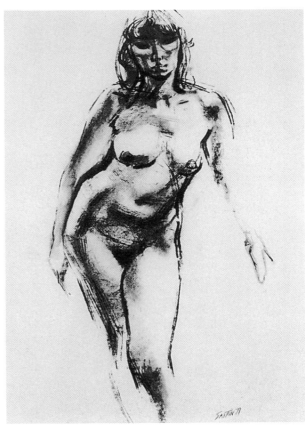

The bearing and movements of the human body: the basics of statics and dynamics **157**

In a study for *Die Hesperiden*, Hans von Marées solves the problem represented by the contrapposto in which the load is divided between a supporting leg and a supporting arm [152]. The substantial width of the female pelvis presses the trochanter outward. Part of the weight of the free leg hangs on the supporting arm. The shoulder girdle obeys the same laws of support and of being supported as the pelvis, with the difference that it has the capacity for displacements within itself. As the supporting members straighten to perform their function, the relief of bearing only their own weight causes the free members to relax. The figure has an unusually striking rhythm: the contour of the load-bearing side plunges like a mountain stream over sheer projections, is blocked and released, only to be held back once more as it prepares for the next leap, whilst the profile of the supported side flows gently and without resistance down to the foot of the free leg.

In the partially side-on view seen in Bammes' *Mädchen, Hemd überstreifend* [153], the concerns and intention behind the form undergo a shift in comparison to Marées' *Die Hesperiden* study (although the static problem is the same).

The full frontal position of Marées' nude causes the figure to remain in an entirely two-dimensional spatial zone, with nothing of the figure's monumental decorative outline being swallowed up. Bammes' artwork is different in that, whilst the functional aspect of the contrapposto does equally play an important role, there is inevitably a stronger connection between the turn and stance of the figure and the intimate character of the scene, and the events in three-dimensional space. Under the conditions imposed by the contrapposto, the surrounding space within which the body moves demands far more intensive statements on the forward and rearward movement within the body. The view we have of the figure therefore influences both the configuration of forces in its outline form and the specifics of the formative intention.

Standing Female Nude [154] by the English artist Saxton, which is very similar to Marées' study in terms of perspective and posture, serves to reinforce the remarks made above. His static/functional rendering of the frontal view is achieved clearly and successfully in terms of the factors discussed here: the vibrancy seen in the progression of the movement, the stability of form of the plastic centres, and their relationships to each other.

Fig. 155 Vera Mukhina (1889–1953).
Female Torso (1927). Wood, 125 x 52 x 52cm (49¼ x 20½ x 20½in).
The wide placement of the legs ensures a stable stance, enabling the upper body to undertake strenuous action.

Fig. 156 Fritz Cremer (1906–1993).
Stehender Akt (1959). Plaster. Height: 60cm (23½in).
The incomplete ponderation of this piece occasions a seeming negation of the weight of its bulky body masses.

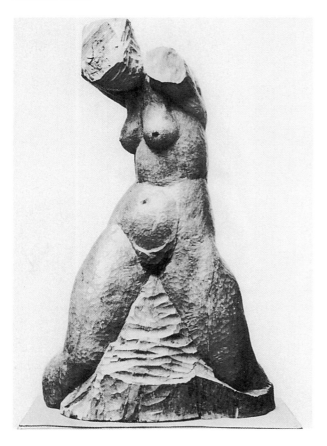

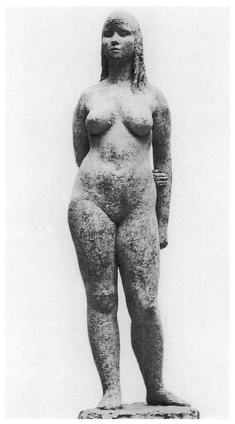

However, if the artist wishes to go beyond the overall character and include the plastic/functional details and the disposition of the soft tissue forms in the frontal view, then the resources used must be significantly increased.

In his *Stehender Akt* [156], Fritz Cremer combines the heavy fullness of female forms with a youthful, restrained shyness. There is a slight hesitancy about the body masses, which are not fully committed to a personally contented, restful state. The gravity line does terminate at the supporting sole, but the centre of gravity is located close to its inner edge. Consequently, the standing leg also follows a vertical alignment. With the weight not fully transferred, the trochanter remains in a moderate, recessed position. This softens the contour of the standing leg side. In this way, the quiet posture relieves the weight of the heavy body, allowing it to remain girlish. This shows a sensitive integration of factual rules into the unity of content and form.

In the above examples, we can read the functional processes seen in the contrapposto, but also their psychic equivalents: a relaxation of the inner state, a basic mood of peace and release. A wide, solid stance, which prioritises stability, is very different, and immediately signals a different mental condition: a figure that wishes to consolidate its stance, to resist any wavering or flinching, to defy any challenge, and to be solidly planted in order to be ready for strong actions. Vera Mukhina's *Female Torso* does not tell us how its gesture will be continued, but when we look at the raised arms, the turning of the upper body, and the powerful, wide stance, we are left in no doubt as to its dramatic character [155].

Michelangelo showed inexhaustible invention in his creation of heroic seated figures [157]. Look at the extraordinary agitation in the seated pose of the nude soldier figure in the *Battle of Cascina*! Surprised by the enemy whilst bathing, the wet, naked bodies are struggling desperately to get back into their clothes. One warrior, whose legs are turned toward the step of the riverbank, is violently turning his upper body, seeing, to his horror, the enemy behind him. The sudden movement throws his upper body into an oblique lateral position. His left thigh is only briefly able to support his precarious seated position. The calf of the other leg is stuck out laterally, providing a counterweight to balance his leaning upper body. His body forms a spiral, from the front view to the full face of the back. What a contrast with Rembrandt's *Seated Woman* [158]! Here, there is no action that

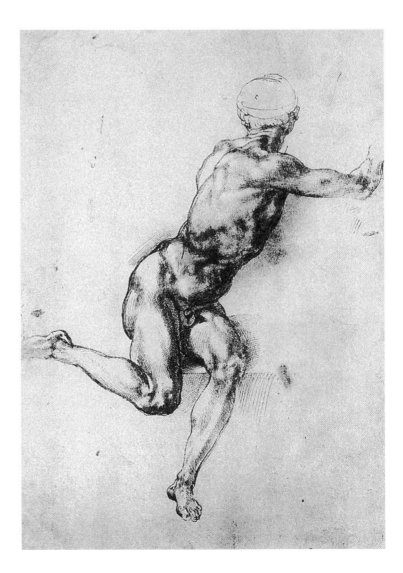

Fig. 157 Michelangelo (1475–1564). A study on card of bathing soldiers. The sharp lateral turn and forward inclination of the upper body over the frontal pelvic alignment and the balancing action of the drawn-in leg evoke a moment of surprise.

indicates a decision. Everything is sinking down, in an immersed state. The coarse, feminine fullness of the figure is not carried by the whole pelvis; part of the weight is taken by the support of the right arm. The sense of boorish heaviness is spread over the elbows and buttocks, which are as wide and massive as a body could possibly be in giving itself over to the pleasures of rest. The legs bear only their own weight, and are almost isolated from the context of the rest of the body. There is no requirement for a secure purchase, only an abandonment in the face of a pleasurably tasted, resting physicality.

Above the wide expanse of her buttocks and her expansive hips, the woman in Degas' pastel drawing, *Woman Combing Her Hair*, is stretching her back in such a way that the straight groove of her spine becomes the picture's central axis [159]. All of the details have been subordinated and banished, but without creating any sense of emptiness. Everything needed to encapsulate the flowering of the body and its functional essence is harmoniously present. A delicate touch of colouring is used to round out the body's volumes, and brings certain firm supportive points out of the deep field and onto the surface of the picture. Only through an insightful observation of the natural form can colour be made into the foundation of the organic form in this way, thus providing the basis for a great artistic form. Physicality is present, but does not predominate within the picture.

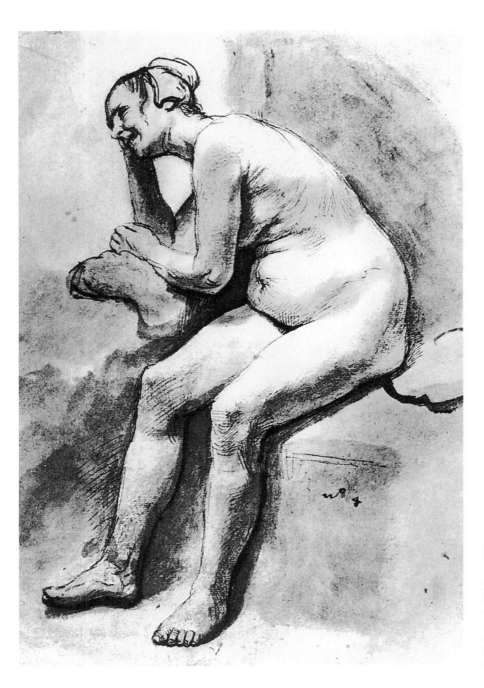

Fig. 158 Rembrandt Harmenszoon van Rijn (1606–1669).
Seated Woman, Supporting Her Head (circa 1631/1632). Pen and brush in ink, 26.2 x 18.6cm (10¼ x 7¼in). The Louvre, Paris.
The tranquillity of the model's seated, supported pose is centralised in the displacements and contractions of the heavy masses of the belly and the hips.

Fig. 159 Edgar Degas (1834–1917).
Woman Combing Her Hair (1885). Pastel.
The Hermitage, Leningrad
In addition to being the axis of the body, the
straight groove of the spine, which represents
the support of this free seated posture above the
steep pelvis, provides the picture's central axis.

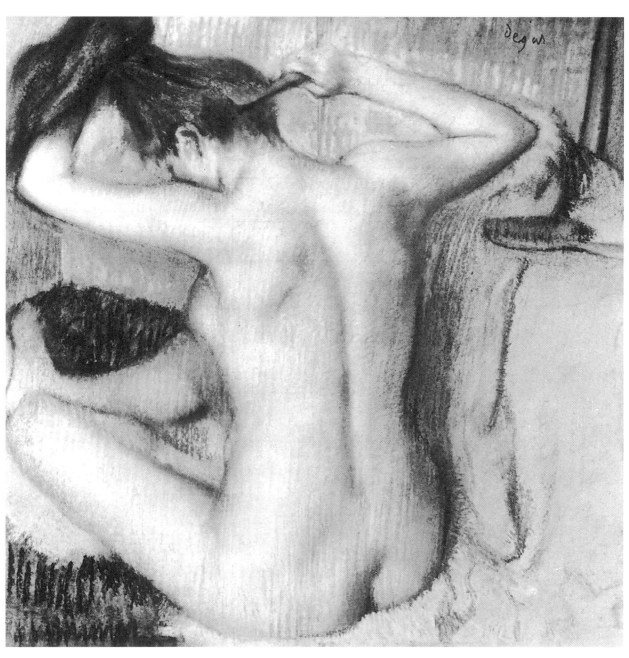

3.5. THE STEP

When we stand still, we are making an effort to keep the joints firm via the muscles, with the aim of securing our balance. In taking a stride [160], the intention is to change location. Dynamic muscular forces therefore gain the upper hand. This process is favoured by the fact that our body exists in an unstable state of balance. Only the slightest contraction of the muscles in front of the transverse axis of the ankle joint is required in order to move the centre of gravity forward to the region above the support of the ball of the foot, and to thereby trigger a fall that is waiting to happen. It is only the timely swinging forward of a leg that arrests our fall, providing a new support. This results in the following sequence: the push away from the ground, the forward swing of the pendulum of a free leg, the placing of the free-swinging leg (resulting in a double support), followed by a change in support, and so on. In walking, there is an alternation between one-sided support and a double support.

3.5.1. The phases of the step

Initial position: The balance is distributed in such a way that the ear openings and the shoulder, hip, knee and ankle joints are all on a perpendicular line (corresponding to the standing posture that is the least taxing to the muscles). The gravity line is at the level of the two ankle joints between the feet [160a].

Readiness position: A forward shift in the body weight (military pose). The perpendicular gravity line is in proximity to the tipping edge (the ball of the foot). The muscles in the rear of the leg and in the back are tensed (the balanced pose) [160b].

The drawing forward of the body, with the line of gravity ahead of the ball of the supporting foot. The free-swinging leg makes a pendulum movement forward, with knee bent, and with the tips of the toes slightly raised [160c].

The push away from the ground, via the ball of the big toe on the supporting foot. The free-hanging leg begins to extend. The heels are lowered, ready for contact with the ground [160d].

Double support is provided as the free-swinging leg lands, coming down heel-first. There is a pronounced raising of the heel of the former supporting leg. The centre of gravity is closest to this leg [160e].

Rolling through the sole of the new supporting leg. The centre of gravity is located approximately in the midpoint of the double support [160f].

Unilateral support with extended leg. Centrifugal force and muscle force brings the perpendicular gravity line close to the supporting foot. The free-swinging leg is lifted from the ground, at an angle [160g].

Fig. 160 The phases of the step.
The step essentially consists of a forward shift of the centre of gravity, arrested by a change in the support of the legs. The centre of gravity, the perpendicular gravity line and the support are marked in red.

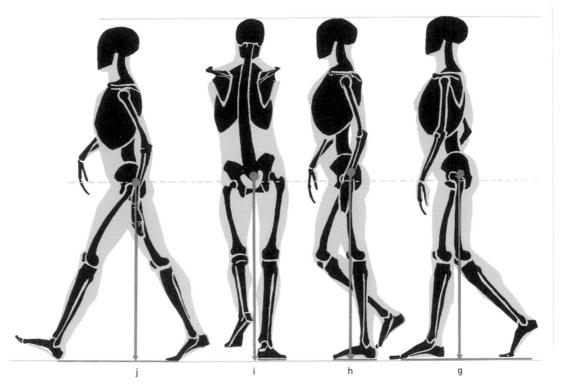

j i h g

Simple support with an extended leg and a free-swinging leg that is bent as it makes a pendulum movement forward. The centre of gravity is at the level of the arch of the foot [160h].

The previous phase in rear view, showing the features of an unbalanced contrapposto. The line of gravity is slightly outside of the supporting foot [160i].

Renewed double support with a greater support surface. The heel of the former supporting leg is raised, whilst the heel of the new supporting leg is planted on the ground [160j].

The arm movement is a pendulum-like motion, helping to maintain the body's balance during the forward step. The arm and leg on the same side always move in opposite directions.

Variations of the step: The stepping speed is affected by the forward shift of the upper body, which effects a rapid fall [161]. The legs are placed far forward to counteract the fall (Barlach, *Mann im Sturm*). This natural consequence is always coupled with the psychological effect of pressing forward. A short stride length, with the upper body leaning back, creates an impression of hesitancy or uncertainty.

3.5.2. The fertile moment

In the artistic depiction of a figure in motion, it is by no means always possible to seize on any observed moment within the sequence of a dynamic process – that is, of a dynamic locomotion process. Some fundamental remarks on this subject should therefore be made at this point [161].

Additionally, some very old artistic aesthetic perspectives on this issue are available to us; perspectives developed in antiquity, and, to a significant degree, by classical German aesthetics (see also the remarks of the author in *Figurliches Gestalten*, Berlin 1978, in the section on 'Die Funktion als Gestaltungsmittel im Kunstwerk'). It makes sense to touch on these questions in the context of the step, of balanced expressive movements (section 3.2.4.), and of running, which has not yet been discussed.

What do we understand by the 'fertile moment'? In a portrait, an artist only rarely seeks to capture a momentary mimic situation (an expressive situation), because such a moment narrows down the experience of the whole person to a sole fleeting moment in terms of their state of mind. Similarly, with regard to the fertile moment of a movement, the artist must seek to become acquainted with the whole movement. In order to make the figure in the artwork move before our mind's eye, it is important to incorporate an idea of the beginning of the movement into its subsequent progression, and to make it possible for the viewer to anticipate the future moments that will follow. Between the beginning and the end of the process,

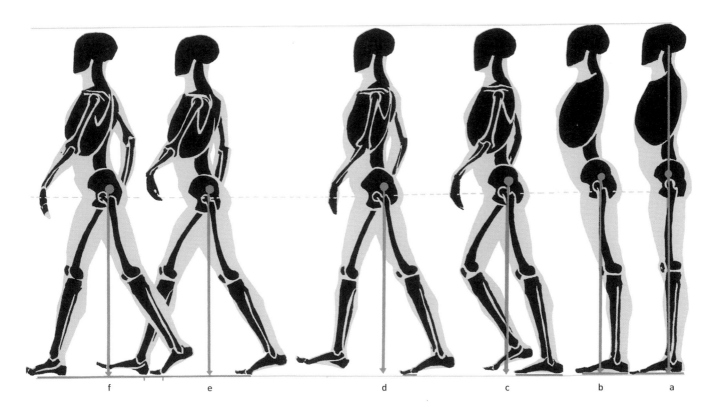

f e d c b a

there lies its point of culmination. With the aid of the strobochromatographic photography technique [139, 172–175], we are able to turn movement analyses into separate images, rather than temporal sequences. In this context, our eyes accept every moment without contradiction, because we see the movements as being, in an unmediated way, components of a sequence, and we are able to assign an order to them: the gymnast kicking herself away from the ground, the upward and forward acceleration, the divergent movement of the legs as she enters the splits jump, the landing, the lunge for a handspring, etc., the movement of taking the run-up for a throw, the shooting of the ball, the preparation for the catch, the fall.

In the fine arts, we would not accept these 'snapshots' so naturally. In a fine arts context, the movement must be separated out from a chain of events. Not every moment is artistically viable in the truest sense of the word. The specific qualities of the individual arts – sculpture, painting, graphical art – impose certain restrictions.

The least fertile moments are the moments when the body is statically unstable, when the figure is fated to fall forward owing to the centre of gravity moving to a position in front of the supporting leg: an unbearable state of ongoing falling in, for instance, a sculpture or a mural. The fertile moment culminates in the phase of the movement sequence that is accompanied by static stability. This phase gives the moment permanence, as the figure is able to pause in this position (the gravity line is within the area of one foot, or between a forward-placed and rearward-placed foot) [160e–h]. Additionally, the fertile moment contains both the conclusion of an action and the beginning of a fresh action (one supporting leg is on the point of leaving the ground, and the other is on the point of returning to it). Thus, the fertile moment unites the present manifestation of a movement with suggestions of its past and future, thereby recruiting the imaginative powers of the spectators, who participate in the creative process, and their ability to mentally extend the movement that they can see. This is vital to the intensity and effectiveness of the artwork.

The intended message of the artwork is the critical factor in choosing the moment of the movement to depict.

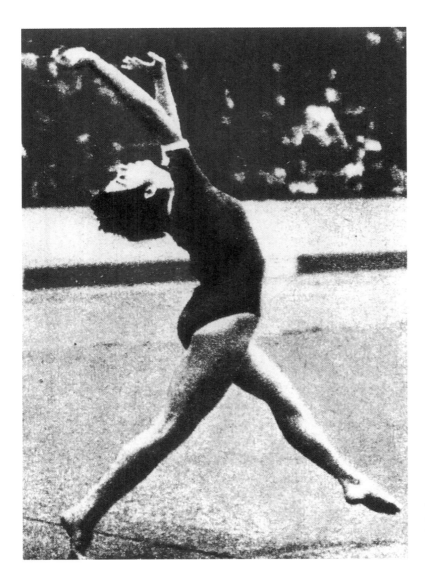

Fig. 161 The dynamic expression of movement of the running action. The movement of the centre of gravity to a point far ahead of the supporting foot causes a pronounced falling action and a movement to intercept it, which becomes the action of running.

3.6. THE ACTION OF RUNNING AND ITS INDIVIDUAL PHASES

The running action is distinguished from the stepping action in that, in running, both feet are never on the ground at the same time: between the push-off (the propulsion moment) of one leg and the landing (the support moment) of the other leg, there is a free aerial moment. Running is a means of forward locomotion that takes place in leaps [161, 162, 164].

In the realm of body culture and of sport [172–175], the purposeful character and laws of running are enriched by a natural union with additional purposeful movements, for which the effects of running create better preconditions (many throwing actions, for instance). In other contexts, on the other hand – such as artistic gymnastics – running may be embellished in various ways. Various aesthetic, non-purposeful movements may be added to heighten the expression of joy and of a positive sense of being alive: these are expressive movements. 'Not only does the increased aptitude for movement that accompanies a cheerful mood affect the progression of movements, it also frequently results in independent, playful movements that have no practical foundation … In extreme cases, this leads to leaping, dancing, and jubilation. The arms, which have nothing to do, are able to swing in empty space. Sport understood as play is a fulfilment of the readiness for movement that accompanies joy.'[15] The fundamental sequence of the pushing off, aerial and landing phases, however, applies to both forms – to the action of purposeful locomotion, and to self-portrayal through an artistic running action [168–171].

The individual phases

The object of the starting action is to bend the leg joints and to curve the spine. This posture allows the spine to be extended in the backward direction during the initial push-off, and to thereby accelerate the body forward, with the centre of gravity positioned between the feet and the support provided by the hands [163a].

15 Karl Leonhard, *Der menschliche Ausdruck*, Leipzig 1968, p. 11.

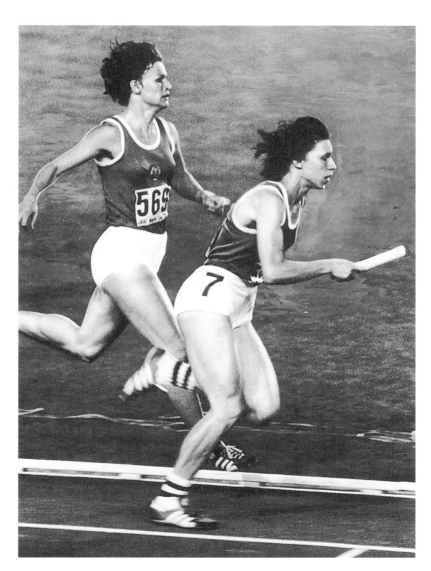

Fig. 162 Two phases of the running movement.
The woman running on the left is in the aerial stage, and is preparing for the landing of the right, forward-swung leg. The woman running on the right is pushing off into the aerial phase with her right leg.

Fig. 163 Phases of the starting action (using line phase drawings taken from Hoke).
In the starting action, the object is to place the centre of gravity well forward, and to angle the legs for an energetic push-off.
a) 'On your marks!' (Centre of gravity red, within the support base.)
b) 'Get set!' (Centre of gravity is located above the arms.)
c) 'Go!' (Centre of gravity at the point of setting off is far ahead of the support area.)
d)–e) Pushing off upwards and forwards.

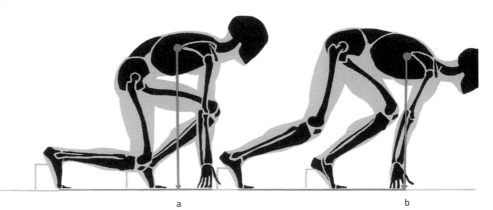

a b

Fig. 164 Phases of the sprint (a reworking of a line phase drawing from Hoke, with the centre of gravity drawn in red).
a) Pushing off.
b) Aerial phase.
c) Preparing to land.
d) Landing.
e) Pushing off.
f) Reaching forward.

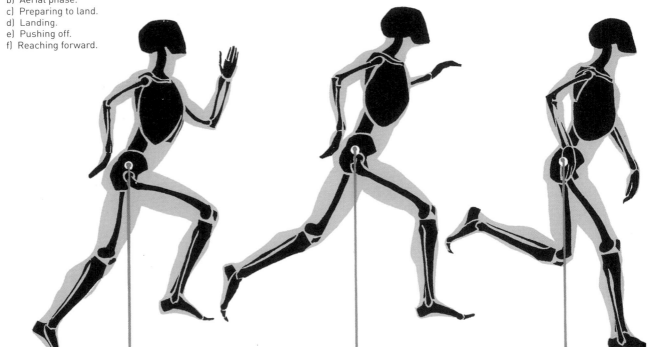

a b c

166 The bearing and movements of the human body: the basics of statics and dynamics

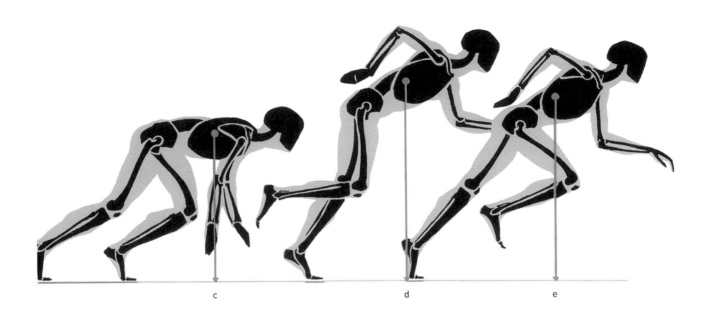

c d e

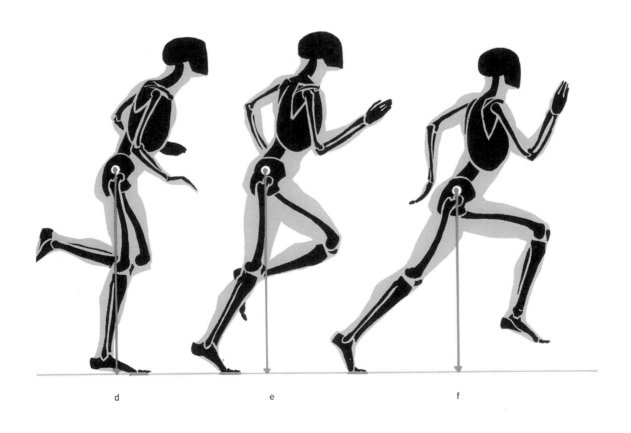

d e f

The bearing and movements of the human body: the basics of statics and dynamics **167**

The buttocks are raised immediately before the action of forward acceleration. The centre of gravity is moved forwards to a point between the supporting hands [163b].

When the command to start is given, the legs kick away, and the hands leave the ground. Because the centre of gravity is located so far ahead of the support base, there is a very great impetus to fall forward [163c].

The leg that is pushing away extends, the bent free-swinging leg is drawn through, and the upper body becomes more erect [165, 166].

The braced leg is fully extended, and the free-swinging leg, heavily bent, is drawn through [163c].

The upper body assumes a more erect position for the push-off into the aerial phase. The free-swinging leg moves in front of the gravity line [164a, 167].

The aerial phase: The front free-swinging leg begins to extend [164b].

The preparation for the landing of the front free-swinging leg, with slight extension. The tips of the toes are placed on the ground [164c, 167].

The rear free-swinging leg is drawn after, heavily bent. The centre of gravity is close to the forward leg

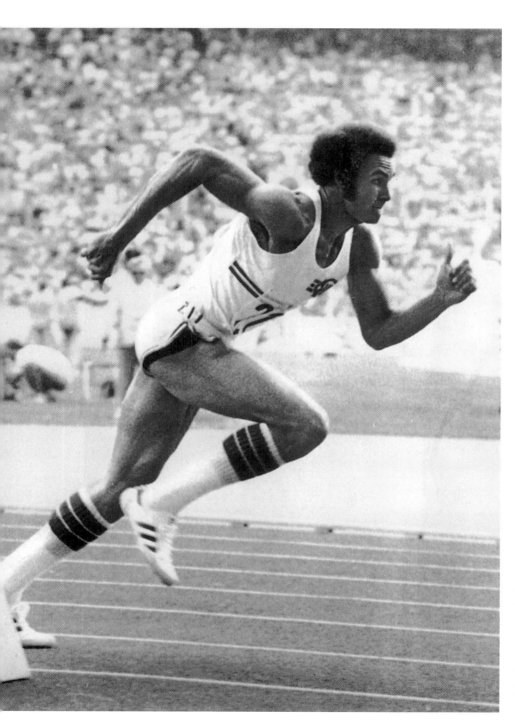

Fig. 165 A runner during the bracing and pushing-off phase.
The dynamic, purposeful character of the action of running, here captured by the camera at fraction-of-a-second intervals, can be seen from the placement of the centre of gravity, which is well ahead of the braced leg that is pushing away from the ground. The falling action provoked by this movement is arrested by the bringing forward of a free-swinging leg. The deploying of the arms in a pendulum action is also a component part of a pure, technically refined, purposeful action. The photograph shows middle-distance runner Alberto Juantoreno. It was taken in 1976, and corresponds to the phase shown in Figure 163.

[164d]. The body is supported on one side by the braced leg. The free-swinging leg is drawn through, heavily bent, with the perpendicular gravity line at the level of the foot. The braced leg presses away from the ground, the free-swinging leg is brought forward. The centre of gravity is now once again in front of the supporting leg [164e]. The free swinging leg reaches forward, and the braced leg presses down, in preparation for the aerial phase.

The shoulders and arms are in intensive movement. The elbow is drawn back to the farthest extent at the point at which the leg on the same side is being placed down on the ground in front.

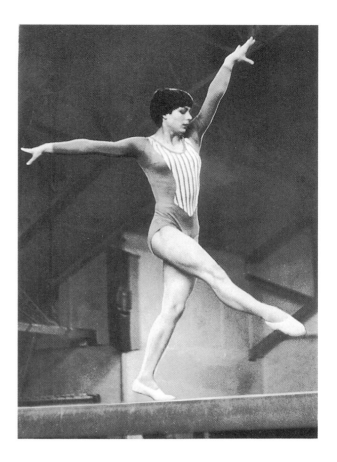

Fig. 166 A gymnast in the striding phase of a composed sequence.
The centre of gravity is duly moved ahead of the supporting foot (the braced leg side), and the falling tendency is forced by pressing down on the ball of the big toe. The elegant pushing through of the free-swinging leg, the extension of the end of the foot, and the graceful attitude of the arms and hands are unambiguously components of the expressive movement, whose primary purpose is to form harmonious gymnastic figures.
Gymnast Heike Kunhardt, 1978, on the balance beam.

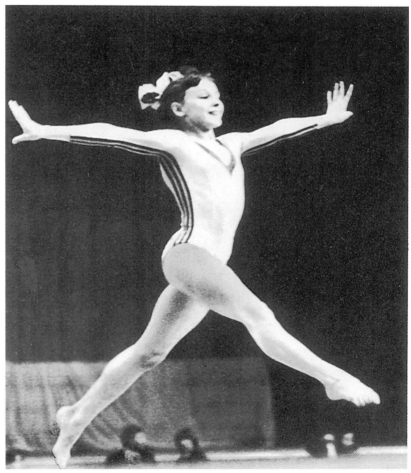

Fig. 167 A floor gymnast engaged in a composed leaping movement.
The swinging motion of the aerial phase, from which a new gymnastic figure will emerge, describes a swift leaping movement in which, here, the body is raised in a well-balanced configuration.
Combined event winner Maria Filatova 1977, performing her free programme.

The bearing and movements of the human body: the basics of statics and dynamics **169**

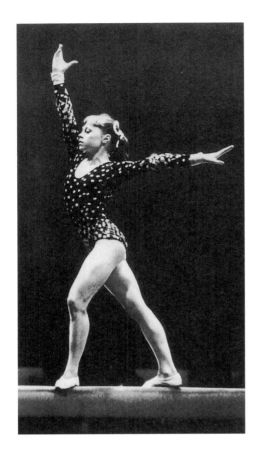

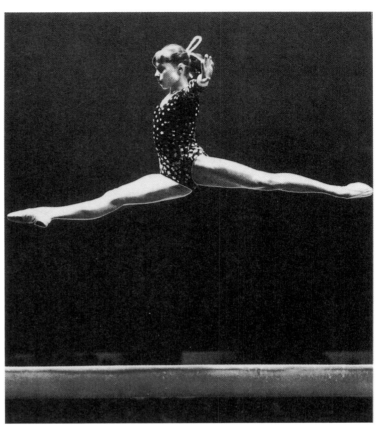

Fig. 168 Expressive gymnastic movements.
The significant components of these
expressive movements in sport consist
in non-purposeful exaggerations. Only
through tremendous discipline, mastery
of the body and much training is it possible
to create a graceful play of harmonious
body gestures.
Gymnast Elena Muchina, performing an
exercise on the balance beam.

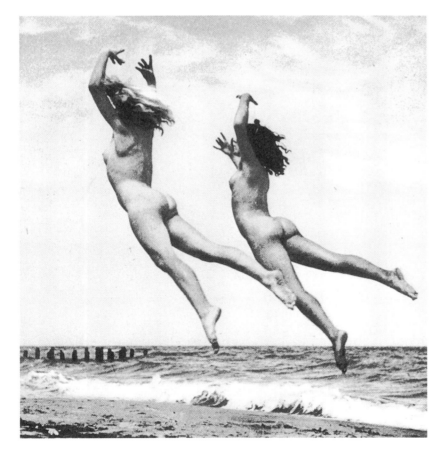

Fig. 169 High jump/long jump as a
composed movement.
The body's release from the ground in the
aerial, rising phase, combined with grace
and lightness, is the crowning expression
of youthful power and triumphant joy in life.

170 The bearing and movements of the human body: the basics of statics and dynamics

Fig. 170 The maintaining of balance in the attitude of classical dance.
Artistic dance is among the most significant forms of expressive movement. Here, the configuration of the postures assumed by the limbs constitutes the climax of a sequence of movements. The dance's brief pause takes the form of a static balancing act.
A student at the Palucca-Schule, Dresden.

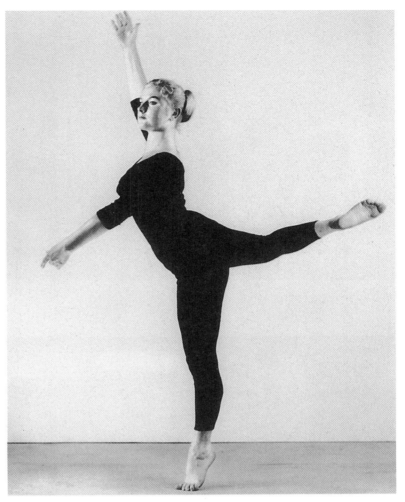

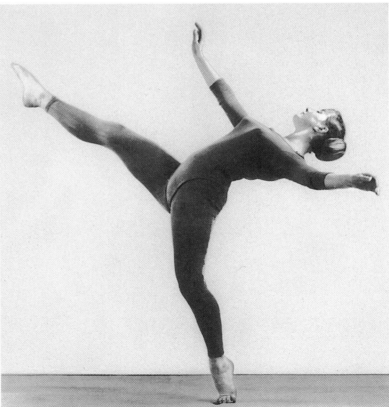

Fig. 171 A difficult balancing position in modern expressive dance.
The high degree of control over the body during a rolling-back movement in which the outflung leg and upper body balance each other characterises a motor activity actuated by the pleasure principle accompanied by a strong sense of order, both inward and outward.
A student at the Palucca-Schule, Dresden.

The bearing and movements of the human body: the basics of statics and dynamics **171**

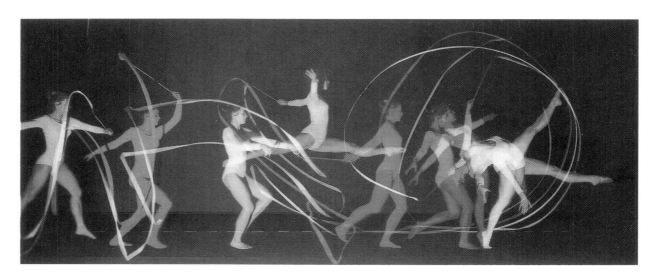

Fig. 172 Artistically composed movement, making use of the action of running.
The push-off, the leap and the aerial phase transition into one another in a harmonious and heightened form (a strobochromatographic photograph by W. Schröter).

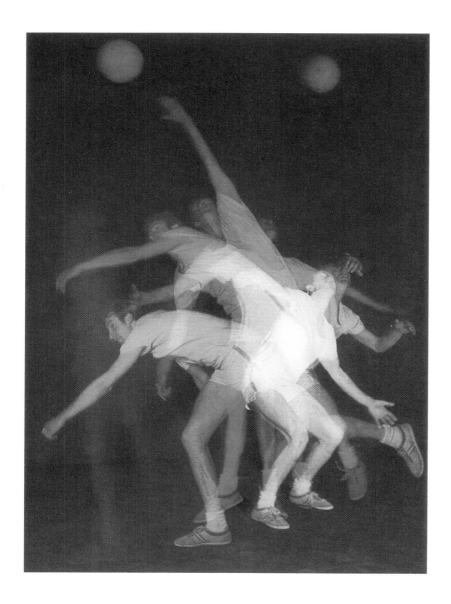

Fig. 173 Combined running and throwing movement.
The ball receives its main driving force from the body's running and swinging motions (a strobochromatographic photograph by W. Schröter).

The bearing and movements of the human body: the basics of statics and dynamics

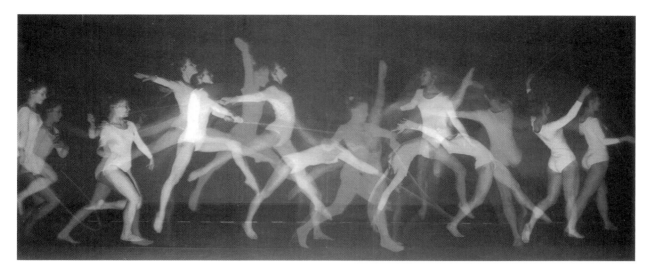

Fig. 174 Artistically composed movement, making use of the action of running. The expressive movement contains playful elements which are deployed in a non-purposive way (a strobochromatographic photograph by W. Schröter).

Fig. 175 Falling movement. The possibilities for catching in a rearward direction are limited. This throws off the centre of gravity and often results in a fall.

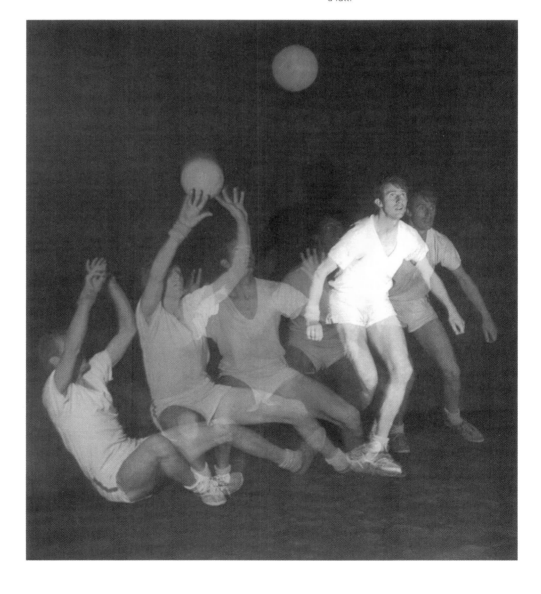

3.7. TREATMENT OF THE RULES GOVERNING LOCOMOTION IN WORKS OF ART

Fig. 176 (top) Luca Cambiaso (1527–1585).
Bearing of the Cross. Red chalk.
Kupferstich-Kabinett, Dresden.
All of the representations of stepping movements seen here contain a momentary, actual falling movement.

Fig. 177 (bottom) Ferdinand Hodler (1853–1918).
Extract from the *Aufbruchs der Jenenser Studenten, 1813* (mural: 1908/1909). University of Jena.
The double support created by such a wide placement of the legs puts the centre of gravity at the 'dead point', making the stepping position into a monumental gesture only.

Models cannot put themselves into a position representing a running action. In the studio, all that can be achieved is an illusory movement; the model might, for instance, stand on a bent supporting leg, leaning their upper body forward, and raising their free-swinging leg to the rear. It is possible to maintain this pose for an extended length of time, and the motif is therefore static, but not dynamic – it is an illusory movement. The only way to solve this problem is through highly concentrated and intuitive observation on a sports playing field, with a drawing instrument to hand. The primary object of this is to incorporate the fluid quality of movement.

Luca Cambiaso's *Bearing of the Cross* artwork [176] provides us with an example of 'posed' movement. The whole of the procession of soldiers – especially the head of the procession – appears, uniformly, to be faltering and stagnating. It becomes apparent that placing the feet 'as if' they are taking a step is completely insufficient to suggest a pressing-forward action if no relationship has been consciously created between the position of the centre of gravity

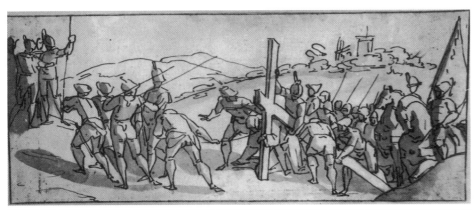

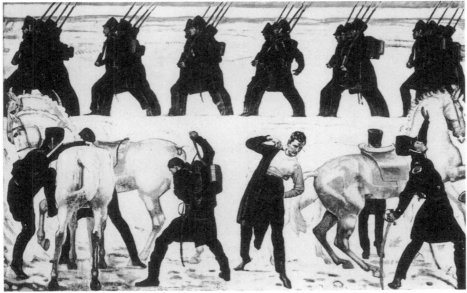

and the supporting feet, and if it is not located close to the tipping edge (forward, in the case of forward movement). This is a fact on which Cesari places great value in his *Two Striding Men* [178]. It is not only the greater freedom of his improvisational graphical invention, the flapping garments and the briefly placed feet that help to create an impression of forward movement – even though double support is provided by both legs. The real critical components of a hurried step are provided by the way the upper bodies are pressed forward, and the way the centre of gravity is placed well to the fore.

A purely factual, dynamic analysis of *Aufbruchs der Jenenser Studenten 1813* by Hodler would show that the frieze-like column of marching men in the upper part of the picture cannot move a step from their places.

Their stride length is far too great to allow the centre of gravity to overcome the 'dead point' and to move forward [177]. The far-forward placed leg is far too deeply bent to be able to push the body's weight forward over it and pull the rearward leg back without an extraordinary gymnastic effort. Any kind of brisk marching motion is out of the question, because the favourable swinging frequency of the pendulum action of the leg in relation to the stride length is interrupted. Hodler has a well-known love of exaltation, and this is

also apparent in his picture in the auditorium hall in Jena. Great pathos, however, arises from a great cause. The youthful students are marching out to free their fatherland from tyranny. This is not an everyday walking action. The step forward may not produce the illusion of real movement – but it does imply a readiness to act. Objective and artistic truth are not always identical!

We can understand Cremer's *Rufer* for the Buchenwald memorial in the same way, as suggesting an exceptional action. This figure, also, is making a mighty step forward [179]. He is taking the first step ahead of his comrades-in-arms, bravely and decisively. He is simultaneously engaged in a call to arms and an act of defiance, in order to resist – and indeed, to overcome – the tormentors. This step is about taking a firm stance, about gaining a firm foothold, as can be seen in the way the extended rear leg resists the impact. This is a good position to adopt if one does not wish to be easily thrown down by an opponent. The content and form are intensively and happily united. Any sense of the pathetic is extinguished by a sense of urgency.

This is also seen in the attitude, internal and external, of Maillol's *L'Action enchaînée* [105]. A heroic female form is shown striving against her bondage. She has prepared herself well for the pull that will break her bonds. To stand firm is to be in a position to act. The

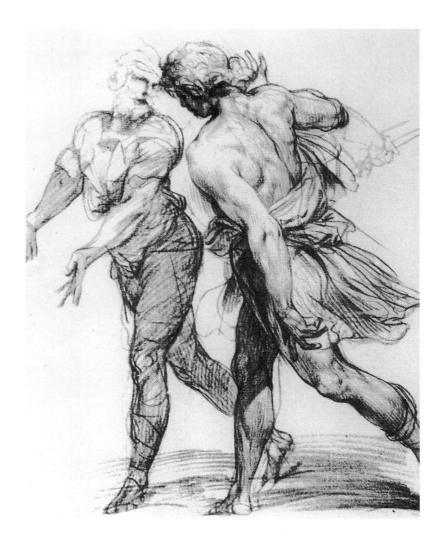

Fig. 178 Giuseppe Cesari (1568-1640). *Two Striding Men.* Kupferstich-Kabinett, Weimar.
The forward body position makes the impression of movement more convincing, even though the 'double support' moment creates a position that cannot be maintained.

The bearing and movements of the human body: the basics of statics and dynamics **175**

fetters are still confining her arms behind her back, and she is looking over her shoulder to gauge the position of the knot. Her athletic body is tautly stretched – a concentration of power that is about to be released. Her massive legs are firmly braced in the ground. This is a powerful woman, who will not be thrown down by any side-blow. The large ground area occupied by her diagonal spatial configuration is a guarantee of this, providing a secure foundation for her hard task of liberating herself.

Franz Stuck's *Läufer* contains a true experience of movement, as opposed to an illusory movement [180]. The shoulder and chest are advanced, and are closer to us than the supporting leg, which takes the slight weight in a light, elastic fashion. The heads of the quadriceps shake under the received weight and give the pull that extends the knee; with their soft tenacity, the muscles stand out from the sharp-edged accents of the joints. The runner's delicately arched foot touches the ground lightly, with the ball of the foot. The head is thrown back, expressing a grim determination. From this point, the form's overall configuration curves in a great C-shape, with a pronounced oblique forward alignment, over the hollow of the throat, the sternum, the abdominal line and the navel, to the pubic bone, where it is picked up by the leg that is directed backward in its swing, and is continued into the foot. Such a clear understanding of the performance of the driving muscular forces, combined with an equally swift and sure capturing of the heightened nervous state associated with the figure's activity, takes the viewer's breath away. The pursuer is also present – in the sheer passion of the runner's expression.

Few graphic artists have possessed such a good understanding of rapid, fleeting movement as Slevogt, or have known how to express it with such great

Fig. 179 Fritz Cremer (1906–1993).
Rufer. From the Buchenwald group.
The suggested step has a more thrusting character.

Fig. 180 Franz Stuck (1863–1928).
Läufer.
The incompleteness of the rendering and the adherence to real dynamic facts (the placement of the body ahead of the supporting leg) create an unambiguous impression of forward movement.

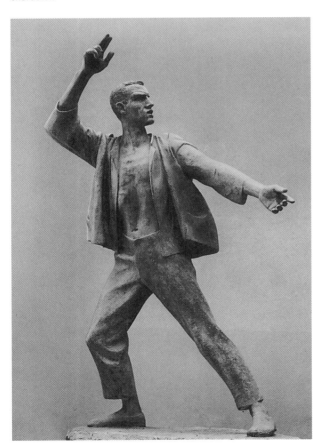

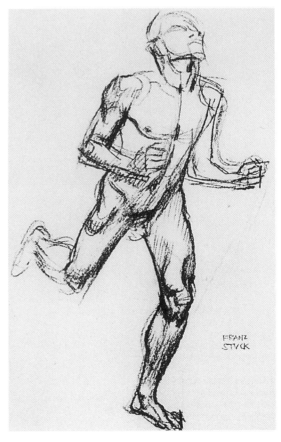

penetrating power [181, 182]. The presentation of movement in the lithographs for *Lederstrumpf* is also a triumph! As he runs, the Native American figure grasps in haste at a knife on the ground. The upper body is swiftly bent well downward at the same precise moment as his rearward leg is raised, as his left hand reaches in passing for the knife. The knee extensor is a massive spring, supporting everything alone; the loose modulation of the swinging thigh, the tautness of the buttocks, the sinking down of the non-weightbearing side. The whole composition has a diagonal alignment that extends the direction of the movement to include the viewer; there is a suggestion that the viewer is running with the figure.

Juxtaposing these two kinds of forms – sculpture and illustrations – is a good way of creating an awareness of the extent to which the individual art genres make their own decisions on how to treat the rules governing locomotion, weighted by their own specific qualities.

3.8. WORKING MOVEMENTS

Working movements are purposeful movements whose aim is to influence our human environment through action. Here, we can explain only the laws governing the basic actions of handling objects. These remarks are no substitute for observing from life: a textbook can only explain the basics.

3.8.1. Lifting, holding and setting down a load at low level

This section is primarily concerned with tilting and rolling. These actions are performed in individual stages:

The feet approach close to the load, in a wide stance; the weight is grasped as far away as possible from its centre of gravity. In the act of lifting (tipping up), the leg

Fig. 181 Max Slevogt (1868–1932). Hector put to flight (1906). Lithograph in *Achill*, detail.
An impression of a forward carriage and the use of the aerial phase of the running action create the illusion of a figure fleeing in great haste, taking great strides.

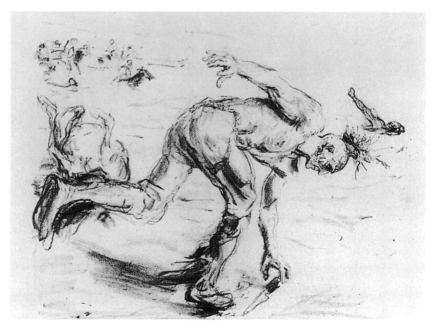

Fig. 182 Max Slevogt (1868–1932). Illustration from *Lederstrumpf* (1909). Lithograph.
The suggestion of movement is not solely due to the impression of haste in the lines, but primarily to the placement of the centre of gravity ahead of the support base.

The bearing and movements of the human body: the basics of statics and dynamics

joints and the spinal column extend in order to support the work of the arms. The shoulder joints are almost directly above the point grasped by the hands [184a, b].

Further tilting and setting upright of the object is achieved by continued extension of the legs, which moves the centre of gravity of the load away from the standing surface of the feet. The body's centre of gravity is in front of the ball of the foot, and the curvature of the spine is flattened out. The shoulders and the point grasped by the hands are in front of the body's line of gravity [184c].

Holding the load: The pillars of the legs are extended. The body is kept close to the object. The perpendicular gravity line is within the heel of the extended leg. The buttocks and rearward leg are displaced to balance the load. The grasping point of the hands is close to the body [184d].

Setting down: The buttocks are drawn back (as they are when the torso is bent forward) in order to balance the weight. The centre of gravity is in the region of the stomach, and the perpendicular gravity line is in the supporting foot. One foot is placed to the rear in order to avoid falling over backwards [184e].

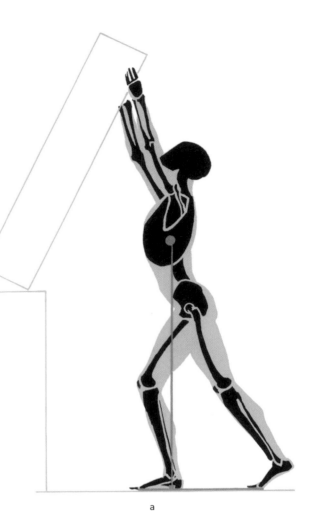

Fig. 183 (top sequence) Moving a load at high level.
a) Stretching up.
b) Holding.
c) Setting down.

Fig. 184 (bottom sequence) Moving a load at low level.
a) Tilting.
b) Further tilting.
c) Bringing the body upright.
d) Holding the tilted load.
e) Setting down the load.

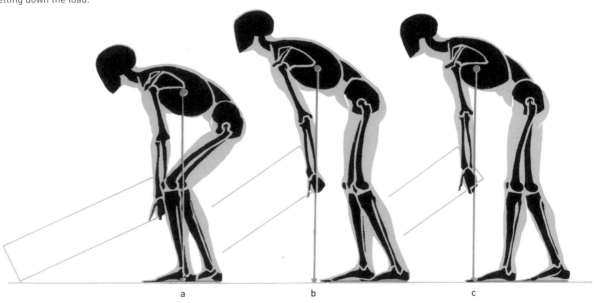

178 The bearing and movements of the human body: the basics of statics and dynamics

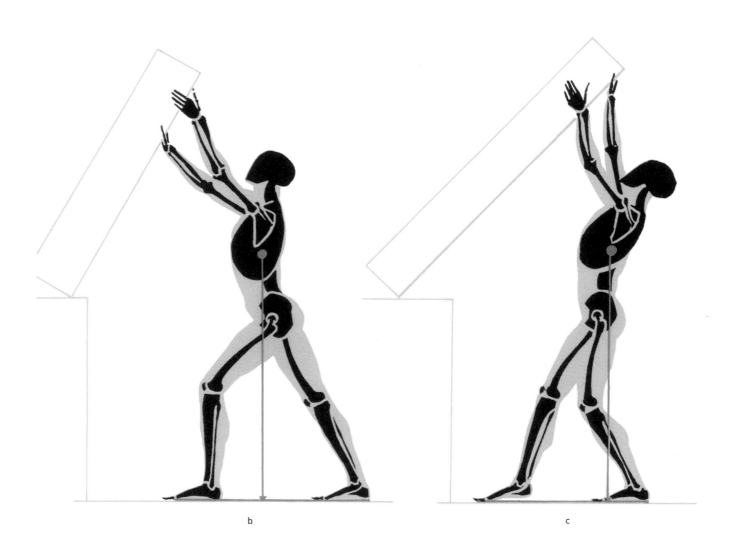

b

c

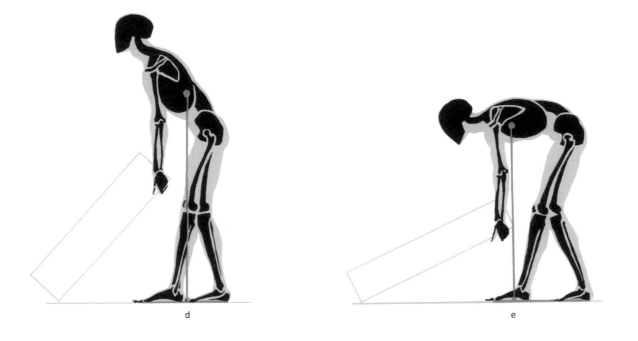

d

e

The bearing and movements of the human body: the basics of statics and dynamics **179**

3.8.2. Bracing, holding and setting down a vertically positioned load

Bracing: The whole body is engaged, creating a single overall consistent movement from the rearward-placed leg to the gripping hands. The stability of the stance is increased through diagonal placement of the feet. One leg is placed forward in a lunge position, in order to take on the load as necessary and to push forward and upward. The rear leg (the bracing leg) provides the propulsion. The centre of gravity is approximately level with the ankle of the forward foot [183a].

Holding: The whole body rests on maximised support, with the soles of both feet firmly planted. The perpendicular gravity line is in the centre of the support base [183b].

Setting down: The body is tightly beneath the load. The rearward-placed leg supports the load. The perpendicular gravity line is in the ball of the rearward foot. The front foot lifts from the floor, in order to relieve the other leg as the body gives way further under the load [183c].

3.8.3. Pulling a load horizontally

Whether the upper body is leant backward or forward, the gravity line will be located outside of the support area. In the first case, the gravity line will be behind the heel of the braced leg; in the second case, it will be in front. The heavier the load, the more oblique the body's position will be, in order to make use of the body's falling tendency to help in the pulling. The braced leg is aligned with the pulling direction, and the upper body continues this alignment, with as little deviation as possible. The free leg swings forward (or, in pulling backward, backwards), in order to catch the body when the weight is shifted. The shoulder also assists in the pulling of a heavy load. In a harness, we try as far as possible to bring the upper body into the opposite horizontal direction to the resistance offered by the load. In this way, we give the upper hand to our own forces as they act upon the object [185a, b, 187].

3.8.4. Pushing a load

From the standpoint of mechanical forces, this action is related to the previous action (in terms of the placement of the legs, the position of the centre of gravity and the upper body). As the pressure is reinforced by the bracing of the rearward leg and by the object's resistance, the spine must increasingly be held firm, to prevent a backward-bending action. The pushing direction can always be seen from the position and alignment of the braced leg. The leg that bears no load performs a checking action in the corresponding direction [186, 188].

Fig. 185 The horizontal pulling of a load.
a) Pulling forwards.
b) Pulling backwards.

Fig. 186 The pushing of a load.

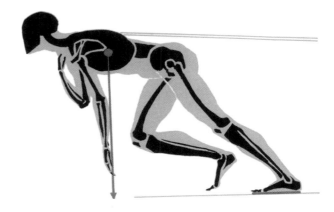

185a

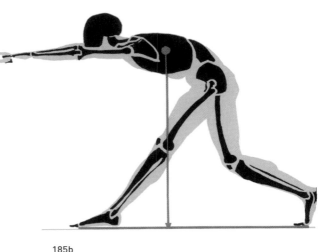

185b

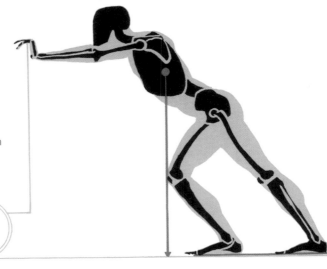

186

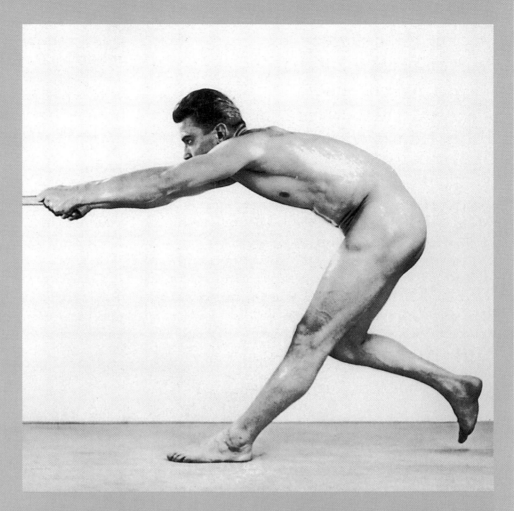

Fig. 187 Pulling horizontally backwards. The force of the braced extended leg is transferred from the flexors of the knee joint to the pelvis, and thence to the torso and arms. The rearward position of the centre of gravity is checked by the back-swung leg.

Fig. 188 Pushing in a horizontal direction. In contrast to backward pulling, the extended, pushing leg is braced forward. The forward-placed leg checks the forward movement of the centre of gravity.
a) Frontal view.
b) Rear view.

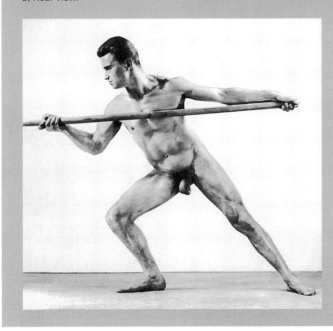

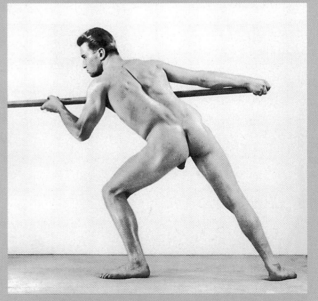

The bearing and movements of the human body: the basics of statics and dynamics **181**

3.9. TREATMENT OF THE BASIC FACTS OF WORKING AND EXPRESSIVE MOVEMENTS IN WORKS OF ART

In sections 3.2.4. ('Expressive balanced movements'), 3.3. ('Sitting and seated poses'), and 3.6. ('The action of running and its individual phases'), repeated emphasis was given to the influence of the psychic expressive components that exist alongside the basic facts of static and dynamic properties, in the sense that the static and dynamic rules are enriched and modified by mental factors, but can never be suspended. Evidently, a realistic artistic modelling technique cannot pass over the treatment of the basic facts of working and expressive movements. These also provide important forming experiences; they are initial, raw materials that can be reworked by the artist to create an artistic form.

We have included artistic works that feature working movements combined with expressive movements in this section (see also section 3.2.4.), because, when speaking about the artistic mastery of one or the other form of movement, it is impossible to draw a sharp distinction between the two. After all, artistic experience, looking at these processes, sees the laws that govern how the process unfolds, but also the quality through which the human agency participates in the process, and even influences it.

Georg Kolbe's *Tänzerin* can surely be regarded as one of the most beautiful aesthetic renderings of musical ecstasy [189]. There is nothing posed about the dancer, who is completely abandoned to her circling movement, her body in a state of harmonious rest in her light, erect, spiralling movement. Not one limb exalts itself to impertinent mechanical function.

And yet everything is in a finely balanced movement. This can be seen in the balance of the arms, in their measured weighing in preparation for the sweeping movement. The heels raise the body upward in a transient elevation, the body's weight is freed as it lifts in rotation above the toes. The feet will follow after the leading motion of the head and the centrifugal force of the arms.

When Slevogt attended a performance by the great Russian dancer Anna Pavlova, he filled a whole sketchbook with studies of movement. In his picture

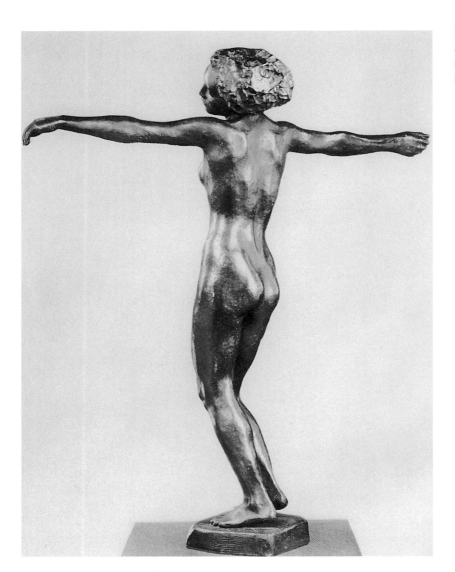

Fig. 189 Georg Kolbe (1877–1947). *Tänzerin* (1912). Nationalgalerie, Berlin. The intention of this artwork is to show the body relieved of weight, circling, at peace with itself.

Fig. 191 (right) Jean-François Millet (1814–1875).
Two Men Digging. Etching. S. P. Avery Collection, Prints Division, The New York Library.
The pressure on the spade is generated by the body's weight, which bears down from above at an angle from a slightly straightened position. The turning of the clods of earth calls for a wide stance in order to maintain balance.

Tänzer, the essential static and dynamic factors are rendered with charming economy [190]. The dancer springs across the floor with light feet, rising swiftly onto tiptoe and standing on the minimum support base. Here, once again, the balance of a body that is inclined to the side and forwards is secured by means of a leg that is raised to the side and rearwards (cf. Figure 170). In both cases, the search for the fertile moment is a significant component of the artistic form-giving process.

This intention can also clearly be seen in *Two Men Digging* by Millet [191]. One has the impression that, in juxtaposing the two figures, the artist has created statuesque renderings of the possible culmination points in their movements, which have a mutually complementary and provoking effect. The foremost figure is set to drive the spade into the ground. His wide stance, with the body placed forward and with the braced leg simultaneously shifting and pressing forward, requires the body to align with the diagonal angle of the spade. This angle also shows the direction of the force before it spends itself in the yielding resistance of the earth, only to renew itself in the throwing and turning of the load represented by the

clod of earth – as it has in the case of the rearward figure. The man will then straighten up and thrust the spade into the ground once again, sinking forwards as the soil yields. The varied rhythm of the whole cycle of this working activity is encapsulated in two crucial moments, and in two figures.

The sharply delineated outline of *Man with Wheelbarrow* [192] immediately tells us the artist's intention: his focus is on the forward angle of the body and the rearward, propelling leg – which, taken together, form a right-angled triangle that rests on its shorter cathetus, with a decisive directional movement.

The credibly heavy load connects to the vertically adjacent hanging of the arm.

In factual terms, the composition of Raphael's *The Massacre of the Innocents* [195] rests upon various forms of overcoming resistance through traction. Differentiated modalities are presented: the action of pulling horizontally backward (cf. Figure 185), and the action of pulling in the upright position. In every case, the force is generated by the extended, braced leg, whilst the free-swinging leg holds itself in readiness to intercept a centre of gravity that lies outside the area of the bracing leg.

Fig. 190 Max Slevogt (1868–1932).
Tänzer. Coloured pen sketch.
Nationalgalerie, Berlin.
The act of balancing on tiptoe creates a brief resting point and climax in the flow of movement.

Fig. 192 Jean-François Millet (1814–1875).
Man with Wheelbarrow. Black chalk.
Museum of Fine Arts, Boston.
The pressure that pushes the load forwards is generated by the extended, pushing rearward leg, the oblique position of which is continued by the rest of the body.

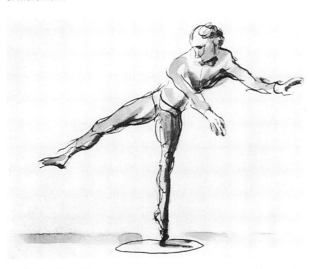

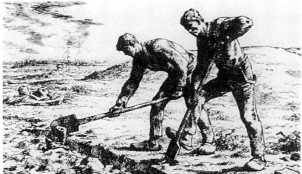

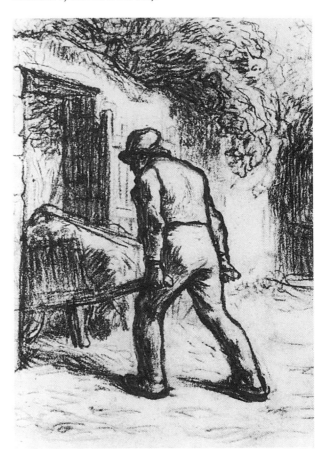

The bearing and movements of the human body: the basics of statics and dynamics **183**

In his *Nude Man from Rear* [193], Signorelli depicts a vertical blow from above. This vehement action is not restricted to the arms. He successfully shows how the full weight of the two-handed stroke is expressed in the participation of the whole body: the act of rising on the tips of the toes, the force exerted by the calf muscles, the stretching and backward inclination of the upper body, the migration of the shoulder girdle in response to the vertical raising of the arms, and the clenched fists.

Like Millet, Goya must have been thinking of the rhythm of a closed cycle of labour when he created (in a few violent brushstrokes) his artwork *Gravediggers* [194]. Unlike Millet, however, Goya gives the climax and the fertile moment of the movement an unambiguous culmination in the foreground figure. In the actual shaping of the movement, the critical factual parameters to which Goya's sensitivity and powers of expression are applied are very similar to those of Signorelli: namely, the totality with which the whole body is devoted to intensive, powerful work. In Käthe Kollwitz's work, this theme finds its highest artistic expression. Her *Die Pflüger* [196], the first work in her *Bauernkrieg* series, shows a barren and comfortless world in which the title figures pull an agricultural implement that does not belong to them, drenching with their sweat the soil that is not their property, and dragging themselves through lives mired in debt since before they were born. Their bent backs are nothing more than a hump, lost in the sombre horizon. The suffering of humanity pushes them down almost into a horizontal position. The human being has become a beast of burden, pulling in harness to break the hard soil for a scanty crop.

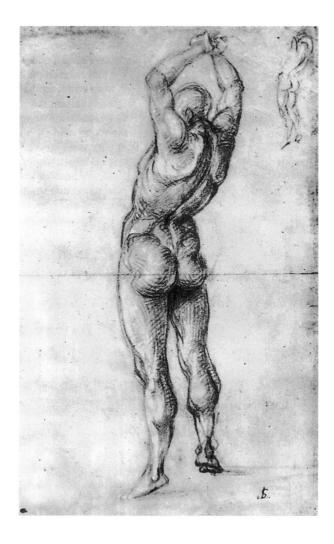

Fig. 193 (top right) Luca Signorelli (c. 1445–1523).
Nude Man from Rear. Black chalk, 41 x 25cm (16⅛ x 10in). Louvre, Paris.
The way the figure is rising onto the tips of the toes, and the rearward movement of the upper body and arms, justifies our interpretation of a sweeping striking motion from above.

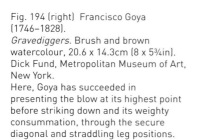

Fig. 194 (right) Francisco Goya (1746–1828).
Gravediggers. Brush and brown watercolour, 20.6 x 14.3cm (8 x 5¾in). Dick Fund, Metropolitan Museum of Art, New York.
Here, Goya has succeeded in presenting the blow at its highest point before striking down and its weighty consummation, through the secure diagonal and straddling leg positions.

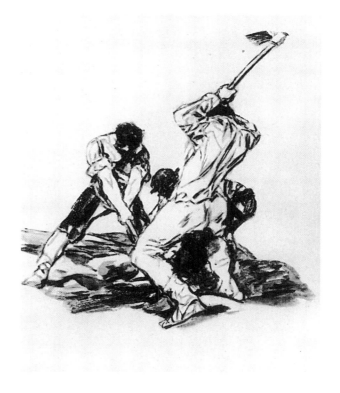

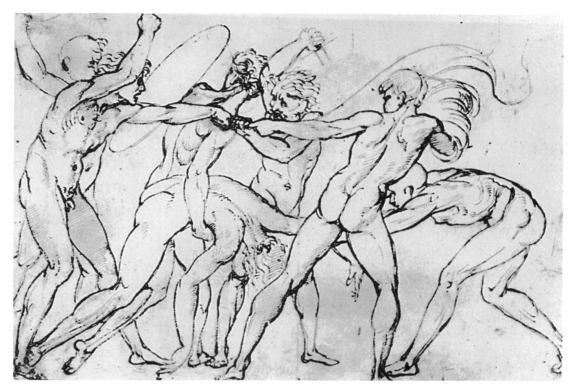

Fig. 195 (above) Raffaello Santi [Raphael] (1483–1520).
The Massacre of the Innocents. Pen and brown ink,
27.5 x 42cm (11 x 16½in). Ashmolean Museum, Oxford.
In terms of movement, the main theme is the different
degrees of intensity, from bracing in order to resist to
a powerful pulling backwards.

Fig. 196 (below) Käthe Kollwitz (1867–1945).
Die Pflüger (1906), an image from her *Bauernkrieg*
series. Etching and aquatint.
The way that both of the men engaged in ploughing are
leant into the drawing harness to the most extreme
forward position of the centre of gravity, close to the
earth, creates a metaphor for human suffering.

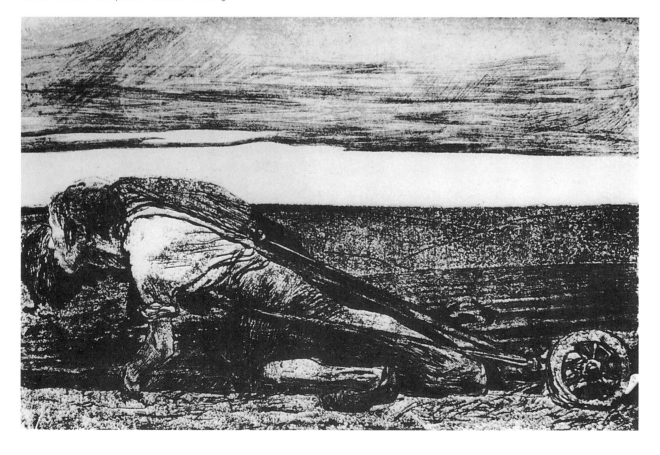

The bearing and movements of the human body: the basics of statics and dynamics **185**

4 The body's plastic building blocks

Artistic anatomy regards all of the factors in the body's shape – the bones, the muscles, the skin and fat, and the sensory organs – as being part of a system known as 'the plastic building blocks of the human body.'

All of these building blocks affect the shape of the body's surface. They are presented here almost entirely in this aspect. The movement apparatus – that is, the system of the bones and muscles – must of course be addressed more thoroughly, to do justice to the extent of its direct influence on the body's form. The same applies to the skin and fat, and to the external structures of the sensory organs.

Discussions of the different specific formative building blocks, however, will be preceded by a brief, incomplete discussion of their general properties and roles, based on the knowledge essential for an artist.

The bones and muscles constitute a system, an indivisible unity. Neither can function without the other. Without the motive power of the muscles, bones would be without purpose, just as muscles would be useless without the support and firm leverage provided by the bones. The skeletal system is therefore described as the passive element of the movement apparatus, with the muscular system described as the active part of the movement apparatus.

4.1. THE GENERAL FEATURES OF BONES

The explanations presented here will not include the wider plastic significance of the bone: forms, surface configuration, individual sections, construction and substance. Instead, our interest focuses on the composition and construction of the joints. This restriction is for the benefit of the most relevant areas.

The responsibilities of the bones are numerous and diverse. The bones (more than 200 in total) form the scaffold and support structure of the skeleton, which holds, secures and provides suspension for the soft tissue components. In particular, it provides the origins and attachment points for the muscles, thereby offering levers of varying lengths for operating the joints. The joint is the commonest form of junction between bones. Bone construction is reinforced in the region of the joint to cope with the higher demands placed on these areas. In addition to providing suspension, some bones (the brain case, the rib cage, the pelvis) may also provide special protection to the soft tissue parts. The spinal

canal provides a mobile, protective tubed structure for the spinal cord.

4.2. GENERAL THEORY OF THE JOINTS

Bones may be connected in various different possible ways: in the form of fixed connections, cartilaginous connections and tight connections, and the articulated joints. It is this last group that will be considered here.

The articulated joints are highly functional bony connections whose function and form properties must be understood in terms of their basic fundamentals. The natural construction of the joint is extremely economical, ensuring maximum security. The extent of joint movement varies from a minimum to a maximum degree, depending on the purpose of the joint and on whether its requirements are best served by restriction or by freedom. All joints have the same components, but the form of the body of the joint and the ligament configuration type determine the type and extent of their mechanical action.

The constituents of a joint: these include the epiphyses, the synovial cavity, the articular capsule, the synovial fluid, the cartilage and the ligaments [197].

The epiphyses are thickenings of the bones at their proximal and distal ends. At least two bones meet at any joint; these will have elevations and depressions, positive and corresponding negative forms. The joint ends' complementary forms determine the range, character, and security of the movement.

The joint cartilage is an elastic, pressure-resistant tissue. It covers the surfaces of the joint, making them smooth and helping the forms to fit neatly together, and thereby contributing to the security of the joint's movement. It acts as a buffer, absorbing shocks and reducing friction. The menisci (supplementary fibrous discs between the joints that act as interstitial components) constitute a specialised form of joint cartilage (in the knees, for instance) that can be passively displaced.

The intra-articular space: (synovial cavity, cavum articulare) is a fluid-filled space that separates the joint bodies, which are held together by relatively tight or loose ligaments (ligamentum) positioned outside of the synovial cavity (and sometimes by additional ligaments inside the synovial cavity). This assists the action of movement in achieving its range and direction.

The articular capsule (capsula articularis) is a sac of tough fibrous tissue enclosing portions of the joint. An inner skin (the stratum synoviale) isolates the synovial fluid (synovia). The outer layer of the capsule contains the articular ligaments, which provide reinforcement. The airtight sealing of the joint is believed to protect its integrity. The viscous fluid (synovial fluid) reduces the friction of the articular cartilage almost to zero.

The basic joint forms [198]: These determine the mechanics of the joints. The various possible degrees of freedom of movement for a joint depend upon the shape of the ends of the joints, and on the number and directional alignment of the joint axes. One can only understand the action of a muscle based on a clear mental picture of the axes that determine the movement of the joint, and the position of the muscle's direction in relation to the axes. This removes the need to memorise the joints' mechanical properties. One must know in general about the position of the muscles and the muscle groups in relation to the joint axes. Deducing the results of their function is then simply an act of logical thought.

Joints with one degree of freedom [198/1a, 1b]: Two possible one-degree joint forms exist: the hinge joint and the rotating joint. The hinge joint performs a movement within a single spatial plane, at right angles to a transverse axis. To facilitate this, the joint bodies must have a cylindrical or roller configuration. Guide grooves and protuberances ensure the secure action of the joint. The lever arms that connect to the roller and bearing structures describe an angle. If this angle is increased, an extension is created; if it is reduced, a flexion is created. (Examples of hinged joints include the elbow joint, the upper ankle joint, the knee joint and the medial and terminal joints of the fingers and toes).

Rotating joints are another form of uniaxial joint, in which level surfaces come into conjunction, which rotate around a longitudinal axis. (Examples: the interconnections between the vertebrae, and the proximal and distal radio-ulnar joints).

Joints with two degrees of freedom [198/2a, 2b]: These joints articulate in two spatial planes around two main axes that are perpendicular to each other: that is, around a transverse axis and a sagittal axis. Two possible constructions exist: the ellipsoidal joint (articulatio ellipsoidea) and the saddle joint (articulatio sellaris). Both joint forms add a sagittal axis and lateral adduction and abduction movements (such as a 'hacking' motion by the hand) to the basic movement of flexion and extension (movement on the transverse axis). In an ellipsoidal joint, congruent joint ends that have the convexity of half of the outer surface of an egg and the concavity of half of the inner surface of an egg respectively come into contact. The combination of the two joint axes produces an ellipsoidal movement (one example is the wrist joint). The construction and function of the saddle joint can be seen in the drawing provided. One bone sits atop the other like a rider in the saddle: the saddle joint's movements resemble those

of the ellipsoid joint, with the rider able to execute both a forwards-and-backwards movement (opposition and reposition) and a movement to either side (abduction and adduction). The definitions of the axes and the movement of the joint are the same. (Example: the carpometacarpal joint of the thumb.)

Joints with three degrees of freedom [198/3]: These joints have a third axis in addition to the two axes previously discussed: a longitudinal axis, with an inward and outward rotation. The longitudinal axis is at right angles to the previous axes; the construction is that of a ball joint, with joint ends in the form of a ball-shaped head and a socket. The three basic axes, each with their corresponding basic movement (for the transverse axis, flexion/extension; for the sagittal axis, adduction/abduction; for the longitudinal axis, inward rotation/outward rotation) are supplemented by countless 'intermediate' axes, which permit an endlessly large number of movements. (Examples: the hip and shoulder joints.)

4.3. THE GENERAL FEATURES OF THE MUSCLE (MUSCULUS)

The muscle is a contractile organ able to exert a pull on a lever, and to thereby create movement at a joint, or – if muscles are applied simultaneously from different sides – to hold a joint firm. The deep, dark red colour of a muscle results from the muscle pigment myoglobin, an oxygen-carrying pigment which transfers oxygen from the blood into the muscles. The hardness of a muscle increases as its tension increases; this also causes a swelling in its volume.

Fig. 197 The construction principles of a joint (the illustration is taken from Rauber-Kopsch). With the exception of the menisci and the fat pad, all of the listed components are essential to a joint's function, and will be found in every other true joint. In this example, the knee joint is shown.

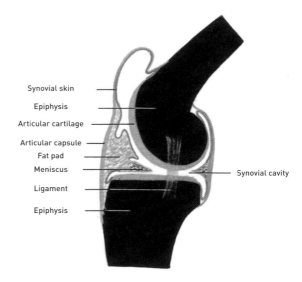

Synovial skin
Epiphysis
Articular cartilage
Articular capsule
Fat pad
Meniscus
Ligament
Epiphysis
Synovial cavity

In its resting state, a muscle is flaccid and soft. Collectively, the skeletal muscles (around 400 in total) are referred to as the musculature. In many instances, the muscles affect the shape of the body's outer surface. This subject matter is therefore materially important to artist anatomy.

4.3.1. Muscle forms [199]

Nature has produced a number of different muscle forms, each suited to a different role and action.

Forms	Examples
Fusiform muscle	Biceps
Unipennate	Extensor digitorum longus (specialised extensor of the big toe
Bipennate	Flexor digitorum longus (specialised flexor of the big toe)
Triangular muscle	Pectoralis major (large chest muscle)
Parallel muscle	Rectus abdominis (straight abdominal muscle)
Multipennate muscle	Quadriceps
Circular muscle	Musculus orbicularis oculi, musculus orbicularis oris

4.3.2. The individual sections of the muscle: its assisting mechanisms and actions

The mass of the muscle proper is called the muscle belly. Depending upon the muscle's requirements, it will begin with a long or with a short tendon (tendo). The tendon is an assisting mechanism, and is not itself a contractile organ. It simply transmits the pull of the muscle to the bones. Whilst the tendon's resistance to pulling strain is considerable, it is very sensitive to pressure. The part of the muscle that springs from the fixed part of the skeleton (or punctum fixum) is known as the origin; the part of the muscle attached to the leverage arm for the movement (the punctum mobile) is known as the insertion [200].

The muscle also has other auxiliary mechanisms: the fluid sacs (bursae) which have the function of a small cushioning water-filled pad at pressure points where muscles rest on a hard bone region, and the synovial tendon sheaths (vagina synovialis tendinum), which is a fluid-filled tube surrounding the tendon that reduces the friction generated by pressure where the tendon is in contact with hard bone. The muscle's action depends upon the alignment of the main lines of the muscle (the connective line between the origin and the insertion) in relation to the joint axes. The levers operated by the muscles are of varying lengths.

4.3.3. The structure of movements

Generally speaking, movements are not isolated events in which only a single muscle is involved. They almost always involve the participation of whole muscle groups. These may, in turn, come together with other muscle groups to form muscle chains [200/1, 201]. The bending action in which we lower our upper body backwards, for instance, involves the participation of the hip flexor muscle group (to hold the joints firm), the knee extensors, the calf muscles (which hold the joints firm in order to prevent the body from tipping forward), and the muscles in the front of the neck (which hold firm to prevent the head from tipping back). The collective functioning of muscles to achieve the same purpose is known as synergism.

Each individual muscle has its opposite, or antagonist, muscle. Analogously, each muscle group has its antagonist group. This is necessary in order to allow us to reverse our movements and, by varying the degree of tension, to keep our movements smooth, continuous and fluid, where they would otherwise be hacking and jerky. Where necessary, the antagonist muscles may be used to brake or stop a movement (in throwing and pushing actions, for instance) in order to prevent damage to the joint through the striking of its component parts.

The part of the skeleton that is to be moved (the punctum mobile) is drawn towards the muscle's origin on the relatively static part of the skeleton (the punctum fixum) [200a] by the muscle's insertion tendon. The pelvis, for example, provides the static foundation for the movement of the legs. A knee extensor muscle originates from the static foundation provided by the pelvis, and has its insertion point at the tibial tuberosity. The leg is moved around the transverse axis of the hip in the direction of the pelvis. Conversely, the pelvis, along with the upper body, tilts around the centre of rotation in the direction of the leg, with the leg remaining static [200b]. From this, we can see that the origin and insertion points of a muscle may change places, with the mechanical action remaining the same.

If a muscle relates to several of a joint's axes of movement (as the gluteus maximus muscle does in the case of the hip joint, for instance) then it may use different sections to perform several functions, or even act as its own antagonist (with abduction and adduction performed by an outer portion and an inner portion respectively, arranged analogously on the outer and inner sides in relation to the sagittal axis).

Fig. 198 Forms of the joints.
Left vertical row: principles of construction of the different forms of joints.
Right vertical row: examples of the different forms of joints.
The axes of the joints have been drawn in to aid comprehension of the joints' mechanics, and of the associated muscle functions.

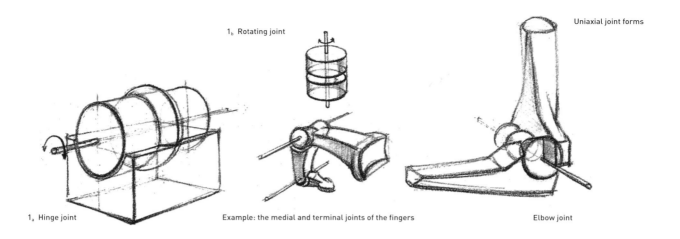

1_b Rotating joint

Uniaxial joint forms

1_a Hinge joint

Example: the medial and terminal joints of the fingers

Elbow joint

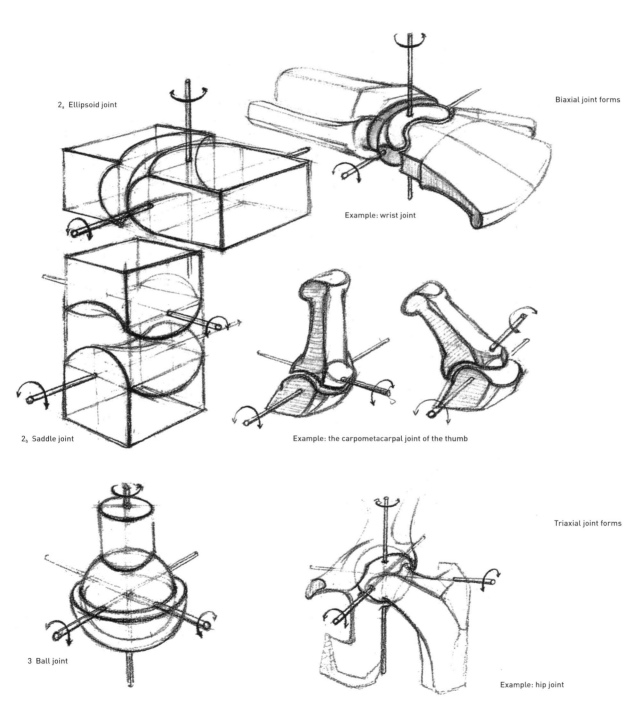

2_a Ellipsoid joint

Biaxial joint forms

Example: wrist joint

2_b Saddle joint

Example: the carpometacarpal joint of the thumb

Triaxial joint forms

3 Ball joint

Example: hip joint

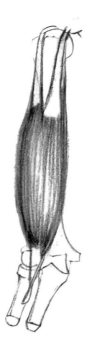

Two-headed muscle
Example: the biceps of the arm

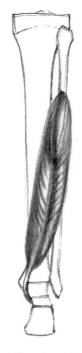

Bipennate muscle
Example: flexor digitorum longus
(flexor muscle of the big toe)

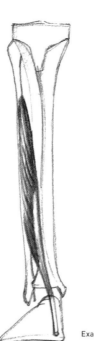

Unipennate muscle
Example: extensor digitorum longus
(extensor of the big toe)

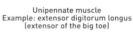

Triangular muscle
Example: pectoralis major (large chest
muscle)

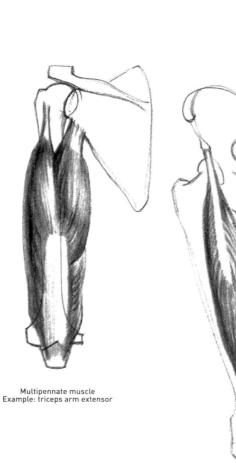

Multipennate muscle
Example: triceps arm extensor

Circular muscle
Example: musculus orbicularis oris

Fusiform muscle
Example: straight head of lower leg
extensor (rectus femoris)

Parallel muscle
Example: straight abdominal muscle

Fig. 199 Muscle forms.
The different volumes and forms of the
muscles affect the shape of the body's
surface in different ways.

190 The body's plastic building blocks

Fig. 200 A muscle marked to show its positional relationship to one or more joints, and its switching of its origin and insertion points.
Knowing the position of a muscle in relation to the joint axes allows us to determine its action and to understand its volume. The points of origin and insertion are determined by which of the sections of the skeleton are static, and which are moving.
a) The punctum fixum (**p.f.**) is located in the pelvis, and the punctum mobile (**p.m.**) is located in the tibia.
Muscle action: the raising of the leg in the direction of the pelvis.
b) The punctum fixum is located in the tibia, and the punctum mobile is located in the pelvis.
Action: the lowering of the pelvis in the direction of the leg.

Fig. 200/1 The chain of muscles that hold the joints firm to maintain a forward bend position.
The securing of the balance necessary for this position begins (starting at the lowest point and ascending) with the muscles in front of the transverse axis of the upper ankle, and continues in the rear part of the thigh, holding in place the forward-inclined pelvis. The holding function for the torso is taken over by the back extensor musculature. Here, all of the muscles in the chain are in an extended, tensed state, and can therefore reverse the position effectively.

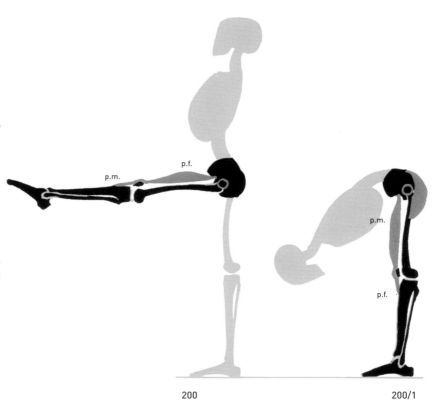

200 200/1

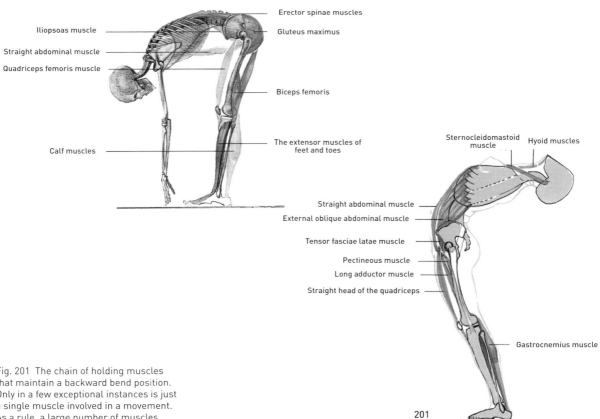

Fig. 201 The chain of holding muscles that maintain a backward bend position. Only in a few exceptional instances is just a single muscle involved in a movement. As a rule, a large number of muscles, forming a 'linked chain', are involved.

The body's plastic building blocks **191**

4.4. GENERAL INFORMATION ON THE SKIN AND FAT

The skin, or cutis, is an enveloping organ capable of expansion. It offers direct protection against mechanical damage, and against chemical and bacterial agents. It plays a role in regulating the body's moisture balance and thermal balance, and functions as a sense organ (the sense of touch). In general, it is capable of significant displacement on its foundation, the greater body fascia, except at a number of points where it is firmly affixed to the underlying bone (the fossae lumbales laterales or dimples of Venus, for instance), and places where increased demand is placed on the skin (the palm of the hand and the sole of the foot). The subcutaneous connective tissue is an intermediate or connective layer that varies in thickness, and is positioned between the skin and the fascia.

4.4.1. Specialised skin structures [203]

The mobility of the skin causes it to bunch up and to form folds (e.g. the transverse folds where body parts converge) [202]. Functioning processes are reflected in the skin, causing it to form ridges and incised depressions, and, conversely, taut and stretched areas [352]. Transverse folds result from the bunching up of the skin transverse to the direction of muscle contraction (on the flexed and extended sides, as with the folds at the finger joints). Twisting actions stretch the skin diagonally, like drapery. Aside from the skin's functionally generated folds, there are also the folds produced by age, or by the state of one's health. Other skin structures include lines, furrows, channels and dimples.

Furrows: On the infant body, the fat welling beneath the skin is tightly constricted at the joints. This is similar to the state of fuller forms in people of an advanced age (a double chin, for instance, is created by the way the subcutaneous fatty tissue at the base of the mouth is constricted and separated from the chin by the chin furrow) [517].The so-called lateral fold (sulcis lateralis) springs from the union of the straight abdominal muscle and the external oblique abdominal muscle, and separates the two muscle plates from each other.

Dimples: These are soft depressions. In a number of places, these skin areas are firmly affixed to the underlying skeleton or musculature by tough fibres.
Chin dimple: The point at which the skin is secured at the end point of the chin.
Cheek dimples: The points at which the skin is secured to the circular muscle of the mouth.
Shoulder dimples: The points at which the skin is secured to the triangular tendinous form of the trapezoid muscle on the spinus scapulae. These dimples are deepened when the shoulder blades are drawn together [392].
Elbow dimple: Frequently double, an elbow dimple is the point at which the skin is secured to the medial and lateral epicondyles of the humerus (epicondylus ulnaris et radialis) [199b, 202b, 126b, c].
Hand and finger dimples: Point at which the skin is secured to the extension side of the basal and median joint of the finger, in children and in adults with pronounced connective fatty tissue, particularly women.
Popliteal dimple: Found on the back of the leg behind the knee, where the popliteal artery is located; it is particularly common in women and children with strong connective skin tissue.

Lines: These are shallow, longitudinal indented furrows. In some areas, they emphasise the secondary gender characteristics. To anyone capturing an artistic likeness, they are of great significance.
In many places, the line of symmetry of the whole body can be traced in the skin. The line begins at the bridge of the nose, passes through the point of the chin and the sternum, acquires a clear vertical direction at the linea alba of the straight abdominal muscle (in men and women alike), and ends at the pubic bone. On the rear side of the body, it extends from the back of the head along the spinous processes, terminating at the sacrum. In the mature female body, in particular, the abdomen has transverse lines – the upper and lower crescent-shaped abdominal lines [126] – lying across the straight abdominal muscle in the proximity of the pubic bone. The lower of these characteristically separates the mons pubis from the abdominal wall. The thigh flexor rises a little upward from the oblique sides of the mons pubis into the inner side of the thigh.
The inguinal crease (linea inguinalis) curves from the anterior superior iliac spine (spinal ilica ventralis) in a bow shape toward the upper limit of the pubic symphysis [125]. The skin fuses with the inguinal ligament, which forms the basis of the inguinal line. In a man, together with the spermatic cord, it forms the inguinal canal. In both sexes, it delimits the abdomen from the extremities [127c, 281].

4.4.2. Fat

The remarks in the previous section on the peculiarities of the skin and its structures relate very closely to the role of the body's fat as a plastic building block of the body. In many places, the fat and skin together model slack or plumped-out skin areas, regions of soft padding, sunken dimples, and rounded body forms [126, 202]. Fat provides reserves (stored fat, or adipose). Insufficient nutrition or illness may cause it to be depleted. Additionally, gaps and hollows between

Fig. 202 A woman with voluminous, subcutaneous fatty tissue.
Fleshy skin (as in the example seen here) produces fewer, deeper folds, whereas thin subcutaneous fatty tissue produces a large number of shallower folds. The bunching up of the skin occasioned by sitting occurs slightly above the navel and pubic bone.
a) The behaviour of the soft tissue forms in frontal view.
b) The behaviour of the soft tissue forms in profile view.

the muscles are filled out by fat (structural fat, such as the fat in the popliteal fossa). It functions as thermal insulation, and as a pressure-distributing cushion (at the ischial tuberosities, for instance).

4.4.3. General and specialised fat deposits

The body of an infant or of a woman is covered by abundant subcutaneous fatty tissue, creating similar soft, rounded forms. A man's body, however, which is designed for a greater combustion process, has a generally reduced thickness of subcutaneous tissue. The thinness of a man's skin causes his muscles and skeleton to appear in sharp profile. Aside from the accumulation of fat, which is common to both sexes, the female body has specialised pads of fat that significantly emphasise the differences of the secondary gender characteristics of men and women [203].

Accumulations of fat are found on the head of both sexes: in the eye sockets, around the masticatory muscles, behind the lower jaw, and around the temporal muscle above and below the cheekbone or zygomatic arch. This fat is retained even after an extended period of starvation.

The throat region: Fat fills out the upper and lower hollows of the collarbone and the hollow of the throat, with softer lineaments seen in women [465, 467].

Buttocks: Fat fills out the space between the paired gluteus maximus muscles, which form a downward-opening triangle. This creates the vertical gluteal cleft, and the horizontal gluteal fold [258].

Knee: Fat fills out the triangular depression in the hollow of the knee, which is created by the inner and outer insertions of the flexors on the head of the tibia. When the knee is extended, the fat of the knee beneath the straight patellar tendon is pressed outward.

Hand and foot: Pads of the palm of the hand and the sole of the foot serve to resist pressure.

Particular fat deposits found in women:

The breasts: From an anatomical perspective, these represent a specialised accumulation of glandular and fatty tissue, attached to the major pectoral muscle by tough tissue [203, 209]. The area of the rib cage's surface covered by well-formed breasts extends approximately from the third to the sixth rib. In a young woman with a healthy constitution, they are taut hemispheres that rest on the rib cage without the formation of any fold; their lower boundary, however, is not horizontal, but declines obliquely outward, almost parallel with the opening of the costal arch.

Changes take place in the breasts during pregnancy – quite independently of breastfeeding – that affect their consistency, meaning that they will never again have the appearance they had before childbirth. The nipples of a young woman's breasts, with their rose-to-brown pigmented areolae, are not located in the centre of the hemispherical shape, but slightly outside of the mid-area.

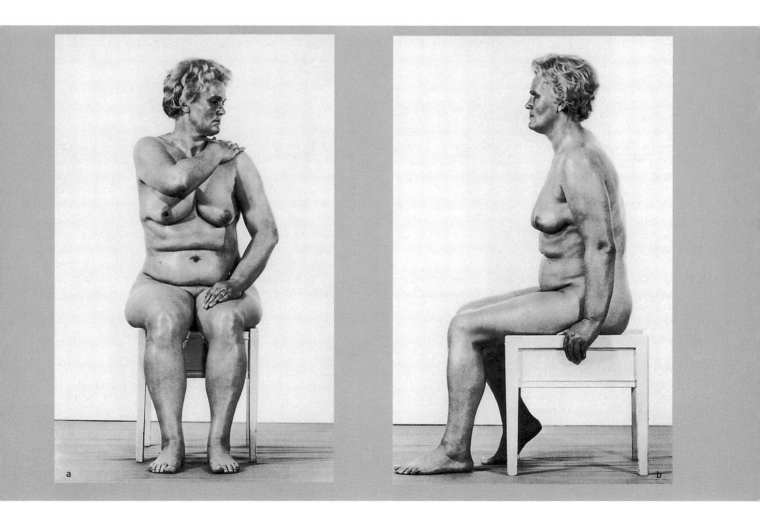

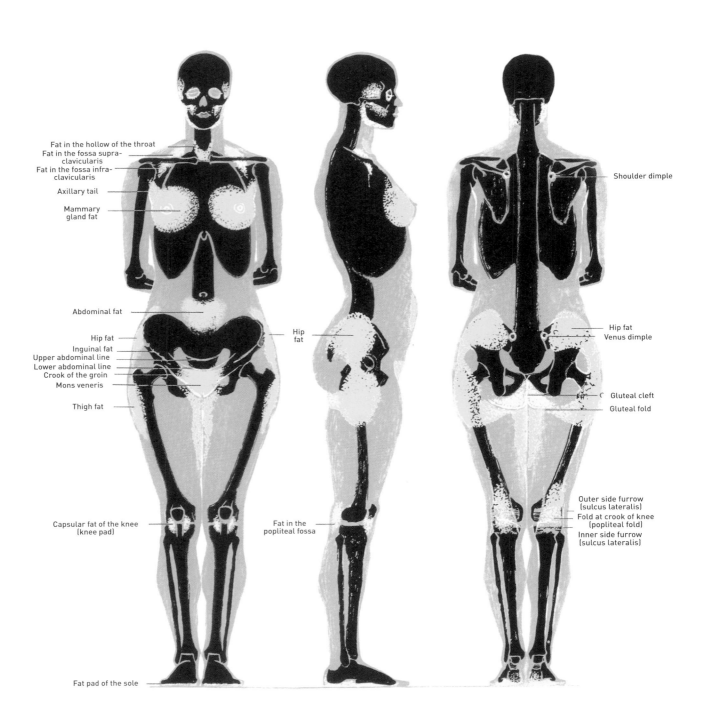

Fat in the hollow of the throat
Fat in the fossa supra-clavicularis
Fat in the fossa infra-clavicularis

Axillary tail

Mammary gland fat

Abdominal fat

Hip fat
Inguinal fat
Upper abdominal line
Lower abdominal line
Crook of the groin
Mons veneris

Thigh fat

Capsular fat of the knee (knee pad)

Fat pad of the sole

Hip fat

Fat in the popliteal fossa

Shoulder dimple

Hip fat
Venus dimple

Gluteal cleft
Gluteal fold

Outer side furrow (sulcus lateralis)
Fold at crook of knee (popliteal fold)
Inner side furrow (sulcus lateralis)

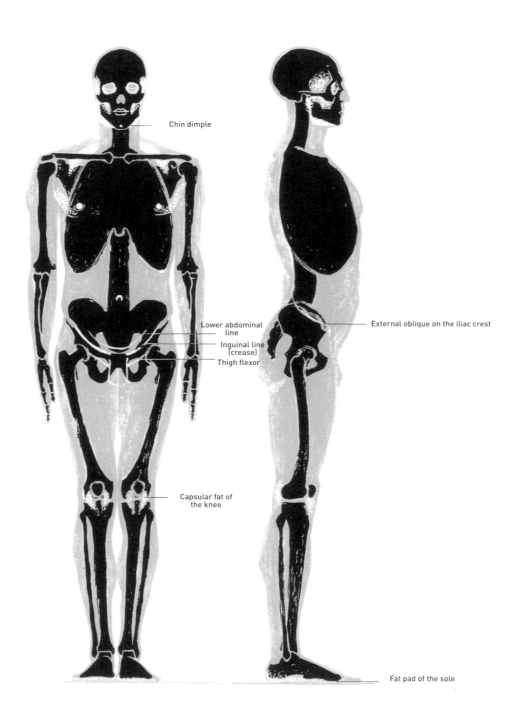

Fig. 203 General and specific fat deposits
and surface structures of the skin.
Pale yellow colour tone: fat pads shared
by both sexes.
Bold yellow colour tones: fat pads found
in women only.
As with proportions, these fat deposits
are classed as secondary gender
characteristics.

Chin dimple

Lower abdominal
line

Inguinal line
(crease)

Thigh flexor

External oblique on the iliac crest

Capsular fat of
the knee

Fat pad of the sole

The developed hemispherical form is characteristic of European women; the breasts of black African women sometimes have a more pointed appearance (a conical breast shape). In this case, the cone form will approach the nipple without significant rounding.

The location, position and form of the breasts change with the position and movements of the body [204–206]. Their attachment to the major pectoral muscle forces them to follow its movements; they are drawn upward by a vertically raised arm [206–207], and apart and outward by a lateral, horizontal arm position. When a woman reclines, her breasts flatten out. When her torso is inclined forward, the breasts' own weight causes them to assume a conical, pointed shape [204, 352]. The axillary tail refers to a cord-like pad of tissue, running from the upper outermost side of the breasts to the armpits. Every variation on the breast form that exists in nature has been depicted in the fine arts: evenly proportioned, well-formed breasts in antiquity; suppression of breasts in the Gothic era; full, rounded

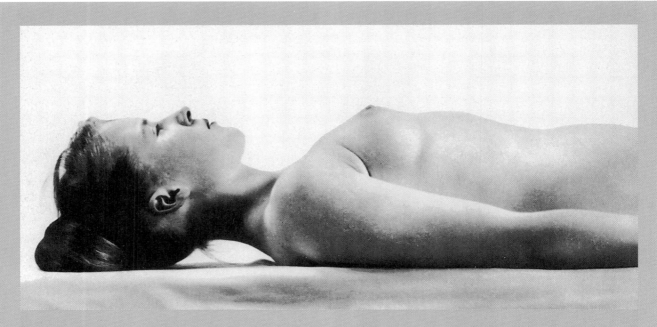

Fig. 204 The behaviour of the breasts in the reclining posture, with the arms by the sides. In this position, the spheroid form of the female breast, which is composed of connective tissue strands and of glandular and fatty tissue, flattens out under its own weight.

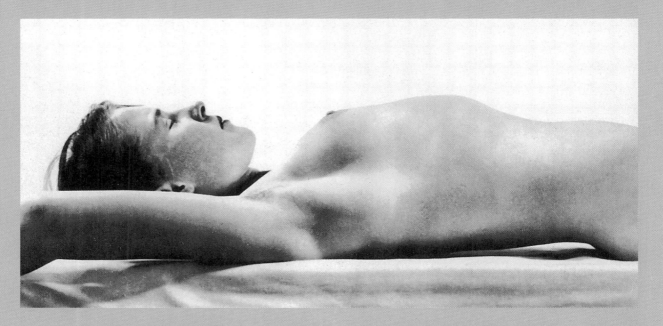

Fig. 205 The behaviour of the breasts in the reclining posture when the arms are raised, with the upper arms placed close to the head. The tight attachment of the connective tissue strands of the breasts to the expanded major pectoral muscle causes them to flatten out further, and also causes the nipples to rise upward (compare the distance between the nipple and the chin as seen in the upper illustration, and in the lower illustration).

breasts in the Baroque era; ugly and emaciated breasts in Goya's etchings; chaste breasts in classicism, but also the striking sensuality of Corinthian prostitutes. This subject speaks volumes on social views concerning the position and importance of women.

Additional fat-padded regions

The side hip region: A little above the iliac crest to above the major trochanter. In particular, this fatty pad covers the gluteus medius, resulting in a soft gradation from the iliac crest to the external oblique abdominal muscle and gluteus medius. Beneath the major trochanter, there is a general large, expansive elevation of fat (to

a lesser degree in youth, and to a greater degree with age) [124a].

The navel region: The lower navel region is hemmed in by a shallow tapered embankment. Even when the body is in a resting position, this area is marked by a depression produced by the tendinous lowermost inscription of the straight abdominal muscle [124a].

The mons veneris: This feature constitutes the characteristic termination of the fat deposits on the front face of the female torso, and is a fatty pad that is triangular in shape, terminating at its upper limit horizontally against the abdominal line, and with the point of the triangle at its lower limit, between the thighs [126a, b].

Fig. 206 The rising of the breast that accompanies the vertical raising of the arm in profile view.
In particular, note the way the armpits are formed by the thick cords of the latissimus dorsi, the pectoralis major and the structure of the dependent axillary tail.

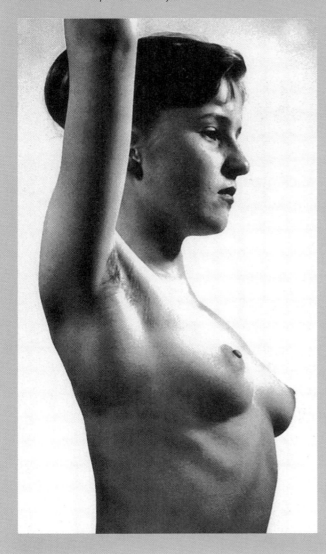

Fig. 207 The lifting of the breast occasioned by a perpendicular arm position in frontal view.
Compare the differences in heights between the lower boundary line of the breasts and the nipples.

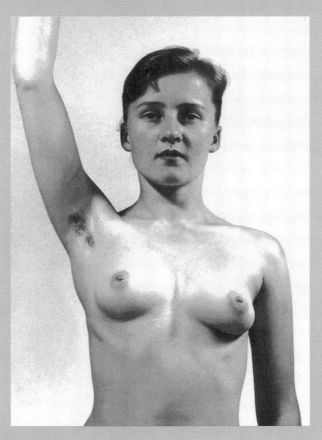

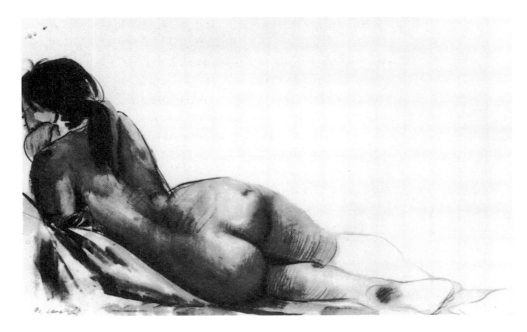

Fig. 208 Giacomo Manzù (1908–1991). *Reclining Female Nude from Behind* (1960). Pencil and tempera, 42 x 57cm (16½ x 22½in). The shimmering, rounded forms of her voluminous buttocks provide a material and formal counterpoint to the dull tones of her waist and the slender back.

Fig. 209 Pierre Paul Prud'hon (1758–1823). *Study of a Naked Girl*. Collection of Henry P. Ntc. Ilhenny, Philadelphia.
This artist frequently addresses the motif of the contrasts of function and form created in the female body by the raising of an arm on one side.

Fig. 210 Fritz Martinz (1924–2002). *Stehender Mann in Rückansicht*. Chalk, 67.5 x 45cm (26½ x 17¾in), from the artist's collection.
The functional static processes of the free leg standing leg position, and its influence on the behaviour of the skin, have prompted the artist to portray the structure of wrinkles in the bunched-up skin expressively, as a component that emphasises how body function is manifested.

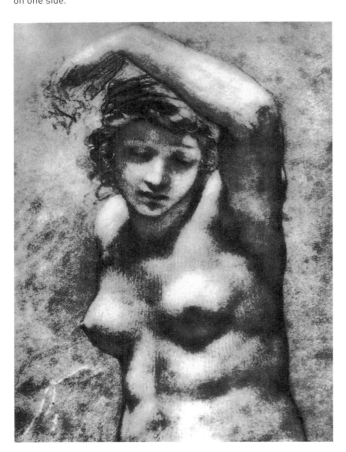

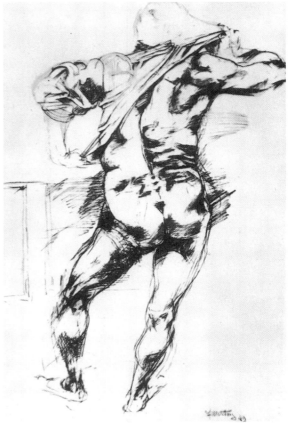

198 The body's plastic building blocks

4.5. TREATMENT OF THE BODY'S PLASTIC FORMATIVE ELEMENTS IN WORKS OF ART

The series of examples that we have given here should most emphatically not be understood as showing the plastic formative elements – skin and fat, bones and muscles – as individual values of visual appearance that are considered and represented in isolation from the artist, especially as an artist's perceptions of form tend toward capturing a sense of unity. However, the way these formative elements combine to construct highly specific, individual, unique forms – with the predominance of one element over another being a significant part of this – means that they are far from being a matter of indifference to the artist. The artistic subject matter that is of interest to an artist may even call for one or the other of the plastic formative elements above all else, meaning that, in order to bring the viewer into his artistic, pictured, envisaged world

as if it were an authentic realm, the artist must, in fact, thoroughly penetrate into the rules governing the behaviour of the plastic building blocks of the body.

There can be no doubt that, in addressing this, an artist is also faced with questions, such as those surrounding the measures of beauty or of ugliness.

When he created his four major studies, with their multiple figures, for *The Last Judgment* [211], Rubens filled one picture exclusively with grossly fat figures; with the well-filled, gluttonous and wasteful from the higher ranks of society. The only way to make these hell-bound figures credible as real, existing in reality, was to make sure that their bodies were subject to the rules governing the displacement, gathering, hanging down, stretching and pulling of the skin and fat masses.

Whereas Prud'hon strove to achieve harmonious proportions, balance, and – in spite of his fundamentally classicistic attitude – a spirited, lively beauty in his relief rendering of the female body [209]. Fritz Martinz, in his artwork *Stehender Mann in Rückansicht* is motivated by the contrapposto attitude to make the wrinkled skin

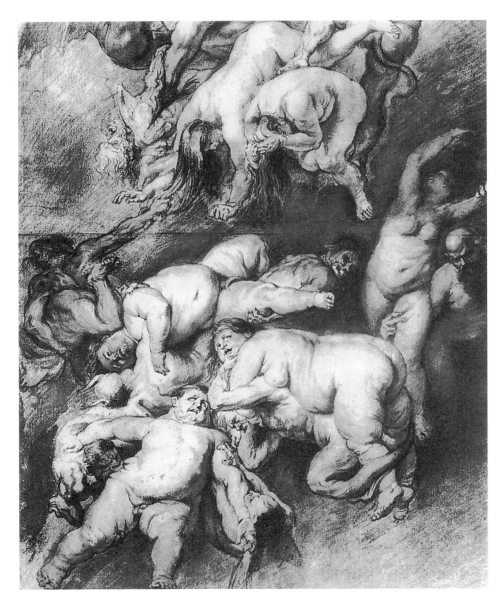

Fig. 211 Peter Paul Rubens (1577–1640).
A draft sketch for *The Last Judgment: The Fall of the Damned* (detail). Black chalk and red chalk, and grey watercolour, reworked with brush and oil paint, 71 x 47.5cm (28 x 18¾in).
The British Museum, London.
In spite of their grotesque, swollen quality, Rubens ensures an organic credibility for these figures thanks to his attention to the rules governing the behaviour of skin and fat masses – the way they drag, bunch up and generate folds. He treats the skin and fat as living drapery.

structure dictated by the configuration of the gathered, contracted side of the body the predominating feature of the form [210]. He reifies the experience of this process as if the skin, with its doughy consistency, had been ploughed up, with hewn notches and cracks. He simultaneously grants the skin, the enveloping organ, a right to speak, in material terms, as part of the artwork. In his *Reclining Female Nude from Behind* [208], Manzù increases this many times over, so that the lustre and shimmer of the swelling, smooth forms almost becomes the predominating surface expression. How subjective the artistic experience of the form is, and how wide the divergences are that exist between different cases, can be seen by comparing the *Stehende weibliche Akte* by Hegenbarth [212] with the artworks of Manzù and Kettner. There can be no doubt that the inspiration for Hegenbarth's nudes was provided by a meagre, 'angular' model whose body dimensions were slender and elongated, whose supporting frame was

rounded out only scantily, with only a few more gentle soft tissue forms here and there.

Kettner, on the other hand, uses well-padded, rolling forms and spheroid body forms to create a human landscape full of life and energy [214]. The delicate tensions in the skin, whose gradations of tone are rendered by Lebedev with an exceptional restraint, reflect the anatomical structures hidden beneath only in hints. Lebedev thereby succeeds in enclosing the figure in a dynamic and continuous outline, and in integrating three-dimensional physicality into the surface in the manner of a relief artwork [213].

Where the skin is subjected to a kind of stretching test through expansion, its thickness is changed. In his *Aufgestützt sitzender weiblicher Akt, von hinten*, Bammes tries to express this using an almost analogous process, transferring the skin tension to the graphical instruments in an almost physically tangible way. In this case, the outline is quite intentionally made open. [215].

Fig. 212 Josef Hegenbarth (1884–1962).
Stehende weibliche Akte.
Meagre growth and scant soft tissue forms provide the artistic motivation for angular, stick-like, hard-edged form structures.

Fig. 213 Vladimir V. Lebedev (1891–1927).
Kneeling Female Nude from Behind
(1915). Pencil, watercolour, 47.8 x 31.4cm
(19 x 12¼in).
Taken together, the soft modelling seen in the lines within the figure, which give the skin an appealing, almost material quality, and the strongly linear configuration of the external contours create a relief-like overall impression.

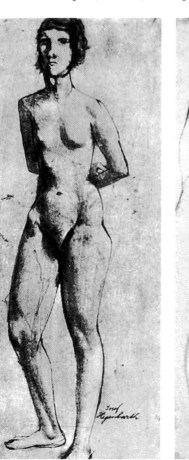 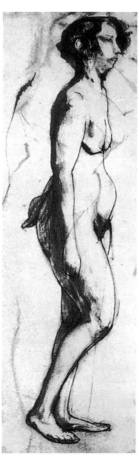 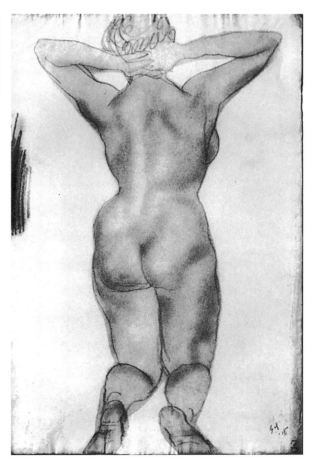

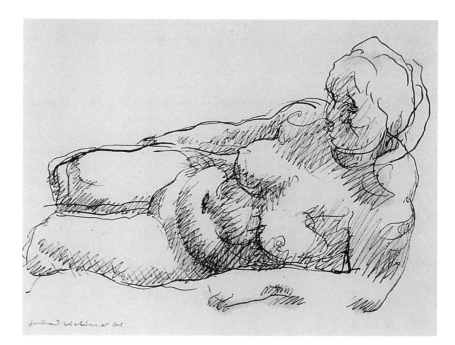

Fig. 214 Gerhard Kettner (1928–1993). *Liegende* (1961). Pen and ink. The rhythm of its spheroid and rolling surface structures transforms the body into a powerful dynamic landscape.

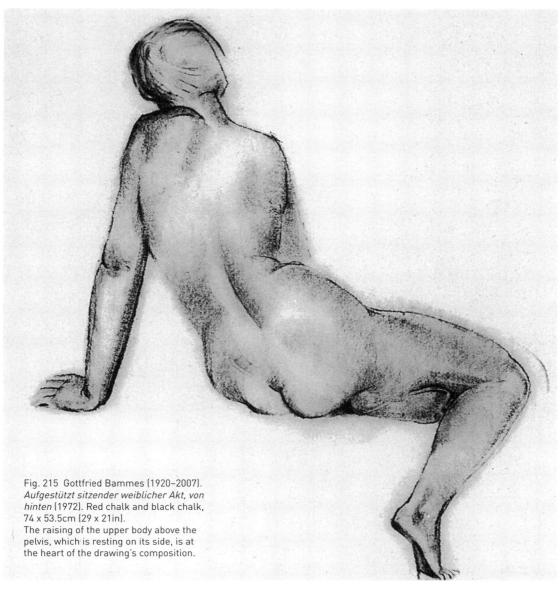

Fig. 215 Gottfried Bammes (1920–2007). *Aufgestützt sitzender weiblicher Akt, von hinten* (1972). Red chalk and black chalk, 74 x 53.5cm (29 x 21in). The raising of the upper body above the pelvis, which is resting on its side, is at the heart of the drawing's composition.

5 The lower extremities

5.1. GENERAL INFORMATION ON THE HIND EXTREMITIES IN ANIMALS AND THE LOWER EXTREMITIES IN HUMANS

The quadruped supports the load imposed by its horizontal trunk on four points, the two feet at the fore and the two hind extremities [216]. The main load, equating to about two-thirds of total body weight, is borne by the forelimbs. In contrast, the hindlimbs propel the body forwards during locomotion. The multiple angles in the joints of the hip, knee, upper ankle and, in some cases, also the joints at the base of the toes, act like a compressed spring that only requires sudden relaxation of the limbs before their extension to trigger propulsion or jumping forwards. The greater the distance between the sections of the extremities and the trunk, the greater the differentiation in the structure and mechanics of the joints. Based on the animal's lifestyle and adaptation to specific features in the terrain, the terminal portion of the extremities, the foot, is most diverse in its structure and function. The sections in the hind extremity in animals are largely the same as in the lower extremities in humans. We distinguish between the pelvis, upper and lower leg and foot. However, the development of the upright posture

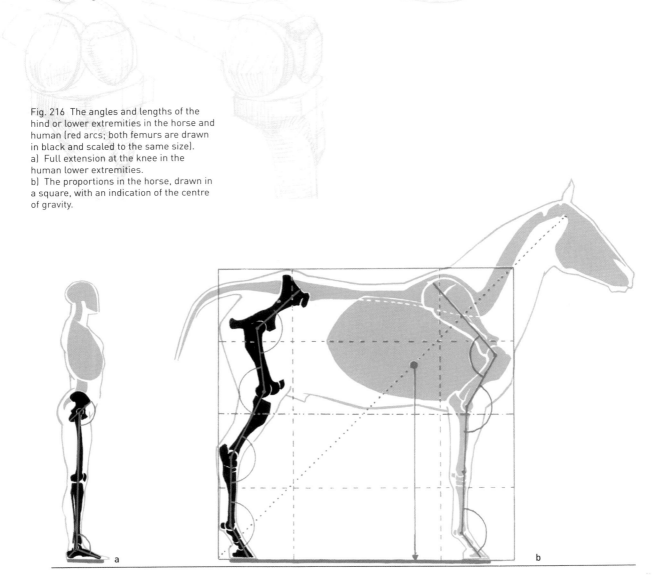

Fig. 216 The angles and lengths of the hind or lower extremities in the horse and human (red arcs; both femurs are drawn in black and scaled to the same size).
a) Full extension at the knee in the human lower extremities.
b) The proportions in the horse, drawn in a square, with an indication of the centre of gravity.

during human evolutionary history imposed specific demands on the construction of the leg – especially in comparison with the higher apes – as it progressively evolved to support the entire load imposed by the body. Adequate adjustments were required to compensate for the loss of support by four feet and quadrupedal locomotion. One pair of legs thus evolved that achieved full extension of the angle between the upper and lower leg at a decisive location, the knee. Among mammals, including the great apes, there is no other example of a pair of column-like legs that is fully extended or capable of full extension, which requires less muscle power due to its favourable static properties. The other two human structural features in the leg manifest in the unusual shift in proportions between the trunk and leg, and in the development of the foot into an elastic arch. The swinging, pendular leg in humans has been substantially elongated when compared with animals. The stride length that is thus achieved is longer relative to that in animals. This elongation of the leg has resulted in almost equal lengths of the upper and lower sections, as described in detail in the main section on proportions. However, the differences between human and animal feet are in their structure. The structural principles of the human foot are not repeated in any organism in the entire animal kingdom as a radical and clear separation in function has occurred for the human arm and leg. The hand is a universal working instrument, while the foot is a specialised organ for locomotion and standing.

5.2. THE CONSTRUCTION OF THE SKELETON OF THE HUMAN LEG AND THE ARRANGEMENT OF THE JOINTS

We include the pelvis in the structure of the leg, as it has become the centre of movement in the body in the form of a solid bony ring [217]. On the one hand, numerous movements originate in the pelvis, such as alignment of the spine or the upper leg. In its function as the connecting bridge between the spine and extremities, the pelvis must be strengthened at the hip joint if the entire load of the vertically oriented body is supported by two legs. The iliac blades have become larger in humans and have adopted the shape of bearing shells for muscle attachment. The orientation of the upper and lower legs which, overall, forms a triangle that rests on its apex at the feet, is of importance in the structure of the leg skeleton in its frontal view, as this allows direct support of the centre of gravity that lies within the pelvic cavity. This is why the axes that pass through the shafts of the upper and lower legs are never parallel. The greater the breadth of the bony ring of the lesser pelvis, the greater the increase in the space between the two hip joints and the more diagonal the course of the theoretical line (that must be imagined as running in an extension from the hip joint via the knee joint) through to the centre of the

ankle joint (load-bearing line). The shaft of the upper leg deviates from the direction of the load-bearing line as the femoral neck is inserted between the head and shaft of the femur as a lever arm for the muscle. This is the reason why the shaft of the upper leg deviates from the direction of the lower leg and thus forms the femorotibial angle (approx. 174°). Both tibias then follow the direction of the load-bearing line. They are therefore not parallel!

In contrast to the arm, three main joints occur in sequence in the leg: hip joint–knee joint–upper ankle joint. The hip joint is a ball and socket joint and, as such, exhibits the greatest variety of movements of all three joints in the leg. The basic adjustment of the position of the foot occurs here, aiming for the best-possible support for the load imposed by the body. The three basic pairs of movement –

flexion–extension (anteversion–retroversion)
adduction–abduction
internal rotation–external rotation

– correspond to the muscle function groups:

flexors–extensors
adductors–abductors
internal rotators–external rotators.

The joints with the largest scope for movement and the powerful and numerous muscles that move these joints have evolved such that they are located as close as possible to the centre of the body. Voluminous muscles thus surround the hip joint. The pelvis, the centre of movement, is also the site where the partial centres of gravity in the body unify to form the centre of mass. The peripheral sections of the extremities become increasingly slender and lighter, the greater the distance from the centre of movement, constituting an advantage in saving muscle power. The main muscle mass in the leg is thus located very close to its main centre of rotation, the hip joint. The column formed by the leg is interrupted by a joint at the knee. This is a biaxial joint with an incongruent structure that mainly allows flexion and extension around the transverse axis. When flexed, it can also rotate around a vertical axis that forms the extended axis through the shaft of the tibia, and thus achieves further differentiation in the position of the foot. The functional groups of muscles are flexors and extensors, internal and external rotators, some of which fulfil all of these functions. The lower leg rests on the arch of the foot at a right angle, to which it is flexibly connected by the upper ankle joint. Alignment of the foot is now only possible in one plane of movement that corresponds to the direction of the position of the lower leg. This restriction means that the tip of the foot can only be raised and lowered around one transverse axis in the upper ankle joint. The mechanics of the leg are thus initiated at the hip joint, with its more universal options for movement, and terminate in restricted movement. All of this must be viewed from the overriding perspective of a highly dependable control of movement: 'for only through such limitation is perfection possible' (Goethe).

5.3. THE KNEE JOINT (ARTICULATIO GENUS)

5.3.1. General information on the femur and tibia

The knee joint is composed of the mobile connection between the femur and the tibia [218]. The former is the longest bone in our body and its longitudinal growth has a significant effect on overall body height and proportions. It is a spirally distorted rod with the construction of a gothic buttress (transferral of the pelvic load through the vertical axis). Looked at from the side, it exhibits a gentle S-shaped curvature. The end of the bone closest to the trunk is crowned with a ball-shaped head that protrudes from the less robust femoral neck. This neck forms a curved connection with the femoral shaft. Two important protuberances arise at this transition (insertion points for the hip muscles), the greater and lesser trochanters (trochanter major and minor). The end furthest away from the trunk broadens out into a massive articular surface with a trapezoid shape. The main portion of the articular surface is made up of two rounded condyles, separated by a gap.

The tibia is elongated and wedge-shaped; its shaft has a triangular cross-section. The end of the bone closest to the trunk expands out from the shaft like the capital of a column and forms the articular surfaces on the tibia for the femoral condyles. The tibial tuberosity (tuberositas tibiae) protrudes from the front of the tibia, about two fingers' breadth below the joint cavity, and is the insertion point for the knee extensors.

The wedge-like narrowing of the shaft in the direction of the ankle is moderately broadened here, with a cone-shaped extension (medial malleolus–malleolus tibiae). The tibial tuberosity and medial malleolus are connected by the flat, S-shaped and muscle-free anterior border of the tibia. The medial surface of the tibia is only covered by skin (for further detail, refer to the Figure 218; the fibula will be discussed in the context of the structure of the ankle).

Fig. 217 The construction of the human leg.
Solid red line: load-bearing line.
Dashed line: axis through upper leg shaft.
a) Anterior and posterior (c) view. The overall conical course converging at the bottom mainly reveals the supporting functions.
b) Lateral view.
All three transverse axes of the leg reveal mainly dynamic functions, whereby all axes are perpendicularly arranged, one above the other.

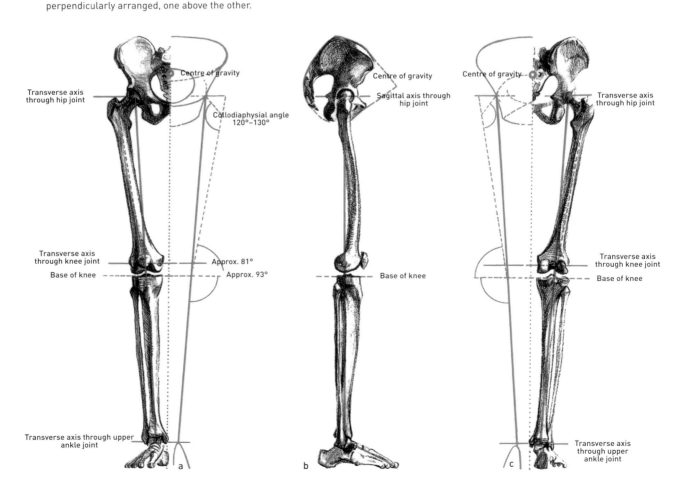

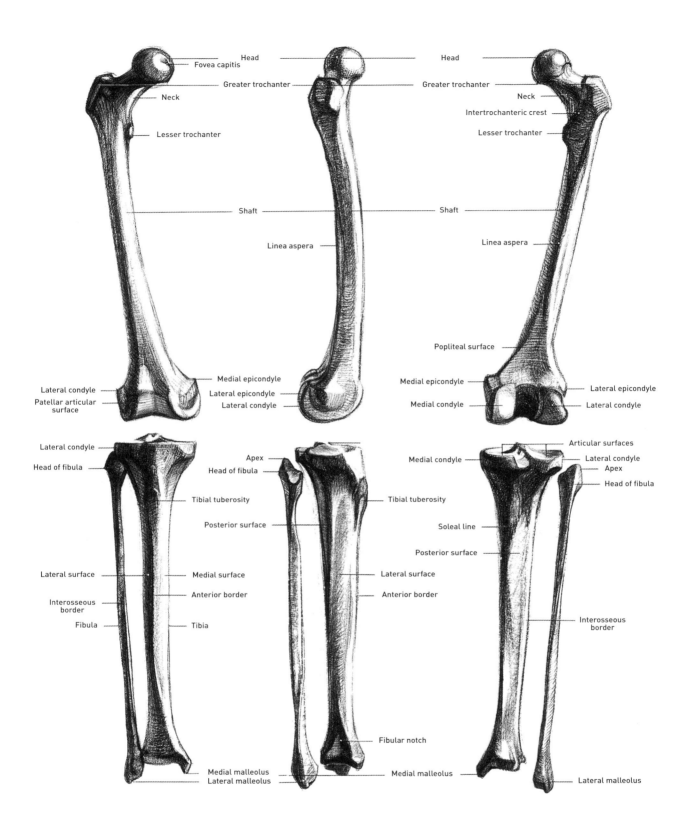

Head
Fovea capitis
Greater trochanter
Neck
Lesser trochanter

Head
Greater trochanter

Head
Greater trochanter
Neck
Intertrochanteric crest
Lesser trochanter

Shaft

Shaft

Linea aspera

Linea aspera

Popliteal surface

Medial epicondyle
Lateral epicondyle
Lateral condyle

Lateral condyle
Patellar articular
surface

Medial epicondyle

Medial condyle

Lateral epicondyle

Lateral condyle

Lateral condyle
Head of fibula

Apex
Head of fibula

Medial condyle

Articular surfaces
Lateral condyle
Apex
Head of fibula

Tibial tuberosity

Tibial tuberosity

Posterior surface

Soleal line

Lateral surface

Medial surface

Posterior surface

Posterior surface

Interosseous
border
Fibula

Anterior border

Tibia

Lateral surface

Anterior border

Interosseous
border

Fibular notch

Medial malleolus
Lateral malleolus

Medial malleolus

Lateral malleolus

Fig. 218 Three basic views of the bones
of the upper and lower leg.

Top: Anterior, lateral and posterior views
of the femur.

Bottom: Anterior, lateral and posterior
views of the tibia and fibula.

Fig. 219 Developmental sequences for the constructional form of the knee skeleton. Visualisation of the differentiation in shape (right vertical sequence) is developed through the use of the simplest of structural elements, a cylinder and flat surface.

1. Horizontal sequence: Profile of the left knee in a lateral view.
2. Horizontal sequence: Left knee in an anterior view.
3. Horizontal sequence: Left knee in a posterior view.

1 Lateral view

Cylinder and flat surface, the structural principle of the knee joint

2 Anterior view

Blueprint of the tibial condyles as a flat surface

3 Posterior view

Posterior split of cylinder into a double roller

Distal surface (shape of the femoral condyles)

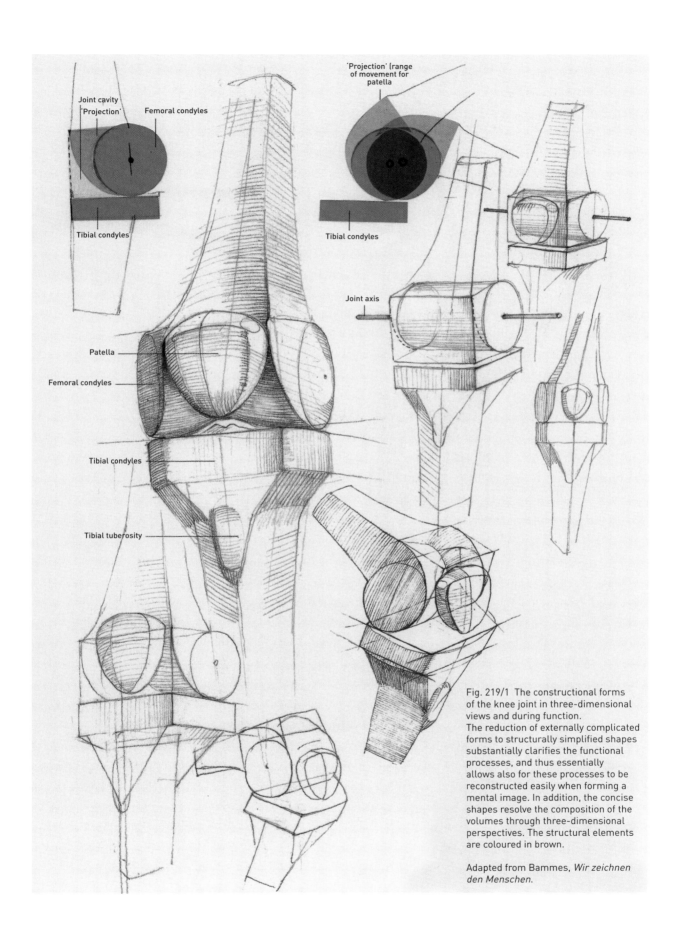

Joint cavity
'Projection'
Femoral condyles
Tibial condyles

'Projection' (range of movement for patella)
Tibial condyles

Joint axis

Patella
Femoral condyles
Tibial condyles
Tibial tuberosity

Fig. 219/1 The constructional forms of the knee joint in three-dimensional views and during function.
The reduction of externally complicated forms to structurally simplified shapes substantially clarifies the functional processes, and thus essentially allows also for these processes to be reconstructed easily when forming a mental image. In addition, the concise shapes resolve the composition of the volumes through three-dimensional perspectives. The structural elements are coloured in brown.

Adapted from Bammes, *Wir zeichnen den Menschen*.

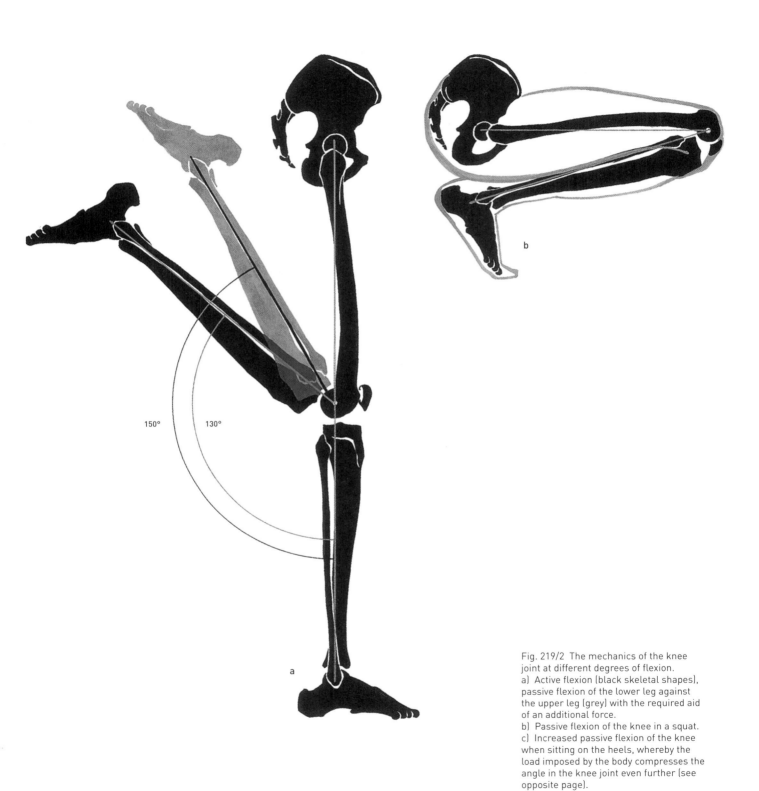

150° 130°

a

b

Fig. 219/2 The mechanics of the knee joint at different degrees of flexion.
a) Active flexion (black skeletal shapes), passive flexion of the lower leg against the upper leg (grey) with the required aid of an additional force.
b) Passive flexion of the knee in a squat.
c) Increased passive flexion of the knee when sitting on the heels, whereby the load imposed by the body compresses the angle in the knee joint even further (see opposite page).

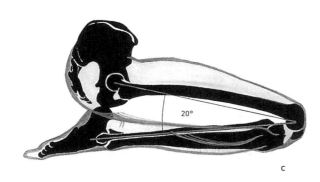

c

5.3.2. Function of the knee

The knee interrupts the column formed by the leg almost exactly halfway down. Through flexion, it helps to overcome obstacles on the ground, to shift the centre of gravity closer to the point of support, to sit, kneel and squat. Extension of the knee supports the equivalent functions in the hip and ankle joints for pushing off and jumping. Flexion shortens the pendulum formed by the leg, such that its frequency is increased (running), and dragging of the foot along the ground during a step is avoided.

5.3.3. Components, structure and constructional form [219, 219/1]

The constructional form arises from the power generated by the knee and several components are involved here.

The paired femoral condyles act jointly as a horizontal cylinder with an axis that runs transversely to the plane of flexion and extension. A 'projection' is added in front of the cylinder that enlarges the contact area between the articular surfaces during extension and simultaneously forms a slightly grooved articular surface for the patella (facies patellaris). The 'projection' and cylinder, rounded into a spiral shape, merge into each other.

The tibial condyles provide a pair of flattened pans, which are separated from each other by a flattened, cone-shaped protuberance (eminentia intercondylica), as an articular surface for the two femoral condyles. The cone-shaped separation protrudes into the cavity between the femoral condyles (fossa intercondylica) and helps to guide movement. Cruciate ligaments (in the cavity between the condyles) and a medial and lateral collateral ligament hold the joint together. During flexion, these latter ligaments relax, thus permitting rotation at the knee (internal and external rotation of the lower leg). The lack of congruence between the articular surfaces is reduced by a pair of crescent-shaped discs of fibrous cartilage (meniscus) with a wedge-shaped cross-section.

The patella is a small, shield-like, convex bone shaped like a rounded-off triangle, with its apex slightly above the joint cavity. Its main function, due to its incorporation into the tendon of the knee extensor, is to safely transfer the force exerted by this muscle across the distal surface (extension) of the flexed knee. To this end, the vertical ledge on its posterior surface nestles into the groove in the patellar surface on the femur (intercondylar notch). The patella is connected to the tibial tuberosity by the patellar tendon (extension of the tendon of the knee extensor). This transfers the extension movement to the tibia.

The lack of congruence between the articular surfaces means that the joint cavity opens up to form a hollow during flexion (hence the danger during sports) [227a, b]. This is filled with a fat pad (corpus adiposum infrapatellare) [228], which protrudes from under the patellar tendon when standing, especially in women, but is retracted into the joint cavity during flexion (hence a clearly delimited patella) [236]. When the knee is extended, the condyles push the fat pad (capsular fat) along in front of them, which prevents impingement of the capsule.

Figure 219 shows a developmental sequence from the basic structural elements and shapes through to their differentiation. It provides a simplification of the important functional and structural information to facilitate the essential acquisition of a mental image. The knee is a focus of case studies and must be comprehensively understood.

5.3.4. Mechanics and plastic changes

Flexion and extension occur around a transverse axis that is not fixed and is dependent on the lengths and points of attachment of the cruciate and collateral ligaments [219/1, 221]. From a position of 180° extension, the knee can be actively flexed by 130° through muscle power [219/2a]. The mechanics of the joint are not yet fully exploited and passive flexion of a further 20° is possible through the application of other forces (load imposed by the body when kneeling, crouching or squatting as well as with the aid of the hand) [219/2a, b, c]. The mechanical processes involved are as follows:
a) tilting the femur shaft in a posterior direction with changes in the position of the axis through the cylinder (rolling movement) [220a, b]
b) initiation of braking of rolling movement (through intervention of the cruciate ligaments) with a reduction in the shift in position and rotation [219/1, 220c]
c) termination of the change in position of the axis which now only rotates around itself (rotation) so it does not snap off the tibial condyles [219/2b, c, 220, 223].

At this point, the joint cavity is opened up to its maximum. The femoral condyles are prominent and clearly visible through the skin. The patella sinks into the intercondylar notch. The entire joint is transformed into a massive, angular cube that is blunt at the front, while the flexed knee pushes out the patella, accentuating it, and the patellar tendon becomes prominent [225, 226].

An additional internal and external rotation [230] of the mobile upper leg on the fixed lower leg arises from the fact that the collateral ligaments relax during flexion and thus permit rotation around a vertical axis. The scope for external rotation is five times greater than for internal rotation. The function of this mechanical process is to allow the foot the mobility to find further favourable options for supporting the body when the knee is flexed (e.g. when climbing).

5.3.5. Correlations and relationships between shapes in the bones of the knee [221, 222]

The limitations of static stretching (see section 5.2) and the minimum structural complexity for maximum loading arise from the demands placed on the knee to support its own weight, as well as additional body weight, not only on both knees, but also unilaterally. On closer inspection, this initially manifests in the mutual continuation of the breadths of the femur and tibia. There is an intrinsic relationship here, which has been highlighted in Figures 221b–k with thicker continuous lines. For example, in Figure 221b, this association between the correlating points in the form of a complete chain can be expressed in numbered sequences: 1 and 1* denote the starting points of the chain. With reference to the static requirements, the load-bearing lines only increase minimally in breadth from this relatively narrow location onwards. They progress fairly precisely in the direction of the middle of the two condyles and end in the breadth of the wedge-shaped tibia. The statically fixed situation is uncovered again in 3 and 3*. The points 1-2-3-4 and 1*-2*-3*-4* are correlated with each other and are the symbols for

Fig. 220 The mechanical processes during flexion of the knee and the behaviour of the ligament apparatus.
a) Extension.
b) Initiation of rolling movement with relaxation of collateral ligaments.
c) Rotational rolling during flexion at a right angle.
d) Rotation around the knee's own axis with relaxation of the collateral ligaments and a tense cruciate ligament.
The opening up of the joint cavity to form a hollow can be attributed to the lack of congruence between the articular surfaces.

Fig. 221 (opposite page) Bones of the knee joint, its relationships between shapes and its function.
a) Degrees of flexion: Active, through intrinsic muscle power of the leg.
Passive, with the aid of a load, exploitation of the load imposed by the body, e.g. when squatting (see also Figure 219/2).
b) Posterior view of the extended knee with its relationships between shapes.
c) Anterior view of the extended left knee with its relationships between shapes.
d) Frontal view of the flexed left knee with its relationships between shapes.

e) View of the flexed left knee in perspective.
f) Flexed right knee with the ligament apparatus and capsular fat.
g) Strong flexion.
h) Flexion with rotation (partial posterior view).
i) View of flexed left knee from above.
j) Partial anterior and partial medial view from below of flexed right knee, with ligament apparatus and capsular fat.
k) Different basic views of the patella.

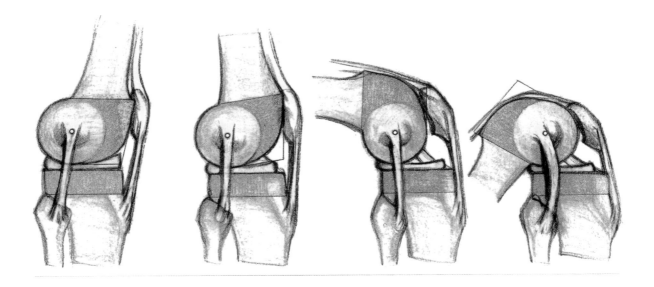

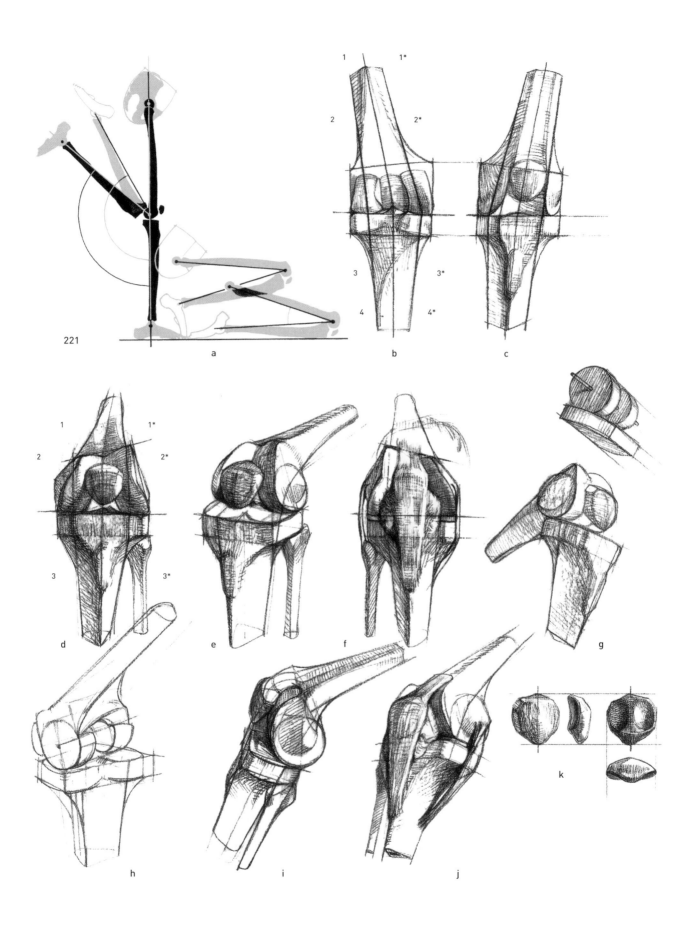

221

a

b

c

d

e

f

g

h

i

j

k

1 1*

2 2*

3 3*

4 4*

1 1*

2 2*

3 3*

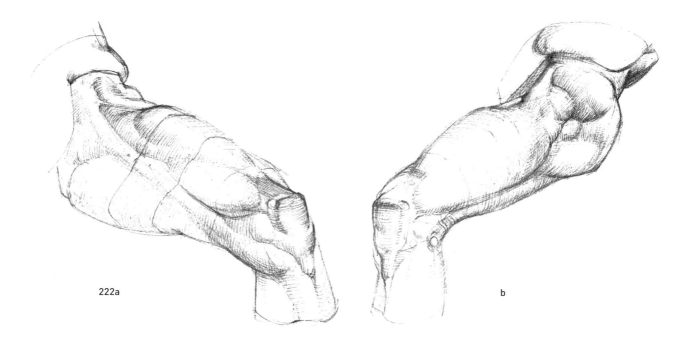

222a b

Fig. 222 (above) Involvement of the
bones of the knee in the structure of the
architectural form of the upper leg (from
a plastic study by Michelangelo).
The complicated plastic situation relating
to the knee and its changes during
movement can only be understood
through knowledge of the constructional
skeletal forms.
a) Partial medial view.
b) Partial lateral view.

Fig. 223 (below) The complicated and
differentiated plastic interaction between
skeletal and soft tissue shapes.

Fig. 224 (right) The plastic situation
in the flexed left knee in different
perspective views.
a, a*) Anterior and medial view.
b, b*) Dominant medial view.
c, c*) Partial posterior medial view.
d, d*) Partial posterior lateral view.
The different views demonstrate the
extent to which the constructional
skeletal forms are integrated into the
physiognomy of the living appearance
(see also Figure 223).

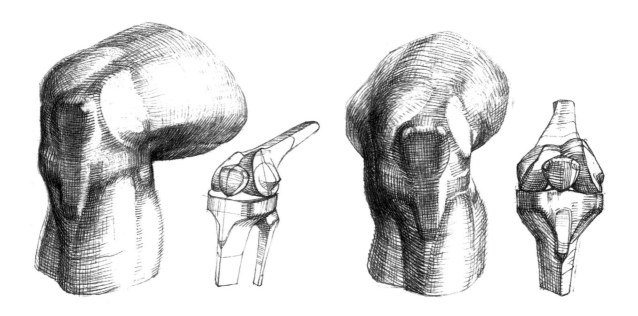

223

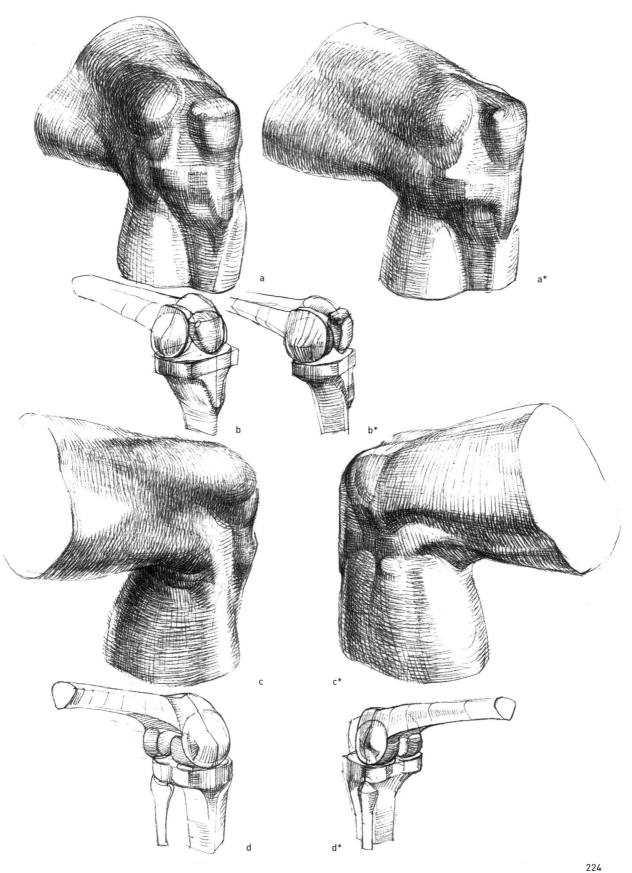

a

a*

b

b*

c

c*

d

d*

224

the statically required moment. However, as joints are also subjected to high dynamic requirements, small breadths are insufficient: the knee expands outwards to an enormous breadth from 2 and 2* down to 3 and 3*. Based on the static principle, the additionally expanded shapes are understood as ancillary shapes that are then reduced again to the specific thicknesses that arise from the transmission of load. The remaining images on this plate show the relationships between directions and thicknesses accordingly. The images here are designed to demonstrate the extent to which the bones of the knee are involved in the structure of the living plastic appearance [222–224].

Summary:

1. The individual sections of the lower extremities in humans correspond to the hind extremities in animals, with a pelvis, upper leg, lower leg (tibia, fibula) and foot (tarsals, metatarsals and phalanges).
2. The human lower extremities differ from the hind extremities in animals in the following important characteristics:

a) The pelvis acts as the support and protective bowl for the vertically oriented load imposed by the trunk and therefore has expanded iliac blades in the shape of basins, which are also the origin of numerous muscles, and permit an upright posture.
b) The upper and lower leg meets at the knee to form a fully extended column-like leg.
c) The leg is a long pendulum with a large stride length.
d) The entire sole of the foot is in contact with the ground. It solves the task of absorbing the load and pushing off the ground through the construction of an elastic arch.
3. The construction of the leg comprises three main joints with three different degrees of movement:
a) The hip joint, in close proximity to the trunk, has three axes with three basic movements:
Transverse axis: flexion–extension (anteversion and retroversion)
Sagittal axis: abduction and adduction
Vertical axis: internal rotation, external rotation
Analogous muscle function groups are associated with the axes.

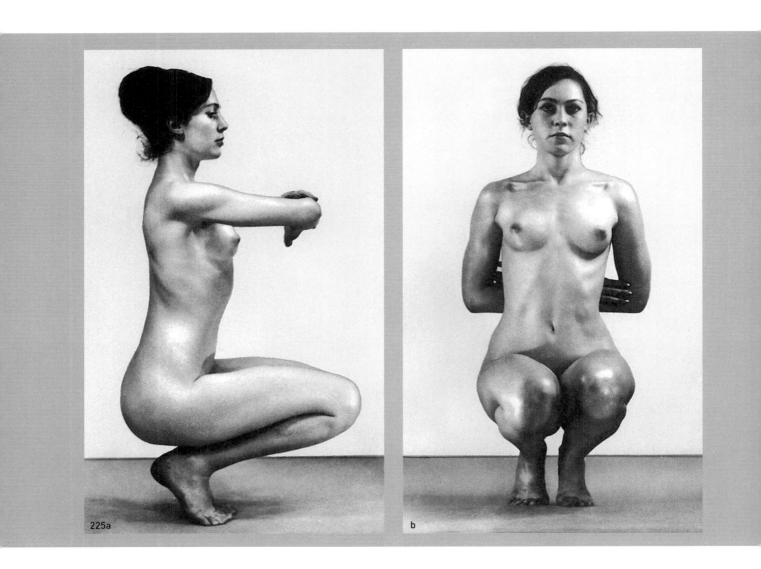

225a

b

b) The knee joint, about halfway between the hip joint and the sole of the foot, has two axes with two basic movements:
Transverse axis: flexion–extension
Vertical axis: internal and external rotation of the knee joint in its flexed state.
c) The upper ankle joint has a transverse axis with one plane of movement: raising and lowering of the tip of the foot (dorsal and plantar flexion).

4. The specific functions of the knee joint:
a) Mobility in the column forming the leg to overcome obstacles on the ground.
b) Increase in power during jumping through flexion and extension. This simultaneously equates to a reduction or increase in the distance between the centre of gravity and the ground.
c) Reduction in the length of the pendulum formed by the leg for running at speed.
d) Spring-like shock absorber (landing).
e) Extension to form a fixed column (reduction of strain on muscle).

5. The components of the knee joint are:
a) The articular surfaces (femoral condyles and tibial condyles) that are not fully congruent.
b) The mobile menisci that increase closure of the joint.

c) The ligaments. The collateral ligaments prevent hyperextension, the cruciate ligaments mainly restrict internal and external rotation in the flexed knee by mutual shortening through twisting.
d) The patella that transfers the force of the extension across the surface of the joint and is incorporated into the quadriceps (patellar) tendon.
e) The patellar tendon that transfers the force of the extension through to the tibial tuberosity.
f) The fat pad that lies dorsal and lateral to the patellar tendon and prevents impingement of the joint capsule when flexion is reversed into extension [227]. The vacuum generated by the opening joint cavity draws the fat pad inwards during flexion.

6. The mechanics of the knee joint allow active flexion by 130°, i.e. compression of the angle as far as 50° [229a], and passive flexion by 150°, so further compression of the angle as far as 30° [229b]. During this process, the femur initially partially rolls off its base, through to rotational rolling, after which it only rotates around the transverse axis through the femoral condyles. Medial rotation of the lower leg against the upper leg during flexion is substantially smaller than lateral rotation.

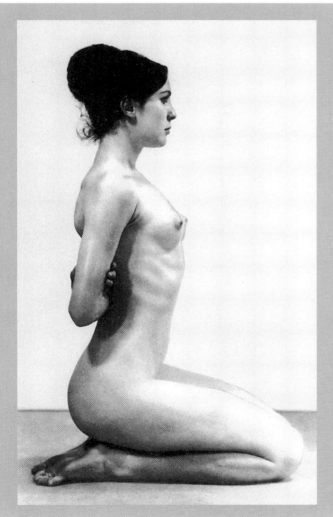

Figure 225 (far left) Passive flexion of the knee in a squat.
a) In a lateral view.
b) In an anterior view.
In both views, the knee takes on a massive, angular, plastic form through the intensive opening up of the joint cavity.

Figure 226 (left) Passive flexion of the knee while kneeling. The load imposed by the body fully compresses the angle in the knee joints.

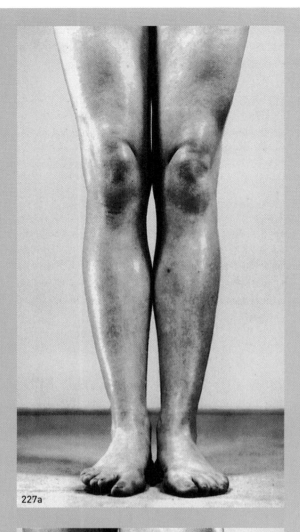

227a

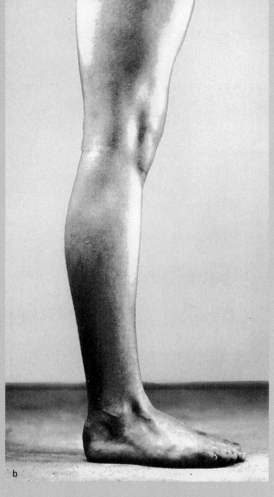

b

Fig. 227 Female knee stretched taut. The knee extensors pull the patella in a cranial direction as far as is permitted by the patellar tendon (inferior apex of the patella slightly above the joint cavity). The capsular fat is pushed out medially and laterally.
a) Anterior view of the knee stretched taut.
b) Lateral view of the knee stretched taut.

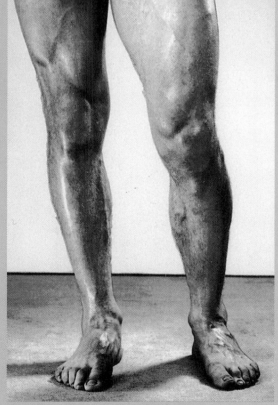

Fig. 228 Male knee, one stretched taut and the other slightly flexed, in a position with one leg engaged and one leg free.
The flexed knee is angular as the capsular fat is drawn deep inside the hollow within the joint through opening of the joint cavity.

Fig. 229 Flexion of the knee joint.
a) Active flexion using the power of the flexors. The capacity for flexion of the knee is not yet fully exploited.
b) Passive flexion with the aid of an external force. Pulling the heel against the buttock constitutes the highest degree of flexion.

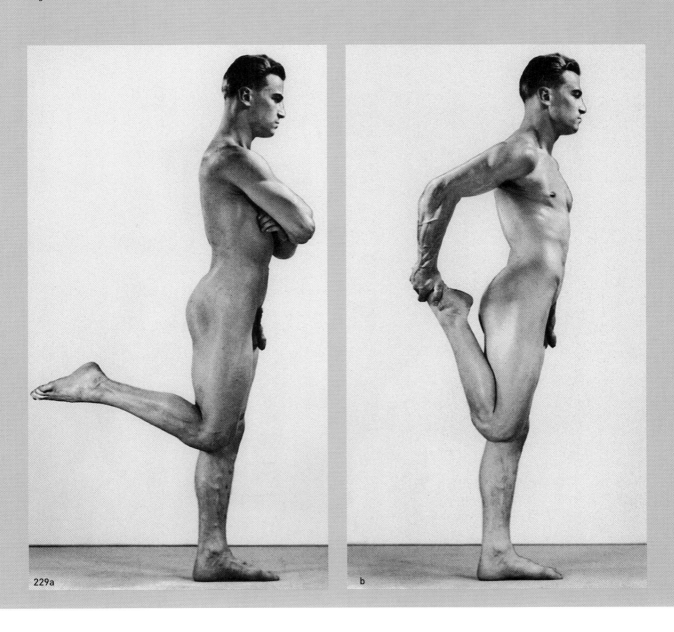

229a

b

5.4. THE MUSCLES OF THE KNEE JOINT

5.4.1. Overview of the general system [231]

Not all of the muscle forces that move the knee act on this joint alone. Some of them also act on the hip joint, while, in turn, its muscles also act on the knee. The muscles overlap in their function and can only be illustrated with difficulty as isolated groups.

The main flexors and extensors of the knee originate on the pelvis and the femur and insert into the lower leg. The majority of these muscles act on more than one joint and overlap in their function. The function derives from their position in relation to the axes through the knee joint:

1. Muscles anterior to the transverse axis are extensors those posterior to this axis are flexors.
2. Muscles in the flexed knee that lie medial to the vertical axis are internal rotators, while those that lie lateral to this axis are external rotators.

The knee extensor is: the four-headed extensor of the knee joint (M. quadriceps femoris) with the
a) straight head (rectus femoris)
b) medial head (vastus medialis)
c) lateral head (vastus lateralis)
d) the head that lies between the vastus medialis and the vastus lateralis (vastus intermedius, not discussed) [232].
 Flexors of the knee are:
1. two-headed flexor of the knee joint (M. biceps femoris) with its
 a) long head
 b) short head
2. semitendinosus (M. semitendinosus)
3. semimembranosus (M. semimembranosus)
 Accessory knee flexors are:
4. sartorius (M. sartorius)
5. M. popliteus (not discussed).

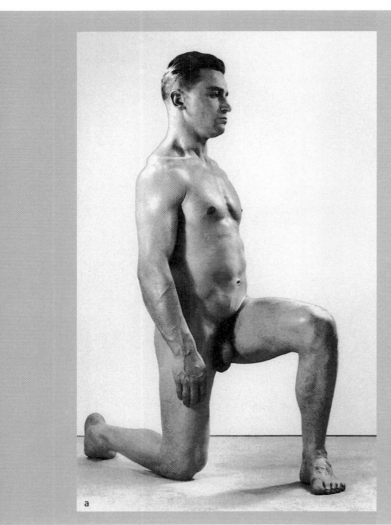

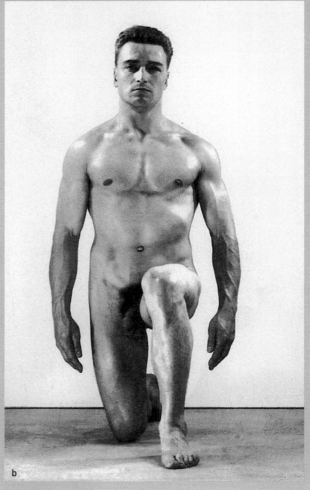

5.4.2. Details on the individual knee muscles anterior and posterior to the transverse axis

Anterior to the transverse axis through the knee joint [236–240]

The four-headed extensor of the knee joint (M. quadriceps femoris):

a) straight head (M. rectus femoris) [232, 233, 237, 238, 240]:
Origin: Pelvis, anterior inferior iliac spine (spina iliaca anterior inferior).
Course and insertion: Runs longitudinally and diagonally over the upper leg, bisecting the transverse axis through the anterior hip and knee.
Insertion: Base of the patella.
Function: Extension of the knee, accessory flexor of the hip, stabilising function when the trunk is inclined backwards, tilting pelvis from a horizontal position to a vertical position.
Plastic appearance: Forms the longitudinal and diagonal height of the anterior portion of the upper leg, with its main accentuation in the upper third of the thigh, transition to a taut form (long tendon above the patella).

b) medial head (vastus medialis):
Origin: Medial portion of the linea aspera on the dorsal surface of the femur.
Course and insertion: Only lower section visible, inserts into the medial border of the patella.
Function: See common function of the heads of the quadriceps below.
Plastic appearance: Bulging, above the medial border of the patella, especially in men [227a, 228].

c) lateral head (vastus lateralis):
Origin: Lateral portion of the linea aspera on the dorsal surface of the femur, below the greater trochanter.
Course and insertion: Lateral portion of thigh, inserts into the lateral border of the patella via a long tendon.
Function: See common function of the heads of the quadriceps below [249].
Plastic appearance: Forms the large muscle mass on the lateral and partially on the anterior portion of the thigh, flattened off by an extensive tendinous sheet (aponeurosis). All of the heads of the quadriceps combine at the level of the patella and continue down to the tibial tuberosity via the patellar tendon.

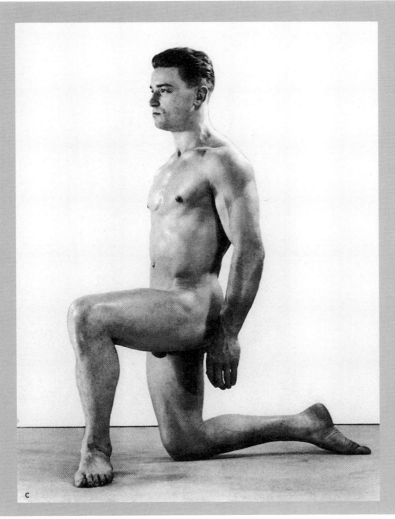

Fig. 230 Internal and external rotation of the flexed knee.
The model placed his foot and lower leg in a fixed position, the tip of the foot is still pointing forwards, in an unchanged position, while the body and upper leg were swung round over the lower leg.
a) Internal rotation (about 40°).
b) Normal position.
c) External rotation (about 10°).

Common function of all heads of the quadriceps [259/1b]: Extension of the knee when standing up, climbing, pushing off, jumping off, spring-like cushioning during strides and landing, stabilising function when the knee is used in a crouching position (downhill skier's position).

Posterior to the transverse axis through the knee joint [231, 235–238, 240]

As a rule, all the flexors [235, 236, 238, 240] have a common origin on the ischial tuberosity (exception: sartorius and short head of the biceps).

Separate insertion into the medial condyle of the tibia (semitendinosus, semimembranosus, sartorius) and lateral head of the fibula (biceps).
Common function: Raising of the heel, stabilisation of the pelvis when the trunk is inclined forwards, tilting of pelvis into an upright position from a stooped posture [259/1].

Common plastic appearance: Far smaller volume than the antagonist quadriceps (note function), direction of volume exactly vertical, formation of the hollow of the knee during flexion. The biceps tendon overlaps the calf muscles in a seated position.

Sartorius or tailor's muscle (M. sartorius) [222, 231, 240, 259/2, 281]: This muscle's action is highly diverse and it acts on two joints, like the other flexors.
Origin: anterior superior iliac spine (spina iliaca anterior superior).
Course and insertion: Diagonally from the lateral anterior portion of the upper leg to the medial surface of the tibia.
Function: Flexion and external rotation of the hip joint, flexion and internal rotation of the knee joint. Sitting cross-legged.
Plastic appearance: A long, strap-like muscle that jumps out and is twisted like a propeller during the functions outlined above. Otherwise, it is embedded in the oblique groove between the extensors and adductors.

Fig. 231 Arrangement of the axes through the hip and knee joints and relative positions of some hip and knee muscles to the axes (semi-schematic). The muscles of the thigh and knee overlap in function; their positions relative to each other make their function predictable.

Fig. 232 Four-headed extensor of the knee joint in plastic and line illustration. The line illustration clearly indicates the fields of origin and insertion.

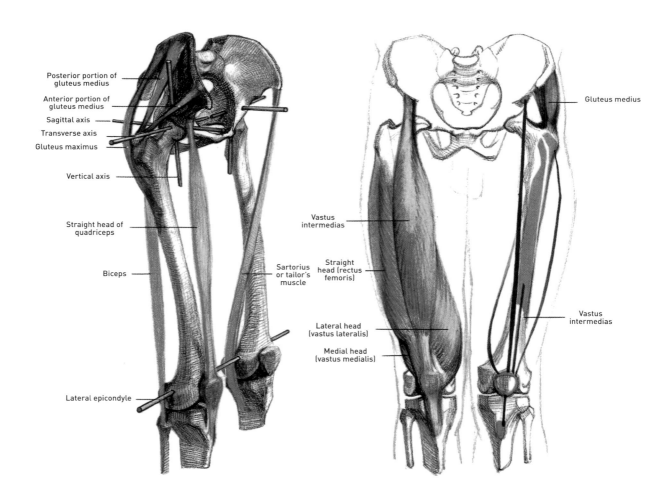

Summary overview: the knee joint (articulatio genus)

Axis	Movement	Muscles involved (full list)
Transverse axis	Extension	Quadriceps
	Flexion	Two-headed flexor of the knee joint (M. biceps femoris) Semitendinosus (M. semitendinosus) Semimembranosus (M. semimembranosus) Sartorius (M. sartorius) Popliteus (M. popliteus) O
Vertical axis	Internal rotation	Semitendinosus (M. semitendinosus) Semimembranosus (M. semimembranosus) Sartorius (M. sartorius) Popliteus (M. popliteus) O Gracilis (M. gracilis) O
	External rotation	Two-headed flexor of the knee joint (M. biceps femoris)

O = not discussed, only depicted

Fig. 233 Lateral view of the extensors and flexors of the knee joint (plastic and line illustration).

Fig. 234 Plastic illustration of the gluteus medius, all other muscles of the upper leg in line illustration.

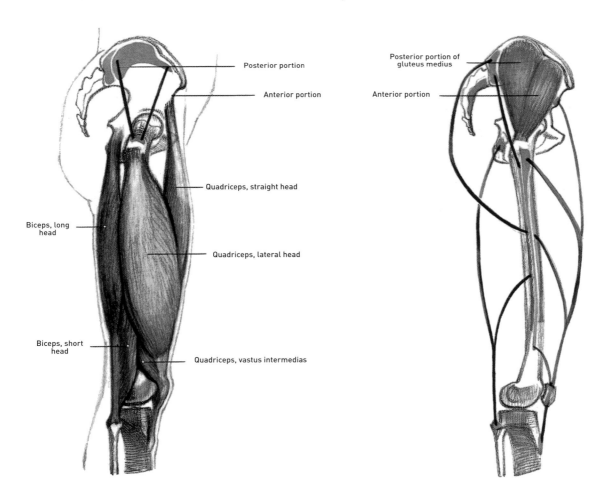

Posterior portion

Anterior portion

Quadriceps, straight head

Biceps, long head

Quadriceps, lateral head

Biceps, short head

Quadriceps, vastus intermedias

Posterior portion of gluteus medius

Anterior portion

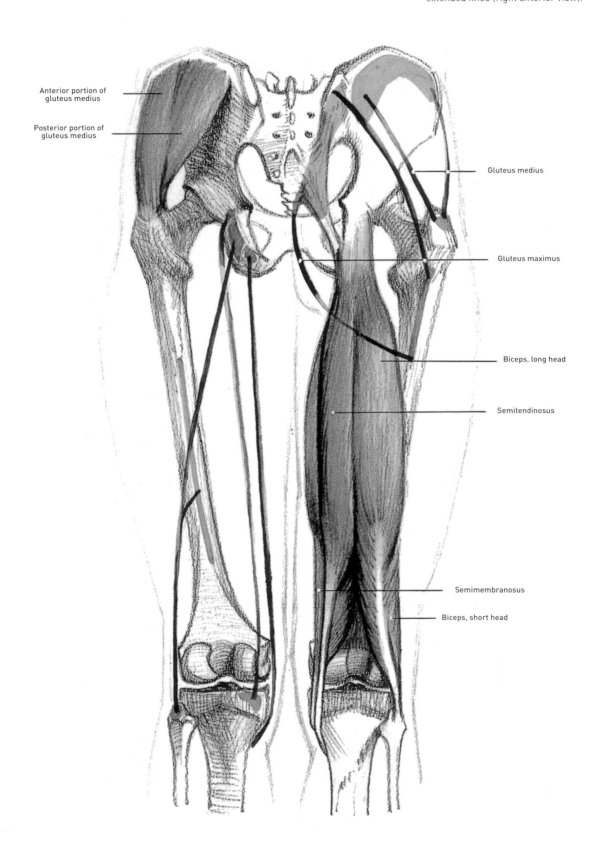

Fig. 235 (below) Posterior view of the flexors of the knee joint (line and plastic illustration). The fact that the knee flexors cross the transverse axis in the hip joint means that they can also fulfil an important function there; extension of the hip joint or regulation of pelvic tilt.

Fig. 236 (top right) External appearance and muscle analysis in the flexed knee (right lateral view).

Fig. 237 (bottom right) External appearance and muscle analysis in the extended knee (right anterior view).

Anterior portion of gluteus medius

Posterior portion of gluteus medius

Gluteus medius

Gluteus maximus

Biceps, long head

Semitendinosus

Semimembranosus

Biceps, short head

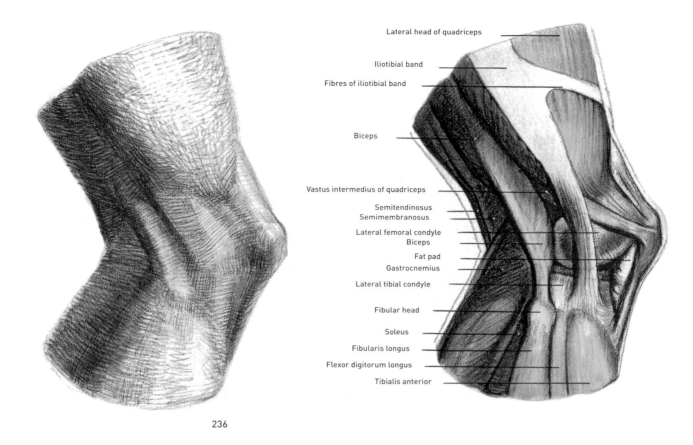

Lateral head of quadriceps

Iliotibial band

Fibres of iliotibial band

Biceps

Vastus intermedius of quadriceps

Semitendinosus
Semimembranosus

Lateral femoral condyle
Biceps

Fat pad

Gastrocnemius

Lateral tibial condyle

Fibular head

Soleus

Fibularis longus

Flexor digitorum longus

Tibialis anterior

236

237

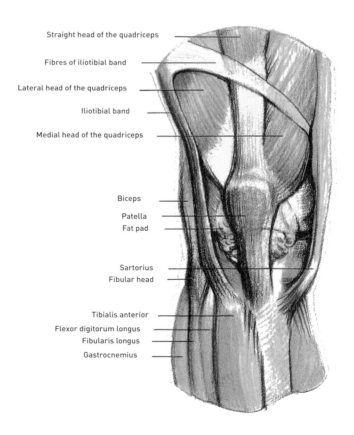

Straight head of the quadriceps

Fibres of iliotibial band

Lateral head of the quadriceps

Iliotibial band

Medial head of the quadriceps

Biceps

Patella

Fat pad

Sartorius

Fibular head

Tibialis anterior

Flexor digitorum longus

Fibularis longus

Gastrocnemius

The lower extremities **223**

Fig. 238 External appearance and muscle
analysis of the flexed hollow of the knee (right).

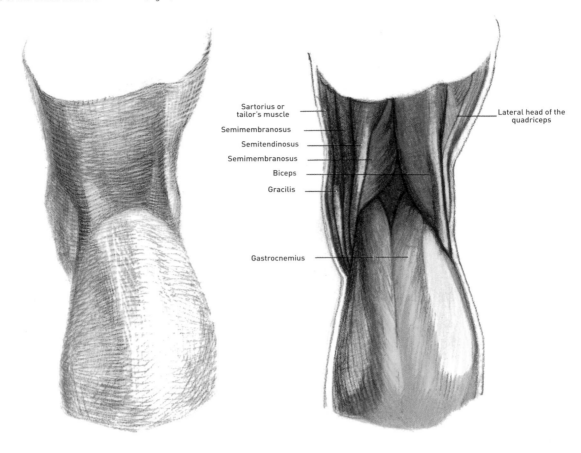

Sartorius or
tailor's muscle
Semimembranosus
Semitendinosus
Semimembranosus
Biceps
Gracilis

Lateral head of the
quadriceps

Gastrocnemius

Fig. 239 External appearance and muscle
analysis in the strongly flexed knee (right
anterior view).

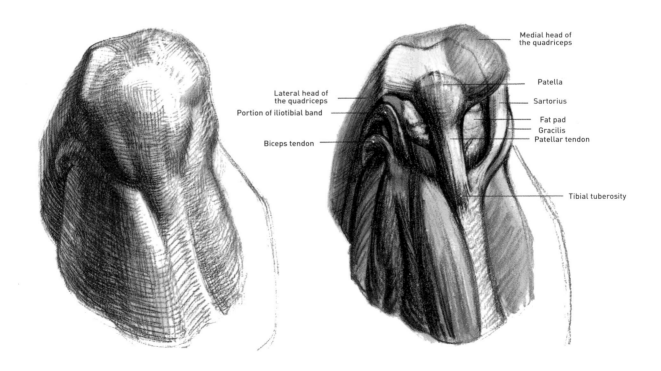

Medial head of
the quadriceps

Patella

Lateral head of
the quadriceps

Sartorius

Portion of iliotibial band

Fat pad
Gracilis
Patellar tendon

Biceps tendon

Tibial tuberosity

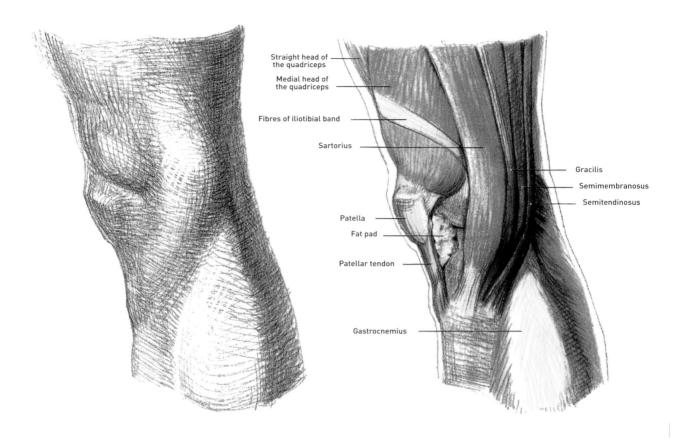

Straight head of
the quadriceps

Medial head of
the quadriceps

Fibres of iliotibial band

Sartorius

Gracilis

Semimembranosus

Semitendinosus

Patella

Fat pad

Patellar tendon

Gastrocnemius

Fig. 240 External appearance and muscle
analysis of the extended knee (right
medial view).

5.5. THE PELVIS

5.5.1. General background and function

The pelvis is a highly complicated spatial form that
requires good conceptual skills to visualise [245].
It is one of the three larger bony cavities capable of
considerable orientation of its volume, and thus also
carries the decisive spatial orientation of the external
tissue forms on its pentagonal shape; it connects
the trunk with the skeleton of the extremities; it
accommodates the cylinder containing the viscera;
and it serves as a site of origin and insertion of many
muscles, in its capacity as the centre of movement.
Its solid ring construction can withstand high loads; it
bears a resemblance to a funnel, the upper opening
of which is expanded by the greater pelvis and is
continued downwards as a narrow tube in the form of
the lesser pelvis. Three individual bones make up its
characteristic spatial form: the anterior and lateral
paired coxal bones at the front and side, with the
sacrum at the back.

5.5.2. Components and structure

The two coxal bones (os coxae) have a complex helical shape, with the following component bones: ilium (os ilium), ischium (os ischii) and pubis (os pubis) [241–243, 244/1, 244/2].

The flat portion of the ilium is called the iliac blade (ala ossis ilii), a frame construction mainly formed by the iliac crest to provide strong attachment sites for the muscles. It culminates ventrally in the anterior superior iliac spine (spina iliaca anterior superior). The two pubic bones are in contact with each other over a brief stretch and then deviate from each other again to form the pubic arch (arcus pubis). The ischium (os ischii) is the lowest point of the pelvis, on which we sit. All three component bones of the coxae fuse together in a central location and form the hip socket (acetabulum). The sacrum (os sacrum) is composed of five fused vertebrae and its overall shape is conical and concave (coping stone principle); it encloses the lesser pelvis dorsally and forms the base for the spine. All three pelvic bones are held together tightly by ligaments. Further information can be found in the illustrations.

Fig. 241 Anterior and slightly tilted view of a male pelvis (the illustration to the right depicts it in the form of a block). The pelvis is one of the most important plastic cores of the body as it is a large bony volume.

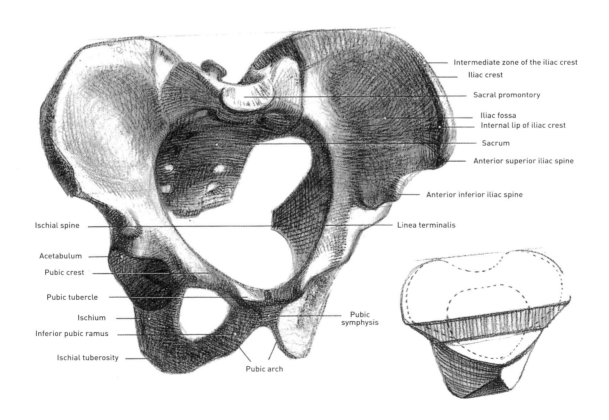

Intermediate zone of the iliac crest
Iliac crest
Sacral promontory
Iliac fossa
Internal lip of iliac crest
Sacrum
Anterior superior iliac spine
Anterior inferior iliac spine
Linea terminalis

Ischial spine
Acetabulum
Pubic crest
Pubic tubercle
Ischium
Inferior pubic ramus
Ischial tuberosity
Pubic arch
Pubic symphysis

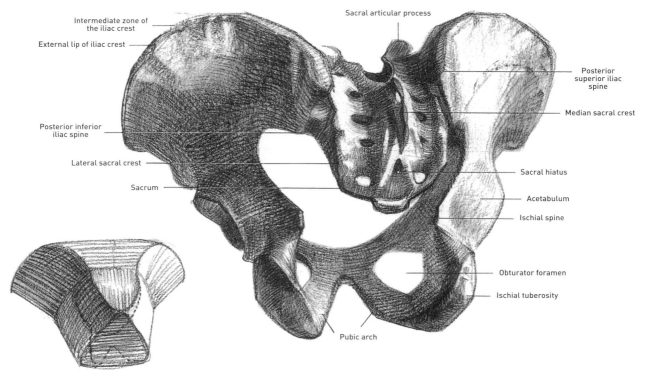

Intermediate zone of
the iliac crest

External lip of iliac crest

Posterior inferior
iliac spine

Lateral sacral crest

Sacrum

Sacral articular process

Posterior
superior iliac
spine

Median sacral crest

Sacral hiatus

Acetabulum

Ischial spine

Obturator foramen

Ischial tuberosity

Pubic arch

Fig. 242 Posterior and slightly tilted view
of a male pelvis (the illustration to the left
depicts it in the form of a block).

Fig. 243 Lateral and medial view of the
right coxal bone.

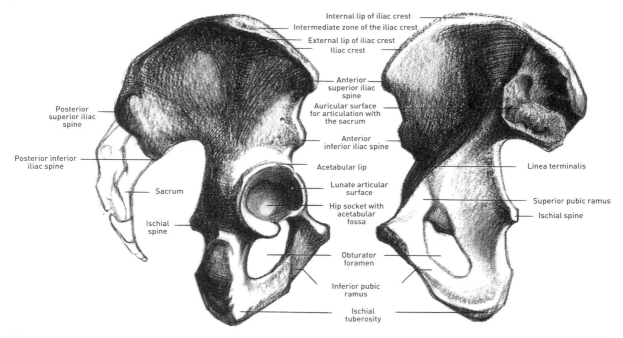

Posterior
superior iliac
spine

Posterior inferior
iliac spine

Sacrum

Ischial
spine

Internal lip of iliac crest

Intermediate zone of the iliac crest

External lip of iliac crest

Iliac crest

Anterior
superior iliac
spine

Auricular surface
for articulation with
the sacrum

Anterior
inferior iliac
spine

Acetabular lip

Lunate articular
surface

Hip socket with
acetabular
fossa

Obturator
foramen

Inferior pubic
ramus

Ischial
tuberosity

Linea terminalis

Superior pubic ramus

Ischial spine

Fig. 244 The constructional form of the pelvis (female) from different spatial perspectives.
The directions of the spatial sagittal and transverse axes that are indicated emphasise the perspective from which the pelvis is being viewed and thus the position of the body in space.
a–g) Gradual change in perspective from front to back.
h) View of the structure from the pelvic floor.

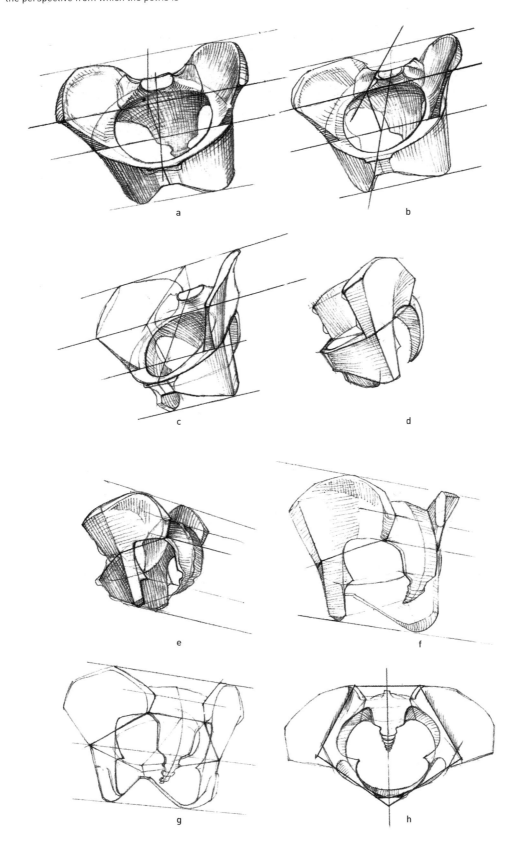

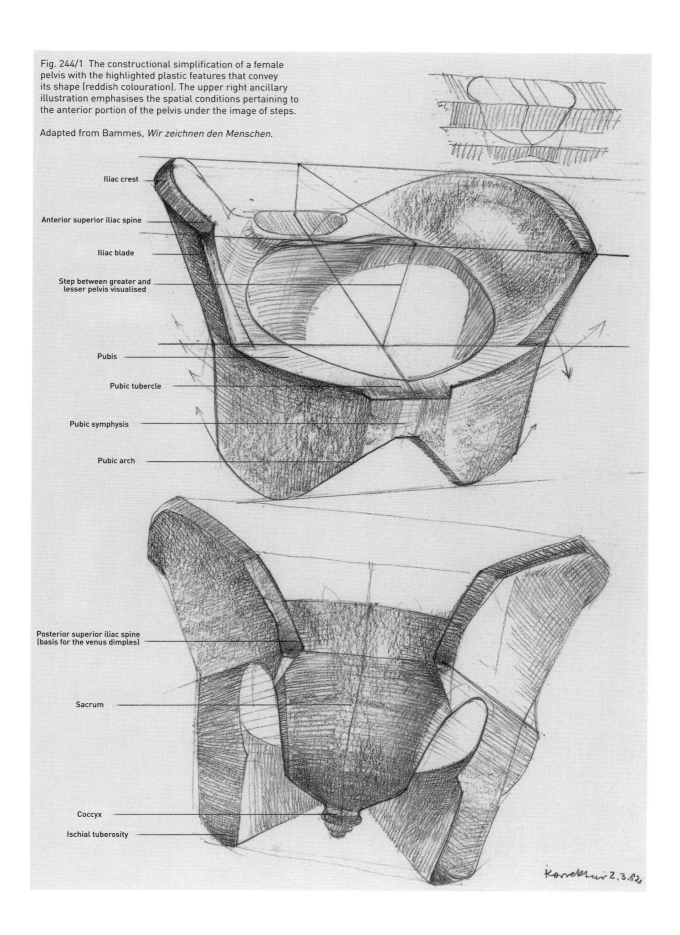

Fig. 244/1 The constructional simplification of a female pelvis with the highlighted plastic features that convey its shape (reddish colouration). The upper right ancillary illustration emphasises the spatial conditions pertaining to the anterior portion of the pelvis under the image of steps.

Adapted from Bammes, *Wir zeichnen den Menschen*.

Iliac crest

Anterior superior iliac spine

Iliac blade

Step between greater and lesser pelvis visualised

Pubis

Pubic tubercle

Pubic symphysis

Pubic arch

Posterior superior iliac spine (basis for the venus dimples)

Sacrum

Coccyx

Ischial tuberosity

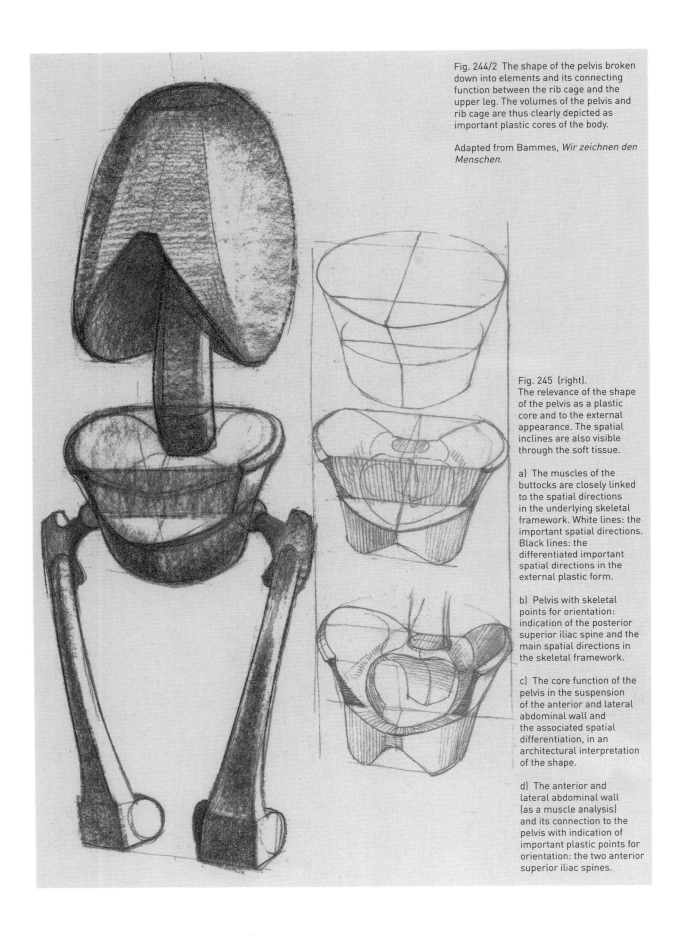

Fig. 244/2 The shape of the pelvis broken down into elements and its connecting function between the rib cage and the upper leg. The volumes of the pelvis and rib cage are thus clearly depicted as important plastic cores of the body.

Adapted from Bammes, *Wir zeichnen den Menschen.*

Fig. 245 (right).
The relevance of the shape of the pelvis as a plastic core and to the external appearance. The spatial inclines are also visible through the soft tissue.

a) The muscles of the buttocks are closely linked to the spatial directions in the underlying skeletal framework. White lines: the important spatial directions. Black lines: the differentiated important spatial directions in the external plastic form.

b) Pelvis with skeletal points for orientation: indication of the posterior superior iliac spine and the main spatial directions in the skeletal framework.

c) The core function of the pelvis in the suspension of the anterior and lateral abdominal wall and the associated spatial differentiation, in an architectural interpretation of the shape.

d) The anterior and lateral abdominal wall (as a muscle analysis) and its connection to the pelvis with indication of important plastic points for orientation: the two anterior superior iliac spines.

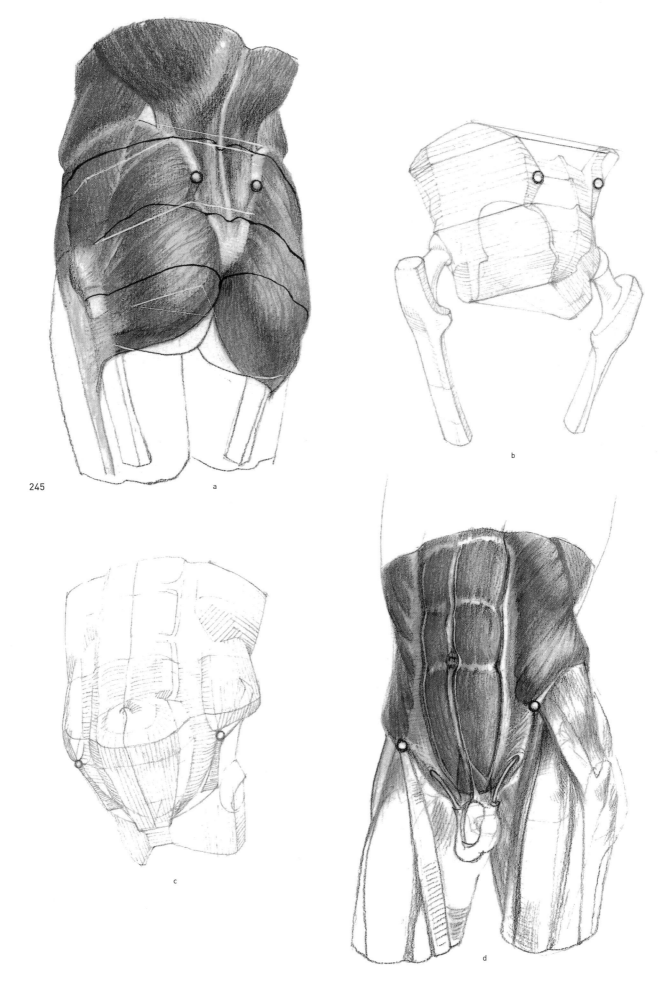

245

a

b

c

d

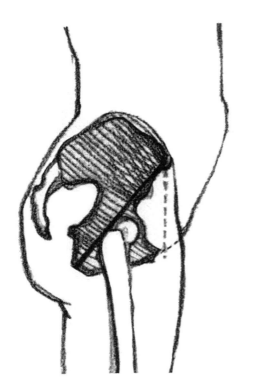

Fig. 246 Normal, anterior tilting of the pelvis showing the Roser-Nélaton line. Attention to the tilted position of the pelvis as the base and plastic core of the trunk is of great importance to nude study.

5.5.3. Construction, differences in shape and plastic appearance

The resilience of the pelvis stems from the fact that it forms a closed ring at the point where the femoral head articulates with it (barrel-shaped niche with clamping against the pubis and strapping between the ischium and ilium). The conical coping stone for the niche is the sacrum.

The sex differences in the pelvis are found in its spaciousness. The baby's body must be able to pass through a woman's pelvis and it is therefore slightly flatter, broader and the angle enclosed by the pubic arch is obtuse [244/1, 244/2].

The two anterior superior iliac spines protrude from the anterior abdominal wall and are both palpable and visible. These denote the 'bursting-out' walls of the pelvis (increase in the bending capability of the trunk, see also developmental pelvic series) [50–52]. The space between these two points also remains constant during postural change, as does the entire pelvic region, thanks to its rigid bony hollow forming a physical and spatial entity that preserves its intrinsic

Fig. 247 The relationships between pelvic tilt and the position of the spine.
In males (left three illustrations) and females (right three illustrations) in normal postures. The more vertical the position of the pelvis, the greater the flattening of the lumbar lordosis and the greater the anterior pelvic tilt, the more exaggerated the lumbar lordosis to compensate for this tilt.

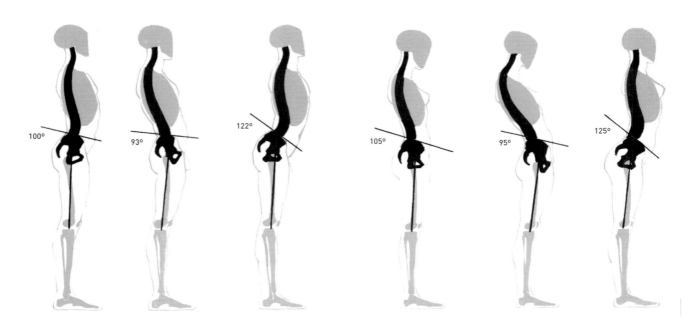

relative shape at rest and during movement. The two anterior superior iliac spines and the iliac crests that rise laterally from these points are of great importance to the plastic appearance of the anterior and lateral abdominal wall and its spatial differentiation [245]. The volume of the rib cage was flattened in a sagittal direction over the course of its evolutionary history (statics) and the same also applied to the pelvis. Starting at the iliac spines, the iliac crests protrude only slightly in a lateral direction. They both rapidly curve inwards in the direction of the sacrum. The two Venus dimples and the apex of the sacrum encompass a clear triangle that, due to its constancy, allows the tiniest of changes in the position of the pelvis to be noted.

5.5.4. Pelvic and spinal posture [246–248]

The degree of anterior tilting of the pelvis in a standing model can be derived from a theoretical line that connects the anterior superior iliac spine and the ischial tuberosity (Roser-Nélaton line). This bisects or is tangential to the greater trochanter on the femur. Pelvic posture varies: the pelvis is usually tilted

forwards slightly more in women than in men. It tilts around the transverse axis through the femoral head in the hip joint, but can be lowered by muscle power (rectus abdominis, gluteus maximus), i.e. positioned more vertically overall.

It acts as a see-saw for the positioning of the upper body. When its posture changes (bending forwards, leaning backwards or sideways), the spine has to respond to this situation and act to compensate it (compensatory movements). A strong pelvic tilt results in hyperlordosis, a pendulous abdomen and severe curvature of the thoracic and cervical spine. Vertical positioning of the pelvis is responded to by the spine through a flat stretched back (see, for example, seated posture).

Fig. 248 The relationship between pelvic tilt and spinal posture in a model.
a) Normal pelvic position.
b) Vertical pelvic position with the upper body leaning backwards.
c) Strong forwards tilt in the pelvis with the upper body shifted forwards.

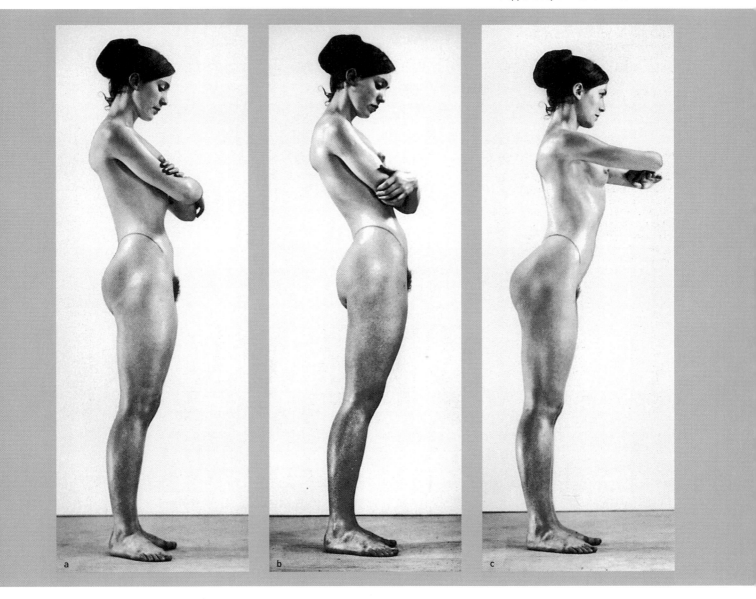

The lower extremities **233**

5.6. THE HIP JOINT

5.6.1. Functions, components and structure

Adjustment of the hip joint broadly initiates the specific use of the foot and permits sitting, all forms of lowering the body, walking, running, climbing and jumping. The distal feet and their joints are almost entirely dedicated to adjustment to the terrain. They counteract the body weight. High above the feet, the hip joint prepares the ground for this task through its diverse options for adjustment that are far more comprehensive than those open to the foot alone. For this reason, there must be high levels of congruence between the femoral head and the acetabulum (ball-and-socket joint). The very deep cup, with its cartilaginous ring, provides a reliable and secure socket for the spherical femoral head during movement. Spirally arranged ligaments control the extent of movement; movement becomes possible when the ligament system relaxes during flexion of the hip. During extension, this system screws the joint in and thus inhibits the upper body from dropping backwards or the leg from moving backwards.

5.6.2. Mechanics [249–257]

The femoral head can move in numerous directions. There are three main directions: flexion–extension, abduction–adduction, internal rotation–external rotation.

Flexion–extension (anteversion–retroversion) [246, 253, 254]: Around the horizontal transverse axis in the frontal plane. The extent of flexion (total of 122°) is far greater than for extension (10 to 13°) and increases when the knee also flexes and, finally, is drawn towards

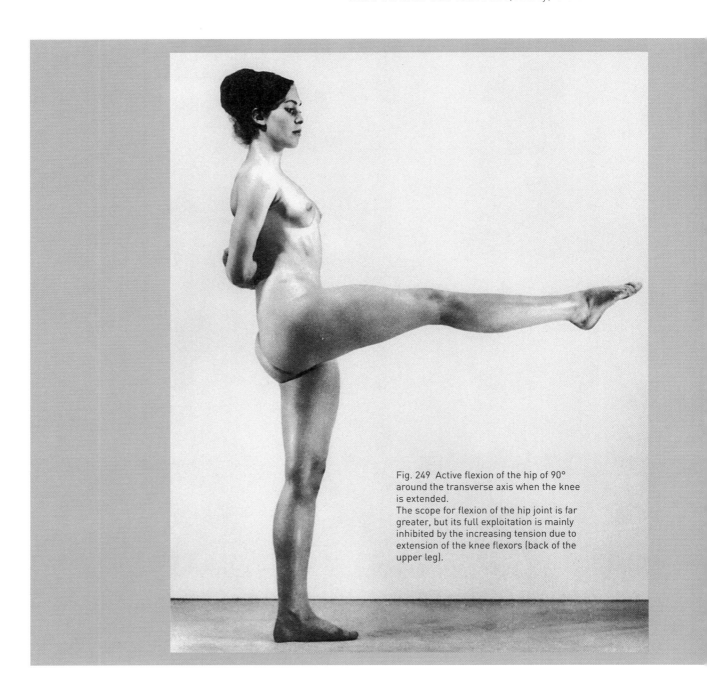

Fig. 249 Active flexion of the hip of 90° around the transverse axis when the knee is extended.
The scope for flexion of the hip joint is far greater, but its full exploitation is mainly inhibited by the increasing tension due to extension of the knee flexors (back of the upper leg).

the chest (passive flexion). Passive hip flexion is achieved through pressing the chin against the knee [250, 251].

Abduction–adduction [254]: Around the sagittal axis in the sagittal plane (from the abdomen towards the back); strict lateral abduction (without external rotation) is 50°, with adduction only amounting to a quarter. A straddling position is a form of abduction.

Internal rotation–external rotation [255–257]: Around the vertical axis (extension of the load-bearing line). The leg can twist inwards more strongly than outwards. For example, this is required during each stride (twisting of the pelvis over the femoral heads) and when changing direction. The difference between Figures 256 and 257 is that the male model has fixed the hip and is rotating the upper leg outwards and inwards (visible based on the position of the lower leg), while the female model is pointing the foot of her supporting leg towards the

viewer and is twisting her pelvis around the fixed hip joint, where the clockwise rotation of the cervical and thoracic spine around the vertical axis in combination with the rotation of the hip substantially increases the field of view.

Fig. 250 Increased hip flexion around the transverse axis.
a) Passive hip flexion with the knee pulled against the body. The scope for flexion is fully exploited through the use of an extrinsic force.
b) Active hip flexion with a flexed knee. The flexors that are relaxed through flexion of the knee allow further active flexion of the hip to above the horizontal line and, in addition, the length of the lever arm formed by the leg is shortened (130°).

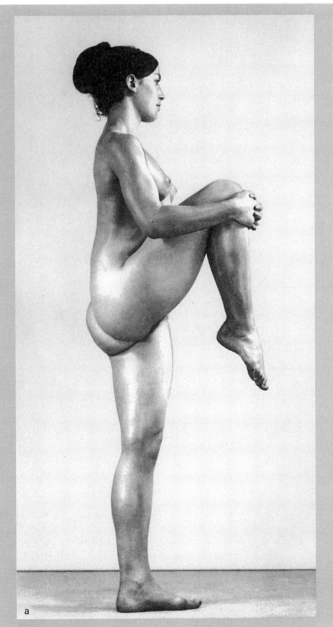

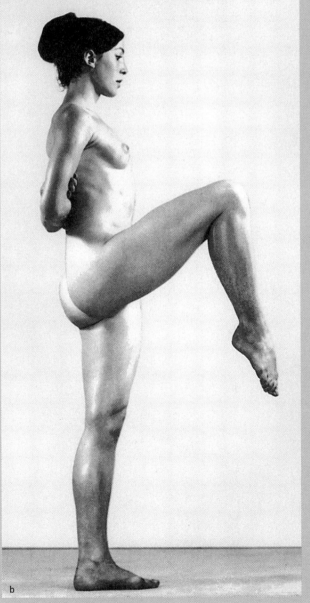

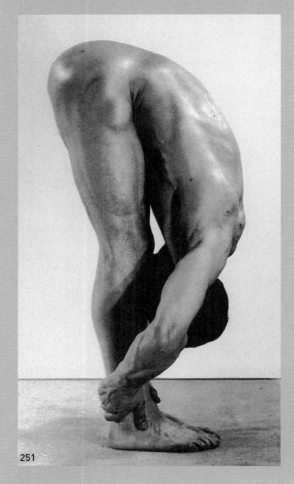

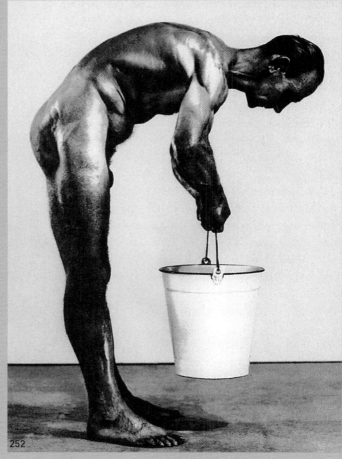

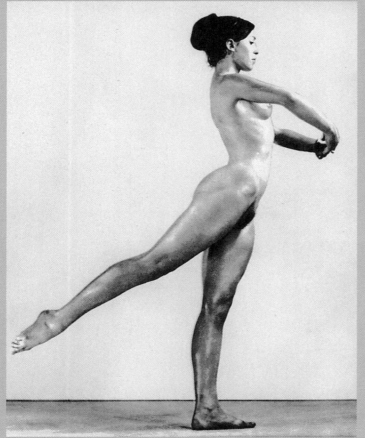

Fig. 251 Passive flexion of the hip around the transverse axis.
The drawing up of the knee towards the chin (the 'knee kiss') is an extreme flexion of the hip that requires the aid of an extrinsic force (hands). The condition for such flexion is training of the capacity for stretching of the knee flexors on the back of the upper leg and the extensors of the back.

Fig. 252 Stabilising function of the gluteus maximus and the knee flexors (back of the upper leg) when moving the upper body into an upright position with an extrinsic load. The gluteus maximus gradually loses power when moving in the opposite direction and the stabilising function must be fulfilled by the knee flexors alone.

Fig. 253 Extension of the hip around the transverse axis through the hip joint in a model.
Extension of the upper leg only amounts to 10°–13°. Any further raising of the upper leg backwards is only possible if the pelvis is tilted forwards simultaneously.

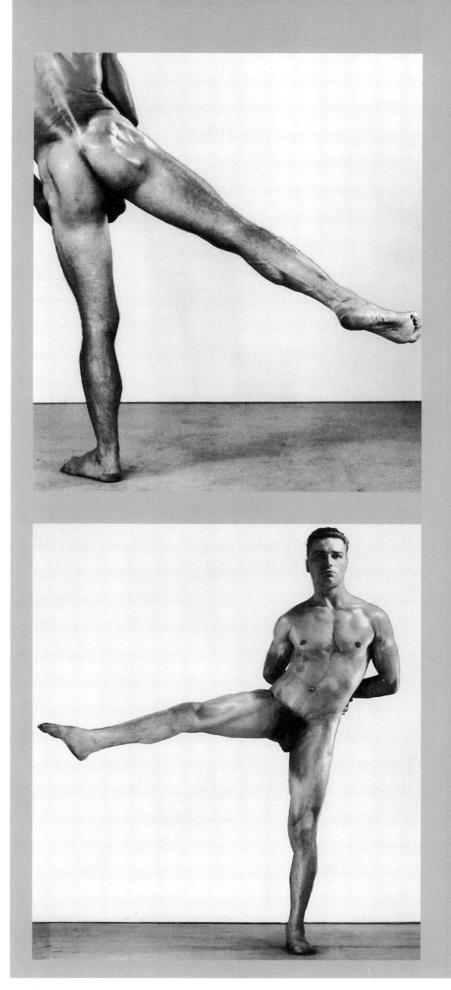

Fig. 254 Lateral abduction of the leg around the sagittal axis through the hip joint. Abduction from the mid-plane in a lateral direction is about 50° from the zero position (at rest) of the leg. Further lateral raising of the leg is only possible through lateral tilting of the pelvis. Adduction of the leg from the zero position only amounts to about 30° (scissors).

Fig. 255 Lateral abduction of the leg at the hip joint combined with external rotation. The greatest extent of external rotation is possible when the contact area between the femoral head and the acetabulum is particularly large.

5.7. THE MUSCLES OF THE HIP JOINT (SUPERFICIAL LAYER)

A tri-axial joint like the hip joint [231, 232, 235] requires a muscle mass that can provide secure control or stability. The muscles surrounding the hip joint in the large arc of the iliac crest are generally compact and form the following groups, based on their position in relation to the axes through the joint:

Posterior to the transverse axis: Extensors [259/2]
Anterior to the transverse axis: Flexors [259/2]
Lateral to the sagittal axis: Abductors [259/1d]
Medial to the sagittal axis: Adductors [259/1g]
Crossing the vertical axis from medial to lateral: Internal rotators
Crossing the vertical axis from lateral to medial: External rotators (see summary overview for the associations for the individual muscles.)

Extensors [245a, 258, 259/2]:
Gluteus maximus (M. gluteus maximus): This is the most compact of all the hip muscles (stabilising function to prevent the pelvis from tilting forwards).
Origin: Primarily the most posterior portion of the iliac blades, lateral margin of the sacrum.
Course and insertion: It fans out from the most posterior margin of the pelvis in a lateral direction and distally to the greater trochanter, the lateral surface of the femur and the iliotibial band and acts in all three axes [231].

Fig. 256 The internal and external rotation in the hip joint around the vertical axis with the pelvis in a fixed position.
a) External rotation amounts to about 50°.
b) Internal rotation amounts to about 40°.
The flexed lower leg acts as the 'hand on the clock face', showing the extent of rotation.

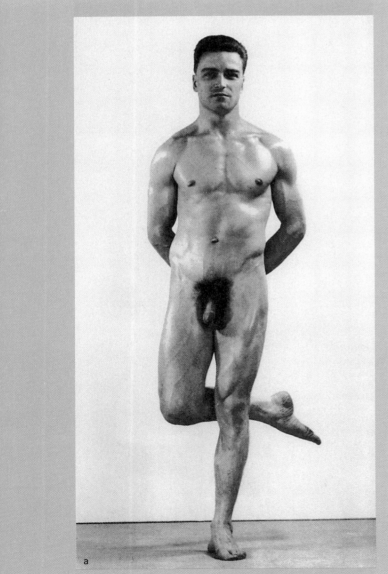
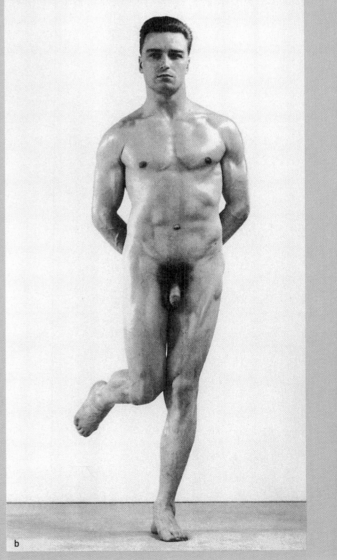

Function: Extension of the hip during running, standing up, jumping, stabilising function when bending the trunk forwards, raising the upper body from a stooped position, steadies the upright stance (balancing of pelvis). The external portion (lateral to the sagittal axis) abducts the leg sideways and the internal portion adducts the leg (pulls legs together). Very important for external rotation as it crosses the vertical axis from posterior to anterior.

Plastic appearance: Its compact form to the right and the left of the sacrum forms a V that is open above and below. The vertical intergluteal cleft is formed by fat deposits. Its change in plastic appearance is typical in the contrapposto position: tension and tautening on the side of the engaged leg with a horizontal gluteal fold, relaxation and loosening on the side of the free leg with drooping and disappearance of the transverse fold. The greater trochanter is not covered (hence trochanteric fossa).

Accessory extensors: Knee flexors (see section 5.4.1.) and adductor magnus (see adductors).

Flexors [259/2]:
Straight head of the quadriceps (see section 5.4.1.) [259/2]
Sartorius (see section 5.4.1.) [259/2]

Fig. 257 The internal and external rotation in the hip joint with a fixed engaged leg. In this case, the pelvis swings round the fixed femoral head.
a) Internal rotation.
b) External rotation.

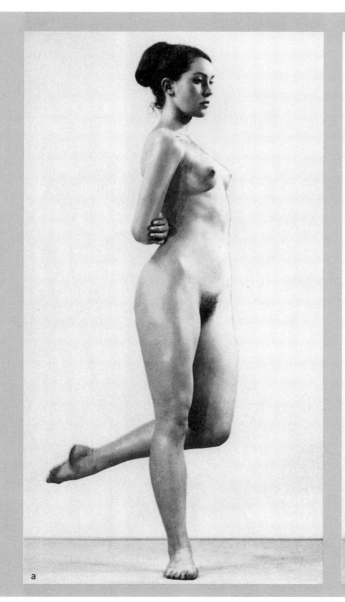
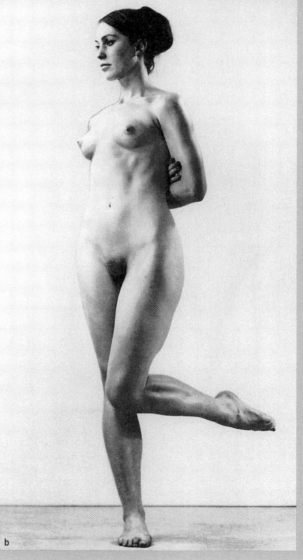

Tensor fasciae latae (M. tensor fasciae latae) [259/2]:
Origin: Anterior superior iliac spine.
Course and insertion: From medially at the front to externally and distally at the back. Includes a band of the deep fascia of the upper leg (fascia lata) and inserts into the lateral tibial condyle.
Function: Flexion of the upper leg on the pelvis, tension of the iliotibial band (thus tautening of the lateral portion of the upper leg), raises the upper body from a horizontal position, internal rotation of the upper leg (crossing of the vertical axis).
Plastic appearance: Flat and pear-shaped appearance. Overlaps with the straight head of the quadriceps in profile, forms a 'V' that is open below, together with the sartorius, from which the quadriceps protrudes.

Abductors [259, 259/1d]:
Gluteus medius (M. gluteus medius):
Origin: Sickle-shaped from the iliac blade (lateral portion).
Course and insertion: Fan-shaped convergence towards the greater trochanter, lateral to the sagittal axis. The anterior portion crosses the vertical axis from the front towards the back and the posterior portion crosses it from the back to the front.

Function: Lateral abduction of the leg when the entire muscle contracts; contraction of the anterior portion effects internal rotation, while contraction of the posterior portion effects external rotation of the upper leg. Fixing of the pelvis in a laterally tilted position, e.g. when the leg is fixed in position; the muscle then pulls the pelvis in the direction of the engaged leg and thus inclines the base of the trunk laterally.
Plastic appearance: Confers a round appearance on the lateral region of the hip.

Accessory abductors: see summary overview.

Adductors [259, 259/2] (composed of five individual muscles; see summary overview):
Common origin: Pectineal line on the pubis and pubic arch. Common course and insertion: fan-shaped, with insertion into medial surface of femur (exception: gracilis into medial tibial condyle).
Common function: Bringing legs together, especially when swimming, adduction of the leg against resistance, stabilising function when in a straddling

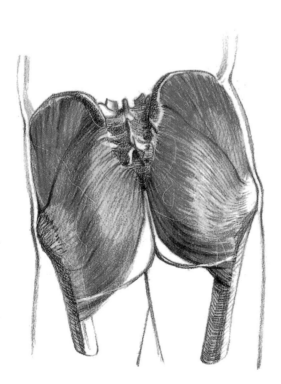

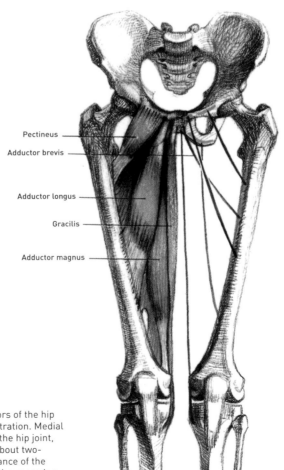

Pectineus

Adductor brevis

Adductor longus

Gracilis

Adductor magnus

Fig. 258 (above) The changes in the plastic appearance of the buttocks when one leg is load-bearing.
The course of the gluteus maximus is not identical to the course of the vertical intergluteal cleft and the horizontal gluteal fold (deposition of structural fat). Together with the engaged and free leg, these two superficial entities follow a set pattern in the sequence of how they overlap with each other.

Fig. 259 (right) The adductors of the hip joint in plastic and line illustration. Medial to the sagittal axis through the hip joint, the adductor group forms about two-thirds of the plastic appearance of the superior medial surface of the upper leg. The fanning out of the muscles from the central origin (pubis) towards the medial surface of the femur produces the shape of an elongated triangular prism.

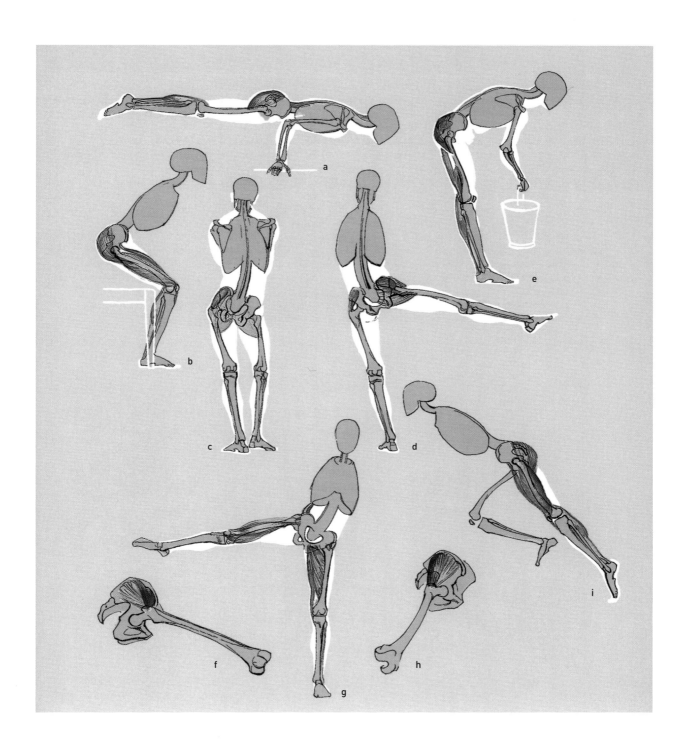

Fig. 259/1 Hip muscles during function.
a) The gluteus maximus fixing the hip joint in position.
b) Joint action of the gluteus maximus, the quadriceps and the gastrocnemius when standing up (mutual participation in raising the body into an upright position).
c) Stabilising function of the pelvis through action of the gluteus medius in the contrapposto position.

d) Abduction of the leg through action of the medial and lateral portions of the gluteus maximus.
e) Formation of a muscle chain when lifting a load (cf. Figure **200/1**)
f) Internal rotation of the upper leg through action of the anterior portion of the gluteus medius.
g) Fixing of the pelvic position by the gluteus medius and the adductors.

h) External rotation of the upper leg through action of the posterior portion of the gluteus medius.
i) Pushing off the ground through extension of the joints by the gluteus maximus, the quadriceps and the gastrocnemius.

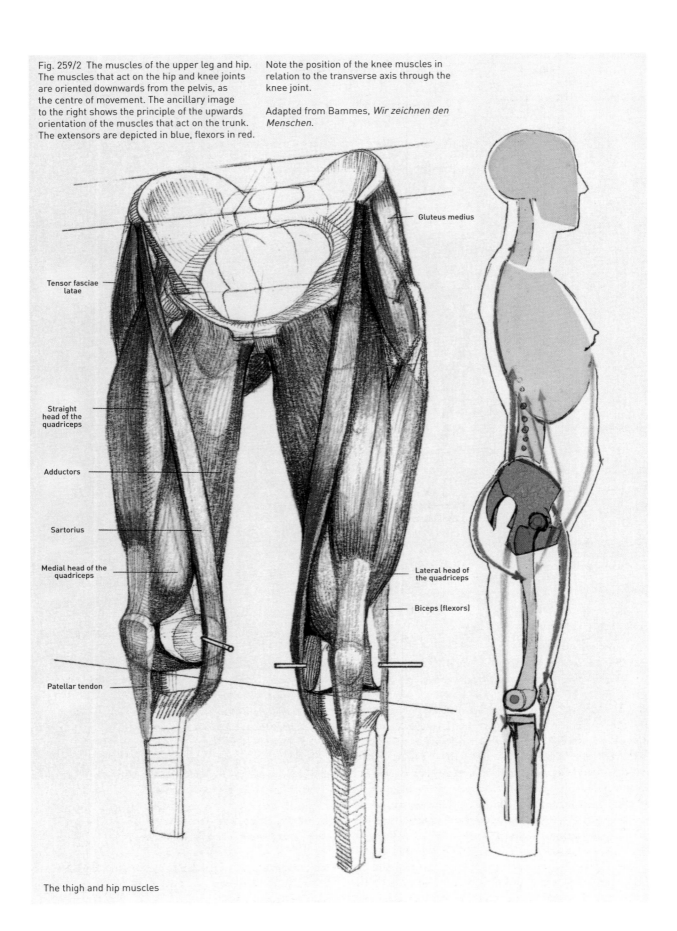

Fig. 259/2 The muscles of the upper leg and hip. The muscles that act on the hip and knee joints are oriented downwards from the pelvis, as the centre of movement. The ancillary image to the right shows the principle of the upwards orientation of the muscles that act on the trunk. The extensors are depicted in blue, flexors in red.

Note the position of the knee muscles in relation to the transverse axis through the knee joint.

Adapted from Bammes, *Wir zeichnen den Menschen*.

Gluteus medius

Tensor fasciae latae

Straight head of the quadriceps

Adductors

Sartorius

Medial head of the quadriceps

Lateral head of the quadriceps

Biceps (flexors)

Patellar tendon

The thigh and hip muscles

Axis	Primary movement	Muscles involved (full list)
Transverse axis	Extension (retroversion	Gluteus maximus (M. gluteus maximus) Biceps, semitendinosus and semimembranosus (M. biceps femoris, M. semitendinosus, M. semimembranosus) Adductor magnus (M. adductor magnus) O
	Flexion (anteversion)	Iliopsoas (M. iliopsoas) O Straight head of the quadriceps (M. rectus femoris) Tensor fasciae latae (M.tensor fasciae latae) Sartorius (M. sartorius)
Sagittal axis	Abduction	Gluteus medius (and minimus) (M. gluteus medius and minimus) gluteus maximus, superior portion
	Adduction	Gluteus maximus, inferior portion of the adductors: gracilis (M. gracilis) O Pectineus (M. pectineus) O Adductor longus (M. adductor longus) O Adductor brevis (M. adductor brevis) O Adductor magnus (M. adductor magnus) O
Vertical axis	Internal rotation	Anterior portion of gluteus medius (and minimus) (M. gluteus medius and minimus) Adductor magnus (M. adductor magnus)
	External rotation	Posterior portion of gluteus medius (and minimus) (M. gluteus medius and minimus) Gluteus maximus Piriformis (M. piriformis) O Obturator internus (M. obturator internus) O Obturator externus (M. obturator externus) Quadratus femoris (M. quadratus femoris) O gemelli (Mm. gemelli) + Iliopsoas (M. iliopsoas) O

O = not discussed, only depicted

position or when skating, stabilising function when standing with weight on one leg; prevention of tilting of pelvis towards the side of the engaged leg.
Common plastic appearance: Fills in the medial portion of the upper leg in the form of a plastic voluminous triangle.

5.8. THE FOOT

5.8.1. General characteristics and function

In humans, a clear division evolved in the function of the upper and lower extremities: the hand evolved into a universal grasping organ and the foot into a specialised supporting organ. The peculiarities in the shape of the foot when compared with the hand are a salient feature of our specific human classification (Braus). The long phalanges lost their grasping ability in the 'foot-hand' and atrophied (reduction in length). Conversely, the tarsals became sturdy bones; the medial border of the foot was strengthened. The compact big toe largely lost its capacity for abduction and moved in line with the other toes.

The human foot rests on the entire sole. To this end, the lower leg is vertical (lever arm for rolling off and pushing off). The load imposed by the body is absorbed in a spring-like fashion by an arch.

5.8.2. Overview of the organisation of the foot [260, 261]

1. Tarsals (short bones): talus, calcaneus, navicular (os naviculare pedis), three cuneiforms (ossa cuneiformia I—III), cuboid (os cuboideum)
2. Metatarsals (long bones): five metatarsals (ossa metatarsalia I–V)
3. Phalanges: proximal phalanges (phalanx proximalis), intermediate phalanges (phalanx medialis), distal phalanges (phalanx distalis).

No individual description of the bones will be provided. Some detailed descriptions will be given where this is indispensable to understanding the construction of the foot.

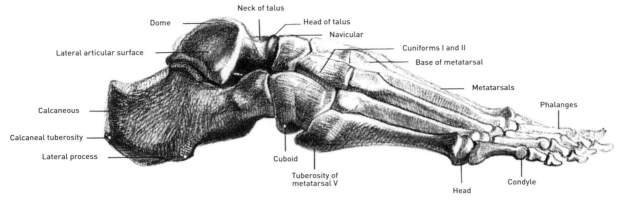

a

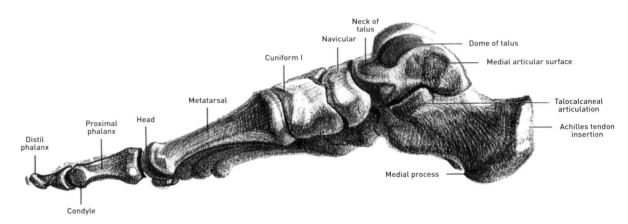

b

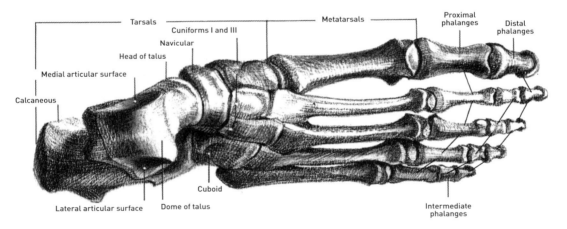

c

Fig. 260 The bones of the right foot.
a) Lateral view.
b) Medial view.
c) Dorsal view.
The skeleton of the foot and its tensile
structures form by far the majority of the
plastic features of the foot in a model.
Note the high cantilever arch of the
medial margin and the flat arch of the
lateral margin of the foot.

5.8.3. The construction of the foot that determines its plastic appearance [262, 262/1, 262/2, 273]

All short and long foot bones (tarsals and metatarsals) are held together tightly and, as a whole, form spring-like, niche-shaped arches that rise above a triangular base (262a, b, c, d, e). The calcaneus and talus have the greatest relative mobility within the overall structure. The reinforced medial margin of the foot rises from the ball of the big toe in the direction of the talus where it culminates (262f, red dashed line) and rests on the calcaneus. Based on its position and orientation, this forms part of the lateral margin of the foot which expands over the foundation, only forming a flat arch. It is supported by plantar fat pads in the foot of a model [262/2c]. The second digit of the foot develops the longitudinal arch most perfectly, even exceeding the height of the medial margin of the foot [262g]. The directions of both margins of the feet are oriented such that they converge behind the heel and they diverge in the shape of a fan in front of the ball of the foot. The calcaneus is the main load-bearing point. The longitudinal arch is complemented by a transverse arch that gradually rises in a medial direction from the lateral margin of the foot and then drops off towards the medial margin. The transverse bow is most pronounced at the level of the navicular. Passive and active factors interact to maintain the structure of the arch: the pressure that is exerted on the arch [262f] (red line) would push the heel and the ball of the foot apart (thrust) and the arch would then collapse; the niche construction is therefore protected by longitudinal and transverse bracing (ligaments), particularly on the bottom of the foot (see also 262c). The cone-like shape of the individual bones of the foot is tailored to the arch. Finally, the short muscles of the foot provide additional bracing.

Fig. 261 The posterior and anterior views of the bones of the right foot. The apex of the transverse arch lies between the first and second digits in the region of the tarsals. From this point, the arch drops off steeply in a medial direction and flat towards the lateral margin of the foot.
a) Anterior view.
b) Posterior view.

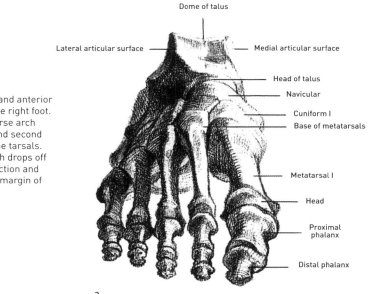

Dome of talus

Lateral articular surface — — Medial articular surface

Head of talus

Navicular

Cuniform I

Base of metatarsals

Metatarsal I

Head

Proximal phalanx

Distal phalanx

a

Dome of talus

Lateral articular surface

Talocalcaneal articulation

Achilles tendon insertion

Calcaneous

b

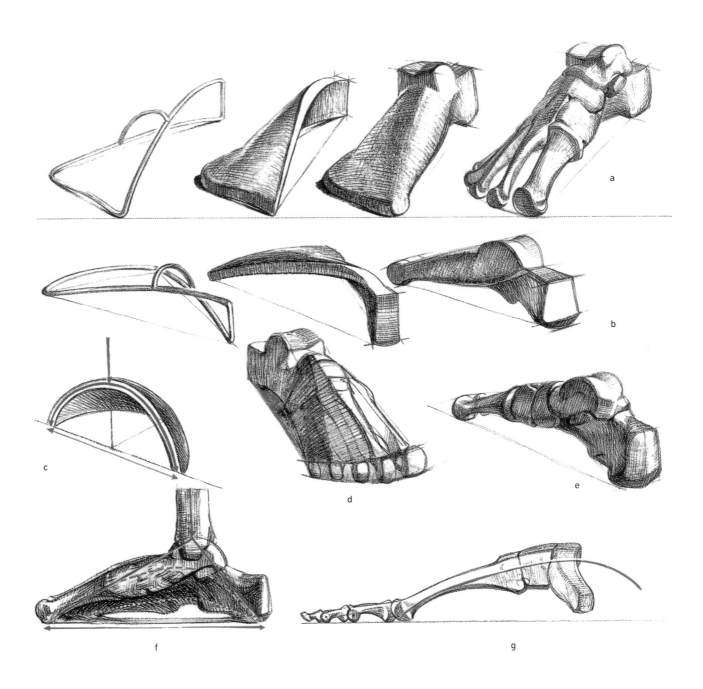

Fig. 262 Didactic developmental series to aid in comprehending and in mastering the drawing of the construction of the foot and its relationships between shapes.
These visualisations are primarily based on the three-point contact of the arched foot with the ground and thus define the decisive directions for the constructional relationships.
a–b) Illustration of the principle of differentiation of primary shapes.
c) Principle of regular niche-shaped arch.
d–e) The arched foot over a substrate.
f) Longitudinal bracing of the arched foot and the compressive and tensile forces (arrows) that act on it.
g) Individual metatarsals and tarsals as components of the arch.

Fig. 262/1 The constructional interpretation of the property of the skeleton of the foot, focussing on the asymmetric niche-shaped arch.
The illustration essentially focuses on the orientation of the margins of the foot and the position of the apex of the niche-shape, from which it drops off steeply in a medial direction and flat in a lateral direction. The heads of the metatarsals are radially arranged building blocks in the shape of the niche.
The cantilevered medial margin of the foot rises from the ball of the big toe towards the back and upwards and intersects the line or orientation through the calcaneus.

Adapted from Bammes, *Wir zeichnen den Menschen*.

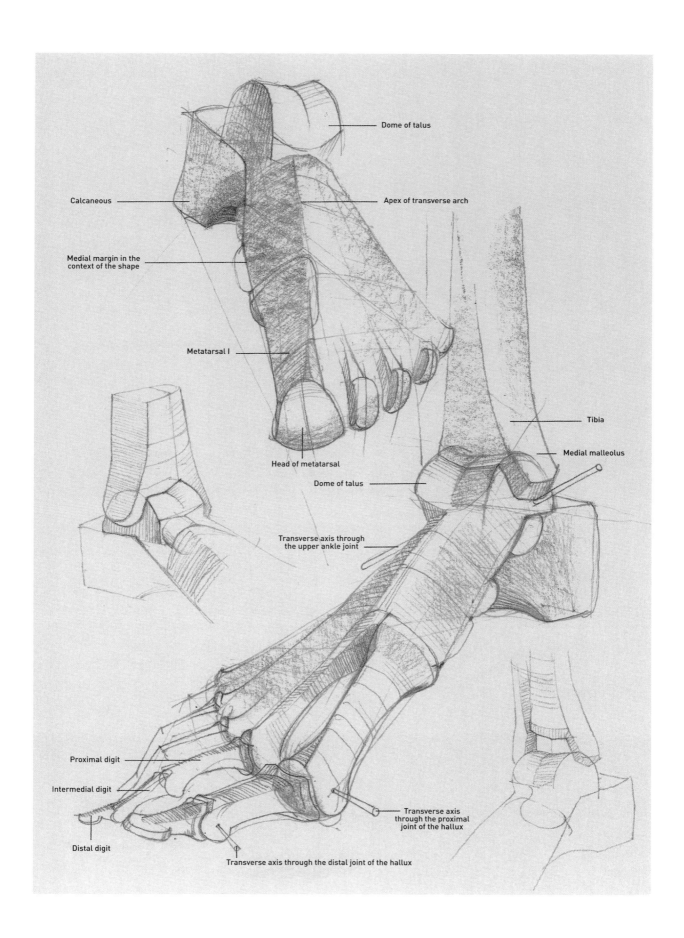

Dome of talus

Calcaneous

Apex of transverse arch

Medial margin in the context of the shape

Metatarsal I

Tibia

Medial malleolus

Head of metatarsal

Dome of talus

Transverse axis through the upper ankle joint

Proximal digit

Intermedial digit

Transverse axis through the proximal joint of the hallux

Distal digit

Transverse axis through the distal joint of the hallux

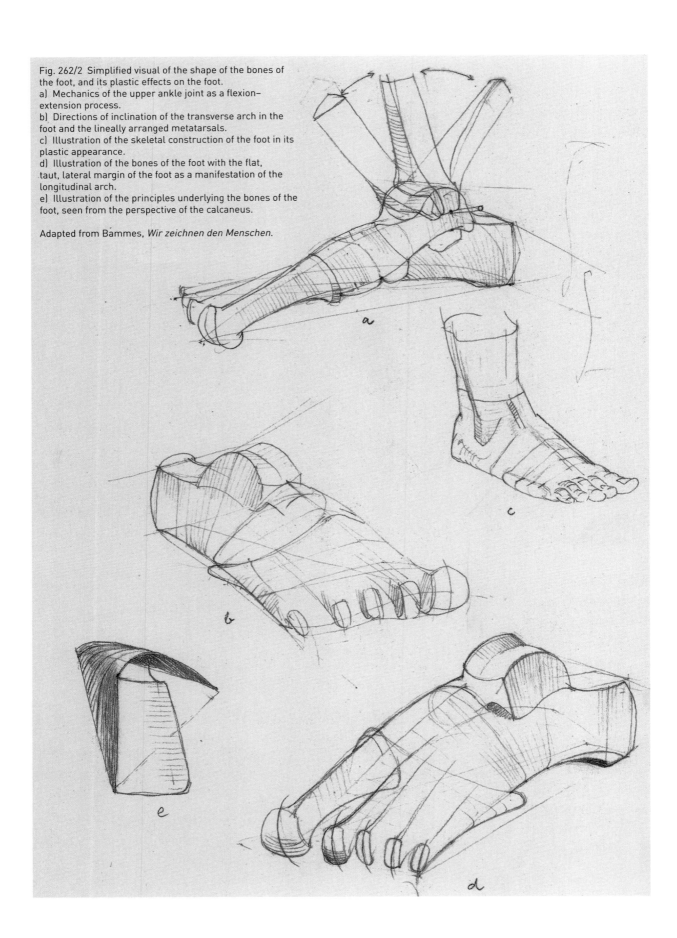

Fig. 262/2 Simplified visual of the shape of the bones of the foot, and its plastic effects on the foot.
a) Mechanics of the upper ankle joint as a flexion–extension process.
b) Directions of inclination of the transverse arch in the foot and the lineally arranged metatarsals.
c) Illustration of the skeletal construction of the foot in its plastic appearance.
d) Illustration of the bones of the foot with the flat, taut, lateral margin of the foot as a manifestation of the longitudinal arch.
e) Illustration of the principles underlying the bones of the foot, seen from the perspective of the calcaneus.

Adapted from Bammes, *Wir zeichnen den Menschen*.

5.8.4. Relationships between shapes

When drawing the bones of the foot – a highly informative exercise – it is best to first ascertain its position in the space (clarification of position – view point) and to define the triangular shape of the sole; the courses of the margins of the foot are indicated starting from the points of contact with the surface below [262a, b, 262/1, 262/2a]. The narrowest diameter of the entire foot that is under maximum load is formed by the dome of the talus. Starting from this point, an internal connecting chain formed by the lowest-lying points can be followed through to the tip of the toe [272a, b]; these create a fluent sequence of statically permissible loading points. For this reason, no 'low-lying point' is permitted to drop below its position in the arrangement, the intrinsic interrelationship between all of the low-lying points. However, the distended articular bodies are built up at the additional loading points (joints) as ancillary shapes; if we take this approach, we are forced into creating a synopsis of the specific details with regard to their meaning and function as a whole.

It is clear that to enable combining a multitude of details into a whole for the purposes of gaining an illustrative synopsis – especially given the numerous spaces in the skeleton of the foot – we first need to lay down the directions, both for the spatial and the complicated torsions within the body itself. On the one hand, the arch of the foot in **262/1** and **262/2** is thus built up based on the delimiting directional courses, e.g. the margins of the foot and, on the other, based on their mutual intersections and superimpositions: the cantilever internal margin of the foot rises up from the head of the ball of the big toe in the direction of the calcaneus which, in turn, is in a directional relationship with the lateral margin of the foot that describes a flat arch. The talus is the static intersection point of an arched fan.

Fig. 263 The bones of the right upper and lower ankle joints.
a) Illustration of the principle underlying the talus, right lateral profile view.
b) Illustration of the principle underlying the talus, dorsal view.
c) Illustration of the principle governing the connection between the two bones of the lower leg and the talus, spatial partial anterior view.
d) True shape of the talus, lifted off its articulation with the calcaneus
e) Medial view of the above.
The blue colouration indicates the facets (articular surfaces) on the bones.

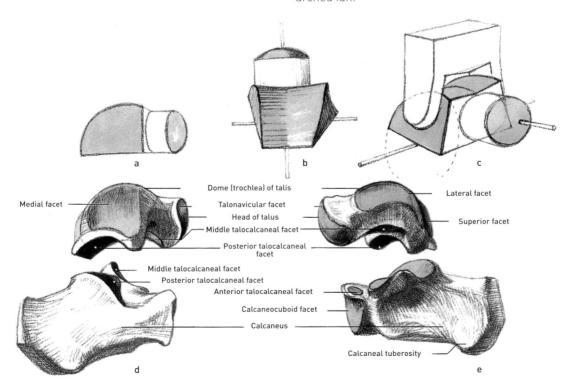

a

b

c

Medial facet

Dome (trochlea) of talis
Talonavicular facet
Head of talus
Middle talocalcaneal facet
Posterior talocalcaneal facet

Lateral facet

Superior facet

Middle talocalcaneal facet
Posterior talocalcaneal facet
Anterior talocalcaneal facet
Calcaneocuboid facet
Calcaneus

Calcaneal tuberosity

d

e

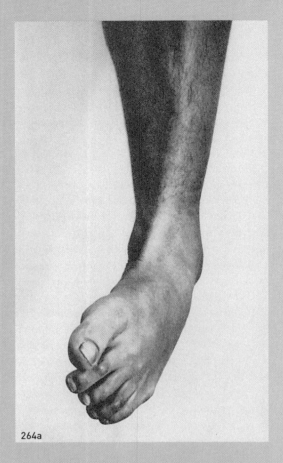

264a

b

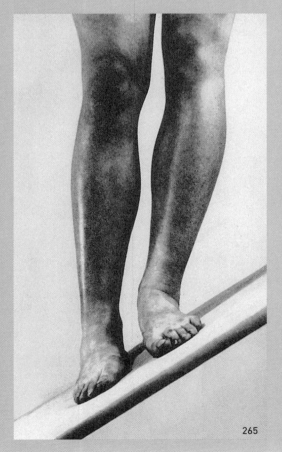

265

Fig. 264 (above) Active mechanics of the foot in the lower ankle joint.
a) Supination (raising of the medial margin of the foot).
b) Pronation (raising of the lateral margin of the foot).
The cupped, swinging movement of the tip of the foot is related to the spatially diagonal direction of the longitudinal axis through the lower ankle joint. Furthermore, the differences in the distances between the medial and lateral malleolus and the sole of the foot that are clearly depicted in **a** and **b** are important in nude studies.

Fig. 266 (right page, top left) The functioning calf muscles when standing on tip-toes (posterior view). The gastrocnemius and soleus muscles share a common insertion via the Achilles tendon and work against the load imposed by the body through acting on the lever arm of the calcaneus; the centre of rotation is the transverse axis through the upper ankle joint. There is a clear relationship between the calcaneus and the direction of the lateral margin of the foot

Fig. 265 (left) Passive mechanics in the lower ankle joints and compensatory functions of the two lower ankle joints when standing sideways on an inclined surface. The ankle joints allow adjustment of the position of the foot on the surface while maintaining an upright stance. The left foot of the model is in a pronated position.

Fig. 267 (right page, top mid and right) The functioning calf muscles when standing on tip-toes (lateral and anterior view).
The load is resting on the heads of the metatarsals and not on the phalanges. Note the sharp accentuations on the medial portion of the calf during this function. Lowering the tip of the foot is called plantar flexion while raising it is dorsal flexion.

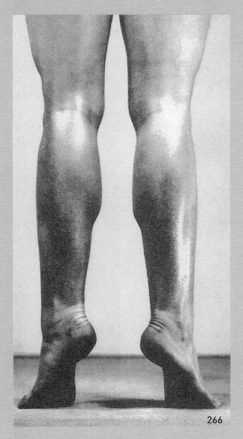

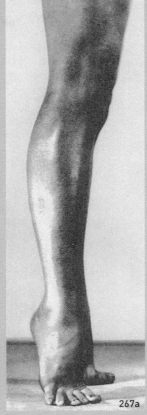

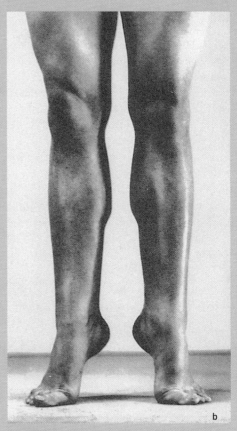

Fig. 268 (below) Feet on an ascending surface. The foot that has been planted is subject to passive movement in the upper ankle joint (dorsal flexion), while the foot that is pushing off the substrate is being actively lowered (plantar flexion).

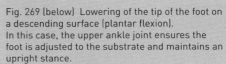

Fig. 269 (below) Lowering of the tip of the foot on a descending surface (plantar flexion).
In this case, the upper ankle joint ensures the foot is adjusted to the substrate and maintains an upright stance.

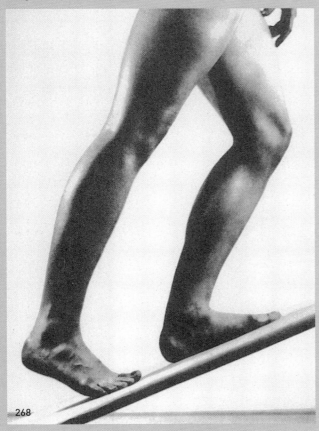

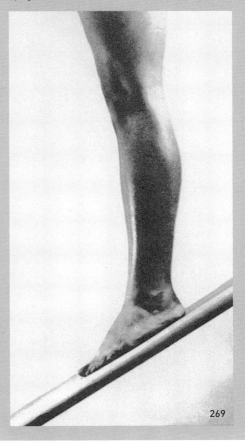

5.8.5. General information on the joints in the foot

The foot has many joints, of which two have specific static and dynamic functions: the upper and the lower ankle joint. We use the upper ankle joint to roll and push off the ground or adjust ourselves to ascending and descending terrain, allowing the lower leg to remain in a vertical position. The lower ankle joint allows us to take up a straddling position with the legs, to traverse descending terrain or use the foot during climbing. Both joints are separated from each other and located one above the other.

5.8.6. Structure, mechanics and changes in plastic appearance in the upper ankle joint (articulatio talocruralis) [273, 280a, b, 276–279]

Raising (= flexion towards the dorsal aspect of the foot = dorsal flexion) and lowering the tip of the foot (= flexion towards the sole of the foot = plantar flexion) is a hinging movement around a transverse axis [273,

274]. To secure the movement of pushing off the substrate, the dome of the talus (trochlea tali) required for this is grasped, as if by tongs formed of the medial malleolus (tibia) and the cone-shaped thickening of the fibula (malleolus fibularis). The lateral and medial ligaments provide additional support. The right angle between the sole of the foot and the lower leg can be actively reduced by 25° when the tip of the foot is raised and increased by 35° when it is lowered. During these movements, either the dome of the talus slides between the prongs or the prongs slide across the dome [269, 270]. The changes in plastic appearance consist of the skin being folded together into wrinkles between the lower leg and the foot when the tip of the foot is raised. The Achilles tendon (insertion into the calcaneus) is stretched and becomes taut during this process. When the tip of the foot is lowered (e.g. standing on tip-toes), the dorsal portion of the foot is lengthened in the direction of the lower leg and its arch emerges in the form of a convex instep. The raised heel moves closer to the posterior portion of the lower leg, without ever losing its feature of a protruding lever arm.

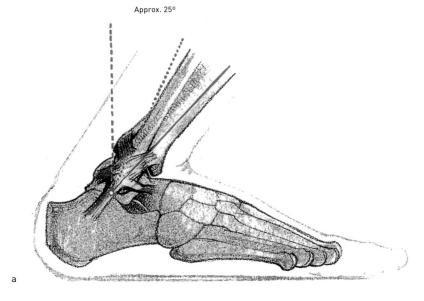

Approx. 25°

a

Fig. 270 The mechanics of the upper ankle joint.
a) Lowering of the lower leg towards the tip of the foot with the sole of the foot planted on the substrate equates to (passive) dorsal flexion.
b) Lowering of the lower leg towards the heel with the sole of the foot planted on the substrate equates to (passive) plantar flexion. Red dashed line: normal position of the lower leg. Red solid line: maximum exploitation of the mechanics of the joint. Ancillary illustration: Dorsal flexion and plantar flexion with the foot moving freely.

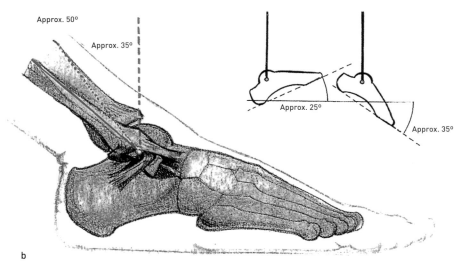

Approx. 50°

Approx. 35°

Approx. 25°

Approx. 35°

b

A small amount of wrinkling of the skin occurs when the calcaneus is angled in such a way in relation to the Achilles tendon. The heel and the calf never merge into each other!

5.8.7. Structure, mechanics and changes in plastic appearance in the lower ankle joint [264a, b, 265, 271] (articulatio talocalcaneonavicularis)

In this second joint in the foot, which lies below the previous one, the margins of the foot are raised medially or laterally around a spatial diagonal longitudinal axis (supination, pronation) (from behind, below and lateral to the calcaneus towards the front, above and medial to the head of the talus) [264, 265]. This course of the axis through the joint that is not identical to the longitudinal direction of the foot requires a compulsory medial and lateral cupped, swinging movement of the tip of the foot when the two margins of the foot are raised alternately. The lower ankle joint has an anterior and a posterior chamber.

The two partial joints essentially arise from contact between the lower surface of the talus and the upper surface of the calcaneus and from contact between the head of the talus and the navicular. Supination is more intensive than pronation. The changes in plastic appearance [271]: during lowering of the lower leg towards the medial margin of the foot (supination), the medial malleolus leaves its high position and moves considerably towards the sole of the foot. The situation is now exactly reversed when compared with the normal position (lateral malleolus lower than medial malleolus). The lateral malleolus is exposed in a particularly accentuated fashion. Conversely, pronation enhances the differences in the distances between the malleoli and the margins of the sole of the foot: the tibial malleolus (medial) now moves even higher up and the fibular malleolus (lateral) drops so far down to the margin of the foot that it loses almost all of its relief.

The proximal interphalangeal joints are restricted ball and socket joints, while the intermediate and distal joints are pure hinge joints.

Fig. 271 The mechanics of the lower ankle joint when the foot is planted on the substrate and the most important ligaments.
a) Normal position.
b) Tilting of the lower leg in a lateral direction (pronation).
c) Tilting of the lower leg in a medial direction (supination).
The intensity of the inclination is emphasised by the red transverse axes (upper ankle joint).
Red dot: centre of rotation around the vertical axis.

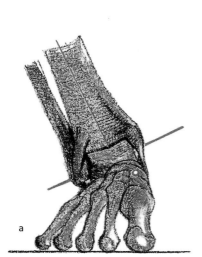
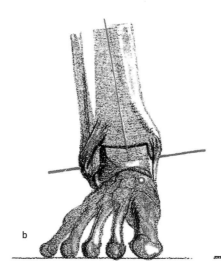
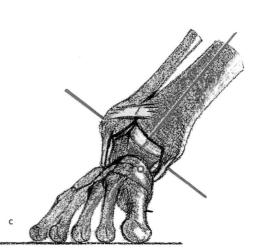

5.8.8. The associated skeleton of the upper and lower leg and foot [262/1, 262/2, 272, 273, 274]

We mentioned earlier on that the load imposed on the foot by the body is distributed across three points of contact, and that this force would push the arch apart towards its ends if the ligaments did not provide bracing for the arch on the plantar side of the foot. However, what happens to the stability of the foot when it is only being loaded on the balls of the feet? The calf muscles pull the calcaneus upwards, whereby the plantar ligaments indirectly come under tension again and thus contribute towards stabilisation, precisely because of the load. The skeleton of the foot does not just intrinsically refer to the associated low points of a statically required structure; the connecting chain,

within the meaning of related direction, strengths and shapes, is continued from the tip of the foot, through the medial margin of the foot [272, numbers 9*–4*], to the tiny breadth of the dome of the talus. The penetrating eye perceives this 'static line' in its progress through to the wedge formed by the tibia and fibula [273]. The medial and lateral malleolus and the tibial condyles are secondary shapes within the scope of the overall structure.

While Figure 273 shows the entire skeleton of the leg with its relationships between shapes and its constructional relationships, in different degrees of flexion of the knee, Figure 274 visualises the different spatial directions for the three axes through the leg that are of great importance to the study of the leg in the model for both drawing and sculpture.

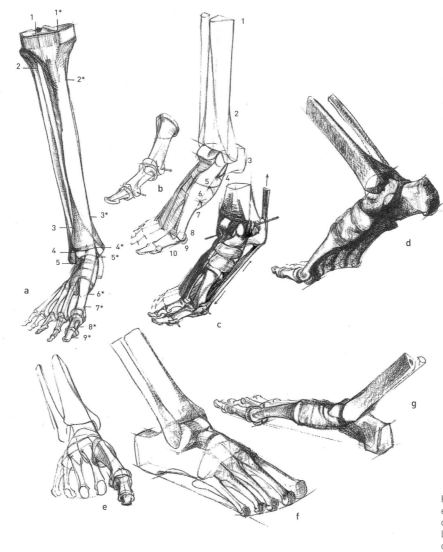

Fig. 272 (left) Relationships between shape and function in the bones of the lower leg and foot. The numbers indicate points in the internal connecting chain.

Fig. 273 (right) The skeleton of the entire right leg in association with an overview of its overall construction. Left illustration: Partial medial view of the skeleton of the right leg and during two phases of flexion of the lower leg.
Right illustration: The constructional elements of the joints and their axes connected in sequence, partial anterior and lateral view.

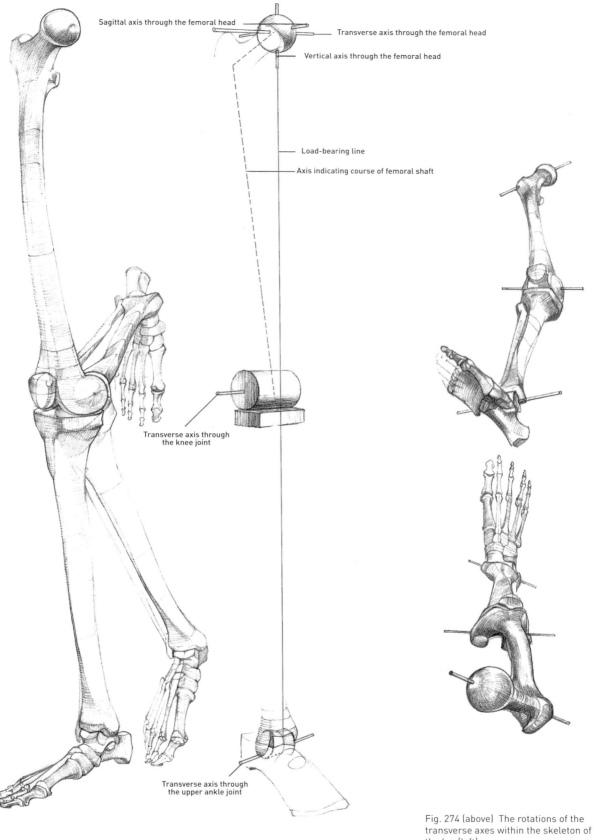

Sagittal axis through the femoral head

Transverse axis through the femoral head

Vertical axis through the femoral head

Load-bearing line

Axis indicating course of femoral shaft

Transverse axis through
the knee joint

Transverse axis through
the upper ankle joint

Fig. 274 (above) The rotations of the
transverse axes within the skeleton of
the leg (left).
The strict view from below (top)
and the view from above (bottom)
demonstrate the important fact that
these sections of the body are twisted
in relation to each other.

The lower extremities **255**

Summary:

1. A clear division evolved in the function of the hand and foot. The hand is a universal grasping organ, and the foot is a specialised supporting and locomotor organ which rolls off the medial margin of the foot, in contrast to the great apes.
2. The foot is divided into the following sections: tarsals, metatarsals and phalanges.
3. The longitudinal and transverse arches (niche-arches) maintain an elastic construction of the foot.
 a) The footprint corresponds to an elongated, narrow triangle with its three main load-bearing points.
 b) A longitudinal arch ascends above this base, the reinforced medial margin of which rises substantially higher than the lateral margin.
 c) Across the transverse arch, the foot descends gently down to the lateral margin and steeply down to the medial margin.
 d) The arched construction is passively maintained by ligaments and actively by the muscles.
4. The most important joints in the foot are:
 a) The upper ankle joint, formed of the dome of the talus and the bony prongs of the tibia and fibula. This hinge joint allows lowering of the tip of the foot (plantar flexion) by about 30° and raising of the tip of the foot (dorsal flexion) by about 20°.
 b) The lower ankle joint allows a medial and lateral cupped or swinging movement of the tip of the foot, resulting from the spatial diagonal course of the longitudinal axis. Lifting the medial margin of the foot (supination) raises the horizontal transverse axis by about 20 to 25°, and lifting the lateral margin of the foot (pronation) only raises it by about 10 to 15°.
 c) The construction of the proximal interphalangeal joints conforms to restricted ball and socket joints that allow flexion, extension, adduction and abduction, while the remaining interphalangeal joints are pure hinge joints with a capacity for flexion and extension.
5. The movements in the main joints of the foot are associated with significant changes in plastic appearance.

5.9. THE MUSCLES OF THE FOOT AND PHALANGEAL JOINTS

5.9.1. Overview of the general system [275] (see also summary overview)

The long muscles that act on the joints of the foot and phalanges surround the tibia and fibula in the form of an elongated cone (main muscle mass above the middle of the lower leg). The short muscles of the foot originate from the foot itself and are not discussed. All muscles anterior to the transverse axis raise the tip of the foot (dorsal flexors) and all those posterior to the transverse axis lower the tip of the foot (plantar flexors). These muscles act to raise the medial margin of the foot (supinators) when they are located medial to the longitudinal axis and when located lateral to the longitudinal axis, they act to raise the lateral margin of the foot (pronators). This means that the axes do not all have their own muscle groups; rather more, depending on innervation, existing functional collectives may be disbanded and combined into new collectives with 'elective affinity'. Former antagonists, such as the dorsal flexors and plantar flexors, can be oriented laterally or medially to the longitudinal axis and then act as pronators or supinators. The muscles of the lower leg are multifunctional. They can solve different tasks, depending on their function.

5.9.2. Muscles anterior to the transverse axis through the upper ankle joint (dorsal flexors)

The superficial muscles alone are discussed here. The reader will find a full list in the summary overview.

Tibialis anterior (M. tibialis anterior) [276, 277]:
Origin: Mainly from the anterior lateral condyle of the tibia and the surface of the tibial shaft that is oriented towards the fibula.
Course and insertion: Runs along the anterior border of the tibia, its long tendon crosses the transverse axis in an anterior direction and the vertical axis in a medial direction through its insertion into the medial margin of the foot (medial cuneiform and first metatarsal).
Function: Raises the tip of the foot, e.g. when taking a step, and ensures spring-like cushioning when the calcaneus comes into contact with the substrate, raises the medial margin of the foot.
Plastic appearance: In a lateral view, its muscle belly overlaps the tibia just below the tibial tuberosity. This emphasises the anterior convexity of the lower leg. Fills the anterior lateral portion of the lower leg. Its tendon protrudes sharply when the tip of the foot and the internal margin of the foot are raised.

Extensor hallucis longus (M. extensor hallucis longus) [276, 277, 278]: Only the final section of this muscle is visible between the extensor digitorum longus and the tibialis anterior (therefore only illustrated). Its tendon protrudes when the big toe is raised (extended).

Extensor digitorum longus (M. extensor digitorum longus) [276, 277, 278]:
Origin: Lateral condyle of the tibia and anterior border of the fibula.
Course and insertion: Divides into four strong extensor tendons above the angle of the foot that insert into the tendinous sheaths on the dorsal side of the phalanges (2–5). Partially located lateral to the vertical axis.
Function: Extends and raises the toes and dorsiflexes the tip of the foot, aids in pronation.
Plastic appearance: Augments the convex appearance of one side of the lower leg. Its tendon fan confers a lively profile on the dorsal aspect of the foot.

5.9.3. Muscles posterior to the transverse axis through the upper ankle joint (plantar flexors)

These muscles counteract the load imposed by the body (pushing off) and are therefore larger in volume and number than the anterior group.

Gastrocnemius (M. gastrocnemius) [276, 278]:
Origin: Arises from two heads above the femoral condyles.
Course and insertion: The two heads merge below the knee. Fusion with the soleus in the centre of the calf and transition into Achilles tendon.
Function: Lowers the tip of the foot, propels body weight forward. Flexion of the knee, e.g. when cycling.
Plastic appearance: Overlays the longer soleus, from which it protrudes in a voluminous fashion. Both heads are flattened in a tendinous manner and thus facetted. Apex of the shorter curve circumscribed by the medial head is lower down than the apex of the longer and flatter curve circumscribed by the lateral head.

Soleus (M. soleus) [276, 278]:
Origin: Soleal line and head of the fibula.
Course and insertion: Fuses with the gastrocnemius, transition into Achilles tendon (strongest tendon in the body) which inserts into the calcaneal tuberosity and serves as a lever arm.
Function: Joint action with the gastrocnemius, posterior fixing of the angle of the foot, pushing off, propelling off substrate (jumping), climbing stairs, climbing, dancing on points, spring-like cushioning during running and landing after jumping.
Plastic appearance: Flattened against lower leg. Forms the lateral contour in a posterior and lateral view, padding underneath the gastrocnemius and thus forms the basis for the calf. Taken together, these muscles do not form a channel in a lateral perspective, at most, a flat notch is observed that arises from two convex shapes.

Flexor digitorum longus (M. flexor digitorum longus) [276, 278]: This is largely covered by other muscles and is therefore not discussed, but only depicted.

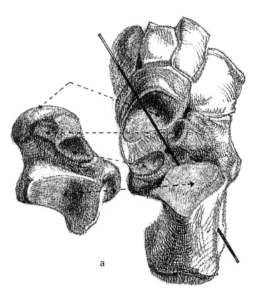

Fig. 275 Course of axes through the upper and lower ankle joints with the associated muscle groups.
a) Direction of longitudinal axis.
Talus tilted off the calcaneus to show the associated articular surfaces (arrows). The associated articular surfaces are shown in the same colour.
b) Transverse axis through the upper ankle joint.
Black ellipses: cross-sections of the tendons of the muscles that raise the tip of the foot (dorsal flexors).
White ellipses: the muscles that lower the tip of the foot (plantar flexors).
c) The same muscle forces allocated to the diagonal longitudinal axis through the lower ankle joint: the pronators lateral to the longitudinal axis and the supinators medial to this axis.
Therefore, no additional muscles are required for the individual functions, but the forces that are available can be combined functionally.

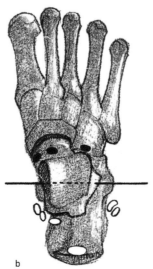

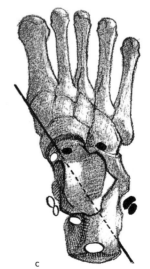

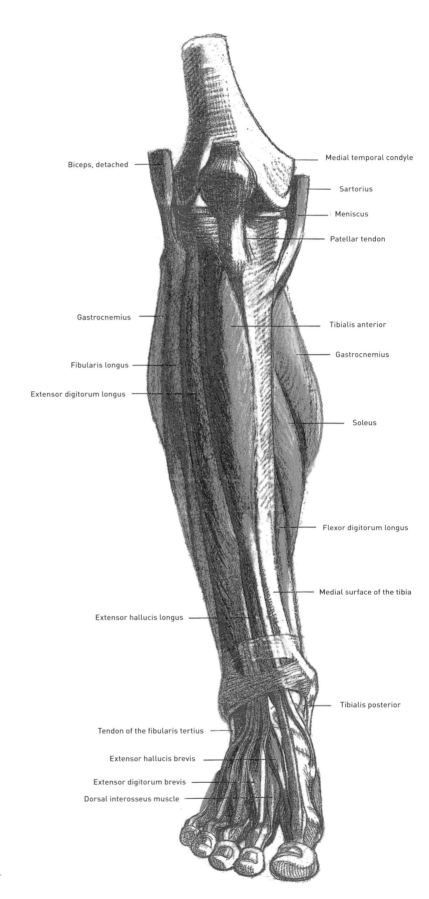

Biceps, detached

Medial temporal condyle

Sartorius

Meniscus

Patellar tendon

Gastrocnemius

Tibialis anterior

Fibularis longus

Gastrocnemius

Extensor digitorum longus

Soleus

Flexor digitorum longus

Medial surface of the tibia

Extensor hallucis longus

Tibialis posterior

Tendon of the fibularis tertius

Extensor hallucis brevis

Extensor digitorum brevis

Dorsal interosseus muscle

Fig. 276 Anterior, lateral and posterior view of the muscles of the lower leg. The numerous superficial and deep muscles form a plastic cone where the volume is always concentrated close to the median line, the medial surface of the tibia always lacks any muscular cover and the muscle volume is reduced close to the ankle joints.
All muscles contribute towards a closed, tense, convex shape in the region of the upper lateral lower leg; the calf muscles merge into the taut Achilles tendon; the tibialis anterior protrudes over the patellar tendon, with an important overlap.

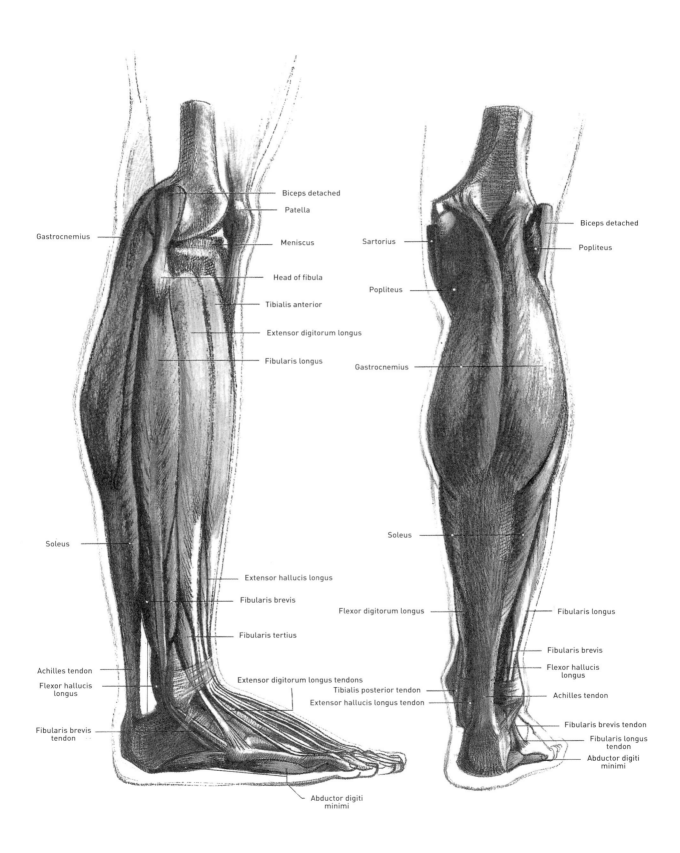

Biceps detached

Patella

Meniscus

Head of fibula

Tibialis anterior

Extensor digitorum longus

Fibularis longus

Gastrocnemius

Soleus

Extensor hallucis longus

Fibularis brevis

Fibularis tertius

Achilles tendon

Flexor hallucis longus

Extensor digitorum longus tendons

Fibularis brevis tendon

Abductor digiti minimi

Sartorius

Popliteus

Gastrocnemius

Soleus

Flexor digitorum longus

Tibialis posterior tendon

Extensor hallucis longus tendon

Biceps detached

Popliteus

Fibularis longus

Fibularis brevis

Flexor hallucis longus

Achilles tendon

Fibularis brevis tendon

Fibularis longus tendon

Abductor digiti minimi

The lower extremities **259**

5.9.4. Muscles lateral to the vertical axes through the lower ankle joint [278a] (pronators, full list in summary overview)

These muscles cover the fibula and pass through the upper ankle joint posterior to the transverse axis (therefore, in addition to raising the lateral margin of the foot, also lowers the tip of the foot).

Fibularis longus (M. fibularis longus) [276, 278]:
Origin: Head and upper lateral surface of fibula.
Course and insertion: Runs posterior to the fibular malleolus (thus posterior to the transverse axis), crosses underneath the lateral margin of the foot and diagonally across the arch of the foot. Insertion into medial margin of the foot (medial cuneiform).
Function: Exact antagonist to the tibialis anterior, lowering of the medial margin of the foot and the tip of the foot.
Plastic appearance: Fills the lateral surface of the lower leg; the fibular malleolus overlaps it in a frontal view. Tension of its tendon when standing on tip-toes.

5.9.5. Muscles medial to the longitudinal axis through the lower ankle joint [277, 278b] (supinators, full list in summary overview)

In addition to its lowering effect on the tip of the foot, the gastrocnemius and soleus [276] also act to raise the medial margin of the foot due to their position medial to the longitudinal axis. The latter function also applies to the tibialis anterior.

5.9.6. The external appearance of the lower leg and foot in relation to function and shape

The dangling foot behaves differently from the foot when its entire sole is planted on the ground or when it is on tip-toes [279a, d]. The fully loaded foot is broad (squeezing out of the plantar fat pads in medial and lateral directions). The ball of the heel is more pronounced medially than laterally. The posterior aspect of the heel is more vertical than when the foot is dangling or on tip-toes (slight supination) [278a, b]. The plantar muscles that help to brace the arch of the foot slightly flex the toes (typically). The arch is slightly flattened off. When standing on tip-toes, the weight of the body is resting on the balls of heads of the metatarsals, not on the toes [279b, c]. The enormous power exerted by the calf muscles angles the heel slightly inwards and strengthens the arch of the foot. The toes are slightly angled and passively extended. In accordance with the greater biological importance of the muscles that lower the tip of the foot (plantar flexors) compared with the muscles that raise the tip of the foot (dorsal flexors) and the supinators compared with the pronators, there are differences in their relative strength. For example, this results in the tension at rest in the supinators and the plantar flexors pulling the medial margin of the foot slightly upwards and moderately lowering the tip of the foot in the relaxed dangling foot.

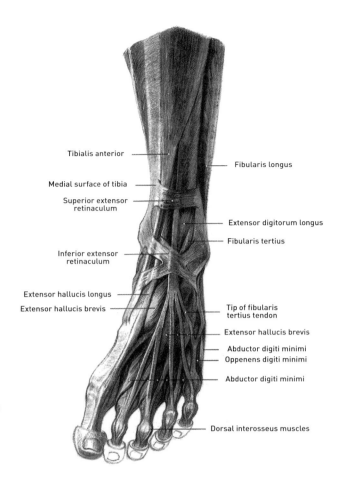

Fig. 277 Muscles and ligaments of the foot (dorsal view).
Only short muscles occur in the foot itself; the muscles of the lower leg only reach the foot in the form of long tendons (reduction of load in periphery of the body).

A synopsis of the lowest points ('notches') also results in a series of relationships in the model [279, 280, 286]. If we connect these up amongst themselves into linking chains, they continue to remain connected to each other – depending on function and position of the sections of the extremities [280g–i]. They simultaneously 'stake out' the peripheral tapering of a section of an extremity and act as 'guards' monitoring the capacity for loading. They inform us of the fact that thoughtless illustrative incision into these shapes that are staked out by low points destroys the relationship between the shapes, both functionally and aesthetically.

Fig. 278 Muscles and ligaments in the foot.
a) Lateral view.
b) Medial view.

a)

Tibialis anterior

Extensor digitorum longus

Fibularis longus

Extensor hallucis longus

Superior extensor retinaculum

Soleus

Extensor hallucis longus

Achilles tendon

Fibularis tertius

Inferior extensor retinaculum (lower band detached)

Extensor hallucis longus

Extensor hallucis brevis

Dorsal interosseus muscle

Tip of fibularis brevis tendon

Extensor digitorum brevis

Fibularis longus tendon

Abductor digiti minimi

Dorsal interosseus muscle

Oppenens digiti minimi

Abductor digiti minimi

a

b)

Gastrocnemius

Tibialis anterior

Medial surface of tibia

Soleus

Superior extensor retinaculum

Flexor digitorum

Extensor digitorum longus

Extensor hallucis longus

Tibialis posterior

Inferior extensor retinaculum

Achilles tendon

Extensor hallucis brevis

Tibialis posterior

Tibialis anterior tendon

Extensor digitorum longus tendon fan

Abductor hallucis

Dorsal interosseus muscle

b

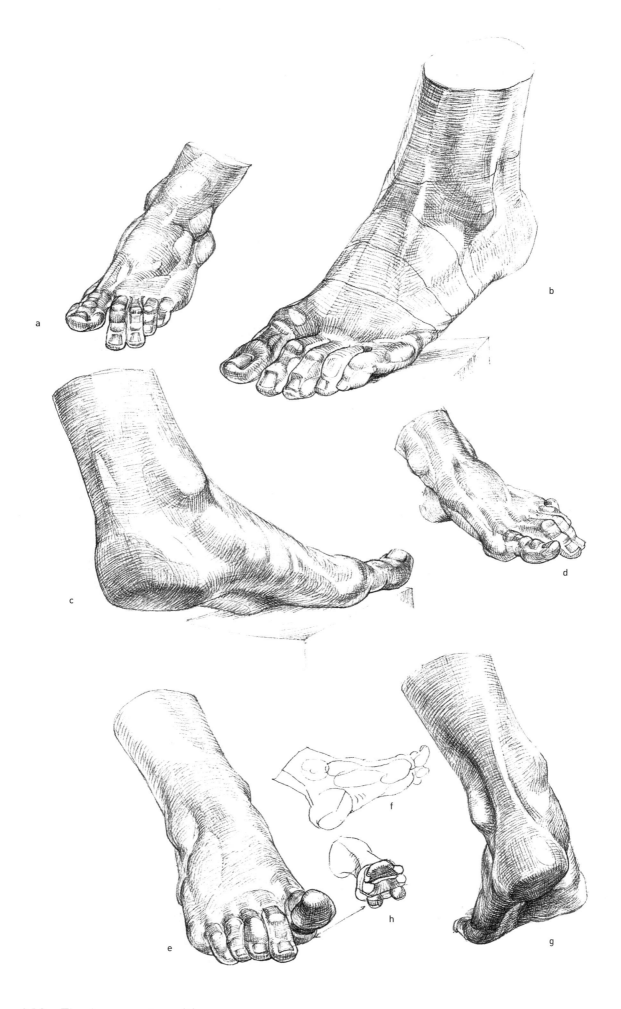

a

b

c

d

e

f

h

g

Figure 280 [a, b, c, g, h, i] shows the connecting chain for the low points in sequences of numbers, in which rhythm and accentuation form the shape during movement. The internal chain from the knee downwards to the ball of the little toe is easy to discern in the lower leg that is raised on tip-toes [280, numbers 1–7], also shown in Figure 286b, c. The long or short convex tension of the lateral and medial contours of the calf, with their apices shifted relative to each other, arises from these basic shapes. In locations where tendons, such as the Achilles tendon, are under enormous tensile stress, their tautness creates a directly perceived connective line between one low point and another. The connecting chain for internal associations thus also becomes the connecting chain for external associations. Standing on tip-toes is a static problem. The fact that the masses adhere to the correct, i.e. functional, order in mutual elevation and continuation is something that the artist should study with great attention here. No matter what action the model may be carrying out in the foot, the artist must never forget to consider the plastic interactions between the skeleton and the soft tissues and their functional, plastic behaviour [279].

Summary overview: the upper and the lower ankle joint

Axis	Movement	Muscles involved (full list)
Transverse axis (upper ankle joint)	Raising of the tip of the foot (dorsal flexion)	Tibialis anterior (M. tibialis anterior) Extensor hallucis longus (M. extensor hallucis longus) ○ Extensor digitorum longus (M. extensor digitorum longus) Fibularis tertius (M. fibularis tertius) ○
	Lowering of the tip of the foot (plantar flexion)	Gastrocnemius (M. gastrocnemius) Soleus (M. soleus) Flexor hallucis longus (M. flexor hallucis longus) Flexor digitorum longus (M. flexor digitorum longus) Tibialis posterior (M. tibialis posterior) Fibularis longus (M. fibularis longus) Fibularis brevis (M. fibularis brevis)
Vertical axis (lower ankle joint)	Raising of the medial margin of the foot (supination)	Gastrocnemius (M. gastrocnemius) Tibialis posterior (M. tibialis posterior) Soleus (M. soleus) Flexor hallucis longus (M. flexor hallucis longus) Flexor digitorum longus (M. flexor digitorum longus) Tibialis anterior (M. tibialis anterior)
	Raising of the lateral margin of the foot (pronation)	Fibularis longus (M. fibularis longus) Fibularis brevis (M. fibularis brevis) Extensor digitorum longus (M. extensor digitorum longus) Fibularis tertius (M. fibularis tertius)

○ = not discussed, only depicted

Fig. 279 The appearance of the foot in the model and its architectural form.
a–f) Architectural form of the foot based on a small model by Michelangelo. The individual concentrations of volumes are treated as built-up shapes extending into the backs of the toes.
b–g) Main, secondary and transitional shapes are given particular emphasis. Particular attention is paid to the toes as segmented entities.
h) Skeletal illustration of the foreshortened big toe.

The reader will find a contiguous illustration of the muscles in the leg as a whole in different perspectives and positions from pages 265–270 in Figures 281–284.

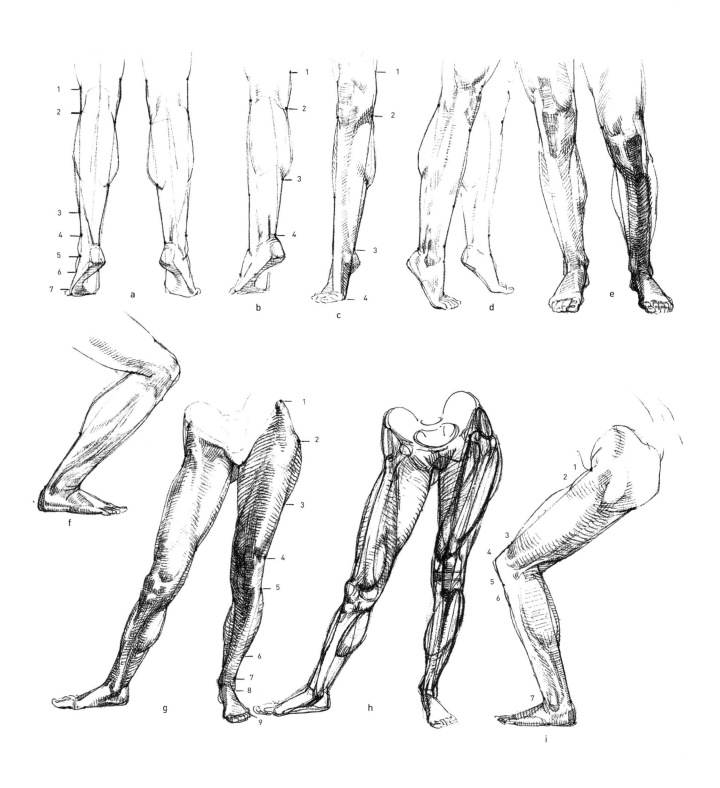

Fig. 280 Relationships between shapes
in the lower leg and foot, as well as in the
leg as a whole, in a model.
The numbers at the side apply to the 'low
points' (connecting chain) associated with
the shape.

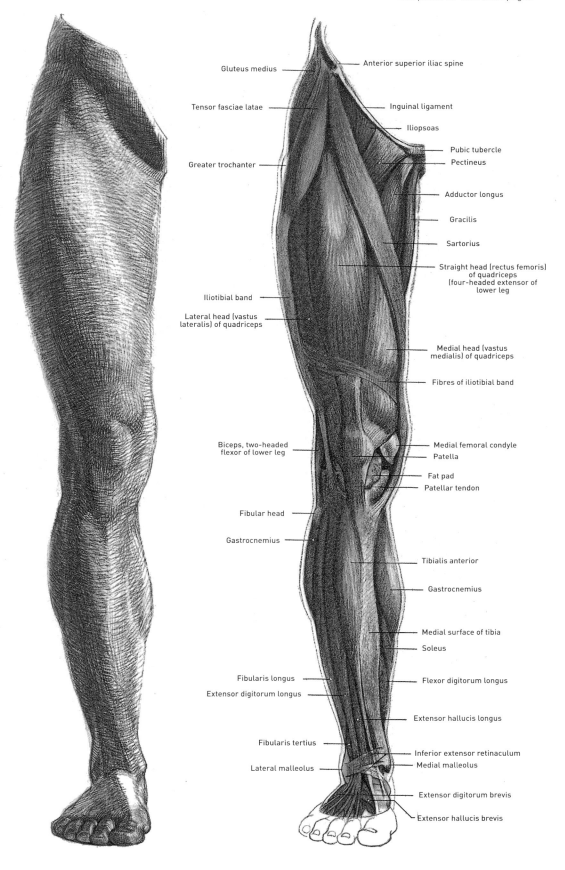

Gluteus medius

Tensor fasciae latae

Greater trochanter

Iliotibial band

Lateral head (vastus lateralis) of quadriceps

Biceps, two-headed flexor of lower leg

Fibular head

Gastrocnemius

Fibularis longus

Extensor digitorum longus

Fibularis tertius

Lateral malleolus

Anterior superior iliac spine

Inguinal ligament

Iliopsoas

Pubic tubercle

Pectineus

Adductor longus

Gracilis

Sartorius

Straight head (rectus femoris) of quadriceps (four-headed extensor of lower leg

Medial head (vastus medialis) of quadriceps

Fibres of iliotibial band

Medial femoral condyle

Patella

Fat pad

Patellar tendon

Tibialis anterior

Gastrocnemius

Medial surface of tibia

Soleus

Flexor digitorum longus

Extensor hallucis longus

Inferior extensor retinaculum

Medial malleolus

Extensor digitorum brevis

Extensor hallucis brevis

The lower extremities **265**

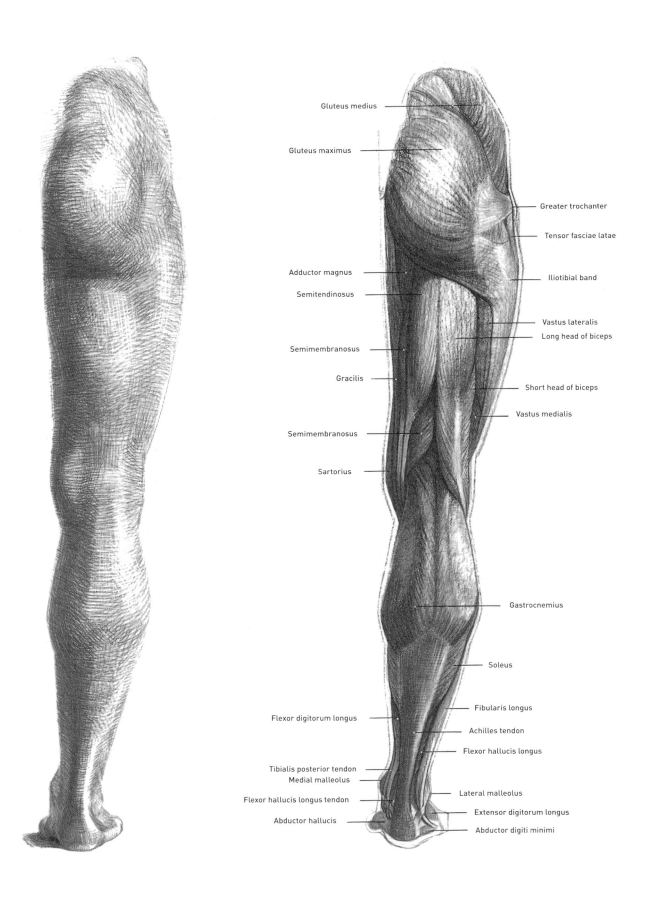

Gluteus medius

Gluteus maximus

Greater trochanter

Tensor fasciae latae

Adductor magnus

Semitendinosus

Iliotibial band

Vastus lateralis

Long head of biceps

Semimembranosus

Gracilis

Short head of biceps

Vastus medialis

Semimembranosus

Sartorius

Gastrocnemius

Soleus

Fibularis longus

Flexor digitorum longus

Achilles tendon

Flexor hallucis longus

Tibialis posterior tendon

Medial malleolus

Lateral malleolus

Flexor hallucis longus tendon

Extensor digitorum longus

Abductor hallucis

Abductor digiti minimi

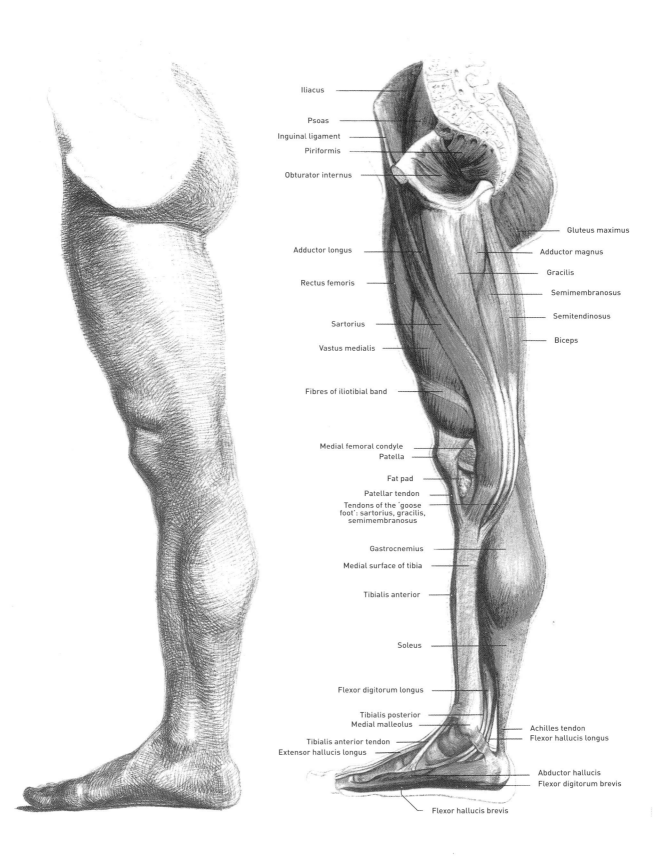

Fig. 282 External appearance of the leg in context and its muscle analysis, medial view.

Iliacus

Psoas

Inguinal ligament

Piriformis

Obturator internus

Gluteus maximus

Adductor longus

Adductor magnus

Gracilis

Rectus femoris

Semimembranosus

Semitendinosus

Sartorius

Biceps

Vastus medialis

Fibres of iliotibial band

Medial femoral condyle

Patella

Fat pad

Patellar tendon

Tendons of the 'goose foot': sartorius, gracilis, semimembranosus

Gastrocnemius

Medial surface of tibia

Tibialis anterior

Soleus

Flexor digitorum longus

Tibialis posterior

Medial malleolus

Achilles tendon

Flexor hallucis longus

Tibialis anterior tendon

Extensor hallucis longus

Abductor hallucis

Flexor digitorum brevis

Flexor hallucis brevis

The lower extremities **267**

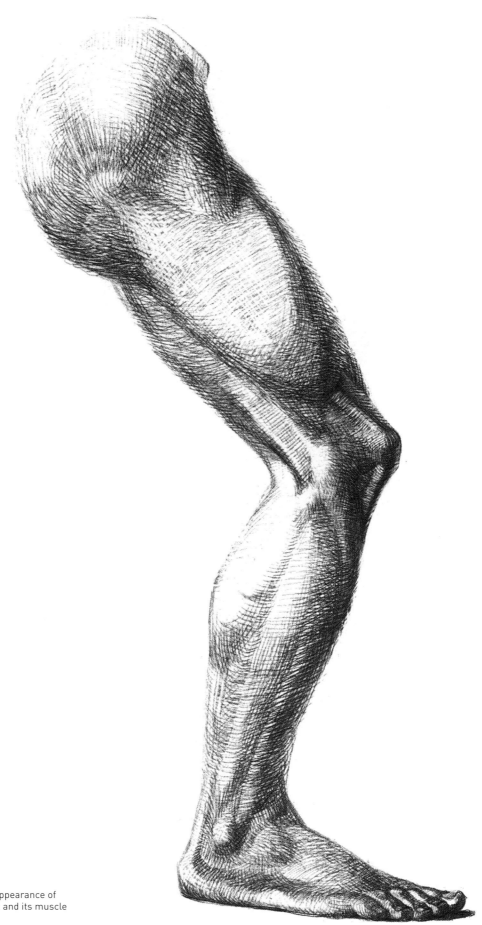

Fig. 283 The external appearance of
the flexed leg in context and its muscle
analysis, lateral view.

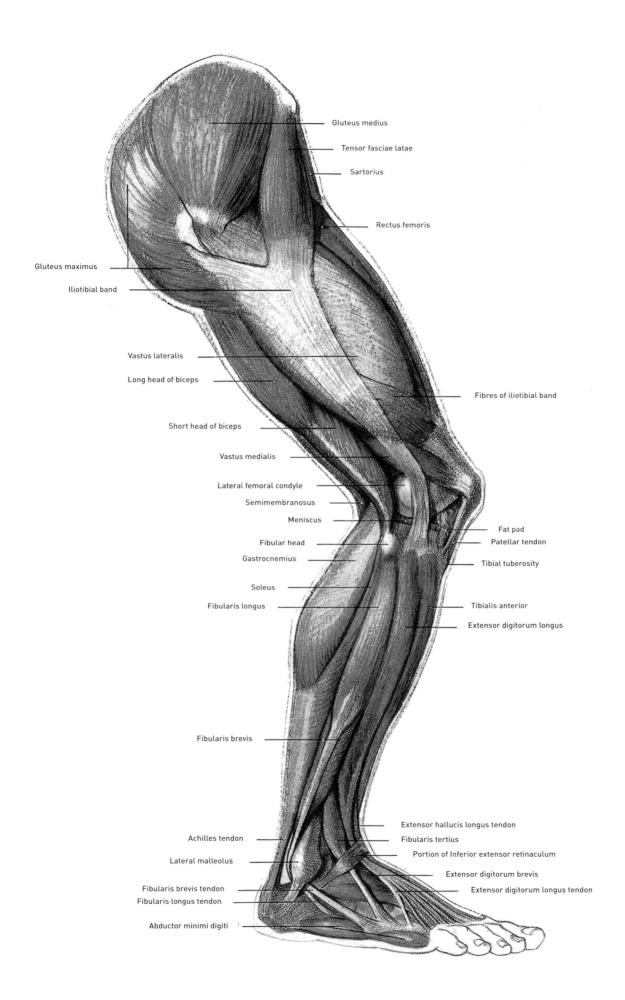

Gluteus medius

Tensor fasciae latae

Sartorius

Rectus femoris

Gluteus maximus

Iliotibial band

Vastus lateralis

Long head of biceps

Short head of biceps

Vastus medialis

Lateral femoral condyle

Semimembranosus

Meniscus

Fibular head

Gastrocnemius

Soleus

Fibularis longus

Fibres of iliotibial band

Fat pad

Patellar tendon

Tibial tuberosity

Tibialis anterior

Extensor digitorum longus

Fibularis brevis

Extensor hallucis longus tendon

Fibularis tertius

Portion of Inferior extensor retinaculum

Extensor digitorum brevis

Extensor digitorum longus tendon

Achilles tendon

Lateral malleolus

Fibularis brevis tendon

Fibularis longus tendon

Abductor minimi digiti

Fig. 284 Muscle analysis in the flexed leg
in context, partial medial view.
Above all, note the spatial relationships
starting with the origin of the sartorius,
through its insertion, along the medial
surface of the tibia and the medial margin
of the foot, through to the big toe.

Tensor fasciae latae

Rectus femoris

Vastus lateralis

Patellar tendon

Tibialis anterior

Extensor hallucis longus

Iliacus

Psoas

Pectineus

Adductor longus

Adductor magnus

Gluteus maximus

Gracilis

Semimembranosus

Sartorius

Vastus medialis

Medial femoral condyle

Fat pad

Aponeurosis of gastrocnemius

Gastrocnemius

Soleus

Medial surface of tibia

Flexor digitorum longus

Achilles tendon

Tibialis posterior tendon

Flexor digitorum longus tendon

Abductor hallucis

5.10. THE ARCHITECTURAL SHAPE OF THE LEG

The shape of the leg in its anterior view is that of a wedge, broadly expanded at the level of the greater trochanter and elegantly narrowed at the ankle [280, 288, 290]. A pillar, that focuses its load across a breadth formed by several points. Is it not surprising how small a platform, the foot, is charged with bearing the load? Is it not wonderful that precisely where the base and column meet in the ankle, the sparse construction is at its most slender, without this bold design compromising the safety of its entirety in any way at all [286]? A structure of great beauty that dispenses with any soft tissue covering around all its joints, where free movement is of essence, or where the muscle groups are located on the relevant side for action based on their more important functions, such that entire sections of the structure can be exposed, as is the case, for example, with the tibia?

An understanding of the constructional aspects equates to partial understanding of the whole, as the construction is not an isolated element but always forms an integral part of the whole. Elements conferring stability are always a prerequisite to an architectural structure, as is shown in the plate by Bartolomeo. A meaningful, rhythmic interaction between the soft tissue shapes can only start based on this foundation of the static factors; this basis is required to render the correlation between the low points into an objectively proven fact, in order to deduce the relationship between shapes from this perspective [288, 289]. Without the fluctuation in tension between the constancy of the scaffold and the variability of the soft tissue shapes, without their mutual induction, the shapes are incapable of expressing themselves, remain tired and lacking in vitality and tension, and lose defining features.

The uppermost rigid border of the leg is the concave iliac blade [280g, number 1], with the greater trochanter forming the lever arm with the greatest projection for those muscles located around the iliac blade. These muscles form a bridge (numbers 1–2) between these two fixed points, upon which further convex shapes can build. From the greater trochanter downwards, the orientation curves in the direction of the knee. A chain of fixed low points is observed, from numbers 2–9. The connection to the greater trochanter only becomes visible again at the knee. In between, the muscle masses formed by the quadriceps protrude as much as is possible, but the extent to which indents are visible is limited to the depth of the connection between the greater trochanter and the cube formed by the knee. Its body (with a trapezoid footprint) remains largely free of any muscle mass. It forms a sturdy interim shape above the development of the mass formed by the cone of the lower leg [285a, 288a, b, c]. The muscle bodies of the upper and lower leg never merge into each other. They always build on the connecting chain (such as in Figure 280g 1–9 or in Figure 286a 1–9 and 1*–9*) and are separated by the taut solidity of the knee. The foot inserts its arch into the clasp formed by the two spatially separated bones of the lower leg, a foot with toes, which are segmented entities and form the finale of the relationship that is initiated at the top of the leg at the pubis and greater trochanter [291a–c].

We can discern the following: the frontal view of the leg mainly reveals its static relationships [288a–c], while the lateral view [289a, b] reveals its dynamic relationships (see also section 1.3.9., Figure 81) as the rhythmic characteristics associated with form can be attributed to a muscle group based on its action on the three 'locomotor axes' (transverse axes through the hip, knee and ankle joints).

The different volumes result from the different relative strengths [285, 289, 290]. The volume of the hip region is determined by the gluteus maximus. Its 'angular' relief forms a narrow, unique cube-like shape in men, that progresses through the trochanteric fossa towards the apex of the greater trochanter. The group around the greater trochanter is padded with fat in women and thus largely flattened. The requirement for attachment to the greater trochanter and the lateral portion of the femur initially forces the gluteus into overlapping the knee flexors [285b] and the same process applies to the gluteus itself, whereby it is overlapped by the vastus lateralis when it penetrates through to the level of the bone. The muscle fan formed by the tensor fasciae latae and the gluteus medius (abductors) – the tip of which is located at the greater trochanter – follows the curvature of the iliac blade in an anterior and posterior direction. This volume is triangular in shape and has a convex surface [288b, c, 289b].

The entire mass of the upper leg – formed of the quadriceps and the knee flexors – exhibits a greater sagittal (rather than transverse) depth (cf. the upper arm which is analogous to this) as the muscle groups are layered in front and behind each other, relative to the transverse axis [287]. They thus fill an ellipsoid cross-section with a sagittal expansion. The quadriceps forms the greatest proportion of this mass. It packs the anterior and lateral portions with a volume that takes a diagonal course [285a], as the rectus femoris is located a long way lateral to the midline of the pelvis; the vastus lateralis originates immediately below the greater trochanter and the vastus medialis only inserts low down into the medial margin of the patella, forming a bulge [288a, b]. However, these muscles would be insufficient to bring the legs together. This is where the adductors come into play, which fill the medial portion of the upper leg in the form of a large, plastic triangle [284, 285]. The adductors and the volume occupied by the quadriceps jointly form a large expansion of muscle across the medial portion of the upper leg. The actual frontal aspect is only formed by the rectus femoris and this takes a course that runs, as a diagonal elevation, ever more upwards and laterally with increasing distance from the knee.

The smaller volume of the flexors, and its overlaps with the other muscles and with the architecture of the knee, has already been entered into previously. The volume of the lower leg forms a cone, with its greatest breadth across the calf [285, 287, 288]. However, the

Fig. 285 The main dimensional orientation of the muscle function groups in the leg.
a) Ancillary illustration: anterior view.
b) Ancillary illustration: posterior view.
The individual muscles with a common function have been grouped together into muscle function groups with complex volumes. The arrows that extend between origin and insertion indicate the associated set pattern for the basic orientation of the volumes. These circumstances are simplified into schematic drawings in the ancillary illustrations. This perceptual approach is indispensable for an understanding of the architectural shape of the leg.

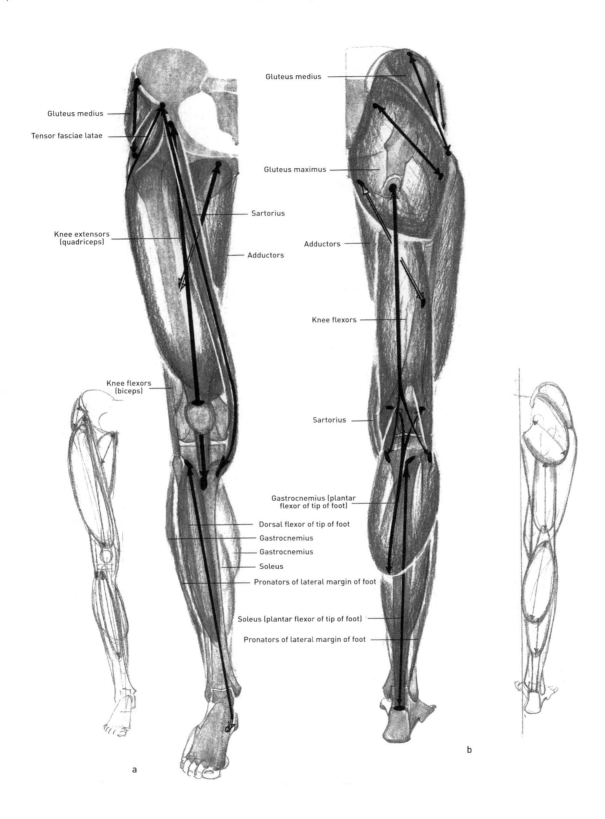

Gluteus medius

Gluteus medius
Tensor fasciae latae

Gluteus maximus

Knee extensors
(quadriceps)

Sartorius

Adductors

Adductors

Knee flexors

Knee flexors
(biceps)

Sartorius

Gastrocnemius (plantar
flexor of tip of foot)

Dorsal flexor of tip of foot
Gastrocnemius
Gastrocnemius
Soleus
Pronators of lateral margin of foot

Soleus (plantar flexor of tip of foot)

Pronators of lateral margin of foot

a

b

Fig. 287 Cross-sections through a male leg. The simultaneous envisaging of cross-sections during plastic nude study and related drawings has the great advantage of encouraging comprehensive, three-dimensional thinking through a precise investigation of the directions and apices of the inclined surfaces.

Fig. 288 The shape of the leg in frontal view, interpreted as an architectural construct and broken down into individual working steps.
a) First step: fixation of the plastic framework shapes that are required for building up the drawing.
b) Second step: incorporation of the essential muscle volumes that occupy the framework shapes.
c) Third step: complex combining of the individual muscles into larger volumes (see also Figure 284).
The red transverse axes allow the general functional identification of the allocated muscle groups. Long solid red line: course of load-bearing line.

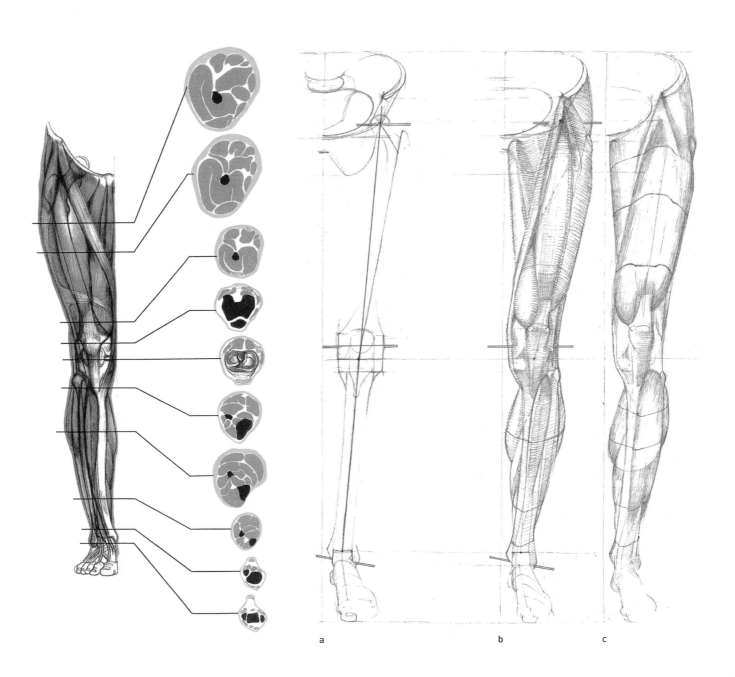

a b c

Fig. 289 The shape of the leg in lateral view,
interpreted as an architectural construct and
broken down into individual working steps.
a) First step: fixing of the static line (red vertical
line) and the sequence of the axes of the leg joint
(red circles and short lines) on the static line.
Ancillary illustration: breakdown by height of
proportional relationships.
b) Second step: allocation of the muscle function
groups to the axes, allowing identification of their
general functions.

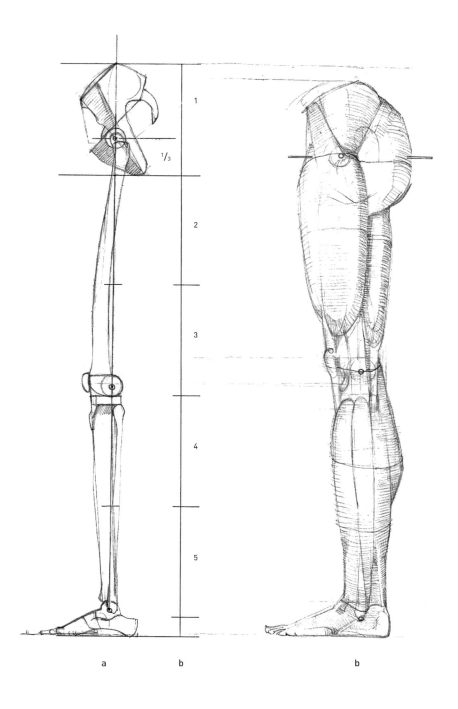

a b b

arrangement of the muscles and their relevance to the axes have resulted in an asymmetric distortion of the cone. The primary forces, the gastrocnemius and the soleus, embrace the calcaneus, and the dorsal extensors – which are less powerful – fill the anterior lateral surface of the lower leg and lie anterior to the transverse axis [285a, 288a, b]. The muscles thus produce a layering of the volume in a sagittal direction that favours a hinge joint, the upper ankle joint.

The lack of primary supinators has meant that the entire medial surface of the tibia is free of any muscle bodies [284], while the pronator group is located on the lateral surface of the calf. This therefore results in a tripartite re-arrangement of the bones of the lower leg, such that the cross-section on the anterior surface starts off as very narrow, then protrudes frontally over the tibia, following the contours of the tibialis anterior, after which it curves sharply into the lateral surface of the calf and follows a linear course through almost the entire depth of the lower leg until the roof-shaped

flattening of the gastrocnemius is reached [285b]. The posterior surface is aligned with the line taken by the gastrocnemius, inclining towards the medial side of the lower leg, whereby it swings in so far towards the midline that the two gastrocnemius muscles meet when the heels are together. The points where the muscles overlap the malleoli are important reference points for the spatial arrangement [289]. The dorsal flexors cover the lateral tibial surface at the front while the medial surface overlaps with the plantar flexors, which is particularly clear at the malleolus. The same applies with reference to the cube formed by the knee (in frontal view). The lateral malleolus protrudes in a cone-like shape from between the dorsal flexors and the pronators, thus fully separating the two groups from each other, such that it is overlapped at the front by the dorsal flexors that raise the tip of the foot, but itself overlaps the pronators that raise the lateral margin of the foot [288b, c]. Just as it is certain that a marked artistic talent founded on an ability to perceive

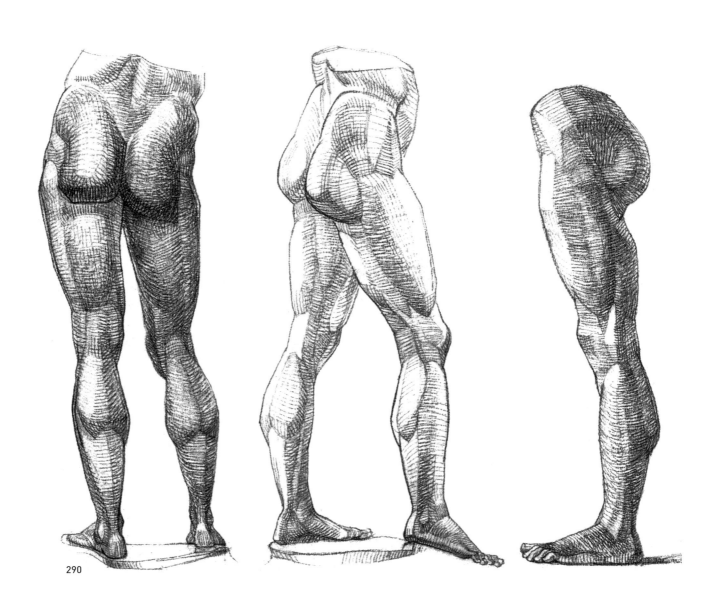

290

and enter into an organic form may mean references to details can be dispensed with, it is an equal certainty that the explanation of details based on the context of the whole will always remain an ongoing task. It goes without saying that the constant striving of artistic anatomy to repeatedly emphasise the bridges between the nude study of the figure and the multitude of contact points and overlaps is also highly important. In other words, we must constantly be shifting from analytical observation of the object back to a synthetic perspective and approach. Examples of corrections of pupils' drawings by the teacher are very useful here, thus demonstrating the seamless transition from processing the anatomical issues through to the artistic study of the nude. The author has therefore included some of his corrections of pupils' drawings of various perspectives of examination [291–292/11, 293].

In his diaries, Leonardo wrote about the limited value of the purely verbal description of shapes: 'The more accurate your description (of the constitution and limbs), the greater the confusion you will create in the mind of the reader ... This is why we must provide both illustrations and descriptions'.[16]

For precisely these reasons, Figures 291–292/11 and 293 are provided here exclusively for illustrative purposes, to convey the architectural understanding of shapes in different ways, through the concentrations and dimensions of the volumes [285], the persistence of relationships between shapes [286], the arrangement of the muscle masses [288, 289], the spatial development of shapes associated with the leg [290, 291], the involvement of cross-sections and the use of lines which render the body fully plastic in appearance [291–292/7], or the functional shifts in the muscle masses [292/5–292/11].

16 *Leonardo da Vinci: Tagebücher und Aufzeichnungen*, Leipzig 1952, p. 35.

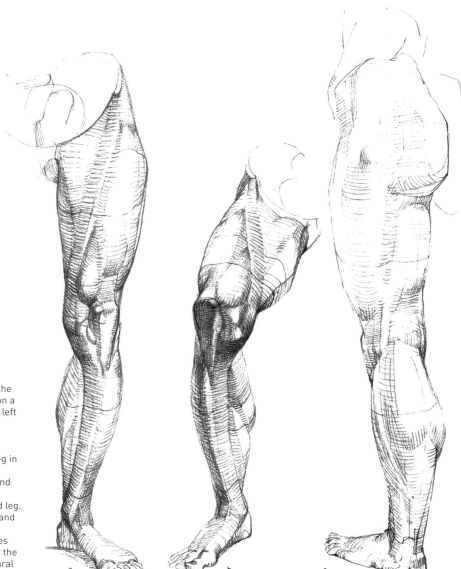

Fig. 290 The architectural shape of the leg in different perspectives (based on a small plastic study by Michelangelo: left and middle).

Fig. 291 Architectural study of the leg in a nude model.
a) Stretched leg in partial anterior and medial view.
b) Anterior and medial view of flexed leg.
c) Stretched leg in partial posterior and lateral view.
The build-up of the soft tissue masses is organised based on the courses of the cross-sections and in a strict structural interactive relationship to the shapes of the superficial framework.

Fig. 292 (below) Demonstration drawing by the author while correcting a pupil (based on a model).
a) Medial view of an extended male leg.
b) Posterior view of an extended female leg.
c) Mainly medial view of a flexed leg.
In this case, the task of the anatomically guided study of the nude consummates mainly in a new, synthetically oriented mental construct, in which all knowledge and ability merge not only into corporeal, spatial, functionally conclusive statements on form but also into an organised whole, taking into consideration the situation pertaining to the study and the model, as well as different solutions to the problem.

Fig. 292/1 Demonstration drawing to help in the basic understanding of the structural volumes in the leg.
The intermediate shape of the knee is emphasised between the conical cylinders formed by the upper and lower leg.

Fig. 292/3 The forms built up graphically to clarify anatomical structure. The individual volumes are organised into the main shapes. The associated structures are developed through hatching that is organised based on the idea of cross-sections.

Fig. 292/2 Demonstration drawing to help in the basic understanding of the structural nature of the leg.
The faceting of the volumes forces the artist into creating the important guiding spatial surfaces of perspective.

Fig. 292/4 Investigation of volumes and cavities.
The study draws attention to the fact that not only the volumes but, equally, the cavities formed by these volumes are required for an architectural artistic understanding.

Adapted from Bammes, *Wir zeichnen den Menschen*.

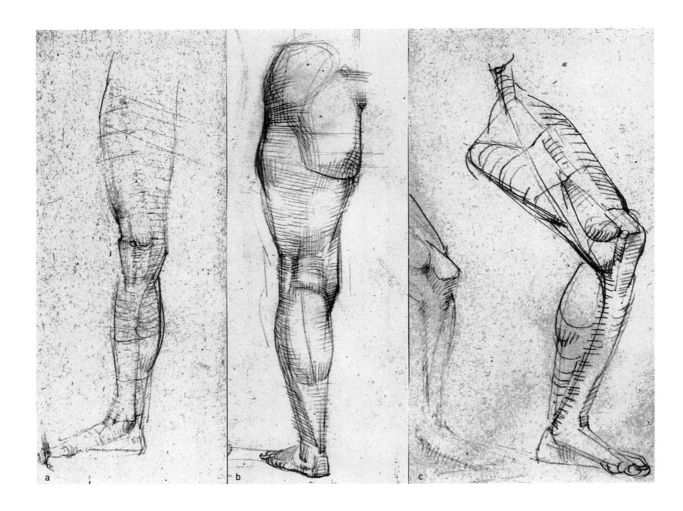

a b c

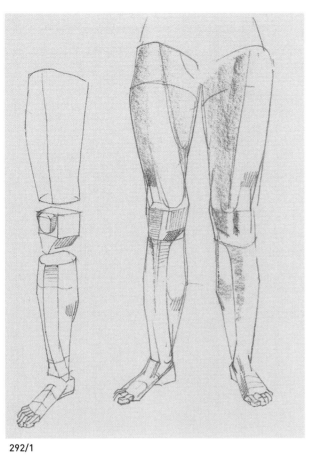

292/1

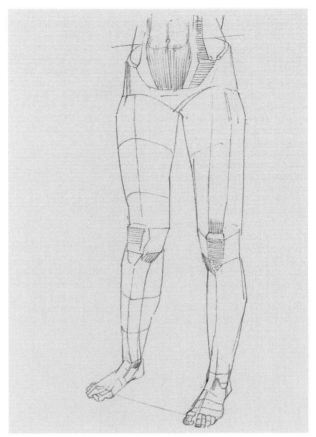

292/2

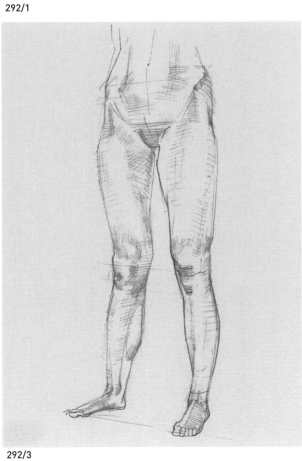

292/3

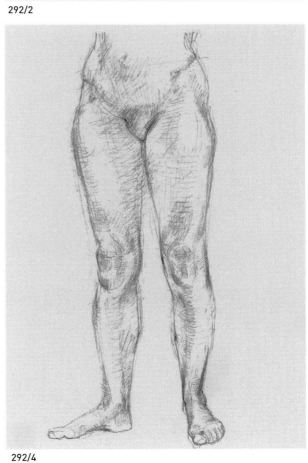

292/4

Fig. 292/5–292/12 The inexhaustible expressiveness of the leg. Anatomical information and its processing must never be isolated procedures in artistic anatomy. What we are studying should not render us indifferent to how we create a drawing. Even though we are aware that the leg and foot are 'only' bodily instruments designed specifically for support and locomotion, they generally reveal a huge abundance of anatomical and structural variation which manifests on an individual basis at all ages, in both genders, and in every type of constitution, depending on how the leg is being used and employed, from nonchalant relaxation through to high tension. Whatever is going on functionally and psychologically higher up the body is immediately reflected in the legs, which constantly shift to balance and compensate for any movement there. An informative, experiential insight into these issues is obtained through architectural observation of the body.

Adapted from Bammes, *Wir zeichnen den Menschen*.

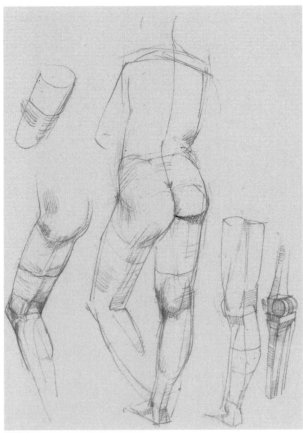

292/5

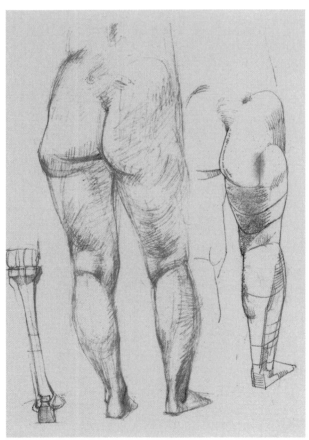

292/6

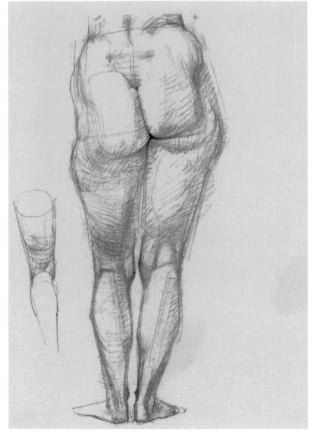

292/7

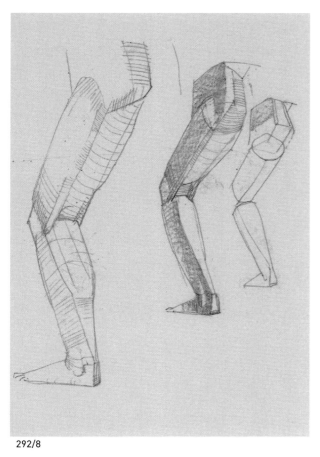

292/8

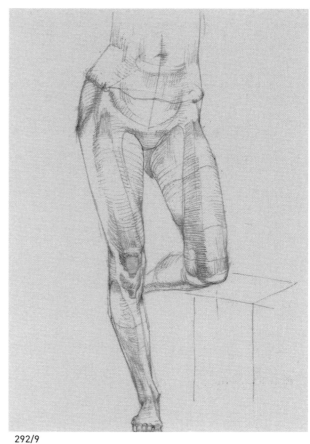

292/9

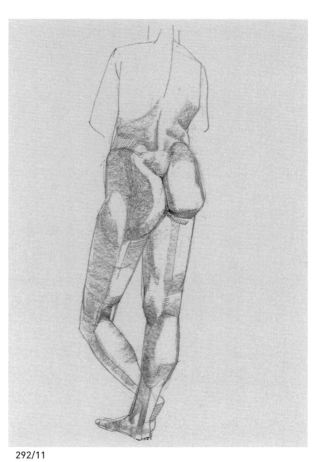

292/10

292/11

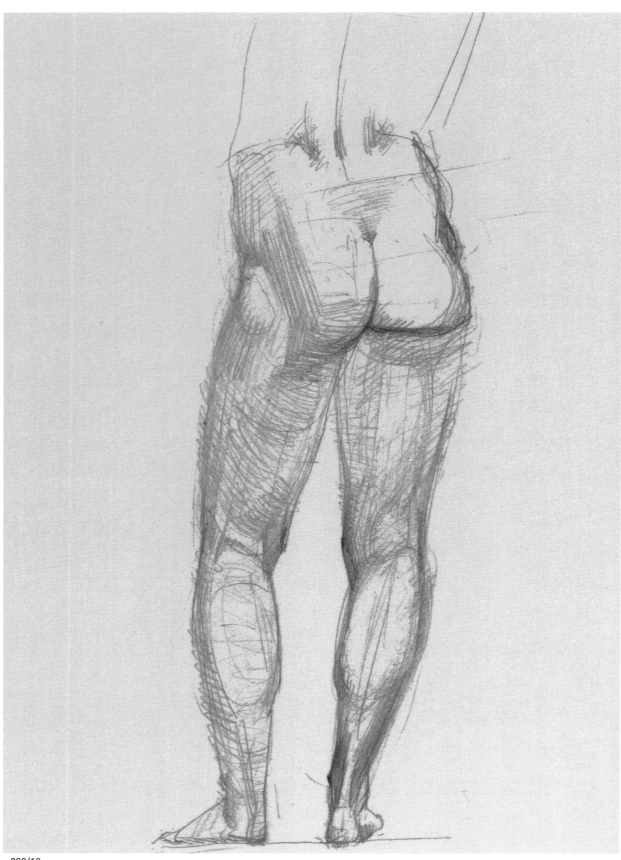

292/12

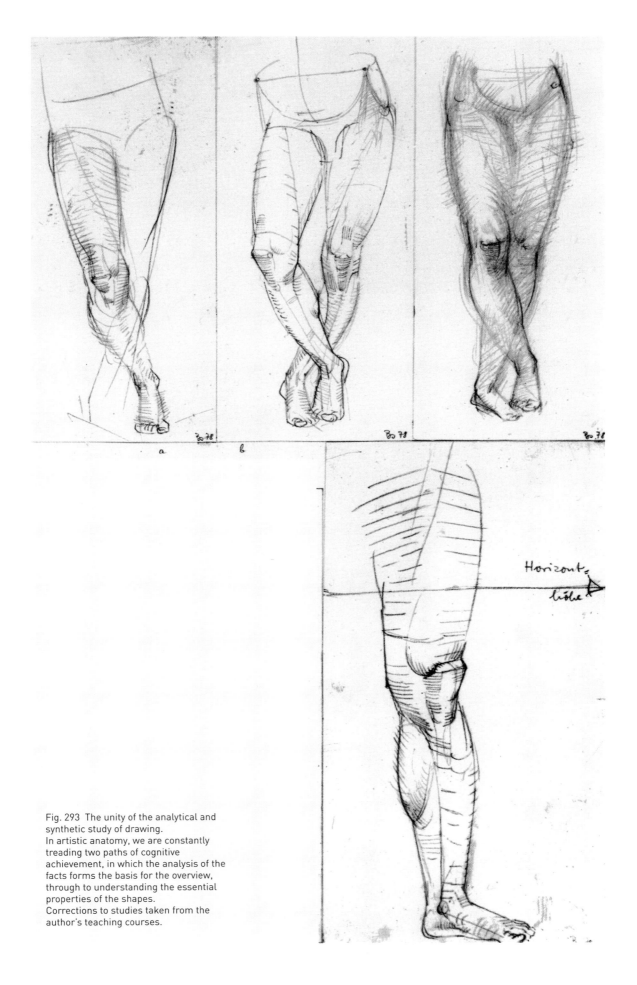

Fig. 293 The unity of the analytical and
synthetic study of drawing.
In artistic anatomy, we are constantly
treading two paths of cognitive
achievement, in which the analysis of the
facts forms the basis for the overview,
through to understanding the essential
properties of the shapes.
Corrections to studies taken from the
author's teaching courses.

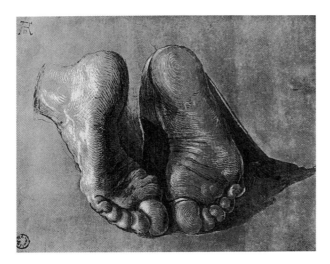

Fig. 294 Albrecht Dürer (1471–1528).
Feet of a Kneeling Man (1508). Brush
drawing on a dark background, study for
St. Peter in the *Heller Altar*.
Feet and hands tell the fate of humans
and, in this sense, Dürer gives them a
'pinched' final appearance.

Fig. 296 Raffaello Santi [Raphael] (1483–1520).
John the Baptist. Pen and ink. British
Museum, London.
Apart from the balls of muscle on the inclined
flank of the body that have been concertinaed,
Raffael pays particular attention to the
investigation of spatial movement in the
vertically positioned leg in this study, in which
he emphasises the functional behaviour of
the angular knee and the conical, cylindrical
shapes of the upper and lower legs, into
which he integrates the individual anatomical
elements that are the focus of the study,
without regarding them in isolation.

Fig. 295 Andrea del Sarto (1486–1531).
Studies of Legs. Uffizi Gallery, Florence.
The trained perception of physical pathos
based on Michelangelo's approach is
visible in the object and detail study,
without, however, overriding the direct
and thorough investigation of the object.

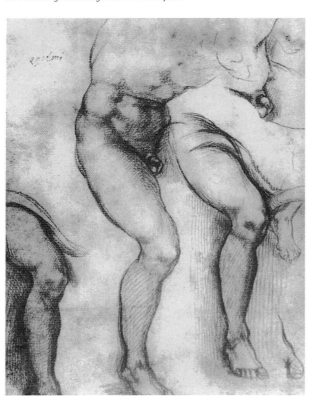

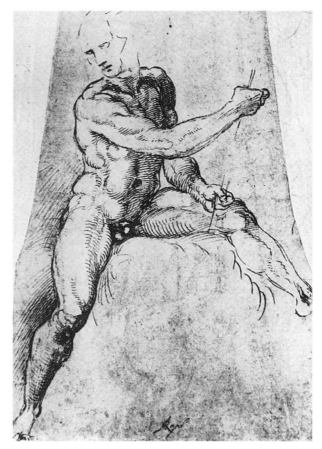

5.11. THE PROCESSING OF ANATOMICALLY OBJECTIVE CONSTITUENTS OF THE LEG IN WORKS OF ART

We can find almost seamless evidence for the fact that the Old Masters also took seriously what has just been stated above, as they repeatedly use the leg as an important element in their investigation into Nature. Also note: nothing was or ever is too minor for it not to be treated with attention and humility by the Old Masters. Leonardo and Michelangelo, Raphael, Andrea del Sarlo, Rubens, Ingres, Delacroix or the German Romantics, as well as Feuerbach, Marces, Rethel or Corinth, Mareks or Moore – to name just a few – carried out studies on the leg, whether this was in the form of fully independent investigations on themselves, ranging from studies of details next to the entire figure or in specific sculpting within the figure. We know of individual studies carried out on Michelangelo's hand during his youth in Florence, in which he attempts to increase his understanding of physicality and details. Multiple precise anatomical analyses of the knee and leg in context by Michelangelo for the figure of *Giorno* in the Medici Chapel have been preserved. All this is carried out with fascinating freshness and intensity, both to achieve sensual and material effects, as well as to render functional and plastic processes comprehensible. In the heroic figurative gestures of the figures on the ceiling of the Sistine Chapel, the leg in the *Study of the Slave* [8] is plastically depicted as large and noble and is integrated as an active limb on equal terms with the facial expressions and gesticulations of the hands, to aid in expressing the tragic mood of the human spirit. Leonardo assesses what is required to ensure the leg becomes functionally expressive with reference to tension and relaxation [5].

In his *Study of a Soldier* [297], Raphael dedicates himself to a detailed specific study of the energetically flexed knee by focusing on the angular shapes of the femoral and tibial condyles within the context of the opened joint cavity. In the study in pen of *John the Baptist* [296], starting from the hip region, he explores the segmentation of the leg and its spatial anteversion and retroversion in the upper and lower leg. In this process, he sees the slightly flexed knee as a sharply profiled, intermediate form that segments the leg, interrupting and separating the cylinders formed by the upper and lower legs.

In close affiliation to Michelangelo's approach, Andrea del Sarto is mainly searching for anatomical delimitations between the leg and the torso, especially in the groin, in the middle study and the study that is furthest to the right [295]. On the one hand, he achieves certainty on the partitioning cavities and, on the other, on the connective bridges in the hip. In contrast, Dürer, who devoted most of his attention in the Dresden sketch book to an initial thesis on the theory of proportions, the dimensions and shape of the leg and its sections in tears, cross-sections and individual studies, studied a very personal physiognomy of the foot in an entirely un-Italian fashion in the *Studies of the Foot* that are depicted (for St. Peter in the *Heller Altar*), a physiognomy, the blood vessels, wrinkles, folds and bumps of which reveal something of the fate of this human being [294].

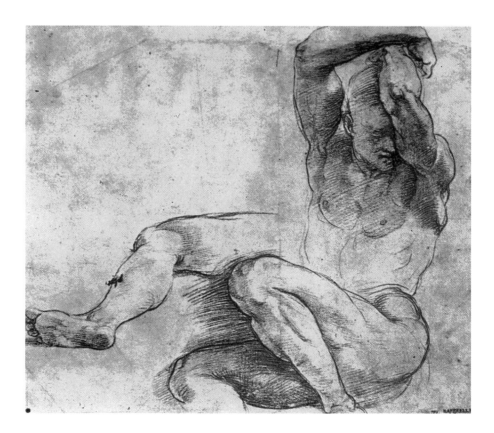

Fig. 297 Raffaello Santi [Raphael] (1483–1520). *Study of a Soldier, His Right Leg Duplicated.* Black chalk. British Museum, London. The situation relating to the strongly flexed knee can be analysed in detail anatomically and indicates very careful study of the nude. In the duplicated leg, the spatially contingent overlaps of the foreshortened volumes are examined with great precision.

In turn, an unknown 17th-century Italian Master sees a fixed, reliable support in the load-bearing leg of a male nude, which ensures an animated pose through a strongly tensed knee extensor and protruding knee flexors, controlling the inclination of the body here as supporting muscles [298]. Just as Prud'hon generally constructs his nude figures – in unity with their grace – never allowing them to slip into pure elegance, he also clearly incorporates the calm interaction between the solid cuboid volume of the knee and the soft curves of the upper and lower legs into his *Seated Female Nude by a Fountain* [299]. This measured and basic approach is recorded in a lively fashion in Kolbe's brush drawings in studies of people squatting, kneeling, sitting, getting up and stretching, bending over or crouching down. The leg is almost always only fleetingly in contact with the ground and Kolbe's brushstrokes thus aspire to create the impression of physicality and expressive function that is full of character, while using a minimum of resources.

The legs of the squatting *David* by Manzù open up an enclosed angle in space for the arms and body [301]. Through this angling, which is closely associated with the substance of the sculpture, the legs penetrate violently into space, with the passively flexed knee joints sharply angled and blunt, cuboid and massive when compared with the other tender, boyish shapes. They appear full of the energy produced by the sudden opening of the legs.

It is not the preserve of the artistic torso, fragmentary and limited to a body lacking in limbs and a head, that is capable of conjuring up an appealing image of the human as a whole. *Studies of Legs* also reveal such images, a story of tension and relaxation, of carrying

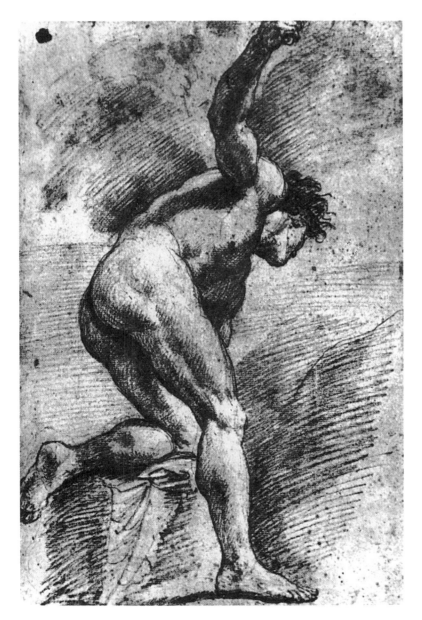

Fig. 298 Unknown artist. Black chalk. Bavarian State Graphics Collection, Munich.
The clearly separated volumes of the leg, the tensions in the knee flexors due to their function and the hollow of the knee enclosed by them, the balled appearance of the gluteus maximus and its insertion penetrating in between the knee flexors and extensors reveal such in-depth observation that anatomical knowledge can be assumed as a basis for this.

Fig. 299 Pierre Paul Prud'hon (1758–1823).
Seated Female Nude by a Fountain. Black
and white chalk on grey-blue background.
Sterling and Francine Clark Art Institute,
Williamstown, MA.
Prud'hon's charmingly warm modelling
of the nude in soft light – who is depicted
in a mixture of classic and romantic
styles – never loses the incisive yet simple
expression of physicality; the treatment of
the two knees provide an apt example.

Fig. 300 Georg Kolbe (1877–1947).
*Female Nude Crouching Down Towards the
Right, Right Arm Raised.* Pen and brush.
Nationalgalerie, Berlin.
The increasing and decreasing breadth
of the brushstrokes in combination with
the lineaments of the pen capture the
expressivity of physicality and movement,
recording a uniform configuration of
strength, in which the emergence of details
can only play a subordinate role.

Fig. 301 Giacomo Manzù (1908–1991).
David (1938). Bronze, height 48cm (19in).
The realistic use of forms by the artist,
reminiscent of Donatello and Rodin,
repeatedly forces him into intensive
investigation of Nature, without him ever
sacrificing the urgency of his figurative style.

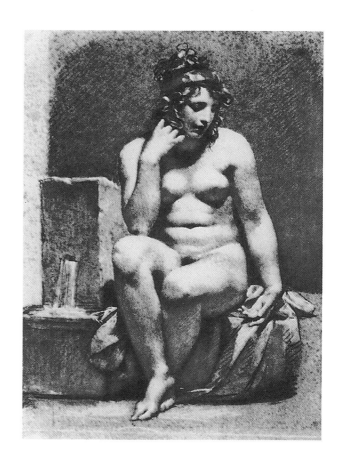

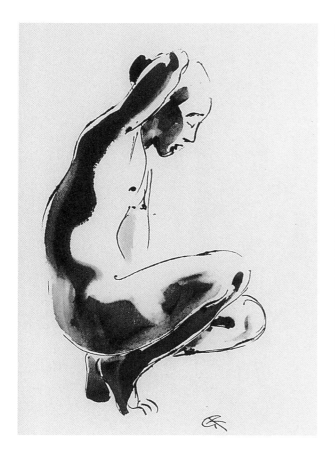

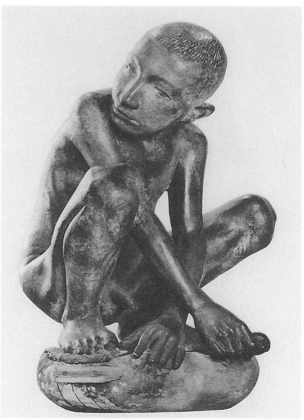

The lower extremities **287**

and being carried, of physical make-up and bodily opulence, of swelling volumes, their concentrations of muscle mass and subtle movements. The correctional study [302] by the author, that was created in front of his students, is borne by such imagery. Finally. Henry Moore's nude *Drawing of a Seated Female Nude* is given as an example of a tremendous attempt at simplification [303]. The simple things are always so difficult as they require enormous knowledge, deep insight and lengthy periods to come to maturity. No matter how archaic and enticing the elementary cylindrical shapes of the thighs and calves and their

angles enclosing space may appear, the in-depth study will reveal that no anatomical fact has been ignored, be it the spatial orientations of the inclination of the surfaces, the tibial tuberosity, the anterior tibial border, the torsion of the medial portion of the knee, through to the tips of the toes, how the malleoli are seated, the relationships between the directions within a foot. And even so, all this is far removed from a simple factual record. Everything depends on the allocation of the correct and appropriate weighting to individual features in the hierarchy of the organisation within the greater scheme of things.

Fig. 302 Gerd Jäger (born 1927).
Seated Nude Male (1967). Cement, height 104cm (41in).
The boyish physique speaks to us through its typical developmental proportions of dominance in length and its angular physical relief. Deviating sharply from reality, the artist also emphasises the spiky, sharp points of the framework of the knee and, in this case, creates his own factual situation that does not equate to the functional processes.

Fig. 303 Henry Moore (1898–1986).
Drawing of a Seated Female Nude (1933).
Ink, brush and pencil, 55.9 x 38.1cm (22 x 15in).
Collection: Dr. Alan Wilkinson, Toronto.
The massive, figurative images created by Moore appear to be solely dictated by expression through the use of archaic and simple forms.
However, close observation – especially of the two legs in the seated figure – demonstrates to us how precisely the anatomical conditions have been integrated.

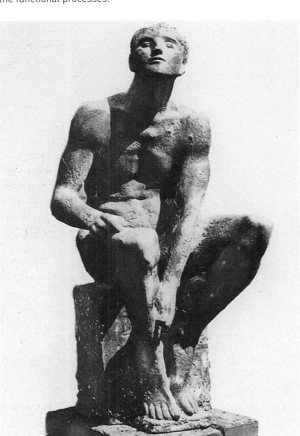

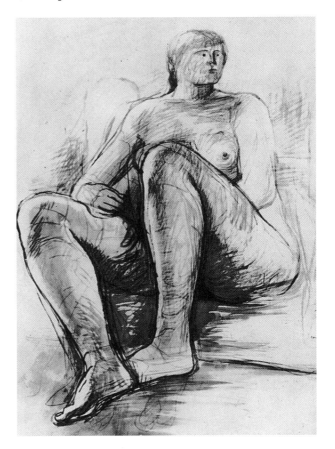

6 The skeleton of the trunk

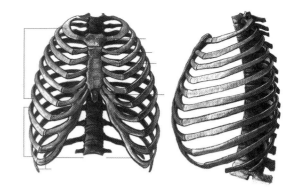

6.1. GENERAL FUNCTIONS AND ORGANISATION

The centre of a human upright stance lies in the pelvis, and its tendency to tilt forwards is stopped by powerful muscle action (gluteus maximus). The shape of the spine arises from the pelvic posture: its double S-shape is acquired, as is the power of the supporting muscles. The pelvis forms the basis for the connection between the upper body and the lower extremities below, and the spine above it. The skeleton of the trunk is composed of the pelvis, spine and rib cage and forms the supporting and protective scaffold for the vital organs.

6.2. THE SPINE (COLUMNA VERTEBRALIS)

6.2.1. General characteristics, functions and organisation [304a, c]

The spine is a supporting and protective axial scaffold that is crowned by the head, which it carries in a spring-like fashion, and it possesses far greater stability than the simple C-shape found in animals thanks to its curved double S-shape. The vertebrae, connected together by specific ligament arrangements, segment the rod, making it elastic and mobile in all directions. Positional changes (e.g. bending, stretching when jumping), as well as breathing (moving the rib cage into an upright position) can thus be supported. The spine provides the organs with an option for attachment as it penetrates deep into the visceral cavities (rib cage, abdomen, pelvis). The spinal cord is enclosed by a protective canal. The following sections are distinguished, based on the shape and structure of the spine:

the cervical spine (CS) with seven vertebrae
the thoracic spine (TS) with twelve vertebrae
the lumbar spine (LS) with five vertebrae
the sacrum (also a component of the pelvis) formed
 of five fused vertebrae, to which the four or five
 coccygeal vertebrae are attached.

6.2.2. Components and structure of the spine

The individual vertebrae reflect the tasks of the whole structure [305, 309]: the vertebral body (corpus) is load-bearing; the spinal cord is protected by the vertebral arch (arcus vertebrae), which forms a ring, and by the spinous process (processus spinosus), which also serves as a lever arm for the muscles, as do the transverse processes (processus transversus). The superior and inferior pairs of articular processes (processus articularis superior and inferior) guide movement between the vertebrae. The shape of the vertebra changes through the different sections of the spine, becoming larger with increasing load [305c]. The intervertebral discs (disci vertebrales), made of solid fibrocartilage that surround a slightly compressed 'fluid cushion' (nucleus pulposus), act as shock absorbers and increase the general mobility in all directions [305g]. Tension in the spine is increased to produce a spring-like flexibility through the additional support of the ligaments connecting the vertebrae.

Ball-bearing mechanics that could easily be assumed to explain movement in all sections of the spine are only not applicable due to the fact that the articular processes limit the scope of movement. Their alignment dictates the type and scope of movements that are possible. The connection to the cranium is also provided by the articular processes.

6.2.3. The shape of the spine [304, 306, 309]

If we initially ignore the substantial differentiation and segmentation of the spine and draw together the sequence of the individual spinous and transverse processes into complex, bracket-like forms, then we find a constructional form of a T-profile, where the upright is formed by the spinous process and the two flanges at the side correspond to the transverse processes [309b]. The specific shapes pertaining to the spine must be clearly visualised, as these, quite literally, embody human posture. The main difference compared with the spine in animals is its concave curvature (kyphosis) in the thoracic section and the opposing convex curvature (lordosis) above and below.

Babies and infants do not yet exhibit the final shape of the spine. This is something that must be acquired with much work and exercise. It is only through the repeated attempts at sitting and standing that the muscles and ligaments are strengthened, after which the lumbar lordosis, thoracic kyphosis and cervical lordosis slowly develop through the forces exerted by gravity and the muscles.

We can explain the double S-shape [306] as follows: in contrast to animals, the human pelvis is slightly raised at the front through rotation around the transverse axis through the hip, i.e., more vertically positioned [a], without, however, fully losing its diagonal

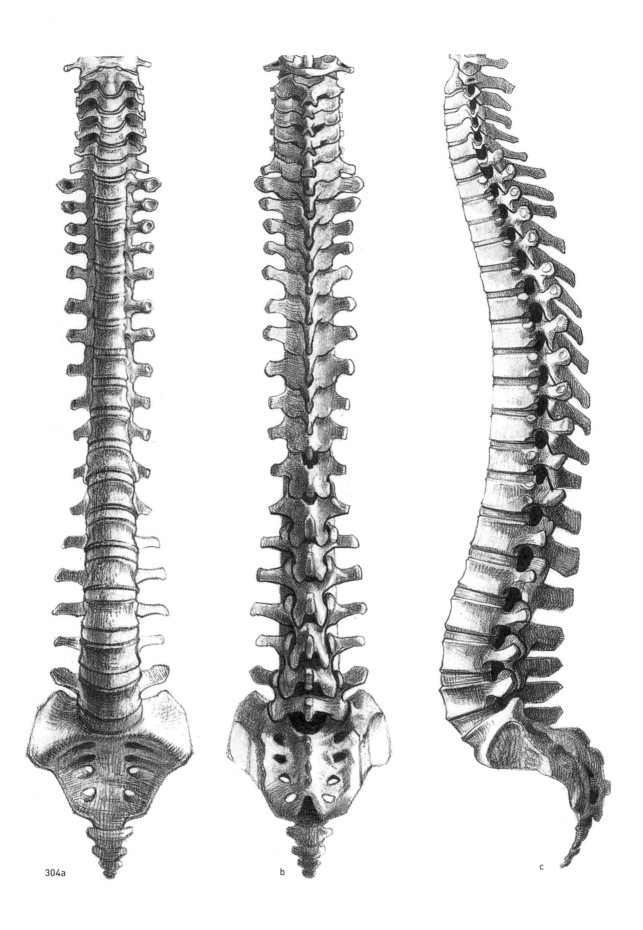

304a

b

c

Fig. 304 (left) The spine in three basic perspectives:
a) Anterior view.
b) Posterior view.
c) Lateral view.
The supporting axial scaffold with multiple segmentations is progressively strengthened towards the pelvis, with increasing load-bearing capacity; sacral and coccygeal vertebrae are incorporated into the double S-shaped curvature.

Fig. 305 Structure of the vertebrae and changes in their shape.
a) Components of a thoracic vertebra (simplified).
b) Cranial view of a thoracic vertebra.
c) Vertebrae from the different sections of the spine drawn on top of each other.
d) Posterior view of a thoracic vertebra.
e) Anterior view of a thoracic vertebra.
f) Lateral view of a thoracic vertebra.
g) Intervertebral discs and nuclei during bending of the spine.

h) Ball-bearing principle of the nuclei between the vertebral bodies (isolated).
i) Tiled arrangement of the articular and spinous processes.
j) Partial lateral view of a cervical vertebra.
k) Cranial view of a cervical vertebra.
l) Cranial view of a lumbar vertebra.
m) Partial lateral view of two thoracic vertebrae, one above the other.

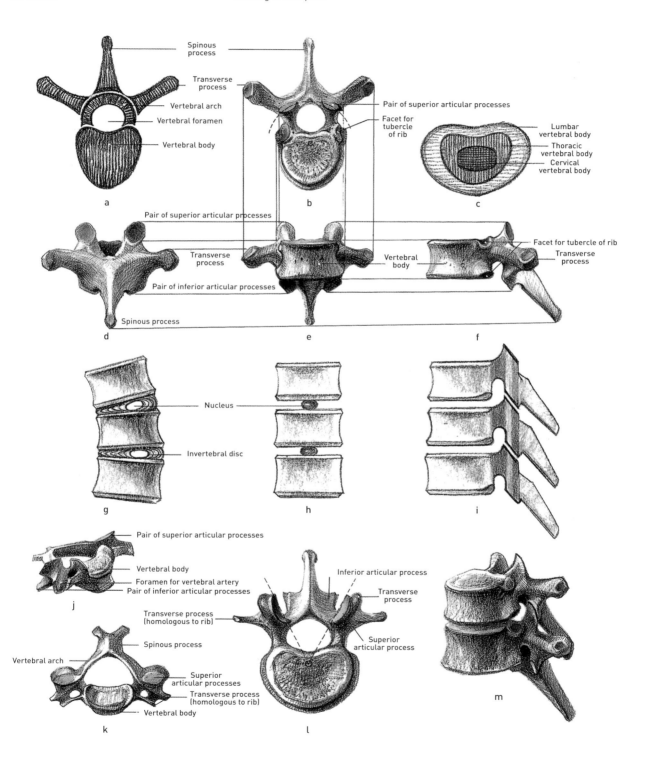

orientation. This forces the spine into bending back just above the pelvis [b], namely, far enough to ensure that the vertical position is not only achieved, but actually exceeds this in a dorsal direction [c; balancing of the upper body over the pelvis]. This impressive bending back (lumbar lordosis) of the spine cannot, however, be extended any further due to the positioning of the rib cage, but must then be bent forwards again over a lengthy stretch [d: thoracic kyphosis]. Our head is balanced on the top of the spine, and not pushed forwards like in animals, thus saving muscle power [d]. This is why the CS has to be bent back again [e: cervical lordosis]. So, how are these clearly separated curvatures spread across the different sections of the spine? Concavity in the short sacrum – strong convexity over a short stretch in the LS – longer, weaker concavity in the TS – shorter convexity in the CS. A perpendicular drawn line, starting from the ear canal, intersects the spine at three points [f]. The load is therefore distributed across several points, thus increasing the load-bearing capacity multifold and also increasing elasticity.

The double S-shape of the human spine that now carries the body upright, removes the load-bearing function from the arms, freeing them up for all-round use, represents a new quality compared with that in animals.

6.2.4. The mechanics of the spine

We can essentially imagine the many 'ball bearings', arranged sequentially and vertically, as having three basic axes:

transverse axes for bending forwards (flexion)–bending backwards (extension)
sagittal axes for lateral inclination
vertical axes for rotation (torsion).

Mobility drops off with increasing load-bearing capacity:
CS with all-round movement
TS with lateral inclination and rotation round vertical axis.
LS with flexion and extension.

Fig. 306 Developmental series to aid in the understanding of the double S-shape of the human spine.
Black: sacral–lumbar section = first S-shape
Grey: thoracic–cervical section = second S-shape.
The curvature of the human spine is statically imposed (balance posture) and arises from the position of the pelvis that is tilted forwards, requiring a strong backwards bend of the lumbar section.

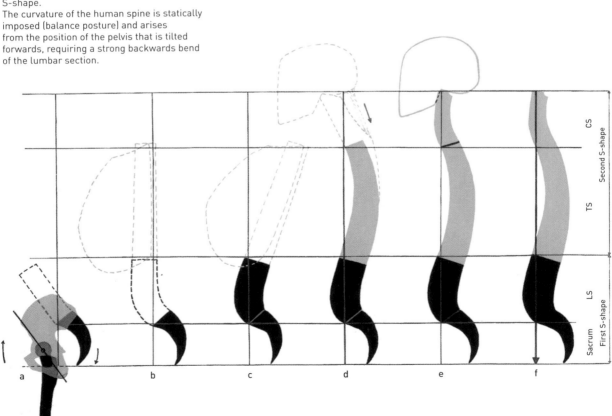

Flexion and extension [307, 310, 312, 313, 314]: The chin reaches the chest in the cervical section (flexion); the forehead can touch the knee if the hip joint and the rest of the spine participate in the action (movement in same direction). Characteristic shapes: rounded back, flattened or mildly kyphotic CS and LS (lumbar kyphosis), protrusion of the spinous process of the seventh cervical vertebra and the string of spinous processes in the LS, deep folds in skin on the ventral side of the body.

Extension [307, 310, 311, 312]: At its most intensive above the sacrum (increase of LS lordosis) and in the CS. The thoracic kyphosis becomes flattened, but never disappears entirely. The skin folds in the lumbar region and the back of the neck have the appearance of 'kinks'. Lateral inclination (lateral flexion) [308, 313] can either occur with equal curvature across the entire spine or take an angled course above the lumbar column. Deep folds of skin on the flexed side of the body and actively tensed muscles on the extended side of the body denote the substantial reduction and increase in distance, respectively, between the pelvis and rib cage [316].

Rotation around the vertical axes is reduced from the neck downwards and is almost zero in the lumbar column [309]. Twisting of the rib cage over the pelvis is only visible from the navel upwards; the overall rotation across all sections is about 30° to each side. Diagonal, spiral-shaped folds occur in the skin on the side of the body that is being turned towards. The CS permits the greatest torsion, for turning the head [315, 317, 318, 319].

We refer to what has already been stated previously with reference to the interdependence between spinal and pelvic posture.

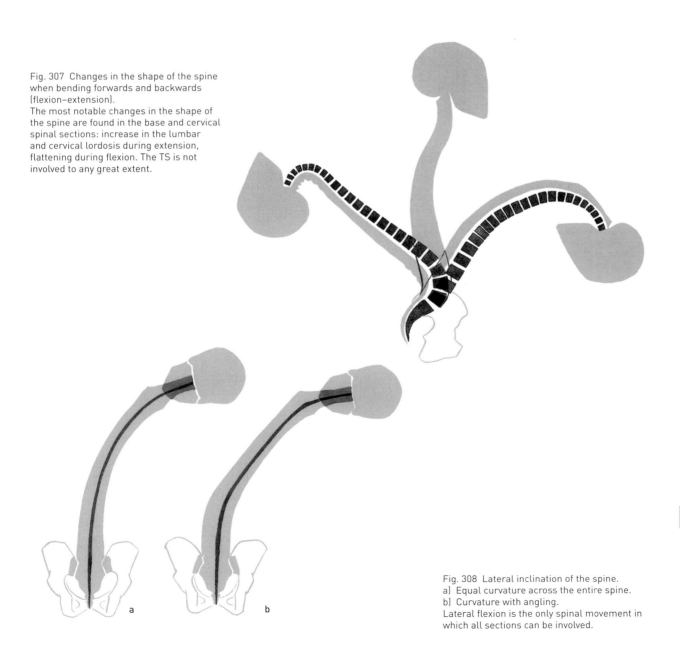

Fig. 307 Changes in the shape of the spine when bending forwards and backwards (flexion–extension).
The most notable changes in the shape of the spine are found in the base and cervical spinal sections: increase in the lumbar and cervical lordosis during extension, flattening during flexion. The TS is not involved to any great extent.

Fig. 308 Lateral inclination of the spine.
a) Equal curvature across the entire spine.
b) Curvature with angling.
Lateral flexion is the only spinal movement in which all sections can be involved.

The skeleton of the trunk **293**

Fig. 309 The spine during rotation around the vertical axis (torsion):
a) Structure of the spine composed of its 24 vertebrae above the sacrum and balancing of the cranium (transparent).
b) Complex summary of the segmentation of the spine into one constructional shape exhibiting the same torsion as in a.
c) Two articulated lumbar vertebrae.
d) Two articulated thoracic vertebrae.
e) Two articulated cervical vertebrae.
f) Principle underlying the arrangement and position of the articular facets in the CS. Torsion only starts above the lumbar spine.

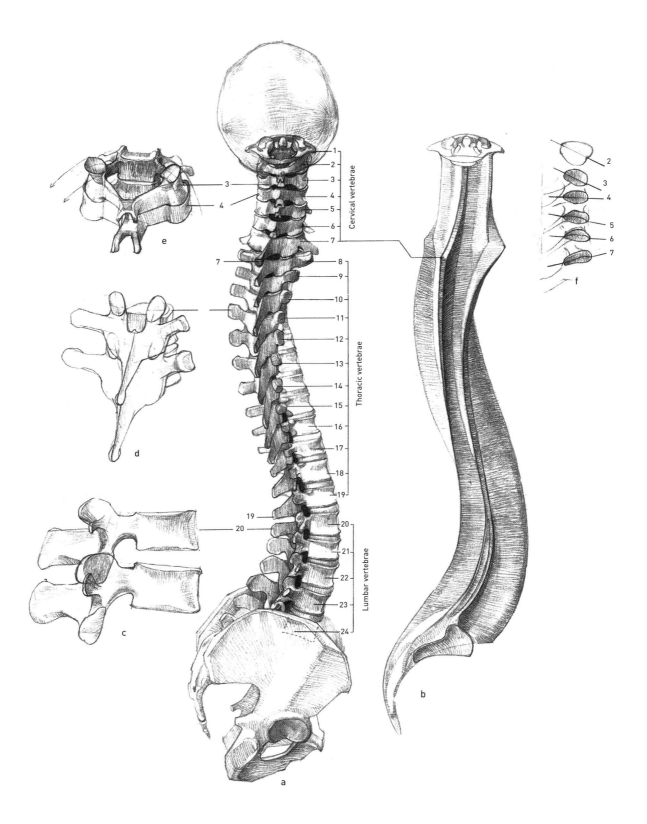

Fig. 310 Clockwise and anticlockwise movements in the different sections of the spine.
Left figure: bending the torso backwards also involves the pelvis, which is tilted backwards, in addition to the lumbar spine and the cervical spine.
Right figure: the pelvis, which is tilted forwards (flexion of the hip), effects the entire flexion, whereby the lumbar lordosis can even be rendered into an extended shape. Counter to the position of the trunk, which is bent forwards, the cervical spine is moving in the opposite direction (head bent backwards).
The shape of the thoracic spine remains largely unchanged when bending forwards and backwards.

Summary:

1. The spine fulfils the following functions:
 a) It is the supporting axial scaffold and forms the connection between the cranium and the other portions of the body.
 b) It encloses the spinal cord and protects it.
 c) It is an elastic rod with multiple segments that permits comprehensive movement and supports breathing through extension and flexion.
2. Individual components, the vertebrae, make up the spine. The vertebrae are based on a common prototype and reflect the functions of the spine.
3. The freely mobile sections divide the spine into:
 CS with seven vertebrae
 TS with twelve vertebrae
 LS with five vertebrae.
4. Components and functions of a vertebra are:
 a) Vertebral body: load-bearing element.
 b) Vertebral arch: protects the spinal cord in the spinal canal.

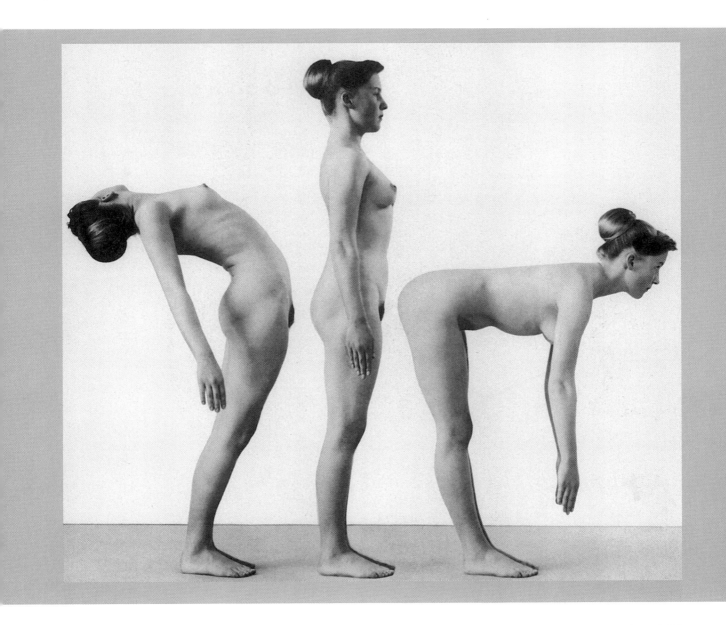

The skeleton of the trunk **295**

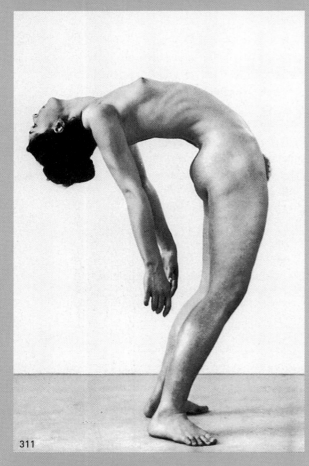

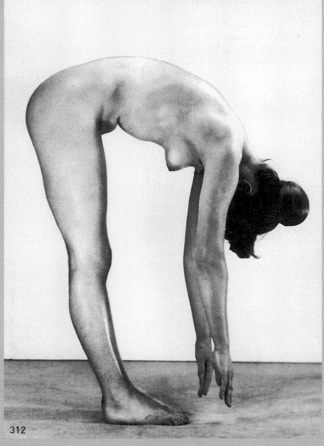

311

312

Fig. 311 The mechanics of the spine when bending the trunk and the head backwards. The lumbar and cervical curvature (lumbar and cervical lordosis) are increased. Movements in the same direction are occurring throughout the entire spine and hip region (vertical positioning of the pelvis).

Fig. 312 The mechanics of the spine when bending the trunk and the head forwards.
In this case, the natural curvatures of the LS and CS are flattened. The actions of the hip joint (increase in tilting forwards of the pelvis) and the entire spine are working in the same direction, with a sharp emphasis in curvature between the LS and TS (lumbar kyphosis).

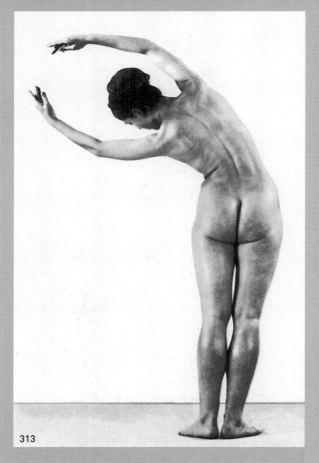

313

Fig. 313 The mechanics of the spine when inclining the trunk and head sideways.
In this case, the course of the curvature of the spine in the model produces a lateral curvature that is regular and moves in the same direction (about 30° to one side).

Fig. 314 The spine in a seated posture on the floor.
In this position, the knees have been drawn towards the upper body. The curvature of the spine results in protrusion of the spinous processes, especially in the LS.

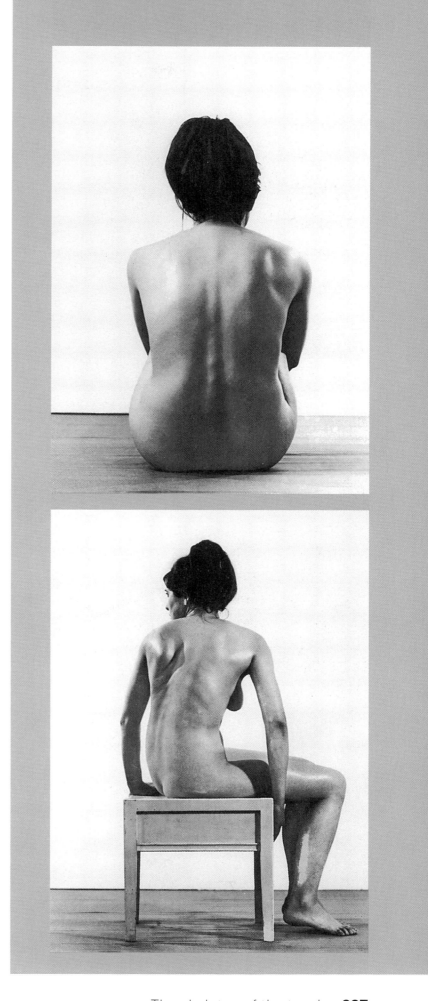

Fig. 315 Torsion in the same direction in the thoracic and cervical spine in a seated posture. The position of the pelvis is largely fixed by the load imposed by the body, such that torsion of the upper body over the pelvis and LS is clearly visible in the TS section. The CS continues the torsion of the TS in the same direction when the head is turned (30°).

The skeleton of the trunk **297**

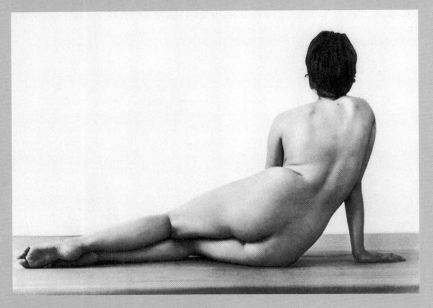

Fig. 316 Passive lateral flexion of the spine. The laterally tilted pelvis and the supporting of the upper body on vertically held arms cause a C-shaped curvature of the spine, starting from the lumbar column. Note how the two plastic cores, the pelvis and rib cage, come into contact with each other on the concave side of the spine (skin folds) and are distanced from each other on the convex side (stretching of skin). The rib cage is compressed on the side where the skin is folded and expanded on the opposite side.

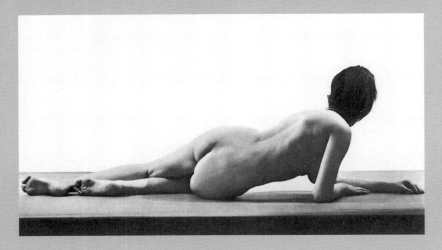

Fig. 317 Torsion of the spine when lying down, with twisting of the upper body. The position of the pelvis on its side gives the observer an almost entirely posterior view, while the back is almost pointing upwards and is strongly twisted against the axis through the pelvis (torsion in the TS).

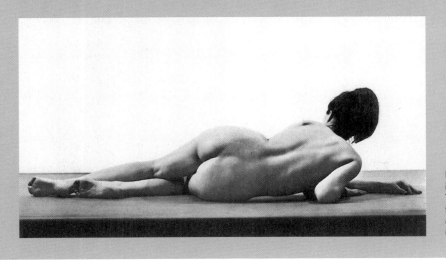

Fig. 318 Combined movement of the spine in when lying down.
The pelvis is on its side, exactly in the frontal plane. The spine undergoes a combined movement of torsion and mild C-shaped lateral flexion.

c) Processes: lever arms for the muscles.
 Spinous process: covers the spinal cord, inhibits hyperextension
 Articular processes (paired, with cranial and caudal orientation): guidance and restriction of movement, prevent spinal cord from being sheared off
 Transverse processes: abutment for the ribs in the TS.

5. The vertebrae in the individual sections of the spine undergo changes depending on their function.

6. Fibrocartilage intervertebral discs are inserted between the vertebrae which contain a semifluid fibrogelatinous mass (nucleus pulposus) that is under pressure and keeps the vertebrae under mutual elastic tension. The intervertebral discs act as shock absorbers, increase mobility between the vertebrae and have a significant effect on the appearance of the spine.

7. In contrast to the C-shape in quadrupedal mammals, the curvature in the human spine corresponds to a double S-shape that permits the load to be distributed across several apices, to balance it in a vertical position and act as an elastic spring.

8. The mechanics allow flexion and extension, lateral flexion and rotation around the vertical axis. Mobility decreases from the neck downwards toward the sacrum. There are specific differences in movement between the TS (mainly rotation around the vertical axis and lateral flexion) and the LS (mainly flexion and extension).

9. Temporary or permanent changes in the position of the pelvis are followed by corresponding changes in the shape of the spine.

The masses that dominate the shape of the trunk are – in spite of overlaps by the shoulder girdle [325] and numerous muscular connections to the arm – the bony cavities formed by the rib cage and the pelvis [320, 321]. We will now focus on the structural make-up of the former.

Figures 320, 321 are mainly dedicated to the function of the trunk muscles and primarily illustrate section 7.2.2., starting on page 318.

Fig. 319 Reflection of the mechanics of the spine in an anterior view, when lying down. In this frontal perspective, the posture mainly manifests in the torsion of the plastic cores against each other [317, 318], which results in spiral 'twisting' of the soft tissue shapes. The soft, pendulous relaxation of the abdominal wall reveals the iliac crest and the anterior superior iliac spine as clear and prominent fixed points in the framework.

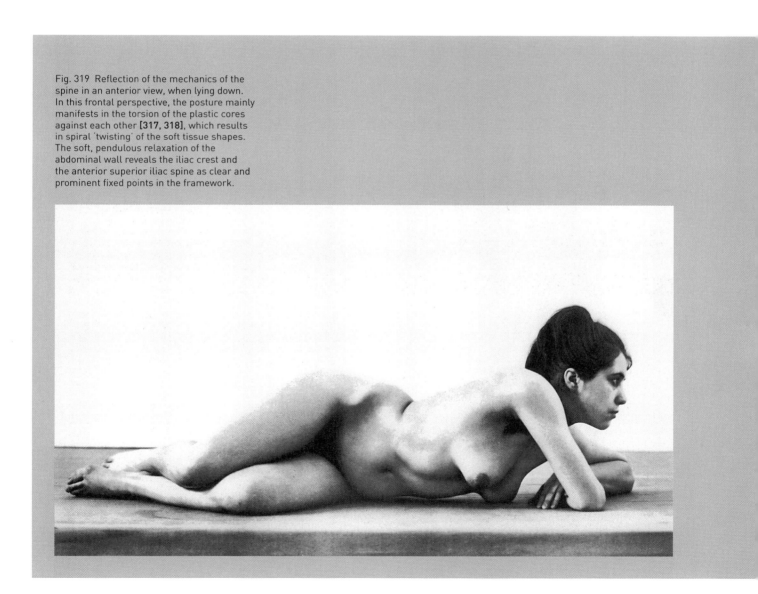

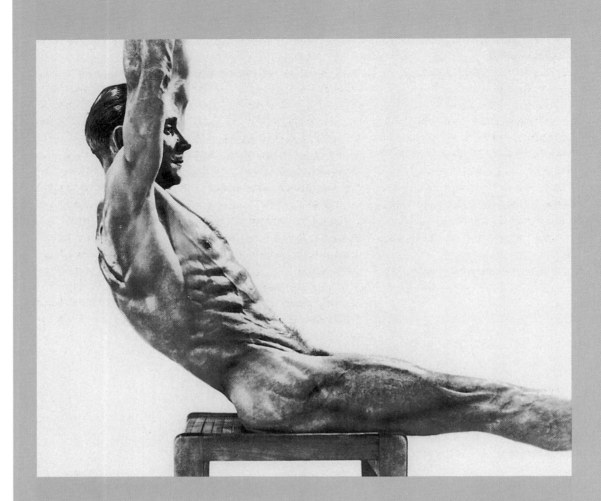

Fig. 320 Ventral and lateral abdominal wall
function when raising the body up from lying
on the back.
The rectus femoris and the iliopsoas provide
functional support for this movement by
jointly raising the pelvis into an upright
position against the fixed upper leg.

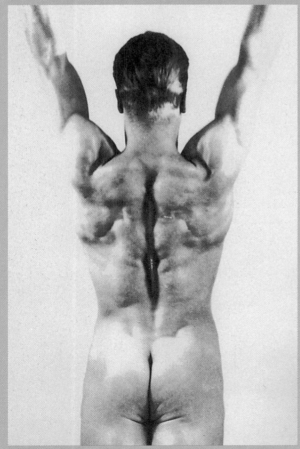

Fig. 321 Trunk muscle function when
hanging from the high bar.
The true trunk muscles (muscles of the
dorsal, lateral and ventral abdominal wall)
safeguard stability in the connections within
the skeleton of the trunk; the muscles
of the trunk and upper arm stabilise the
connections between the pelvis and rib cage
and the upper arm; the muscles of the trunk
and shoulder girdle stabilise the connections
between the skeleton of the trunk and the
shoulder girdle (fixing the shoulder girdle
in position). Using this as a base, some of
the muscles that insert into the upper arm
alleviate the traction acting on the shoulder
joint, especially the massive deltoid muscle.

6.3. THE RIB CAGE (THORAX)

6.3.1. General characteristics, functions and organisation

The rib cage is an elastic, bony cavity, the volume of which can be enlarged or reduced, which protects the organs in the chest and also some of the abdomen. It is shaped by gender, constitution, profession and sports, age, health status and disease. Its posture in association with the spine expresses emotional conditions (despondency, nonchalance, submission, pride, healthy satisfaction with life, etc.).

Its rounded, flattened cone is composed of [322]: twelve pairs of ribs, of which there are seven 'true' ribs and five 'false' ribs (the latter two of which are floating ribs); twelve thoracic vertebrae; the sternum, which is composed of three bones; the spine.

Fig. 322 Adult rib cage (male).
This forms the largest bony cavity and the most important plastic core in the male upper body.

6.3.2. Components and structure of the rib cage [332]

The ribs (costae) are curved, elastic bones. The posterior end of the rib – head of the rib (capitulum costae) – articulates with two vertebral bodies; the tubercle (tuberculum costae) articulates with the transverse processes (abutment) [324h, j]. The blunt anterior end of the rib is attached to the costal cartilage (cartilage costalis) that creates an elastic bridge to the margin of the sternum. The first seven ribs are called 'true ribs' because they connect directly to the sternum via their costal cartilage, while the next three ribs are called 'false ribs' as they are only connected to the cartilage of the previous rib via a short piece of cartilage. The two floating ribs (costae fluctuantes) have no connection at all to the sternum. The sternum is a bony plate that is divided into three sections, the manubrium (manubrium sterni), sternal body (corpus sterni) and the xiphoid process (processus ensiformis).

The manubrium is trapezoid in shape. The manubrium articulates with the two clavicles via the clavicular notch (forms the basis for the plastic appearance of the jugular notch) and also with the first pair of ribs via the costal incisures [365]. The sternal body drops down vertically, expands towards its base, and the costal incisures along its lateral borders articulate with six costal cartilages on either side. This forms the furrow that separates the large paired pectoral muscles and the breasts in men and women.

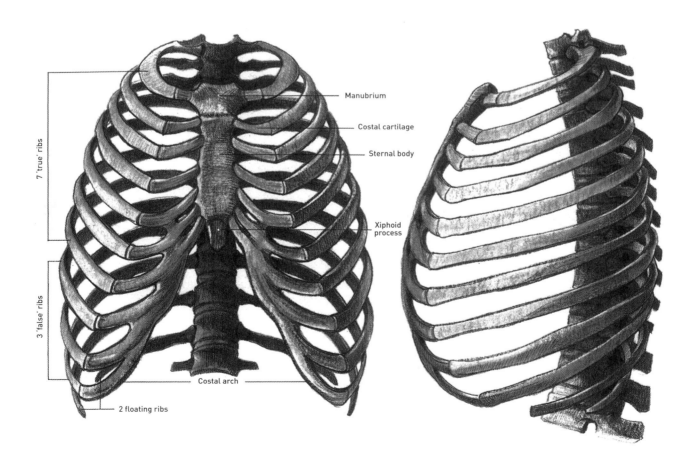

7 'true' ribs

3 'false' ribs

Manubrium

Costal cartilage

Sternal body

Xiphoid process

Costal arch

2 floating ribs

6.3.3. The plastic shape of the rib cage [323–327]

Its construction in humans is that of a bilaterally symmetric, rounded cone, on the volume and orientation of which other bony and muscle portions are only built up as ancillary shapes. It is therefore regarded as a plastic core. No understanding of the body's architecture is possible without the concept of its plastic appearance! The sagittal depth of an animal's rib cage exceeds that of its width; this is the other way round in humans, where the cross-section of the rib cage is similar to that of a bean. The flattening of the rib cage in humans is imposed by static requirements; the arms are suspended such that they can dangle down freely. It changes its shape between birth and old age (pointed and narrow in babies, similar to in animals, and flat and caved in in the elderly). We envisage the rib cage as a closed entity. Its cranial opening is dominated by the heart shape created by the first pair of ribs and their connection to the sternum [324f]. From here, the plane formed by the opening rises up diagonally in a dorsal direction to the articulation of the first pair of ribs with the spine, in the form of a slightly concave surface. The sternum drops off steeply in an anterior direction, exhibiting a slight kink. At this level, the costal

cartilage expands the frontal flattening of the rib cage. Only once the transition to the ribs from the surface described by the sternum and the costal cartilage is reached do we find an accentuation of curvature, which initiates the partly lateral surface of the flank of the rib cage as a new spatial orientation. The rib cage opens up below the xiphoid process in a more or less acute angle (costal arch). The costal arch progressively opens up in a caudal direction, following a convex curved form. This forms the caudal opening of the rib cage, including the floating ribs, the spine and the xiphoid process, which has a far greater breadth than the upper opening. In a frontal and dorsal view, initially from the first to about the third rib, the rib cage expands very rapidly and accentuates the general convex curvature here. However, following this, the contour drops off steeply in a caudal direction, with only moderate broadening of the chest cavity, as far as about the eighth rib, where the volume decreases again slightly. The last floating rib is connected to the spine substantially lower down than the xiphoid process. The breadth and shape of the dorsal surface of the rib cage become clear when the model crosses his or her arms in front of the chest and the shoulder blades thereby reveal the dorsal surface of the thorax. This is a specific, individual human spatial

Fig. 323 The simplified constructional shape of the rib cage.
The depictions in the form of a block express the dome-like nature of the structural shell in its basic perspectives. Views in perspective with clarification of overlaps in the ancillary illustrations.

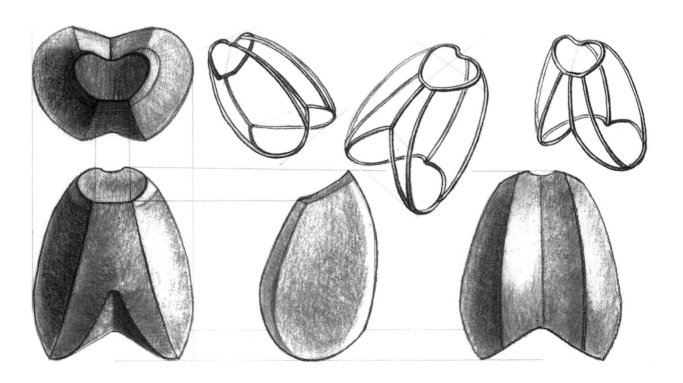

Fig. 324 The constructional shape of the rib cage in different spatial perspectives. The multiple segmentation of the bony cavity has been drawn together into one complex shape. The alignment of the spatial axes provides information on the position of the body in space, the accentuation of the cross-sections informs on the apices of the spatial incline of the surfaces surrounding the body.
d) Describes the shape of the symmetrical plane of the rib cage, relative to the horizontal sections.
h) Connection between the rib and vertebra with its axes associated with raising and lowering of the rib cage during breathing (cranial view).
j) The connection between the rib and vertebra in a three-quarter view from a dorsal perspective.

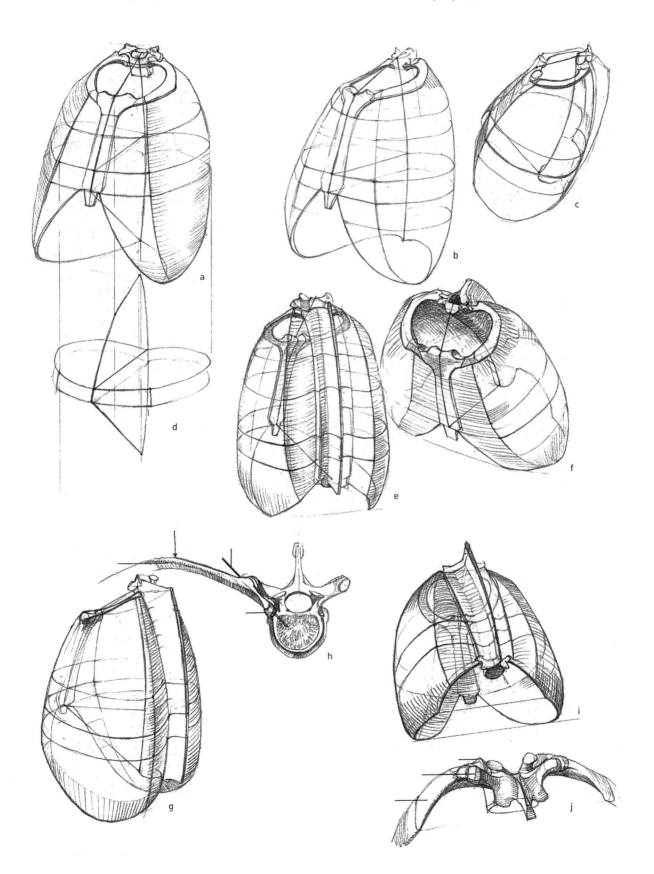

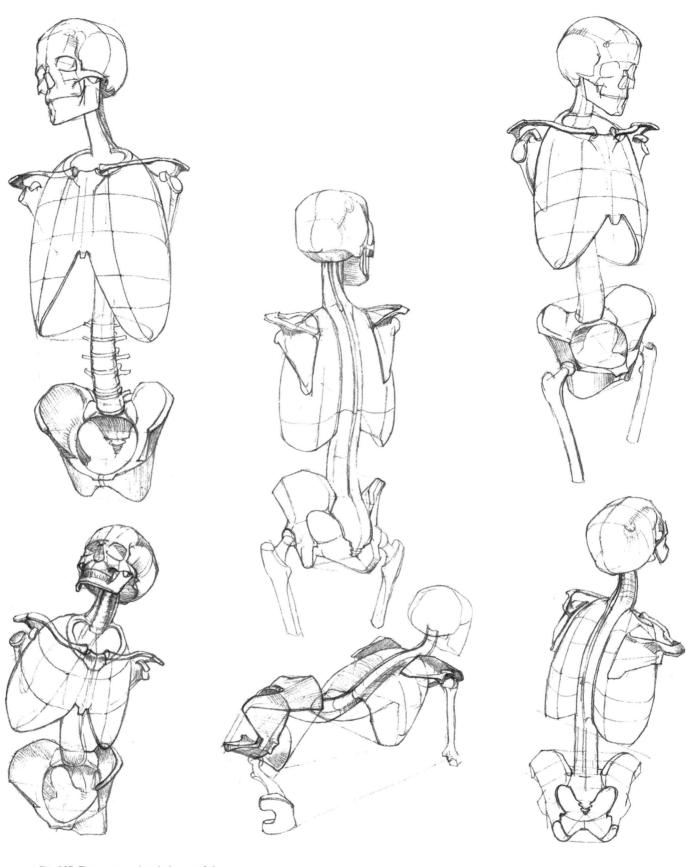

Fig. 325 The constructional shapes of the
skeleton of the trunk in context, different
perspectives and different functions.
Comprehension of the interrelationships
between the shapes and positions of the
plastic cores is an important prerequisite
for insightful life drawing.

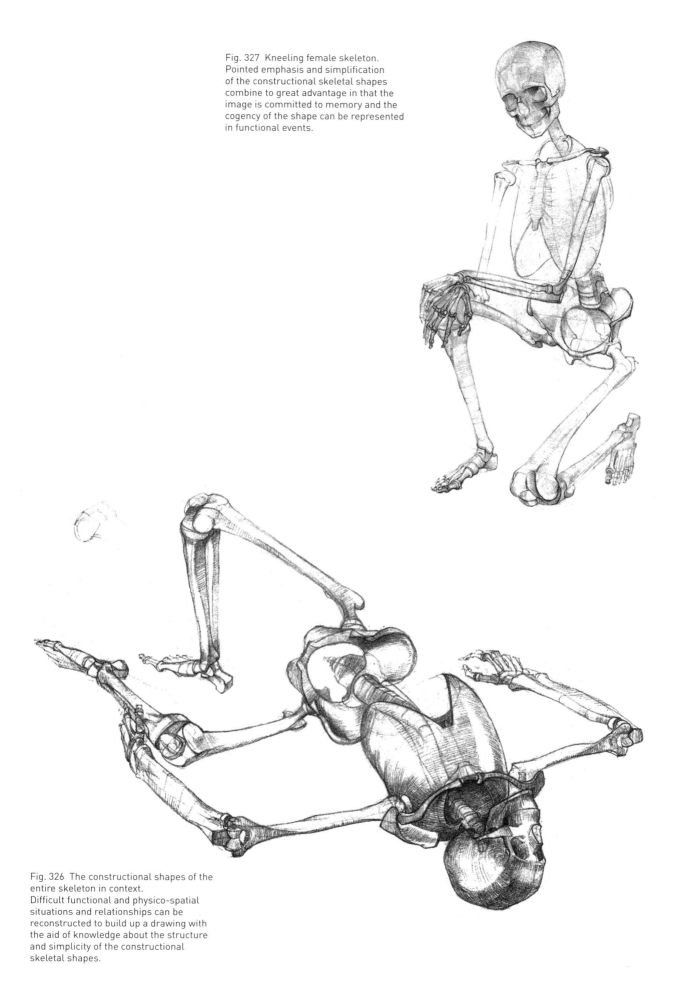

Fig. 327 Kneeling female skeleton.
Pointed emphasis and simplification
of the constructional skeletal shapes
combine to great advantage in that the
image is committed to memory and the
cogency of the shape can be represented
in functional events.

Fig. 326 The constructional shapes of the
entire skeleton in context.
Difficult functional and physico-spatial
situations and relationships can be
reconstructed to build up a drawing with
the aid of knowledge about the structure
and simplicity of the constructional
skeletal shapes.

form that has no equivalent and must be studied in detail. We must learn how to imagine and draw the rib cage in all its foreshortened aspects, must understand how to produce the shapes from inside out that are created by overlaps of the costal arch during twisting [324–326]. To this end, the author developed a constructional model made of wire that aids in this undertaking and greatly facilitates modelling and drawing.

6.3.4. The mechanics of the rib cage

The most important mechanical processes are the raising and lowering of the ribs to increase the volume of the rib cage during inhalation and reduce it during exhalation, or to accommodate movements between the pelvis and the rib cage. Mechanical prerequisites: the parts that make up the passive respiratory apparatus, the ribs with their connections to the spine and the sternum, and the flexible costal cartilage with its facility for lateral and sagittal expansion, create the conditions for the mechanical processes. The ribs are raised and lowered around an axis that passes between the spine and the heads of the ribs, as well as through the articulation between the transverse processes and the tubercles of the ribs [324h, j]. These also move apart laterally during raising of the ribs, and the rib cage shortens and broadens. The sternum rises upwards during inhalation and reduces the distance between the tip of the chin and the jugular notch [328, 329]. Therefore, during deep inhalation, important changes occur in the shape of the rib cage: the overall volume rises due to the increase in the diameters of the breadth and depth of the rib cage, with simultaneous shortening of the length of the rib cage. Conversely, deep exhalation reduces the diameters, the volume of the rib cage becomes smaller, it flattens and lengthens.

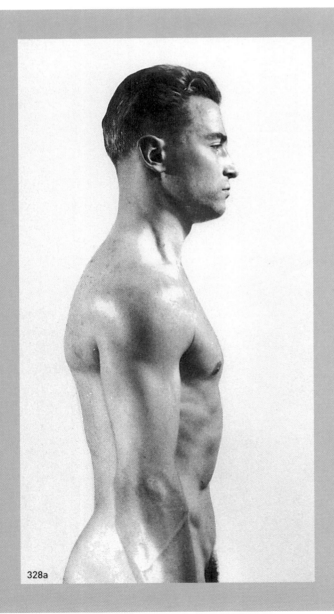

328a

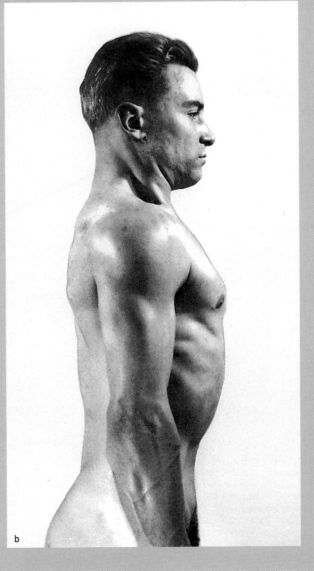

b

Summary:

1. The rib cage is a versatile open-work cavity that is composed of the ribs and their cartilage, the spine and the sternum.
2. The shape and posture of the rib cage are valuable with reference to their expressiveness of psychological factors.
3. A distinction is made between seven 'true' and five 'false' ribs. The former are directly connected to the sternum, while three of the latter are connected via cartilage to the costal cartilage of the rib above and two are floating.
4. We distinguish between the manubrium, sternal body and xiphoid process as constituents of the sternum.

5. The rib cage in animals has an almond-shaped cross-section, with a blunt pole at the spine; the human rib cage is kidney-shaped, with the concave side of the shape facing the spine.
6. The ribs, which descend diagonally downwards, are raised laterally and anteriorly during breathing. The centres of rotation for this movement are found in the double articulation between the rib and the transverse processes and the bodies of the vertebrae.
7. Deep inhalation increases the volume of the rib cage, shortening its length and expanding its breadth. Exhalation reverses these conditions.

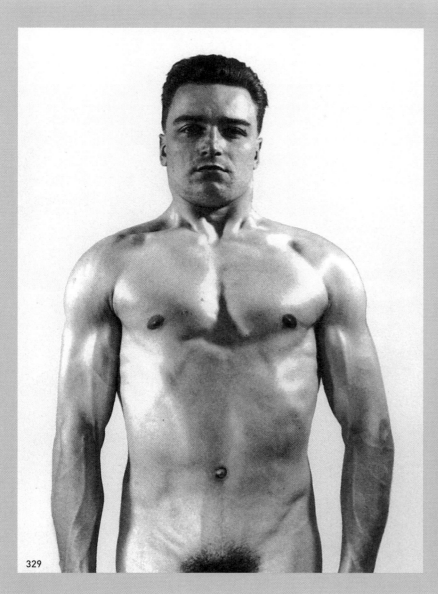

329

Fig. 328 Exhalation and deep inhalation in a lateral view.
a) Exhalation. The volume of the rib cage is compressed, the neck is 'normal' in length.
b) Inhalation. The rib cage rises up at the front (apparent shortening of the neck), the sternocleidomastoid – a muscle that runs diagonally across the neck – becomes an accessory to breathing, deepening the supraclavicular fossa.

Fig. 329 Deep inhalation in a frontal view. Note the lateral and sagittal expansion and shortening of the length of the volume of the rib cage and the convergence of the sternum and the tip of the chin (apparent shortening of the neck).

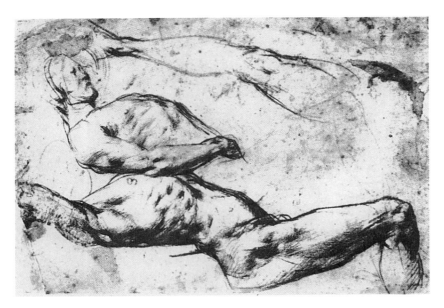

Fig. 330 Jacopo da Pontormo
(1494–1556).
Studies for the Pietà. Chalk, 48 x 24cm
(19 x 9½in). Boymans-van Beuningen
Museum, Rotterdam.
The arching of the rib cage as the
core of the volume of the upper body
arises from the costal arch and is
clearly delimited from the receding
abdominal wall, whereby the artist
emphasises the variable structure of
the framework shape against the
slack tension of the abdomen.

Fig. 331 Michelangelo (1475–1564).
Study for Adam in the fresco depicting
the *Creation of Adam* on the ceiling of the
Sistine Chapel. Red chalk, 19.3 x 25.9cm (7½
x 10¼in). British Museum, London.
The colossal rib cage of the 'Father' of
humanity is simultaneously a massif covered
in valleys, hills and hollows – a commanding
conveyor of numerous details through its
enormous basic shape.

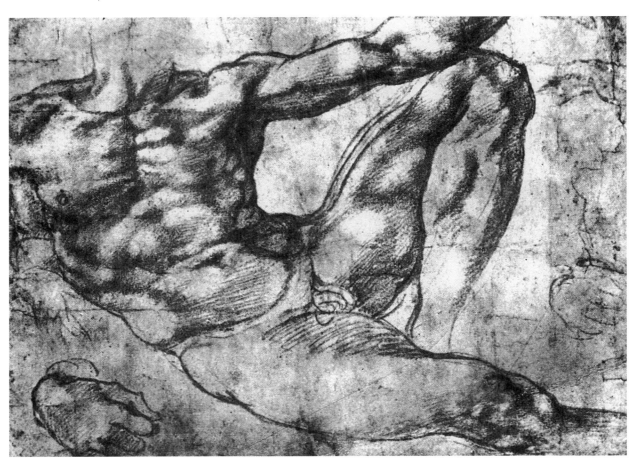

6.4. THE PROCESSING OF ANATOMICALLY OBJECTIVE CONSTITUENTS OF THE SKELETON OF THE TRUNK IN WORKS OF ART

There is no doubt: while we are now already inserting a sequence of examples from art after the detailed explanations provided in word and image on the skeleton of the trunk, this is designed to be more than simply relief from any potential monotony. Instead, the observation of life studies – also the removal of the soft tissue and concentration on the skeletal shapes – aims to guide the reader towards an understanding of how intrinsically important the plastic cores are, in the form of the rib cage and pelvis, as well as the supporting axial skeleton, the spine, in order to master nude drawing. Even just the observation of

Fig. 332 Peter Paul Rubens (1577–1640).
Nude Man with Raised Arms. Collection of Queen Juliane of the Netherlands, Den Haag. The drawing reflects, in great detail, the events taking place in the plastic appearance of the body when a heavy object is pushed upright using both raised arms. During this process, the rib cage is also raised by the pectoral muscles and is impressively offset from the surrounding soft tissue in the form of an ovoid volume, a component of artistic expression.

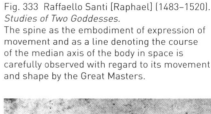

Fig. 333 Raffaello Santi [Raphael] (1483–1520).
Studies of Two Goddesses.
The spine as the embodiment of expression of movement and as a line denoting the course of the median axis of the body in space is carefully observed with regard to its movement and shape by the Great Masters.

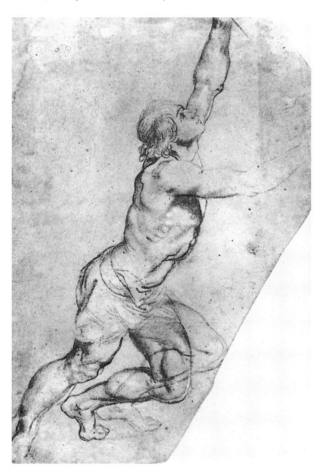

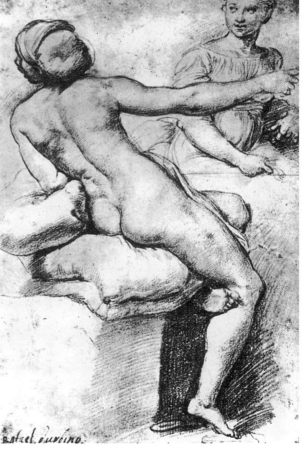

the course of the spine always has two simultaneous meanings: on the one hand, it denotes the position of the body, its movement in space and, on the other, it forms the backbone of expression through movement or function. Furthermore, the quality and extent of its movement and posture provide the benchmark for the relationships that the plastic vessels and cores, the pelvis and rib cage, enter into with each other. Plastic cores (the far more comprehensible term used by the sculptor for 'primary plastic masses') immediately makes us imagine a core and shell, of an inside and outside, of solid and soft elements, but, above all, of the cardinal and subordinate. What we can essentially derive from this is that we can gain an insight into the atelier of artistic creation with the aid of a work of art, through learning to understand how transparent the living model, the nude, is to the artist, giving him or her even more freedom to play with pairs of contrasts, such as – loose, hard – soft, brittle – tractable, determined, etc. We want to witness how the artist exploits definitive visual positions through knowledge and experience, to use this as a basis from which to enter into the wide world of imagination, where fact and fiction are joined together.

We are right at the heart of the problem with Michelangelo's *Study for Adam* in the fresco depicting the *Creation of Adam* [331]. Adam, the father of humanity, a youthful giant. The colossal, blunt, domed shape of his rib cage is ready to rob God of his breath. Positioned on the naked Earth, the arched scaffolding of the ribs protrudes from the flanks in the form of a long, drawn-out bow on the side of the body that is tensed and a short bow on the compressed side. Here, it sinks deep into the soft tissue and almost touches the narrow pelvic girdle. No matter how much detail there may be on the rib cage, these remain trivial shapes that are incapable of overshadowing the spheroid shape of the massif that they are located on. The large remains untouched by the many small forms.

In his *Studies for the Pietà* [330], Pontormo not only angles the rib cage off from the pelvis in the lumbar region, but he adheres to additional functional circumstances: the volume of the rib cage also increases through the arms being held above the head (note the difference in expression compared with the study above, where the arms are aligned with the body), such that the costal arch and the lower margin of the rib cage strongly delineate the ovoid form of the bony

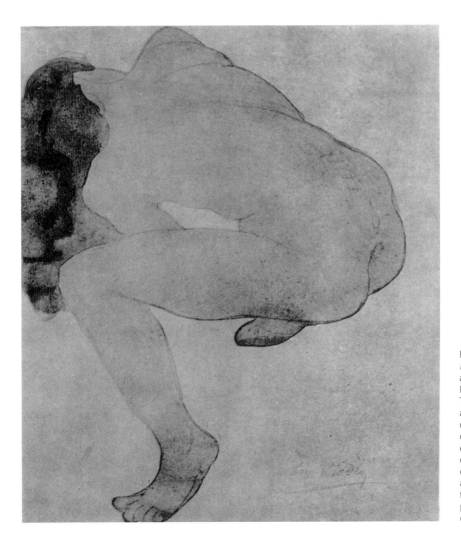

Fig. 334 Auguste Rodin (1840–1917). *Nude with Loose Hair*. Pencil and watercolour. Rodin Museum, Philadelphia, PA.
The close proximity of the upper body, arm and leg has the appearance of a decorative blotch that has been created effortlessly based on its aesthetic effect. In fact, it is packed with lively contemplation and observation of essential plastic functional issues, as demonstrated, for example, by the flexion and rotation of the spine which produces the torsion between the rib cage and pelvis.

vessel from the soft, sunken abdominal wall and the tilted pelvis.

The *Nude Man with Raised Arms* [332] is similar to the above. Rubens makes lifting up the load credible at the main load-bearing point in the spine, in the bending of the lumbar region. A hollow back results from this pressure, in which the axes through the base of the pelvis and buttocks and those through the rib cage in the upper body are impressively angled away from each other. The volume of the rib cage increases once more through the action of the vertically raised arm and due to this, in particular, is visible in the form of an independent, plastic core.

The impression created by the laterally reclined upper body in Raphael's *Studies of Two Goddesses* [333] is sustainably determined by the course of the median axis, the spine. Working with great precision through observation, the position of the pelvis is initially fixed with the aid of the dimples of Venus, the coccyx and the border of the ilium. The delicate furrow of the lumbar column starts above the sacrum – a soft triangular indentation – and the C-shape of the spine curves outwards, lengthy and shifted laterally, and supports and holds the remainder of the upper body in this

position. The shape described by the rib cage is strongly aligned with the course of the median axis.

Even though Rodin, in contrast to Raphael, for example, attributes a far higher independent intrinsic value to the graphic study and he prefers binding the configurative outline of the nude to the surface, he neither neglects physicality, nor expressive actions, by taking this approach. *The Nude with Loose Hair* [334], bending forwards and plunging into its own internal space, also does not, in the slightest, conceal the substance of the converging plastic cores of the pelvis and rib cage. The convex shape of the lumbar kyphosis rises up from between the vertical position of the voluminous pelvis in its seated position and the flat, voluminous back – without actually being highlighted. The combination of torsion and leaning forwards is indicated solely by the overlap between the lateral bulge of the rib cage by the tensed waist.

Similar to Schadr's *In the Storm* [336], Aghayan's inspiration for the small flat repoussé relief, *Nude* [335], finds its origin in the rotation of the pelvis and rib cage, which produces strong tension between shapes due to the swelling of the volume in the region of the pelvis and hip and the petering out in the profile view of

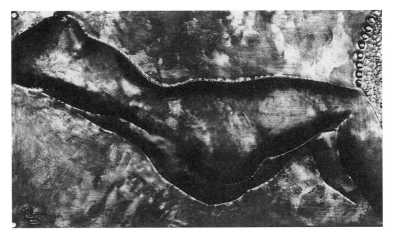

Fig. 335 Eduard Makarovich Aghayan (1936–1993).
Nude (1967). Copper repoussé, 15.7 x 26.3cm (6 x 10¼in).
The appeal of this small plastic work of art lies in the development of a central shape in the region of the hips and buttocks, which then peters out compositionally through to the narrow lateral view of the upper body and legs, through exploitation of the torsion of the rib cage.

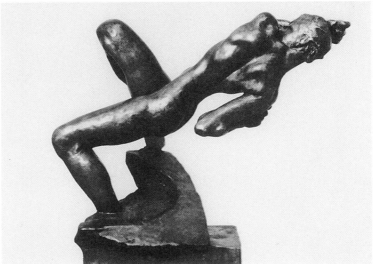

Fig. 336 Iwan D. Schadr (1887–1941).
In the Storm (1931), preliminary design.
Tinted gypsum, 54 x 59 x 26cm (21¼ x 23¼ x 10¼in).
The motivation in this case also uses the twisting of the body as a functional basis for exploiting spatial capture and the shapes that arise from this.

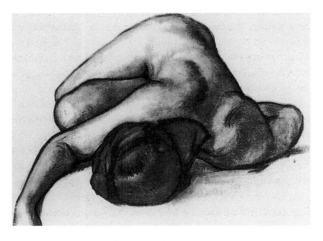

Fig. 337 Vera Mukhina (1889–1953).
Lying Female Nude (1911). Charcoal,
52.7 x 67.8cm (20¾ x 26¾in).
Axial rotation plays an important role for
the sculptor, in particular, with reference
to the organisation of the body in space
and its functional expressiveness.

the rib cage and legs. The narrow break in the torsion
at the waist is of equal importance to the functional
event as the spatial overlaps of the spine, an internal
shape that flows into the lumbar region.

The robust, sensual physicality of the *Woman in
Front of Mirror* by Deineka [338] avoids creating the
impression of inflated shapes through the artist's use
of the iliac crest, the placement of the sacrum, the
strong curvature of the iliac blades and, especially, the
elongated furrow formed by the spine, to create clarity
with reference to the articulation and stabilisation of
the shapes.

Irrespective of the fact that the concept for the
foreshortening in the *Lying Female Nude* by Mukhina
[337] swallows up all of the interim sections of the

Fig. 339 Henri Matisse (1869–1954).
*Two Sketches of a Nude Girl Playing a
Flute*. Pencil. The Fogg Art Museum,
Harvard University.
The ancillary drawing on the right once
again investigates two important issues:
the two ovoid shapes of the mass of the
pelvis and rib cage angled against each
other and with their connecting soft
tissue shapes. The extensor of the back,
which is overlapped, is integrated as a
short, energising interim shape between
the rib cage and pelvis.

Fig. 338 Alexander A. Deineka (1891–1966).
Women in Front of Mirror (1928). Watercolour,
57.8 x 43.8cm (22¾ x 17¼in).
The emphasised iliac crest and the deep
elongated furrow formed by the lumbar spine
contribute towards stabilising the enormous
shapes overall. The taut vertical posture
of the spine simultaneously acts as the
individual's psychological axis.

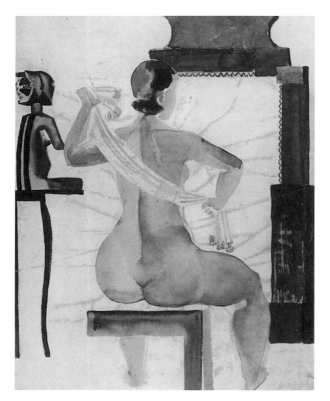

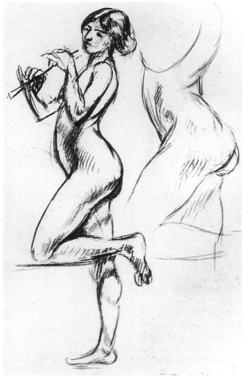

body that segment it in the development of depth perception, the study is still an informative example of the positioning of the axes through the rotating planes of the body.

In the *Two Sketches of a Nude Girl Playing the Flute* [339], Matisse dedicated the left-hand study to the expression of the overall process pertaining to posture, while the right-hand ancillary drawing contains some investigations that are essential to our problem. In this drawing, quite objectively, Matisse once again clarifies the relationship between the pelvis and the rib cage by emphasising the angling of the two axes describing the posture of the pelvis and the rib cage, such that both plastic cores rotate around an angle that opens towards the back in the form of ovoids. With equally astute observation, he also notes the short, taut interim shape of the extensor of the back, overlapped by the pelvis and rib cage, and the long, tense bridge formed by the abdominal wall. The *Nude Boy from the Back* [340], showing the basic motif of the static function of unequal loading of the legs during a standing posture, provides the incentive for Mareks to formulate the events that result from this with reference to shape: the load-bearing leg is shifted diagonally outwards at the level of the greater trochanter and is at an angle. The C-curvature of the spine arises from the pelvis dropping down on the side of the free leg, thus compensating for the pelvic tilt. The spine appears as a curved line and determines the course of the upper body.

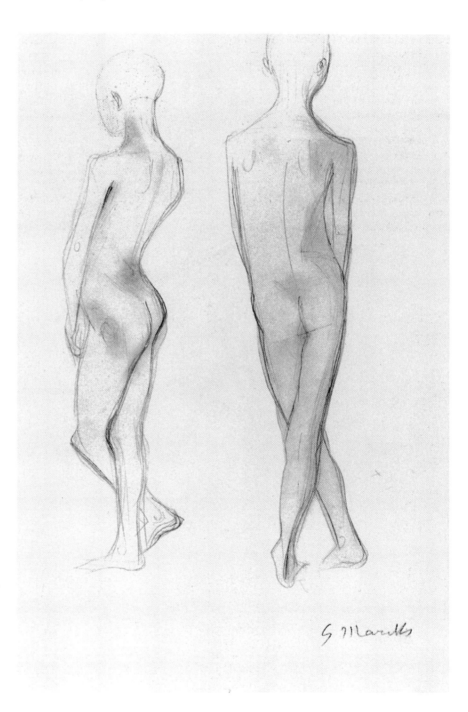

Fig. 340 Gerhard Mareks (1889–1981). *Nude Boy from the Back*. Pencil, slightly brushed. Kupferstich-Kabinett, Dresden.
The basic motif is the overall sequence of movement between the upper and lower body when one leg is engaged, with the axial curved line of the spine further underlining the postures and shifts in the body.

Fig. 341 Overview of the organisation of the trunk
muscles.
Red: pure trunk muscles (connections between pelvis, rib
cage and spine).
Orange: trunk–upper arm muscles (connections between
the skeleton of the trunk and the upper arm).
Yellow: trunk–shoulder girdle muscles (connections
between the skeleton of the trunk and the shoulder blade
and clavicle).
a) Illustration in partial dorsal view.
b) Illustration in partial ventral view.
c) Isolated illustration of the structure of the trunk.
The arrows indicate the primary directions of action on the
portions of the skeleton that are moved by the muscles.

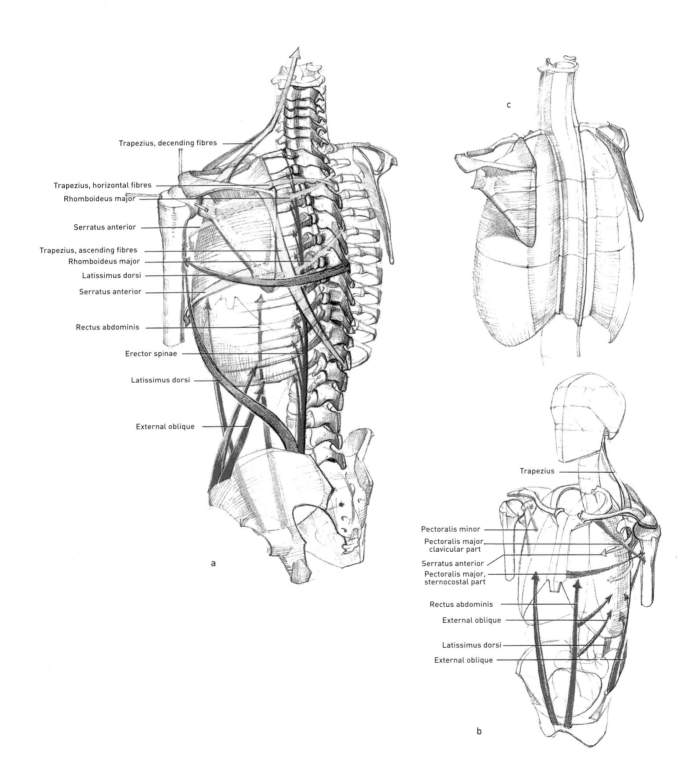

Trapezius, decending fibres

Trapezius, horizontal fibres
Rhomboideus major

Serratus anterior

Trapezius, ascending fibres
Rhomboideus major
Latissimus dorsi
Serratus anterior

Rectus abdominis

Erector spinae

Latissimus dorsi

External oblique

a

c

Trapezius

Pectoralis minor
Pectoralis major,
clavicular part
Serratus anterior
Pectoralis major,
sternocostal part

Rectus abdominis

External oblique

Latissimus dorsi
External oblique

b

7 The muscles of the trunk

7.1. OVERVIEW OF THE GENERAL SYSTEM AND THE FUNCTIONS OF THE MUSCLES OF THE TRUNK

The functions of the muscles of the trunk are: bridging of the gap between the pelvis and rib cage, protection of the viscera, changing and stabilising the positional relationships between the two bony cavities, changing the appearance of the abdominal cavity (stomach crunch), accessory function in respiration, and all-round incorporation of the spine in its contractile effects, based on position in relation to the transverse, sagittal and vertical axes [349].

We distinguish between three large groups of trunk muscles [341a, b]:

1. the pure trunk muscles that are exclusively attached to the skeleton of the trunk (e.g. rectus abdominis, external obliques, erector spinae, etc.),
2. the trunk–shoulder girdle muscles (see section 8.4.2.) that use the skeleton of the trunk as a fixed base for movement of the shoulder girdle (e.g. trapezius, serratus anterior, etc.),
3. the trunk–upper arm muscles (see section 8.6.2.) that originate from the skeleton of the trunk and insert directly into the upper arm (e.g. latissimus dorsi and the pectoralis major).

The two latter groups will be discussed later on.

7.2. THE PURE MUSCLES OF THE TRUNK

These seal the ventral, lateral and dorsal abdominal wall and their position is related to all axes through the spine. Their expansion is flat, with little volume, but their plastic appearance is of great importance. In conjunction with other trunk and hip muscles, they form mutual continuations that act as a natural corset formed of muscle loops [348].

7.2.1. The muscles of the ventral and lateral abdominal wall [310, 342, 344, 345, 348/1, 348/2, 349, 351]

The rectus abdominis (M. rectus abdominis): Of all abdominal muscles, this paired muscle plate (horizontal bands of collagen) protrudes the furthest forwards.

Origin: Pubic crest (pubic tubercle).
Course and insertion: The muscle runs in a direct vertical direction and inserts into the fifth to seventh costal cartilage at the level of the xiphoid process.
Function: Reduction in the distance between the pelvis and rib cage, raising the upper body from a horizontal position, stabilisation when bending the torso backwards and during lateral flexion of the torso, raising of the pelvis when suspended from the arms, stomach crunch (exhalation and excretion).
Plastic appearance: Fibrous vertical furrow (linea alba = white line). Horizontal bands of collagen are visible in nude models with thin skin, most clearly at the level of the navel. This partitions the largest plate of muscle in a caudal direction. The entire muscle appears like a shield that is resting on its lower tip. Bending the torso backwards increases the distance between the pelvis and rib cage and therefore stretches it into taut tension (reduction in the sagittal dimension of the body).

The external oblique (M. obliquus externus abdominalis) [320, 343, 344, 351]: This forms part of the ventral, but mainly the lateral, abdominal wall.
Origin: Lateral margin of the iliac crest, inguinal ligament, tendinous sheath (aponeurosis) of the rectus abdominis.
Course and insertion: Surrounds the body in a spiral shape, running from ventrally and laterally below, laterally upwards and dorsally, where it inserts into the rib cage. Its individual digitations insert into the fifth to twelfth ribs.
Function: Draws the rib cage downwards against resistance, pushes the pelvis forwards or to the side, suspension, lateral flexion of the trunk, raising the upper body from a horizontal position. Stabilising function when bending the torso backwards and during rotation of the trunk with simultaneous flexion (scything movement).
Plastic appearance: Primarily forms the soft bulge, or 'roll' produced by the relaxed muscle above the margin of the iliac blade as a fold over the iliac crest in men (disappears in the female model). On the ventral side, very close to the anterior superior iliac spine, the 'muscle corner' is typically offset from the rectus abdominis (initiation of the groin in classical statues). Particular folding and tension in the contrapposto position or during lateral flexion of the trunk.

Fig. 342 The antagonistic action of the pure trunk muscles (semi-schematic). The evaluation of the modes of action of the muscles forming the ventral, lateral and dorsal abdominal wall can be derived from an assessment of their positional relationships to the transverse, sagittal and vertical axes through the spine.

Fig. 343 The external oblique and its association with the rectus abdominis. Both muscle plates form a staggered spatial arrangement that is dependent on the plastic skeletal shapes, in between which they are attached.

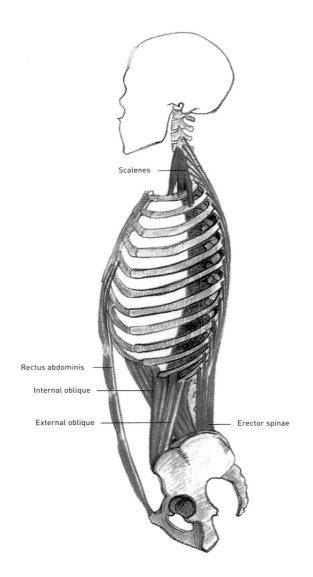

Scalenes

Rectus abdominis

Internal oblique

External oblique

Erector spinae

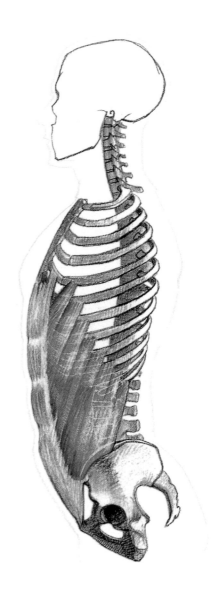

Fig. 344 Cross-section through the trunk at the level of the third lumbar vertebra (after Braus: the fascias surrounding the muscles are shown using black lines). The cross-section provides information on the main orientations of the ventral, lateral and dorsal abdominal walls and on the apices of their curvatures.

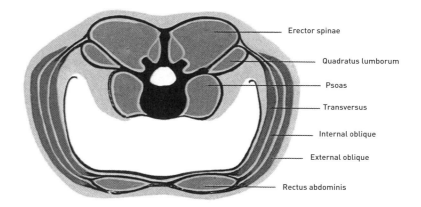

Erector spinae

Quadratus lumborum

Psoas

Transversus

Internal oblique

External oblique

Rectus abdominis

Fig. 345 The ventral and lateral abdominal walls.
a) The rectus abdominis (exposed from its sinewy sheath) and deep lateral muscle layers.
b) The rectus abdominis in its sinewy sheath (aponeurosis) and superficial lateral abdominal muscles.

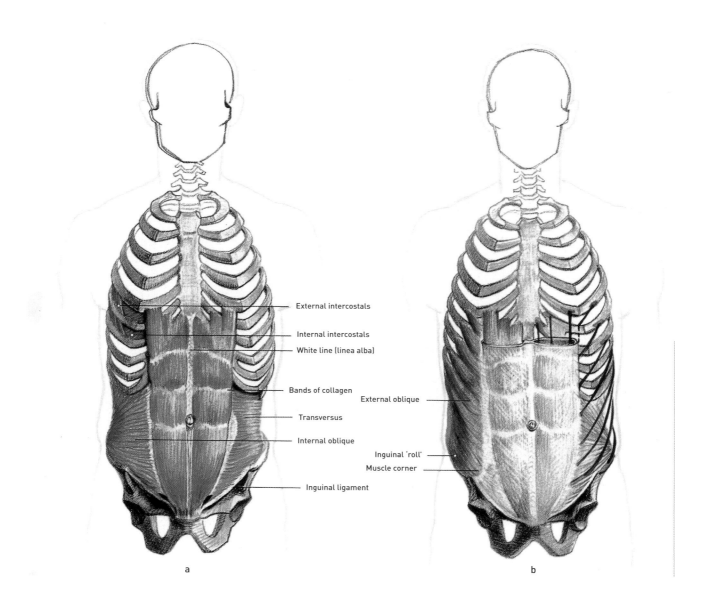

External intercostals

Internal intercostals

White line (linea alba)

Bands of collagen

Transversus

Internal oblique

Inguinal ligament

External oblique

Inguinal 'roll'

Muscle corner

a

b

The internal oblique and the transversus are not discussed as they are not visible externally [345a].

Joint action by all abdominal muscles is favoured, in particular, by the tendinous sheath (aponeurosis [345b]) of the rectus abdominis, into which the crossed layers of the transversus, internal and external obliques [342–344] insert. The aponeurosis incorporates the orientation of the muscle insertions into the structure of its tissue and thus translates the effects of muscle contractions to the other side of the body. This produces a reticulated framework for the abdominal wall. Sections of individual muscles can thereby easily form chains of muscle loops [348]. For example, the internal oblique takes on the orientation of the pectoralis major on the opposite side of the body. The diagonal that is thus created continues in practice through the gluteus medius. This means that internal connectivity is produced that extends from the greater trochanter through to the internal surface of the upper arm. The ventral side of the trunk – actually very exposed due to the large gap between the rib cage and pelvis – is surrounded by a protective corset ([348], see page 320).

7.2.2. The muscles of the back, respiratory muscles and some of the muscles of the trunk and their functions [321, 341a, 342, 344–347, 349, 350/1, 350/2]

These form part of an extremely complicated system that we will only touch upon for the purposes of the artist. The actual extensors of the back are in the deep muscle layer. Of these, a lateral tract of the deep back muscles are of greatest importance to the plastic appearance: the iliocostalis and the longissimus dorsi. These two form a plastic, bulging strand to the right and left of the lumbar spine, similar to a column cut in half longitudinally, which maintains the trunk upright or inhibits the upper body from bending forwards. Its relationship to all axes makes it 'multifunctional'. The erector spinae (M. erector spinae) is composed of the iliocostalis (M. iliocostalis) and the longissimus dorsi (M. longissimus dorsi).

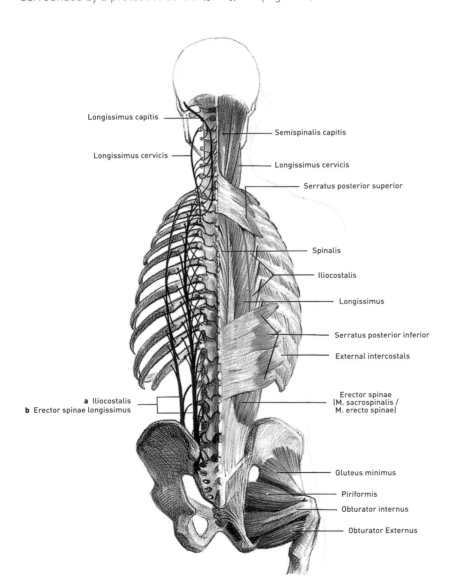

Longissimus capitis
Longissimus cervicis
Semispinalis capitis
Longissimus cervicis
Serratus posterior superior
Spinalis
Iliocostalis
Longissimus
Serratus posterior inferior
External intercostals
a Iliocostalis
b Erector spinae longissimus
Erector spinae (M. sacrospinalis / M. erecto spinae)
Gluteus minimus
Piriformis
Obturator internus
Obturator Externus

Fig. 346 Some of the neck, back, respiratory and accessory respiratory muscles.
The two lateral strands of the erector spinae (left, black lines showing their course), some neck and deep hip muscles (the latter to complement the discussion of the hip muscles).

Origin (for both muscles): Sacrum and posterior portion of the ilium.

Course and insertion: Both sides of the spinous processes of the spine, splitting into ever more strands in a cranial direction and inserting into the spine and ribs.

Function: Maintaining the body's upright stance, deepening of the lumbar lordosis (hyperlordosis), moving the upper body into an upright position from an inclined posture, extension of the thoracic kyphosis (therefore, an accessory respiratory muscle), supports lateral flexion on one side, stabilising function on the other side. Involvement in rotation round the vertical axis (torsion).

Plastic appearance: The main mass is rooted in a strand-like fashion in the lumbar region and therefore embeds the spinous processes in a deep furrow, without overlaying them. The tension caused by stretching the muscle when bending forwards flattens the semi-circular 'muscle column'

(protrusion of the spinous processes). In a lateral view, it appears as a short, but prominent, taut interim shape between the pelvic region and the rib cage and, as such, is overlapped from above to below. It rapidly branches out above the lumbar region and is no longer of any importance to the plastic appearance.

The pure trunk muscles are also involved in breathing. We distinguish between two forms of respiratory mechanisms:
1. chest or rib respiration (movement of the ribs)
2. diaphragm or abdominal respiration (movement of the diaphragm and abdominal cavity).

The rib cage has intrinsic intercostal muscles for raising and lowering of the ribs. In addition, the superior and inferior posterior serratus muscles (M. serratus dorsalis cranialis et caudalis) act during inhalation and exhalation: the ribs are raised by the extensors of the back, stretching the thoracic kyphosis, thus promoting inhalation [329].

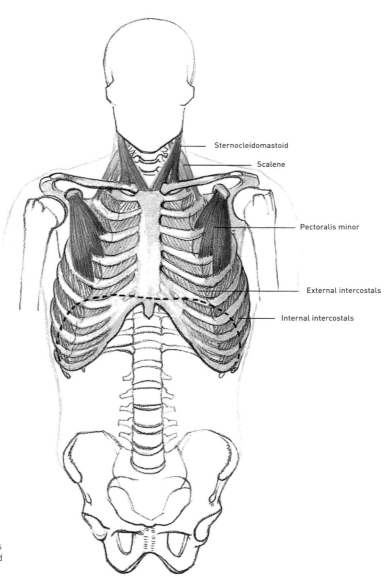

Fig. 347 The involvement of the sternocleidomastoid and the pectoralis minor shown during inhalation (dashed line: flattening of the diaphragm).

Sternocleidomastoid

Scalene

Pectoralis minor

External intercostals

Internal intercostals

Abdominal respiration is due to the action of the diaphragm, the muscle dome of which contracts during inhalation (flattening and thus expansion of the internal chest cavity downwards). The abdominal wall protrudes outwards. During exhalation, the abdominal muscles press against the abdominal cavity and push the viscera upwards. The abdominal wall retracts [328a].

When illustrating the male upper body (frontal view), the untrained eye exhibits a tendency towards using a 'typical' trapezoid shape that is generally characteristic in men. However, the flanks of the rib cage with the pectoralis major form a rectangle when the arms are dangling down [348/1]. It is only once the arms are raised horizontally that the upper body appears to form a trapezoid as it is only now that the latissimus dorsi becomes visible in a deep dorsal layer (see also Figures 385, 350/1, 350/2).

A careful study of the pure trunk muscles [348/2] must focus primarily on the plastic spatial relationships: the ventral abdominal wall (rectus abdominis) extends between the pubis and rib cage in the most anterior spatial zone. The lateral abdominal wall (external oblique) is offset against this, one step behind, and thus creates a spatial zone that is positioned further back (ancillary illustration).

Fig. 348/1 (opposite) Frontal view of the rectangular shape of the male upper body. The pure trunk muscles (muscular connections between the pelvis and rib cage (see also Figures 259/2, 343, 344, 345, 348/2) and trunk-upper arm muscles (see also Figure 341) create a visual impression of a rectangular shape for the frontal view of the male trunk, emphasised by the toned flanks of the trunk.

Adapted from Bammes, *Wir zeichnen den Menschen*.

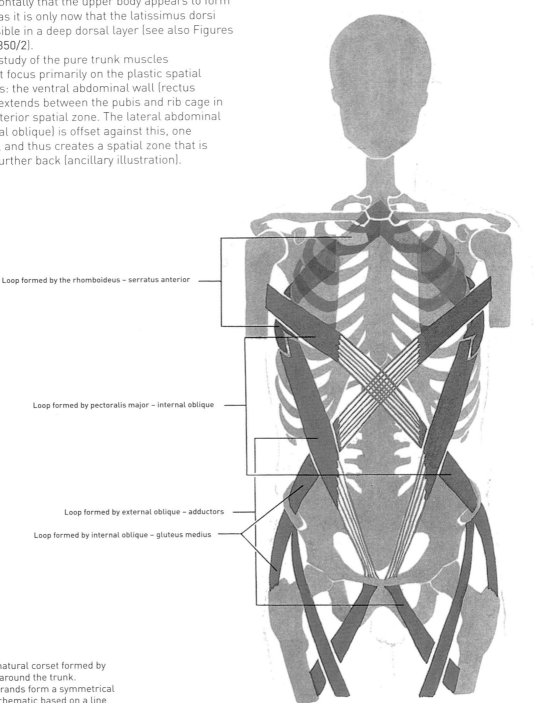

Loop formed by the rhomboideus – serratus anterior

Loop formed by pectoralis major – internal oblique

Loop formed by external oblique – adductors

Loop formed by internal oblique – gluteus medius

Fig. 348 The natural corset formed by muscle loops around the trunk.
The muscle strands form a symmetrical framework (schematic based on a line drawing from Benninghoff).

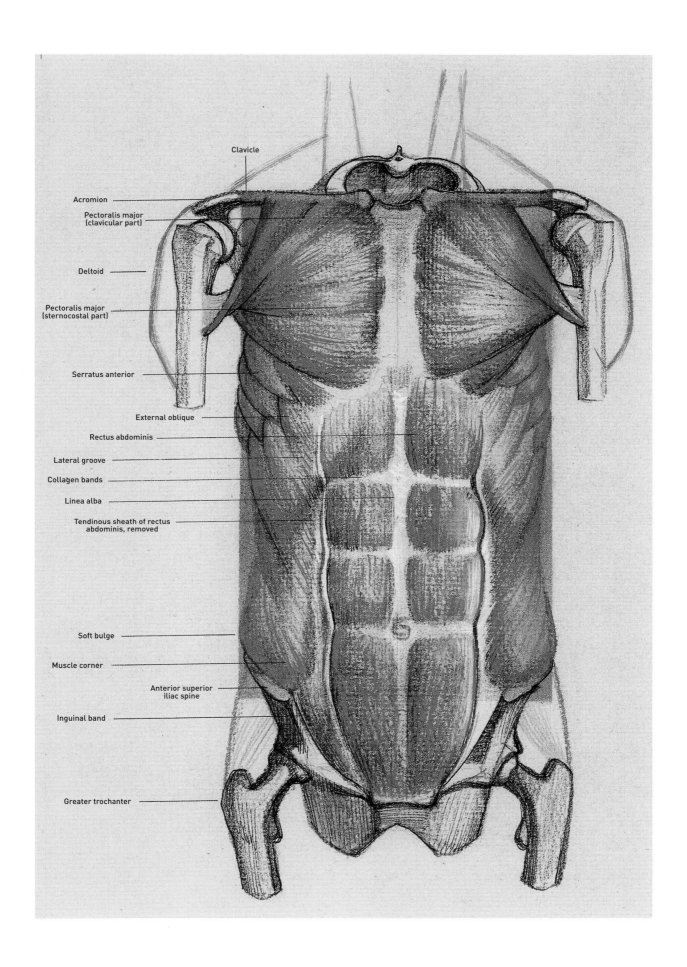

Clavicle

Acromion

Pectoralis major
(clavicular part)

Deltoid

Pectoralis major
(sternocostal part)

Serratus anterior

External oblique

Rectus abdominis

Lateral groove

Collagen bands

Linea alba

Tendinous sheath of rectus
abdominis, removed

Soft bulge

Muscle corner

Anterior superior
iliac spine

Inguinal band

Greater trochanter

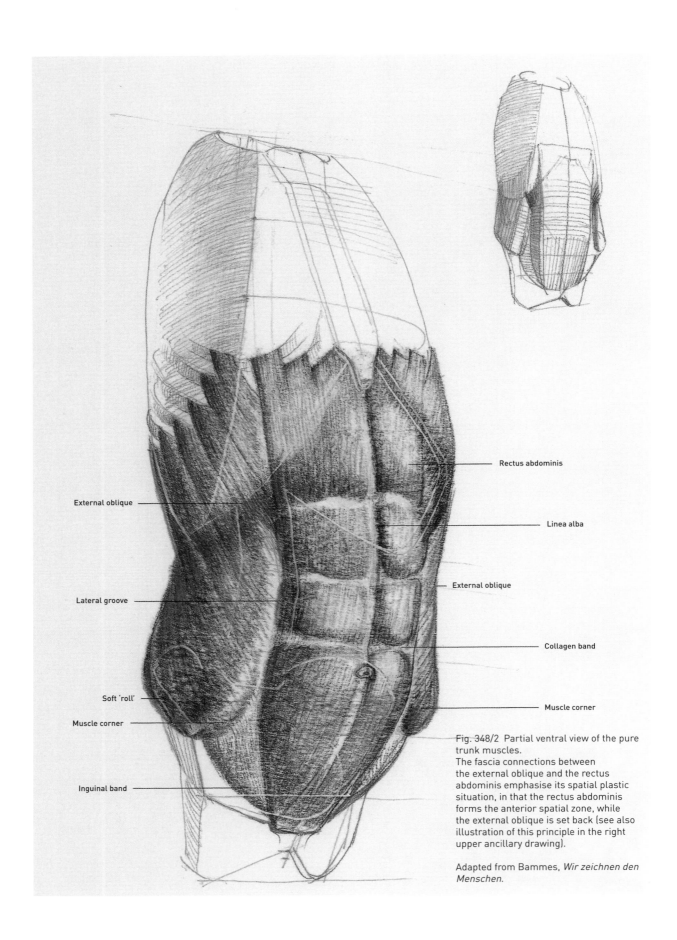

Rectus abdominis

External oblique

Linea alba

External oblique

Lateral groove

Collagen band

Soft 'roll'

Muscle corner

Muscle corner

Inguinal band

Fig. 348/2 Partial ventral view of the pure trunk muscles.
The fascia connections between the external oblique and the rectus abdominis emphasise its spatial plastic situation, in that the rectus abdominis forms the anterior spatial zone, while the external oblique is set back (see also illustration of this principle in the right upper ancillary drawing).

Adapted from Bammes, *Wir zeichnen den Menschen*.

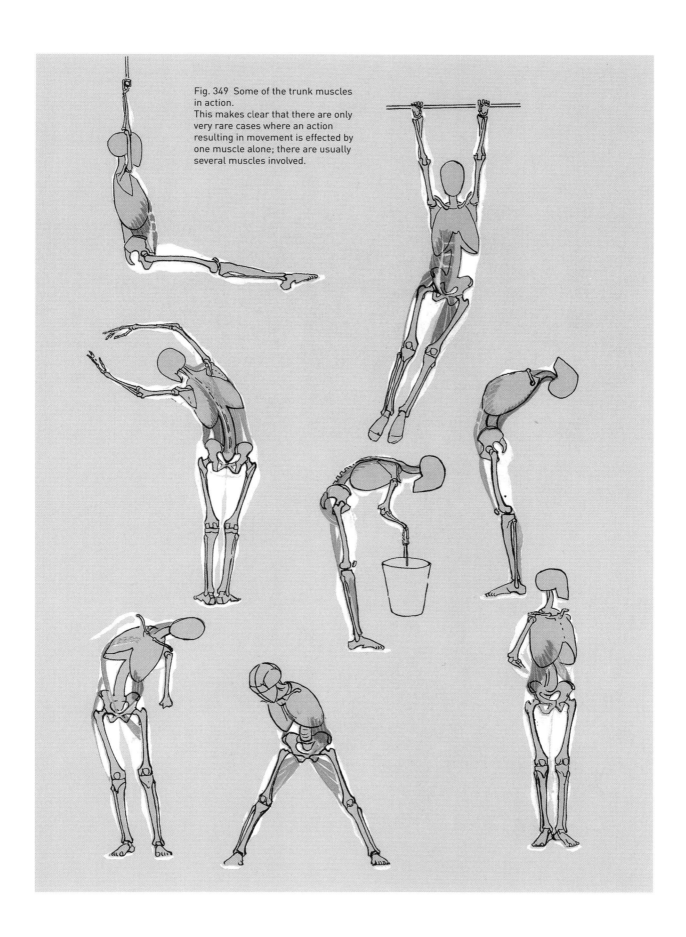

Fig. 349 Some of the trunk muscles in action.
This makes clear that there are only very rare cases where an action resulting in movement is effected by one muscle alone; there are usually several muscles involved.

Fig. 350 Dorsal view of the muscles of the trunk with a raised arm.

Fig. 350/1 (opposite) The muscles of the trunk in a contrapposto posture, dorsal view.
It can be difficult to follow the courses of the muscles, especially since the muscle layers overlap. Understanding this complex muscle relief can be facilitated by looking at the same posture in the skeleton.

Adapted from Bammes, *Wir zeichnen den Menschen*.

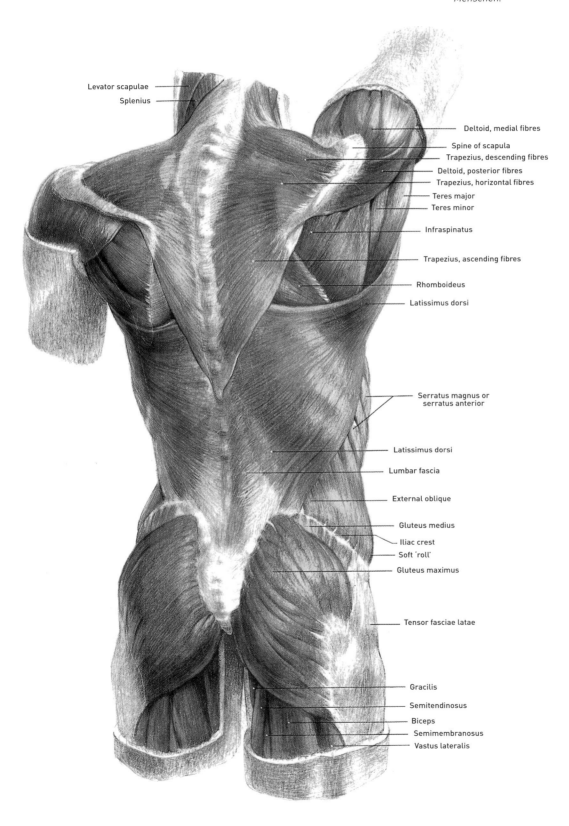

Levator scapulae

Splenius

Deltoid, medial fibres

Spine of scapula

Trapezius, descending fibres

Deltoid, posterior fibres

Trapezius, horizontal fibres

Teres major

Teres minor

Infraspinatus

Trapezius, ascending fibres

Rhomboideus

Latissimus dorsi

Serratus magnus or serratus anterior

Latissimus dorsi

Lumbar fascia

External oblique

Gluteus medius

Iliac crest

Soft 'roll'

Gluteus maximus

Tensor fasciae latae

Gracilis

Semitendinosus

Biceps

Semimembranosus

Vastus lateralis

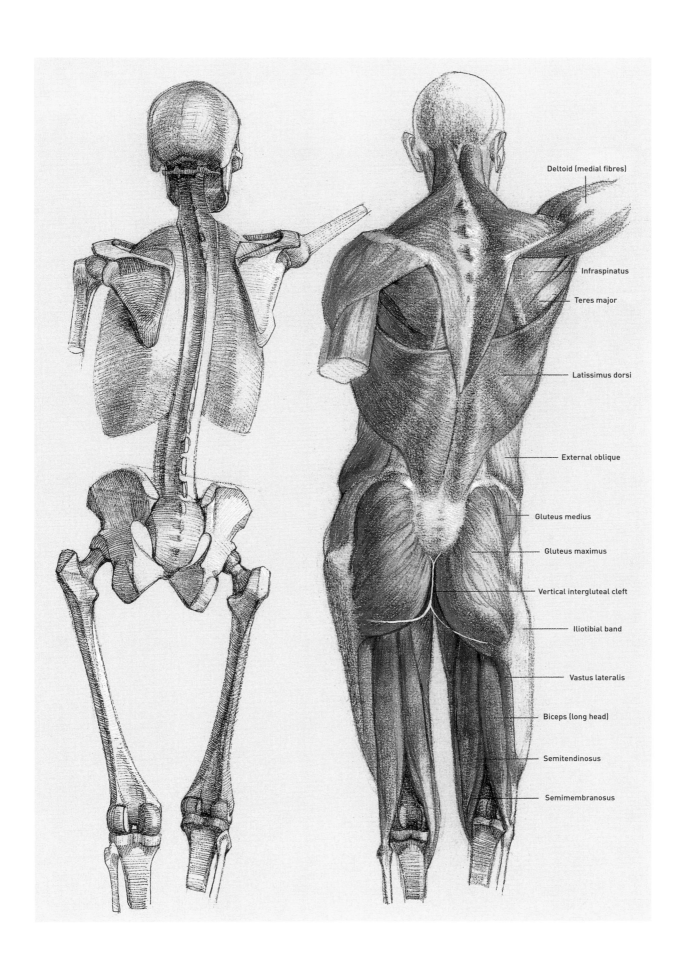

Deltoid (medial fibres)

Infraspinatus

Teres major

Latissimus dorsi

External oblique

Gluteus medius

Gluteus maximus

Vertical intergluteal cleft

Iliotibial band

Vastus lateralis

Biceps (long head)

Semitendinosus

Semimembranosus

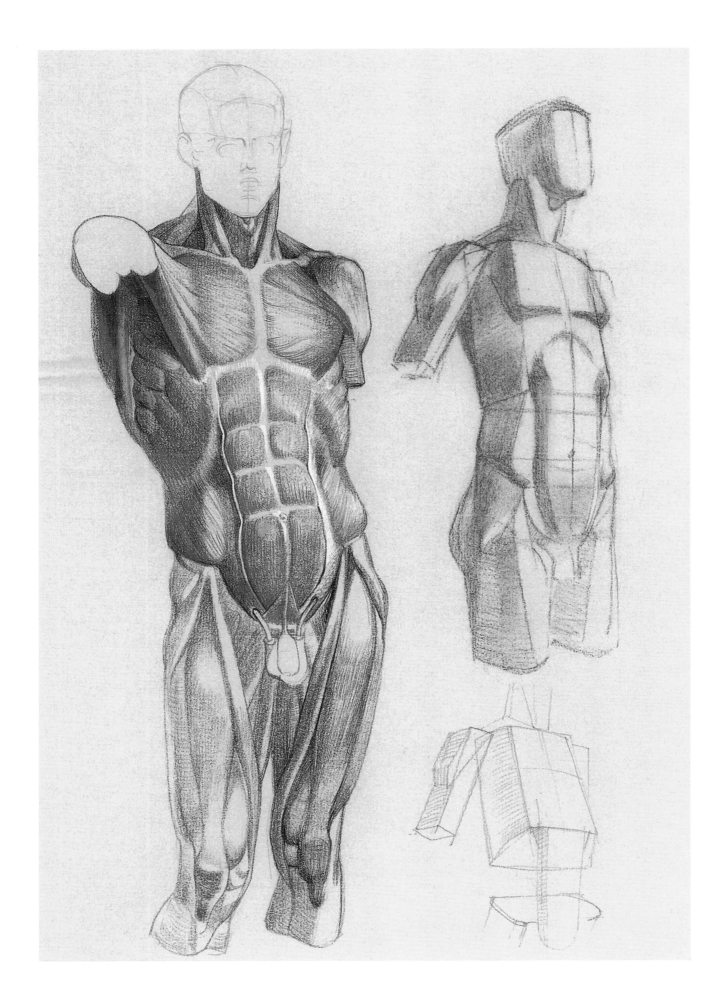

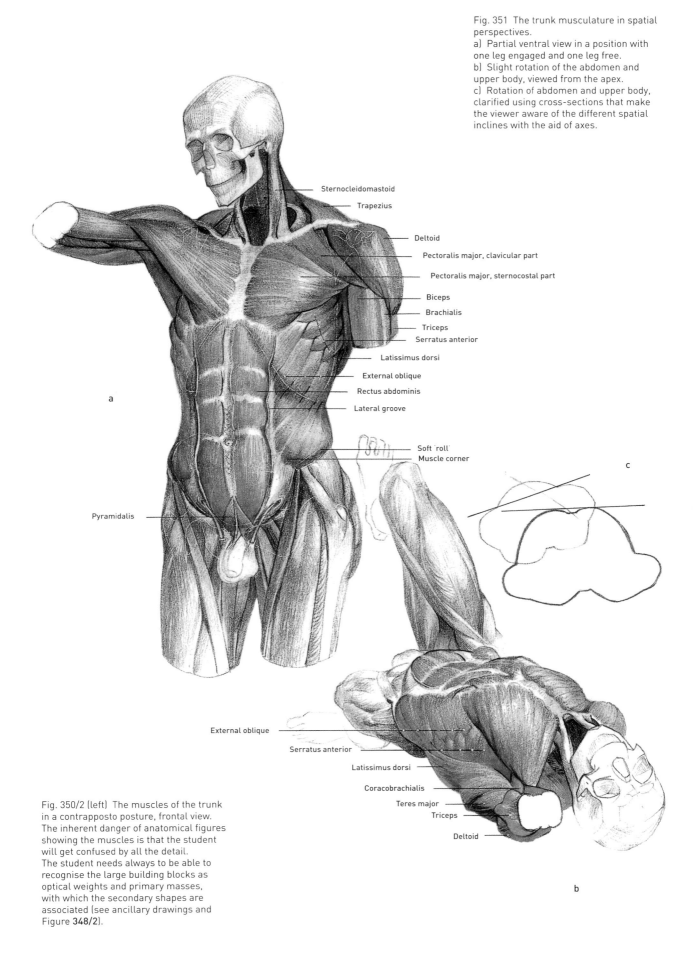

Fig. 351 The trunk musculature in spatial perspectives.
a) Partial ventral view in a position with one leg engaged and one leg free.
b) Slight rotation of the abdomen and upper body, viewed from the apex.
c) Rotation of abdomen and upper body, clarified using cross-sections that make the viewer aware of the different spatial inclines with the aid of axes.

Sternocleidomastoid

Trapezius

Deltoid

Pectoralis major, clavicular part

Pectoralis major, sternocostal part

Biceps

Brachialis

Triceps

Serratus anterior

Latissimus dorsi

External oblique

Rectus abdominis

Lateral groove

a

Soft 'roll'

Muscle corner

c

Pyramidalis

External oblique

Serratus anterior

Latissimus dorsi

Coracobrachialis

Teres major

Triceps

Deltoid

Fig. 350/2 (left) The muscles of the trunk in a contrapposto posture, frontal view. The inherent danger of anatomical figures showing the muscles is that the student will get confused by all the detail.
The student needs always to be able to recognise the large building blocks as optical weights and primary masses, with which the secondary shapes are associated (see ancillary drawings and Figure **348/2**).

b

The muscles of the trunk **327**

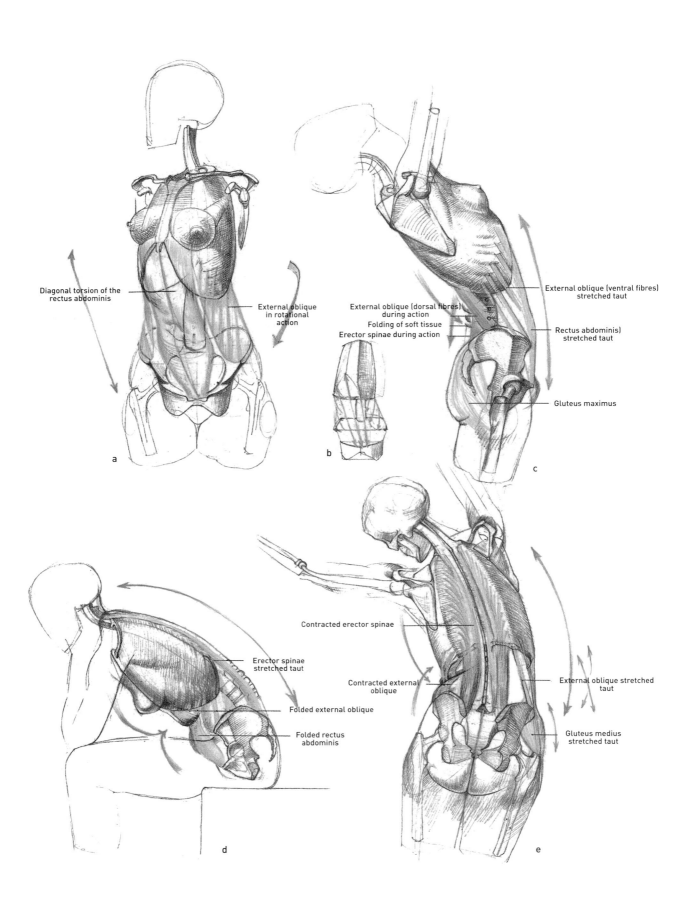

Diagonal torsion of the
rectus abdominis

External oblique
in rotational
action

a

External oblique (dorsal fibres)
during action
Folding of soft tissue
Erector spinae during action

b

External oblique (ventral fibres)
stretched taut

Rectus abdominis)
stretched taut

Gluteus maximus

c

Erector spinae
stretched taut

Folded external oblique

Folded rectus
abdominis

d

Contracted erector spinae

Contracted external
oblique

External oblique stretched
taut

Gluteus medius
stretched taut

e

Fig. 352 The laws governing the behaviour
of the shapes of the soft tissues of the
trunk during four basic movements.
a) Rotation of the rib cage against the
pelvis through torsion of the spine. Result:
spiral course of shapes in the ventral and
lateral abdominal walls.
b) Illustration with process broken down
into elements for greater emphasis.
c) Bending trunk backwards. Result:
shapes pushed together and skin folds in
lumbar region, the ventral abdominal wall
and portions of the lateral abdominal wall
are stretched. Breasts tilted upwards.
d) Bending trunk forwards. Result:
relaxation of ventral abdominal wall and
abdominal skin, with folding above the
navel, erector spinae stretched taut and
spinous processes protruding under the
skin, relaxation of the breasts.
e) Lateral flexion. Result: pushing
together of the lateral abdominal wall and
skin with deep fold. Erector spinae, lateral
abdominal wall and skin on opposite side
stretched taut.
The directions of the arrows indicate
folding and stretching.

7.3. THE LAWS GOVERNING THE BEHAVIOUR OF THE SHAPES OF THE SOFT TISSUES IN THE TRUNK

At this point, we must expand our focus and step back from the purely anatomical analyses so we can focus once more to a greater extent on the trunk as a whole, especially on the laws governing the behaviour of the shapes of the soft tissues, which include the skin, muscles and, in the female body, deposits of fat and the breasts. The behaviour of the soft tissues in the trunk deserves our attention as it differs in many ways from the behaviour in the extremities. The greater looseness and thus more easily influenced plastic appearance, namely, of the pure trunk muscles, is based mainly on the fact that these muscles span greater distances between the pelvis and rib cage, in contrast to the bony stabilisation provided by the lever arms in the extremities. The spine, alone, on the dorsal side of the trunk, gives these muscles the opportunity of direct 'roots' as it is the only bony connecting bridge. The laws governing the plastic appearance are found in relation to all basic movements of the trunk through reduction in the distance between the pelvis and rib cage, or their rotation. The soft tissues must essentially react to these changes between their origins and insertions through either being stretched taut or folded. This means that the changes in positional relationships between the pelvis and rib cage automatically result in far more radical plastic changes in shape and course of the muscles than, for example, in the muscles of the upper and lower legs and arms. In contrast to other parts of the body, the many flat muscle plates on the trunk must have a far greater capacity for receding and folding. Based on a few fundamental movements, we would now like to investigate these issues, not least with a view to gaining the ability of predicting the expected basic plastic characteristics using our functional mental imagery. What must happen based on a set pattern when...?

First question: What will happen when the pelvis and the rib cage are no longer in one plane, but are twisted against each other due to rotation of the spine through its vertical axis (torsion), when the pelvis is turned towards us, but the rib cage is turned away from us [349 bottom right and middle, 353, 354]? What this means for the skeleton: the final point in the symmetry axis through the rib cage, the xiphoid process, is no longer vertically positioned over the pubic symphysis, but laterally rotated; the flanks of the rib cage are no longer positioned over the iliac crest. Consequences for the ventral and lateral abdominal wall and for the skin: all components reflect a screw-like, twisted shape. Above its attachment to its base, the midline of the body (linea alba of the rectus abdominis) must follow the xiphoid process that has been averted and move in a lateral direction in a long, spiral-shaped torsion. The lateral abdominal wall, the origin of the rotation, moves more strongly into the frontal view (vertical course of its muscle fibres), while the other side withdraws more

strongly from view. The skin, as mere drapery, allows us to deduce both the longer or shorter ventral and dorsal diagonal folds, especially in the region of the navel and the back of the rib cage. The breasts are barely affected by these processes as they are not in contact with either the rectus abdominis or the external oblique [352a, b].

Second question: What will happen if the trunk is bent backwards and the arms are simultaneously raised vertically [311, 349 middle right]? What this means for the skeleton, the two plastic cores, the pelvis and rib cage, and the spine: the extension of the back results in a substantial increase in the lateral and frontal distance between the rib cage and pelvis (iliac blades and pubis). Consequences for the ventral and lateral abdominal walls: the ventral abdominal wall (rectus abdominis and the most anterior portions of the external oblique) are subject to strong tension through stretching, as a result of which the sagittal distance between the stomach and back decreases

greatly (lateral view). The elevation of the rib cage causes the rectus abdominis to be stretched taut into a more narrow strip, the taut, stretched lateral abdominal wall recedes inwards (greater indentation of the waist) and the anterior and lateral borders of the rib cage are sharply offset from the shapes with soft tissue [355, 356]. The skin reflects the stretched muscles, the midline of the rectus abdominis becomes deeper, the navel – generally a transverse oval cavity at rest – is distorted into a long vertical groove. The fat pad below the navel is flattened and elongated. On the back, the distance is reduced between the masses formed by the erector spinae and the skin, resulting in folding that – depending on the consistency of the skin – produces transverse folds. The breasts follow the vertically raised arms, become flatter, the nipples rise upwards, the dome of the breast loses the skin fold that otherwise forms its lower border. These circumstances can be explained by the fact that the connective tissue

Fig. 353 The laws governing the behaviour of the shapes of the soft tissues in the trunk during rotation.
a) Torsion of the thoracic portion of the spine moves the rib cage into a different plane compared with the pelvis. This twisting causes diagonal folds in the skin on the back, which are sometimes even more prominent than shown here.

b) The front of the body also reveals these 'torsions' in the skin and muscles when the pelvis is fixed and the rib cage rotated over it. The vertical groove in the ventral abdominal wall (linea alba) follows a course from the pubis to its next point of attachment at the xiphoid process, running 'diagonally'.

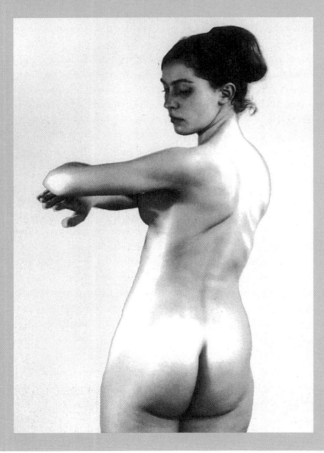
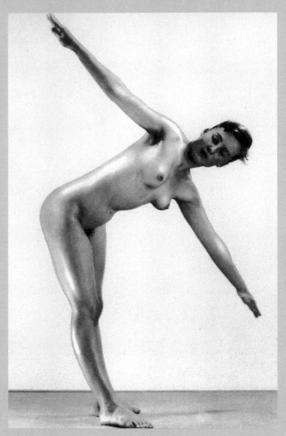

of the breasts is closely linked to the pectoralis major and any movement of the arm to above the horizontal requires the breasts to follow the movement of this muscle [352c]. Third question: What will happen when the trunk is bent forwards like it would be when leaning forwards in a seated position? The distance is reduced between the two plastic cores, pelvis and rib cage, particularly on the ventral side and partially also laterally [150, 320, 349 middle, 352d, 357, 358]. The significant buckling of the ventral abdominal wall and the associated substantial excess of skin mass can only be compensated for by deep transverse infolding and subsequent bulging outwards. The deepest skin fold is always found just above the navel, while the stretch between the navel and the pubis is folded no further, or only in a very minor and superficial manner [202a, b]. The fat pad below the navel sticks out in the shape of a barrel. The greater the horizontal inclination of the rib cage, the more the breasts are subject to gravitational force, dissociating themselves from the rib cage and dangling downwards in the shape of drops. In contrast, the muscles and the skin on the dorsal side undergo such strong tension due to extension, that the bulge of the erector spinae is strongly flattened and the spinous processes in the region of the lumbar spine are visible in the form of a series of humps.

Fourth question: What will happen when the trunk undergoes lateral flexion? The two vessels, pelvis and rib cage, must move closer to each other on one side and further away from each other on the opposite side, irrespective of whether standing, seated or lying down. The distance between the two can be reduced such that the last floating rib comes into contact with the iliac crest. Consequences for the abdominal wall: the abdominal wall is folded inwards in a deep fold between the rib cage and the pelvic wall on the folded side. Bulges are formed above and below. The opposite side is characterised by tension due to stretching of

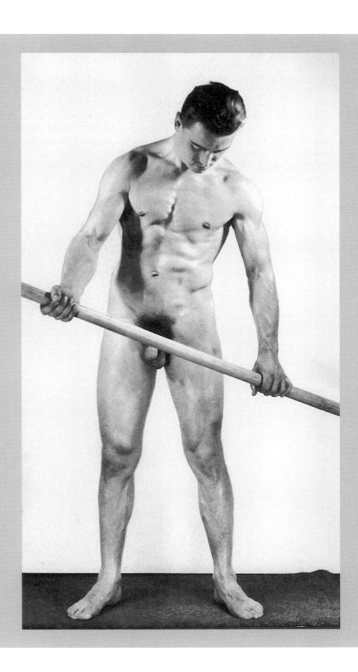

Fig. 354 The spiral features of the ventral and lateral abdominal wall during rotation of the upper body.
The male model is exerting pressure against the pole through rotation of his upper body, whereby all muscle fibre orientations in the abdominal wall are tensed in a diagonal direction and appear in the form of an oblique structure.

The muscles of the trunk **331**

the muscles and skin. The rib cage and pelvic margin are pronounced and the waist appears drawn inwards. At the front, the course of the axis through the breasts also changes. This axis will no longer run parallel to the axis of the clavicle, but logically converge with it on the side that is flexed, as the rib cage is not just repositioned like a rigid object during lateral flexion, but changes its shape in this process: the ribs are pushed together on the flexed side and spread further apart on the extended side. The flanks are therefore of different lengths [349 middle left, 352e].

With reference to artistic studies, this behaviour of the soft tissue masses with regard to function and shape is usually viewed as a welcome enrichment in motifs, usually for the combination of one basic movement with another. There are numerous modifications for standing, sitting and lying down or for movements associated with a change in location. However, the essence of the functional behaviour of the soft tissue masses can always be reduced to the different forms and degrees of tension and relaxation.

The anatomical issues illustrated up to this point have by no means achieved a complete discussion of the peculiarities pertaining to the plastic appearance of the torso or trunk. To reach this point, we must first have looked into a further chapter, on the upper extremity. This is because the basis for the freely swinging arms, the shoulder girdle and the muscles that originate from and insert into it, is intrinsically associated with the plastic appearance of the trunk. Only once these have been explained, can we resume and finalise the discussion we have started here in sections 8.7 and 8.8, by examining the architectural shape of the trunk, its relationships and functions.

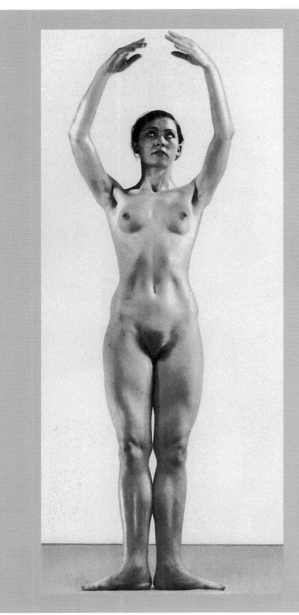

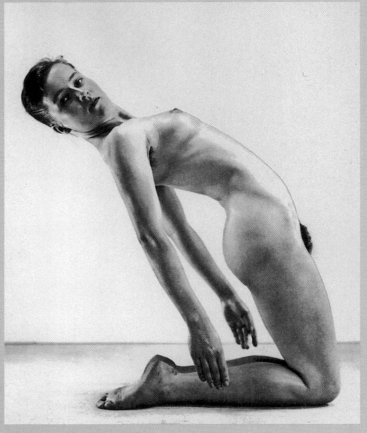

Fig. 355 The behaviour of the ventral and lateral abdominal wall during simple movement of the upper body into an upright position. The circumstance, alone, of raising the arms results in the rib cage also being raised, thus increasing the distance between the margins of the rib cage and pelvis. The abdominal wall is stretched, its vertical and lateral grooves become deeper and the navel is elongated.
As the lateral abdominal wall is also involved in the extension of the shapes of the soft tissues, this manifests in a deeper waist. The breasts are clearly affected by the tension in the pectoralis major and are raised upwards by this muscle.

Summary:

1. The muscles of the trunk bridge the gap between the bony cavities formed by the rib cage and the pelvis, change their positions relative to each other, are involved in breathing and carry out the stomach crunch.
2. They fully incorporate the spine and are responsible for its posture and position during movement. Ventral and dorsal muscles act as antagonists.
3. The ventral and lateral abdominal walls are formed by:
 the rectus abdominis
 the external oblique
 (the internal oblique, only depicted)
 (the transversus, only depicted)
 (the pyramidalis, only depicted).
 Their orientations complement each other.
4. A resilient, elastic reticulated muscular framework is produced through the mutual overlapping and underlapping, the amalgamation of which is also continued in the courses of the fibres in the rectus abdominis sheath.
5. The structure of the back muscles is highly complex. The actual extensors of the back are in the deep muscle layer. The lateral strand of the deep back muscles is of greater relevance to the plastic appearance, formed of the iliocostalis and the longissimus dorsi.
6. The diagonal, downwards orientation of the ribs allows them to be raised and to thus enlarge the volume of the rib cage (inhalation). Conversely, lowering of the ribs reduces the volume of the rib cage (exhalation).

Fig. 356 (opposite, right) Behaviour of the abdominal wall and breasts when the upper body is bent backwards.
The ventral and some parts of the lateral abdominal walls are stretched and under tension as the pelvis and rib cage move away from each other, while they move closer to each other dorsally. Due to this, the ventral abdominal wall becomes taut from the anterior superior iliac spine and pubis upwards, while folding occurs of skin and muscles in the lumbar region. Flattening of the breasts is due to their increasing horizontal position on the one hand, and, on the other, due to the traction of the pectoralis major when the arms are stretched backwards behind the body.

Fig. 357 The behaviour of the abdominal wall when seated and leaning forwards. As the anterior borders of the pelvis and rib cage move closer to each other when seated and leaning forwards, there is excess skin and muscle tissue just above the navel, especially in the ventral abdominal wall, which produces deep folds, while the abdominal wall between the navel and pubis bulges outwards.

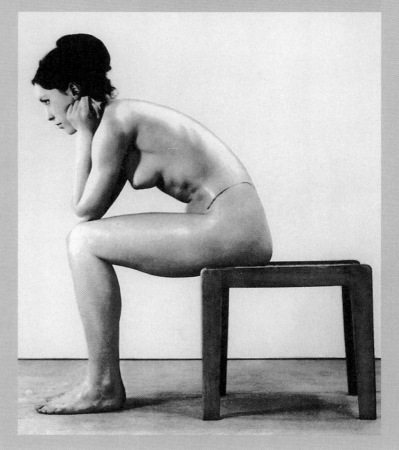

7. We distinguish between two forms of respiration:
 a) chest or rib respiration (increase and reduction of the volume of the rib cage through movement of the ribs).
 b) diaphragm or abdominal respiration (increase and reduction of the volume of the rib cage through raising and lowering of the diaphragm).
8. The diaphragm is a thin, dome-like muscle that separates the chest and abdominal cavities. It contracts during inhalation, thus flattening, increases the chest cavity in a caudal direction and presses on the viscera, which pushes the abdominal wall outwards.
9. When the diaphragm relaxes (highest level during exhalation), the abdominal wall pushes the viscera upwards from below. The bulge in the abdominal wall disappears. The diaphragm and abdominal wall act as antagonists.
10. The changes in the positional relationships between the pelvis and rib cage have huge implications for the behaviour of the parts of the body with soft tissue (muscles, skin, fat pads, breasts) and the plastic appearance.
11. Torsions between the pelvis and rib cage produce spiral distortions of the muscles and skin. Reductions in the distance between the pelvis and the rib cage are associated with an increase in distance on the opposite side.
12. This results in contrasting plastic changes in shape: tension and relaxation of soft tissue always occur simultaneously and enrich the nude model as an object of study.

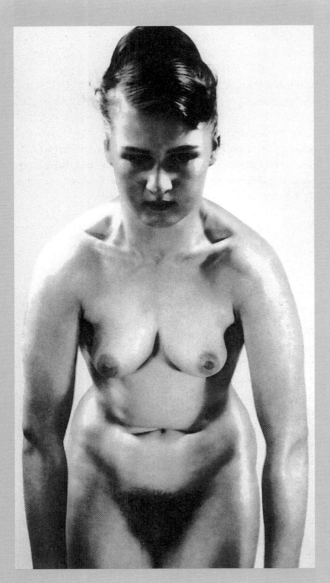

Fig. 358 The behaviour of the abdominal wall and breasts when the trunk is bent forwards.
The decrease in the distance between the ventral borders of the rib cage and the pelvis favours both protrusion of the upper body and the lower abdomen. These are separated by the deep fold just above the navel. The shape of the cavities that are thus created should not be neglected by the artist, any more than the supraclavicular and infraclavicular fossas. The bending forwards of the upper body also has an effect on the appearance of the breasts, which are now shaped more by their own weight.

8 The upper extremities

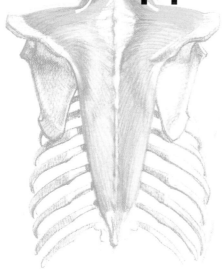

Fig. 359 The construction of the arm.
Solid red line: common rotational axis for the upper arm in the shoulder joint and for the radius in the elbow joint
Dotted red line: course of the axis through the upper arm and the axis through the shaft of the ulna, which together form the carrying angle.

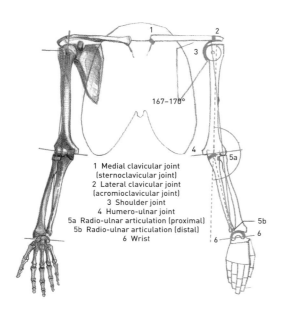

167–170°

1 Medial clavicular joint
(sternoclavicular joint)
2 Lateral clavicular joint
(acromioclavicular joint)
3 Shoulder joint
4 Humero-ulnar joint
5a Radio-ulnar articulation (proximal)
5b Radio-ulnar articulation (distal)
6 Wrist

8.1. GENERAL INFORMATION ON THE FORELIMB IN ANIMALS AND THE UPPER EXTREMITIES IN HUMANS

In quadrupedal mammals, the forelimbs almost exclusively act to support the body and transfer propulsion from the hindlimbs. The extent to which uniformity can be achieved in the associated structural properties in the anterior and posterior feet is demonstrated in the ungulates, as the most extreme case. The great apes exhibit the greatest similarities to human upper extremities. However, the forelimbs in apes are also mainly used for locomotion. The organisation of the sections is the same in humans and quadrupedal mammals. The following sequence is found from the trunk towards the periphery: shoulder girdle–upper arm–lower arm–hand (or foot). The number of bones involved in the structure of the terminal section of the extremity varies greatly and differs with increasing distance from the body.

Freed from its weight-bearing function, the upper extremities in humans acquired entirely new abilities. The process of activity created a universal working instrument that simultaneously became refined as a product of this activity. A complete change in appearance occurred due to the constant interactions between the individual parts of the body, their isolated movements, and other underlying conditions which are still to be understood. From the forelimbs emerged the upper extremities in humans today.

8.2. THE CONSTRUCTION OF THE ARM AND THE ARRANGEMENT OF ITS JOINTS

The bony base for the arm is the open-work, dorsal, highly mobile shoulder girdle with the clavicle (clavicula) and shoulder blade (scapula). The bone in the upper arm (humerus) is suspended freely from the shoulder girdle, continued by the two bones in the lower arm (ulna and radius). The hand (manus) is connected to this. Similar to the leg, the arm (extended, palm facing forwards) possesses a continuous imaginary axis through the middle of the humeral head, the lateral epicondyle of the humerus and the head of the radius, down to the ulnar head (common rotational

Fig. 360 The sequence of joints (basic shapes) in the construction of the arm and their axes (enlarged illustration).
a) Entire arm, its angling and common rotational axis associated with rotation of the radius (solid red line).
b) Shoulder joint with the transverse axis for anteversion and retroversion of the upper arm.
c) Wrist with the first row of carpal bones and their transverse axis for flexion and extension in the distal articulation of the wrist.
d) Proximal and distal radio-ulnar joint with the rotational axis for supination and pronation of the hand.

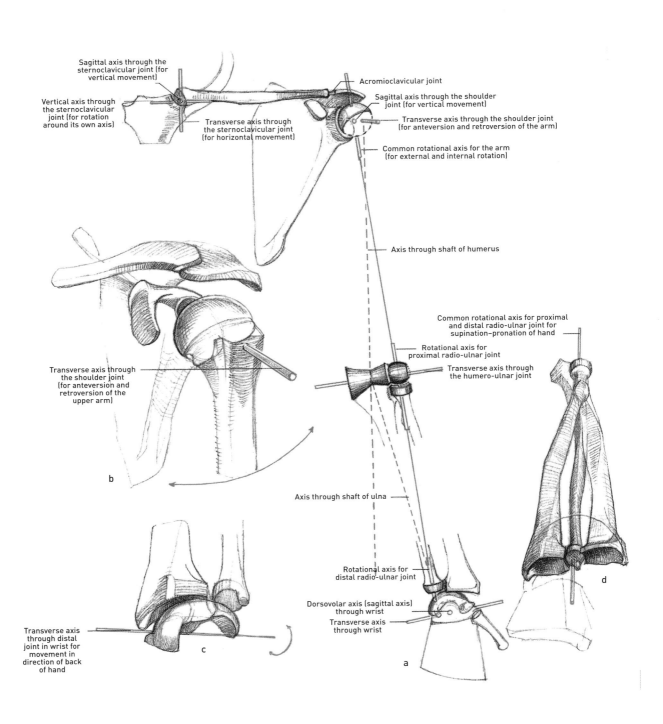

axis for the upper arm and the rotating movement in the hand) [360d]. The ulna is angled against the upper arm (carrying angle) as a result of the transverse axis through the trochlea of the humerus not being at a right angle to its shaft. The carrying angle is usually more pronounced in females. The arm is constructed to allow universal use of the hand. The number and alignment of the joints underlines this [359]:

1. Sternoclavicular joint (similar to ball-and-socket joint) [359, 360a]
2. Acromioclavicular joint (similar to ball-and-socket joint) [359, 360a]
3. Shoulder joint (ball-and-socket joint with three basic axes) [359, 361]
4. Humero-ulnar joint (hinge joint with one transverse axis) [361]
5. Proximal and distal radio-ulnar joint (rotational joint with one vertical axis – common rotational joint for the arm) [360a]
6. Wrist joint (ellipsoid joint with sagittal and transverse axis) [360a, 361].

This results in the following possible movements:

1. Shoulder joint:
 transverse axis: anteversion and retroversion
 sagittal axis: abduction and adduction
 certical axis: internal and external rotation of the arm.
2. Elbow joint (combination joint with three partial joints):
Transverse axis through the humero-ulnar joint:
 flexion–extension [361]
 Vertical axis through the radio-ulnar joint:
 supination–pronation of the hand [360a].
3. Wrist joint:
 Transverse axis: flexion–extension (volar flexion–dorsiflexion) [360a, 361]
 Sagittal axis: radial and ulnar abduction.

The main masses of the most powerful muscles are seated close to the trunk, as is the case for the leg. The periphery is only reached by weak muscles or by long tendons.

The spatial orientation of the three transverse axes in the freely mobile pendulum that is formed by the arm is of equal importance to those in the leg for studies for drawing and sculpture [361].

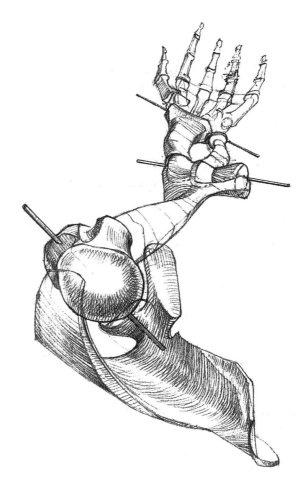

Fig. 361 The transverse axes in the arm. The helical course of the axes relative to each other is of equal importance as in the skeleton of the leg with regard to the plastic definition of the points where the joints are located in the skeleton. View from above. Ancillary drawing: view from above of the shoulder girdle in a model.

8.3. THE SHOULDER GIRDLE

8.3.1. Function, construction, components and structure [362–366]

The bony ring that is mobile and open at the back allows suspension of the free swinging pendulum formed by the arm (supported by the rib cage) and rough adjustments for use of the hand. This ring is only in bony contact with the skeleton of the trunk at one specific point (sternoclavicular joint). Muscle forces regulate the position of the swivelling platform for the arm.

The clavicle (clavicula) is an S-shaped, curved rod, the lateral, flattened end of which touches the spine of the scapula [362, 364, 365]. The two jointly form the protective roof of the shoulder for the head of the humerus and articulate with each other (acromioclavicular joint – Articulatio acromioclavicularis). The clavicle articulates with a notch in the manubrium, which forms the sternoclavicular joint (Articulatio sternoclavicularis). The length of the clavicle determines the width of the upper body. The shoulder blade (scapula) is a large, triangular bony plate with a framework construction (strengthened margins), the function of which is to form a small, flat socket for the head of the humerus and to serve as an origin and insertion point for numerous muscles, thanks to its large area [363–365]. A raised portion of bone that originates from the medial border of the shoulder blade becomes more and more pronounced, forming the spine of the scapula (spina scapulae), finally breaking free from its flat substrate and curving forwards to meet the clavicle (for further detail and terminology, see Figure 363). The shoulder girdle is highly variable in its plastic appearance and surrounds the dome-like structure formed by the rib cage, without fully obscuring it as the plastic core of the upper body.

Fig. 362 (right) Clavicle.
a) Anterior view: its shape is elongated.
b) Cranial view: it has a curved S-shape.

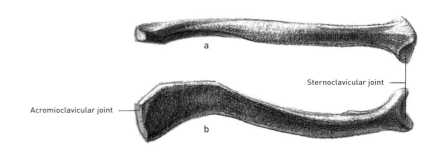

Fig. 363 (below) Scapula.
a) Dorsal view.
b) Medial view.

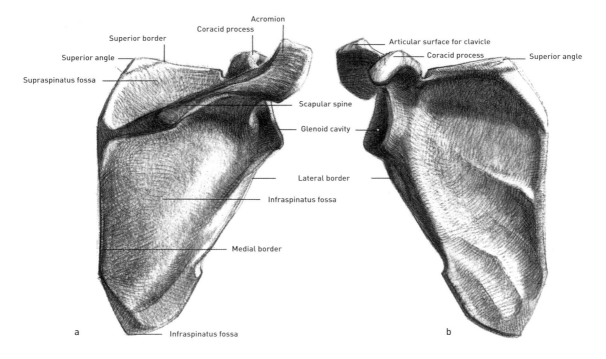

Fig. 364 The right shoulder girdle.
a) Partial posterior and medial view.
b) Spine of scapula and clavicle in contact at rest.
c) Functional principle governing the behaviour of the
acromion during raising and lowering movements in the
acromioclavicular joint.

d) Raising of the shoulder girdle with unrealistic
detachment of the tip of the scapula from the trunk to
demonstrate the function of the acromioclavicular joint
(dorsal view), in phases.
e) Raised shoulder girdle with realistic behaviour of the
acromioclavicular joint (see also c), view from the plane
through the middle of the body).

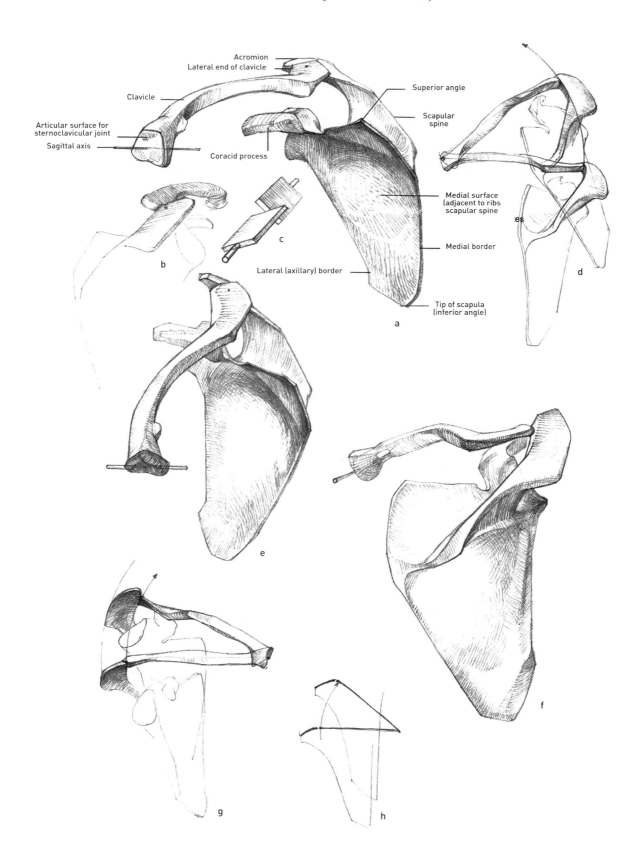

Acromion
Lateral end of clavicle
Clavicle
Articular surface for
sternoclavicular joint
Sagittal axis
Coracid process
Superior angle
Scapular
spine
Medial surface
(adjacent to ribs
scapular spine
Medial border
Lateral (axillary) border
Tip of scapula
(inferior angle)
a
b
c
d
e
f
g
h

Fig. 365 Left and right shoulder girdles in a realistic relationship to each other.
a) Partial posterior lateral view. In particular, note the point-like connection between the clavicle and the manubrium!
b) First cervical vertebra in detail.
c) Cranial view of the shoulder girdle and its relationship to the heart-shaped cranial opening of the rib cage.

Fig. 366 (opposite) Transitional views of the natural and constructional shape of the shoulder girdle.
a) Anterior and slightly lateral view.
b) Identical to **a** with emphasis on the Baroque 'facade', through which the dome of the rib cage penetrates in a cranial direction.
c) Identical architectural problem as in **b**, but partial frontal view, not abstract.
d) Identical architectural problem in partial posterior view and more of a cranial perspective.
c) Realistic illustration in partial left posterior view.
f) Realistic illustration in partial left anterior view and strong cranial perspective.

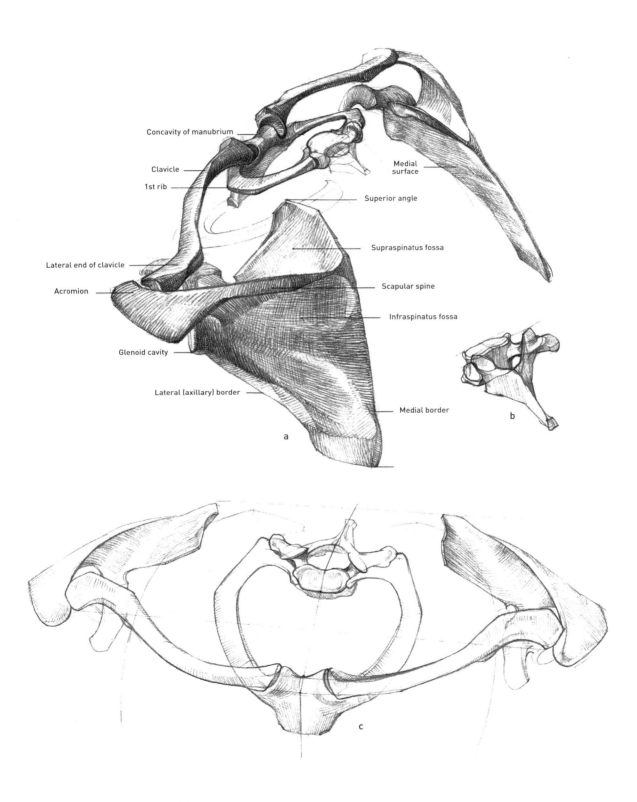

Concavity of manubrium

Clavicle

1st rib

Lateral end of clavicle

Acromion

Glenoid cavity

Lateral (axillary) border

Medial surface

Superior angle

Supraspinatus fossa

Scapular spine

Infraspinatus fossa

Medial border

a

b

c

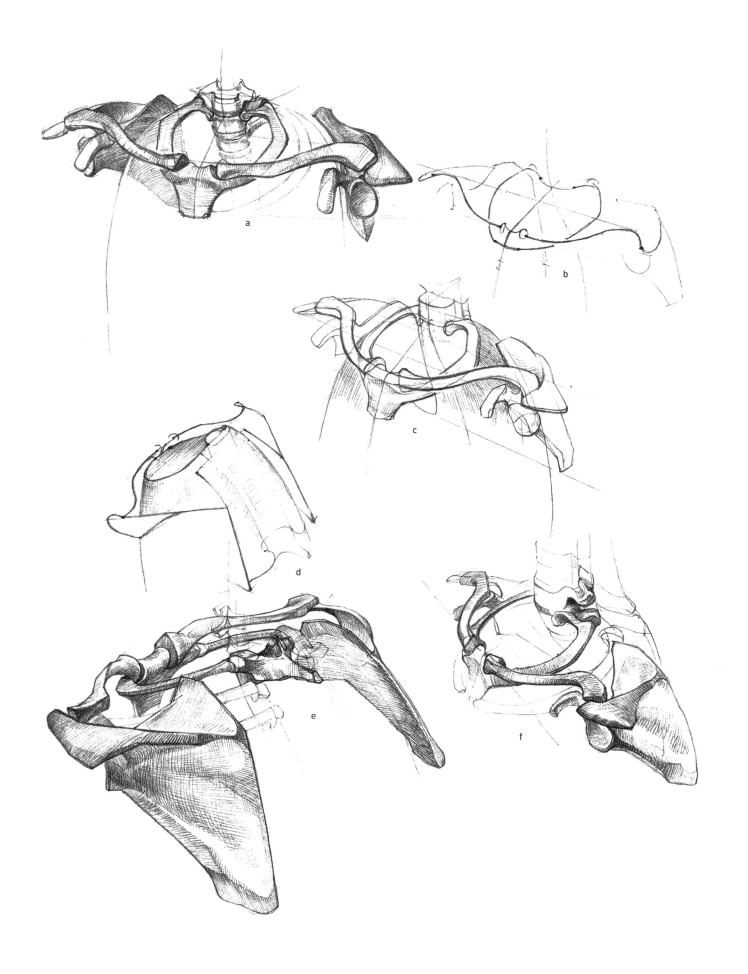

a

b

c

d

e

f

8.3.2. The mechanics of the shoulder girdle and its changes in plastic appearance [367–379]

The acromioclavicular joint compensates for the movements in the sternoclavicular joint. For example, if the scapula and clavicle were rigidly attached to each other, then the scapula would be pulled away from the body when the clavicle was pulled upwards. The crucial component here is the sternoclavicular joint, which permits vertical and horizontal displacement of the scapula and allows the glenoid cavity to be rotated upwards [364, 369, 379]. This involves the inferior angle of the scapula moving round the wall of the rib cage. This is required to allow the arm to move above the horizontal position, into a vertical position. The reason for the comprehensive mechanical processes is to significantly expand the range of movements in the arm and to adjust the scapula in the same plane of movement that the arm is moved into. The glenoid cavity forms its abutment (e.g. important for resting arms on a surface) [372]. Pulling the shoulder girdle upwards shortens the neck; deep folds are created in the skin along the spine when the shoulder blades are drawn together [374a]; arms crossed in front of the chest [378, 379] pull the shoulder blades round to the flanks of the rib cage and thus lead to a rounded back [371, 372, 373b].

Summary:

1. The upper extremities include the shoulder girdle and the free arms.
2. Its release from its weight-bearing function has permitted the development of the arm and hand into an organ for all-round use.
3. The shoulder girdle, composed of the clavicle and scapula, is a mobile bony ring that is open at the back and significantly increases the range of movement for the arm.
4. The differentiated movements in the upper extremities are controlled by over double the number of joints when compared with the leg:
 a) via the medial clavicular joint (sternoclavicular joint) [364a]
 b) via the lateral clavicular joint (acromioclavicular joint) [364a]
 c) via the shoulder joint [360a, b]
 d) via the humero-ulnar joint [360a]
 e) via the proximal and distal radio-ulnar joints [360c]
 f) via the wrist [360c].

Fig. 367 The adjustment of the scapula in the direction of movement of the arm.
a) Moving the arm sideways and horizontally.
b) Raising the arm vertically.
c) Area of movement of scapula over the flank of the rib cage (grey colouration).

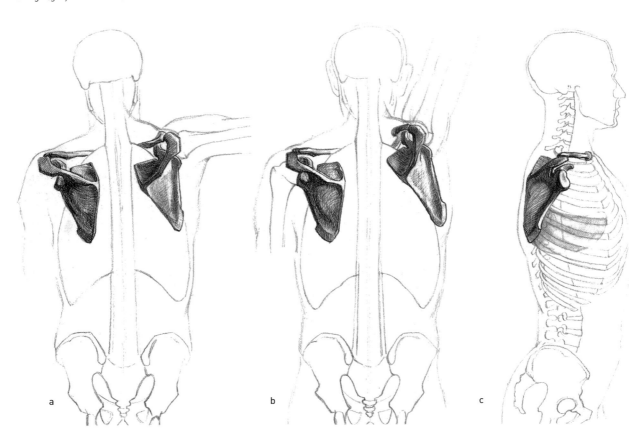

a b c

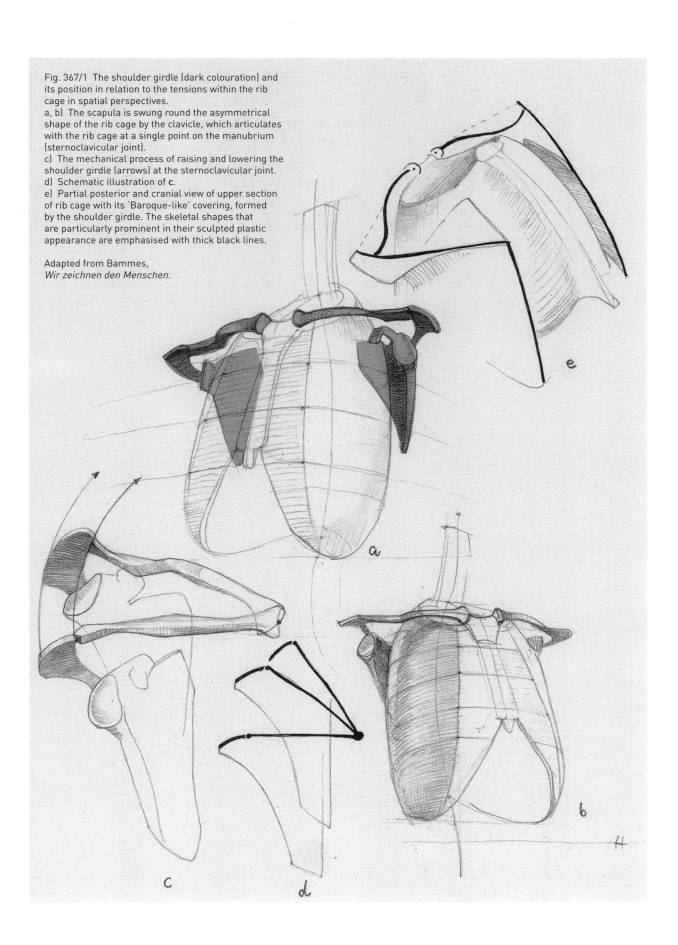

Fig. 367/1 The shoulder girdle (dark colouration) and its position in relation to the tensions within the rib cage in spatial perspectives.

a, b) The scapula is swung round the asymmetrical shape of the rib cage by the clavicle, which articulates with the rib cage at a single point on the manubrium (sternoclavicular joint).

c) The mechanical process of raising and lowering the shoulder girdle (arrows) at the sternoclavicular joint.

d) Schematic illustration of c.

e) Partial posterior and cranial view of upper section of rib cage with its 'Baroque-like' covering, formed by the shoulder girdle. The skeletal shapes that are particularly prominent in their sculpted plastic appearance are emphasised with thick black lines.

Adapted from Bammes,
Wir zeichnen den Menschen.

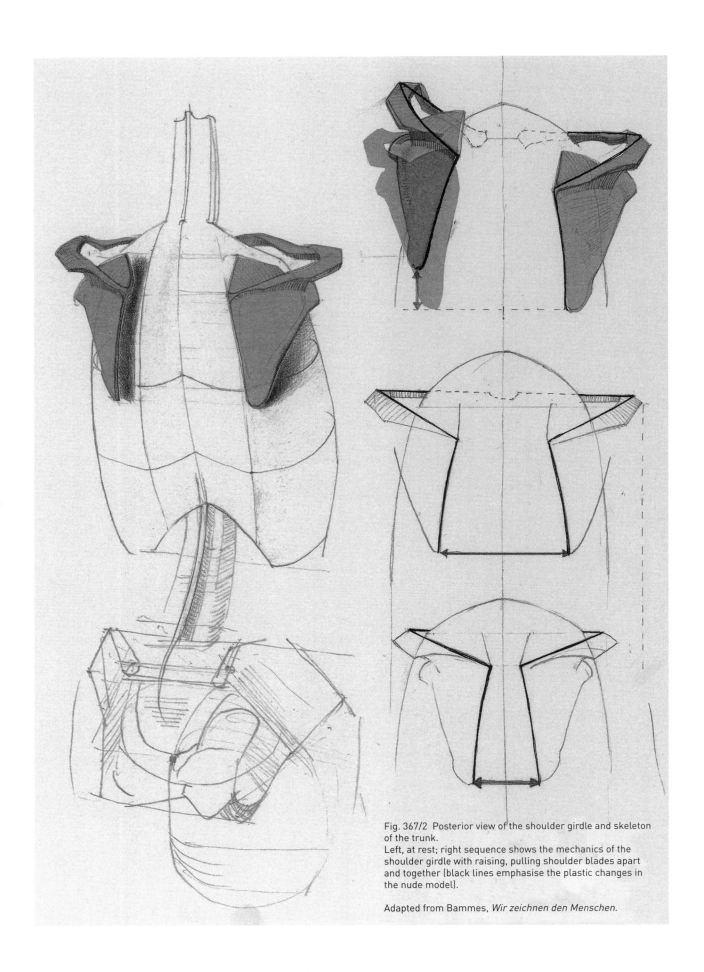

Fig. 367/2 Posterior view of the shoulder girdle and skeleton of the trunk.
Left, at rest; right sequence shows the mechanics of the shoulder girdle with raising, pulling shoulder blades apart and together (black lines emphasise the plastic changes in the nude model).

Adapted from Bammes, *Wir zeichnen den Menschen*.

5. The clavicle forms the only bony connection to the rib cage, pushes the free extremity away from the trunk, swings the arm around the thorax [367/1a, 367/2] and counteracts any compressive loads transferred to the body via the stretched arm.
6. The flat bony scapula serves as an area of origin and insertion for numerous muscles, creates the connection to the arm via the shoulder joint, acts as an abutment for the arm and shifts in accordance with its direction of action, and fulfils a protective function.

7. The joints of the shoulder girdle are the medial and lateral clavicular joints that work together [367/1].
8. The mechanics of the shoulder girdle permit basic movements in vertical and horizontal directions and rotation.
9. The arm can only be raised as far as the horizontal position in the shoulder joint. The glenoid cavity must be rotated upwards to allow the arm to move further into a vertical position [367b].

Fig. 368 Position of the shoulder girdle at rest. The parallel positioning of the medial borders of the shoulder blades and the spine and the overriding importance of the shoulder blades to the plastic appearance of the upper back are of note here.

Fig. 369 The diagonal positioning of the shoulder blades when the arm is raised vertically. Vertical raising of the arm to above the horizontal position is only possible through involvement of the scapula, whereby its glenoid cavity is rotated upwards to support this movement and its tip migrates in an anterior direction. This causes clear diagonal alignment of the medial border of the scapula. Note the characteristic fold in the muscle and skin around the roof of the shoulder.

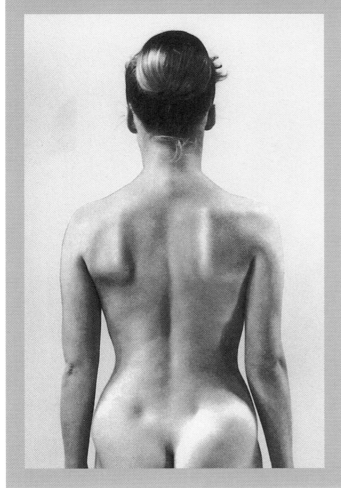

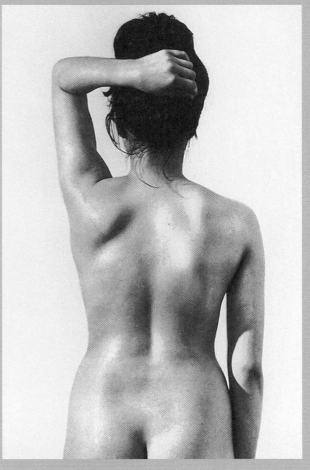

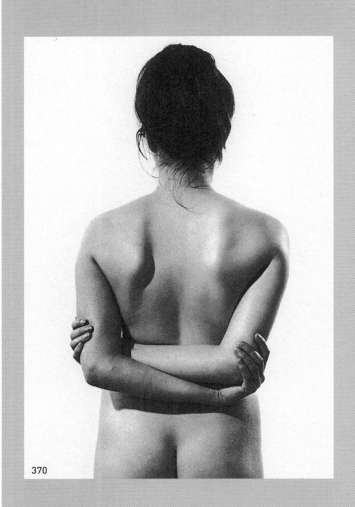

370

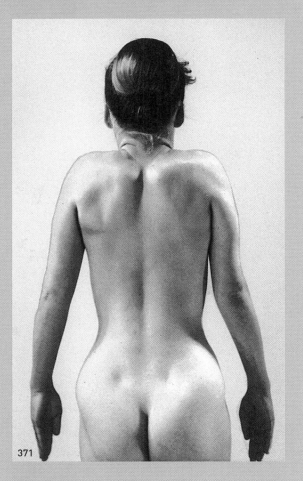

371

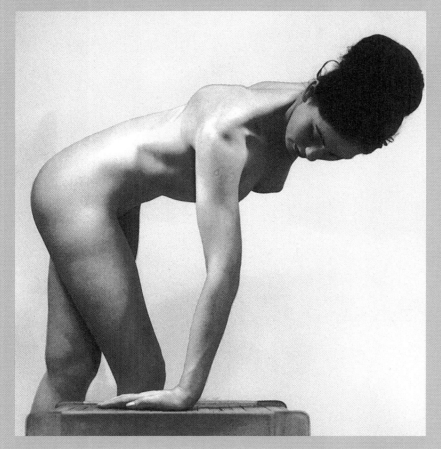

Fig. 370 The position of the shoulder blades when the arms are crossed behind the body.
The tip of the left shoulder blade exhibits a tendency towards being pulled off its substrate. The medial borders of the shoulder blades are parallel.

Fig. 371 Shoulder girdle pulled upwards. The vertical raising of the shoulder blades is associated with an apparent shortening in the length of the neck and increasing parallel contours in the upper body.

Fig. 372 Natural hyperextension in the female arm.
In contrast to the male arm, the female arm can often be slightly hyper extended at the humero-ulnar joint, especially in the young. Normal extension is 150–160°. Note the position of the shoulder blade in this image, which has moved its glenoid cavity behind the line of force exerted by the arm, in order to absorb the compressive load.

Fig. 373 The behaviour of the shoulder blades during horizontal movement of the arms.
a) Moving forwards of the shoulder blades as a result of crossing the arms in front of the body: the two medial borders of the shoulder blades distance themselves from each other as far as possible, as the shoulder blades follow the direction of the arms through to the flanks of the rib cage. This causes the curvature of the back of the rib cage to be almost fully exposed.
b) The shoulder blades are moved into the same plane as the horizontally outstretched arms through contraction of the horizontal fibres of the trapezius, whereby the two medial borders of the shoulder blades are moved very close together, with sharp vertical folding of the skin over the spine.

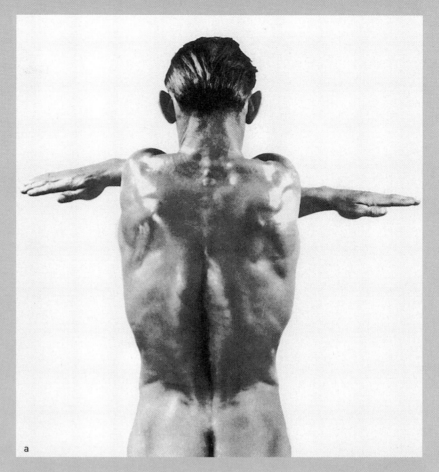

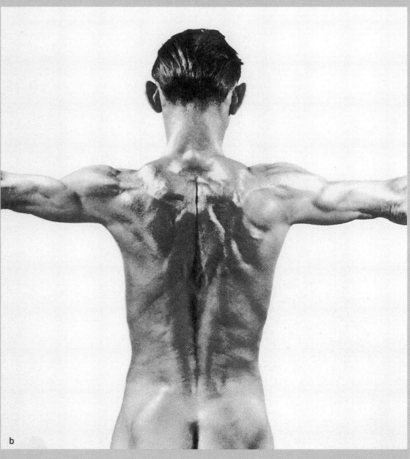

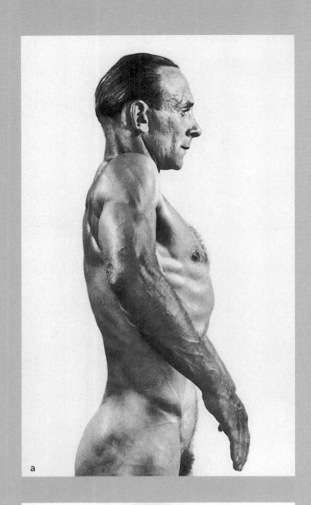

a

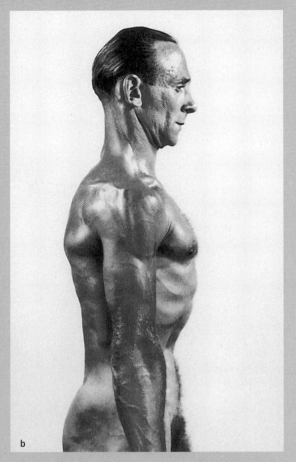

b

Fig. 374 The vertical movements of the shoulder girdle.
a) Raising of the clavicle from a horizontal position amounts to about 30°.
b) Lowering generally occurs as far as the horizontal line through the clavicle.

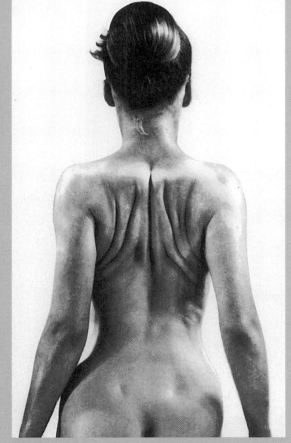

Fig. 375 The shoulder blades pulled together horizontally and backwards. The deep muscle and skin folds are produced through contraction of the horizontal fibres of the trapezius, which strongly pulls the medial borders of the shoulder blades towards each other.

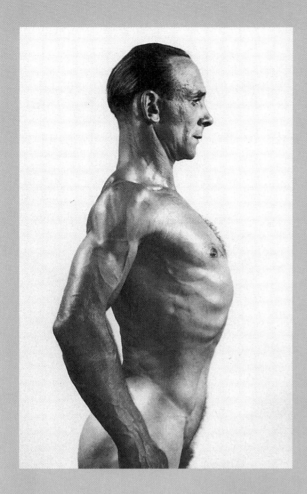

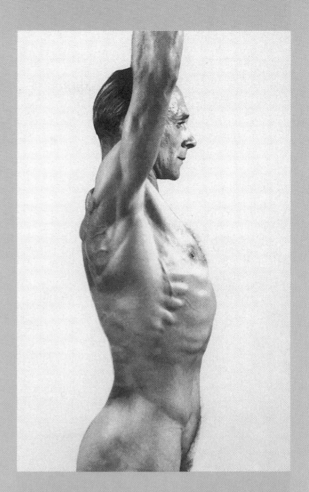

Fig. 376 (top left) Lateral view of the shoulder blades pulled towards each other backwards and horizontally. The shift of the shoulder blades towards the back and thus also of the arms makes the curvature of the rib cage particularly prominent.

Fig. 377 (top right) The rotational action of the serratus anterior on the shoulder blade during vertical raising of the arm. The muscle forces that adjust the position of the scapula for vertical raising of the arm include a fan-shaped muscle, the serratus anterior, of which about four digitations are visible in the nude model, but which are often misinterpreted as prominent ribs.

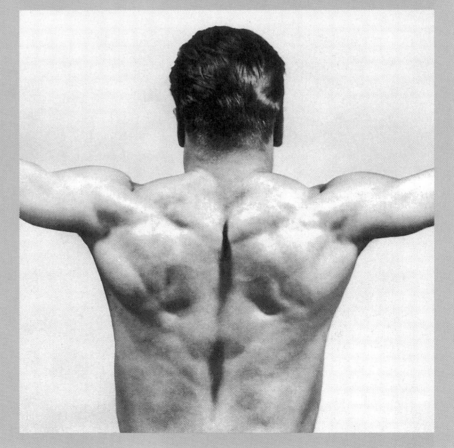

Fig. 378 Humerothoracic muscles and humeroscapular muscles in a stabilising function whilst using the iron cross in gymnastics.
Their stabilising function counteracts the sinking down of the body between the grasp of the hands.

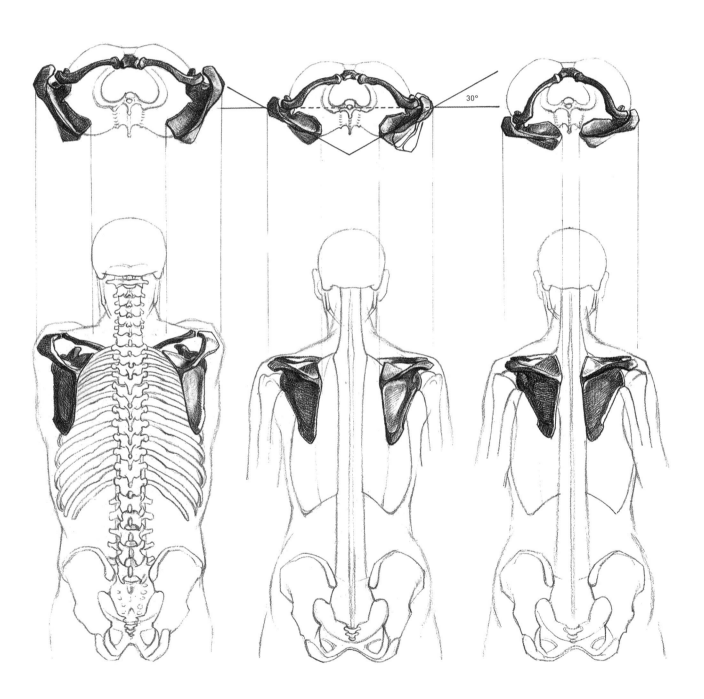

Fig. 379 Cranial and posterior view of the horizontal movement of the shoulder girdle. The clavicle and scapula swing round the manubrium as the centre of rotation.

30°

8.4. THE MUSCLES OF THE SHOULDER GIRDLE (SCAPULOTHORACIC MUSCLES)

8.4.1. Overview of the general system [341, 380]

The muscles that act on the shoulder girdle belong to the group called the scapulothoracic muscles (see page 315) and their function is to move it in a vertical and horizontal direction, to fix it in various positions or to rotate the glenoid cavity. Their arrangement in a vertical and horizontal sequence is derived from this. The skeleton of the trunk serves as the point of origin. The scapula is thus the 'centre of radiation' for the different, sometimes complementary, muscle forces pulling in different directions (e.g. upwards–backwards – forwards–downwards, see directions of arrows in Figures 341, 380, 381).

There are important antagonistic and synergistic relationships between the scapulothoracic muscles to ensure the moveable platform for the arm is shifted back and forth, upwards and downwards, or is fixed in position during simultaneous contraction.

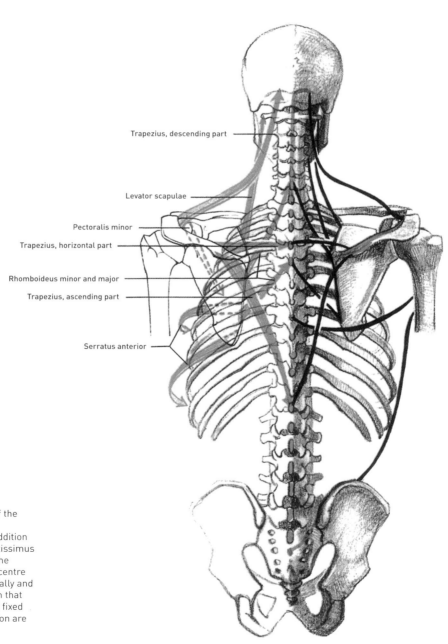

Trapezius, descending part

Levator scapulae

Pectoralis minor

Trapezius, horizontal part

Rhomboideus minor and major

Trapezius, ascending part

Serratus anterior

Fig. 380 Overview of the system of the scapulothoracic muscles.
Line illustration on left, with the addition of one humerothoracic muscle (latissimus dorsi). The figure illustrates how the scapula lies predominantly at the centre point of muscles that act on it radially and it thus becomes a base for the arm that can be shifted in all directions and fixed in position. The directions of traction are indicated by arrows.

8.4.2. The scapulothoracic muscles [341, 381–383]

The trapezius (M. trapezius):

Origin: Occipital protuberance (protuberantia occipitalis externa), nuchal septum (septum nuchae), spinous processes of first to twelfth thoracic vertebrae.

Course and insertion: The muscle is composed of descending, horizontal and ascending parts and inserts into the superior margin of the entire spine of the scapula and the lateral portion of the clavicle.

Function: Descending part – holds the shoulder girdle in a 'floating' position at rest and acts against loading (carrying of a weight) or pulls the shoulder in a cranial direction. When the scapula is fixed in position, lateral flexion of the head or resistance against the head being pushed forwards.
Ascending part = Pulls the scapula in a caudal direction, stabilisation when used for support or hanging from a high bar.
Horizontal part = Pulls the scapula in the direction of the spine (stabilising function, e.g. during tug-of-war).

Plastic appearance: Attachment to the spine is via very thin tendinous fibres. A tendinous rhombus on the back of the neck keeps the spinous processes free of muscle. Formation of dimples in the shoulder during contraction. The fine muscle bundles running from the occipital protuberance and nuchal septum insert into the clavicle through spiral overlaps. They form the outline of the neck in profile and the triangle of the neck in a frontal and dorsal view.

The serratus anterior (M. serratus anterior) [391]:

Origin: First to ninth ribs (three-quarters of the flank of the rib cage).

Course and insertion: From its fan-shaped origin, concentration on the medial surface of the medial border of the scapula, thus running underneath the scapula and providing padding for it.

Function: The middle and upper parts pull the scapula in an anterior direction (antagonist to the horizontal part of the trapezius). The part that extends caudally, and in a dorsal and cranial direction, pulls the scapula forwards and downwards. Stabilising function when pushing against a resisting force. Rotates the glenoid cavity upwards through the joint action of its ascending parts and the descending and ascending parts of the trapezius (vertical raising of the arm) [387, 391, 397].

Plastic appearance: It originates in digitations from the ribs and interleaves with the digitations of the external abdominal oblique muscle. Of a total of nine digitations, the upper ones are covered by the pectoralis major, such that only about three or four appear on the surface (commonly misinterpreted as ribs).

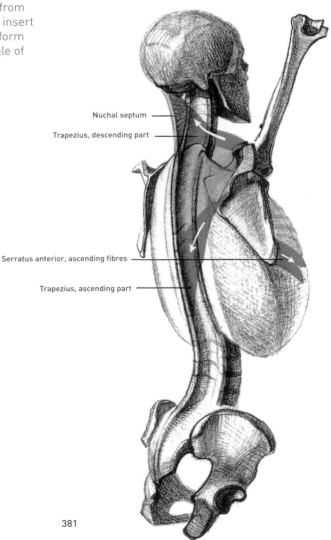

Fig. 381 Muscles that act on the scapula during vertical raising of the arm.
The scapula is acted on at three different locations simultaneously and in the same direction and is turned upwards together with its glenoid cavity.

Fig. 382 Joint action between the trapezius and the latissimus dorsi during dips on the parallel bars.
The ascending parts of each of these muscles (dark colouration) prevent the body weight from collapsing between the supporting arms through contraction in the direction of the spine.

Fig. 383 The trapezius during vertical raising of the scapulae.
Parts of the trapezius descending from above (dark colouration) move the scapulae through contraction in the direction of their origin at the back of the neck and the nuchal septum.

Nuchal septum

Trapezius, descending part

Serratus anterior, ascending fibres

Trapezius, ascending part

381

8.5. THE SHOULDER JOINT

8.5.1. Function, components, structure

In accordance with the requirement for all-round movement of the arm [360a, b, 376, 387], the round head of the humerus and the small, flat bean-shaped glenoid cavity of the scapula only come into contact on a small area. Insertion of the head of the humerus into a deep socket (as is the case in the hip) and a humeral neck are absent. The head is directly attached to the shaft. Angular bony lateral protrusions are found at the level of the joint (greater and lesser tubercle for muscle attachments).

8.5.2. The mechanics of the shoulder joint

The three basic movements of the ball-and-socket joint equate to its three axes [360a, 387].

Anteversion and retroversion of the arm occur round the horizontal axis through the plane of the scapula (that is, not precisely identical to the frontal plane). The arm thus swings independently within the area monitored by the eyes. The anterior pendulum movement is more intensive than the movement swinging the arm backwards [360b]. Abduction and adduction of the arm occur around the sagittal axis (perpendicular to the transverse axis). The arm is raised slightly towards the front by 90° (it thus continues the spatial orientation of the scapula).

The vertical axis (rotational axis, see Figures 359, 360a) is required for internal and external rotation. We can carry out a rotation of exactly 90° if the lower arm is flexed.

All three combined basic movements allow the upper arm to circumscribe a conical space with a circular to ellipsoid footprint.

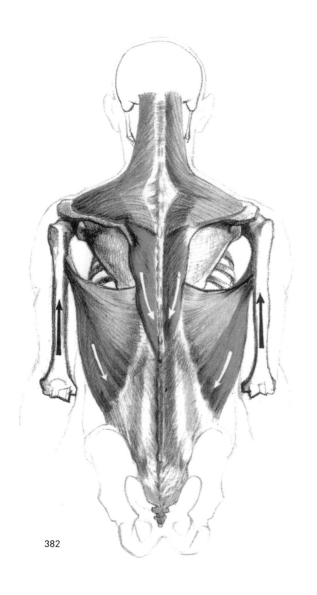

382

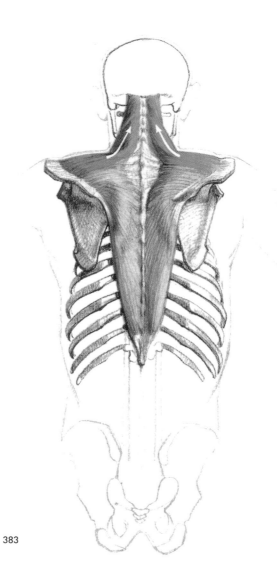

383

8.6. THE MUSCLES OF THE SHOULDER JOINT

8.6.1. Overview of the general system [387]

Two muscle groups act on the shoulder joint: the humerothoracic muscles (see section 7.1.) and the humeroscapular muscles. The first group inserts into the humerus from the back and creates the connection to the pelvis (latissimus dorsi), as well as to the rib cage (pectoralis major).

8.6.2. The humerothoracic muscles

The latissimus dorsi (M. latissimus dorsi) [384, 385]:
Origin: Via thin tendons from the spinous processes of the seventh to twelfth thoracic vertebrae and from the lumbar fascia (fascia lumbodorsalis – sheath around the deep back muscles), from the iliac crest, the sacrum and from the bottom three ribs.
Course and insertion: Concentric insertion into the medial surface of the humerus from its broad origin. The most cranial fibres take a curved course, push the tip of the scapula against the rib cage and overlap the ascending fibres.
Function: Pulling the raised arm downwards and backwards ('scything movement'), internal rotation of the humerus (moving the back of the hand towards the buttocks), moving the arm backwards to throw or push something, pulling arms towards the body (swimming), stabilisation during the iron cross on the rings, when hanging from the high bar, pulling the body upwards towards the hands (pull-up), stabilising function to prevent shoulder being pushed upwards during dips on the parallel bars.
Plastic appearance: Forms the bulging, rounded posterior wall of the axilla.

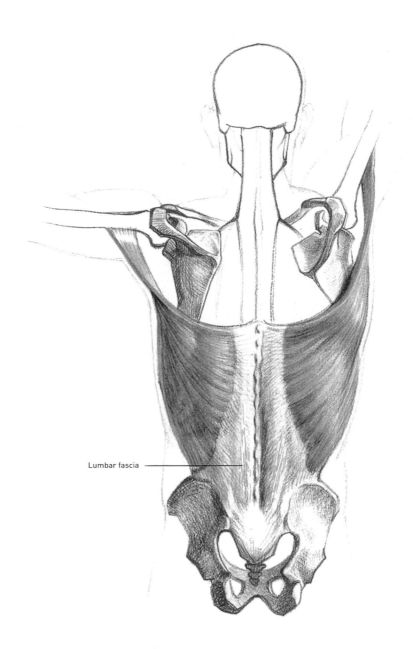

Lumbar fascia

Fig. 384 The latissimus dorsi.
Note the overlaps between the muscle fibres close to the insertion and their tension due to extension on the right-hand side as a favourable prerequisite for a powerful bringing down of the arm.

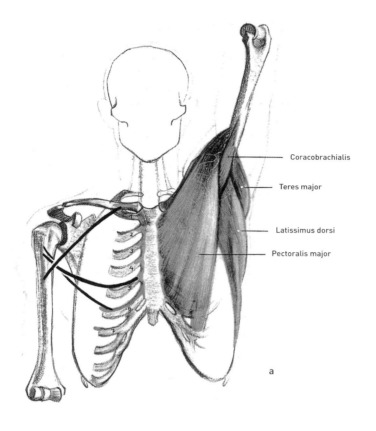

Coracobrachialis

Teres major

Latissimus dorsi

Pectoralis major

a

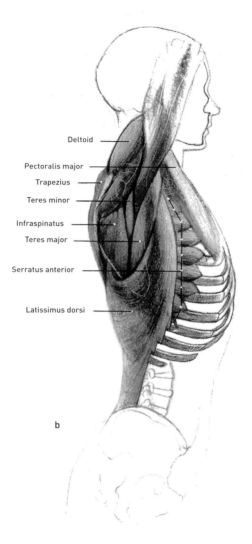

Deltoid

Pectoralis major

Trapezius

Teres minor

Infraspinatus

Teres major

Serratus anterior

Latissimus dorsi

b

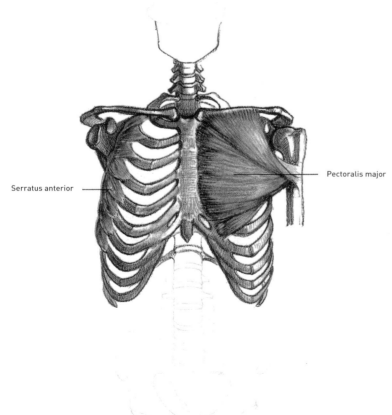

Serratus anterior

Pectoralis major

Fig. 385 Formation of the axilla when the arm is raised.
a) Frontal view.
b) Lateral view.
The insertions of the two humerothoracic muscles into the anterior and posterior humerus are very close together, which produces a hollow between the two muscles, the flank of the rib cage and the head of the humerus.
Left side of line in illustration **a** for pectoralis major; origin and insertion marked in red.

Fig. 386 Serratus anterior (left) and pectoralis major (right) at rest.

The pectoralis major (M. pectoralis major) [296/1, 296/2, 385, 386]: This is composed of three main parts: clavicular, sternocostal and abdominal parts with an overall fan shape.

Origin:

Clavicular part: medial two thirds of the clavicle,
sternocostal part: border of the sternum and cartilage of the second to seventh ribs,
abdominal part: aponeurosis of the rectus abdominis.

Course and insertion: Concentric insertion into the medial surface of the humerus (next to the latissimus dorsi) through ascending, horizontal and ascending fibres from the transverse U-shaped field of origin. At the point of insertion, its bundles of fibres overlap like the stems at the base of a fan at their centre of rotation.

Function: Antagonist and synergist to the latissimus dorsi.

Descending part: anteversion of the arm,
ascending part: pulling down raised arm, stabilising function when hanging from the high bar, lifting of the body during pull-up, adduction of the arm against a resistance, stabilising function during the iron cross on the rings,

horizontal part: crossing of arms over chest, pressing the palms of the hands together.

Plastic appearance: Turns the upper body into a rectangular shape due to its shield-like appearance, forms the anterior portion of the axilla, is transformed into a triangular shape when the arm is raised vertically. A full, round bulge appears towards the arm as the overlapping bundles of fibres untwist.

8.6.3. The humeroscapular muscles [387]

The deltoid (M. deltoideus) [387, 388]: This surrounds the shoulder joint on three sides, with its three parts: the anterior, medial and posterior parts. It plays a similar role in the shoulder joint to the gluteus maximus in the hip.

Origin:

Anterior part: lateral third of the clavicle,
medial part: roof of shoulder,
posterior part: lower border of the spine of the scapula.

Course and insertion: From the horseshoe-shaped ring formed by the shoulder girdle, concentric insertion into the upper third of the outer humerus.

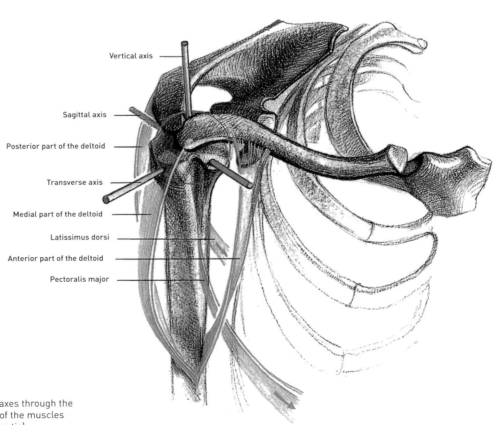

Vertical axis
Sagittal axis
Posterior part of the deltoid
Transverse axis
Medial part of the deltoid
Latissimus dorsi
Anterior part of the deltoid
Pectoralis major

Fig. 387 The three main axes through the shoulder joint and some of the muscles that act on it (semi-schematic). The positional relationships of the individual muscles to the joint axes provide information on possible functions.

Function:

 Anterior part: anteversion of the arm (due to its position anterior to the transverse axis) through to a horizontal position,
 medial part: raises the arm laterally to a horizontal position (lateral position in relation to the sagittal axis).
 posterior part: responsible for retroversion of the arm.
 The anterior and posterior parts also rotate the arm internally and externally as they also cross over the vertical axis in a diagonal direction. All three parts act together to protect the joint capsule from tensile loading (carrying of a weight).

Plastic appearance: Compact, similar to the functionally related gluteals. Its volume exhibits clear accentuations. The head of the humerus is visible in women in the form of a sphere. The deltoid never covers the roof of the shoulder! When the arm is raised, two parallel folds always appear in the roof of the shoulder.

The infraspinatus (M. infraspinatus) and the teres minor (M. teres minor): Originate from the scapula and insert into the lesser tubercle on the humerus. These muscles rotate the arm externally or adduct the abducted arm: both are partially covered by the deltoid [392b, 415].

The teres major (M. teres major): originates from the inferior angle of the scapula, inserts into the medial surface of the humerus and adducts the arm: it rotates the arm internally as it crosses the vertical axis from posterior to anterior. It forms a horizontal bulge as the nude models train [385, 388a].

The coracobrachialis (M. coracobrachialis): Located on the medial side of the humerus and is only visible when the arm is raised [415].

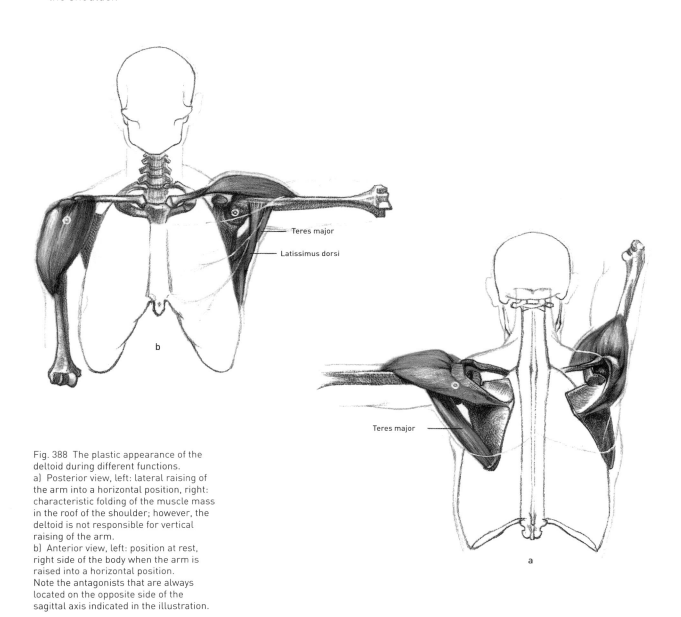

Teres major

Latissimus dorsi

b

Teres major

a

Fig. 388 The plastic appearance of the deltoid during different functions.
a) Posterior view, left: lateral raising of the arm into a horizontal position, right: characteristic folding of the muscle mass in the roof of the shoulder; however, the deltoid is not responsible for vertical raising of the arm.
b) Anterior view, left: position at rest, right side of the body when the arm is raised into a horizontal position.
Note the antagonists that are always located on the opposite side of the sagittal axis indicated in the illustration.

Axis	Movement	Muscles involved (full list)
Transverse axis	Anteversion	Deltoid (M. deltoideus), medial and anterior parts Pectoralis major (M. pectoralis major), clavicular part Coracobrachialis (M. coracobrachialis, only mentioned)
	Retroversion	Deltoid (M. deltoideus), posterior and medial parts Latissimus dorsi (M. latissimus dorsi) Teres major (M. teres major)
Sagittal axis	Abduction	Deltoid (M. deltoideus), medial part Supraspinatus (M. supraspinatus) +
	Adduction	Deltoid (M. deltoideus), anterior and posterior parts Pectoralis major (M. pectoralis major) Latissimus dorsi (M. latissimus dorsi) Teres major (M. teres major)
Vertical axis	Internal rotation	Deltoid (M. deltoideus), anterior part Dubscapularis (M. subscapularis) O Teres major (M. teres major) Latissimus dorsi (M. latissimus dorsi)
	External rotation	Deltoid (M. deltoideus), posterior part Infraspinatus (M. infraspinatus) Teres minor (M. teres minor) O

+ = not discussed, not depicted

O = not discussed, only depicted

8.7. THE ARCHITECTURAL FORM OF THE TRUNK AND THE RELATIONSHIPS BETWEEN ITS SHAPES

The reader may be surprised that we are only now aiming to provide a larger synthesis on the architectural shape of the trunk and its relationships between shapes, after we have already covered the trunk muscles in Chapter 7 and the laws governing the behaviour of the soft tissue shapes in the trunk (section 7.3.). However, this can be explained by the fact that it is impossible to explain the plastic shape of the trunk or torso in anything approaching a comprehensible fashion without investigating the shoulder girdle, the mobile base for the free pendulum formed by the upper extremity. Both the shoulder girdle, as a bony contributor towards the external appearance, and the muscles that originate from and insert into it complete significant plastic manifestations in the higher portion of the upper body, extending downwards to the higher portion of the upper arm (deltoid). This element of the appearance first required explaining to ensure the necessary understanding of the anatomical facts. The plastic appearance of the body will never be comprehended without an insight into the relationships between the soft tissue shapes and their underlying framework architecture [395, 396]. This is because the pelvis and spine, rib cage and shoulder girdle form the

defining basis for the trunk. The term 'architecture' is particularly apposite where spaces must be included in the conceptual process, as is the case for the rib cage, pelvis and cranium.

8.7.1. The anterior view [389, 390, 395–398]

Two relatively constant vessels, even during movement, the pelvis and rib cage, form the substructure for the superficial plastic appearance, its plastic cores. The basin of the greater pelvis opens up towards the abdominal side of the body, at the two anterior superior iliac spines. The front of the abdomen is suspended between these two points, demarcated by the inguinal ligament, which connects the pubis and the iliac spines in a curved line (inguinal incision in men). This is where the final frontal attachment (muscle corner) is for the external obliques that press forward. Over their further course, around the iliac crest in a dorsal direction, the external obliques appear 'rolled up' and removed from the lateral hip muscles, as a seam on a quilt (soft bulge or 'roll') [395].

In spite of all the overlaps, the rib cage remains a domed structure, the frontal flattening of which is created by the common plane formed by the sternum and costal cartilage, a plane that descends steeply in an anterior direction from the jugular notch towards the xiphoid process, from where the costal arch opens up in angular form towards the flanks [389, 396a, b]. The rectus abdominis also fails to entirely level this delimiting line. This muscle takes on the function of an

elongated, connecting, intermediate form between the rib cage and the pelvis, which protrudes the furthest outwards of all the abdominal muscles and emphasises movement and shape through its vertical furrow (linea alba) [395]. The chest muscles are horizontal, flat, curved shields that 'bind' the upper portion of the thoracic dome and, together with the flanks of the rib cage, give the upper body its cuboid shape. The architecture of the female trunk is similar overall, apart from the proportions. The breasts are hemispheres that are placed on top of and cover the pectoralis major [397].

The clavicle – even if it is suppressed as an isolated structure – forms the plastic delimitation between the chest, neck and triangle of the neck [396c, d]. There is a small gap (infraclavicular fossa) between the deltoid, that attaches to the lateral portion of this rod that is curved in the horizontal plane, and the pectoralis major. This is where the two muscles meet and produce a notch through their convex shapes [92a, 389, 390]. From the medial portion of the clavicle, the column formed by the neck twists spirally in a posterior direction towards the back of the head.

The frontal relationship between shapes can only be understood through the interaction between the two main shapes, rib cage and pelvis, and their intermediary forms (soft tissue masses) [395]. Movement in relation to the shapes formed by the tensed flanks of the rib cage is never directed towards the roof of the shoulder, but towards the supraclavicular and infraclavicular fossas [394, 395, 396a, 397a, c]. The dome of the rib cage disappears under the axilla, which is particularly clear when the arm is raised. This results in the internal connections to the base of the neck. No matter how the rib cage moves about above the bony ring formed by the iliac crests, both cavities always appear like two egg-shaped domes, with their poles directed upwards and downwards, respectively. The folds and tautly stretched connecting interim forms reveal to what extent the two cavities are shifting relative to each other and increasing or reducing the gaps [352, 396a].

The most important points on the architecture and rhythm in a lateral view [81, 391] have already been covered in section 1.3.9.

Fig. 389 The frontal view of the trunk, external appearance.
When studying the figure, the plastic appearance of the trunk – as is the case for almost all manifestations associated with the body in the model – should not just be observed from the perspective of the 'positive' shapes that are tensed outwards and convex, but always in interaction with the 'negative' shapes, the cavities. Together these produce the expression of physicality.

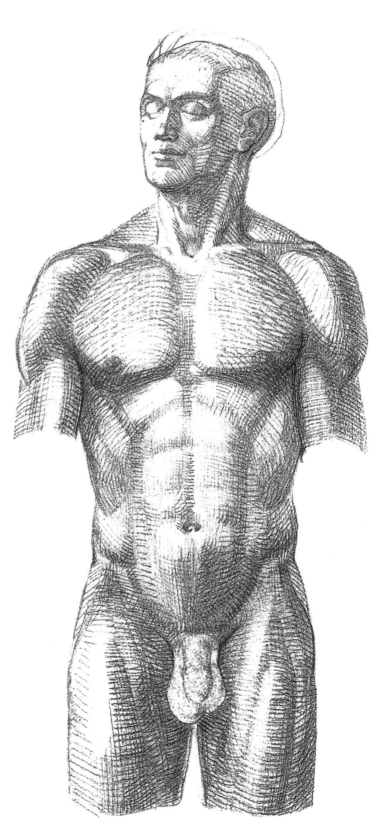

Fig. 390 The frontal view of the trunk,
muscle analysis.
The study of the muscles does not
simply serve the purpose of gaining
an understanding of their origins and
insertions and plastic appearance, but
also aims to clarify the cavities produced
by the muscles.

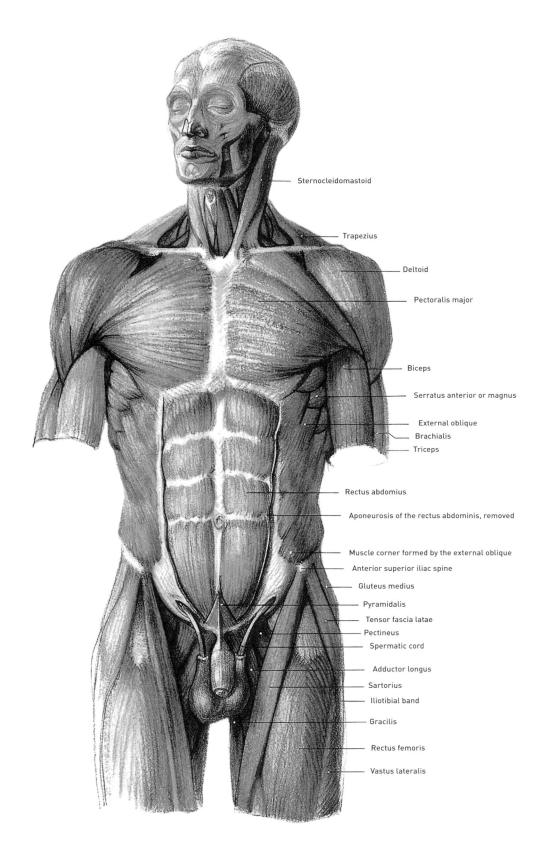

Sternocleidomastoid

Trapezius

Deltoid

Pectoralis major

Biceps

Serratus anterior or magnus

External oblique
Brachialis
Triceps

Rectus abdomius

Aponeurosis of the rectus abdominis, removed

Muscle corner formed by the external oblique
Anterior superior iliac spine
Gluteus medius
Pyramidalis
Tensor fascia latae
Pectineus
Spermatic cord
Adductor longus
Sartorius
Iliotibial band
Gracilis
Rectus femoris
Vastus lateralis

Fig. 391 The lateral view of the trunk.
a) External appearance.
b) Muscle analysis.
The relationship between the plastic cores and their positions relative to each other also reveals the dominating, dynamic nature of the overall shape of the trunk in a lateral view, resulting from the position of the muscles in relation to the bony cavities and the joints.

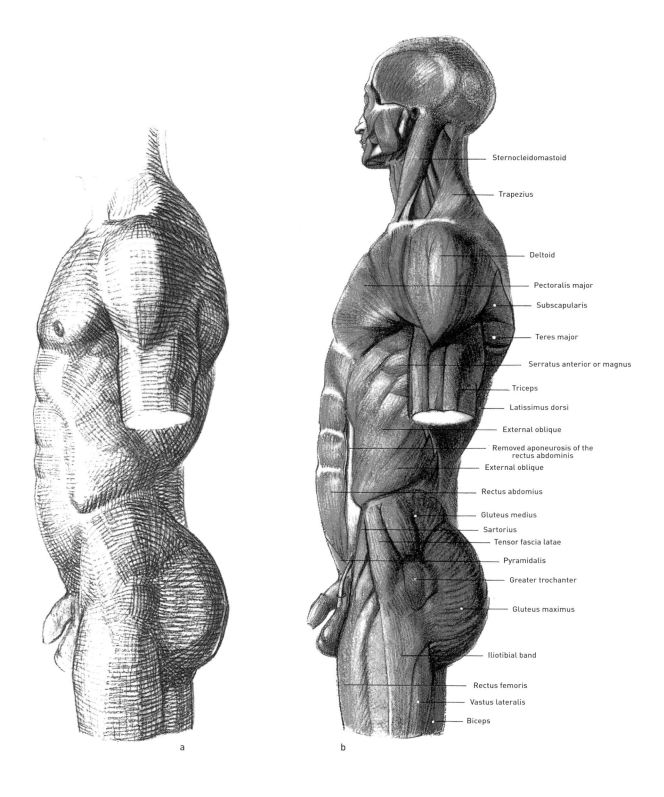

Sternocleidomastoid

Trapezius

Deltoid

Pectoralis major

Subscapularis

Teres major

Serratus anterior or magnus

Triceps

Latissimus dorsi

External oblique

Removed aponeurosis of the rectus abdominis

External oblique

Rectus abdomius

Gluteus medius

Sartorius

Tensor fascia latae

Pyramidalis

Greater trochanter

Gluteus maximus

Iliotibial band

Rectus femoris

Vastus lateralis

Biceps

a

b

8.7.2. The dorsal view [392, 399, 400]

The dorsal view of the trunk invites us towards consolidation to a greater extent than the frontal view [395]. 'Notching' or structural orientations are almost entirely missing here; there is no costal arch that is sharply offset, no muscle like the pectoralis major that rests on its substrate in the form of a raised and pronounced step. The surface of the back, viewed in its entirety, forms a high trapezium, as the shoulder blades with their muscles and the latissimus dorsi that rounds the tip of the shoulder blade form the lateral contours [394g]. The back thus appears broader than the chest. The axial skeleton (spine) is deeply embedded into the trapezium formed by the male back and around this axis, like a mussel shell, the two halves open up, pivoting backwards like wings. The spine is an expressive carrier of motion. Therefore, draw it first, before you group the masses around it. The spine of the shoulder blade – angled like a hipped roof – traverses the descending surface of the back. In the 'corner' of the dimple in the shoulder, it forms the culmination point where the following three spatial directions meet: the triangle of the neck formed by the trapezius, the incline from the medial border of the shoulder blade to the spine, and the gentle anterior and lateral slope of the surface of the muscle in the infraspinatus fossa (of the scapula). The tip of the shoulder blade protrudes as the most prominent point on the back. The back gives the clearest indication of the angling between the orientations of the rib cage and the pelvis: the lumbar region is enclosed by these two entities in the form of a spatial 'negative'; the extensors of the back form a column-like interim shape. The two buttocks, separated at the top by the curved wedge of the sacrum, are semi-circular in shape from top to bottom [245]. The extent to which the buttock, in the form of a cube-like entity, tapers off in a dorsal direction is revealed by its cross-section [393, 396c]. Cross-sections are of great importance to sculptors if they wish to understand the spatial inclines of the surfaces surrounding the body. The sequence of correlation points through the deep lateral 'indents' in the dorsal view indicate the direction and shape of simple basic forms. The relationship runs through the arms from the elbow to the waist [394g,1–5]. It is only here that a trapezoid expansion starts again, running down to the greater trochanter (numbers 5–8). Figure 394f shows even more extended relationships in a full figure pushing something, with correlation points running from the axilla down to the heel and from one hand to the other [394, 1–12]. The taut, extended features alternate with the bulges of the muscle bellies throughout this chain of points, but always such that the mutually complementary and continuous framework shines through.

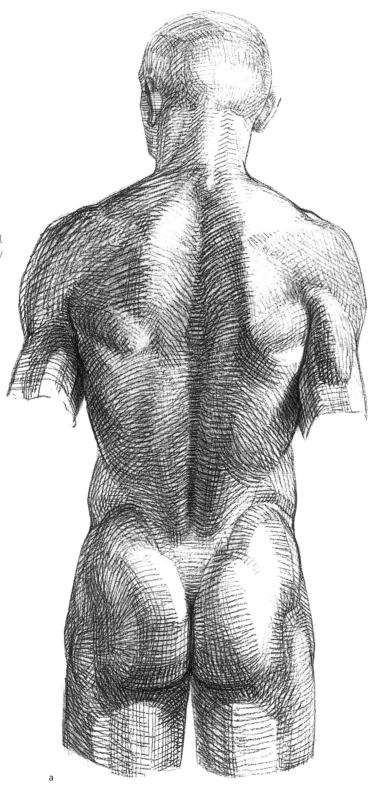

a

Fig. 392 The dorsal view of the trunk.
a) External appearance.
b) Muscle analysis.
The bilateral symmetry, on which the frontal and dorsal view of the trunk is also based, largely obscures the dynamic build-up of shapes, emphasising the static features, in which the cavities play a more weighty role than in the lateral view. A representation of the individual volumes of the muscles is also required, with reference to the superficial plastic appearance, as a way of providing grounds for all types of cavities that form or develop, based on the laws governing the underlying structures (pockets, dimples, furrows, folds, fissures or hollows).

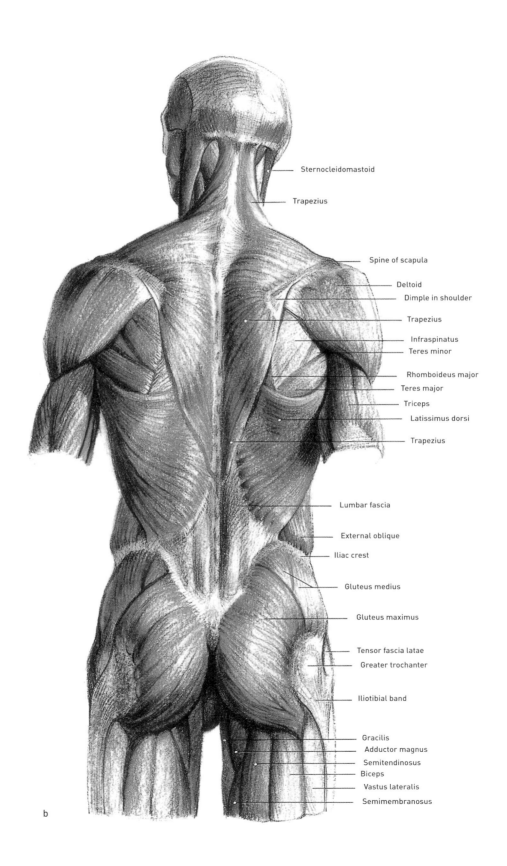

Sternocleidomastoid

Trapezius

Spine of scapula

Deltoid
Dimple in shoulder
Trapezius

Infraspinatus
Teres minor

Rhomboideus major
Teres major
Triceps
Latissimus dorsi

Trapezius

Lumbar fascia

External oblique

Iliac crest

Gluteus medius

Gluteus maximus

Tensor fascia latae
Greater trochanter

Iliotibial band

Gracilis
Adductor magnus
Semitendinosus
Biceps
Vastus lateralis
Semimembranosus

b

8.7.3. The architectural shape of the trunk during action

The transparency of the individual building blocks, the plastic cores and their layered shapes that is recommended for the construction of the architectural shape, is not only of value for providing greater insight into the posture of the trunk at rest [394]; it also presents an opportunity, to an even greater extent, to gain further insight into the trunk when it is in action. Even more than before, it will now become clear whether the constructional framework of these shapes can be momentarily imagined and realised, as the processes involved in their movement hardly provide a basic view that could be memorised, but transformed into perspectival views. Once again, particularly in this case, constructional drawing does not simply involve adding one volume to the next. This

is actually the second step in the process. In the first step, the artist must define the directions taken by the relationships between the shapes which – as explained already – must occur through the linking up of the 'low points' that arise from the meeting of convex shapes [394–396]. This process allows the indication of both the orientation, optical weighting for basic shapes, and an ordering of forms, in which the convex shapes arch upwards from the main shapes as ancillary shapes. Likewise, the concepts of cross-sectional shapes and knowledge of the laws governing the soft tissue shapes (see section 7.3.) must be incorporated into constructional drawing, as this, in particular, provides important information on tautness or relaxation, on bulges or hollows, thereby revealing the solid vessels that are connected to them in a new light, like the pelvis and rib cage, and the shiftable façades of the shoulder girdle. However, in this case, constructional drawing

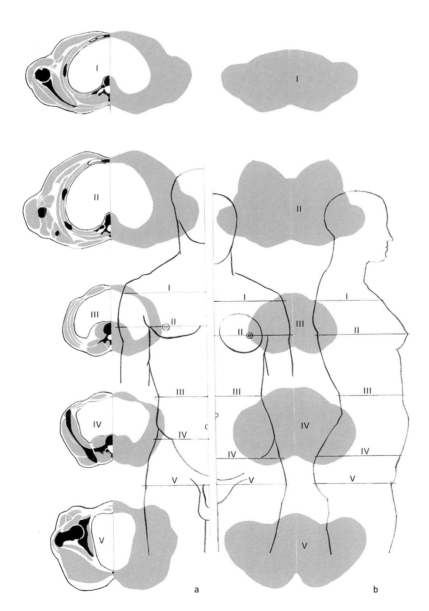

a b

Fig. 393 Cross-sections through the trunk.
a) Left vertical sequence; male.
b) Right vertical sequence; female.
The cross-sections in the different horizontal planes are highly specific and typical and clarify the very different surface inclines of the body as an expression of the changes in its volume in space.

once again means largely distancing oneself from analytical observation, in order to visualise the new structural constellation of forces that is dependent on function in a synthetic synopsis.

The question of delimitation between one individual anatomical object and another is also not essential here, but rather more the question of what physical and spatial relationships and overall images they combine to create, what position they occupy in space and what spaces they mutually form themselves [397, 398]. This means that efforts to simplify the sections of the body that are in action and the behaviour of the connecting bridges (potentially as far as a strong reduction into elements) also plays an important role here [399]. Once again, the architectural investigation of the body is based on an insight into the combination of two aspects: the simplification of shapes, on the one hand, and the accentuation of shapes on the other. This is

nothing other than highlighting the importance of the physical form. The means used to achieve this vary greatly. For this reason, the author again includes a series of his own correctional drawings, whereby the processing of anatomical circumstances and functional events in physical architectural interpretations and their close relationships, and general problems associated with nude studies of the figure, may become clearer [397–400]. The artist should also ask the model and himself or herself who is experiencing what and where, where is tension occurring and where is there folding of soft tissue [399, 400]? What happens when the arm is raised (extension of the latissimus dorsi), how are the relative positions and relationships between the plastic cores affected? What do the breasts 'endure' when the arms are folded behind the head [400]? Experiencing these movements in one's own body can help greatly to revitalise a dry anatomical analysis.

Fig. 394 Relationships between shapes in the trunk during action.
The numbering along the side indicates the intrinsically linked 'low points' which can be drawn together into basic forms, to which differentiated shapes can then be allocated. This allows the construction and justification of the structure of the shape.

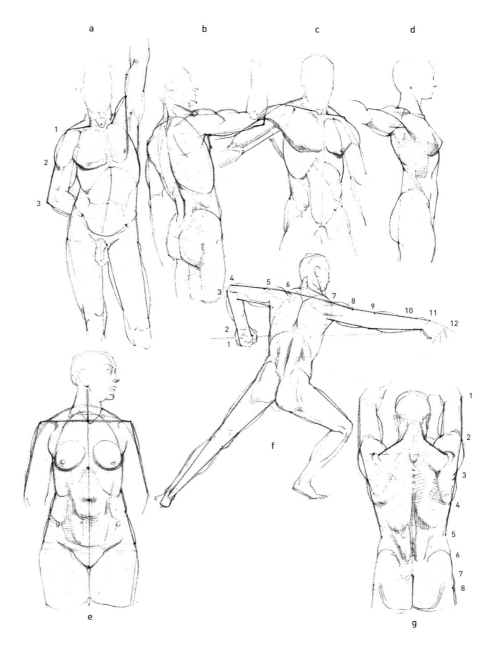

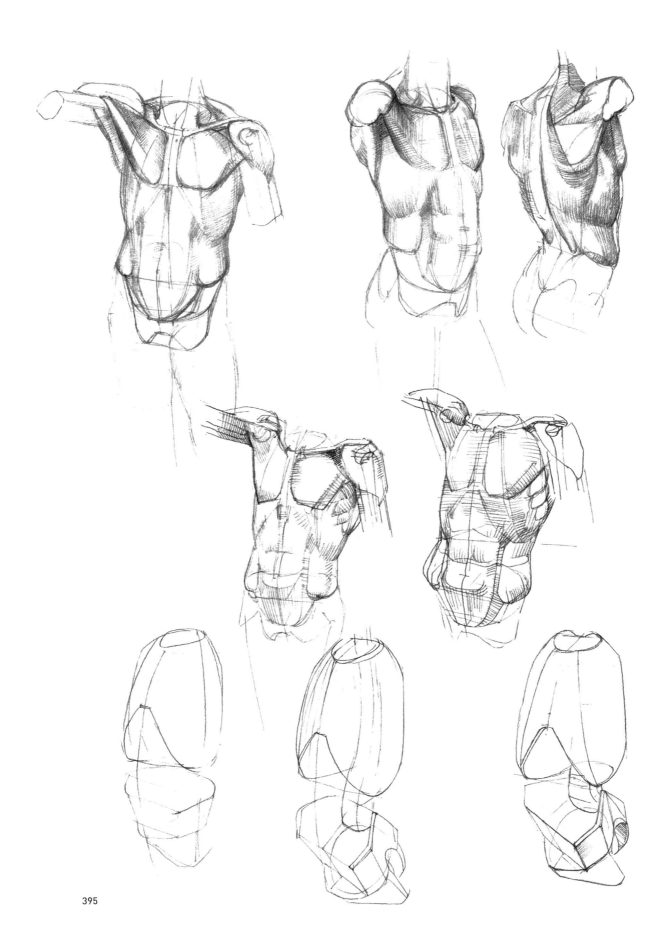

395

Fig. 395 The architectural form of the plastic appearance of the trunk during action.
This illustration is based on constructional drawing, in which the interaction of the individual elements of the form, to produce a structural configuration of the forces involved, takes precedence. This also always includes the highly central expressiveness of the framework shapes.

Fig. 396 The architectural form of the plastic appearance of the trunk and the laws governing the behaviour of the soft tissue shapes.
It is especially the flat and fan-shaped muscles of the trunk acting as bridges between the bony cavities and as shapes building up the structure on the plastic cores, and the skin covering all of this, that differ greatly in their behaviour when compared with other parts of the body. Folding, tension, torsion, concertinaing, the formation of

creases and hollows, all play a far greater role here than in the rest of the body.
a) Architecture of the trunk during torsion.
b) The rotational process broken down into elements and the required behaviour of the abdominal wall.
c) Cross-sections for the architecture of the trunk.
d) Architecture of the trunk viewed in perspective.
e) Behaviour of the folded and twisted abdominal wall when lying down (based on a plastic study by Michelangelo).

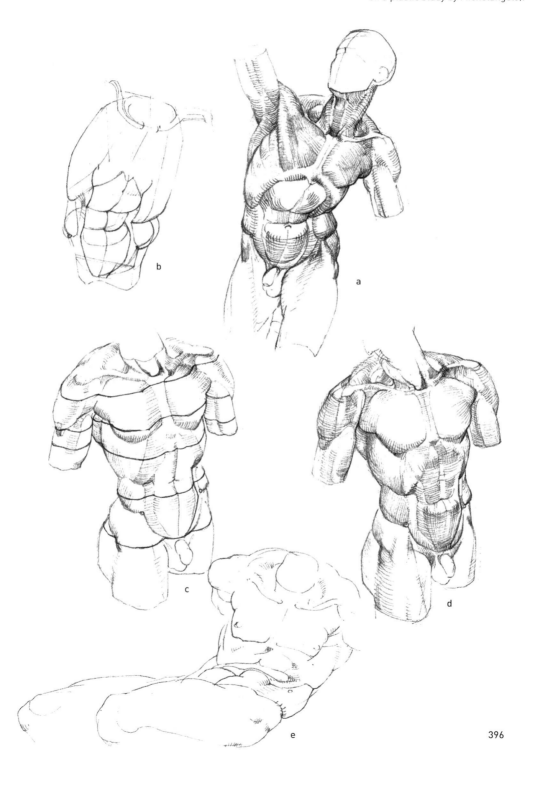

396

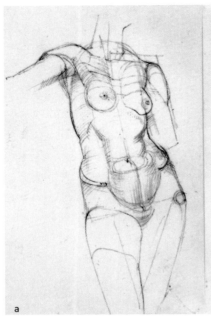

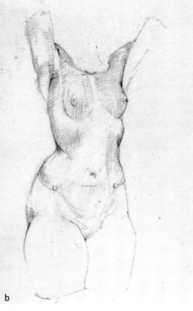

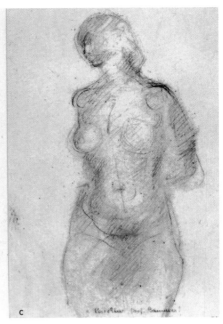

a

b

c

Fig. 397 Demonstration drawings by the author when correcting students in relation to the problem of capturing the corporeality of the trunk (based on a model).
The build-up of the plastic appearance of the trunk explained through drawings may vary according to the aspect or focus, depending on the problem, the individual student and the object of study:

a) The architecture of the body during action. This demonstration is focusing on the joint structural action of skeletal and soft tissue shapes.
b) The plastic appearance of the body during action. The focus here is on visualising the tensions due to extension in the abdominal wall and the breasts.

c) Physicality arising from spatial investigations. In this case, the formation of the convex shapes of the body arises from an assessment of the development of depth (of space) in relation to the volume of the body.
The analytical evaluation of the situation has largely been replaced by a synthetic approach.

Fig. 399 (right, top) The behaviour of the trunk muscles during action (dorsal views) from the perspective of architectural understanding of form.

Fig. 400 (right, bottom) The behaviour of the plastic appearance of the trunk during two actions: contrapposto position and arm-raising (left).
The behaviour of the breasts and the axilla when the arms are raised and folded above the head (right). The breasts rise upwards and flatten due to extension of the pectoralis major. The axilla opens up between the upper breast and pectoralis major at the front and the insertion of the latissimus dorsi, latero-dorsal in this image.

Adapted from Bammes,
Wir zeichnen den Menschen.

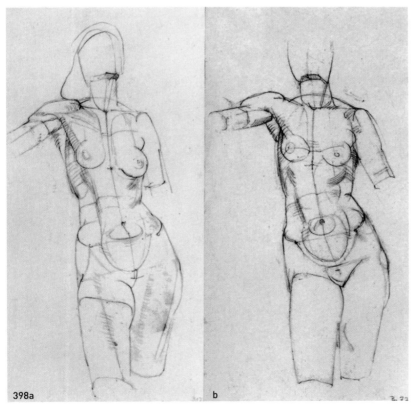

398a

b

Fig. 398 Demonstration drawing by the author when correcting a student in relation to the problem of the corporeal illustration of the trunk during action (based on a model).

The task essentially involves visualising the cogency of the architectural form in the case of a static posture with one leg engaged and during walking. The problems relate to the laws governing the behaviour

of the body from the perspective of static, functional and physical-spatial aspects.
a), b) Two different views of the same pose in a model.

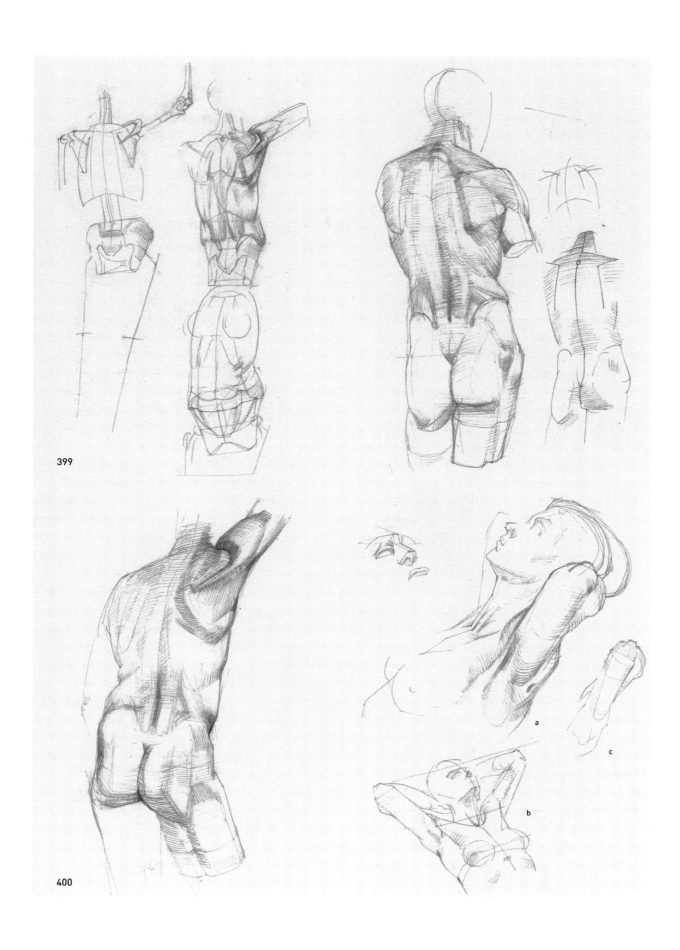

399

400

a

b

c

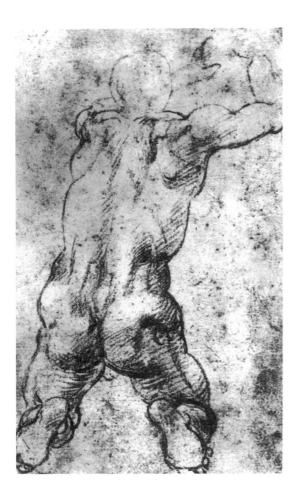

Fig. 401 Michelangelo (1475–1564).
Male Nude. Black chalk, 25.5 x 15.5cm
(10 x 18in). Casa Buonarroti, Florence.
The behaviour of the masses making up
the trunk, the protrusion of the rib cage
against the solid outlines of the pelvis,
buttocks and hips and the strands of the
dorsal extensors in the lumbar region
that are holding the torso upright are
illustrated here in a kneeling nude who is
reaching upwards.

Fig. 402 Jacob de Gheyn II (1565–1629).
Four Studies of a Woman. Pen and ink,
some black chalk on grey paper, 26.1 x
33.6cm (10¼ x 13¼in). Musées Royaux des
Beaux-Arts, Brussels.
The artist's orientation towards the realistic
representations of the Dutch is palpable
through to all the minutiae, especially in
the study of the behaviour of the soft tissue
shapes of the trunk, the creasing of the
skin and the folds in the abdominal wall
and breasts.

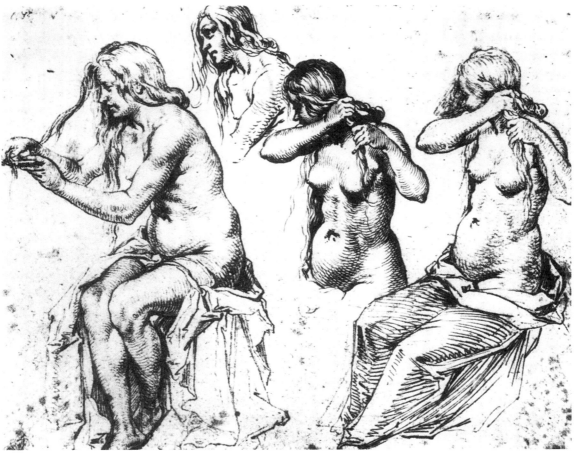

8.8. THE PROCESSING OF ANATOMICALLY OBJECTIVE CONSTITUENTS IN THE PLASTIC APPEARANCE OF THE TRUNK IN WORKS OF ART

Given the fact that the elaborations in section 7.3. focused on illustrating the behaviour of the soft tissue shapes of the trunk as an interaction primarily between tension and relaxation, the works of art have been selected mainly based on this aspect. The analytical analysis can, of course, not relate solely to the soft tissue shapes and their behaviour because, as we have seen, tension and relaxation are only to be understood as manifestations resulting from the changes in relationships between the pelvis and rib cage. Even though we have already dedicated a separate section (6.4.) to this, we cannot avoid touching upon such issues again.

The dorsal view of a kneeling *Male Nude* [401] with its upper body stretched upwards is one of many of Michelangelo's works in which the mechanics of the body, its positioning of the extremities and the relationships between the pelvis and rib cage are always simultaneously recognised as conditions for the behaviour of the musculature, and it is only through the unity of these two elements that the full physical and emotional passion is expressed. In our illustration, the drawing of the pelvis is essentially based on two simple issues: the flanks of the rib cage rise upwards above its base by the raising of the arms, resulting in the lateral abdominal wall being unmistakably drawn inwards between the two vessels, and forms a tapered intermediary section that is not usually particularly prominent in the resting male body.

The *Four Studies of a Woman* by Jacob de Gheyn [402] are studies of the nude that are entirely free of speculation, conforming with the realistic tradition of Dutch art, and the plastic changes in the abdominal wall that are associated with each change in posture in the model are followed with great attention: in the left figure that is inclined slightly forwards and twisted sideways, the abdomen forms a round protrusion, touches the thighs and is folded, with multiple small creases above the navel. The two subsequent slight changes in the seated posture also result in visualisation of the changes in the depth of the spaces within the soft tissue shapes.

The masterfulness of Rembrandt's *Seated Female Nude* [403] is based on its high atmospheric content, created by his declining to include detailed observation and everything being pulled together into huge, undulating, flowing expressiveness of form, without any loss of corporeal realisation. Furthermore, contrary to

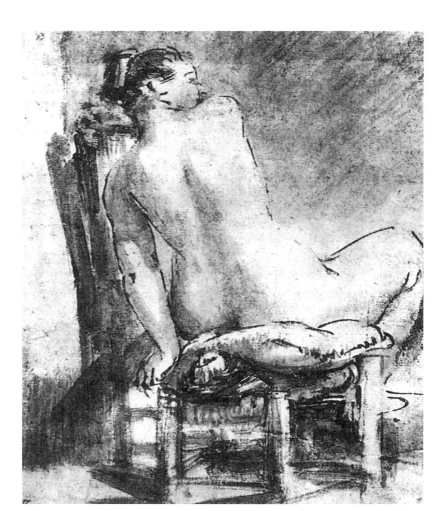

Fig. 403 Rembrandt Harmensz van Rijn (1606–1669).
Seated Female Nude (around 1661). Pen, washed, on brownish paper, 22.4 x 185cm (8¾ x 72¾in). State Collection of Graphics, Munich.
The contour between the waist and hip on the right side that is lacking in solidity conveys the boundless transition between body and space, just as it expresses the 'disruption' of tension in the skin.

Jacob de Gheyn or to an Italian, instead of representing tangible facts, he is searching for the precise indication of the issue that also corresponds most closely to his personal empathy, and we would certainly be misunderstanding the instruments he has used if we interpreted the interruptions in the line drawn with the pen on the extended side of the waist as a chance occurrence. The disruption of a usually clear contour, precisely at this location, cannot be interpreted as anything other than rendering this characteristic more tangible. We are also overwhelmed by this sensation in the *Study of a Reclining Nude* [404], where Delacroix interprets the simultaneity of subsidence and tension in the region of the abdomen as an event resulting from the shape. In this case, the cross-hatching pen lines down the body follow the compliant soft shapes, also of the relaxed breast drooping down to the side, while the breast on the opposite side of the body is rendered into a soft, rising mound through the effect of the raised arm.

The manifestation of effects of opposites that are also loaded with tension in postures at rest – the jutting outwards of the stabilising framework, the drooping of relaxed softness in a position on the side, the protrusion of the relaxed abdomen with gravity acting on it – are functional as well as form motifs for Despiau. The measured approach that the sculptor also aspired to in his drawing of a *Reclining Nude* [405] – the calmly flowing, but still very pronounced contours – reveal his basic classical approach that was not lost, even once he indulged in enthusiastic study of the structure of the human body under Rodin's tutelage. The 1920s were important in the artistic works of Matisse in that, during this time in which many odalisque illustrations were created, he once again dedicated himself to the plastic beauty of the female body, after the impulsive planar

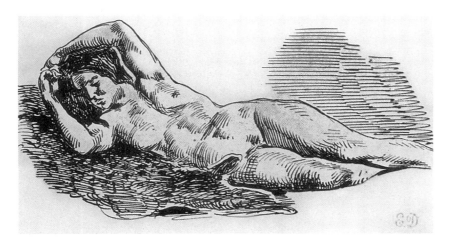

Fig. 404 Eugene Delacroix (1798–1863). *Study of a Reclining Nude.* Pen and ink. Musée des Arts Decoratifs, Paris. The soft receding of the body between the pelvis and rib cage or the breasts flattened in the reclining position are realised with the surprising simplicity of the means and materials in question.

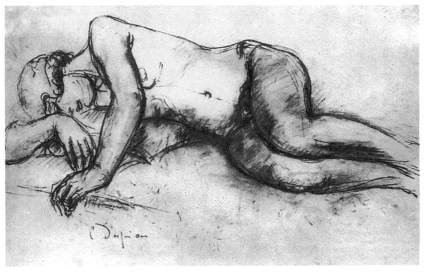

Fig. 405 Charles Despiau (1874–1946). *Reclining Nude.* Red chalk on yellowish paper, 73.2 x 36.2cm (28¾ x 14¼). Prague National Gallery. The great simplicity with which the body is treated, namely, in the contour, evinces a sensitivity for the weight of the positioning and the accents that provide stability, as demonstrated by the energetic marking of the iliac crest on the sunken flank of the body that is drawn with a thin line.

and ornamental creation of figures. He experienced the female body in its three dimensions, in its volumes that created spaces, in the configuration of the forces of repose and action. Quite contrary to his later and earlier paintings, he used the most subtle of graphic means to, for example, convey the roundness of a concertinaed body, to create the depression formed by the soft hollow of the navel, to build up a sequence of overlaps of forms that were raised and had collapsed in on themselves, to explore depths between heights, convex and concave shapes, and he brought into play the entire opulence of the consistency of the skin, the acting forces of mass, traction and thrust, light, shadow and reflexes in his designs [406].

Overall, this constituted an opulence, the different impressions of which are rarely combined into such wonderful unity, but also has not existed in such quality in many of the periods of artistic drawing – certainly not in the 20th century. We have already pointed out that not all impressions created by the figure were approached by artists without filtering out some elements. In the *Female Nude* [407], which is almost expressionist, on the one hand Koepping places the emphasis of his design on the angling of the upper body to one side over a narrow waist, resulting in the contrast between the flow of the lines on the tensed side of the body and the kink in the other side of the body becoming the primary motivation for the form. On the other hand, he links a second motif to this: the flame-like graphic rendering that he uses to give the skin its texture provides its own additional interpretation of the animated form that is thus created.

Fig. 406 Henri Matisse (1869–1954).
Large Seated Nude. Lithograph.
The period of graphics in the years around 1925 is dominated by sensual, physical odalisques and nudes in the case of Matisse. Shape and voluptuousness are subject to careful observation and accorded high status through the means used to produce the image.

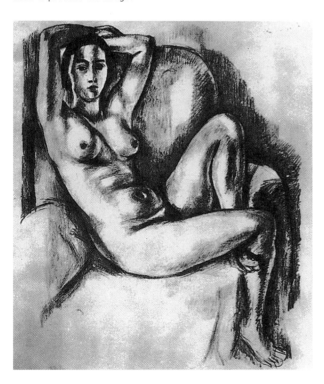

Fig. 407 Karl Koepping (1848–1914).
Female Nude. Kupferstich-Kabinett, Dresden.
The rhythmic eddies of pull and tension in the skin enhance the body's expressiveness and are simultaneously its consequence.

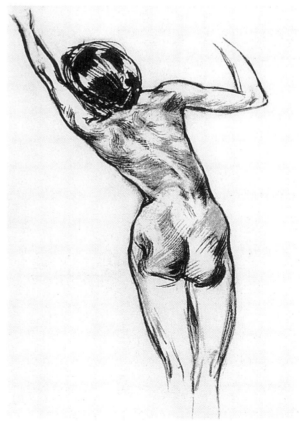

8.9. THE BONES OF THE UPPER AND LOWER ARM

The bones of the upper and lower arm and the hand make up the free pendulum formed by the upper extremity. The humerus corresponds to the femur, with the ulna and radius corresponding to the tibia and fibula.

8.9.1. The bone in the upper arm (humerus) [408a, b]

We briefly touched on the proximal end with its head, in association with the shoulder joint. The humerus is a long bone, with its distal end forming a cylinder (trochlea). Its medial, concave ridge (margo medialis) culminates in a sharp protrusion (medial epicondyle, epicondylus medialis) which is the origin for the flexors of the wrist and accentuates the angled position

between the upper and lower arm. The shallow, concave lateral ridge ends in the lateral epicondyle (epicondylus lateralis) (origin of the extensors of the wrist). The trochlea that is sandwiched between the two condyles will be discussed in the section on the elbow joint. There is a triangular fossa above the trochlea on both the anterior and posterior surfaces and this contributes towards defining the scope of movement.

8.9.2. The ulna [408a, b, 410]

The proximal end of the ulna surrounds the trochlea of the humerus like a spanner. Of an elongated S-shape, the shaft progressively becomes narrower in a distal direction, is triangular in cross-section, and culminates in a small wheel-like head (caput ulnae). This feature and the elbow (olecranon) are the most important points with reference to plastic appearance. A semilunar notch (incisura trochlearis) is cut into the cube formed by the elbow, which articulates with the trochlea.

Fig. 408 The bones in the upper and lower arm (right).
a) Anterior view of humerus.
b) Posterior view of humerus.
c) Anterior view of ulna.
d) Ulna and radius, connected by ligaments.

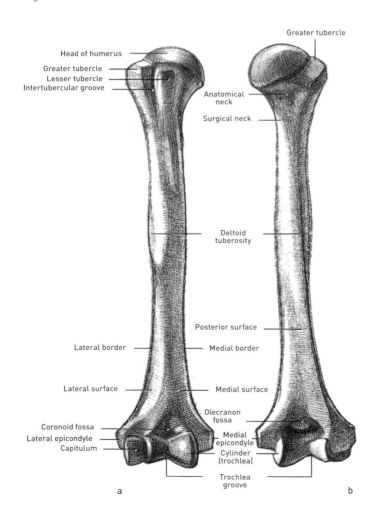

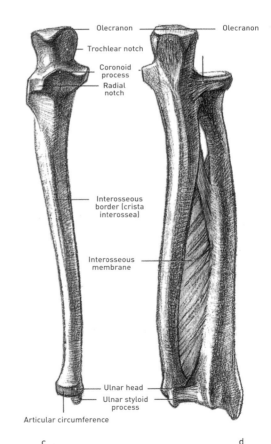

8.9.3. The radius [360d, 408c, 410]

This bone plays a major role in the articulation with the hand and rotates it, hence its curved shape, so it can cross over the ulna. Its proximal end has a wheel-shaped radial head (caput radii). Towards the wrist, the distal end of the radius takes on the shape of a flattened cone. It ends in a blunt, ellipsoid with a hollow carpal articular surface (facies articularis carpea) that articulates with the convex shape of the carpal bones in the wrist (ellipsoidal joint).

Fig. 409 The bony components of the elbow joint.
a) The surfaces that articulate with each other are shown in the same colours.
b) During extension, anterior view.
c) During flexion, medial view.
The colouration shows that the elbow joint is a compound (combined) joint and its articulations are surrounded by a common capsule.

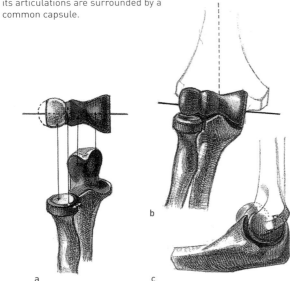

8.10. THE ELBOW JOINT (ARTICULATIO CUBITI)

8.10.1. Functions

This brings together three partial joints (combined joint) that join the distal humerus to the ulna and radius; the latter, in turn, articulate with each other. Functions: mobile interruption and thus shortening of the pendulum formed by the arm, supports swinging movement in the hand through flexion and extension, food consumption through hand to mouth movement, rotation of hand.

8.10.2. Components, structure and constructional shapes of the three partial joints [409, 410]

Precisely aligned articular bodies in the humero-ulnar joint (articulatio humeroulnaris) ensure secure guidance during flexion and extension. The transverse,

grooved cylinder on the humerus (trochlea humeri) and the semilunar 'claws' of the ulna serve this purpose.

The radio-ulnar joint (articulatio radioulnaris proximalis and distalis) is composed of a proximal and distal articulation between the radius and the ulna. Together, the two joints form a hinge or rotary joint as the cylinder of the radial head rotates in the radial notch (incisura radialis) on the ulna and, conversely, ulnar notch on the radius rotates around the ulnar head close to the wrist, like a door on its hinges.

The humero-radial joint (articulatio humeroradialis) is an articulation between the capitulum on the humerus (capitulum humeri), an almost spherical appendage on the trochlea, and the shallow cup (fovea capitis radii) on the head of the radius. This joint acts as an additional abutment for the radius for rotation around the vertical axis and flexion and extension.

8.10.3. The mechanics of the elbow joint and its changes in plastic appearance

Flexion–extension in the humero-ulnar joint: This is the result of the pure hinge joint with its transverse cylinder, with an axis that can be envisaged as emerging directly below the medial and lateral epicondyles [410]. The angle of extension between the humeral shaft and the ulna is 180° (often slightly hyper extended in women and children, see Figure 372) and the angle is reduced to 40° during flexion. During this process, there are radical changes in plastic appearance: at rest (extended position), the elbow is positioned above the transverse axis. Together with the lateral and medial epicondyles, this forms a flat triangle (with its base aligned with the axis).

When the elbow is flexed at right angles, the olecranon moves out of the olecranon fossa and is now positioned below the transverse axis; the triangle that is thus formed rests on it apex. In a lateral view, the olecranon is sharply delineated and appears to extend the upper arm downwards. The dorsal portion of the cylinder is only grasped very slightly by the 'claws of the ulna' when the arm is strongly flexed. The elbow flattens off; two typical accents are created. An area with three points is created in association with the two epicondyles.

Rotation of the hand at the proximal and distal radio-ulnar joints [360d, 411a–c]: The position of the hand in which the palm faces forwards or upwards is called supination. Without this, it would be impossible to carry an object, e.g. by holding it underneath (a tray, etc.). The thumb points in a lateral direction. From this position, the hand can be rotated such that its dorsal aspect faces forwards or upwards (pronation) and the thumb is now in a medial position. In this process, the radius rotates around the fixed ulna, crossing over it. The rotational axis is crucial to this movement (see section 8.2.), passing through the centre of the ulnar and radial heads, and which can be extended in an imaginary line through to the centre of the humeral head [360d, 411a–c]. Rotation of the hand is often associated with turning the entire arm around this rotational axis. This allows the hand to be rotated by almost 360°.

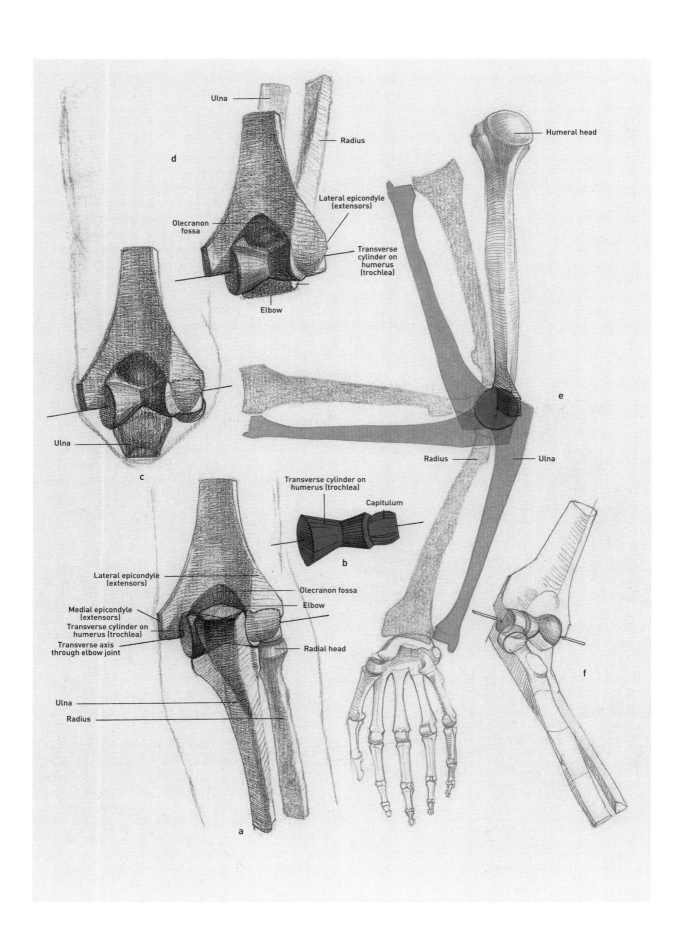

Ulna

Radius

d

Lateral epicondyle
(extensors)

Olecranon
fossa

Transverse
cylinder on
humerus
(trochlea)

Elbow

Humeral head

e

Ulna

c

Radius

Ulna

Transverse cylinder on
humerus (trochlea)

Capitulum

b

Lateral epicondyle
(extensors)

Olecranon fossa

Elbow

Medial epicondyle
(extensors)

Transverse cylinder on
humerus (trochlea)

Transverse axis
through elbow joint

Radial head

Ulna

Radius

a

f

Fig. 410 (left) Structure and mechanics of the elbow joint.
a) Posterior view of the extended elbow joint: elbow positioned above the imaginary transverse axis through the olecranon fossa.
b) The transverse humeral cylinder (trochlea) with the trochlear groove for guiding the ulna and the capitulum as an abutment for the radial head, shown in isolation.
c) Posterior view of the elbow joint flexed at a right angle: the ulna is positioned below the lateral and medial epicondyles
d) Posterior view of the strongly flexed elbow.
e) Right upper and lower arm skeleton in different positions (as in **a**, **c** and **d**)
f) The elbow joint flexed at approximately a right angle and in a spatial perspective, constructional drawing.

Adapted from Bammes, *Wir zeichnen den Menschen.*

In order to describe the changes in plastic appearance, we are assuming that the arm is flexed and resting on a surface with the back of the hand pointing upwards or forwards (pronation). This results in the following: clear protuberance of the ulnar head in the wrist (lateral side), spiral torsion of the muscles, whereby the extensors of the wrist that originate from the lateral epicondyle are twisted towards the radius that is located medially (especially the extensor carpi radialis longus and brevis and, above all, the brachioradialis). Torsion of these muscles results in their extension at their origin and thus in a flattening of the pit in the muscles at the lateral epicondyle. Analogous to this, the flexors that originate from the medial epicondyle are twisted. They are forced into taking a diagonal course through the swerving movement of the radius. Their mass thus enlarges even further on the palmar side of the lower arm [434].

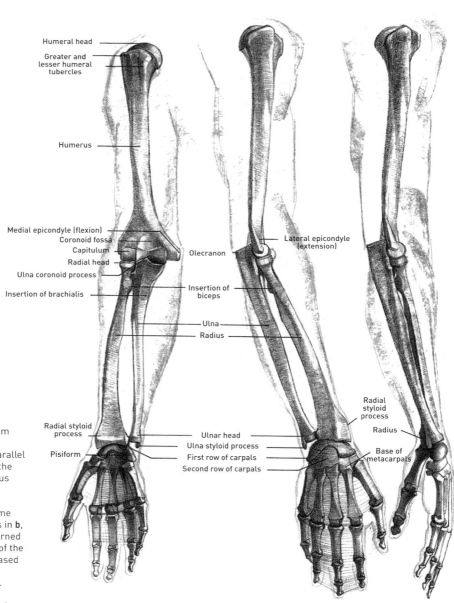

Fig. 411 (right) The articulated skeleton of the arm.
a) Anterior view of the arm (palm facing forwards).
b) Lateral view with greatest parallel positioning of the two bones in the lower arm (with rotation of radius round the ulna).
c) Most extreme cross-over of the ulna by the radius in the same lateral view of the upper arm as in **b**, but with the back of the hand turned forwards. The internal rotation of the hand can be substantially increased through internal rotation of the upper arm at the shoulder joint.

Adapted from Bammes, *Wir zeichnen den Menschen.*

Humeral head
Greater and lesser humeral tubercles
Humerus
Medial epicondyle (flexion)
Coronoid fossa
Capitulum
Radial head
Ulna coronoid process
Insertion of brachialis
Olecranon
Lateral epicondyle (extension)
Insertion of biceps
Ulna
Radius
Radial styloid process
Pisiform
Ulnar head
Ulna styloid process
First row of carpals
Second row of carpals
Radial styloid process
Radius
Base of metacarpals

a b c

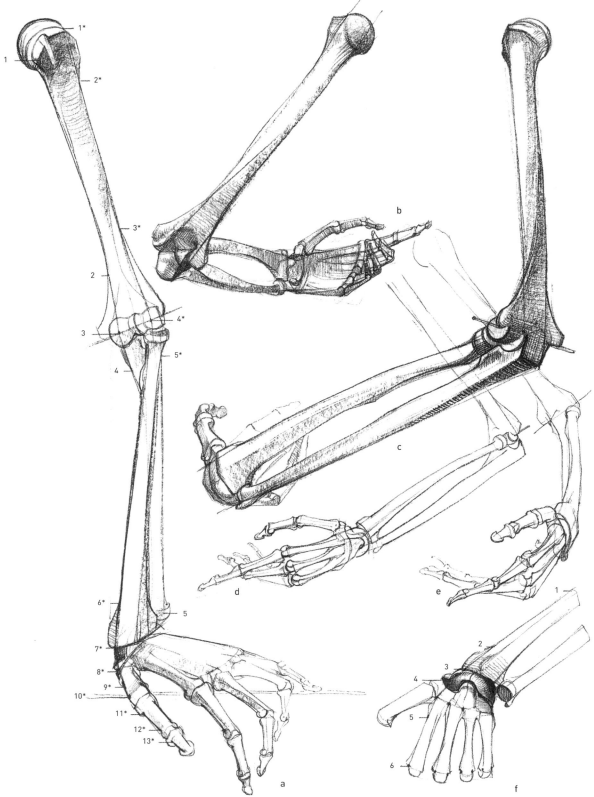

Fig. 412 The skeleton of the arm and
its relationships between shapes and
functions.
The numbers along the side indicate the
'low points' for the internally associated
correlation chain, which can also be
followed during movement of the skeleton
and is of greatest importance to the
creation of a transparent arrangement
when starting a drawing for a study.

8.10.4. Relationships between shapes in the skeleton of the arm during action [412]

Whoever wishes to understand or produce a model of an arm with its volumes, directions and relationships correctly put together, must learn to draw the skeleton of the arm during action. The sequence of internally associated points with the constructionally required breadths indicates the orientations of the individual sections, their spatial relationships to each other and the functional processes (e.g. supporting weight on the hand, crossing over of the bones in the lower arm, behaviour of the fingers, etc.). Recognition of associated directions and shapes is an urgent requirement in the arm, as is rarely applicable to any other part of the body. The relationships must be traced from the head of the humerus through to the terminal digit of the thumb or index finger. First, the directions and proportions, then the positions of the axes through the joints in space, must be assessed to determine how one section is affected by the next. Let us investigate this based on Figure 412a, to see how the breadth of the shaft and orientation of the upper arm continues from its head through to the elbow joint. The shaft ends in the centre points of the trochlea (numbers 3 and 4*). The head of the humerus and the medial and lateral epicondyles are necessary, but simultaneously only stabilising ancillary shapes. The ulna continues the line of the humerus from 3 and 4* through to the ulnar head (5). The crossing over of the radius is added to this basic orientation, dictated by the mechanics of the elbow. It articulates at the point of rotation (4*), crosses diagonally over the ulna and the correlation chain is continued via 6*, 7* to 13* with increasing widening of the shaft for the hand. The distensions of the strengthened joints are, once again, only ancillary shapes. Even the muscles do not change these fundamental connections! We can also follow the relationship from the point of rotation for the radius through to the tip of the index finger in Figure 412d. All breadths and additional shapes can be allocated to and are subordinate to this relationship, down to the last and finest of details. The ability to see through and synopsize can be practised on the skeleton in general, particularly so on the skeleton of the arm!

Summary:

1. The free, mobile arm is composed of the humerus, the ulna and radius, which are connected by a combined or compound joint, the elbow joint.
2. The elbow joint interrupts the pendulum formed by the arm and allows the hand to be used at any given point within the conical space that is described by the distal end of the arm, starting at the shoulder joint.
3. The elbow joint is divided into:
 a) the humero-ulnar joint
 b) the radio-ulnar joint
 c) the humero-radial joint.
4. The humero-ulnar joint is formed by the transverse trochlea, with its groove for guiding the ulna and the ridge of the ulnar olecranon for guidance. During flexion, the upper and lower arm form an angle of 40° at this hinge joint, with a possible extension of 180°. Hyperextension is common in women and children.
5. The radio-ulnar joint is a double joint that is functionally associated but forms two anatomically separate joints, the proximal and distal radio-ulnar joints:
 a) The proximal joint is composed of the trochlea, the radius and the radial notch on the ulna,
 b) The distal joint is formed of the ulnar head and the ulnar notch on the radius.
 The hand is rotated (120 to 140°) round a rotational axis. This movement arises from the connection between the centre of the ulnar head, the centre of the radial head and the centre of the head of the humerus.
6. The construction of the humero-radial joint is that of a ball-and-socket joint, which is formed of the cup in the radial head and the capitulum on the humerus. The radius is attached to the ulna such that only one movement is permitted during flexion–extension and supination–pronation. This supports the previous two joints.
7. Supination and pronation of the hand is usually combined with external or internal rotation of the entire arm, allowing the hand to be rotated by 360°.
8. The normal position of the arm at rest is a slight crossing over of the ulna and radius. The space between the two bones in the lower arm is greatest in this position.

8.11. THE MUSCLES OF THE ELBOW JOINT

8.11.1. Overview of the general system

The muscles that act on the elbow joint are located anterior and posterior to its transverse axis and are therefore flexors and extensors [413a, 417]. Some of these muscles originate from the scapula and thus also act secondarily on the shoulder joint.

Flexors are:
the two-headed biceps (M. biceps brachii)
the brachialis (M. brachialis)
the brachioradialis (M. brachioradialis; this will be discussed with the muscles of the lower arm)
The extensor is:
the three-headed triceps (M. triceps brachii)
The two functional groups are located anterior and posterior to the transverse axes through the shoulder and elbow joints and thus exhibit a large sagittal and a narrow transverse expansion [413b, c].

Supinators–pronators (rotational muscles of the hand) are primarily located in the deep muscle layer. They must cross over the rotational axis. We will touch upon these muscles if they are supported by superficial muscles, but will not discuss the main supinators–pronators in detail.

8.11.2. The flexors

The biceps (M. biceps brachii) split into a long and a short head in the direction of the scapula [414a, 415, 417, 418].

Origins: Posterior superior margin of the glenoid cavity (long head). Coracoid process on the scapula (short head).

Course and insertion: The two heads fuse above the middle of the humerus, forming a spindle-shaped muscle belly which inserts into the tuberosity of the radius.

Function [418b]: This muscle acts on more than one joint as it is not only located anterior to the transverse axis through the elbow joint, but also anterior to the shoulder joint; therefore, flexion of the elbow and anteversion of the arm at the shoulder joint, fixing of the unflexed elbow, especially under loading; supination of the hand when the arm is flexed and the back of the hand is pointing upwards (pronation), the biceps tendon loops round the neck of the radius in this position (see Figure 414a, right ancillary illustration). Shortening during contraction unravels this loop and the radius rotates outwards.

Fig. 414 (right, top) The muscles of the upper arm.
a) Anterior view of the flexors.
Ancillary illustration: unravelling of the biceps tendon and the associated supination (palm of hand pointing upwards).
b) Lateral view of the flexors and extensors that build up the sagittal volume.
Ancillary illustration: biceps tendon looped round the radius close to its insertion (pronated position of back of hand).
The juxtaposition of the lateral and anterior views highlight the differences in the dimensions in the upper arm, with a large sagittal and a narrow transverse expansion.

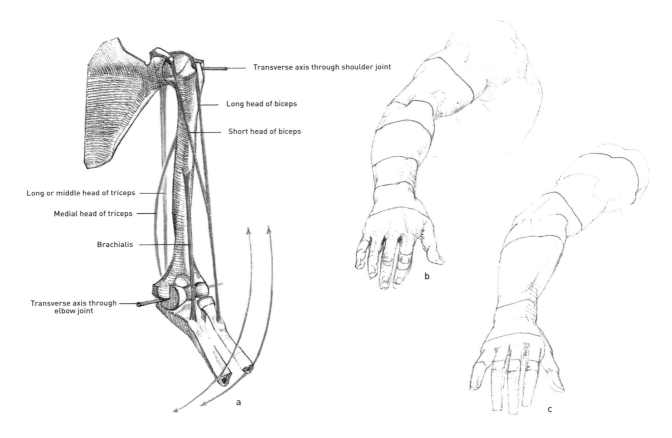

Fig. 413 The system of arrangement of the muscles in the upper arm and the associated characteristics of the volume of the upper arm.
a) Line illustration of the muscles of the upper arm. Red: flexors; blue: extensors; arrows: extent of flexion and extension of lower arm.

b) Differences in sagittal and transverse expansion in the volumes of the upper and lower arms.
c) The same problem as in b, but broken down into more elements.
The relative positions of the upper arm muscles anterior and posterior to the transverse axes through the shoulder and

humero-ulnar joints indicates the flexors and extensors. Viewed together, these muscle layers build up to form great sagittal depth (see cross-sections through upper and lower arms, page 382).

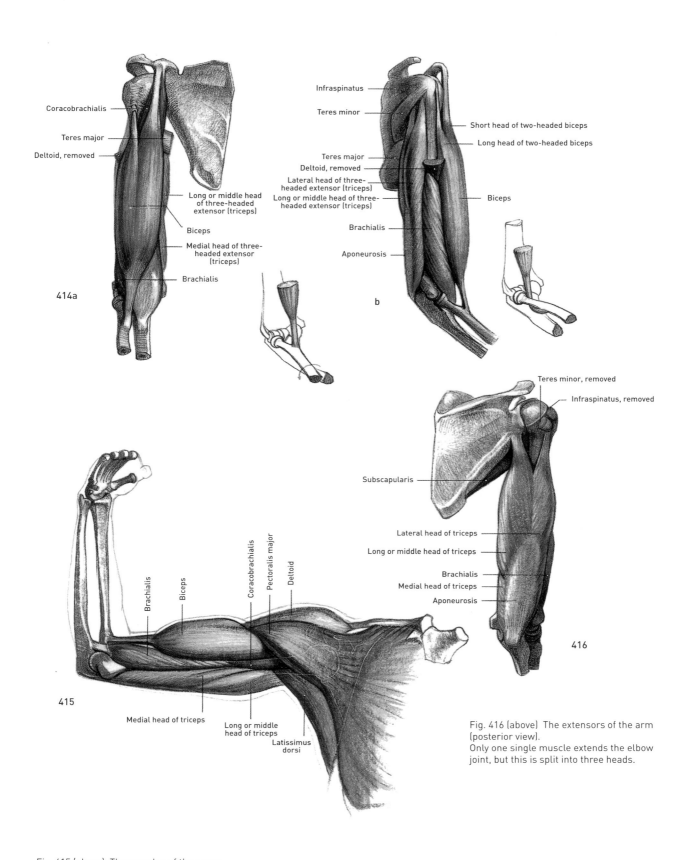

Coracobrachialis

Teres major

Deltoid, removed

Long or middle head of three-headed extensor (triceps)

Biceps

Medial head of three-headed extensor (triceps)

Brachialis

414a

Infraspinatus

Teres minor

Short head of two-headed biceps

Long head of two-headed biceps

Teres major

Deltoid, removed

Lateral head of three-headed extensor (triceps)

Long or middle head of three-headed extensor (triceps)

Biceps

Brachialis

Aponeurosis

b

Teres minor, removed

Infraspinatus, removed

Subscapularis

Lateral head of triceps

Long or middle head of triceps

Brachialis

Medial head of triceps

Aponeurosis

416

Brachialis

Biceps

Coracobrachialis

Pectoralis major

Deltoid

Medial head of triceps

Long or middle head of triceps

Latissimus dorsi

415

Fig. 415 (above) The muscles of the upper arm during action.
The medial view of the upper arm shows the two flexors, not only acting on the elbow joint, but the biceps also acting to produce anteversion of the arm at the shoulder joint and as a powerful supinator.

Fig. 416 (above) The extensors of the arm (posterior view).
Only one single muscle extends the elbow joint, but this is split into three heads.

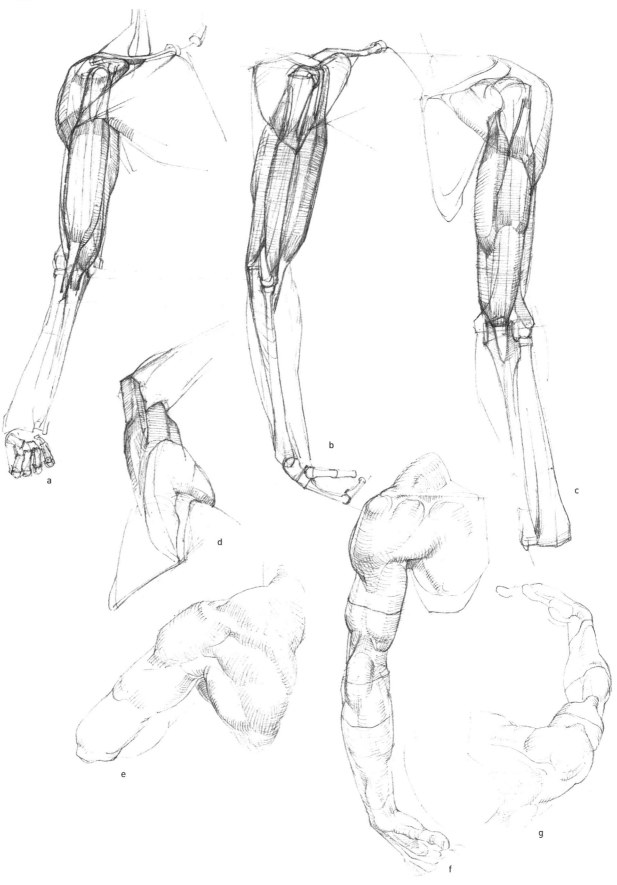

a

b

c

d

e

f

g

Fig. 417 (left) The architectural form of the muscles of the upper arm and the differences in dimensions of volumes in the arm in the model.
a)–c) The sagittal layering of the muscles in the upper arm.
d) The muscles in the upper arm in association with the deltoid, arm raised.
e) Posterior view of the upper arm in association with the plastic appearance of the shoulder.
f) The upper arm dangling down in the model, with cross-sections.
g) The same arm with cross-sections. View from the shoulder.

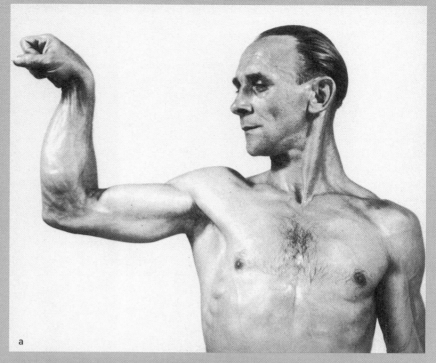

a

Fig. 418 The biceps during action.
a) Flexion of the elbow joint, position of hand in pronation.
b) Supinatory activity of biceps starting from pronation.
The comparison of the differences in plastic behaviour informs us that the biceps achieves its greatest extent of contraction through the combination of flexion of the arm and supination of the radius.

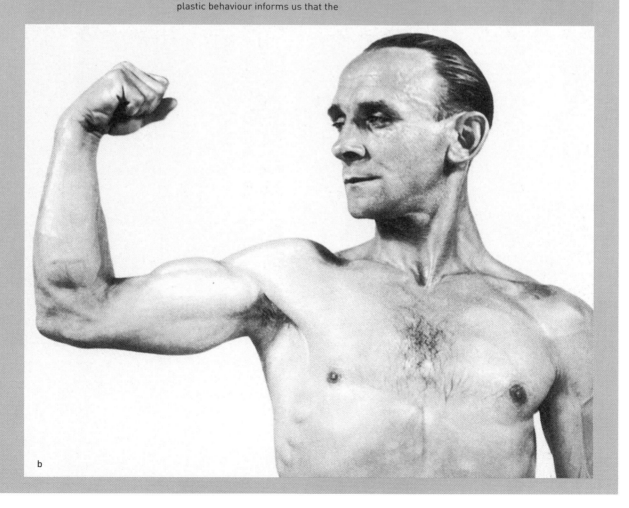

b

Plastic appearance: This muscle exhibits its greatest increase in volume when it is contracted. The elongated spindle shape at rest wells up to the size of a fist and contrasts with the taut shape of the tendon at its insertion. The muscle belly also exhibits two accents during action; it is not simply bulbous and round [415, 416, 418].

The brachialis (M. brachialis, also called the elbow flexor) forms a bed of padding underneath the biceps [414, 416].
Origin: Anterior surface of the humerus at the level of the insertion of the deltoid.
Course and insertion: Crosses over the transverse axis through the elbow joint, inserts into the ulna close to the rotational point with a short, compact tendon.
Function: Dedicated, primary flexor of the lower arm.
Plastic appearance: Even though its anterior aspect is covered by the biceps, it protrudes to a greater and lesser extent on the medial surface of the arm. It increases the sagittal depth of the flexors.

8.11.3. The three-headed extensor (M. triceps brachii) [413, 415, 416, 417c]

This is the only antagonist to the flexors and, as such, its three heads are located behind the transverse axis through the elbow joint, with some of the muscle also located behind the transverse axis through the shoulder joint at its origin.
Origins: Inferior posterior margin of the glenoid cavity (middle head), posterior surface of the humerus (medial head), posterior and distal to the head of the humerus (lateral head).
Course and insertion: The three heads merge into an aponeurosis that transitions into a strong tendon at its insertion into the olecranon.
Function: As an antagonist to the biceps, it also acts on two joints: retroversion of the arm at the shoulder joint through action of the long middle head. All three heads extend the elbow joint (throwing, hitting, pushing), fix the arm when it is doubled up, push the load imposed by the body upwards from a flexed position (press-ups, bent arm supporting weight of body on parallel bars).
Plastic appearance: Confers a 'flame-like' appearance on the posterior aspect of the arm. During contraction, the aponeurosis forms a taut, tensed surface that is drawn inwards and is surrounded by the protruding muscle heads. There is a deep furrow between the flexors and extensors where they meet (medial side of humerus), from which the medial (lesser) tubercle on the humerus protrudes. The posterior portion of the deltoid crosses diagonally over the origins of the long and lateral heads.

Summary overview: the actions of the muscles of the elbow joint

The humero-ulnar joint

Axis	Movement	Muscles involved (full list)
Transverse axis	Flexion	Biceps (M. biceps brachii) Brachialis (M. brachialis) Brachioradialis (M. brachioradialis) (discussed in section on lower arm)
	Extension	Triceps (M. triceps brachii)

The proximal and distal radio-ulnar joint

Axis	Movement	Muscles involved (full list)
Rotational axis	Pronation	Pronator teres (M. pronator teres) O Pronator quadratus (M. pronator quadratus) +
	Supination	Supinator (M. supinator) + Biceps (M. biceps brachii) Brachioradialis (M. brachioradialis) (discussed in section on lower arm)

+ = not discussed, not depicted

O = not discussed, only depicted

8.12. THE HAND (MANUS)

8.12.1. General functions, specific features and importance of the hand

We associate the term 'hand' with an organ that is capable of all-round use. Liberated from its supporting function, its digits – the fingers – have increased in length and in the capacity for finely differentiated individual movement. The thumb takes on notable significance thanks to its opposability to all other fingertips. The thumb, above all, turns the hand into a grasping tool. It has turned into a thing for us that helps us to work; we thus also associate the term 'hand' with great value. It is the sensory organ for blind and sighted people, the companion for our emotions (as an instrument to express them). Its character and shape echo the qualities expressed by the face and the entire body. Marked by work, life and fate, the physiognomy of an aged hand [440] therefore approaches the quality of the immediate expression found in the physiognomy of the face. How high does the 'multifunctional hand' (Goethe) rise above the bare fulfilment of primary functions in life! Work, that gigantic metabolic process that takes place between humans and Nature, requires the existence of the hand and it, in turn, became ever more subtle because of it. Through our hands we shape

the world, without which we would be thrown into it, helpless. When art strives to embody the nobility of the human image, it rarely dispenses with the hand, our second portrait. Depicting hands in art has almost become a form of touchstone for artistic excellence. Wishing to abstract the hand into 'primeval shapes', such as a spoon, spade, scoop, pincer, trowel, hammer is nothing other than subjective interpretation. The primeval shape of the hand is not the abstraction, the hand 'is'! In life, as in works of art, the hand signifies human actions and attitudes. Deep understanding and immersion into its essence gives the artist and the observer a greater insight into the person in the illustration. Wilhelm Waetzoldt granted three roles to the hand in his work *Die Kunst des Porträts*; it accompanies language through gestures, its fineness, and its sensitivity is an expression of the soul of the owner; who would wish to argue with this at the sight of Mona Lisa's hand when she is resting on her arm with equal assurance and ease? Does not the fine, sensitive hand reflect an entire social situation when fingertips are nestling against velvet, silk, brocade and fur? Furthermore: it creates bridges for personal interactions as it expresses action. The threatening, clenched fist, the hand used when taking an oath or the pleading, open hand are all symbolic; the soft, mature female hand of Saskia who is passing her red flower to the observer thus creates a secret bond with the

Fig. 419 The bones of the hand.
a) Anterior view with outlines of the palm.
b) Posterior view.
The plastic structure of the back of the hand is largely conferred by the skeleton as there are few muscles and no padding.

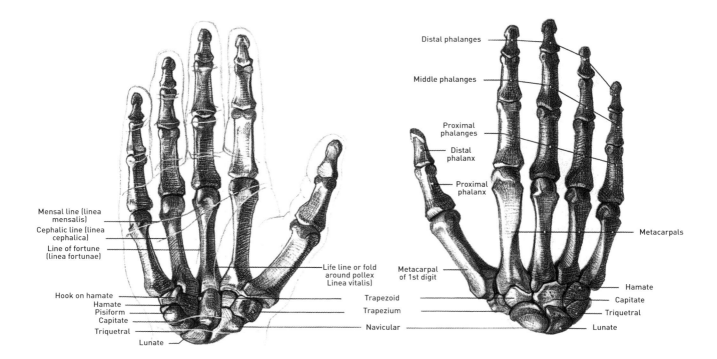

a

Mensal line (linea mensalis)
Cephalic line (linea cephalica)
Line of fortune (linea fortunae)
Hook on hamate
Hamate
Pisiform
Capitate
Triquetral
Lunate
Life line or fold around pollex Linea vitalis)

b

Distal phalanges
Middle phalanges
Proximal phalanges
Distal phalanx
Proximal phalanx
Metacarpal of 1st digit
Trapezoid
Trapezium
Navicular
Metacarpals
Hamate
Capitate
Triquetral
Lunate

observer. The hand is essentially of formal importance for the composition, it is the optical correlate to the face.

Understanding the evolution, structure and function of the hand means penetrating a little further into the knowledge of the greatness of humanity.

8.12.2. Organisation, constructional form and proportions of the hand [419–421, 424, 425, 429]

Organisation: We distinguish between three sections of the skeleton of the hand:
1. carpals (carpus), a group of eight short bones,
2. metacarpals (metacarpus), a trapezoid or plate-shaped grasping area formed of five long bones,
3. phalanges (digiti) extensions to the metacarpals that can be bent and splayed.

Constructional form: The carpals are divided into a proximal or first row of carpals and a distal or second row of carpals [423]. The first row is composed of four bones (see illustration for names) that jointly form a C-shaped bow with the task of articulating with the radius. The second row forms the connection (four bones) between the metacarpals and the first row of carpals, into which the capitate (Os capitatum) protrudes.

Together, the metacarpals form the bony foundations for the palm and the back of the hand as well as the base for the fingers. The flat longitudinal arch formed by the metacarpals ends in the heads of the metacarpals; the transverse arch that extends between the fifth and the second digits has its apex between the second and third metacarpals [424c, g, 425b, c]. The arched nature is even clearer on the palmar side of the hand due to its strong concavity. The metacarpal of

Fig. 420 The constructional form of the metacarpals and carpals.
a) Palm in an anterior view, back of hand facing upwards.
b) Medial view (on side of thumb).
c) Palm in an anterior view, palm facing upwards.
d) Lateral view (on side of little finger). The more pronounced transverse arch adjacent to the carpals and the flat transverse arch across the heads of the metacarpals are important in the plastic appearance.

Fig. 421 The constructional form of the first and second rows of carpals (articular surfaces in blue colouration).
a) The first row of carpals composed of three bones is drawn together as one form and dissociated from the second row of carpals to clarify the structure of the midcarpal joint.
b) First and second rows of carpals combined.

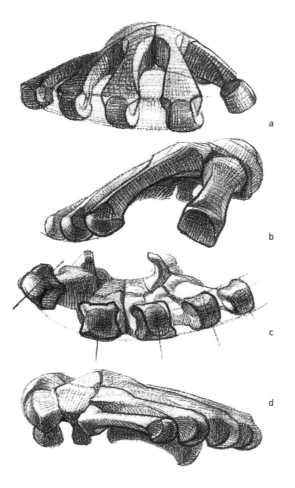

a

b

c

d

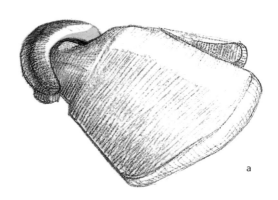

a

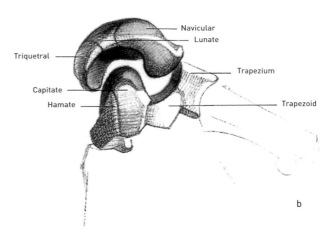

Triquetral

Navicular
Lunate

Trapezium

Capitate

Hamate

Trapezoid

b

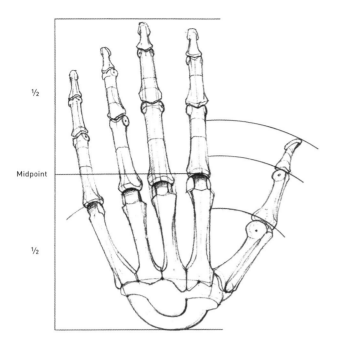

½

Midpoint

½

the first digit (pollex) is freely mobile (saddle joint) and occupies a special position. At rest, it inserts itself into the transverse arch almost at right angles, such that it can brush across the palm. The first digit only has proximal and distal phalanges.

Proportions [422]: The entire length of the hand corresponds to the length of the face or one tenth of body height. Together, the carpals and metacarpals of the third digit are as long as the phalanges of the third digit. The palm of the hand – without the pollex – forms a trapezoid shape. Its greatest length (side of hand with second digit) corresponds to its greatest breadth (connection between the heads of the metacarpals), its shortest length (side of hand with fifth digit) corresponds to the shortest breadth (connection between the bases of the metacarpals from the second to fifth digits).

Fig. 422 The proportions of the hand. The distance from the proximal end of the carpals to distal end of the metacarpal of the second digit corresponds almost exactly to the length of the phalanges of the third digit. The greatest breadth of the palm formed by the metacarpals corresponds to approximately the length of the metacarpal of the fifth digit.

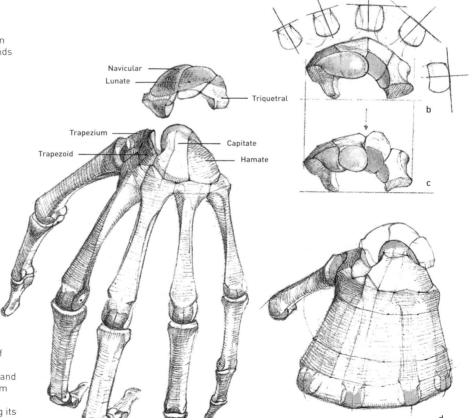

Navicular
Lunate
Triquetral
Trapezium
Trapezoid
Capitate
Hamate

b

c

a

d

Fig. 423 The structure of the bones of the hand.
a) Skeleton of the hand with the first and second row of carpals dissociated from each other.
b) The second row of carpals showing its transverse arch (proximal view) and the principle of radial arrangement of the heads of the metacarpals.
c) Transverse arch of the second row of carpals (proximal view) in isolation. Note the apex (arrow) between the second and third bones.
d) Metacarpals and second row of carpals drawn together as a whole, with the first row of carpals indicated.

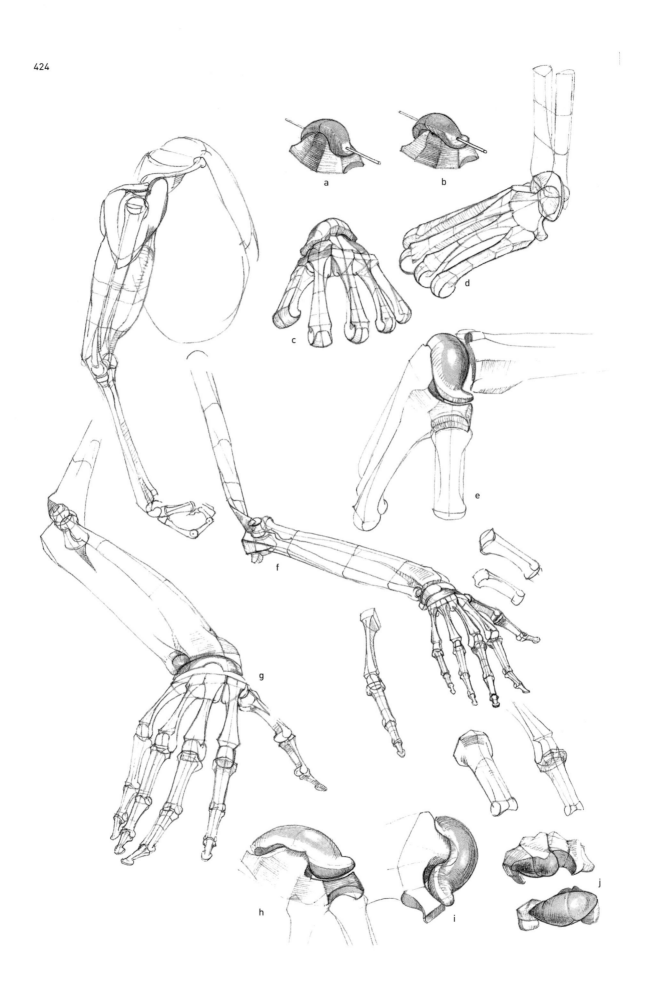

a

b

c

d

e

f

g

h

i

j

388 The upper extremities

Fig. 424 (left) The constructional shapes of the skeleton of the upper and lower arms.
a), b) Articulated first and second rows of carpals. The first, C-shaped row articulates with the second like a hinge joint, with the two jointly forming a midcarpal joint with a ~-shaped joint cavity that effects dorsal flexion.
c) The radial arrangement of the transverse arch formed by the carpals and metacarpals.
d) Tilting movement (dorsal flexion) of the midcarpal joint in association with the skeleton of the lower arm.
e) Flexion of the wrist towards the palm of the hand (volar flexion). The first row of carpals forms an ovoid shape that articulates with the facets on the ulna and radius.
f), g) Articulated skeleton of the lower arm and hand, the latter with the elbow abducted.
h), i) Midcarpal joint in detail. The positive and negative forms articulate with each other alternately and from both sides.
j) First and second rows of carpals dissociated from each other, seen from proximal and distal direction.
The articular surfaces are indicated in blue colouration.

8.12.3. The joints of the hand [423a, b, c, 424, 425]

We distinguish between a proximal radiocarpal joint and a distal, or midcarpal, joint both of which participate to varying degrees in flexion and extension, as well as the metacarpophalangeal joints, proximal interphalangeal and distal interphalangeal joints in the second to fifth digits.

The proximal, actual wrist joint, the radiocarpal joint (articulatio radiocarpea): three of the four bones in the first row of carpals jointly form a C-shape. The proximal surface of the sickle shape is ellipsoid and rounded, and articulates with the corresponding facet in the end of the radius (ellipsoidal joint). The transverse axis runs from the margin of the radius through to the margin of the ulna. Perpendicular to this, the sagittal axis runs through the capitate (second row of carpals) from the dorsal to the volar aspect of the hand (dorsovolar axis) [421, 426a, b, d, e].

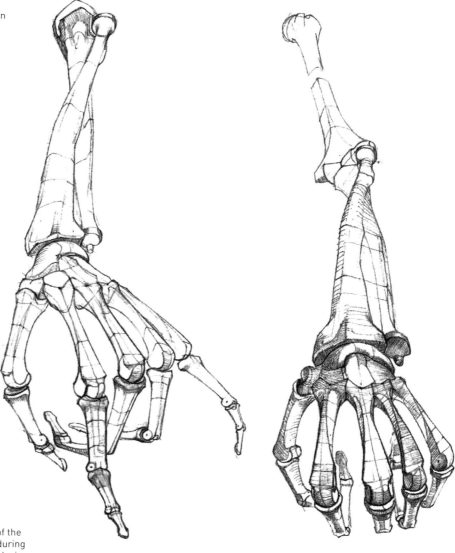

Fig. 425 The constructional shapes of the skeleton of the lower arm and hand during action. One of the most important tasks in studies for drawing is the safeguarding of the organic functional continuation from one section to the next.

The distal or midcarpal joint (articulatio intercarpea) arises from the capitate in the second row of carpals being inserted into the hollow in the C-shape formed by the first row (development of a hinge joint); on the other hand, a cylindrical, rounded portion of the navicular (first row) articulates with a corresponding facet in the second row. The joint cavity thus forms an irregular horizontal ~ . The single axis through this joint passes through the capitate in the form of a transverse axis (pure hinge joint) [421, 424h, i, j].

8.12.4. Mechanics and changes in the plastic appearance of the two joints in the hand

In the actual wrist joint (articulatio radiocarpea), we carry out flexion in the direction of the palm (volar flexion) and in the direction of the back of the hand (dorsal flexion) [426a, 429c, 430].

Volar flexion moves the hand into an angle of 60° to the lower arm, while movement in the opposite direction only angles the hand at 50° in relation to the lower arm. This dorsal flexion occurs mainly in the hinge joint formed by the midcarpal joint.

First, volar flexion accentuates the ellipsoid head shape of the first row of carpals, in particular, which is pushed out of its bony grasp of the radius; second, the bony distal end of the lower arm is accentuated and, third, there is the transition from the carpals to the metacarpals. The skin is stretched over the joint on the back of the hand, with multiple transverse folds developing in the palm [426b, 430a].

During dorsal flexion (midcarpal joint), it is mainly the pisiform (the fourth bone in the first row of carpals) and the trapeziometacarpal joint of the pollex (trapezium) that protrude [430b]. The second basic movement in the wrist is abduction in the direction of the radius and ulna

Fig. 426 The mechanics of the wrist joint.
a) Dorsal flexion equates to about 50°, largely occurring in the midcarpal joint.
b) Volar flexion of about 60° occurs in the proximal radiocarpal joint.
During volar flexion, three accents, one behind the other, develop on the back of the hand.

Fig. 427 The mechanics of the proximal radiocarpal joint.
a) Abduction of the radius of about 30°.
b) Abduction of the ulna of about 40°.
The ovoid shape of the first row of carpals articulates mainly in the facet on the radius. The centre of rotation for this movement across a surface lies in the capitate in the second row of carpals. The side opposite to the direction of abduction forms accents that are particularly marked during abduction.

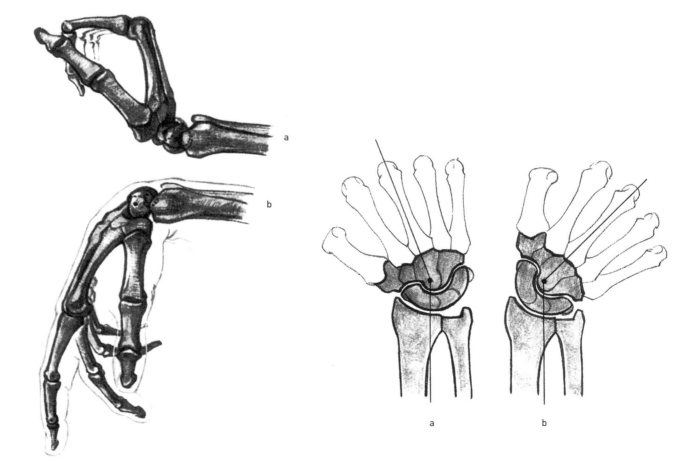

(radial and ulnar abduction) [427, 431, 432]. This occurs around the sagittal axis (with the centre of rotation in the centre of the capitate). During this process, the C-shaped bow formed by the first row of carpals moves back and forth in the facet on the radius, with the 'hacking movement' most intense in the direction of the ulna (ulnar abduction). This is associated with the fact that the styloid process on the radius is bent outwards more convexly than in the position at rest; the distance to the base of the pollex is increased. This latter feature is more strongly accentuated. On the opposite side, the edge of the fifth digit moves closer to the ulna (folding of the skin). Conversely, abduction in the direction of the radius increases the distance between the ulna and metacarpals on the side of the fifth digit. The styloid process on the ulna becomes an interim accent, while the pollex moves closer to the radius on the opposite side.

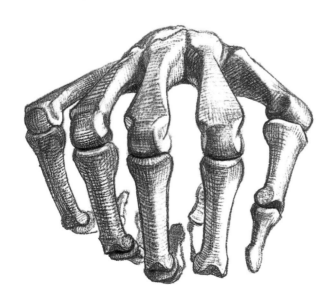

Fig. 428 The skeleton of the hand in a fist. Flexion of the metacarpophalangeal joints causes the fingers to automatically form a fist due to the radial position of the heads of the metacarpals. The knuckles that protrude in the fist are the exposed heads of the metacarpals.

8.12.5. Structure and mechanics of the joints of the digits [423, 424, 428]

In the metacarpophalangeal joints (articulationes metacarpophalangeae), the heads of the metacarpals articulate with facets on the proximal phalanges, similar to ball-and-socket joints (restricted ball-and-socket joint construction due to the collateral ligaments that are found here). We flex the proximal digits at right angles to the palm of the hand around the transverse axes, with the digits being splayed around the sagittal axes. During flexion (making a fist), the heads of the metacarpals protrude in the form of humps [425, 428, 433]. The subsequent middle and distal interphalangeal joints (articulationes interphalangeae manus) are pure hinge joints with transverse axes for flexion and extension, whereby flexion occurs approximately at right angles to the previous phalanx. The significance of the pollex stems from the particular mobility of its metacarpal, the base of which articulates with the trapezium (Os multangulum major in the second row of carpals) and forms a saddle joint that permits abduction and adduction, in addition to opposing the fingertips (opposition) and moving back into a neutral position (reposition).

8.12.6. Relationships between shapes in the skeleton of the lower arm and hand [424g, f, 425, 429]

Even in an entity like the hand that is highly differentiated and has multiple segments, we can trace the relationships between shapes in long chains of associated breadths, strengths and directions: connection of the shaft of the humerus with the conical centre of the trochlea in the elbow joint, assumption of this breadth in the ulna and radius, continuation of the breadth of the ulna and radius in the breadth of the carpal rows. For example, the 'low point' of the radius is continued by the 'low point' of the carpals across the wrist (5*); this relationship persists through the metatarsal of the second digit and into its tip (9*) [429a]. These relationships are the first and final concern when drawing the skeleton of the hand with its many individual shapes. Without this, it is impossible to recognise the ancillary forms as such, and to arrange them in order. What pertains to the relationship between breadths also applies to the strengths. And we pay particular attention to a further relationship: the dependency of the position of the hand (supination–pronation) on the spatial position of the radius in relation to the ulna [429a, a*, b, b*, c, e].

Summary:

1. The hand is distinguished from the foot mainly due to its grasping ability with the aid of the thumb (pollex), that is fully opposable to all fingers (opposition).
2. The effect of work has crowned the hand with a high degree of perfection. 'It is not only the organ of work, it is also the product of work' (Engels).
3. Following on from the perfection of the hand, which is no longer required in a weight-bearing capacity, changes occurred in the rest of the body that interact with it.

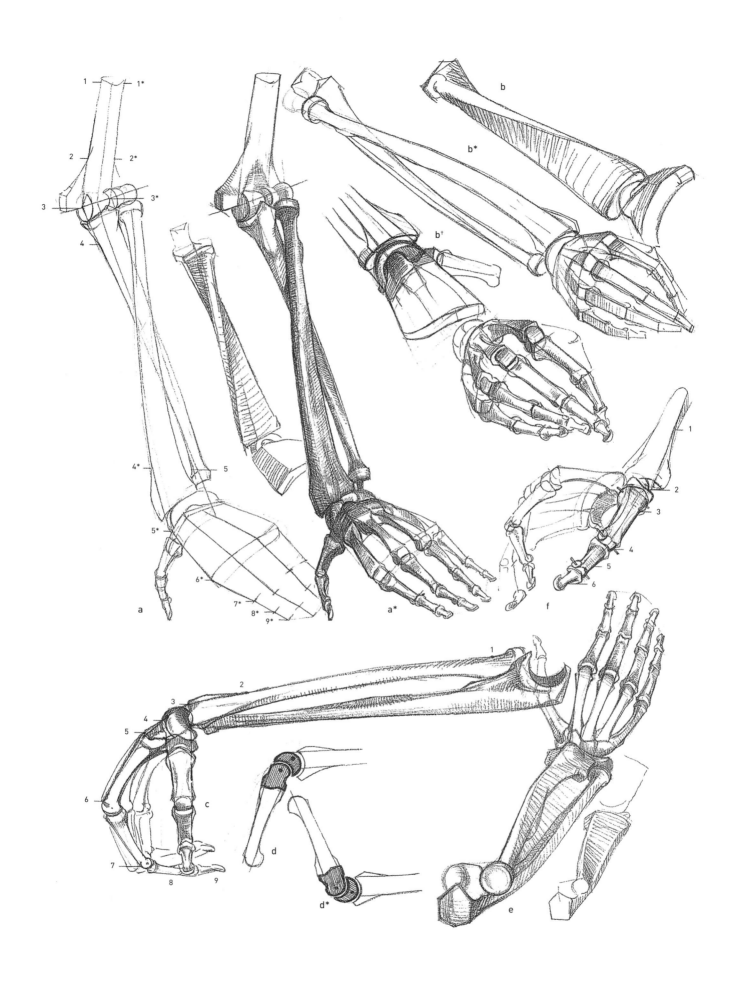

a

a*

b

b*

b†

f

c

d

d*

e

Fig. 429 Skeleton of the lower arm and hand and its relationships to function and between shapes. The numbering along the side indicates the 'low' points for the internally linked correlation chains. Note the twisted plastic appearance of the ulna and radius as a complex interpreted form [a, b, e, d, d*]. Longitudinal cross-sectional view of the behaviour of the wrist joint during dorsal flexion and volar flexion.

4. The hand is not only used for work, but is also a sensory organ (touch) and an instrument used for expression (gestures). It is the second human face and is thus of great importance in portraits.
5. The hand is divided into sections: carpals, metacarpals, digits.
6. The carpals are composed of a proximal, first, and a distal, second, row of bones that articulate with each other.
7. The joints of the hand are:
 a) The proximal radiocarpal joint, formed of the first row of carpals with its ellipsoid shape that articulates with the facet in the radius (ellipsoid joint). The movements that occur here are flexion–extension (volar flexion–dorsal flexion) around the transverse axis and radio-ulnar abduction around the sagittal axis.
 b) The distal midcarpal joint is formed of the first and second rows of carpals and its main function is extension.
8. The trapeziometacarpal joint of the pollex has a saddle joint with the capability of opposition and reposition in relation to the other digits and of abduction and adduction.
9. The proximal joints in the digits, composed of the heads of the metacarpals and the proximal ends of the proximal phalanges, have a ball-and-socket construction with restricted movement: flexion–extension, abduction (splaying)–adduction (closing together) of the fingers and only passive rotation around the longitudinal axis.
10. The interphalangeal joints in the digits are pure hinge joints that are capable of flexion and extension.

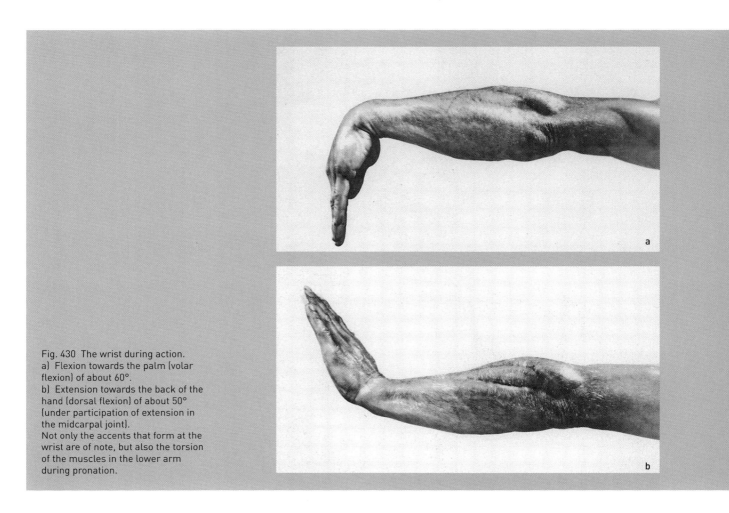

Fig. 430 The wrist during action.
a) Flexion towards the palm (volar flexion) of about 60°.
b) Extension towards the back of the hand (dorsal flexion) of about 50° (under participation of extension in the midcarpal joint).
Not only the accents that form at the wrist are of note, but also the torsion of the muscles in the lower arm during pronation.

The upper extremities **393**

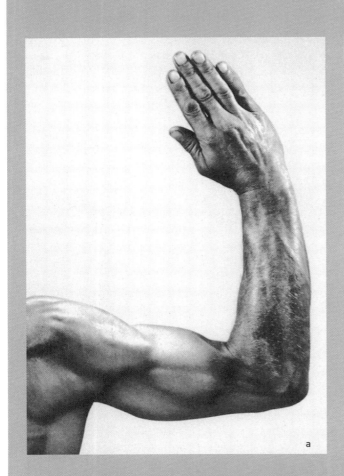

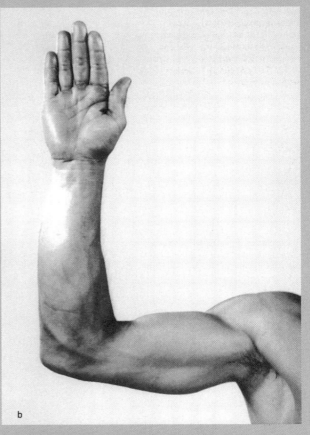

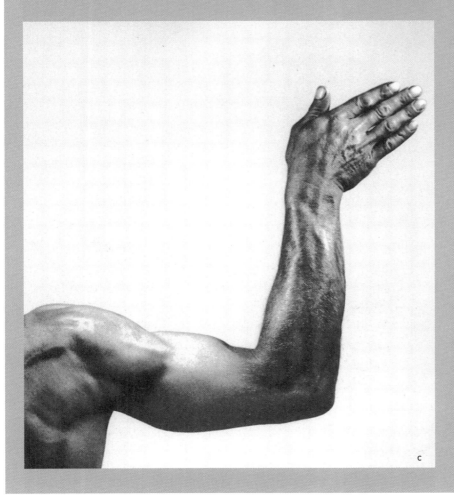

Fig. 431 Abduction of the hand.
a) Angling of the hand towards the side of the pollex or radius is called radial abduction and amounts to about 30°.
b) Hand in neutral position.
c) Angling of the hand towards the fifth digit or ulna is called ulnar abduction and amounts to about 40°.
The accents created by these two basic movements are worthy of careful observation during studies for drawing.

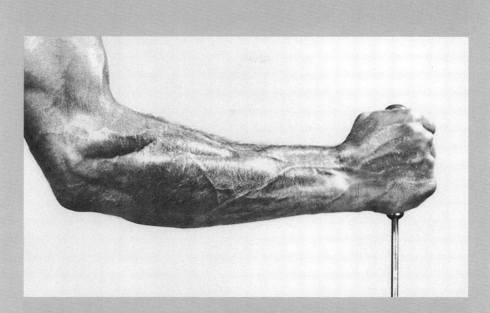

Fig. 432 The wrist during radial abduction.
Abduction of the wrist is of great
importance to holding objects and for
potentiating the arm's striking movement.

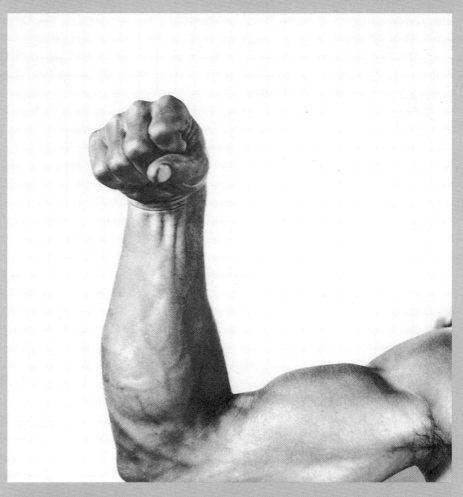

Fig. 433 Flexion of the finger and wrist joints. The latter
flexion, in particular, causes all flexors of the wrist to
protrude with sharply profiled tendons, indicating powerful
action of the muscles on the palmar side of the lower arm.

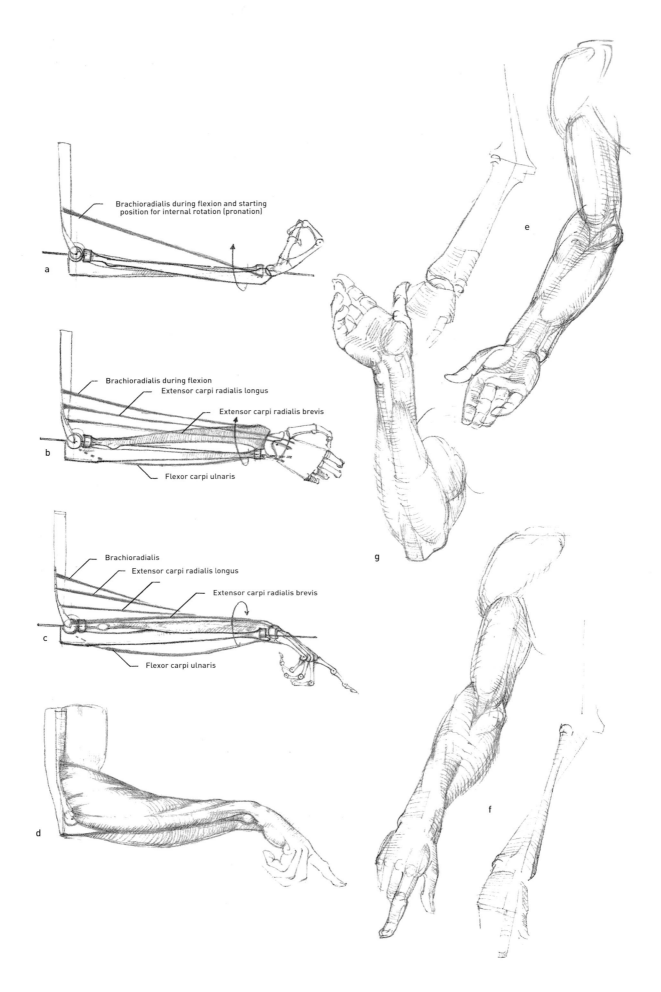

Brachioradialis during flexion and starting position for internal rotation (pronation)

a

Brachioradialis during flexion
Extensor carpi radialis longus
Extensor carpi radialis brevis

Flexor carpi ulnaris

b

Brachioradialis
Extensor carpi radialis longus
Extensor carpi radialis brevis

Flexor carpi ulnaris

c

d

e

g

f

Fig. 434 The set pattern dictating the plastic behaviour of the muscles in the lower arm.
a) Tension in the brachioradialis during flexion of the elbow joint.
b) Ulna and radius in parallel position. Load-bearing function of flexors of the arm, extensor carpi radialis longus and brevis as muscles stabilising the wrist against ulnar abduction. Flexor carpi ulnaris being crossed over by the ulna.
c) The hand during pronation (dorsal apect of hand pointing upwards), whereby the muscles running parallel in **b** must now undergo spiral torsion; the flexor carpi ulnaris emerges to a greater extent.
d) Illustration of the plastic appearance of the twisted lower arm.
e) The skeleton of the lower arm underlying the shapes near the wrist during supination.
f) The skeleton of the lower arm as an underlying 'tetragonal' shape near the wrist during pronation.
g) Volumes of the flexors and extensors in the lower arm, clearly divided into two groups by the ulna.

8.13. THE MUSCLES ACTING ON THE JOINTS IN THE HAND AND DIGITS

8.13.1. Overview of the general system [434, 435]

The lower arm is largely occupied by muscles with the task of moving the joints in the hand and digits. Their conical mass lies immediately below the elbow joint (removal of load on periphery). These muscles only reach many of the joints they act on via long tendons that must run across multiple joints that lie between their origin and insertion. The plastic appearance of the wrist is thus largely determined by the skeleton.

The muscles are arranged according to the following principle: the flexors of the wrist and the superficial flexors of the digits originate from the medial epicondyle on the humerus, the extensors from the lateral epicondyle. The flexors radiate out to the palmar side of the lower arm and the extensors to the dorsal side of the lower arm from these two central points.

8.13.2. The extensors and flexors of the wrist (dorsal flexors and volar flexors)

The pure extensors of the wrist insert into the bases of the second, third and fifth metacarpals on the dorsal side of the hand (dorsal to the transverse axis). The pure flexors of the wrist insert into the bases of the second and fifth metacarpals on the palmar side of the hand and into the pisiform (palmar side of transverse axis).

New functional groups can be created from the same muscles if we regard their arrangement in relation to the sagittal axis [435]: starting from the sagittal axis, radial abductors include all those muscles that insert into the base of the metacarpals both on the volar and dorsal sides of the hand on the side of the radius; starting from the sagittal axis, ulnar abductors include all those muscles that insert into the base of the metacarpals both on the volar and dorsal sides of the hand on the side of the ulna.

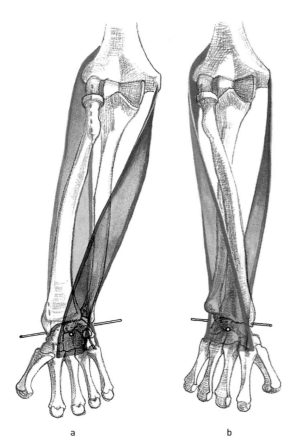

a b

Fig. 435 Basic arrangement of the muscle groups in the lower arm and their positions relative to the axes through the wrist. The groups have separate, centralised origins on the medial and lateral epicondyles of the humerus and insert into the palmar and dorsal 'corner points' on the metacarpals.
a) Hand in supination.
b) Hand in pronation.
(Blue: flexors; red: extensors.)

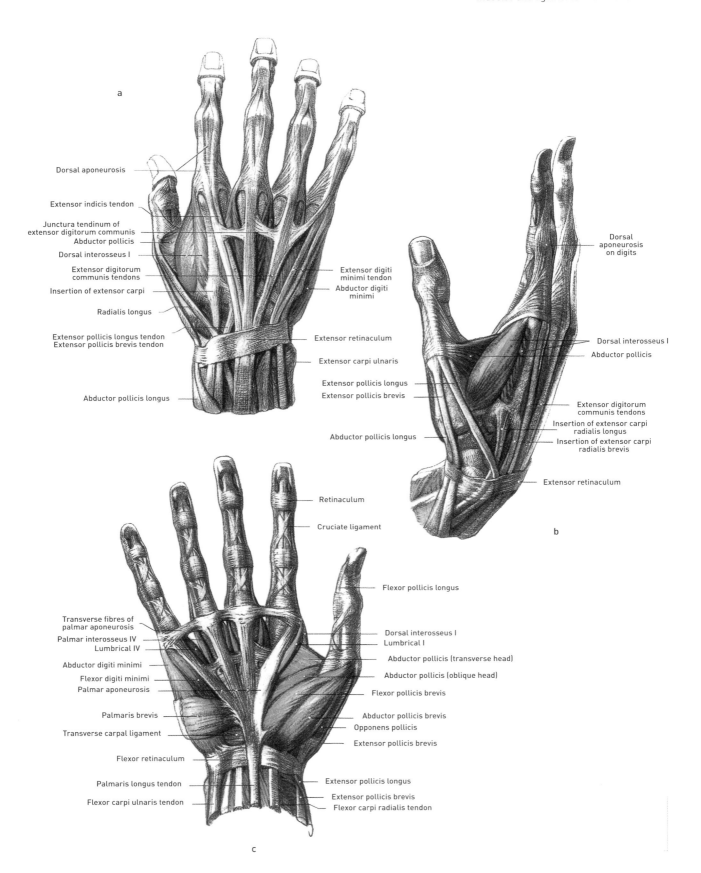

Fig. 436 Different basic views of the muscles and ligaments in the hand.

a

Dorsal aponeurosis

Extensor indicis tendon

Junctura tendinum of extensor digitorum communis

Abductor pollicis

Dorsal interosseus I

Extensor digitorum communis tendons

Insertion of extensor carpi

Radialis longus

Extensor pollicis longus tendon
Extensor pollicis brevis tendon

Abductor pollicis longus

Extensor digiti minimi tendon

Abductor digiti minimi

Extensor retinaculum

Extensor carpi ulnaris

Extensor pollicis longus
Extensor pollicis brevis

Abductor pollicis longus

b

Dorsal aponeurosis on digits

Dorsal interosseus I

Abductor pollicis

Extensor digitorum communis tendons

Insertion of extensor carpi radialis longus

Insertion of extensor carpi radialis brevis

Extensor retinaculum

Retinaculum

Cruciate ligament

Flexor pollicis longus

Transverse fibres of palmar aponeurosis

Palmar interosseus IV

Lumbrical IV

Abductor digiti minimi

Flexor digiti minimi

Palmar aponeurosis

Palmaris brevis

Transverse carpal ligament

Flexor retinaculum

Palmaris longus tendon

Flexor carpi ulnaris tendon

Dorsal interosseus I

Lumbrical I

Abductor pollicis (transverse head)

Abductor pollicis (oblique head)

Flexor pollicis brevis

Abductor pollicis brevis

Opponens pollicis

Extensor pollicis brevis

Extensor pollicis longus

Extensor pollicis brevis

Flexor carpi radialis tendon

c

Name, position and action of these muscles can be derived from the schematic overview.

The group of pure dorsal flexors includes:
1. extensor carpi radialis longus (M. extensor carpi radialis longus),
2. extensor carpi radialis brevis (M. extensor carpi radialis brevis),
3. extensor carpi ulnaris (M. extensor carpi ulnaris).

The digits also have extensors.
The group of pure volar flexors includes:
1. flexor carpi radialis (M. flexor carpi radialis),
2. flexor carpi ulnaris (M. flexor carpi ulnaris).

The digits also have long flexors.

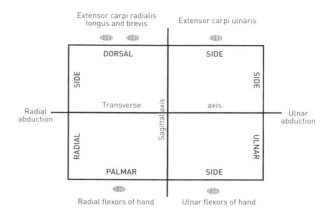

Fig. 437 The volar gripping surface of the hand and its specific superficial structures. The volar side of the hand is cup-shaped and the palm is strengthened by the formation of eminences and pads. These eminences are visibly separated from each other by folds (lines) which are already present in new-born babies and have been given names since time immemorial.

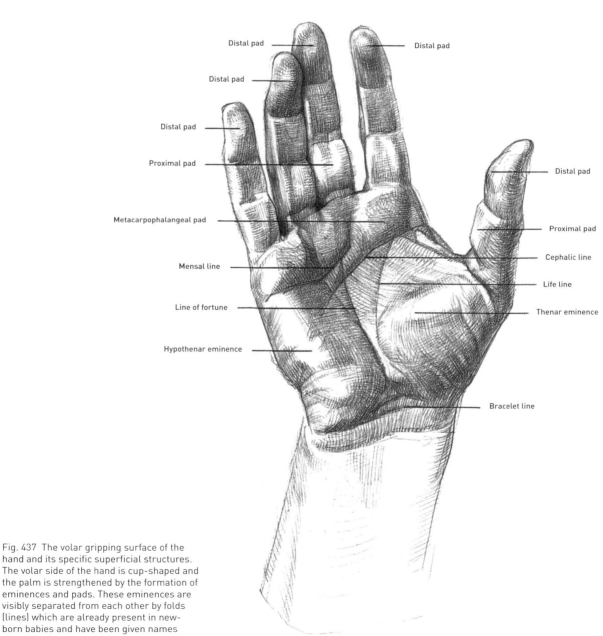

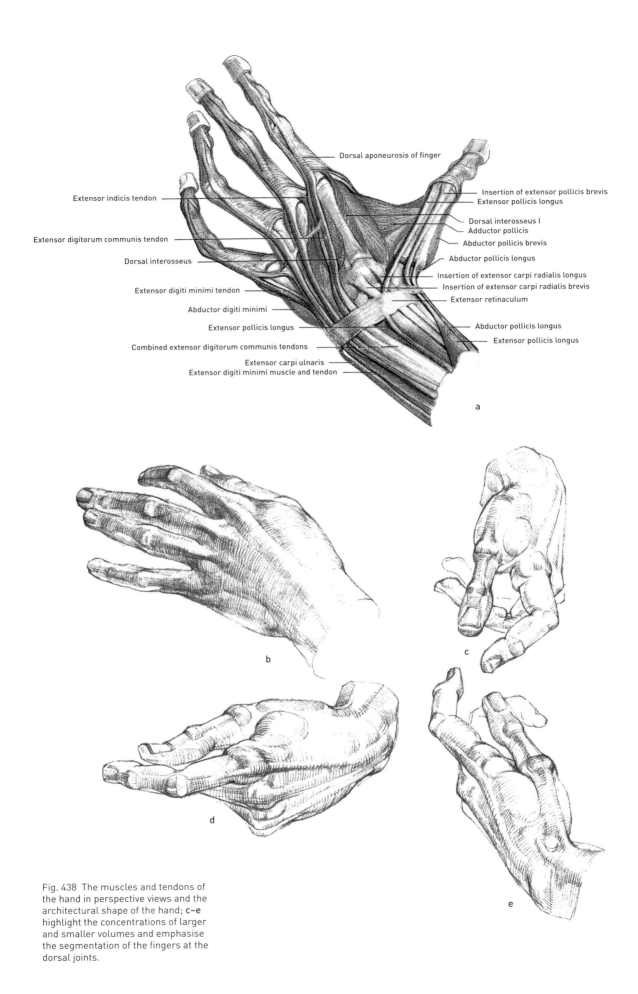

Dorsal aponeurosis of finger

Extensor indicis tendon

Extensor digitorum communis tendon

Dorsal interosseus

Extensor digiti minimi tendon

Abductor digiti minimi

Extensor pollicis longus

Combined extensor digitorum communis tendons

Extensor carpi ulnaris
Extensor digiti minimi muscle and tendon

Insertion of extensor pollicis brevis
Extensor pollicis longus

Dorsal interosseus I
Adductor pollicis

Abductor pollicis brevis

Abductor pollicis longus

Insertion of extensor carpi radialis longus
Insertion of extensor carpi radialis brevis

Extensor retinaculum

Abductor pollicis longus

Extensor pollicis longus

a

b

c

d

e

Fig. 438 The muscles and tendons of
the hand in perspective views and the
architectural shape of the hand; **c–e**
highlight the concentrations of larger
and smaller volumes and emphasise
the segmentation of the fingers at the
dorsal joints.

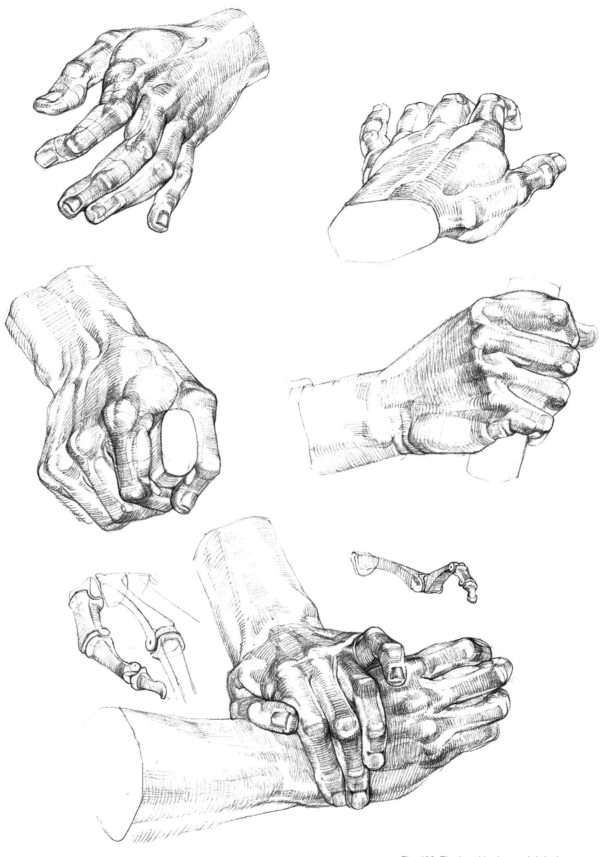

Fig. 439 The hand in the model during
different actions and in different perspectives.
The hand's variable behaviour, depending on
whether it is gripping an object or just resting
on it must be expressed in the drawing.

8.13.3. The extensors and flexors that act on the joints of the digits [436, 443, 444]

We only consider the superficial muscles here.

Extensors: The extensor digitorum communis (M. extensor digitorum communis) [443b] traverses the dorsal wrist and is flanked by the extensor carpi radialis longus and brevis on the side of the radius, and the extensor carpi ulnaris on the side of the ulna. The four tendons insert into the dorsal aponeurosis of the second to fifth digits. The extensor digitorum communis thus acts to support dorsal flexion of the hand (see above).

Flexors: The flexor digitorum superficialis (M. flexor digitorum superficialis) [443a] is largely covered by the palmaris longus, adjacent to and covered by the flexor carpi radialis on the side of the radius and by the flexor carpi ulnaris on the side of the ulna.
Insertion: Middle phalanges of the second to fifth digits.
Function: Turns the fingers into 'claws'. It supports flexion of the wrist.

The palmaris longus (M. palmaris longus): Sandwiched between the flexor carpi ulnaris and the flexor carpi radialis [417]. It inserts into a fan-shaped aponeurosis on the palm of the hand (aponeurosis palmaris), which it tenses. It thus folds the hand. Its tendon protrudes during flexion and folding of the palm. It supports flexion of the wrist.

The many other long muscles in the deep layers (that act on the joints in the hand and digits), the short muscles that originate within the hand itself, and the muscles of the pollex require specific study.

The brachioradialis (M. brachioradialis) acts neither on the joints of the hand, nor on the joints in the digits. Its main mass is in the lower arm, but it acts on the elbow joint [434a–d, 443a, b].
Origin: Lateral ridge of the humerus (margo radialis humeri), proximal to the lateral condyle.
Course and insertion: Its volume decreases in a conical shape, insertion via a long tendon, proximal to the styloid process on the radius.
Function: It is a weight-bearing muscle, due to its long lever arm (radius). Of all the flexors, it is the main muscle involved (not the biceps!) when carrying a weight with the elbow flexed. It crosses diagonally over the rotational axis through the radio-ulnar joint when the arm is flexed and pronated and thus becomes a supinator.
Plastic appearance: Protrudes from the lateral upper arm between the triceps and the brachialis. The lower arm thus overlaps the upper arm in the usual way. In a pronated position, it follows the position of the radius and is spirally twisted from the lateral upper arm through to the medial lower arm [434].

The plastic appearance of the muscles of the lower arm must be mainly viewed from the perspective of the functional groups. The volume of the flexors (more numerous) produces a massive bulge on the palmar side of the lower arm, such that it also determines the plastic appearance in a dorsal view; this is because the flexor group is separated from the 'thin' extensor group by a furrow along the ulna, behind which the flexor carpi ulnaris sticks out by some margin and thus confers a bowed shape on the lower arm from the elbow to the head of the ulna.

Summary overview: the actions of the muscles of the wrist joint

Axis	Movement	Muscles involved
Transverse axis (radio-ulnar axis)	Flexion (volar flexion)	Flexor carpi radialis (M. flexor carpi radialis) Flexor carpi ulnaris (M. flexor carpi ulnaris) Palmaris longus (M. palmaris longus) Flexor digitorum (M. flexor digitorum, only superficial muscles mentioned and depicted)
	Extension (dorsal flexion)	Extensor carpi radialis longus (M. extensor carpi radialis longus) Extensor carpi radialis brevis (M. extensor carpi radialis brevis) Extensor carpi ulnaris (M. extensor carpi ulnaris) Extensor digitorum communis (M. extensor digitorum communis)
Sagittal axis (dorsovolar axis)	Abduction towards radius (radial abduction)	Flexor carpi radialis (M. flexor carpi radialis) Extensor carpi radialis (M. extensor carpi radialis)
	Abduction towards ulna (ulnar abduction)	Flexor carpi ulnaris (M. flexor carpi ulnaris) Extensor carpi ulnaris (M. extensor carpi ulnaris)

8.13.4. The soft tissue forms and specific superficial shapes of the hand and their relevance to plastic appearance [436a, b, c, 438, 439, 440, 441]

We have already expressly referred to the fact that the plastic entity formed by the multitasking hand is largely determined by its skeletal structure, and that we would be well advised to be familiar with all its details for the purposes of studies on form and function for drawings. We stick to this premise, even if we must add further entities here that contribute towards the plastic form and appearance. On the palmar side of the hand, these are the hypothenar and thenar eminences formed by the short muscles of the little finger and thumb, respectively, which are important pads for gripping and are complemented by other pads on the palm that extend through to the flexor surface of the phalanges [437]. Characteristic lines and folds that follow a set pattern are produced in the hand as a consequence of the formation of eminences and the limited movement of the fingers imposed by the types of joints, all of which can result in folding of the palm. These lines and folds have been given names since time immemorial, which still persist today. In contrast, apart from the muscles connecting the thumb and index finger, the back of the hand has no padding and is thus highly sensitive to pressure and blows. Finally, the webbing between the four fingers with their three segments must be included in the important skin formations. The fingers of the elderly hand, in particular, exhibit folds in the skin that are no longer very elastic on the extensor side of the middle and distal joints, which form a reserve for movement during flexion of the fingers [450]. Michelangelo was keen on working on their plastic appearance and using these as elements for segmenting the dorsal aspect of the fingers.

The palm of the hand [436c, 437, 441, 457]: The decisive features contributing towards shape are the hypothenar and thenar eminences of the little finger and thumb. As the latter exhibits far greater independent mobility, the number of muscles guiding its movement is also greater, as is the volume of the eminence when compared with the little finger. It is built up through small thumb muscles like the adductor pollicis, the flexor pollicis brevis, the abductor pollicis brevis and the opponens pollicis. These originate close to the carpals and sometimes in the region of the middle of the palm, losing their bulging mass in the

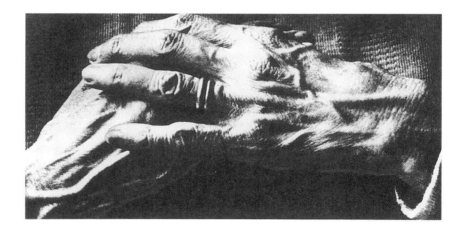

Fig. 440 Elderly hands.
The anatomical features, especially the bones of the hand, are the defining factors in the plastic appearance of the back of the hand. The consistency of the skin in elderly people reveals knuckles, joints and tendinous strands. As is the case in the face, the hand with its creases, folds and winding vessels thus becomes a standard bearer for physiognomy.

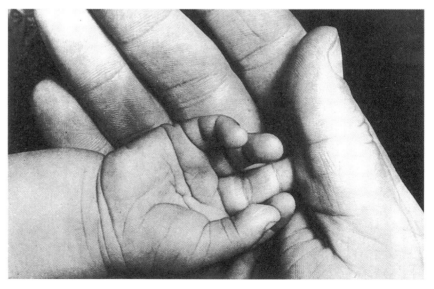

Fig. 441 A young hand and an old hand.
In both young and old, the appearance of the palmar side of the hand is largely determined by its pads and eminences, the volumes of which are clearly separated from each other by 'lines' and furrows. The folds that are already present in the infant's hand constitute a large portion of the required 'skin reserves' for the tensing, opening palm of the hand.

direction of the proximal joint of the thumb. As the lines in the hand can be regarded as the result of options for folding the palm (especially through movement of the fingers), the thenar eminence of the thumb also has a curved, delimiting line that surrounds it, the life line (linea vitalis). This occurs as a result of the opposability of the thumb against the rest of the palm [419a]. The hypothenar eminence of the little finger is composed of fewer underlying muscles with smaller volumes: the palmaris brevis, the abductor digiti minimi and the flexor digiti minimi brevis [436c].

The third eminence – not to be regarded as muscular in origin, but rather as a fat pad – is the area of skin that extends from the edge of the webbing between the fingers to about the last quarter of the palm close to the fingers. This area is delimited towards the palm by a double fold that is separated and does not run across the entire palm. One of these is the mensal line (linea mensalis), that curves across the hypothenar eminence, starting from the lateral margin of the palm, and disappears shortly before the webbing between the middle and index fingers. The second line, the cephalic line (linea cephalica), originates slightly more proximally, at about the level of the middle of the hypothenar eminence (without starting from its lateral margin), crosses over the palm transversely and disappears from the palm on the side of the index finger. Both lines arise due to flexion in the proximal joints of the second to fifth fingers. The steepest line, dependent on the action of the adductor pollicis, that can extend from the middle of the wrist in the direction of the head of the third metacarpal, is the line of fortune (linea fortunae). This brings the other lines together into an M-shaped system of folds in the palm. The lines only appear as 'graphic' entities when the palm is taut, but form the basis for deeper plastic folds when it is relaxed.

This is more easily observed in the left hand, the non-working hand, than the more compact right working hand. The webbing that stretches between the fingers is of importance to shape in that it extends almost as far as the middle of the proximal phalanges of the fingers, mainly on the side of the palm. This is where the pads on the phalanges start with a double fold separating them from the palm, without, however, bearing any relation to the position of the proximal joints [419]. This is only the case for the double folds of the middle joints, while there is once again discrepancy between the folds and the course of the distal joints. These folds make the distal phalanges appear longer than they actually are.

When we flex the second to fifth fingers at the proximal joints, the heads of the metacarpals protrude in a plastic form from the dorsal hand. It is only in this condition where it becomes fully clear how deeply the proximal joints are embedded in the webbing.

The back of the hand: The interosseous muscles close the gaps between the metacarpals, but are not visible to the eye as individual shapes. However, the back of the hand is not entirely devoid of soft tissue shapes in the form of muscles [436a, b]. For example, there is muscular padding in the shape of the adductor pollicis and the dorsal interosseous I between the metacarpal

of the thumb and that of the index finger. The skin over this becomes taut if the thumb is abducted sideways [438a]; however, if the thumb is adducted, especially when grasping hold of an object, then this ball is squeezed out in the form of a high, powerful bulge in the direction of the metacarpal of the index finger [438b, c, d, e, 439]. In addition, this also applies to the pads on the fingers when under pressure. At rest, a soft, convex curvature protrudes laterally along the edge of the back of the hand on the side of the little finger. This is associated with the hypothenar eminence, but is also offset against the back of the hand as an independent, rounded volume in the case of a strong grip or when the hand is pressed against a surface in specific positions.

The tendons of the extensors of the fingers confer a lively appearance on the bony back of the hand, namely when the fingers are extended at the proximal joints [436a, 438, 439]. This may be less apparent in the more delicate female hand, which also has a little more subcutaneous fat than the male hand. In cases where the female hand has a rounded shape like that of a child, small dimples are formed in the surface of the skin over the proximal joints of the fingers. Great attention must therefore be paid to the interactions between the actual skeleton of the hand and the behaviour of the associated soft tissue shapes when drawing the hand, especially during action. This applies equally to the expressive power of the set pattern of folds and creases in the palm of the hand as to the back of the hand, where the main bony components interact characteristically with some soft tissue shapes at the locations stated above.

Fig. 442 Muscles of the arm and hand during action.
a) Elbow flexors when carrying a load: biceps, brachialis, brachioradialis.
b) Flexor carpi radialis.
c) Flexor carpi radialis longus and brevis during stabilising action (with radial abduction).
d) Alternation between use of muscle groups during blows.
e) Extensor carpi radialis longus and brevis, providing resistance against ulnar abduction caused by a weight.
f) Flexors of digits and hand when grasping hold of an object.

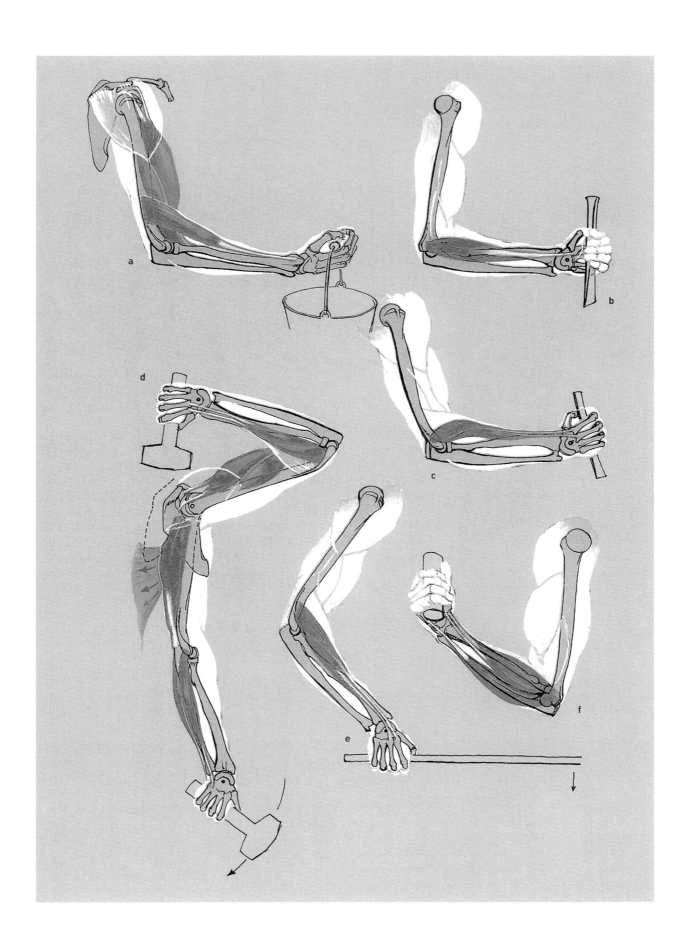

Fig. 443 Muscle analysis of the arm in context.
a) Medial view of arm dangling down.
b) Lateral view of arm dangling down. The dangling arm is not 'dead', but expresses precisely that it is dangling down: slight flexion in the elbow and internal rotation in the lower arm, soft flexion of the wrist, with slight abduction of the elbow and flexion of the joints in the digits. These manifestations are triggered by the predominance of relaxed muscle tone in each preceding muscle group.

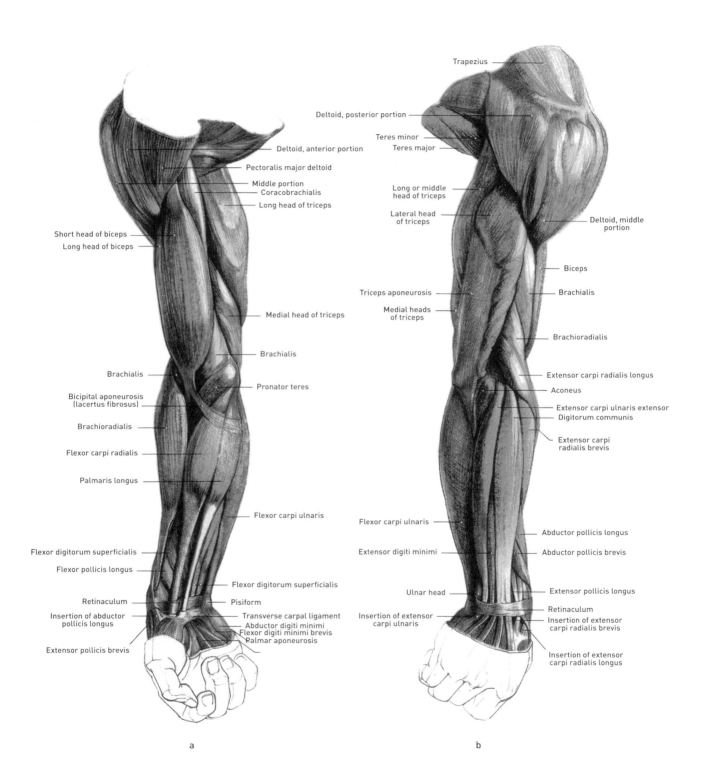

Deltoid, anterior portion
Pectoralis major deltoid
Middle portion
Coracobrachialis
Long head of triceps

Short head of biceps
Long head of biceps

Medial head of triceps

Brachialis

Brachialis
Pronator teres

Bicipital aponeurosis (lacertus fibrosus)

Brachioradialis

Flexor carpi radialis

Palmaris longus

Flexor carpi ulnaris

Flexor digitorum superficialis
Flexor pollicis longus

Flexor digitorum superficialis

Retinaculum
Pisiform
Insertion of abductor pollicis longus
Transverse carpal ligament
Abductor digiti minimi
Flexor digiti minimi brevis
Palmar aponeurosis
Extensor pollicis brevis

a

Trapezius

Deltoid, posterior portion

Teres minor
Teres major

Long or middle head of triceps

Lateral head of triceps

Deltoid, middle portion

Biceps

Triceps aponeurosis

Brachialis

Medial heads of triceps

Brachioradialis

Extensor carpi radialis longus
Aconeus
Extensor carpi ulnaris extensor
Digitorum communis
Extensor carpi radialis brevis

Flexor carpi ulnaris

Abductor pollicis longus

Extensor digiti minimi

Abductor pollicis brevis

Ulnar head

Extensor pollicis longus

Retinaculum
Insertion of extensor carpi ulnaris
Insertion of extensor carpi radialis brevis

Insertion of extensor carpi radialis longus

b

Fig. 444 The external appearance of the
arm in its entirety.
a) Lateral view.
b) Medial view.
In contrast to the previous figure, the
gripping of an object and the different
associated plastic behaviour are
emphasised here.

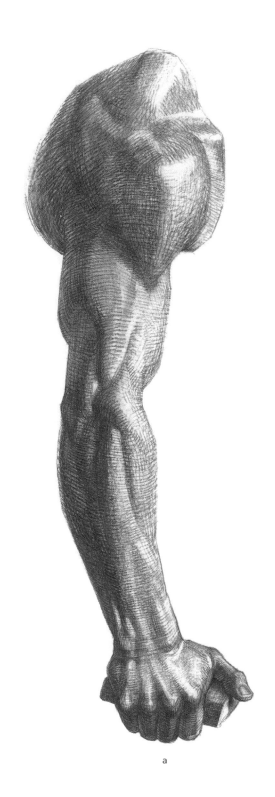

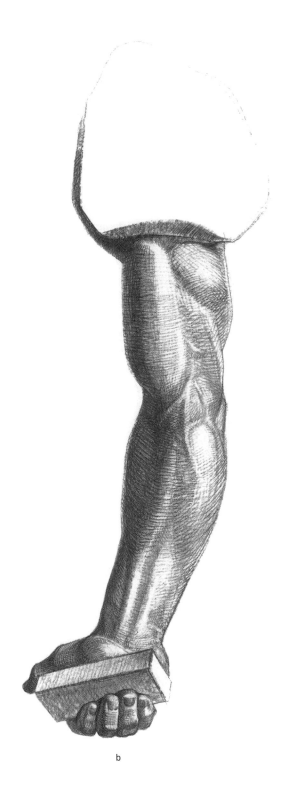

a

b

8.14. THE ARM AND HAND AS ONE ENTITY AND DURING ACTION

The individual performance only becomes meaningful within the context of the overall event. We can actively interact with the environment thanks to the hand and arm. We will only select a few basic types for discussion here from the all-round activities. To this end, only one function will be analysed, while others will only be mentioned.

Free movement of the arm [442] may consist of guiding the arm to use the hand with the trunk in a fixed position (grasping and using a tool) [432]. How many links of the chain are interlocked when striking a heavy blow with a hammer: raising the arm into a vertical position with scapulothoracic muscles (see section 8.4.2.), resulting in an expedient passive force in the latissimus dorsi and pectoralis major for pulling down the arm, also passive force in the triceps as the elbow joint is flexed, radial abduction of the hand by the radial abductors (extension of the ulnar abductors). At the point of impact: rotation of the scapula back into

a neutral position, pulling down of the arm with the aid of the pectoralis major and latissimus dorsi, extension of the elbow joint by the triceps to increase the power of the blow, further increase in the force of the blow through abduction of the hand towards the ulna by the ulnar abductors (simultaneous stabilisation of the wrist at impact).

The arm fixed in position is used to support the freely swinging trunk (pull-up, climbing, crawling).

Accompanying movements of the arm: regulating balance, e.g. when dancing, swinging arms when walking, swimming, defensive movements when falling or catching objects, defence for the purpose of maintaining distance.

Arm movements to take possession of something: pulling things towards us from within our sphere of action (martial arts like wrestling, tug-of-war, embracing people or objects).

Connecting movements: the aim of such movements is to connect with an object to produce a new functional system (cycling, rowing, riding).

Movements relating to the body: the extensive chain, formed from flexion of the spine, via the shoulder

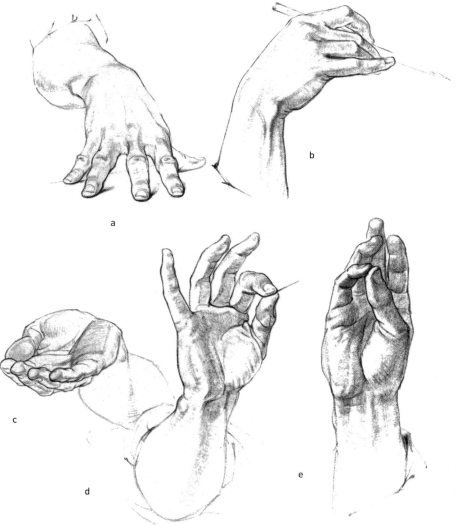

a

b

c

d

e

Fig. 445 The hand being used for some basic activities.
a) Splaying and supporting movement of the fingers (formation of a fan).
b) Controlled guidance of a small object.
c) Formation of cupped hand through adduction of the fingers.
d) Opposability of the index finger and thumb when gripping fine objects.
e) Opposability of the thumb and little finger.

girdle and through the arms to the fingertips, allows all points of our body to be reached. The plethora of motifs relating to movement in the visual arts arises from this (personal care, getting dressed, etc.).

The highly differentiated functional ability of the hand itself creates the following basic shapes during its use [445]: Opposition of fingers and thumb for activities requiring the finest of manipulation (tightening a screw, drawing, writing, picking up tiny objects, holding small devices).

Formation of a hook through flexion of the fingers in the metacarpophalangeal and the wrist joints (carrying loads).

Making a fist: to use as a weapon, enclose and grasp an object.

All these functions take place immediately within the hand and are the final target of a long chain, with the aid of which the actual instrument of action can be used at any location within our sphere of action.

Forming a fan through splaying of the fingers.

Formation of a cupped hand through adduction of the fingers.

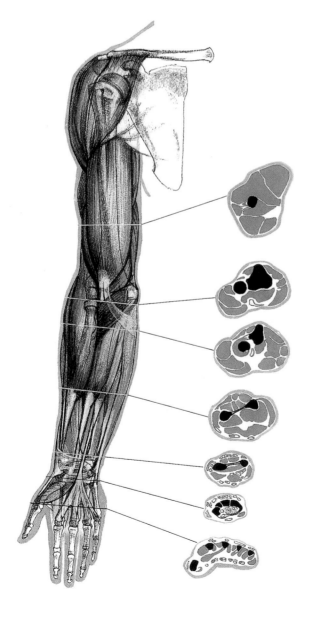

8.15. THE ARCHITECTURAL FORM OF THE ARM AND THE RELATIONSHIPS BETWEEN ITS SHAPES

When the arm is illustrated, its 'physiognomy' must express what it is doing, whether it is dangling down or supported on a substrate, the arms are akimbo, or carrying something [447–450]. The muscle volumes and their accents, the orientation of the sections of the arm, the rhythmic arrangement and the relationships between shapes provide information on this.

When the arm is loose and dangling down [443], there is slight flexion at the elbow (the muscle tone of the flexors dominates), the ulna and radius are slightly crossed over each other (mild pronation of the arm as a result of the domination of the internal rotators), the hand is slightly flexed (result of the dominant flexors in the hand and fingers); the fingers are also flexed for the same reason and the mass of the ulnar abductors causes slight ulnar abduction. This example alone is designed to demonstrate that any study of the arm, no matter how 'passive' the model's posture, must convey this condition with all its characteristics of looseness or tension.

An understanding of the distribution of the masses is also important to the study of the arm [448a–d, 449]. A ball-and-socket joint like the shoulder requires compact muscle masses that act on all sides of the joint. This is why the squat shape of the deltoid surrounds the head of the humerus, extending towards the front, back and side. The point-like insertion squeezes in between the brachialis and the biceps. The volume of the upper arm is sagittally layered from the biceps through to the triceps, as a simple hinge joint would render any other arrangement useless (see cross-section illustrations). It is as if the 'tetragonal shape' of the upper arm persisted through to the shoulder girdle in a mysterious, 'subterranean' way, so to speak (Figure 447a, numbers 3 and 3* to 1 and 1*). The taut shapes, like those of the biceps and triceps, dive down, as it were, briefly emerging at the surface as a 'low point' and then disappearing again.

Several cross-sectional shapes [446] must be referred to in order to gain an understanding of the volumes in the upper and lower arm, with their variable arrangement in dimensions: the upper arm forms a volume with a sagittal depth, the lower arm has a volume that is perpendicular to this [439, 447].

The mass of the lower arm is offset from the upper arm with its transverse volume (origins of the flexors and extensors of the wrist on the medial and lateral epicondyles of the humerus) that is at right angles to the tetragonal, sagittally layered cross-section of the upper arm [413b, c, 446, 448]. The tetragonal

Fig. 446 The arm with its cross-sections. Investigations using cross-sections have the advantage of indicating the dimensions of the volumes and their spatial inter-relationships.

shape of the skeleton of the wrist is released from this muscular 'embrace' [434e, f, g]. This circumstance is also worthy of note for a further reason: the orientation of the radius (Figure 457c, numbers 7*, 6*) breaks through the cone of the lower arm and targets its centre of rotation of the vertical axis through the humero-radial joint (number 5*). This results in the expressive overlaps between the soft muscle cone and the tetragonal lower arm close to the hand. All of the detail studies in Figure 447a–d once again reveal entire correlation chains at their 'low points', which are indicated by the sequence of numbers running from the shoulder girdle downwards, along the main shapes that are never obscured by ancillary or intermediate shapes, through to the points of the joints in the fingers and the ancillary shapes of the finger pads [438, 439].

Fig. 448 (opposite) The architectural form of the arm in contrast with the constructional shapes of the skeleton. The architectural form proves to be the result of a constructional artistic approach to the structural interactions between framework and soft tissue shapes.

Fig. 447 The architectural form of the arm and its relationships associated with function and form.
The lateral numbers indicate the 'low points' of the form which, when connected, indicate the fundamental shape and orientation of the volumes. Using this basic guide, it is then easy to allocate or subordinate the differentiated shapes in relation to each other.

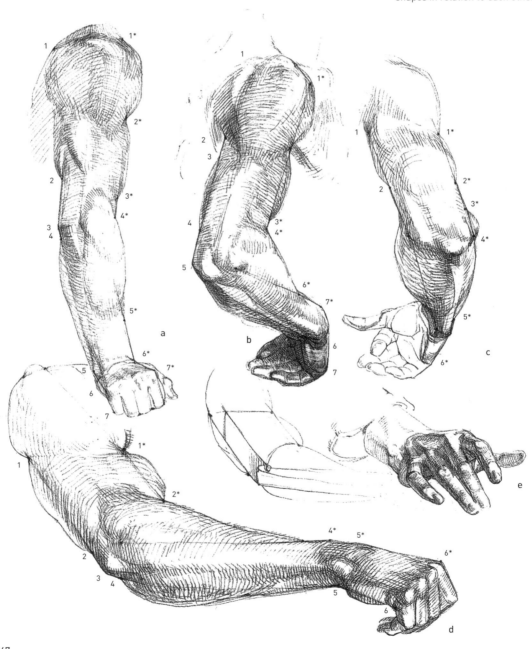

447

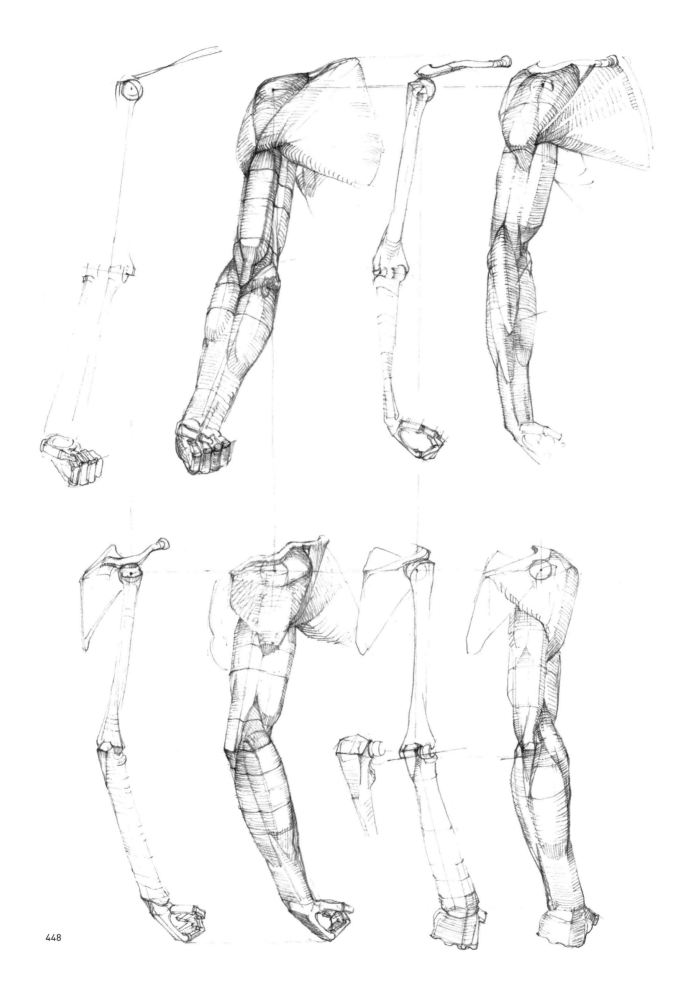

The upper extremities **411**

Fig. 449 Different views of the architectural form of the arm when supported on a substrate and when holding an object. Apart from the structural interactions between the framework and soft tissue shapes, the main dimensions of the volumes that are offset against each other are made clear.

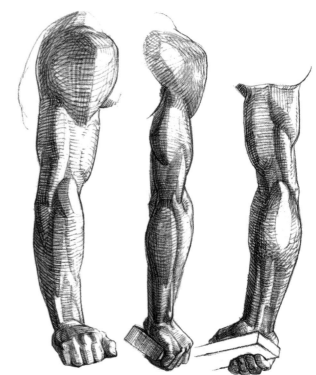

Fig. 450 The integration of important anatomical issues to clarify function and expression. Irrespective of the action and posture of the arm and hand – whether hanging, grasping, pushing or pulling – the essential anatomical details must always express or reflect action or non-action. Reduction of the shapes to architectural building blocks is, once again, an important aid here, through to testing pure capacity for envisaging the situation.

Adapted from Bammes, *Wir zeichnen den Menschen*.

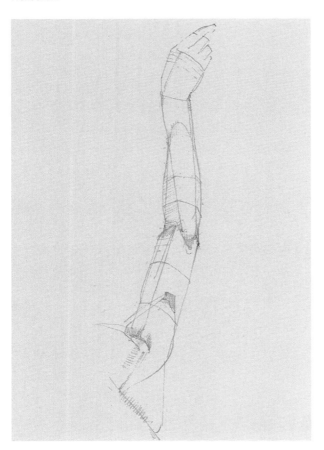
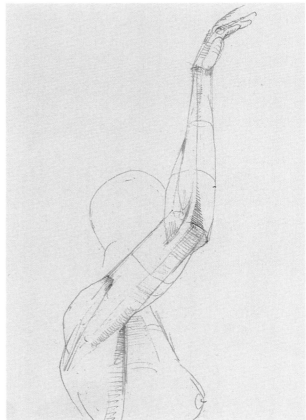

8.16. THE PROCESSING OF ANATOMICALLY OBJECTIVE CONSTITUENTS OF THE ARM AND HAND IN WORKS OF ART

Given the varying motivations of artists studying the arm and hand which persist to this day, it would be impossible to undertake any attempt to convey the diversity of representations by the Masters, even if we substantially increased our selection of artistic examples here. For some, the hand is simply a natural object that is deserving of the highest levels of admiration due to its contrasts in shape and masses and, for this reason alone, offers great incentives for study. Another artist will see the hand as providing a potted social and individual history of the person, while a third artist sees it as echoing the face and the entire body, a fourth perceives it as a unique instrument of unlimited ability, another as a highly sensitive sensory organ, with yet another seeing in it a medium of expression that participates in forging emotions and thoughts. The reader will note that some of these motivations are to be entered into here.

Studies of the Arm after Michelangelo [452] mainly focuses on two problems: one the one hand, namely physicality – the plasticity and variable uniqueness of the volumes in the upper and lower arm – and on the other, that associated with functional events. When studying this, we must not omit to notice the intensity with which the pivots in the skeleton are depicted: the position of the flexed elbow in relation to the location of the lateral epicondyle on the humerus (origin of extensors) and how the ulna can be followed down through to the ulnar head, a component immediately adjacent to the wrist. The radius is rotated inwards across the ulna (pronation) and the lower arm muscles

Fig. 452 After Michelangelo.
Studies of the Arm. Black chalk. Uffizi Gallery, Florence.
The furrow between the functional groups of flexors and extensors extends along the lower arm from the elbow to the ulnar head. A focus of detailed observation, the torsion of the extensors of the wrist has been followed from its origin due to the internal rotation of the radius, as has the increase in the volume of the flexors of the hand.

Fig. 451 Peter Paul Rubens (1577–1640).
Studies of Arms and a Man's Face for *The Death of Decius Mus*. Black chalk, heightened with white. Victoria and Albert Museum, London.
Rigorous assessment of the skeletal markers ensures the form is always stabilised in the passionate, dynamic movements and shapes of the muscles.

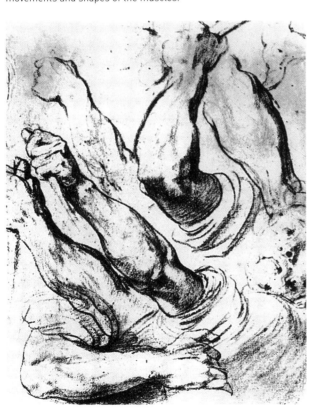

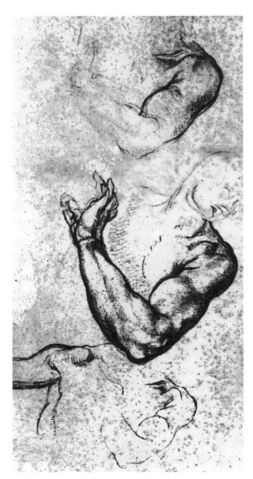

have therefore followed this movement and thus describe the required torsion: internal rotation of the extensors of the wrist and plastic protrusion of the flexors of the wrist. The muscles of the lower arm follow a spiral movement [434a–d].

Rubens' *Studies of Arms and a Man's Face* [451] approaches the task largely in the same way as the example given above, namely, with reference to its solution regarding plasticity and function. The anatomical circumstances have also been studied in great detail here, a phenomenon that is not always encountered in Rubens' work. While he always treats the orientation points of the skeleton with great care, he usually grants himself a high level of poetic licence in his portrayal of the soft, swelling masses. However, this is not the case here, where, in his quest to express power, he ensures he is informed on all the details relating to the location and shape of muscles in action.

We wish to use Goltzius' *Four Studies of Hands* [453] as one of the numerous examples of how important

artists repeatedly use the readily available hand as a model for practice and self-assessment of their ability. A contradiction in the design draws our attention with regard to how the relaxed hand resting on a surface is treated, which may not simply be subjective in nature, but probably also reflects the artist's affiliation to late Dutch Mannerism: the wrist, with its compact Michelangelesque power, bony and knotted, capable of great force, and the feminine elegance, in which the fingers are splayed in a classical manner with the middle and ring fingers touching and the index and little fingers maintaining a clear distance to the middle pair of fingers.

John's *Figure Study* [456] is important in our selection of examples in that it is dominated by what is almost a functional centre, the supporting arm, the design of which, however, is not in harmony with the rest of the body. It is positioned in a lapidary fashion, with a column-like tautness, typical to a female in its development of the lateral angle of the arm, with a

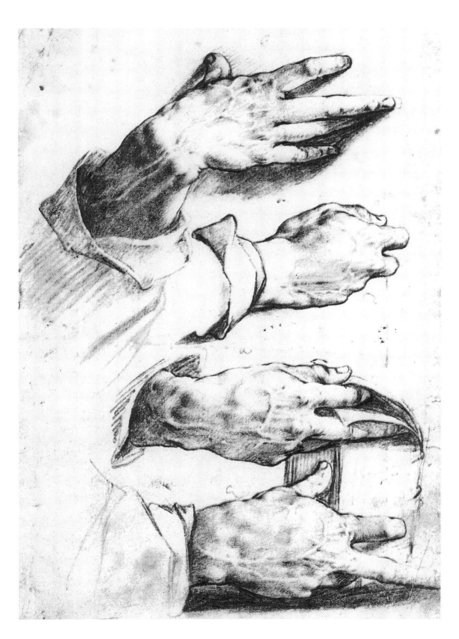

Fig. 453 Hendrick Goltzius (1558–1616). *Four Studies of Hands* (excerpt). Städtisches Kunstinstitut, Frankfurt am Main.
The knotted, and by no means always anatomically correct, superficial hand equates to a Manneristic interpretation, with Michelangelo as the great artistic paragon – something which is not always readily appreciated.

Fig. 454 Käthe Kollwitz (1867–1945).
Head of a Child in its Mother's Hands,
(1900). Study of *The Downtrodden*. Pencil,
20.8 x 20.8cm (8¼ x 8¼in). Kupferstich-
Kabinett, Dresden.
The worn hands – seeming tender and
protective as they cup the face, but also
like they are searching in pain – represent
the mother's face.

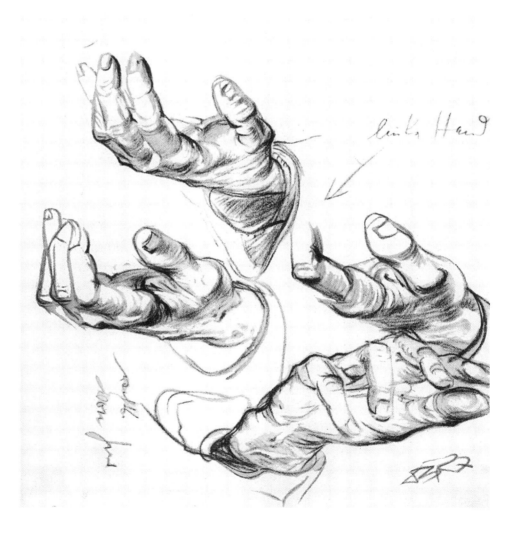

Fig. 455 Otto Dix (1891-1969)
Studies of Hands (1927). Red chalk,
45 x 38cm (17¾ x 15in).
What is highly revealing in this artistic
study of the hand is how the artist allows
the fingers to emerge from the palm: he
perceives these locations as sockets for
cylindrical connecting pieces.

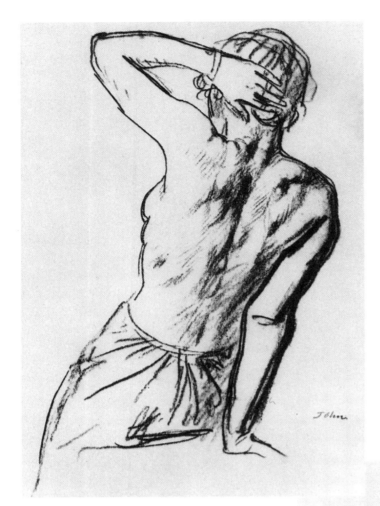

Fig. 456 Augustus John (1878–1961).
Figure Study. Red chalk. Douglas Gordon
Collection, Baltimore, Maryland.
In contrast to the remainder of the
back, the supporting arm is drawn with
lapidary simplicity: the acuteness of its
natural lateral angle, the energetic black
line targeting the elbow to indicate the
extensors of the elbow, the transverse
fold of skin over the elbow and the
emphasis on the supporting nature of
the arm.

Fig. 457 Gottfried Bammes (1920–2007).
Studies of Hands (1972). Red chalk,
40 x 27cm (15¾ x 10¾in).
The shifts in the skin in the folded palm
follow a set pattern of creases.

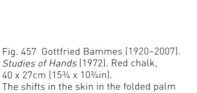

sharp emphasis on the medial epicondyle that forms the apex of the different directions taken by the medial lines of the arm, the small indent on the elbow with its skin fold, and the overlapping of the upper arm due to the compression of the scapular muscles. Together with the characteristic style of the line, the supporting function of the arm is emphasised through the task of perceiving the space in front of it.

It is rare that such a meaningful expression of social and personal history has been conferred on a hand using its differentiated and compressed conditions as Käthe Kollwitz has [454]. Worn, as is the fate of those without rights, the bony, loving hand forms a tender receptacle, sadly touching the deathly peaceful face of the child, and allowing a strand of hair to run through its fingers. Benevolence, resignation, despair of the mother's hand; it alone is the means of the expression of misery. There is no need of the face.

Although Dix's *Studies of Hands* [455] are not directly associated with a conceptual idea, they are among the most sensitive examinations in expressiveness. The artist considers the synergy in the ensemble made up by the fingers and their individual actions, the degrees of flexion and their functions. He investigates their position in space, conceives them as rounded tetragons, and perceives the fingers as pieces stuck into a pipe, coupling at their bases.

Fingers that hold a fine object, with the thumb opposed to the fingers, are unified at their common meeting point, forming a cavity. This is the motivation in Bammes' *Studies of Hands* [457]: to view the system of bulges and compressions, of deep gulleys and ravines as a realistic construct, as the profile of a landscape at a detailed level, or as an arrangement following the pattern of scrunched-up paper.

The physical and spatial examination – conveyed using a minimum of means – certainly also plays a significant role in Marcks' *Studies of Hands* [468]. He takes the view of a poet. He reveals the ethereal elements in the delicate female hand, pays homage to its tenderness and fragility. He pushes the extremely thin, nervous fingertips into their surroundings like quivering feathers that are capable of detecting the invisible.

Fig. 458 Gerhard Marcks (1889–1981). *Studies of Hands.* Pencil, 28.6 x 24.7cm (11¼ x 9¾in). Kupferstich-Kabinett, Dresden.
The artist develops the slender, delicate and sensitive hand using very simple, assertive and accentuated lines.

9 The neck

The neck is inserted between the base of the skull and the bony rib cage, and its specific physicality is based on the beginning and end of its skeletal framework. Its cross-sections are forcibly adapted to the cross-section of the trunk at the level of the clavicle and the base of the skull.

9.1. FUNCTION AND BORDERS

Humans enlarged their field of vision through their upright stance. The head is now balanced from below on a shortened cylinder; the high mobility found in animals is now reduced to a certain degree. The neck harbours the trachea and the oesophagus. The cervical spine is the most mobile section of the spine, to ensure that the sensory organs are easily directed towards signals. Movement of the neck is also associated with facial expression (e.g. tilting the head when in doubt, shaking it in negation, etc.). The borders of the neck are: the cranial margin of the sternum and medial section of the clavicle, the acromion (roof of the shoulder), the cranial margin of the scapular spine, the skull with its occipital crest, mastoid process and the inferior margin of the mandible.

9.2. COMPONENTS AND STRUCTURE OF THE CERVICAL SPINE

The cervical spine is composed of seven vertebrae, with an overall convex shape in an anterior direction, and carries the skull in a mobile and elastic fashion.

The first two cervical vertebrae – atlas and axis (epistropheus) – are unique, both in function and design. The former supports the skull [459a, d, h–k] on its two flat articular facets, that expand the ring on each side, and this vertebra has no body. This thickening simultaneously permits articulation with the axis that lies below it [459e–k], which has a small vertebral body that is expanded in the direction of the atlas by a projection (dens), around which the atlas rotates on its support [305, 309]. The five subsequent cervical vertebrae are all very similar and all exhibit the same underlying structure.

9.3. THE CRANIAL JOINTS AND THEIR MECHANICS

There is an upper and a lower cranial joint. The first of these (articulatio atlantooccipitalis) is an ellipsoid joint, with the occipital condyles on the base of the skull articulating with the facets on the atlas. The transverse axes through the two joints that work together allow the nodding of the head (25 to 30° forwards and backwards). Slight lateral inclination is dependent on the sagittal axes. The lower cranial joint (articulatio atlantoaxialis lateralis) allows the head to rotate around the dens to either side by about 30° [463]. We rarely move our heads using only these two joints – the entire CS is usually involved.

Fig. 459 The first two cervical vertebrae.
a) Anterior view of atlas.
b) Posterior view of atlas.
c) Lateral view of atlas.
d) Cranial view of atlas.
e) Dorsal view of axis (epistropheus).
f) Anterior and slightly caudal view of axis.
g) Lateral view of axis.
h) Articulated atlas and axis (lateral posterior view).
i) Rotation of atlas around dens on axis.
j) Atlas and axis on top of each other, lateral view.
Blue: articular surfaces
The two cervical vertebrae occupy a unique position in the cervical spine based on their structure and function. The atlas carries the head; the axis permits controlled rotation of the atlas resting on it around the dens (rotation of head).

9.4. THE JOINT ACTION OF THE CRANIAL JOINTS WITH THE REST OF THE CERVICAL SPINE

The movements in the two cranial joints can run in the same direction (co-directional) as those in the remainder of the CS or in the opposite direction (counter-directional).

9.4.1. Co-directional and counter-directional movements around the transverse axes [462a, b, 464, 466, 468]

The following are co-directional movements: flexion, especially in the atlanto-occipital joint (chin drawn down to neck), flexion in the remainder of the CS until the chin touches the chest. In this process, the cervical lordosis shifts into a mildly kyphotic shape: the spinous process of the seventh cervical vertebra is erected and produces the typical hump in the contour of the neck (tension of the nuchal septum that renders the contours of the back of the neck taut) [460, 461, 468, 469a].

Co-directional extension: first, movement of the tip of the chin away from the neck (dropping backwards of head), then extension of the entire CS, such that the occipital region of the skull comes to rest on the shoulder blades (face pointing upwards and backwards), thus increasing the cervical lordosis; the angle between the base of the mandible and the neck almost disappears in the contour of the front of the neck. The larynx protrudes [467, 468b].

Counter-directional movement: flexion of the lower CS, but extension in the atlanto-occipital joints (occipital region of the skull close to back of neck, face remains vertical, chin pushed forward). The head has therefore been stretched forwards (look-out posture) [464c].

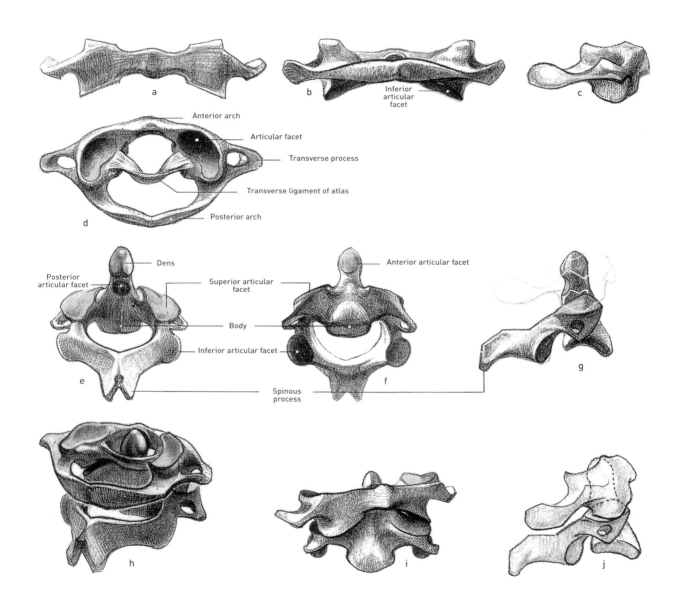

a

b Inferior articular facet

c

Anterior arch

Articular facet

Transverse process

Transverse ligament of atlas

Posterior arch

d

Dens

Posterior articular facet

Superior articular facet

Body

Inferior articular facet

Spinous process

e

Anterior articular facet

f

g

h

i

j

Fig. 460 The entire skeleton in
movement with an emphasis on its
constructional form and mechanical
processes.
The focus of this illustration is on
visualising the processes during
flexion and the erection of the spinous
processes of the cervical spine, as well
as on the cranial view of the shoulder
girdle and its behaviour.

Fig. 462 (right) The spine in its entirety
and the constructional form of the first
two cervical vertebrae.
a) The flexed spine, largely composed of
the individual shapes being combined into
constructional complexes.
b) The flexed spine, largely composed of
the individual shapes being combined into
constructional complexes, with emphasis
on the action of the cervical spinous
processes and their scale-like movement
during flexion.
c) The constructional forms of the
first three cervical vertebrae in spatial
perspectives, atlas and axis dissociated
d) The dissociated dens of the second
cervical vertebra (axis).
e) The axis in spatial perspective in an
anterior and partial lateral view.

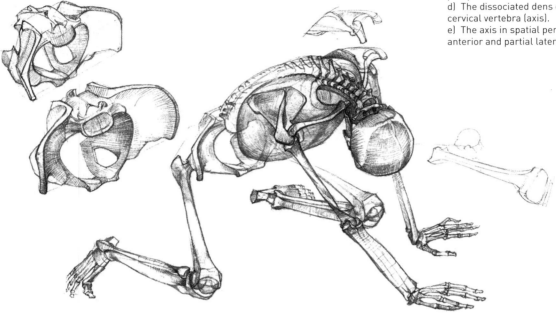

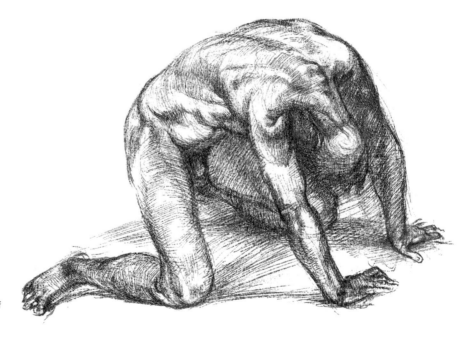

Fig. 461 Study on the plastic behaviour of
the neck and shoulder girdle in a model,
in a partial anterior view.
The focus is on clarification of the
tensions in the back of the neck, with
the cervical spinous processes and the
transition to the thoracic spine; further,
the sequence of overlaps of the plastic
cores and muscles in the remainder of
the body.

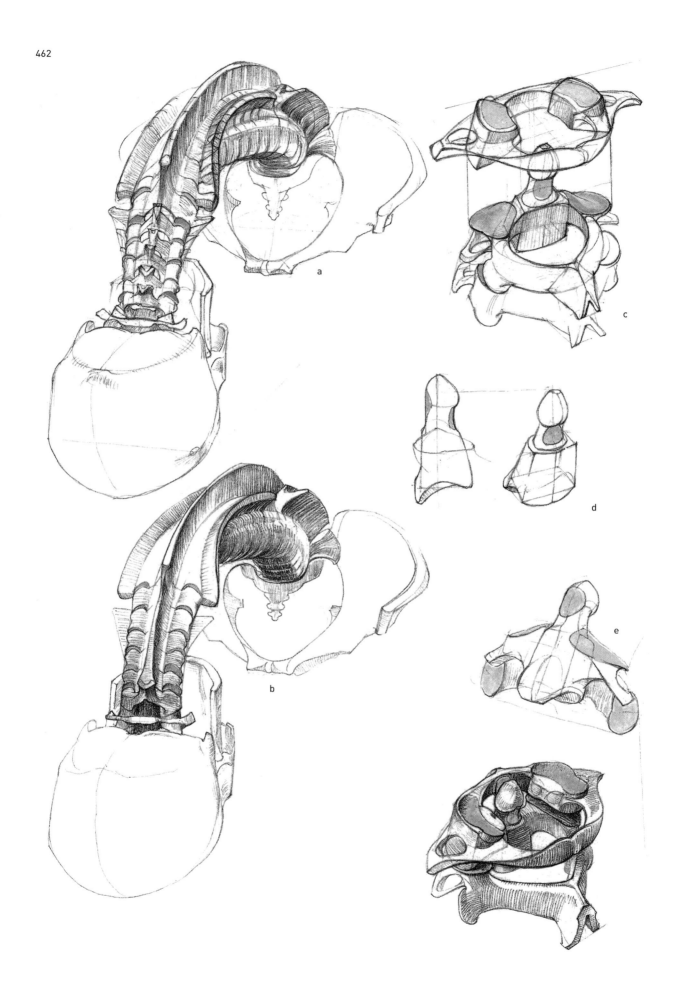

a

c

d

e

b

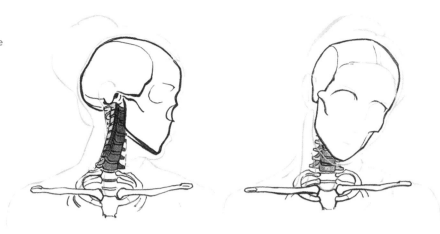

Fig. 463 (right) Rotation and lateral inclination of head. The high degree of mobility of the entire cervical spine makes the head the ideal seat of the sensory organs used for perception: the visual, olfactory and auditory senses.

Fig. 464 (below) The mechanics of the cervical spine.
a) Co-directional flexion in the cranial joints and in the remainder of the CS.
b) Co-directional extension.
c) Counter-directional movement: extension in the cranial joints and flexion in the remainder of the CS.
d) Counter-directional movement: flexion in the cranial joints and extension in the remainder of the CS.

Fig. 465 (opposite, top) Rotation and lateral inclination of the head in the model. Rotation of the head towards the shoulder amounts to about 80° towards each side. The sternocleidomastoid, which protrudes as a strong vertical strand on the opposite side to the direction of rotation, is heavily involved in this movement. Lateral inclination of the neck to each side amounts to about 45°. Once again, the sternocleidomastoid protrudes on the opposite side to the inclination, as it takes on the stabilising function for the head.

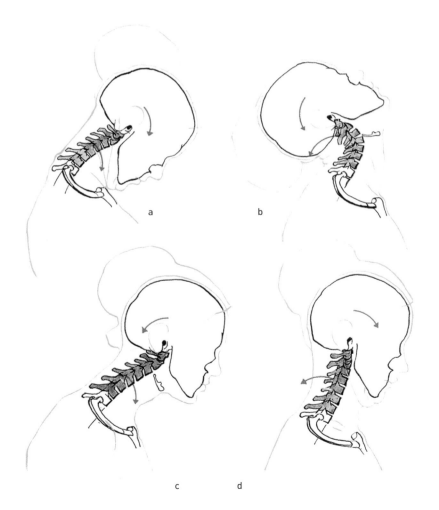

a

b

c d

Fig. 466 (opposite, bottom) Counter-directional movement of the cervical spine in the model.
a) Pushing head forwards.
b) Pulling head backwards.
Pushing the head forwards occurs through the combination of two movements in opposite directions, namely, flexion in the lower cervical spine and extension in the cranial joints. Conversely, pulling the head backwards occurs through slight extension of the lower CS and flexion in its superior section (drawing the chin in). Both neck–head postures are also associated with their own psychological expressions.

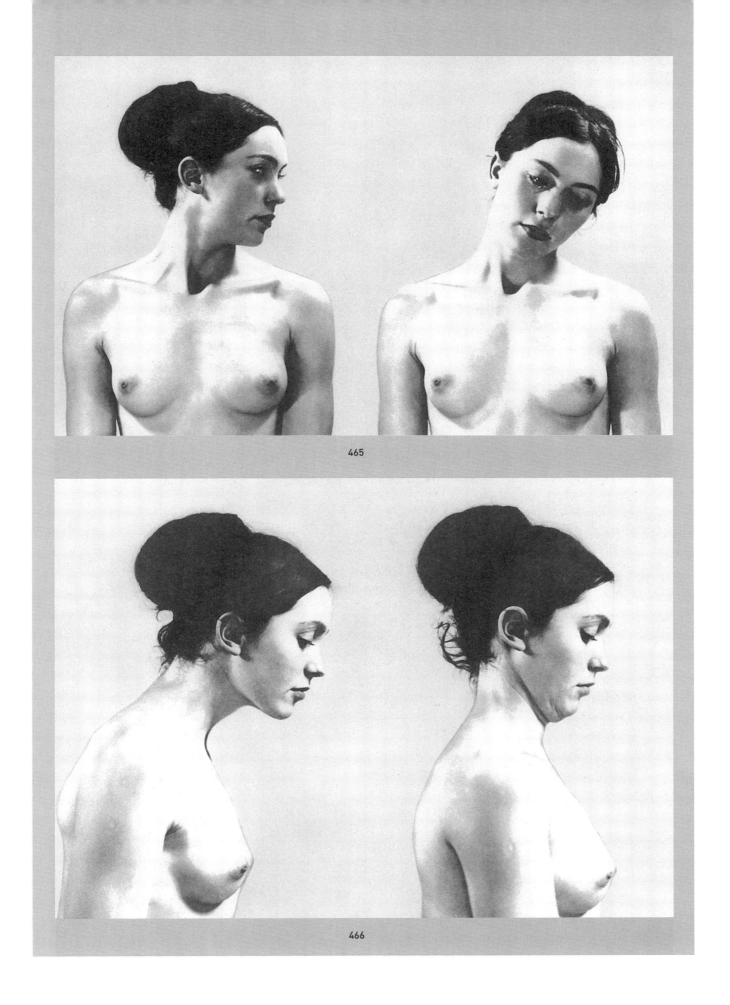

465

466

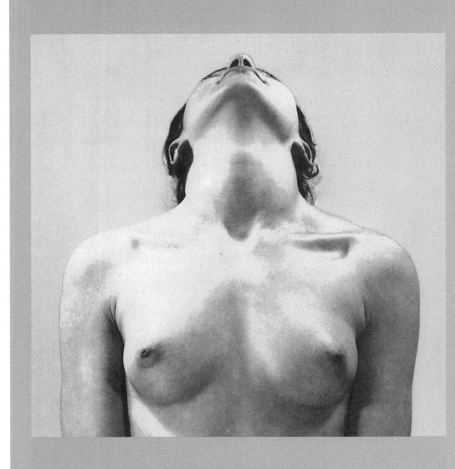

Fig. 467 Frontal view of extension of the cervical spine.
The range of flexion and extension both reach about 40°. There is strong flattening of the angle between the neck and chin during extension, resulting in high tension in the muscles that form the base of the chin and the muscles above the hyoid bone (suprahyoid and infrahyoid muscles) and protrusion of the larynx.

Fig. 468 Co-directional movements of the cervical spine during extension and flexion.
a) Flexion. Note the protrusion of the spinous processes at the transition of the cervical spine to the thoracic spine.
b) Extension. Note the tension extending from the jugular notch to the tip of the chin and the C-shaped fold between the sternocleidomastoid and the trapezius. The co-directional movement in flexion and extension is due to the fact that the mechanics of the atlanto-occipital joints persist continuously through the other joints in the CS.

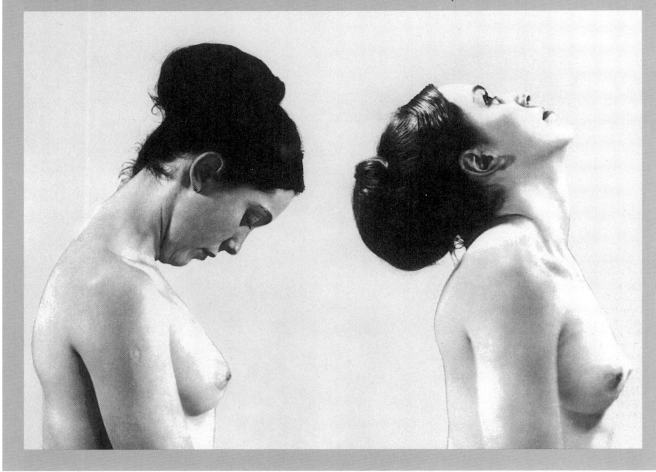

Conversely: extension of the lower CS, but flexion in the atlanto-occipital joints (pulling chin towards body). The gaze remains oriented forwards. This results in a pantomime-like expression of restraint, grandeur, aloofness, of defiance [466b].

9.4.2. Lateral inclination

We incline the neck and head to the side around the sagittal axis (co-directional involvement of all joints in the CS). The range to each side amounts to about 45°.

Co-directional movements are possible (the facial axis remains vertical: traditional Indian dance, expression of restraint, grandeur, aloofness, defiance) [466b].

9.4.3. Rotation around the vertical axes

The basic movements mentioned above are rare in their pure form. We usually combine them. This means that an unlimited selection of advantageous initial positions of the head is available for exploitation by our sensory organs [463, 465, left].

Fig. 469 Sternocleidomastoid and neck muscles during action.
The illustrations reveal the diversity of sternocleidomastoid function, which is by no means only limited to rotation of the head. It is an important component in the illustration of the neck and its expressiveness.

a) Flexion of the CS.
b) Extension of the CS.
c) Pushing head forwards.
d) Pulling head backwards.
e) Rotating head.
f) Inclination and stabilising function.

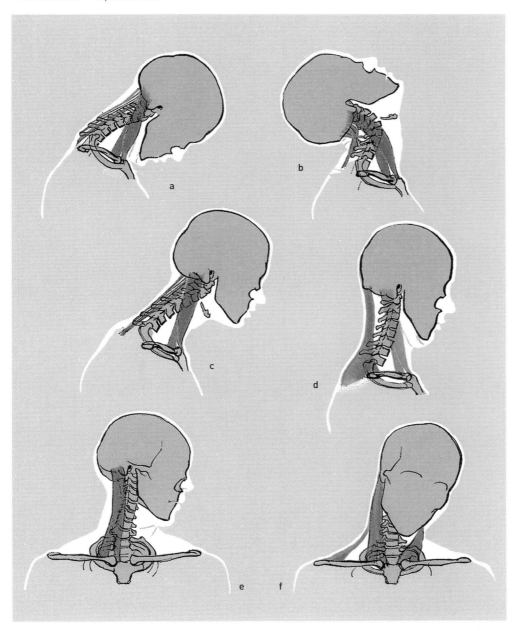

9.5. THE MUSCLES OF THE NECK

It comes as no great surprise that the many and complicated joints in the neck have a complex muscle apparatus. We only describe what is absolutely necessary [469, 470a, b, 471, 472, 475].

9.5.1. Overview of the general system

The cranial joints have their own short muscles. These will not be discussed as they are in the deep muscle layer. The cervical spine, from the second vertebra onwards, also has short muscles (deep layer). These will not be discussed. There are also longer muscles that act on the cervical spine and the head:

the semispinalis capitis (M. semispinalis capitis = also M. transverso occipitalis),
the longissimus cervicis and capitis (M. longissimus cervicis et capitis),
the levator scapulae (M. levator scapulae) that extends the CS when the shoulder blades are drawn together,
the trapezius (M. trapezius, see scapulothoracic muscles), which acts to bend the head backwards.

These muscles that act on the CS and head are extensors of the CS and head when they are posterior to the transverse axes [469b]. Muscles that are anterior to the transverse axes through the CS and cranial joints act mainly as flexors of the CS and head [469a, c]. All muscles located laterally to the sagittal axes incline the head and neck to the side [469f]. All muscles that cross over the vertical axes rotate the neck and head [469e].

Fig. 470 The muscles of the head and neck.
a) Frontal view.
b) Lateral view.
In addition to the trapezius and the sternocleidomastoid, which form the supraclavicular fossa close to the clavicle, the infrahyoid muscles that are visible in the 'V' between the two sternocleidomastoid muscles and insert into the hyoid bone are worthy of note, both with reference to their plastic appearance and function. They give the front of the neck the shape of a ship's bow and hold the hyoid in a 'floating' position jointly with the suprahyoid muscles.

Fig. 471 (below, top left)
Sternocleidomastoid and trapezius
illustrated in isolation.
Knowledge of the spatio-spiral torsion
of the sternocleidomastoid between
its origin and insertion is required to
understand the plastic appearance
of the neck. Together, the two
sternocleidomastoid muscles form a 'V'
that is tilted backwards, between the
branches of which the larynx and the
infrahyoid muscles protrude forwards like
a ship's bow.

Fig. 472 (below, bottom left) Posterior
view of the muscles of the neck.
In the model, we also see a sequence
of important overlaps that inevitably
occur due to the intrinsic torsion in the
sternocleidomastoid between its origin
from the occipital region and its insertion
into the clavicle at the front, apart from
the partial overlaps in the remaining
lateral muscles of the neck.

Fig. 473 (below, right) Hyoid, larynx and
thyroid gland.
a) Anterior view.
b) Lateral view from left.
The thyroid cartilage of the larynx and the
hyoid bone that is connected to it make
the most important contribution towards
the shape in the region of the throat.

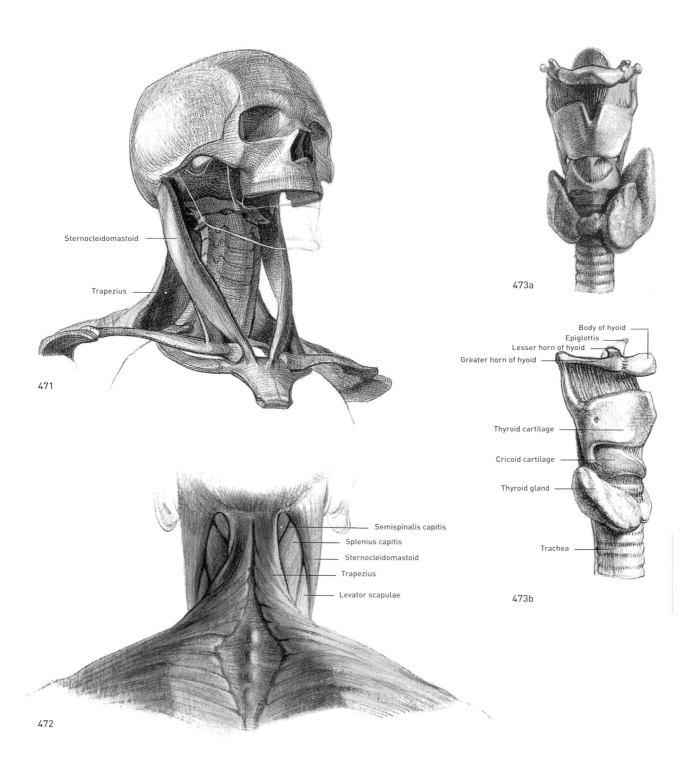

Sternocleidomastoid

Trapezius

471

473a

Body of hyoid
Epiglottis
Lesser horn of hyoid
Greater horn of hyoid

Thyroid cartilage

Cricoid cartilage

Thyroid gland

Trachea

473b

Semispinalis capitis
Splenius capitis
Sternocleidomastoid
Trapezius
Levator scapulae

472

The neck **427**

Details on the most important muscles of the neck

Superficial flexors of the CS and head:

Platysma (not depicted): The most superficial of all the muscles in the neck.
Origin: Subcutaneous tissue of lower part of face, mandible to chin.
Course and insertion: Extends down across the neck, inserting into the fascia in the region of the clavicle.
Function: Draws the mandible and the angle of the mouth downwards when given a fright. Flexes the head against resistance when the jaw is closed by the masticatory muscles.
Plastic appearance: In spite of its thin nature – which does not obscure the plastic appearance of the remaining muscles of the neck – it is of great importance in wrinkling skin with little subcutaneous fat into protruding strands.

The infrahyoid muscles [470a, b, 474]: These are a group of vertical anterior neck muscles that insert into the hyoid (Os hyoides), a small, horseshoe-shaped bone (the primary function of the hyoid is to create the transition from the horizontal muscle floor in the oral cavity to the vertical muscles in the neck). From here, these muscles regulate the relative positions of the larynx, mandible and trachea [473, 474, 475]. They are involved in pulling the chin towards the body and in flexion of the neck. The infrahyoid muscles include: the omohyoid (M. omohyoideus), the sternothyroid (M. sternothyroideus) and the thyrohyoid (M. thyrohyoideus).

The suprahyoid muscles [470b]: These primarily form the base of the oral cavity. Through mediation by the hyoid in the throat, their horizontal position is continued in the vertical orientation of the previous group. These are included in the cranial muscles (see section 10.4.3.).

The sternocleidomastoid (M. sternocleidomastoideus, see below).

Superficial extensors of the CS and head:
 splenius capitis (M. splenius capitis)
 digastric
 hyoid
 thyrohyoid
 thyroid cartilage
 thyroid gland
 sternothyroid
 omohyoid (linear depiction)
 sternohyoid
 splenius (M. splenius cervicis)
 sternocleidomastoid
 trapezius

Fig. 474 The infrahyoid muscles. The hyoid is suspended from a 'sling' attached to the digastric and provides the transition from the vertical action of the infrahyoid muscles and the horizontal action of the suprahyoid muscles, mainly located in the floor of the oral cavity, thus providing a connection through to the tip of the chin which acts to draw the mandible downwards (open the mouth).

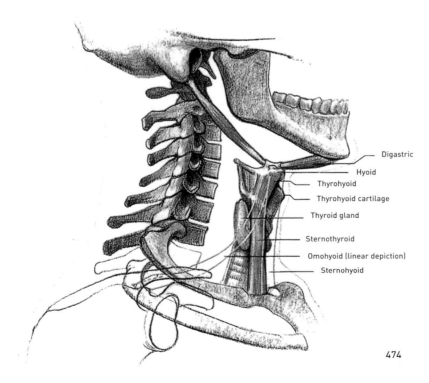

Digastric
Hyoid
Thyrohyoid
Thyrohyoid cartilage
Thyroid gland
Sternothyroid
Omohyoid (linear depiction)
Sternohyoid

474

Superficial muscles involved in lateral flexion:
 splenius capitis and cervicis
 longissimus capitis (M. longissimus capitis) [346]
 scalenes (Mm. scaleni) [342]
 trapezius
 levator scapulae (M. levator scapulae) [380]
 sternocleidomastoid

Muscles involved in rotation of the head:

The sternocleidomastoid (M. sternocleidomastoideus) [470, 471, 475]: Of greatest importance to plastic appearance. It is amazing in its diversity of functions.

Fig. 475 The muscles of the neck in partial frontal view (the thyroid gland is not depicted).
The supraclavicular and infraclavicular fossas are important in the plastic appearance of the neck region, the creation of which can be attributed to the gap between the sternocleidomastoid and the trapezius, and the pectoralis major and the deltoid, respectively.

Origin: Manubrium (upper third of sternum) and one part from the clavicle (medial section).
Course and insertion: Both heads fuse and twist round the lateral surface of the neck (crossing vertical axes through CS); it ends up behind the transverse axes through the upper CS; insertion into the mastoid process behind the ear. It therefore also has a strong lateral position relative to the sagittal axes.
Function: Rotation of the head around the vertical axes (military turning of the head) [465, 469]. In this process, the strand on the opposite side to the direction of rotation contracts. Its course is then vertical. Inclination of the head to one side (opposite side fulfilling stabilising function). Stabilising function when allowing head to drop back; stabilising function when raising the body from a horizontal position (tension, to support the head). Jutting the head forwards, by carrying out a co-directional movement between the cranial joints and the remainder of the CS (flexion in the CS and extension in the cranial joints). Extension of the head, especially when acting together with the trapezius. Accessory function in respiration (raising of front of rib cage).
Plastic appearance: See next section.

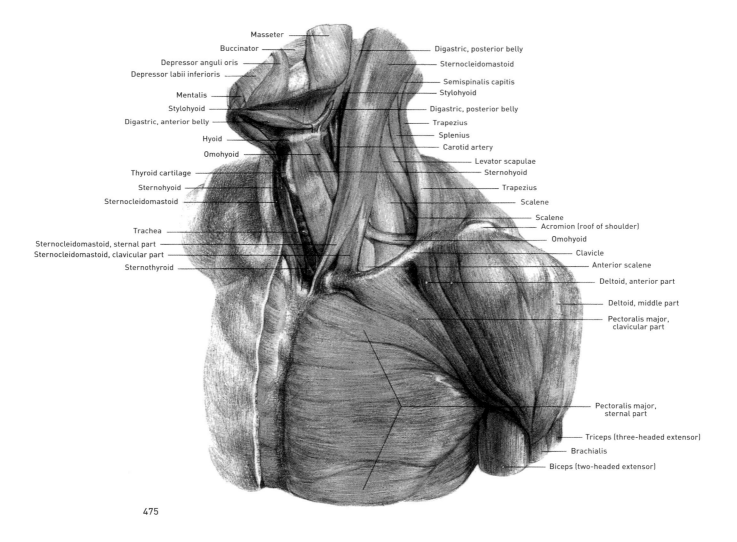

Masseter
Buccinator
Depressor anguli oris
Depressor labii inferioris
Mentalis
Stylohyoid
Digastric, anterior belly
Hyoid
Omohyoid
Thyroid cartilage
Sternohyoid
Sternocleidomastoid
Trachea
Sternocleidomastoid, sternal part
Sternocleidomastoid, clavicular part
Sternothyroid

Digastric, posterior belly
Sternocleidomastoid
Semispinalis capitis
Stylohyoid
Digastric, posterior belly
Trapezius
Splenius
Carotid artery
Levator scapulae
Sternohyoid
Trapezius
Scalene
Scalene
Acromion (roof of shoulder)
Omohyoid
Clavicle
Anterior scalene
Deltoid, anterior part
Deltoid, middle part
Pectoralis major, clavicular part
Pectoralis major, sternal part
Triceps (three-headed extensor)
Brachialis
Biceps (two-headed extensor)

475

9.6. THE PLASTIC APPEARANCE OF THE NECK

It rapidly becomes clear that we cannot simply envisage the neck as a cylinder when we immerse ourselves in its specific corporeal, spatial form. It bears the closest resemblance to a rounded-off tetragon, with a greater sagittal than transverse depth, wider at the front than at the back of the neck. The cross-section of the neck flattens off laterally, close to the base of the skull; it turns into a longitudinal ellipse, while it forms a transverse ellipse close to the trunk. The sides of the neck are twisted superficially, exhibiting propeller-like torsion: the two sternocleidomastoids originate from the sternum and clavicle in the coronal plane, rise upwards like the branches of a 'V', spread apart and insert behind the ears, forming a bulge. The 'coiling' is so advanced here that the muscle strand is forced to take on a semi-circular shape in its spatial orientation, that is dictated by the nuchal line on the base of the skull (running from one mastoid process to the other).

The anterior and lateral portions of the trapezius insert into the roof of the shoulder; by rising up to the occipital protuberance, it also follows the spatial spiral, with a parallel space between it and the sternocleidomastoid. This creates the supraclavicular fossa above the clavicle. Overall, the neck spirals upwards from its frontal aspect, achieving a rotation of almost 180° at the back of the neck. The flat triangle of the neck is also involved in this. The jugular notch offsets the frontal middle neck from the sternum. This arises from the penetration of two entities with different orientations: from the forking of the two sternocleidomastoids, running upwards and backwards and from the bow that is jointly formed by the infrahyoid muscles, the horseshoe-shaped hyoid, the thyroid cartilage of the larynx (called 'Adam's apple' in the vernacular) and the vessels in the neck. The bow shape pushes outwards and upwards towards the front between the V-shape of the sternocleidomastoids, that run upwards and backwards, until it reaches the hyoid (neck angle), where the transition to the horizontal area of the floor of the oral cavity occurs. The sternocleidomastoid [465] alone imparts the typical elements of the process underlying many basic movements of the neck and head: when turning the head to the side, the contracted opposite side protrudes from the sternum and clavicle in the form of a vertical bulge with sharp edges. The ear is vertically positioned above the jugular notch [465, left]. It almost disappears under skin folds on the non-contracted opposite side. During lateral flexion, it stabilises the head in a tilted position and therefore activates the relief of the neck. Its volume becomes more rounded and broad when the neck and head are extended [467]. When this posture is viewed in profile, its taut course disappears and it turns into a bulging convex shape [468, 469]. Separated by a deep fold, it directly overlies the lateral triangle of the neck. When the head is pushed forwards, the sternocleidomastoid is positioned vertically over the clavicle (profile view), whereby the larynx and the infrahyoid muscles impressively shift their bow shape forwards from the depths of the jugular notch [466, 469b]. All of this shows how little help a schematic idea is if it is based on geometric shapes, in this case, a cylinder. Great art will always draw its inspiration from the source. This requires dedicated contemplation of Nature, intellectual penetration of the visible, and creative processing.

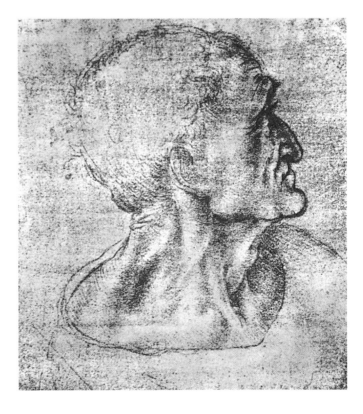

Fig. 476 Leonardo da Vinci (1452–1519). *Head of a Man*, study for the head of Judas for *The Last Supper* (ca. 1497). Red chalk, Windsor no. 12547.
While Michelangelo works out the plastic appearance of the neck into its finest detail and uses it to express passionate excitement, Leonardo sees it as a significant element in the physiognomy of ageing.

9.7. THE PROCESSING OF ANATOMICALLY OBJECTIVE CONSTITUENTS RELATING TO THE PLASTIC APPEARANCE OF THE NECK IN WORKS OF ART

If we wished to prove the extent of artists' aesthetic interest in the shape and plastic appearance of the neck, it would be a simple proposition to use it to indicate status and type of the individual, youth and age, masculinity and femininity, both in portraits and in the nude figure, in practice and in aesthetic theory. Artistic hymns of praise have been sung about the noble, long, slender neck. However, in art, we also view the neck as a bearer of the signs of fate, an example of this being the Düreresque drawing of a mother with the unsightly protruding strands of the platysma or, in contrast, the proud, massive column-like form that supports the head of the *Partisanin* by Eugen Hoffmann. The author's very limited selection here provides examples of the youthful female neck to reveal a few incidences, resulting from shapes that take place in forms with a soft balance of physicality and spatial formation due to the anatomy, as well as through the orientation of

the head (Raphael, Schnorr von Carolsfeld). We will also add the great detail in the thin neck of an elderly male (Leonardo) and its expressive function due to the positioning of the head (Michelangelo).

In his study for *The Wedding Banquet of Cupid and Psyche* [478], Raphael, the great admirer of feminine grace, certainly understood the well-proportioned curve of the neck as a sign of its beauty when he observed the spaces at its base – the jugular notch and supraclavicular fossa – to be levelled off in his model through being filled with fatty tissue, and depicted this as such, as is typical for the youthful adult neck. The thus softened superficial relief thereby greatly aids him here in his intentions with reference to form, as he can allow the rhythm of the nuchal line to flow over the softly protruding trapezius and continue through the rounded shoulder, without interference from any details. He emphasises this rhythmic outpouring even further in the middle Grace by introducing even greater spatial torsion into the muscular triangle of the neck, formed by the trapezius, through rotation of the head. The form and manner of the composition for this nude expression demonstrate once again that these are not functional pieces of art, but a means of ensuring the forms strike a chord.

This also applies to Michelangelo, but the meanings are different. The expression of his nudes does not combine to produce harmony in relation to shapes. In

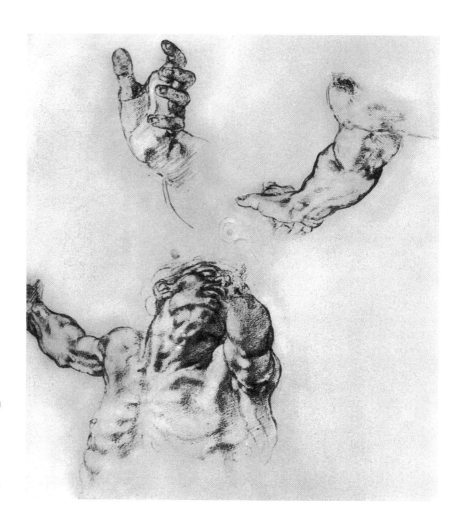

Fig. 477 Michelangelo (1475–1564).
Studies for *The Punishment of Haman*.
Black chalk, 33.3 x 22.7cm (13 x 9in).
Teylers Museum, Haarlem.
Just as Michelangelo does in all his figures, especially in his late period, he beholds a dramatic and tragically moving human image, in which he also includes a powerful, titanic neck expressing great suffering through being turned to one side, the relief of which is full of detail and expresses the revolt of the soul against the body that is bound to the Earth to no lesser extent than the body in its entirety.

their earthly framework they are a muted, whispered, sighed, groaned lament, and his enormous anatomical knowledge and ability to sense the physical suffering are challenged with finding the strongest, most captivating expression that is possible, with his own inner state searching for an admonishment that is appropriate – a physical image that does this challenge justice. This is also why the older Michelangelo gets, and the more acute the crises of his times, the greater the massive excess in relation to dimensions and movements. The studies for *The Punishment of Haman* [477] also speak this language. The way in which the tortured man is nailed to a fork in a tree, twisted, spread-eagled and crooked, is reflected in the massive neck writhing through the force exerted by the sternocleidomastoid, the entire spiral of the body is continued through the opposite side being consumed

by deep folds, the larynx protrudes from between the infrahyoid muscles as a sign of the head dropping backwards, accompanied by tension in the muscles in the floor of the mouth. Lateral rotation, lateral flexion and extension, with the face half obscured, greatly foreshortened arms and hands – an image of dissonant forms, a picture of agony.

As his model for the head of Judas for *The Last Supper* [476], Leonardo selected a gaunt, elderly man, whose jagged neck is in tune with the hooked physiognomy of the profile. Incidentally, this often features in the artistic sketches by the artist, and also in the anatomical studies on the deltoid and pectorals [3, 4]. What is already present there, in all its precision as a purely anatomical investigation, appears here in the head of Judas like a transferral of the objective constituents to the living appearance:

Fig. 478 Raffaello Santi [Raphael] (1483–1520).
The Three Graces, study for *The Wedding Banquet of Cupid and Psyche*. Red chalk.
Royal Library, Windsor.
The beauty of the youthful Graces and their measured, graceful physical expression manifests both in the harmony of their overall appearance and in the emergence of the details, as well as in the expression of the neck and its shape.

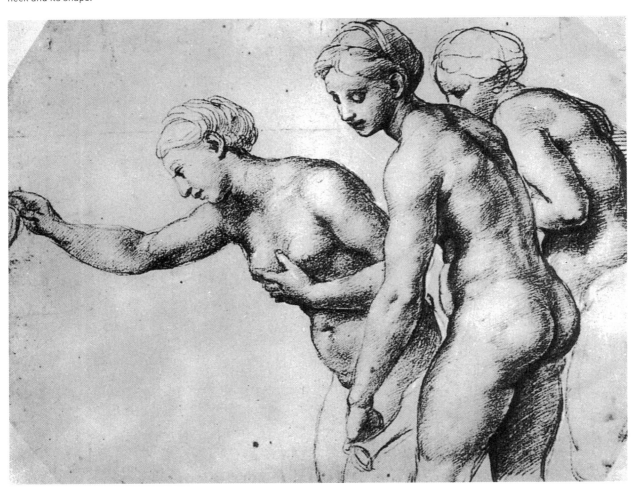

the sternocleidomastoid with its forked origin from the sternum and clavicle, the larynx and the skin on the throat, the nuchal portion of the trapezius and the deeper muscle layer of the neck in the supraclavicular fossa. However, we are not aiming for detailed 'proof of knowledge', no more than we generally use the 'soundness' of the anatomy as a criterion for judging artistic merit. The study is also of relevance to us in another way: Leonardo does not just see the entire interplay of the neck muscles and their individual plastic appearance, but also what effect this has spatially – the pits, dips, hollows, the lively up and down of the relief, the contradictory and shrivelled elements, which probably appeared exactly perfect for the traitor Judas.

The mind-set that drawing in the Romantic period conveys through all its subjects aims at far higher things than just the solidity of the perfect mastery of the art – otherwise it would not be a mind-set. Nevertheless, it attributed a great deal of importance to the mastering of artistry because it formed a vital component in the presentation of a natural form refined in spirit and morals. Therefore, in the Romantics' view, the drawn natural entity was suffused with inner nobility and lively warmth, whether this pertained to a plant or a human, a head, an arm, a shoulder or a neck. Like many of his peers, Schnorr von Carolsfeld aspired towards a natural form that was cleansed of all randomness and brought to full maturity [489]. The neck that turns and accomplishes this through the strength of its perfect form, under mild tension, with well attuned ordering of the large and small, is a creation that is equally deserving of admiration as it would for the entire human being.

Fig. 479 Julius Schnorr von Carolsfeld (1794–1872).
Studies for Selection by the Emperor. Kupferstich-Kabinett, Dresden. Romantic art, the important achievements of which are rooted in a culture of excellence in drawing, was capable of expressing the stirrings of the soul and unifying this through the aforementioned powers of observation, even in preparatory detail studies.

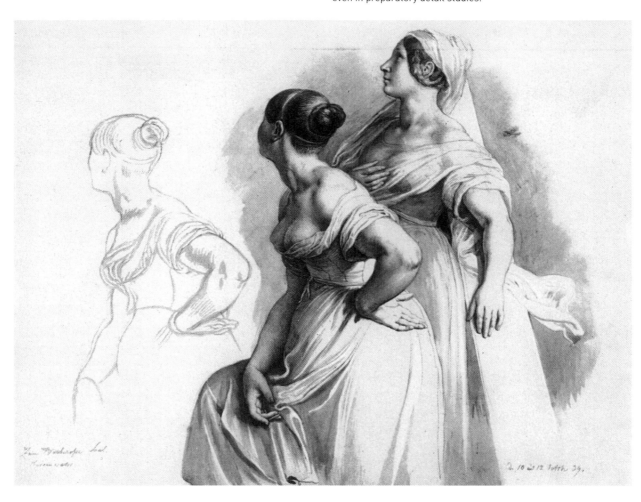

10 The head

Such a high concentration of individual direct and indirect expression, of differentiation of shapes, characteristics pertaining to age, gender, constitution and ethnicity is to be found nowhere else on our body as in the head. It is not counter to human dignity to dedicate an objective investigation to this, the crowning feature of the organisation of the human body. Quite the contrary, the uniqueness of its individuality raises the question on its general structural principles, physical and spatial arrangements and the architectural framework.

Fig. 480 Lateral view of the skull. The two portions of the skull, the brain case and the facial skeleton, fulfil their functions in different ways: the brain case has a protective and enveloping function by enclosing its hidden insides from the outside, while the facial skeleton forms the supporting scaffold that builds up the shapes of the face from inside.

10.1. GENERAL CHARACTERISTICS AND FUNCTION

We have focused mainly on the locomotor apparatus up to now, on parts of the scaffold and its connecting joints, on mechanisms of movement and forces involved in movement. However, the head cannot be regarded in such a way as it is not part of the locomotor apparatus. It carries, harbours and protects the brain, the main sensory organs, the internal structures within the mouth and nose, where the airways and food passage start. The skeleton of the head is not just a supporting scaffold, as is the case in the locomotor apparatus, but also a protective capsule enveloping the brain. Nature has shifted many of the vital functions and the instruments for orientation, such as the face and hearing, taste and smell, as well as articulation and

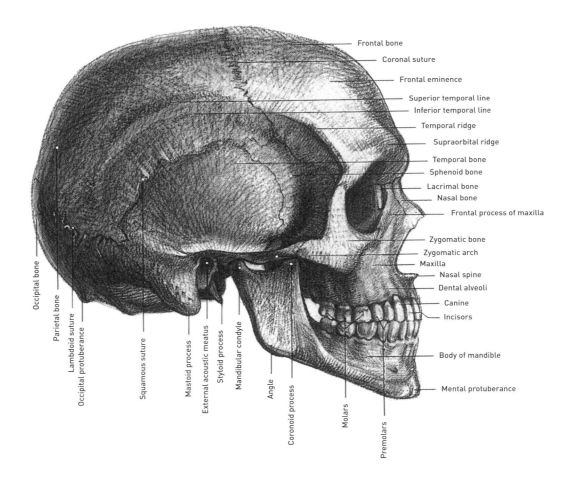

Frontal bone
Coronal suture
Frontal eminence
Superior temporal line
Inferior temporal line
Temporal ridge
Supraorbital ridge
Temporal bone
Sphenoid bone
Lacrimal bone
Nasal bone
Frontal process of maxilla
Zygomatic bone
Zygomatic arch
Maxilla
Nasal spine
Dental alveoli
Canine
Incisors
Body of mandible
Mental protuberance

Occipital bone
Parietal bone
Lambdoid suture
Occipital protuberance
Squamous suture
Mastoid process
External acoustic meatus
Styloid process
Mandibular condyle
Angle
Coronoid process
Molars
Premolars

the production of sounds, the cavities for breathing and the intake of food to the head. The sensory organs, the nose, eye and mouth, are driven by minimum muscle power. A similar statement can also be made with reference to how the head is carried, as it is balanced so well that relatively little muscle power is required to move it.

10.2. COMPONENTS AND ORGANISATION OF THE SKULL (CRANIUM)

10.2.1. Overview of the bones and the organisation of the skull [480–485]

Two large sections of the skull are distinguished, based on their different functions: the brain case (neurocranium) and the facial skeleton (cranium faciale or splanchnocranium).

The brain case is an egg-shaped capsule that envelopes the brain, with a 'pointed' pole at the forehead, a broad and blunt occipital region, tilted backwards and downwards through its vertical axis that runs from the supraorbital ridge through the external acoustic meatus, and enclosed by the following zones: the forehead to the temple; crown–occipital region; external base of cranium.

In contrast, the facial skeleton, the skeleton that actually forms the internal supporting scaffold for the face – with the exception of the ancillary shapes – forms a vertical bow (see section 2.2.2) that is delimited by the supraorbital ridge at the top, the mental protuberance at the bottom and the mandibular fossa at the back.

To provide the reader with further detailed information, we list the 29 bones that make up the mosaic of the skull here, but do not discuss them any further:

Brain case (neurocranium):
 one frontal bone (os frontale)
 two parietal bones (ossa parietalia)
 two temporal bones (ossa temporalia)
 one occipital bone (os occipitale)
 one sphenoid bone (os sphenoidale)

Facial skeleton (cranium faciale):
 ethmoid bone (os ethmoidale)
 nasal bones (ossa nasalia)
 two lacrimal bones (ossa lacrimalia)
 two inferior nasal conchae (conchae nasales inferiores)
 vomer (vomer)
 zygomatic bones (ossa zygomatica)
 two palatine bones (ossa palatina)
 two maxillae (maxillae)
 one mandible (mandibula)
 six auditory ossicles (malleus, incus, stapes)
 one hyoid bone (os hyoides)

Fig. 481 Frontal view of the skull.

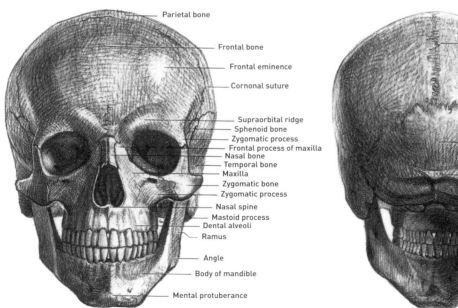

Parietal bone
Frontal bone
Frontal eminence
Cornonal suture
Supraorbital ridge
Sphenoid bone
Zygomatic process
Frontal process of maxilla
Nasal bone
Temporal bone
Maxilla
Zygomatic bone
Zygomatic process
Nasal spine
Mastoid process
Dental alveoli
Ramus
Angle
Body of mandible
Mental protuberance

Fig. 482 Dorsal view of the skull.

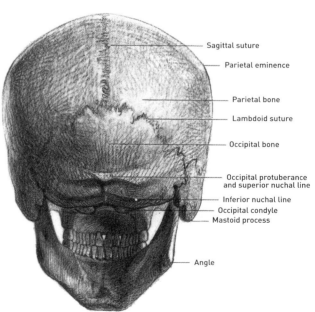

Sagittal suture
Parietal eminence
Parietal bone
Lambdoid suture
Occipital bone
Occipital protuberance and superior nuchal line
Inferior nuchal line
Occipital condyle
Mastoid process
Angle

10.2.2. The brain case

From its lateral view (norma lateralis) [94, 480] the temporal bone lies in a central position, meeting with the vertical walls of the parietal bone above, the deeply recessed sphenoid at the front, the occipital bone at the back and incorporating the external acoustic meatus below. Behind this, the mastoid process (processus mastoideus) protrudes downwards. Immediately in front of the external acoustic meatus is the recess that forms the mandibular fossa for the articulation with the mandibular condyle; directly above this, the horizontal, limb-like zygomatic process extends towards the zygomatic bone. The entire vertical, slightly convex region of the temple arches upwards as far as the temporal line (linea temporalis).

The frontal view [481] is dominated by the forehead that curves convexly downwards, ends in the supraorbital ridge and encircles a large portion of the outer orbits with processes adjoining the nasal and zygomatic bones. The two frontal eminences (originally ossification centres for the two frontal bones that do not fuse into one bone until adolescence is reached) protrude from the frontolateral portions of the curved surface of the forehead. An important accent in the curvature at the transition from the crown to the lateral region of the skull is formed by the parietal eminence (tuber parietale), also originally an ossification centre.

The reader will need to study the images to achieve a greater understanding of these and other views which follow in the next section.

10.2.3. The facial skeleton [483, 484b]

We will also keep this brief as we will be returning to this in the subsequent section on the constructional form and plastic appearance of the skull.

The external portions of the orbits (orbita) [481]: The two rectangular pyramidal orbits penetrate deep into the skull, with the tips of the pyramids converging. The margins of the orbits circumscribe a rounded parallelogram, not an oval or circle! The superior and inferior margins run parallel to each other, oriented downwards towards the lateral angle of the eye. The orbital margins deviate from a precise frontal plane as they slope back and towards the sides (important for the plastic appearance). The superior margins of the orbits are positioned vertically over the inferior margins.

The bony nasal cavity [480, 481]: The soft tissue of the nose (connective tissue and cartilage) narrows the broad, bony, pyriform aperture into two small holes. This opening is encompassed by the two delicate nasal bones and maxillary processes. A vertical bony and cartilaginous separating wall (nasal septum, septum nasi) in the middle of the nasal cavity splits this cavity in two. The cartilage of the nasal septum has a suitable point of attachment in the form of the anterior nasal spine (spina nasalis anterior).

The jaw [480, 481, 484]: This includes the upper and lower jaw, which make up important parts of the face. These portions are mainly responsible for the shift in proportions between the infant and the adult head.

The upper jaw (maxilla) rises upwards from the dental alveoli to the frontal, nasal and lacrimal bones, surrounds the nasal cavity below and at the side and connects to the zygomatic bone. The frontal process of the maxilla (processus frontalis) transfers the force generated by mastication to the frontal bone, with the zygomatic process (processus zygomaticus) transferring this force to the zygomatic bone.

The lower jaw (mandibula) is a solid bone in the shape of a horseshoe. Its horizontal portion harbours the dental alveoli and its vertical portion bends upwards at the angle of the mandible, forming a fork at the top with the coronoid process and the mandibular capitulum (processus muscularis and capitulum mandibulae, respectively). The mandibular capitulum bears a condyle that articulates with the mandibular fossa in the base of the skull, in front of the acoustic meatus (jaw joint) [484c]. The pronounced mental protuberance (trigonum mentale) of the chin is a characteristic of modern humans, particularly marked in those of European descent.

10.3. THE CONSTRUCTIONAL FORM AND PLASTIC APPEARANCE OF THE SKULL

The function of the brain case and facial skeleton, to support and provide external protection, reveals the essence of its construction and peculiarities with reference to its plastic appearance. In order to gain an overview, we will now work out its basic shape and view its idiosyncrasies in association with the demands placed on it [486a, b]. Ancillary forms, like the zygomatic bone, zygomatic arch, nasal cavity, dentition, cavities and gaps will not be considered for the time being.

10.3.1. The constructional form of the brain case [483, 484a, b, c, 485]

Let us start with the most important observation: the brain case exhibits curvatures, apices and lines that define the areas of decisive spatial orientations and positions in relation to each other. A comparison with the shape of an egg is only appropriate in that this emphasises the narrowing towards the forehead and broadening towards the occipital region. We must literally view the brain case as a house with a footprint, side walls and a roof, the surfaces of which are angled against each other. The footprint is formed by the base of the skull, a rounded pentagon, with its narrow side pointing towards the forehead. The descending surface does not drop off from the forehead to the occipital region in one plane, but is angled at the level of the foramen magnum [486b, c]. The line through this angle traverses the base of the skull from one mastoid process to the other. The normal position of the head maintains the occipital portion almost in a horizontal position, while the middle and anterior portions ascend from the angle up to the upper margin of the orbital cavity. The side walls are erected over this base: the frontal wall of the forehead, the temporal walls at the side and the occipital wall at the back.

The forehead [484–487] exhibits the flattest curve when compared with the other walls. This is a rectangle with a diagonal orientation, the lower edge of which

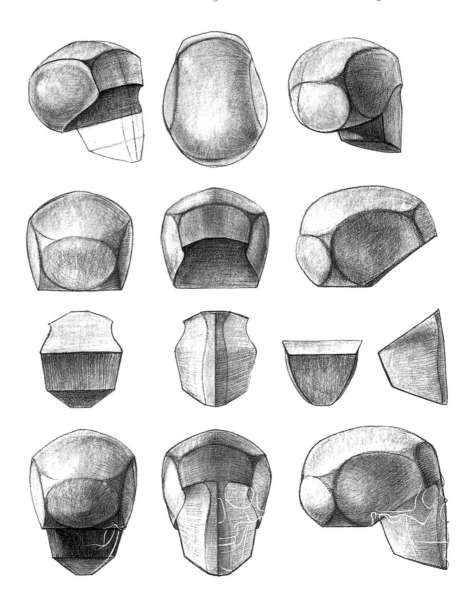

Fig. 483 Different views of the basic constructional form and plastic appearance of the skull. The two middle rows: brain case and facial skeleton separated from each other. The highly differentiated shapes of the skull have been summarised into strongly simplified basic volumes to emphasise the relationships and ratios between the two portions and their defining spatial surface orientations.

curves in a concave fashion at the superior margin of the orbital cavity, with the convex curvature of its upper delimitation culminating laterally, slightly above the two frontal eminences. The short lateral delimitation is formed by the zygomatic process of the frontal bone and part of the temporal line.

The bones in the region of the temple comprise the temporal walls [486c]. These laterally curved shells arch upwards, projecting slightly outwards over the narrower base of the skull. Their lower delimitation follows the anterior and middle portion of the base of the skull, their upper and dorsal delimitation approximates to that of the curved temporal line [484–487].

The occipital region forms the back wall, approximately above the occipital protuberance [485c]. This closes the brain case like an apse at the horizontal semicircle formed by the occipital crest (running between the two mastoid processes).

The roof of the skull [483, 484a, b] crowns the lateral surfaces that curve upwards and are rounded at the sides without a smooth transition. The curved apical surface of the roof is also at an angle to the carrying walls [485, 486c, 487/1].

10.3.2. The constructional form of the facial skeleton [483, 484a, b]

The jaw makes up the main mass of the facial skeleton. This forms the supporting base for mastication and is constructed to cope with the demands of the forces exerted by mastication. While the brain capsule has already been strengthened as a protective casing, such that it can withstand masticatory forces without any specific architecture (Benninghoff), the jaw requires its own pressure-absorbing features (e.g. the masticatory pressure on the incisors is 20 to 25 kg). Three main columns of pressure absorption can be discerned [484a]. One arises from the two canines and runs upwards to the right and left of the bony side wall of the root of the nose and to the frontal bone (frontonasal column). A second, forked main column (zygomatic column) consists of one limb that runs across the zygomatic bone, around the medial and lateral margins of the eye to the frontal bone and the anterior arch of the temporal line, while the other limb runs horizontally across the zygomatic arch into the posterior arch of the temporal line. Overall, the temporal line forms the frame for the lateral walls of the skull. The third main column arises from the molars and ends in the middle of the base of the skull.

All three columns contribute towards the construction of the facial skeleton with the basic shape of a blunt ship's bow [484b, 486b, c]. This shape includes the filled in, prominent orbital cavities and the nasal cavity and rises up along the vertical symmetry axis from the mental protuberance, via the nasal spine, to the root of the nose. The blunt ridge formed by the frontonasal column resembles the bow of a cog-built vessel. It is like a wedge stuck between the two eyes and zygomatic bones. The upper and lower rows of teeth, planted deep into the jaw, are of subordinate importance as individual shapes but, overall, they expand the footprint of the jaw

into a voluminous Latin 'V', with its greatest diameter running from one angle of the jaw to the other. From here, the ramus of the mandible is bent upwards to the articulation, via its condyle, directly under the temporal wall. The ramus of the mandible and the temporal wall are a combination shape, due to the construction underlying the transmission of masticatory forces.

The zygomatic process and the zygomatic bone branch off from the frontonasal column as a relatively independent ancillary shape [486c]. They determine the width of the face, together with the zygomatic arch [487c, e]. The zygomatic bone and zygomatic arch are seated on the lateral shells of the skull like a handle [487c, e, 487/1].

Fig. 484 The constructional form of the skull and its relationships between shapes.
a) Frontal view of the skull, with the most important masticatory force lines drawn on the left half.
b) The vertical and horizontal structures on the facial skeleton, formed based on the laws governing these structures.
c) The mobile connection between the mandible and the lateral base of the skull is created by the jaw joint.
d) The three-dimensional view of the architectural interpretation of the shape of the skull.
The middle supporting column, that arises from the mandible, runs through the molars, around the bony nasal cavity and ends in the medial wall of the hollow pyramid formed by the orbit. The lateral supporting columns run up the ramus of the mandible, the jaw joint and the temporal region.
The masticatory forces that meet at the apex are neutralised.

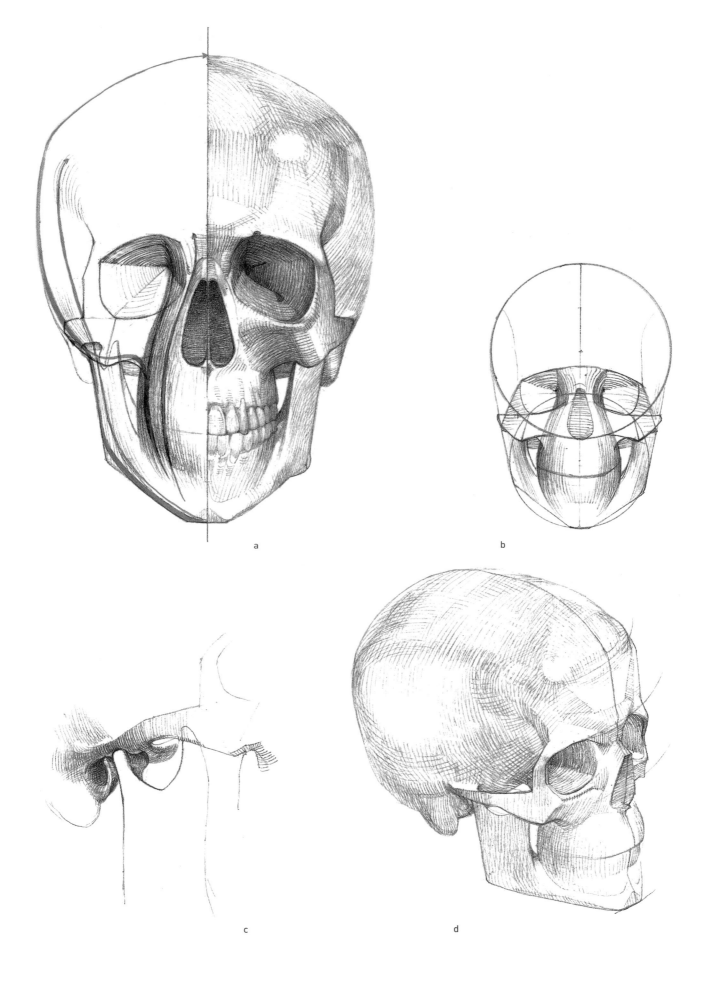

a

b

c

d

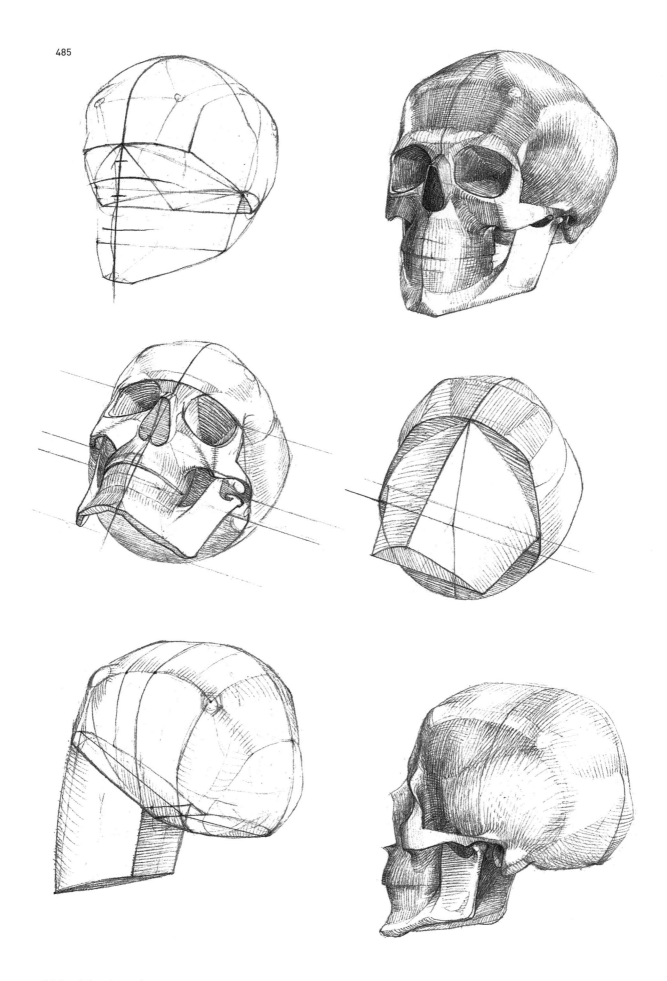

485

Fig. 485 (left) The constructional form of the skull and three-dimensional views of the differentiated, architectural shape of the skull. Modelling of the physicality of the skull as an architectural entity is based on the spatial orientations and relationships between the individual shapes within the whole.

When viewing the skull from an artistic perspective, its large shape must be recognised as the penetration of vertical and horizontal framework shapes: the vertical form is defined by the frontonasal wedge, the ascending rami of the mandible, the lateral margins of the orbits and the lateral walls of the temples. The horizontal form is defined by the bar created by the zygomatic process and the zygomatic bone, the bracket formed by the zygomatic arch and the inferior and superior margins of the orbits, as well as the frontal eminences. Such perspectives help to overcome the imitative nature of life studies.

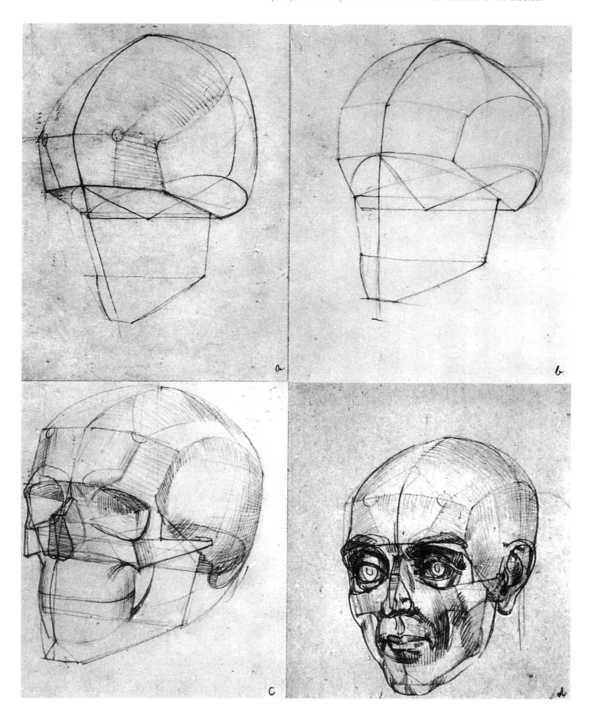

Fig. 486 Draft sketches of the architecturally interpreted shape of the skull during different phases of its illustration (demonstration drawing by the author during corrections of student's drawings).
a), b) The first step consists in clarifying the issues relating to perspective and the position of the body in space by indicating the course of the symmetry axis and the horizontal axes through the skull. The volumes of the brain case and facial skeleton are drawn out in full.
c) The process of building up and differentiation during the development of the architecture of the skull based on the previous primary decisions.
d) The incorporation and build-up of the partial shapes of the head based on the architectural foundations.

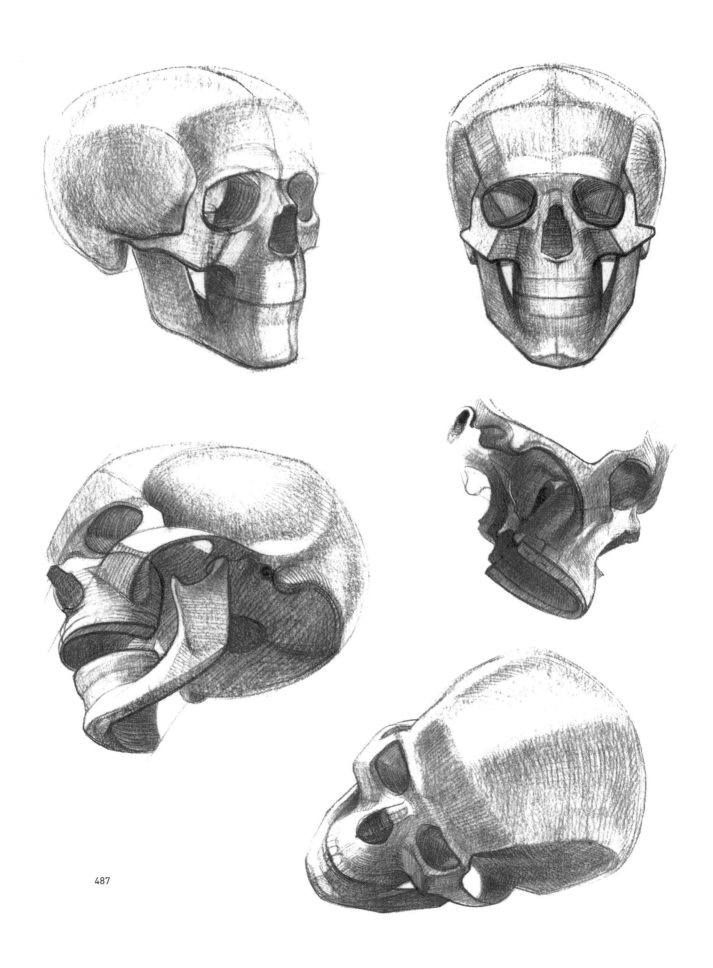

487

Fig. 487 (left) The constructive structural, architectural form of the skull in different perspectives.
Laying down of general principles for dealing with spatial issues is insufficient for such difficult shapes as the skull and head. Were such a decision taken initially, the different natures of tension in the skeleton of the skull – due to its varying intensities of curvature of the forehead, axis through the eyes or central facial column (jaw region) – would then have to be differentiated immediately.

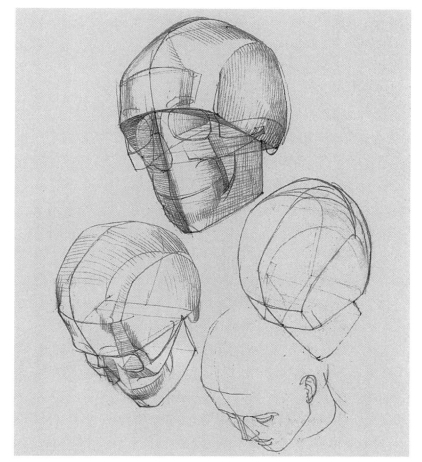

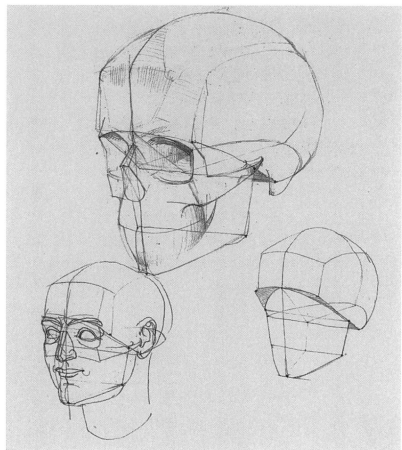

Fig. 487/1 (right) Different three-dimensional perspectives of the architectural form of the skull.
Particularly with reference to its richness in differentiation of shapes, the study of the functional unity of form in the skeleton of the skull requires abstraction to the fundamental shapes that are recognisable, which arise from the interweaving of functional demands and solutions.

Adapted from Bammes, *Wir zeichnen den Menschen.*

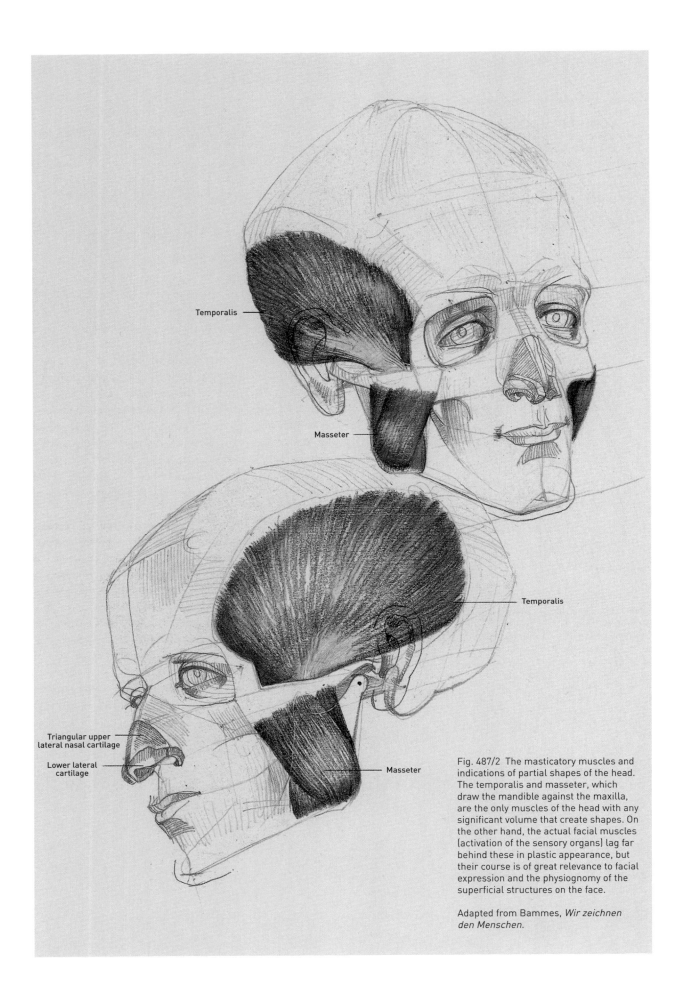

Temporalis

Masseter

Temporalis

Triangular upper
lateral nasal cartilage

Lower lateral
cartilage

Masseter

Fig. 487/2 The masticatory muscles and indications of partial shapes of the head. The temporalis and masseter, which draw the mandible against the maxilla, are the only muscles of the head with any significant volume that create shapes. On the other hand, the actual facial muscles (activation of the sensory organs) lag far behind these in plastic appearance, but their course is of great relevance to facial expression and the physiognomy of the superficial structures on the face.

Adapted from Bammes, *Wir zeichnen den Menschen.*

10.4. THE MUSCLES OF THE HEAD

There are three groups of muscles of the head, classified based on function: the facial muscles that underlie facial expression, the suprahyoid muscles (base of the oral cavity) that connect the hyoid to the skull and the masticatory muscles [475, 477/2, 489, 490, 517].

10.4.1. General preliminary comments and overview [488, 517]

While the task of the other skeletal muscles involves connecting one bony point with another via one or several joints and acting on a lever arm, the function of most of the facial muscles is to influence sensory perception, either promoting the perception of stimuli or defending against stimuli. It is therefore advantageous if only one end of such muscles is connected to the bony scaffold, with the other inserting into soft tissue, like skin, fascia and cartilage. The skeletal muscles create shapes on the bones, forming raised areas or depressions. In contrast, the facial muscles that underlie facial expression cannot influence the construction and relief of the skull through their contraction as they are very delicate. However, their effect on the production of pads, dimples, furrows and creases in the skin is of greatest importance, especially as continued, ongoing use results in permanent features that are characteristic of expression and that we refer to as physiognomy [502, 503]. Those facial muscles that cluster around the sensory organs, which must implement movement in the soft tissues and are not required to perform heavy mechanical functions, have the capacity of particularly free and easy movements that serve to express our emotional ups and downs. They play the role that language has taken over, as the means of expression and communication. We call these the muscles of facial expression [517]. Their delicate nature and development leads to significant individual variation, but how they are used by the brain enhances these differences even further. Some sensory organs have many muscles. A large number of muscles surround the mouth, the tool for food intake, and the nose; there are fewer around the aperture between the eyelids which, instead, has fairly well developed muscles, while the ear and occipital region exhibit only rudimentary muscles.

Fig. 488 (below) The system underlying the arrangement of the oral muscles.
The line illustration showing the schematic arrangement of the oral muscles makes two fundamental forms of arrangement clear: the radial arrangement with the function of opening the lips in all directions, and the circular arrangement which closes the lips.
Strong red colour: superficial muscle layer.
Lighter red colour: deep muscle layer .
Arrows: direction of contraction of muscles towards their origins.

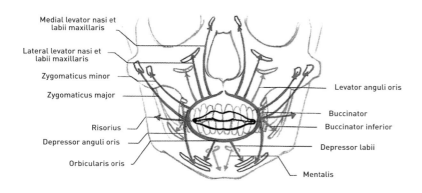

Medial levator nasi et labii maxillaris
Lateral levator nasi et labii maxillaris
Zygomaticus minor
Zygomaticus major
Risorius
Depressor anguli oris
Orbicularis oris
Levator anguli oris
Buccinator
Buccinator inferior
Depressor labii
Mentalis

Axis	Movement	Muscles involved
a) Muscles of facial expression	Muscles in the vicinity of the mouth and nose	Orbicularis oris (M. orbicularis oris) Buccinator (M. buccinator) Lateral levator nasi et labii maxillaris (M. levator nasi et labii maxillaris lateralis) Medial levator nasi et labii maxillaris (M. levator nasi et labii maxillaris Medialis) zygomaticus major (M. zygomaticus major) Zygomaticus minor (M. zygomaticus minor) Levator anguli oris (M. levator anguli oris) Risorius (M. risorius) Depressor anguli oris (M. depressor anguli oris) Inferior depressor labii (M. depressor labii inferioris) Mentalis (M. mentalis) Facial portion of the platysma (pars facialis platysmalis) Nasalis (M. nasalis)
	Muscles in the vicinity of the eye	Orbicularis oculi (M. orbicularis oculi) Corrugator supercilii (M. corrugator supercilii)
	Muscles of the external ear	Auricular (M. auricularis anterior) O Superior auricular (M. auricularis superior) O Posterior auricular (M. auricularis posterior) O
	Muscles of the brain capsule	Epicranius (M. epicranius, venter occipitalis) Frontalis (M. frontalis) O Epicranius temporoparietalis (M. epicranius temporoparietalis) + Depressor supercilii (M. depressor supercilii)
b) Suprahyoid muscles (not discussed)	Some of these open the jaw	Digastric (M. digastricus) Stylohyoid (M. stylohyoideus) O Mylohyoid (M. mylohyoideus) O Geniohyoid (M. geniohyoideus)
c) Masticatory muscles (only plastic muscles discussed)	Muscles that close the jaw	Masseter (M. masseter) Temporalis (M. temporalis) Medial pterygoid (M. pterygoideus medialis, not plastic) +

+ = not discussed, not depicted

O = not discussed, only depicted

10.4.2. The muscles of facial expression [488, 489, 490, 517]

The muscles in the vicinity of the mouth and nose

Concentric muscle strands target the mouth from above, below, the sides and diagonally. They effect the variable forms of opening the mouth. However, the force required to press the lips together is produced by the orbicularis oris. This combines many of the muscles that open the mouth into its oval shape.

The orbicularis oris (M. orbicularis oris): Composed of parallel fibres that surround the lips and form their fleshy basis. Its circular course sends out fibres that attach it to the jaw.

Function: Closing of the mouth. If only the outermost margin is contracted, then the excess flesh of the lips is pushed forwards like a snout.

Facial expressions: The tightly closed mouth appears strict, decisive, hard, ready to act, the relaxed open shape of the mouth casual, indifferent, sated, satisfied.

The buccinator (M. buccinator):

Origin: Alveolar processes of the last molars in the maxilla and mandible.

Insertion: Angle of mouth. The two limbs that originate from the maxilla and mandible cross over each other at the insertion into the orbicularis oris of the mouth, such that the upper limb acts on the lower lip and the lower limb on the upper lip.

Plastic appearance: Forms basis for the lateral wall of the oral cavity.

Function: Shifts food that has not been chewed back between the dentition during mastication through lateral diversion. When the mouth is closed, compresses the air that has been collected (blown up cheeks) from the sides and thus forwards (blowing, whistling, puffing).

Facial expressions: Pulls the angles of the mouth apart during laughing and crying (antagonist of orbicularis oris).

Fig. 489 (below, top) The muscles of the
face (lateral view, superficial layer).
The difference between the facial muscles
(with the exception of the masticatory
muscles) and the muscles of the
locomotor apparatus is that they originate
from a solid point on the bone and insert
into soft tissue and are not required to act
on a bony lever arm.

Fig. 490 (below, bottom) The muscles of the
face (frontal view).
The radiation of the facial muscles into the
soft tissue forms associated with the sensory
organs is one reason for the exceptional range
of facial expressions.

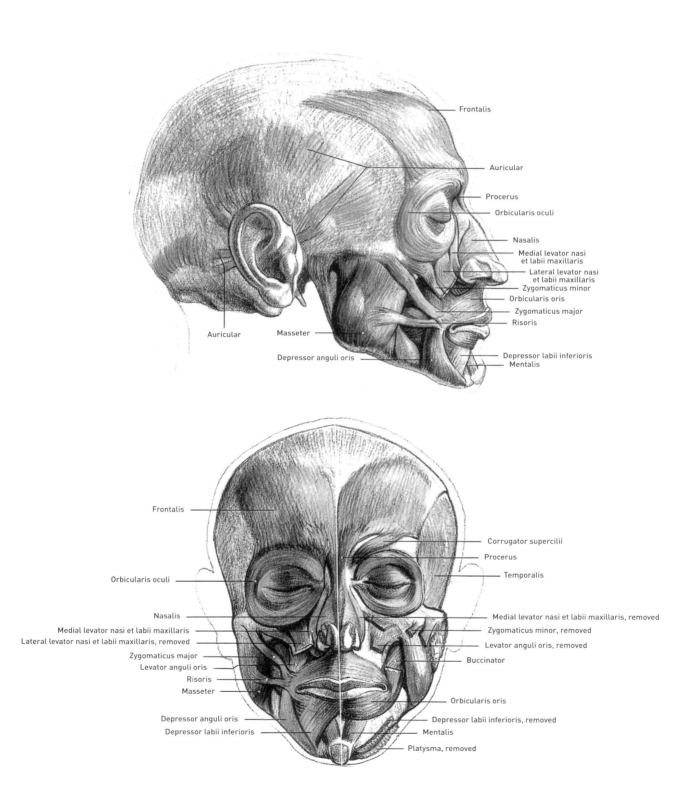

Frontalis

Auricular

Procerus

Orbicularis oculi

Nasalis

Medial levator nasi
et labii maxillaris

Lateral levator nasi
et labii maxillaris

Zygomaticus minor

Orbicularis oris

Zygomaticus major

Risoris

Depressor labii inferioris
Mentalis

Auricular

Masseter

Depressor anguli oris

Frontalis

Corrugator supercilii

Procerus

Temporalis

Orbicularis oculi

Medial levator nasi et labii maxillaris, removed

Nasalis

Zygomaticus minor, removed

Medial levator nasi et labii maxillaris

Levator anguli oris, removed

Lateral levator nasi et labii maxillaris, removed

Buccinator

Zygomaticus major

Levator anguli oris

Risoris

Orbicularis oris

Masseter

Depressor labii inferioris, removed

Depressor anguli oris

Mentalis

Depressor labii inferioris

Platysma, removed

The lateral levator nasi et labii maxillaris (M. levator nasi et labii maxillaris lateralis):
Origin: Below the orbit.
Insertion: Quadrangular in shape, directed downwards and inserting into the skin of the upper lip and the nasal wing.

The medial levator nasi et labii maxillaris (M. levator nasi et labii maxillaris medialis):
Origin: Frontal process of maxilla.
Insertion: As in previous muscle.
Function: Both levator nasi et labi maxillaris raise the upper lip and the nasal wings.
Facial expressions: Revulsion, unease, disgust and similar, also volatile, uncertain mood.

The zygomaticus major (M. zygomaticus major):
Origin: Zygomatic bone.
Insertion: Takes a diagonal course and inserts into the angle of the mouth.
Function: Pulls the angles of the mouth apart and upwards.
Facial expressions: This is the typical laughing muscle.

The zygomaticus minor (M. zygomaticus minor): Located very close to the major muscle, which is why it used to be interpreted as one muscle, together with the two levator nasi et labi maxillaris.

The levator anguli oris (M. levator anguli oris):
Origin: Canine fossa of maxilla.
Insertion: Angle of mouth.
Function: pulling angle of mouth upwards.

The risorius (M. risorius):
Origin and insertion: Angle of mouth and skin of cheek.
Function: Pulls angles of mouth apart, formation of dimples in the cheek.

The depressor anguli oris (M. depressor anguli oris):
Origin: Broad origin from margin of mandible.
Insertion: Angle of mouth.
Function: Pulling angle of mouth downwards. The nasolabial sulcus then no longer curves around the mouth but takes a linear course downwards from the nasal wings.
Facial expressions: Grumpiness, dissatisfaction, disdain, hate, spite.

The depressor inferioris labii (M. depressor inferioris labii):
Origin: From the mandible, slightly lateral to the mental protuberance (partially covered by depressor anguli oris).
Insertion: Skin over lower lip; covers the orbicularis oris here.
Function: Pulls down lower lip to the side.
Facial expressions: Irony, contempt, disapproval.

The mentalis (M. mentalis):
Origin: Below the dental alveoli of the two second incisors (mandible).
Insertion: Skin of chin dimple.

Function: Pulls skin of chin upwards, thereby also shifting the furrow between the chin and the lower lip upwards. This results in the lower lip being pushed forwards.
Facial expressions: Pouting, sulking, starting to cry.

The nasalis (M. nasalis):
Origin: Lateral to the nostril.
Insertion: Into bridge of nose, partially extending across nasal wings.
Function: Pulls down nasal soft tissue, which is occasionally already visible in profile during speech.

The muscles in the vicinity of the eye

The orbicularis oculi (M. orbicularis oculi): This covers the surrounding of the eye, including the lids, like a pair of glasses. Its oval shape is spatially adjusted to the aperture of the orbit and the eyeball and it therefore extends in more than one plane.
Origin: Medial angle of eye.
Insertion: Skin of eyelid and skin around eye.
Function: Closes eyelids and protects eyeball, moves lacrimal fluid.
Facial expressions: It acts like an 'elastic band' during contraction, that folds excess material. Concentric skin folds surround the eye ('crow's feet' in the elderly). It produces the laughter lines.

The corrugator supercilii (M. corrugator supercilii):
Origin: Frontal bone (root of nose).
Insertion: Penetrates from the deep layer through orbicularis oculi to reach the surface and inserts into the skin of the eyebrow.
Function: Draws eyebrows together over root of nose (vertical wrinkles in forehead above nose).
Facial expressions: The skin between the eyebrows is folded into multiple, deep vertical creases. This creates the impression of thoughtfulness, gloom, sinister decisiveness and displeasure. In combination with the frontalis, which pulls the eyebrows upwards, without the vertical creases produced by the corrugator supercilii ever fully disappearing, it creates an impression of suffering and pain.

Muscles of the brain capsule and the outer ear (incomplete discussion)

The epicranium covers the roof of the skull with a thick layer (scalp) that is composed of the pericranium (skin) and a thin, solid aponeurosis (galea aponeurotica). The epicranium can be moved about on the roof of the skull due to its connective tissue. The muscles originate from, or insert into, the aponeurosis.

The frontalis (M. frontalis):
Origin: From the scalp at the level of the hairline.
Insertion: Into the skin of the eyebrows.
Function: Pulls the eyebrows upwards.
Facial expressions: Depending on its thickness, a few or numerous transverse creases are produced in the skin on the forehead (frown). It also raises the

upper eyelid indirectly, creating the impression of attentiveness, thoughtfulness and intellectual contemplation.

The depressor supercilii (M. depressor supercilii):
Origin: From the bony bridge of the nose.
Insertion: Skin of the glabella.
Function: Pulls the skin of the forehead downwards which thereby forms a transverse crease.

The muscles of the outer ear are numerous and highly developed in quadrupedal mammals, but rudimentary and puny in humans. They will therefore not be discussed, but simply included in Figure 489.

10.4.3. The suprahyoid muscles [474, 475]

These have already been mentioned in section 9.5.2. and were listed in the overview of the muscles of the head. Some of the muscles in this group are involved in opening the jaw (digastric and mylohyoid muscles). The suprahyoid muscles are generally understood to include those muscles that connect the skull and the hyoid bone and form the floor of the mouth.

10.4.4. The masticatory muscles [487/2, 489, 490]

The muscles of facial expression contrast with the skeletal muscles that act on the jaw joint. In actual fact, its structure is complicated. We will make do with simply noting that it is a hinge joint, composed of the two processes of the mandible (reference in section 10.2.3.), with an orthogonal condyle that articulates with a shallow fossa, anterior to the external acoustic meatus (opening–closing). However, the condyles can also be moved laterally (grinding movement) or in an anterior direction (rasping). Mastication of food is associated with huge forces (20 to 25kg per cm^2 on the incisors). The muscles that close the mouth are therefore the most powerful muscles of the head and have a significant effect on the plastic appearance of the face. For this reason, only these muscles will be discussed. The two most important muscles that close the jaw are:

The masseter (M. masseter):
Origin: Lower margin of the zygomatic arch and zygomatic bone.
Course and insertion: Two portions that overlap each other and insert diagonally backwards and downwards into the angle of the mandible.
Function: Exertion of pressure for mastication through closure of the jaw.
Plastic appearance: It is of great importance to plastic appearance. It occupies the angle of the jaw as a quadrangular shape and fills the space between the protruding zygomatic bone and the zygomatic arch through to the angle of the mandible, but without exceeding the breadth of these cheek bones. It swells up into a bulbous shape when food is being chewed intensively. However, when the jaw is closed strongly due to emotional states such as defiance, anger, decisiveness, it confers an energetic

hardness on the cheek and is thus important to facial expression (expression of 'doggedness').

The temporalis (M. temporalis):
Origin: Temporal fossa, delimited above by the semi-circular temporal line (linea temporalis) and the temporal fascia.
Course and insertion: Arises from its fan-shaped origins and its insertion is concentrated on a small area, the coronoid process of the mandible.
Function: Closure of the jaw, exertion of pressure for mastication, most powerful masticatory muscle.
Plastic appearance: Covered by fatty tissue in middle age, fills most of the temporal fossa, more prominent in the elderly due to loss of fat. It is easily visible during chewing, alternately swelling up and receding.

The muscles that open the mouth include:
the lateral pterigoid (M. pterygoideus lateralis)
the digastric (M. digastricus)
the mylohyoid (M. mylohyoideus)
the neck muscles that run downwards from the mandible.

10.5. SHAPES OF PARTS OF THE HEAD

10.5.1. Form and plastic appearance of the eye

'The eye is the final and greatest result of the light acting on the organic body. The eye is created by the light and, as such, achieves everything that light itself can. Light transfers what is visible to the eye, the eye transfers this to the human. The ear is deaf, the mouth is dumb; but the eye perceives and speaks. In it, the world is reflected from the outside and the human from the inside. The totality of the internal and external is completed by the eye' (Goethe, in a posthumous publication on his theory of colour).

Softly cushioned by fat, the almost spherical eyeball rests in its bony, pyramidal cavity. It sinks inwards if weight is lost and the fat disappears due to age or disease. The upper eyelid is particularly mobile when sliding vertically across the anterior surface of the eyeball, while the lower eyelid is less mobile (palpebra superior and inferior) [491]. The eyebrow and upper eyelid are separated by the bulging orbital fold that sometimes overhangs to such an extent that the upper eyelid is buried under it (age). In those of Asian descent it also spans the medial angle of the eye (epicanthic fold) and thus rises above the axis through the eye that ascends in a lateral direction.

The medial angle of the eye bulges outwards slightly and encloses a small, reddish nodule, the lacrimal caruncle. The palpebral fissure, a mask-like cut-out of the skin covering the eyeball, is asymmetrical and almond-shaped, with a moderate ascension in its transverse axis from the medial to lateral angles of the eye. The more strongly concave curve of the upper eyelid, with its apex in the medial third, is at a far

greater distance above the transverse axis through the eye than the softly concave curve of the lower eyelid below it. The groove is deepest close to the lateral angle of the eye.

The way in which the edges of the eyelids surround the iris is of great importance to the expression of the eye: the eye appears stony, as during consternation, if the iris is fully revealed and the gaze appears tired and dull if the eyelids cover most of the iris. The eye appears calm when the upper eyelid slightly intersects the iris and the lower eyelid runs tangentially to it.

When drawing, bear the following in mind: the palpebral fissure reveals part of the surface of a sphere like the husk of a chestnut fruit that has split open. Attention must be paid to this for all degrees of opening of the eye [492]. Furthermore: the palpebral fissure appears like a 'paper mask' if we do not give the eyelids the plastic volume that they actually possess. Otherwise, it is impossible to illustrate how the eyelids surround the eyeball in all perspectives and how they mutually intersect with the surface of the sphere in the form of a plastic frame during rotation [487/2].

10.5.2. The form and plastic appearance of the nose [487/2, 493, 494, 497]

The face preserves marked, permanent features in its physiognomy thanks to the shape of the nose. Leonardo created a table for basic types of noses and Dürer explored its structural variation in his study on proportions. During Goethe's lifetime, paper cut-outs and silhouettes strived to demonstrate the individual characteristics of the person based on the nose, and no caricaturist will ignore the nose of the subject of his or her derision.

A distinction is made between the root, bridge, tip, side walls and wings of the nose. It is rooted in the transition between the frontal bone and the two delicate nasal bones. At the side, the frontal process of the maxilla also makes a contribution towards its structure. The connections between these bones can vary greatly in shape and already affect the character of the bony nose, without its soft tissue [493].

The soft tissue portions of the nose are essentially made up from the triangular lateral nasal cartilage

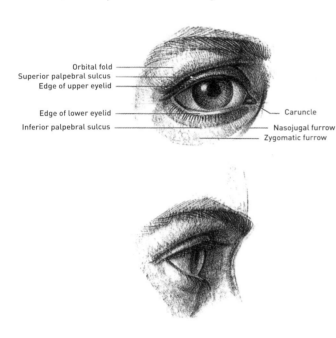

Orbital fold
Superior palpebral sulcus
Edge of upper eyelid

Edge of lower eyelid
Inferior palpebral sulcus

Caruncle

Nasojugal furrow
Zygomatic furrow

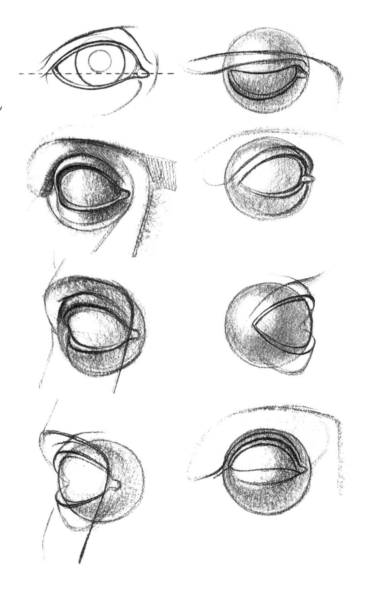

Fig. 491 (above) The external shape of the eye and its immediate surroundings. The superficial structures that surround the eyeball, such as excess skin and creases, are features that are present in every eye and follow a set pattern in relation to form, position and course.

Fig. 492 (right) The eyeball and the eyelid in different perspectives. The fundamental requirement for the three-dimensional artistic study of the eye is the recognition of the eye and the eyelids that cover it as part of a spherical body. The eyelids resemble the husk of a chestnut fruit that has split open, they have their own volume and form important intersections with the eyeball in different perspectives.

450 The head

and the greater alar cartilage of the nasal wings. A supporting internal 'beam' is formed by the septal cartilage, which, together with the vomer and ethmoid bone, divide the nasal aperture into two nostrils, at the tip of which skin fills in the gaps to the cartilage of the nasal wings. The lateral cartilage provides direct continuation of the bony nasal shape and forms the lateral roof of the nose. The alar cartilage is composed of multiple smaller and larger pieces that are reminiscent in shape of spirals in a ram's horn.

The tip of the nose takes its shape from the alar cartilage, which also provides the framework for the nostrils; its internal curvature adjoins the nasal septum, through to the tip. Age, ethnicity, gender, genetics and external factors contribute towards the innumerable variations in the shape of the nose. For example, an infant's nose is never sharp (snub nose) as the maxilla, which contributes towards the lateral structure of the nose and has not yet expanded.

The bridge of the nose in those of African and Asian descent is indented. The longitudinal axes through the two nostrils form an obtuse angle, creating a broader nose than in those of European descent. The nose in the latter comprises all variations, from the concave shape of the saddle nose, through to the convexity of the hooked nose (nose curving outwards).

In males, the transition from the frontal to the nasal bones is deeper as the relief of eyebrow region of the forehead is more pronounced than in females.

When drawing the nose, the beginner must always regard it as an architectural body, a roof with its surfaces running towards the eye, cheek and upper lip. The beginner must also always remember to angle the bridge of the nose off against the lateral surfaces, no matter how narrow it is [497].

The framework of the two nasal wings, which surrounds the nostrils in an elliptical shape, meet at the ridge of the nasal septum at a more or less obtuse angle. The nasal septum also has a certain thickness and interrupts the convergent elliptical surfaces of the nostrils, including their framework.

Fig. 493 (right) Anatomical structure of the bony and cartilaginous nose.
The cartilaginous nose covers the bony nasal aperture that opens to the front and gives the nose a double aperture that is directed downwards.
a) Cross-section through the nasal cavity with insertion of the nasal cartilage.
b) Anterior view of the bony and cartilaginous nose.

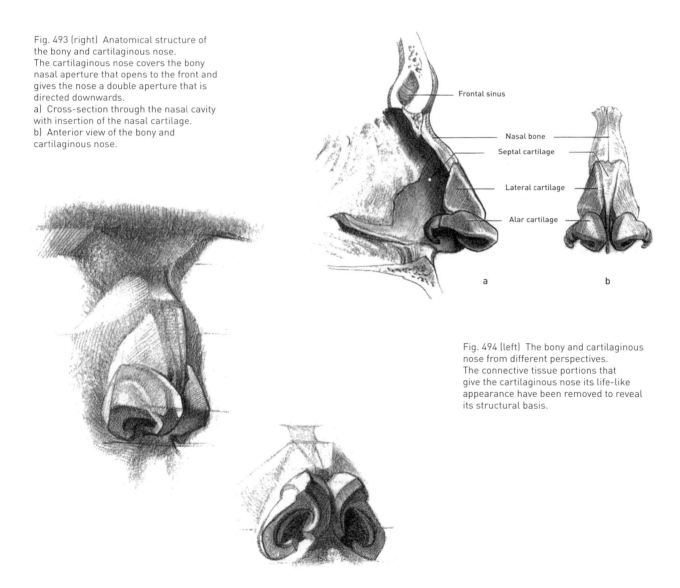

Frontal sinus

Nasal bone

Septal cartilage

Lateral cartilage

Alar cartilage

a

b

Fig. 494 (left) The bony and cartilaginous nose from different perspectives.
The connective tissue portions that give the cartilaginous nose its life-like appearance have been removed to reveal its structural basis.

10.5.3. The mouth [487/2, 495]

Connective tissue and the orbicularis oris, which inserts directly into the upper and lower lips, form the anatomical basis of the mouth. The transparent, thin skin on the lips allows the numerous blood vessels to shine through it and give the lips their red appearance. The oral fissure, that is closed by the lips resting against each other, rarely forms just one simple line. It curves downwards in the middle due to the labial tubercle – swinging in a lateral direction in a flat S-shape to the oral commissure (angle of the mouth), which is sometimes pulled deeply inwards – or peters out in a flat fashion, is occasionally angular, or rounded and indented.

A nodule (modiolus) protrudes at either side of the oral commissure as a number of muscle fibres of different origins cross over each other here.

The vermilion border of the upper lip is shaped like a Cupid's bow. The superior vermilion border forms a notch where the labial tubercle bulges forwards and downwards, which is where a shallower furrow (philtrum) that runs downwards from the nasal septum meets up with the lips. The lower vermilion border may also be slightly indented in the middle, but this indent is far flatter than in the upper lip. The two lips are occasionally full, sometimes thin bulges. The protuberant lips that are characteristic for people of African descent are due, on the one hand, to the projection of both jaws and, on the other, to the greater development of the orbicularis oris.

Tooth loss results in the lips sinking inwards. The flowing line of the vermilion border is best developed in the infant. The nose delimits the lips from above, the nasolabial sulcus at the sides and the mentolabial sulcus below. We refer to the upper lip as the space between the tip of the nose and the oral fissure, while the lower lip lies between the oral fissure and the mentolabial sulcus.

In a partial lateral view of the mouth, its undulations are foreshortened, intersect and require a physical and spatial interpretation [496a, b, 497, 498].

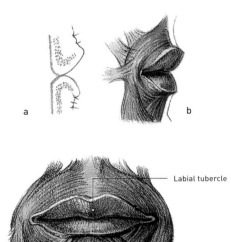

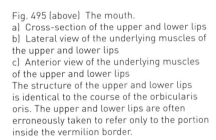

Labial tubercle

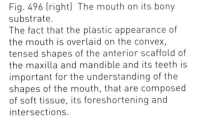

Fig. 495 (above) The mouth.
a) Cross-section of the upper and lower lips
b) Lateral view of the underlying muscles of the upper and lower lips
c) Anterior view of the underlying muscles of the upper and lower lips
The structure of the upper and lower lips is identical to the course of the orbicularis oris. The upper and lower lips are often erroneously taken to refer only to the portion inside the vermilion border.

Fig. 496 (right) The mouth on its bony substrate.
The fact that the plastic appearance of the mouth is overlaid on the convex, tensed shapes of the anterior scaffold of the maxilla and mandible and its teeth is important for the understanding of the shapes of the mouth, that are composed of soft tissue, its foreshortening and intersections.

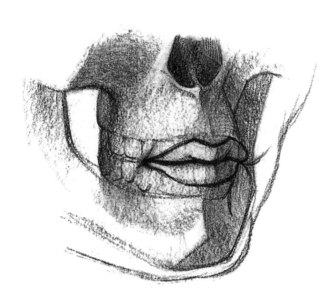

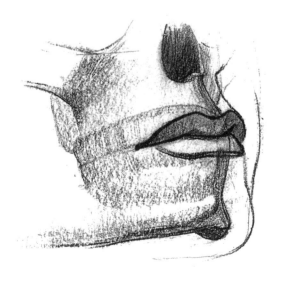

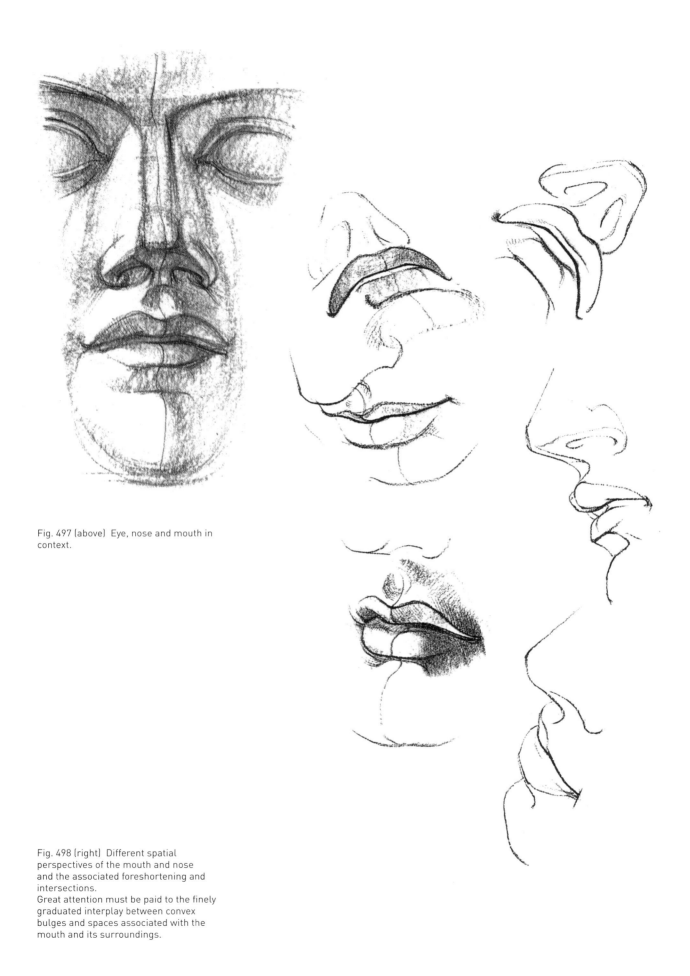

Fig. 497 (above) Eye, nose and mouth in context.

Fig. 498 (right) Different spatial perspectives of the mouth and nose and the associated foreshortening and intersections.
Great attention must be paid to the finely graduated interplay between convex bulges and spaces associated with the mouth and its surroundings.

10.5.4. The ear [499]

The ear is divided into three parts: the inner, middle and external ear. The parts of the ear that are important for the hearing process are located deep inside the skull and will not be discussed. However, the external ear – the pinna, with its delicate organisation – is of greater importance in portraiture than the dreadful, distorted trumpets that so many miserable studies would suggest.

The pinna (auricula) receives the sound waves and guides them into the acoustic meatus. Its basic shape is that of a bowl with multiple folds and its convex underside faces the skull. The external margin of the pinna is stabilised by the rolled-up frame, the helix, which arises from the depth of the auricular fossa and the skin on the side of the cheek, initially rising up, and curves like a spiral in elongated convexity, upwards into the ear lobe. The ear lobe (lobulus auriculae) is a soft skin formation that contains no fat. It is attached underneath the elastic cartilage base of the pinna. The pinna has a second curved, protruding fold, the antihelix, with irregular spacing to the outer margin. Its upper portion forks into two branches that enclose a small triangular fossa (fossa triangularis). A cartilaginous prominence, the tragus, protects the external acoustic meatus from the front. The antitragus is located opposite this, separated by a small indent, in which the antihelix culminates. The overall orientation of the pinna is not vertical on the skull. The line from the start of the antihelix to the attachment of the ear lobe to the cheek is inclined towards the occipital region at its upper end. The appearance of the ear is subject to great individual variation, without nullifying the laws that govern its structure.

Fig. 499 The anatomical structure and the living appearance of the ear. The external ear maintains its shape through its characteristically folded cartilage, in association with soft tissue. In spite of the modifications in shape that are thus facilitated, the spiral, folded bowl form is always present.

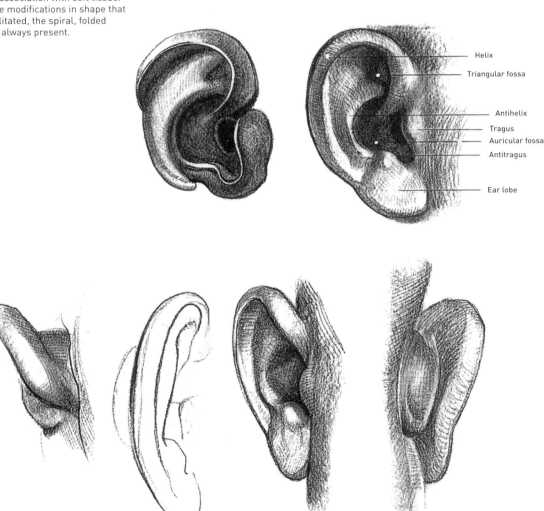

Helix

Triangular fossa

Antihelix

Tragus

Auricular fossa

Antitragus

Ear lobe

10.6. FACIAL EXPRESSION AND PHYSIOGNOMY

10.6.1. General preliminary comments

Nobody will today seriously argue against fact that the colourful elements of a figurative image – so long as they are consciously included as part of the design – will have a basic emotional effect on the observers, of exhilaration, seriousness or joyfulness. The immanent form means creating, as it were, a willingness to make the soul receptive; but as it is based on intrinsic values, or the viewer's personal response, it is impossible for it to exhaust the plethora of human emotions and events. It is equally undeniable that the synthesis of the material and intrinsic value of the form only becomes possible through interpenetration. The artist must newly master the factual, personal value of the expression of what is human every day if the image, which is reflecting inter-human relationships after all, is not to grind to a halt on a coloured spot or in an emotional lull. The togetherness of colour and shape still form part of artistic excellence, and the deepest artistic desire of all still focuses on revealing the essence of what it is to be human. A human's generic and individual traits, physical and spiritual elements, actions and thoughts, consciousness and historicity, social and moral characteristics, feelings and desires, are all inevitably at the centre of artistic activity, if effect is understood to be communication and being moved. Humans cannot survive other than through the interleaving of their inner selves with an external world. This amalgamation brings forth the inter-human behaviours and their symbols of expression that are created and expressed, received and understood. They express a person's social interactions or isolation, devotion and rejection, love and hate, affinity and repulsion. Humans are arrested by the world through their highly sensitive sensory organs, a natural world of external and internal cocooning. They must navigate through this world and are thus incessantly producing expression and understanding expression.

Learning to interpret a little the meaning of the stimuli leading to expressions by no means indicates that anatomy for artists has any recipes for how to 'create' expression. The 'creation' of a natural facial expression can only be aspired to by those who simply copy external signs of the state of being and idolise rules, instead of diving in and immersing themselves with the humbleness that is required for something that cannot be rendered formulaic. The observation of facial expressions alone is insufficient for the creation of artistic expression. These are also just raw materials.

When the movement of the hand is contributing towards expressing a thought or feeling (i.e. is indicating emotional or conscious content that is perceptible to the senses), this is almost impossible to break down into a mechanical process. Likewise, the unlimited richness of facial expressions that is based on fine-grained events in the nervous system which reflect psychological processes can no longer be analysed as a 'mechanical performance'. This is because the facial

musculature – with which we familiarised ourselves in the previous pages as an instrument of the psyche – provides internal stimuli with the best of prerequisites for its 'playful use'. On the one hand, the facial muscles can convey emotional states so much more easily as they are freed from carrying out mechanical work and liberated from bony lever arms. On the other, the requirement for expression has created its own keyboard. This where we also encounter the widespread fallacy that facial expressions accompany, and are the result of, an inner state. They are not equivalent to its external components. Furthermore, the movements of the facial expressive apparatus also create an inner state in reverse. If we make a sad face, we will eventually observe that this feeling of sadness enters into our soul. This relationship of existence within each other is therefore not equal to dualism; this is why Lersch called it a polar co-existential relationship.

With the exception of the masticatory muscles, the facial muscles can easily move soft tissues like skin or cartilage. So, given this circumstance and the fact that they have no effect on the shape of the skull, as the skeletal muscles do on the locomotor apparatus, and their volume is so small, why have we dedicated so much space and importance to them? This is because they have an enormous influence on the plastic appearance of the face and shape its individual features during momentary and permanent action. Depending on the distance available to a facial muscle between its origin and insertion, and on the thickness of the skin, the depth and number of wrinkles that arise as a result will vary [517]. Fleshy skin creates a few deep folds, while fine and delicate skin will have numerous shallow creases. The orientation of the creases is dependent on the direction of the muscle's pull, which the folds always cross orthogonally, e.g. the frontalis with its vertical course produces horizontal transverse folds. Radially aligned muscles are required when the apertures of sensory organs are to be expanded, while closing them requires circular organisation. These produce radial creases. For example, the orbicularis round the mouth or eye fold the surrounding skin in a ray-like fashion, temporarily during youth and permanently later on in life (crow's feet next to the lateral angle of the eye, concentrically arranged wrinkles around the mouths of the aged).

10.6.2. The terms facial expression, bodily expression, physiognomy, physiognomics

The dynamic momentary process of movement in the facial features, the movements of the facial musculature that create expression, is called facial expression: and we repeat, once again, that the external (expressive) signs are not the result of an internal condition, i.e. this is not a case of metaphysical dualism of soul and body. Emotion and expression find their bases in each other, content and appearance, sign and meaning in unity (Lersch). The strong feelings that express the experiences in the relationship between humans and what they perceive or do can manifest in different ways (Teplow). These produce changes in the function of the respiratory and cardiovascular

organs. These processes associated with expression are physical events that are triggered by the autonomic nervous system: the pulse is accelerated, we turn red or pale; the tone and timbre of the voice changes (Rubenstein calls the expression of emotions through the intonation of the voice 'vocal expression'). Darwin viewed movements associated with expression as expedient, rudimentary, instinctive actions. However, the actions associated with expression in humans today are far more than just a remnant of instinctive processes. On the contrary, they fulfil functions in the here and now in interactions with other human beings, as they are a means of communication – and influence. Movements associated with expression therefore have a culturally formalised function and thus symbolic meaning. How, when, where, how often, in what form an individual uses movements for expression is controlled by the social environment; the signs are fixed or transformed. It is impossible to separate what natural and what social contingency underlies movements

associated with expression. The natural and the historical are fused into one entity (Rubenstein). Play on the instrument of expression is not just limited to the facial muscles, but can involve the entire body. A man in despair throws himself into a chair, grasps hold of the armrest tightly, throws his hands up to his face, ruffles his hair; the joyful man stretches and throws his arms apart to embrace the world. Movements associated with expression involve the entire body. This is called bodily expression. A dominant emotional permanent state such as that of despair or pride is expressed in permanent physical posture; conversely, the person in question may also regain their internal positivity by changing their posture to a more upright position. Even at a distance, posture characterises the person distinctly. The frequent repetition of a specific facial expression eventually produces permanent features in the face that are also present at rest. Relationships to others, the wealth of experience and the propensity of the skin to eventually fix what is constantly repeated

Fig. 500 Closing of the apertures of the sensory organs. Opening and closing of these apertures form part of the natural reactive processes involved in sensory perception or shielding off, but can also be dissociated from this original function and used as a sign for defensive behaviour.

are the factors that are acquired from the sphere of life, which confer something permanent and static on the features [502, 503]. Added to this are the endogenous components, such as ethnicity and constitution. These make up a person's appearance. The science that attempts to draw conclusions on character, based on the fixed external features of the face, is called physiognomy (see also Lavater, *Physiognomische Fragmente*, from 1775/78, which have, by the way, proved to be untenable, no matter how fashionable Lavater's preaching made this 'science' at the time).

10.6.3. The foundations of facial expressions

Some of the natural foundations of facial expression have already been described: the facial muscles. These are the physical keys for an internal process that announces itself externally in a few zones through specific, characteristic forms of expression: around the eyes with varying degrees of opening the aperture between the eyelids, through variation in the direction of gaze; in the region of the forehead through the peculiarities in how it is folded; in the region of the mouth, etc. [500, 501]. The facial musculature must initially fulfil primary functions with an important purpose; the reactive behaviour of the sensory organs would be impossible in their absence. Much of what is demonstrated in adult facial expressions only becomes comprehensible based on the development of infant facial expressions (which is impossible to cover here in any detail). Even the most simple sensory perceptions and sensations guide the movements of the face (Krukenberg), without an underlying emotional 'experience' always being at work within the meaning discussed above. The facial senses react to what they perceive and steer (according to Krukenberg) the facial movements along specific lines that leave their mark through repetition. Adults retain the meaning of what were once infant sensory reactions in some of their forms of facial expression; for example, the infant will pull the angles of the mouth downwards and open it as a response to a bitter taste (the flow of saliva apparently washes out the bad taste), and this later on develops into a symbol for disgust in adults.

Furthermore, we note another revealing phenomenon: when, for example, a child listens intently to a sound (stimulation of hearing), it also opens its mouth (in the same way as also when the eyes are opened wide when expressing wonder) [514]. The reaction of the hearing or the eye has extended itself to a non-stimulated organ (the mouth) (spreading reaction according to Peiper). In this process, the reactions of the stimulated sensory organs can be attenuated or enhanced (holding ears closed to keep out noise and simultaneous closing of the eyes and the mouth). The eye, which we shield in very bright light with our eyelids and eyebrows, reacts by reducing the stimulus. There is no emotional background for this [504].

Finally, instinctive movements can be transformed into movements of expression. These originally fulfilled functions with a physical purpose: the environment offers the infant a plethora of stimuli. These awaken the desire in the infant, such as grabbing hold of an item and to test it to see if it is edible. It grasps and tastes it, thus satisfying an instinct that is of vital importance. Such targeted action can later on become dissociated from its original physical purpose and exist independently. The desire to grab hold of something may evolve into indicating, pointing at something as a means of communication, a means of expression.

Numerous studies have been conducted on facial expressions in humans. Producing a summary of the most important research and interpretation of expressions for the fine artist or actor is a rewarding undertaking. Of particular note here are publications by Lersch (*Gesicht und Seele*), Rubinstein, Peiper (*Entwicklung des Mienenspiels aus der Sinnestätigkeit*), Leonhard (*Der menschliche Ausdruck*) or Krukenberg. It is with enormous regret that the author must dispense here with providing any further detail and background. He took the decision to briefly illustrate these problems in a similar way in this publication, *The Complete Guide to Anatomy for Artists & Illustrators*, as the many perspectives would otherwise exceed this less demanding scope. In addition, the reader will find more detail, especially in relation to questions on artistic illustration, in the author's book *Figürliches Gestalten*, Berlin 1978. We will therefore make do with a superficial discussion of this problem.

The perception of taste

Taste is the most important of all senses in babies. The face concentrates expressions centring on the mouth. It protrudes the lips, puckering them, bringing the tongue into close contact with the maternal breast, in order to taste the pleasant sweetness of the milk. However, if the tongue comes into contact with something that tastes unpleasant, then the lips open up, the upper and lower lips are pulled apart, the flow of saliva washes out the nasty taste and the angles of the mouth are spread apart. The quadrangular distortion of the mouth that is typical for infants is the result. Later on in life, these movements of the mouth are retained, without having any immediate purpose; the object that is worth approaching or defending against does not even need to be present; the imagination is already producing similar movements of the mouth: our emotions express the pleasant sensations which we experience by means of the mouth, through actions associated with our tasting something sweet – we chirrup with our lips and tongue, or simply pucker our lips.

Likewise, we fend off what is unpleasant, revolting, disgusting, repugnant and engenders aversion using the primitive instinct, as if we were tasting something bitter and wished to allow it to escape, through raised teeth and lips [511, 504d]. This has resulted in the development of the expression of revulsion. A peculiarity of our emotions is the associated polarity, such as desire–aversion, love–hate, joyfulness–suffering. These also influence facial expressions. Irrespective of whether objects, states or circumstances really exist or are only a product of our imagination, these will produce the same qualitative facial expressions depending on the denouement of a sensation of desire or aversion, with only the

graduation, the varying intensity, based on the strength of the experience. For example, observe the face of someone listening to a report on an accident. The power of our imagination can trigger facial expressions that resemble the horrified faces of those actually witnessing the event. When expressing the affect (emotion) of anger [512], we raise our lips, bare our teeth and flare our nostrils, breathing heavily. Intense and acute affects such as anger, fright, joy, fear, grief, despair [513] that are a reaction to something affect all psychological functions and change the vital activities of the organism (flushing red, going pale). Anger, joy, hate manifest in increased motor function (dancing, shouting, threatening), fear inhibits motor function (freezing in shock).

Anger and fury [512] were certainly once a condition in human ancestors that preceded fighting (Teplow), during which balled fists and bared teeth were used. Affect, in particular, expresses the emotional state very clearly, often in the form of bodily expression. The loud crying and howling in children retains the quadrangular open mouth, as if trying to get rid of whatever triggered the aversion like a disgusting taste. In order to test the

taste of something pleasant, the puckered mouth turns the red portion of the lips inwards. How often does the child express attention in these ways when investigating something! When sulking, however, the red portion of the lips is pushed outwards defensively [504f, 510]. We believe we can recognise the remainders of an ancient reaction that had a purpose in the past in these facial expressions, which we have already referred to above. No wonder that the mouth, with its numerous muscles, offers unending options for expression that are not available to the same extent in other regions capable of expression.

Facial and auditory perception

Movements associated with approach or defence as the basis for expression also pertain to the facial sensory region [501]. We open our eyes to allow the stimulus to enter, or close them so we don't have to look at whatever is unpleasant. Eager attention results not only in particularly high raising of the eyelids, but also of the eyebrows. We blink when listening critically to something, if in doubt or sensing contradiction [508].

Fig. 501 The widened eye.
High levels of attention, fulfilment and openness are indicated by the widened eye here, added to which, the mouth is also ready to communicate.

We hereby also incorporate our intellectual attitudes towards things and our ethical feelings into our facial expressions. Animals can always move their ears in a finely controlled manner in response to noises, to the extent that we can read psychological processes based on their position e.g. flattening of the ears in hostility. Humans have lost this ability. A human incorporates the entire head, even the entire body, into movements associated with listening. The eye is involved and supports the facial expressions associated with listening in a highly expressive manner (spreading reaction). Our defensive response to ear-splitting noise is associated with squeezing the eyes shut and turning the head away; whereas we not only turn our ear towards the pleasant sound of music or bird song, but the eye also widens. The eye is also 'listening' (spreading reaction). However, we also observe that many people close their eyes while listening to music or thinking. In such cases, the purpose is to inhibit the eye in its receptive function and to thus increase concentration.

10.6.4. Forms of facial expression [504–516]

The extent of the opening of the eye distinguishes a child's laugh from that of an adult. A few weeks after birth, the infant starts to indicate its inner state by smiling. It is sated and thus satisfied. It opens up its shining eyes, flares its nostrils at the sight of its mother's breast and, later on, thrashes its arms and legs about at the sight of the bottle in anticipation of enjoyment. The adult pulls the eyelids together with the orbicularis oculi. The laughing lines surround the angles of the eye concentrically. When experiencing joy [504b, c, 516], the angles of the mouth are pulled upwards, triggered by the zygomatic muscles. The risoris pulls the mouth apart even more and, above all, creates the dimple in the cheek that is associated with laughing. The shape and position of the nasolabial sulcus also change with the widening of the mouth, into an S-shape. The skin covering the zygomatic bone folds up into a rounded pad. The medial and lateral levator nasi et labii maxillaris flare the nostrils (aids in perceiving pleasant odours). Crying mainly changes

Fig. 502 Physiognomy in the elderly. The static expression of the face that is shaped over the course of life by the environment and fate is called physiognomy and is referred to as the 'indirect' expression (that is, without any immediate projection of the emotional state).

Fig. 503 The superficial shapes in elderly physiognomy. The superficial formations that have become manifest in the zones involved in facial expression, such as creases, furrows or skin sacs and pads on the base formed by the skull, form the individual features of the face and its physiognomy, its indirect, mediate static expression.

the apertures of the eyes and nose. Only very minor changes turn the smiling mouth into a crying mouth. Crying narrows the palpebral fissure and the nostrils; the nose becomes narrow; a child opens its mouth and distorts it into a quadrangular shape [504g, 509]. Adults pull the nasal wings downwards with the nasalis, and the angles of the mouth downwards with the depressor anguli oris; the orbicularis oculi closes the eye, the corrugator supercilii and the frontalis pull the tip of the nose and the eyebrows upwards. Moroseness and discontent are announced in a very similar way to crying in adults. The depressor anguli oris turns the angles of the mouth downwards; the nasalis narrows the nostrils and pulls the tip of the nose downwards. In this process, the nasolabial sulcus is initially extended downwards and laterally, then curves around the angle of the mouth in a short hook-like shape, which is often also emphasised by a second short hook-like crease [504g, 517]. The forehead mainly advertises thinking processes. Its folds have vividly been referred to as the 'scars of thoughts'.

Attention, amazement, eager expectancy, surprise, consternation – all produce transverse folds in the forehead, caused by the frontalis, which raises the eyebrows and thus sometimes also reduces the shadowing of the eye; the eye appears brighter, it flashes. Concentrated observation and paying close attention to specific objects [505] forces the eyes into a targeted gaze and the pupil constricts. Reflection and contemplation [506] allow the gaze to become distant, the axes through the eyes no longer intersect as in the former case; the pupils dilate as they are not focused on anything. The penetrating, questioning gaze often produces transverse folds in one side of the forehead. The eyebrow on this side then also rises upwards. Surprise [513, 514] widens the eye and it is fairly common for the mouth and nose to be stuck in an open position. Consternation pulls the eyelids apart, exposing the white of the eyeball; the edges of the eyelids reveal the full circular iris, the eyebrows rise high up into the forehead, the mouth is gaping, the strands of the platysma are tensed and cramped, running from the chin downwards to the neck. The position of the facial skin contributes essential emphasis towards all facial expressions and reinforces the mental state. Physical and psychological calm [515] relaxes the facial muscles and thus smooths the countenance. During sleep or after waking, a tranquil sheen covers the face. In death comes the slackening of the facial muscles, which had furrowed the face while dying, especially if in excruciating pain. Death extinguishes all muscle tone. How often does regal poise shine through the features! Nervousness and tension cramp the face as the nerves do not permit any relaxation in muscle tone. Eager attention increases the tension in the skin. Disappointment and dejection [507] slacken the region of the mouth and we pull a long face. An uplifted mood (mood is the 'general emotional condition that affects the entire behaviour and all experiences of a human during a certain period' – Teplow) broadens the face so that the mouth and eyes flash, the skin on the cheeks is folded, the nose expands its nostrils [516]. Not all facial features are 'true', convention and mimicry have taken effect; what is 'expressed' is not wholly intrinsic. Some people control themselves in joy and suffering, others are more effusive, and this can be seen in their foreheads. The natural appearance of one person is sunny, while another is gloomy and constantly overshadowed by melancholy. Its impression may have constantly cast a shadow over the facial expressions, possibly favoured by a skin that has the tendency to leave repeated expressions in the form of permanent traces. Physiognomy is not created by a prescribed process of development, nobody can separate the natural from the social; the environment shapes the physiognomy, as do the genes, work and profession, as well as climate, experiences and upbringing. 'Nothing living is one, it is always many' (Goethe).

Fig. 504 The modes of action of some of the facial muscles.
a) Pursed lips, due to action of the orbicularis oris.
b) Raising of the angles of the mouth (smiling) by the buccinator.
c) Pulling upwards of the angles of the mouth (laughing) by the zygomaticus major and the risoris.
d) Interplay between the corrugator supercilii, the medial and lateral levator nasi et labii maxillaris and the depressor anguli oris when expressing disgust and revulsion.
e) Interplay between the depressor anguli oris and the depressor inferioris labii in the lower lip when expressing contempt.
f) The mentalis pushing up the skin of the chin ('pouting').
g) Interplay between the frontalis, corrugator supercilii, orbicularis oculi, nasalis and depressor anguli oris when crying.
h) Raising of the eyebrows by the frontalis when expressing attention.
i) Interplay between the orbicularis oculi, corrugator supercilii and frontalis when gazing at bright light.

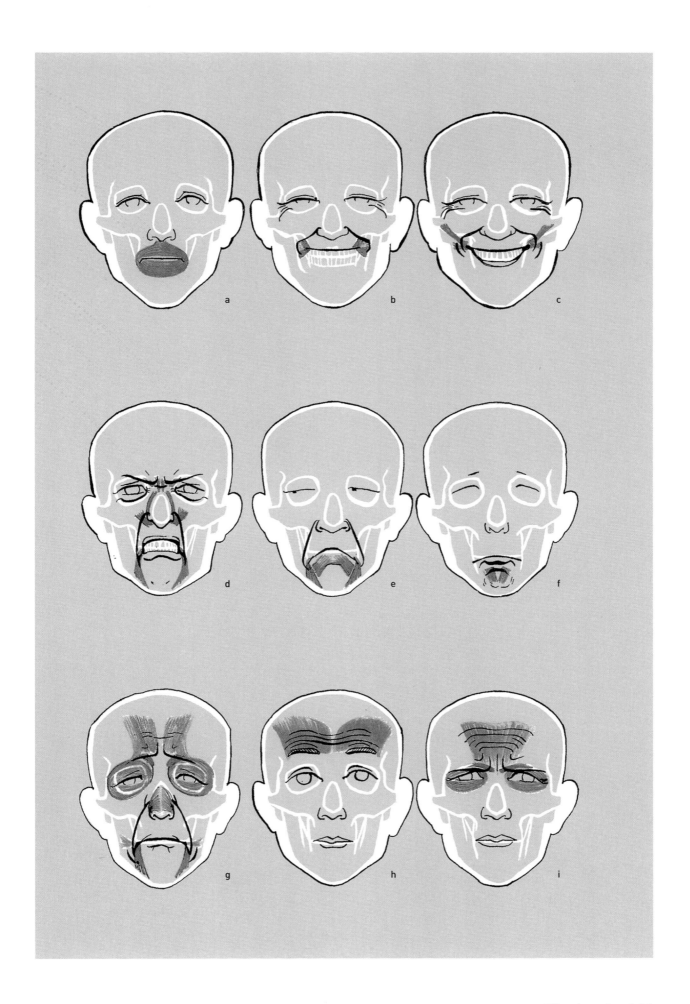

a

b

c

d

e

f

g

h

i

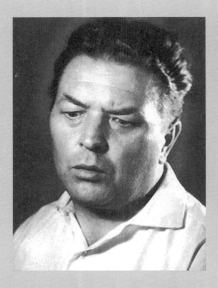

Fig. 505 Sharp focusing on a nearby object. Lines through the pupils intersect, the eyebrows are drawn together and the puckered mouth betrays the pointed direction of internal focus that excludes any breadth of thought.

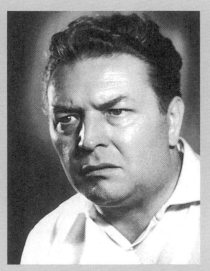

Fig. 506 Thoughtfulness. The gaze is directed into the distance (lines through pupils running parallel) and the calm, closed mouth would indicate a generally balanced inner state if the pulling together of the eyebrows did not indicate the difficulties associated with the thought process.

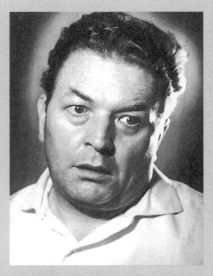

Fig. 507 Disappointment. In disappointment, there is a drop in tension, a shift from expectant tension into a passive posture. This process is particularly visible here through the slackening around the region of the mouth.

Fig. 511 Disgust, revulsion. The expressive signs consist of the open mouth, as if something bitter needed to be washed out through raising and lowering of the angles of the mouth, the wrinkling of the nose with a transverse fold over the root of the nose and the defensive narrowing of the palpebral fissure. A countenance that involves almost the entire face.

Fig. 512 Fury, anger. The protruding lower jaw with bared teeth may once have been required for acts of violence. The countenance is underpinned by the flared nasal wings and wide eyes that are alert. We interpret this face as a threat.

Fig. 513 Horrible surprise. The decisive component in making this face is in the region of the eyes, which open abnormally wide. The mouth appears to be opening and about to make a sound and thus indicates the unforeseen and unpredictable in association with fear.

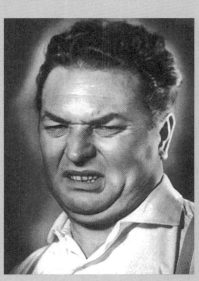

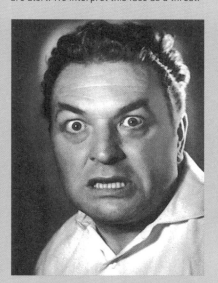

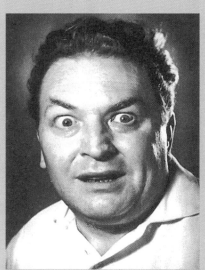

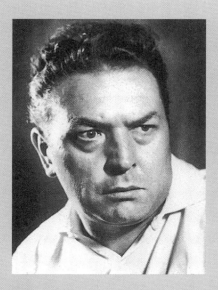

Fig. 508 Critical listening. The deliberately directed observation is mixed in with the primary active process of acoustic perception. The wrinkling of the eyebrows with the transverse fold over the root of the nose confers an active tension on the eye with a targeted gaze that does not indicate immediate identification with what is being heard.

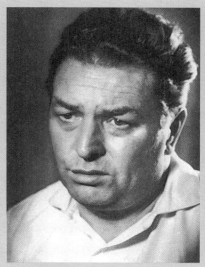

Fig. 509 Pain.
The behaviour of the palpebral fissure in the lateral angle (narrowing), compression of the nasal wings, the protruding lower lip, similar to when pouting, and the T-shaped creases in the forehead are all characteristic of the expression of pain. The agony in the expression reflects helplessness and suffering.

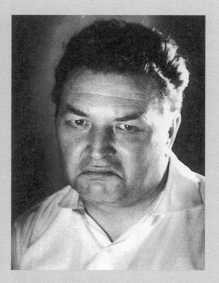

Fig. 510 Disapproval.
The expression of the negative disposition is produced in the region of the mouth by pulling the angles of the mouth downwards, whereby the nasolabial sulcus becomes deeper and encompasses the angles of the mouth from the nasal wings downwards.

Fig. 514 Bafflement, attention, amazement. These closely associated forms of interest are best represented by the fully open eyes. The added opening of the mouth shows the simultaneous deliberate slackening of this region and thus the lack of immediate readiness for action.

Fig. 515 Satisfaction, relaxation.
The general drop in tension in the musculature and its transition to a relaxed state in the face also results in smoothing of the skin and balanced features.

Fig. 516 Joy, laughing.
The raised, life-affirming mood spreads across the entire face in that the lips are opened wide and the cheeks folded into characteristic creases, and this extends up to the eyes, narrowing the palpebral fissure.

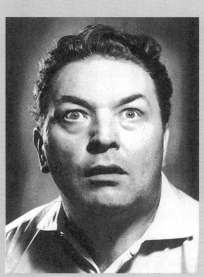

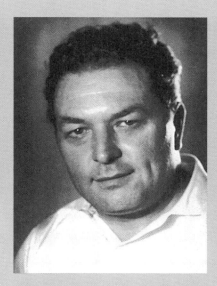

Summary:

1. Facial expressions are understood as the momentary, transient aspects of the face. Physiognomy results from fixation of frequent repetitions of a facial expression and from the genetic make-up.
2. The facial musculature is the diverse instrument of expression for an inner state as these muscles are only attached to the bone at their origin and radiate into soft tissue, where they insert.
3. The number and depth of creases, which develop orthogonally to the direction of muscle pull, depend on the length of a facial muscle and the thickness of the skin.
4. Artistic anatomy repudiates the insinuation that it intends to provide recipes for how to 'create' emotions.
5. The soul of the human opposite us cannot be interpreted solely by its expression, let alone be revealed, through the intrinsic value of colour. In order to accomplish this, the artist must penetrate into the essence of the expression of changing human emotions.
6. The interweaving of the internal and external in humans shapes which produces expression is received and understood.
7. The expressions created by the face do not simply accompany the internal state.
8. There is a polar, co-existential relationship between facial expression and emotional processes (Lersch) as the production of facial expressions, in turn, also has an effect on the emotional state.
9. Some specific principles must be considered with reference to facial expressions: the purpose of the reactive behaviour of the sensory organs (weakening or strengthening of perception of a stimulus); what were once infant reactions may be retained later on without having any physical purpose; these become a general symbol of expression for behaviour and attitude. A stimulus acting on one sensory organ may also spread to another organ that is not stimulated (a spreading reaction, according to Peiper). Movements associated with instinct may be transformed into movements of expression.
10. Form, duration, use of an expression and its meaning and symbolism, arise from the inter-human relationships. It thus has a strong social component. If artists wish to fathom, and proclaim something about, a human then they must study human interactions and dedicate themselves to the human social sphere.

10.6.5. The external appearance of the head, its superficial structures and the body-space problem [487/1, 519]

There are many other problems and preliminary steps that must be mastered before we have reached the point of achieving a synthesis of content and form and have fused the unique personal features with what is common to all humans.

The beginner must not be tempted to strive towards feigning similarities during initial drawings of the head, wanting to create a portrait. Studies must focus on the head with its proportions, masses, spaces, cubes. At a later stage, the artist may then move on to processing the uniqueness of the personality in a portrait and the typical enhanced features of the likeness. The beginner must sometimes also have the courage to scale down grand visions – though admirable! – in order to gain more assurance subsequently when tackling forms at a higher level. It does the artistic imagination and intuition no harm at all to first just understand the head at a very simple level, comprehending it as two egg-shaped volumes that are inserted into each other and have a horizontal and vertical expansion (brain case and facial skeleton).

The brain case must be depicted as the outer shell surrounding a volume, with walls at the side, front and back, and a roof, which are delimited by edges that are angled against each other to a greater or lesser extent [487, 487/1, 519]. The bones of the brain case are only important here with reference to plastic appearance.

When drawing the head, it makes sense to initially proceed as if the model had no hair. The parts of the roof of the skull that are hidden by the hair are drawn out, as for the rest of the skull. Once this substrate with its bulges and surface orientation has been illustrated, and it is impossible to avoid depicting its volume, the hair is then subsequently placed on its solid base as a three-dimensional entity. The forehead varies in height and breadth. Drawing inferences from the height of the forehead with regard to intelligence is deceptive, as the forehead may also continue to rise under the hairline. Attention must be paid to tendencies towards a steep or receding gradient of the forehead, the intensity of its transverse and longitudinal bulges and the sharp or soft transition to the lateral walls of the head.

For beginners, it is better to portray the volume as slightly more angled as this is easier to grasp. Just as the enveloping bone of the brain case unambiguously outlines its shape, it loses much of its superficial character in the face, where skin and fat make a significant contribution. It has meaning in providing support. Even so, the facial skeleton never loses its plasticity in its function as a supporting scaffold. It also lays the foundations for representation of its plastic appearance. For example, we are thinking of the jaw bones, root of the nose, zygomatic bones and zygomatic arch.

The horseshoe shape of the maxilla and mandible with their dentition pushes the muscular and connective tissue portions of the mouth outwards into transverse and longitudinal bulges. In those of African descent, the jaw with its teeth protrudes particularly far forwards (prognathism), while the tip of the chin (mental protuberance) is set back, with both of these features being racial characteristics. In those of European descent, the mental protuberance protrudes, commonly with an admixture of hardness and coarseness. The mental protuberance is initially incorporated into a broader or narrower expansion in the frontal plane, before the mandible curves round to the sides. The lower jaw reaches its greatest breadth at the angle of the mandible, which may be even further

Fig. 517 The factors that shape the surface of the face. The directions of muscle pull in the facial muscles (not depicted evenly and symmetrically – dark red arrows: superficial layer; light red arrows: deep layer) cause a set pattern of folds in the skin with an orthogonal course relative to the direction of muscle pull. Structural fat and depot fat (in yellow) round off the shapes of the skin over the bony base.

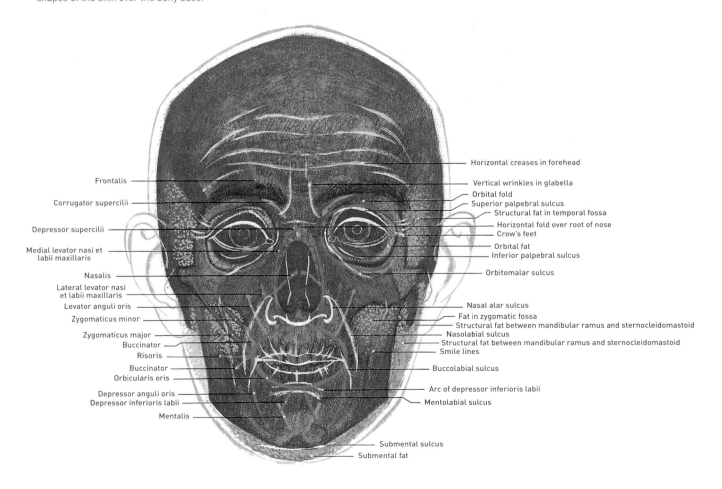

enhanced by the masseter which inserts here. The zygomatic bones and zygomatic arches determine the width of the face. These are relatively gracile in those of European descent. Above all, they recede strongly in a dorsal direction, deviate from the frontal plane and create the 'trim' bow-shape of the face; the sharp protruding nasal bridge also contributes greatly to this appearance. The zygomatic bones are in the frontal plane in those of Asian descent. Their faces therefore appear flatter, the lateral angles of the eyes are shifted a long way forwards and very little of the eyeball is therefore visible in profile.

The soft tissue shapes [517] do not always seal the gaps between the muscle bulge formed by the mouth, the masseter and the zygomatic bone; we find deep hollow shapes here in thin people, which produce the smile line [518]. This can extend down across the mandible. A flat or sharply indented furrow arises from the angle of the mouth, the buccolabial sulcus, the course of which, running towards the mental protuberance, more or less follows that of the depressor anguli oris which originates from the chin and surrounds the angles of the mouth laterally. The lower peripheral portion of the orbicularis oris separates the lower lip from the chin at the mentolabial sulcus. Between the buccolabial sulcus and the smile line, the nasolabial sulcus forms a furrow, arising from the nasal wings and delimiting the orbicularis oris at the side and above (see page 451).

The orbitomalar sulcus runs down from the medial angle of the eye, delimiting the orbit from the nose. It marks the orbital aperture along the lacrimal bone. Between the edge of the lower lid and the upper edge of the zygomatic bone, one to two creases, the inferior palpebral sulci, take a flat lateral course. With age, these often expand into bags under the eyes [502, 503, 517]. The submental sulcus separates larger deposits of connective and fatty tissue under the floor of the mouth (double chin) from the actual bony chin. The student is to be urgently advised not to bury these folds as lines when drawing the head. Folds are spaces and markers for orientation for the behaviour of embedded features.

The method of drawing the head in blocks with its large and small cubes and building it up from bodies with linear edges is not new: Albrecht Dürer was already using this method in 1512 on heads in his Dresden sketchbook. This remains a method to help in clarifying volumes. When drawing a head, this is a beneficial way of releasing the lines and arcs from their lack of relationship to the body and making it clear to the student that all contours and internal shapes fulfil the function of creating physicality. Above all, this also teaches the student to draw the volumes in addition to the body. Using an analogy, we can express this is as follows: as is the case for a cast in gypsum, we regard the model head as the positive form. It is composed of numerous convex protuberances that have indents – spaces – embedded in between them. The surfaces drop down to the medial angle of the eye from the root of the nose, from the eyebrow to the upper eyelid, from the lower eyelid to the zygomatic bone, from the wings of the nose to the cheek, from the lower lip to

the chin, etc. This results in open volumes, interstices, which would equate to protuberances in the negative in the gypsum. When studying the external appearance of the head, it is therefore important to always bear in mind this 'negative relief' of the space that is both surrounded and surrounding. Or to use a different analogy: the basic shape – the negative surface around the shape of the object – is just as important as the shape of the object itself. This is because the basic shape significantly influences the body-space relationships, composed of contrasts such as high–low, concave–convex, outwards–inwards, with regard to the position, direction of movement and meaning of the object. No body can exist without its environment, no fully three-dimensional entity without its volume. The depths of the head – and this applies no less to the entire body – incorporate space; the protuberances on the head repel it. This is the reason why we are striving to simultaneously ingrain the feeling for space using the means of cuboid, block-like drawing. The more intensively artists strive towards using ever sparser markers and simpler means during their development, the clearer their perception of the relationships between body and space must be and the greater their knowledge, in order to recognise relationships between shapes and reproduce them [521]. All their efforts, after all, are essentially dedicated to one central objective: the expression of human nature.

Fig. 518 (below) The mouth and its surroundings. The superficial structures, depicted here in three dimensions, are not incidental manifestations, but the physiognomic results of the muscles acting under the skin and their bony foundations.

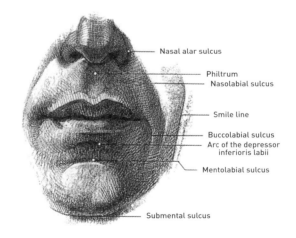

Nasal alar sulcus

Philtrum
Nasolabial sulcus

Smile line

Buccolabial sulcus
Arc of the depressor inferioris labii

Mentolabial sulcus

Submental sulcus

Fig. 519 (right) Heads in spatial perspectives. The constituent shapes and superficial formations of the head on the foundations of the skull jointly make up the individual ensemble of the physiognomy (based on manipulation of Renaissance heads).

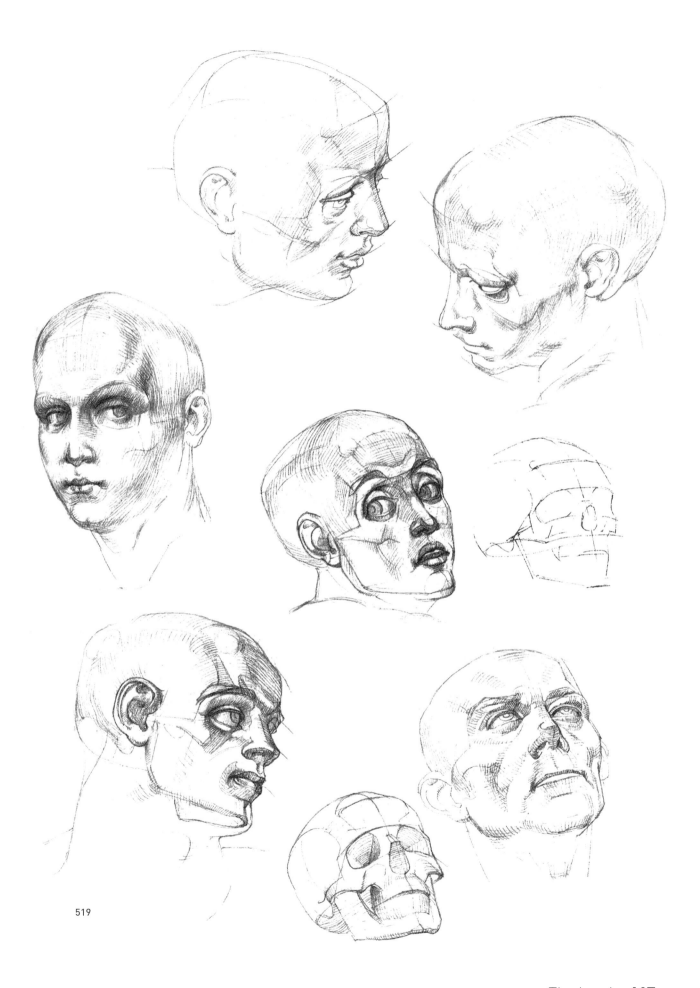

519

10.7. THE PROCESSING OF THE IMMEDIATE AND MEDIATE FACIAL EXPRESSION IN PORTRAITS

The author has already entered into the objective bases of the artistic depiction of expression in detail, both with regard to theory and through a far greater range of examples, in his publication *Figürliches Gestalten*, Berlin 1978, and so we will therefore satisfy ourselves here with a very brief outline. Above all, let us remind ourselves again that we take the immediate or direct expression of the face to mean the dynamic production of facial expressions, their appearance and disappearance, as the external manifestation of an instantaneous emotional state. For artists, this also constitutes a natural impression, as does the mediate, indirect facial expression of their model that is static and permanent in nature and has become fixed in the shape of the physiognomy. Both these forms of facial expression can trigger lively interest in the model; the artist may perceive the constellation of facial expressive signs, a smile or a glance from the side, as highly appealing in the characterisation of the person and, likewise, the combination of an unusual section of the face, its asymmetries and strange constituent shapes. However, simple adoption of the two forms of facial expression is not sufficient to demonstrate the artistic value of his or her depiction. Without a doubt, however, the processing of these objective impressions contributes an inestimable richness towards portraits and images, without which they would otherwise be condemned to unbearable tedium.

Our selection of examples aims to do justice to both perspectives, but also to examples where the artistic approach to constituent forms in the face is informative.

With reference to the latter, we will first look at two female portraits, by Pontormo and Marcks [520, 521].

Fig. 520 Jacopo da Pontormo (1494–1557). *Head of a Woman*. Red chalk, 22.8 x 17.2cm (9 x 6¾in). Uffizi Gallery, Florence. Although the definiteness and simplicity of the shape of the head have clearly been derived from an ovoid shape, detailed observation with such a high level of precision and its condensed nature informs us about a physical structure that can be presumed for the greater whole.

Fig. 521 Gerhard Marcks (1889–1981). *Portrait of a Girl*. Pencil. Kupferstich-kabinett, Berlin.
Our gaze is attracted to the shadowed eye, embedded in its surroundings, glancing dreamily into the distance, and to the delicate and relaxed mouth. The face becomes ethereal, but also palpable due to the modulations of its volumes.

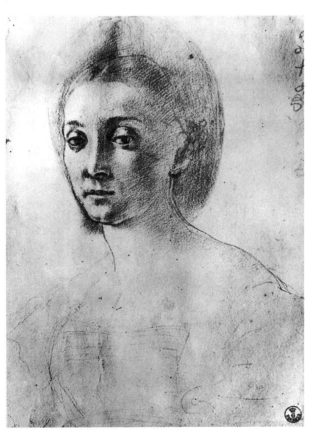

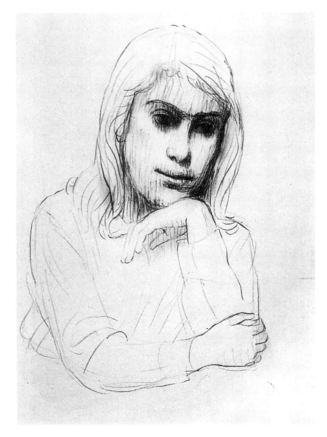

It is precisely the overall fineness, the lack of sharpness of the youthful female head that appeals to the artist, inspiring him to render the wonderful coherence of the ovoid shape of the head in its elementary plastic substance into the dominating, overarching expression. However, he also recognises the danger of the associated polished appearence and we therefore see, with reference to both artists, how each attempts to avoid this in his own way. Pontormo accomplishes this by using a denser graphic structure at the fixed points of the chin, zygomatic bone and forehead and by embedding the strongly curved sphere of the eye into its significantly flatter and tensed surroundings. In contrast, Marcks emphasises the volumes of the face and the graphic texture serves the purpose of realising the development of depth, thus allowing the curvature of the overall ovoid shape and the differentiation of the constituent form to emerge 'of its own accord'.

The calm, dreamy gaze, with an indeterminate direction of the pupils, is emphasised by Marcks by shadowing the eyes and through the model's posture, allowing greater access to the person's inner state than would be possible, for example, in one constrained by suffering or an emotional outburst. The warm, maternal sympathy exhibited by Käthe Kollwitz towards the existence of the disenfranchised and downtrodden people of her times repeatedly led her to strive towards expression of the inner and outer pain of those people, and thus also the expression of her personal empathy [522]. She revealed this both in the overall expressive gesture and through nuances in the finest detail in facial expressions. The woman's head is thrown back in despair, the mouth slack and speechless. Warding off doom, the hand moves into the orbit, the eyebrows are painfully drawn together over the root of the nose, rising up to the forehead. Therefore, while the instantaneous expression of an emotion inevitably

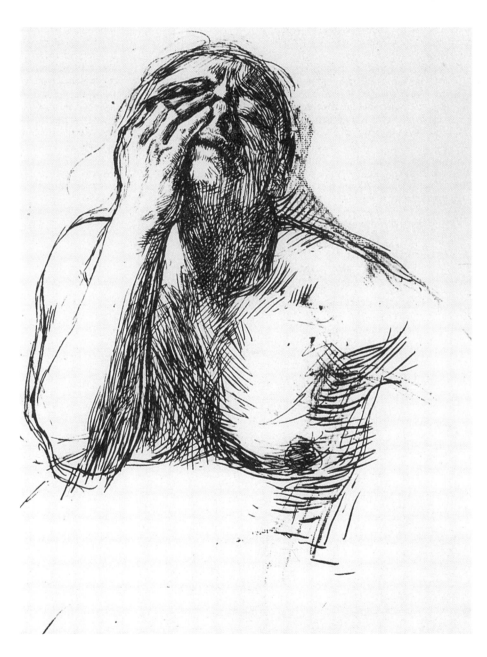

Fig. 522 Käthe Kollwitz (1867–1945).
Study (ca. 1903). Ink, 42 x 25.2cm (15½ x 10in).
In this overall expression of sadness, the artist depicts the totality of the pain that has overcome a woman, where there is no room for anything but the the overriding emotion of helplessness and hopelessness. Playing on our personal emotional turmoil, Kollwitz elicits our solidarity through sublimation of the suffering.

pushes the potential scope of the inner person into the background, the calm equilibrium between the internal and external state provides a more complete picture of the human in his or her entirety.

Petrow-Wodkin's image of the great Russian poet [523] is probably by rights included today among the greatest achievements in the field of artistic portraiture in 1920s Soviet art. Petrow-Wodkin has condensed the deep, inner nobility in the external appearance into crystal-clear shapes, as is the case for many of his works of art. There is no location in the portrait of the outstanding poet where the form has not been penetrated in the finest of detail and, even so, the modelling of the plasticity maintains the highest degree of reservation, such that all elements – the facial section, neck, clothing – remain closely connected to the area of the image. Humanity of a monumental magnitude is created, permeating into every corner.

In Manzùs' *Portrait of Inge* [524], the strong plastic and simultaneously lyrical effect of the closed oval of the face is based on the sparse use of graphic means. The spherical shapes of the bulge of the forehead, the orbital fold over the eye, the zygomatic bone, mouth and chin are created by grouping the spatial depths around them, expressed by the brushed lead that is then superseded by the sharp accents of lines. The use of these instruments in this manner is like the approach taken by a sculptor, who perceives the face as a musical landscape. We can probably interpret Maljawin's self-portraits, of which only two are compared here, as a test bed for the artistic mastering of the expression of the soul [525]. Figure 525a shows the artist in a sharply drawn frontal perspective, at the same horizontal level as the observer. The eye and its surroundings demarcate the tension of deep observation, possibly in conjunction with looking into

Fig. 523 Kusma Petrow-Wodkin (1878–1939).
Portrait of the poet Anna Ach-matowa (1922).
Oil on canvas, 54.5 x 43.5cm (21½ x 17⅛in).
Even though the features of the important Soviet poet have been penetrated in the finest of detail to reveal their shapes, the artist has abstained from recording all minutiae and has used sparse modelling in the narrow context of the object and space.

Fig. 524 Giacomo Manzù (1908–1991).
Portrait of Inge (1957). Pencil, 49 x 63cm (19¼ x 24¾in).
The spheroid shapes that punctuate and segment the oval of the face are essentially transformed into convex forms simply through brushing in spatial depth. The curvatures of the forehead, orbital fold, zygomatic bone, mouth, nose, cheek, chin are nothing other than the complements of space arising from this.

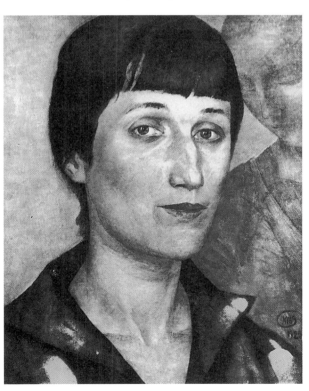

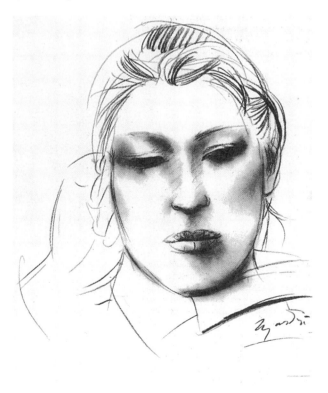

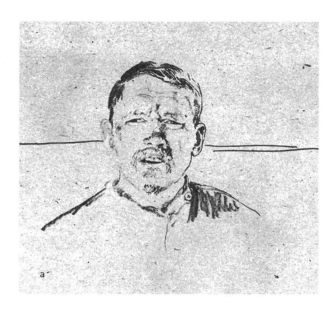

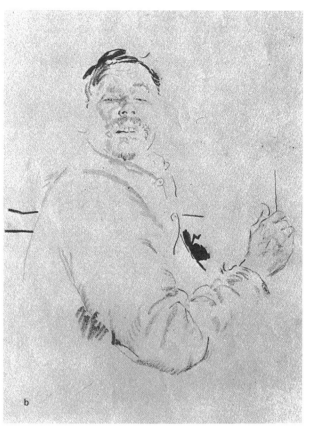

Fig. 525 Filipp A. Maljawin (1869–1940). Self-portraits (1923).
a) *Self-portrait*. Pencil, 32.9 x 22.2cm (13 x 8¾in).
b) *Self-portrait*. Pencil, 43 x 31.5cm (17 x 12¼in).
Both drawings explore emotional expression. In the first case,
the object is the close observation of the self, with the critical
vertical creases in the forehead and eyes that are looking into
bright light and the absent-minded open mouth. In the second
case, the expression of a more commanding mood is dominant; the
forehead is smooth, the degree of absent-mindedness is reduced
in the lesser opening of the mouth, the horizon has been pushed
downwards and increases the vertical exaggeration.

Fig. 526 Josef Hegenbarth (1884–1962).
Young Woman (1953). Brush, ink,
46.5 x 33.5cm (18¼ x 13¼in).
The integration of the model's individuality
into the artistic dialect of the specific
and the general, manifests in the firm
assertiveness of the forms – the woman's
very striking features, in unison with an
unreserved posture and superior glance
– as a representation of intelligence and
female confidence.

a bright light – as is indicated by the creases in the forehead and the pinched eyelid section. The mouth is opened slightly, probably as a result of a spreading reaction originating from the eye, which is perceiving the stimulus. In contrast, the vertical 'frown lines' over the root of the nose have given way to a more relaxed, commanding mood (525b). This interpretation is supported by the more gentle opening of the mouth, the smooth forehead, but above all, the head is tilted slightly backwards and the horizon indicated is lower down.

To what extent the mediate (physiognomic) or the immediate (facial expression) expressiveness of the face becomes clearly defined through its depiction is not, of course, dependent alone on the expressive facial zones and their forms of expression as seen in isolation. This question is resolved both through the artists themselves and also the observers, in that both need to maintain a view of the face as a whole. This is how, for example, the vertical and diagonal creases

in the forehead in Bammes' *Self-portrait* [527] are to be interpreted in association with the resting position of the eye and mouth: namely, not as a component of facial expression, but as components of the physiognomy, as a sign of constant, sharp observation that has turned into permanent features.

Hegenbarth's great mastery of drawing lies, not least, in the capacity of creating a distillation of form of notable individuality through the inspiration of shapes in the human opposite him. Through this process, he derives from this person such a measure of uniqueness and distinctiveness that it is exactly this that results in the qualitative transition from staying true to the model, to movement into the sphere of the general and important: this, quite simply, results in the portrait of a young woman [526]. Proud and liberated in posture and gaze, superior thanks to the power of the emergence of form, self-contained through the unity in structure of the graphic instrumentation, it is a clever, unambiguous representation of intelligence and self-confidence.

Fig. 527 Gottfried Bammes (1920–2007).
Self-portrait (1976). Silver pen on prepared wood, 21.2 x 28cm (8¼ x 11in).
To what extent the long, vertical crease in the forehead and associated smaller wrinkles have become a component of the physiognomy can be derived from the observation of the calm, relaxed position of the eyes and mouth.

Final comments: Anatomy for artists and artistic freedom

How diverse and complex is the human physique! The skeleton gives it support, the muscles its posture [528–530]. It is the visible analogue of the inner state. The skeleton, with its muscles in context, as the ultimate connection point for all discourses, must only be understood as the last depicted summary of the facts relating to the entire locomotor apparatus, and should not be construed as an end in itself. After all, the human being is far more than just his or her physical structure. This is only part of a human's essence, even if it is of great importance to the artist: this is because the human form is viewed by the artist's eye as an expression of character. Unfortunately, the skeleton with its muscles remains the focus of publications on anatomy for artists, based on which many nude studies are oriented. It acts as a symbol for the explanation of physical competence and superficiality. We thus return to the original point: a modern publication on anatomy for artists must fight alongside art. The study of humans requires intellectual immersion and penetration, penetration that is condensed into an internal image, the image of the human.

So long as artists act as mediators, as emotionally perceptive and knowledgeable interpreters of the interactions between the outside world and the human being; so long as they collect the unbounded rays of being and focus them, as if using a burning lens, then release them into the outside world again; so long as they simultaneously pursue an understanding of themselves in the form of understanding the outside world, internalising it to shine light on it in mutual contact with the outer world, then they will be bound in service to art through their personal and social sensibilities.

Artists immerse themselves into the human form with heart and mind, without being overwhelmed, but will not get close to it without painful practice. The encounter with the naked human being is part of the physical and intellectual encounter with the self, as his or her physical expressiveness and posture is an expression of the inner state. The human being opposite, and his or her form, is subject to different subjective artistic interpretations, and the degree of responsibility and freedom applied to this is also highly variable. The author preferred to draw on those examples from art in which the structure of the body, the body as an architectural entity, had been comprehended, as he regarded this as more informative. What right does anatomy for artists have to refer to the architectural when encountering nudity, i.e. the natural, which is essentially designed space? This rather blunt term 'architecture' is used to provide a didactic analogy, more broadly speaking, an art-pedagogic aim, a programme and a method. 'Architecture of the body' – this term encourages us to follow the volumes that are built around and delimited. The 'walls' that surround them have a meaningful function, they create the building blocks that shine through the 'façade' that compartmentalises the shapes. The 'architecture of the body' – this term aims to paraphrase the essence of a constructional element, with all its necessities and requirements of internal relationships and allocations; each and every structural element serves the purpose of a part of a whole and it is only in this sense, not in the mechanistic sense, that anatomy for artists believes itself permitted to familiarise the artist with the structural elements, with constructional forms, volumes, movements and proportions. Therefore, anatomy for artists wishes to teach how to penetrate into the unique and the general, and it is exactly this that rises above the simple repetition of facts. Where it essentially aims to help artists is in the transformation that they implement when they objectify things. Artistic truth is logic based on imagery that is found in the dialogue between subject and object, between the individual and the social. As is so often the case, anatomy for artists must observe very closely! Natural facts are its object. It would, however, be inconceivable if it represented a work of art as a sum of 'truths'. During the first stage of imagination, artists are not focusing on the facts at all. However, the deeper the conversation, the more carefully they will listen to the language of the human being opposite them. They learn how to understand what appears unique and what is general and, through this, what is of importance. Artistic thought is therefore – as we saw at the start – generalisation. How the appearance is merged into the form of an image is a matter for the artist and is a component of his or her freedom, not a freedom from something, but for

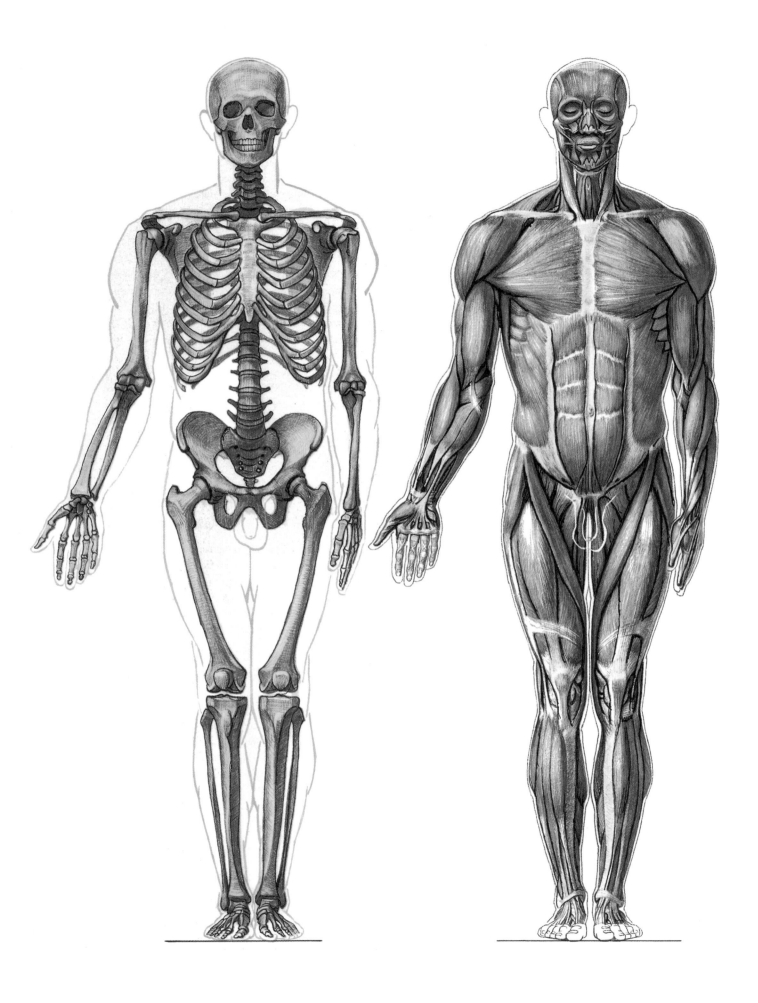

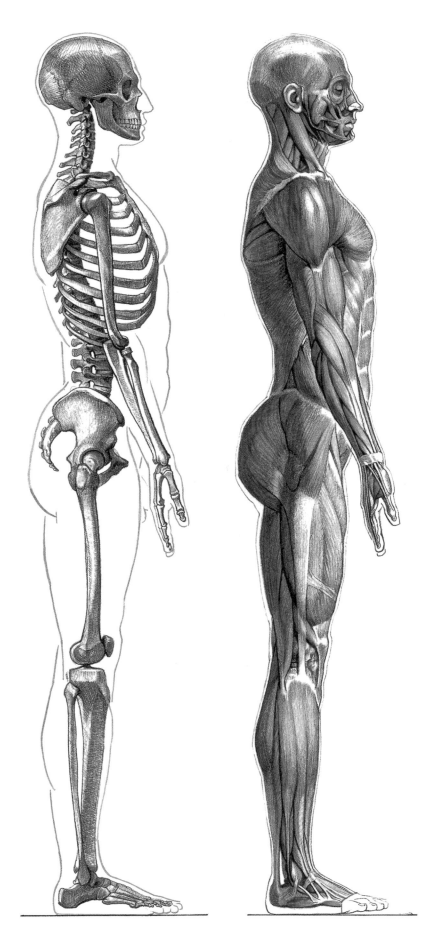

Fig. 528 Frontal view of the skeleton and the skeleton with its muscles.
The didactic, informative value of skeletons and muscular figures in anatomy for artists remains indisputable to this day. However, in the overall process of teaching anatomy for artists, as well as in the study of the nude figure, the aim cannot be to simply reproduce predominantly analytical information. The muscular relief must only serve the purpose of constructing a new figure.

Fig. 529 Lateral view of the skeleton and the skeleton with its muscles.

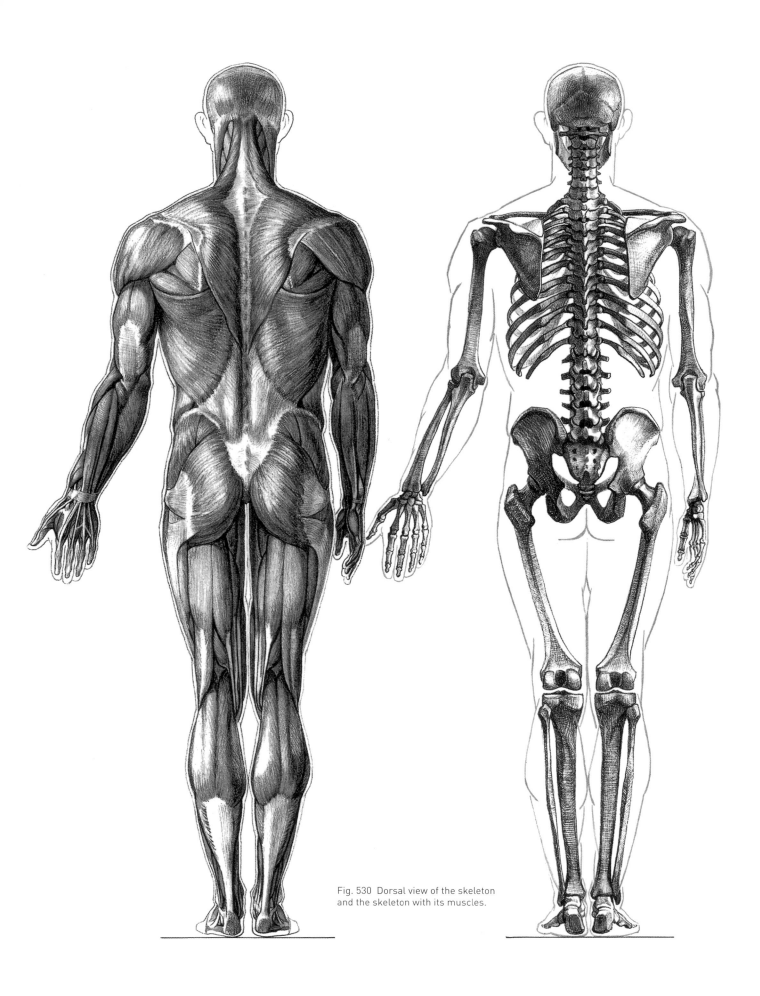

Fig. 530 Dorsal view of the skeleton
and the skeleton with its muscles.

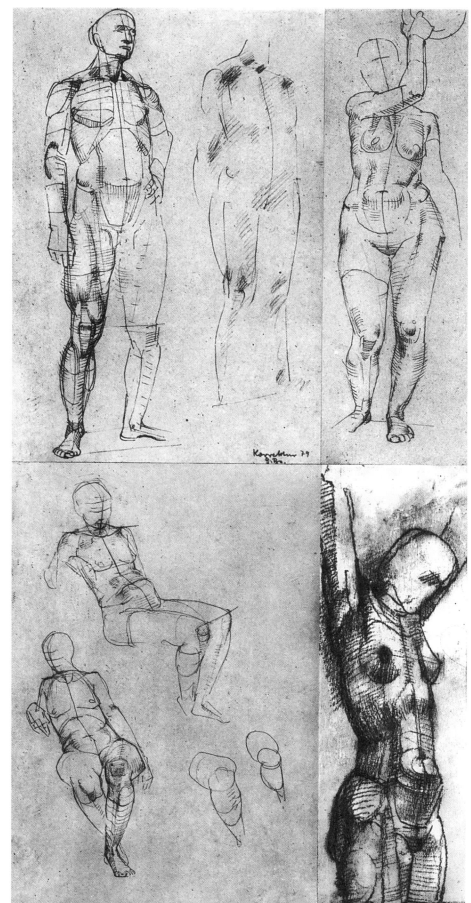

Fig. 531 Drawings by the author for demonstration purposes when correcting students in relation to the problem of mastering the body's architecture in drawing. The studies serve the purpose of understanding constructional drawing with its tensions and interactions, in which the dominant synthetic construction of the figure, the position of the body in space, the expressive value of the posture and function and the structural unity of the skeletal and soft tissue shapes are worked out.

The primary operation that is central to each of these investigations is the creation of a spatial reference system (courses of the axis through the centre of the body and the related transverse axes) that simultaneously indicates the position of the body in space and its fundamental, functional behaviour.

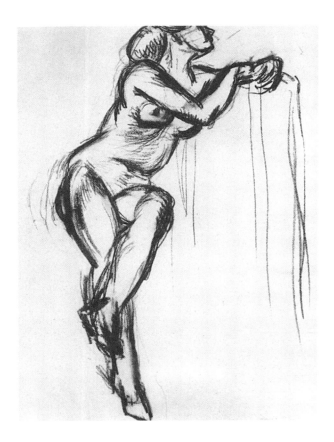

something [532–537]. If artists misjudge or disavow the communicative nature of art in favour of the narrower introspection of their self, then they will easily regard their own inner selves as representative of the entirety of humanity. They will thereby be robbing themselves of the freedom of taking the decision on the 'What' and 'How' in relation to their own values, and in the realisation of these values. Artists must remain open to all means and options for observation and processing, penetration, research and investigation. If they dispense with the available aids, they will narrow down their own artistic sphere of action – failing to overcome and master the art of conferring shape on something – and rob themselves of the freedom of decision on many options. Anatomy for artists offers itself as the means of choice for unimpeded progress, without obstacles.

It aims to be an aid to freedom, for boundless imagination, for artistic etherealisation. After all, when something has become second nature – solid knowledge, artistic craft – it throws off the chains of constant factual recapitulation.

Anatomy for artists focuses on the freedom of locating the form for artistic inspiration. It is about unrestricted, liberated play; freedom of the availability of the moment, to ensure this is inscribed into the protocol of life through the richness of work and an all-round accomplished ability. Anatomy for artists is about the freedom of insight, comprehension, grasping

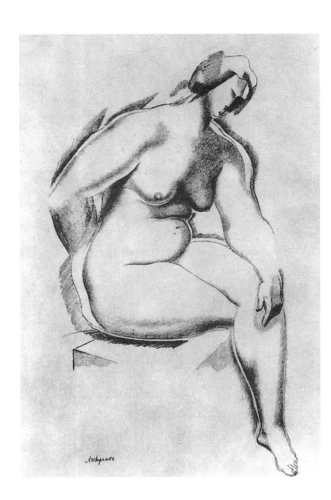

Fig. 532 (above, left) Henri Matisse (1869–1954).
Nude (1949). Pencil, 30.5 x 23cm (12 x 9in). Alfred Stieglitz Collection. Metropolitan Museum of Art, New York.
In spite of the palpable connection between how this nude is drawn and the later, purely decorative, planar figurative rhythms, it is distinguished from them by the strong synthesis of physicality and function. The powerful sequence of convex curves expresses the torsions and tensions of the twisted seated posture, just as precisely, securely and keenly as through the expression of the opposed and connected volumes.

Fig. 533 (left) Alexander Archipenko (1887–1964).
Seated Female Nude. Pencil, 48 x 32.5cm (19 x 13in). Collection A. Haskell Esq., C.B.E. The forms of the body expand in a round, soft, almost gentle manner, but are still powerful, without wishing to captivate us with female grace or canonised beauty. The simplicity of the corporeal formulations and the absolute incisiveness of the anatomical structure, free of superficial detail, give the buoyancy of the sequence of shapes stability and permit them to combine into highly stylish and expressive forms.

something and being consumed by it, without being impeded by the obstacles of inability.

The reader should also understand that being free to do something means the ability to develop and transform creations by first adhering to the constraints imposed by their recognised principles, and thus move beyond them within the bounds of their meaning. Anatomy for artists aims to familiarise through acquaintance with the fundamental principles. In Goethe's opinion, every individual organic form – plant, animal, human – is a representation of a general model that intrinsically permits continuation, that goes beyond the scope of the model.

That recognition of human form takes place as the one aspect of becoming aware of the world, always in a comprehensive fashion and refined through to full clarity, and is the essence of anatomy for artists. The artists' self-awareness and experience of the world, their own being in its complexity of the depths of the intellectual and spiritual, with all its contents relating to feelings and morals, intellectual and sensual attitudes, their physical and psychological state, transform the image of the world in the instant when their genius takes hold of it.

'The act of an artist taking possession of anything from nature means that it is no longer part of nature; we could even say that the artist creates the object at that moment by extracting from it what is important, characteristic, interesting or, rather more, giving it greater value' (Goethe, Introduction to the *Propylaea*).

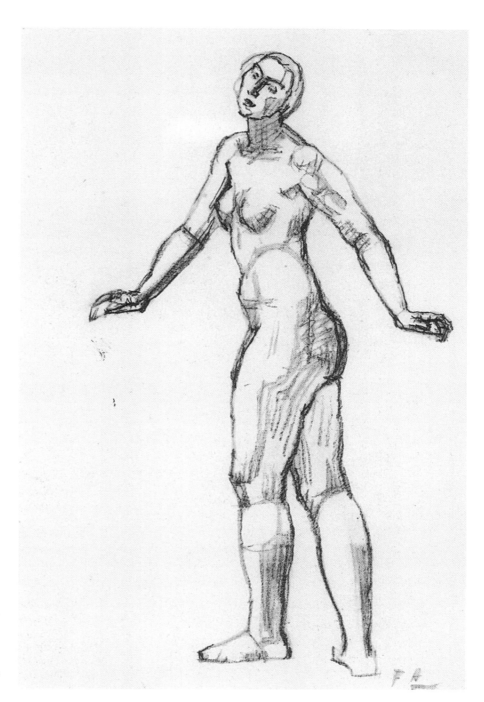

Fig. 534 Ferdinand Hodler (1853–1918).
Nude woman, standing, view from left side, turned towards left, study for *Gaze into Infinity*. Pencil, 42.7 x 29cm (16¾ x 11½in). The monumental nature of Hodler's figurative style arises from the vertical exaggeration of the form's gestures as well as from the brittleness of the structure, made up from elemental basic shapes. The construction of the architectural form, for which he piles up and layers the masses, is, on the other hand, calculated on the basis of such a strong effect of the solid outlines that the emphasis on the contours that produces the austere physicality simultaneously reconnects it to the surface.

Final comments: Anatomy for artists and artistic freedom **479**

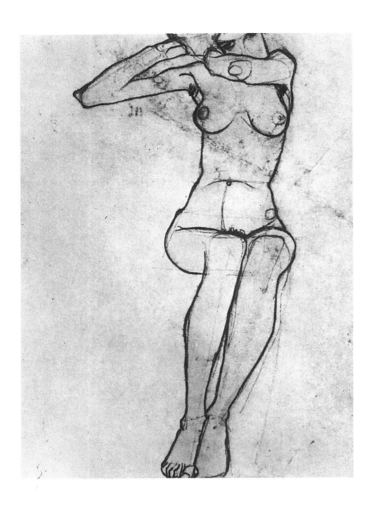

Fig. 535 Egon Schiele (1890–1918).
Seated Female Nude (1910). Pencil, 44.5
x 31.5cm (17½ x 12½in). Galerie Michael
Pabst, Vienna.
The violent and stark form of expression
that is unique to the artist and
expressionism, its targeted deformation of
the human form harbours an unarticulated
ambivalence of objectification and
de-objectification, thanks to its organic
truthfulness. With a mysteriousness that
is impenetrable, Schiele used anatomical
knowledge and relentless observation
to consign the nude to a semblance of
humanity, especially in this later period.
The full poignancy of this tendency is only
latently present in this image.

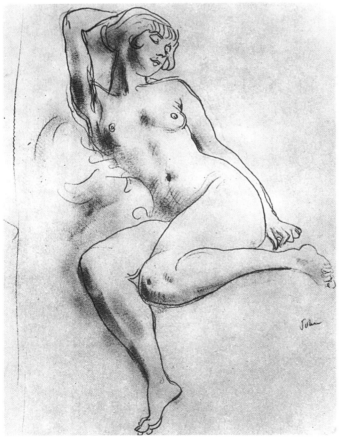

Fig. 536 Augustus John (1878–1961).
Nude Study. Pencil. Filzwilliam Museum,
Cambridge.
In spite of the apparent ease and
effortlessness with which John produced a
nude study, nothing was lost with regard to
subtlety and condensed observation. He was
artistically affiliated to the masters of line
and form and, stimulated by the beauty of
the human body, he transformed this into a
graceful play of physical lineaments. Sparse,
accurate indications of the essential physical
and organic characteristics emphasise the
intensity of the natural perception.

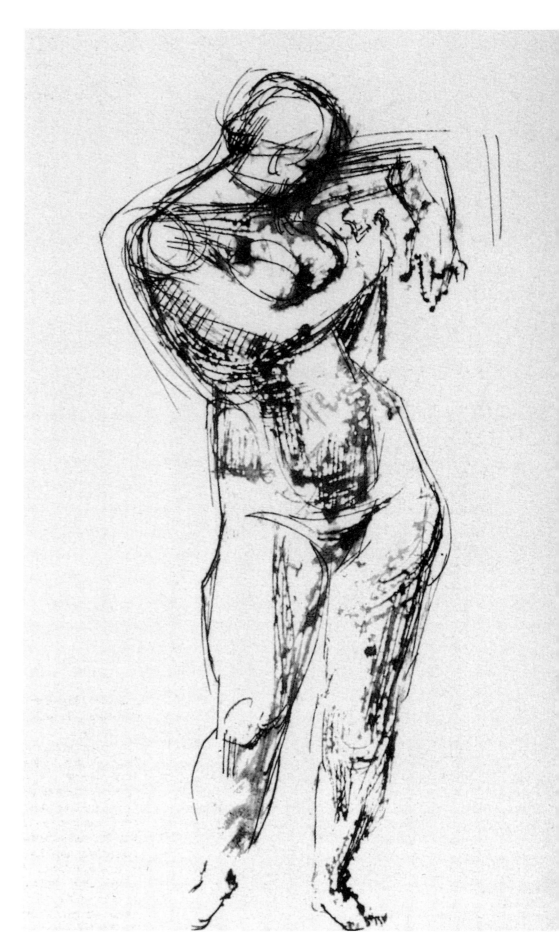

Fig. 537 Gottfried Bammes
(1920–2007).
Woman Washing (1972). Pen and
brown ink, 21 x 29.5cm (8¼ x
11⅝in).
The sharply articulated
ponderation and the tense
interaction of the physical
structure are used as the main
design components to produce
expressiveness.

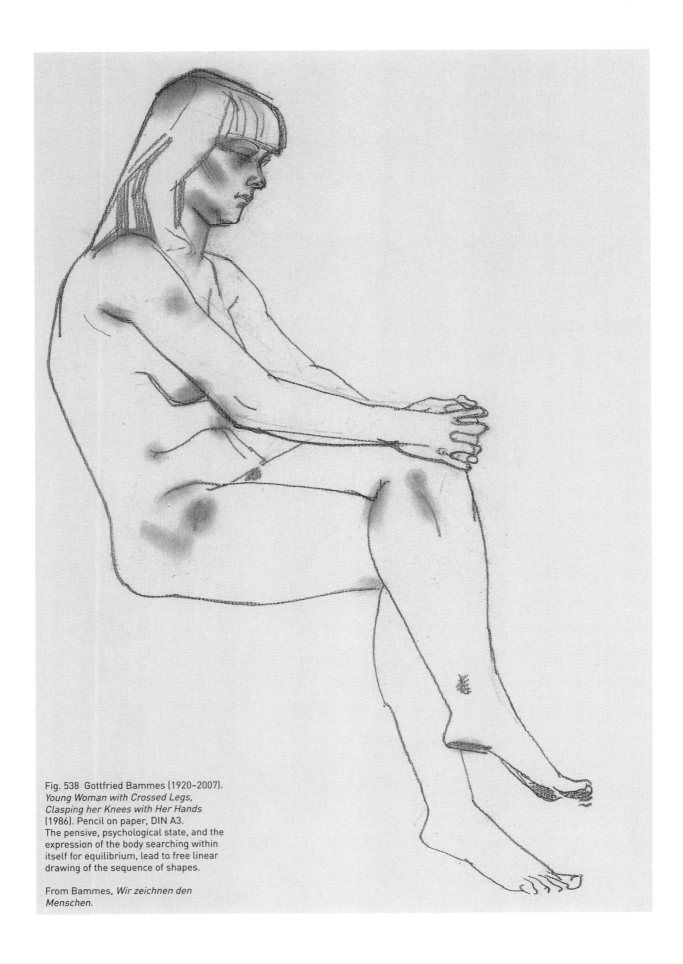

Fig. 538 Gottfried Bammes (1920–2007).
Young Woman with Crossed Legs,
Clasping her Knees with Her Hands
(1986). Pencil on paper, DIN A3.
The pensive, psychological state, and the
expression of the body searching within
itself for equilibrium, lead to free linear
drawing of the sequence of shapes.

From Bammes, *Wir zeichnen den*
Menschen.

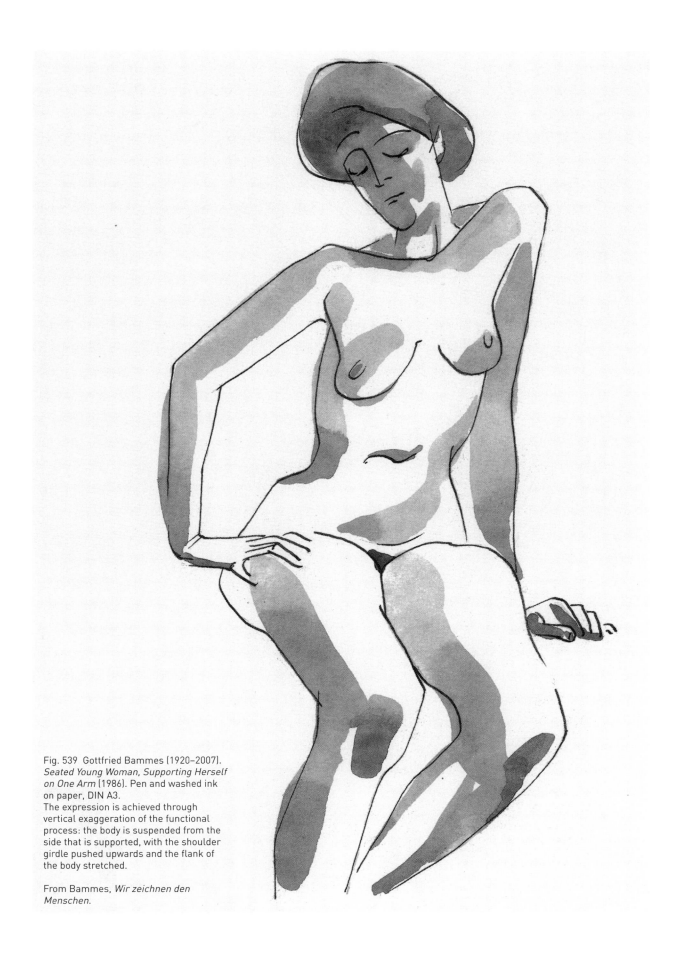

Fig. 539 Gottfried Bammes (1920–2007).
*Seated Young Woman, Supporting Herself
on One Arm* (1986). Pen and washed ink
on paper, DIN A3.
The expression is achieved through
vertical exaggeration of the functional
process: the body is suspended from the
side that is supported, with the shoulder
girdle pushed upwards and the flank of
the body stretched.

From Bammes, *Wir zeichnen den
Menschen*.

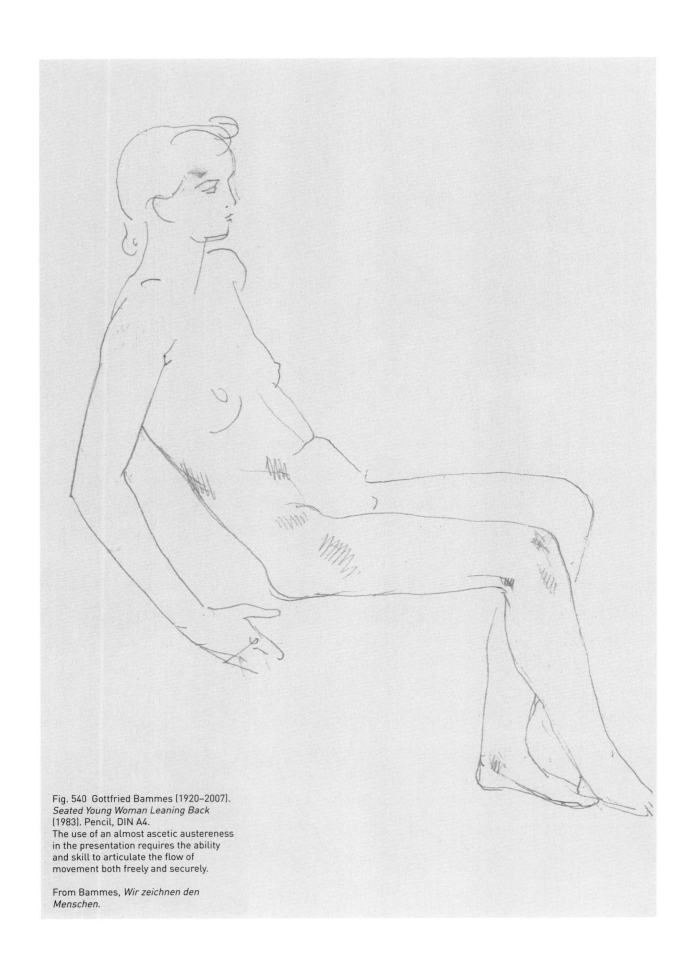

Fig. 540 Gottfried Bammes (1920–2007).
Seated Young Woman Leaning Back
(1983). Pencil, DIN A4.
The use of an almost ascetic austereness
in the presentation requires the ability
and skill to articulate the flow of
movement both freely and securely.

From Bammes, *Wir zeichnen den
Menschen.*

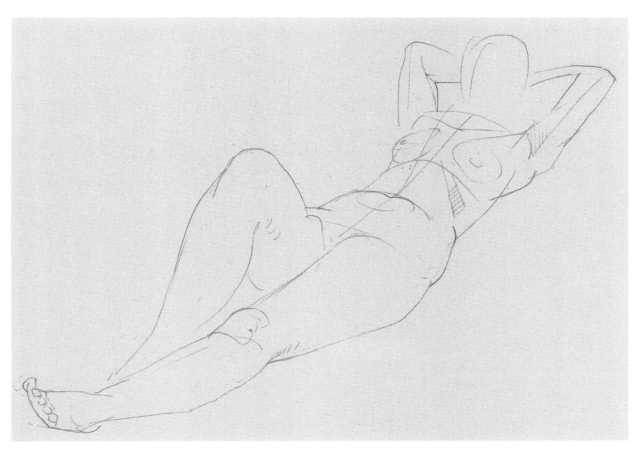

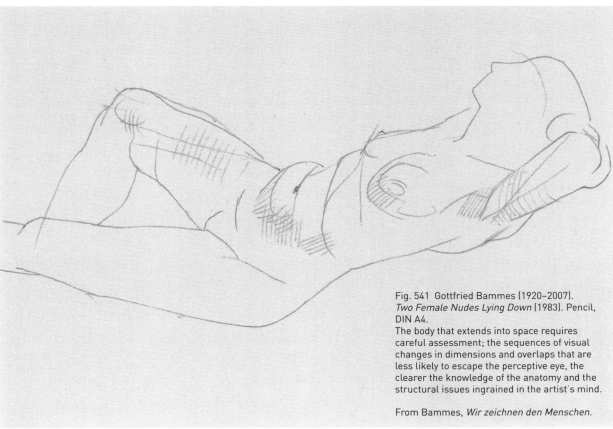

Fig. 541 Gottfried Bammes (1920–2007).
Two Female Nudes Lying Down (1983). Pencil,
DIN A4.
The body that extends into space requires
careful assessment; the sequences of visual
changes in dimensions and overlaps that are
less likely to escape the perceptive eye, the
clearer the knowledge of the anatomy and the
structural issues ingrained in the artist's mind.

From Bammes, *Wir zeichnen den Menschen*.

References

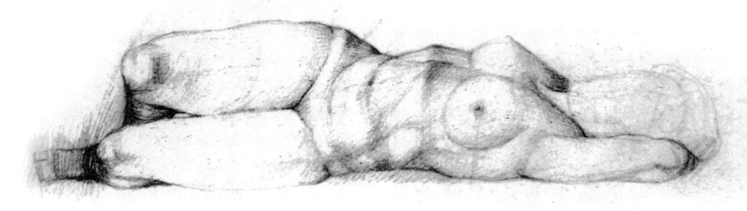

AESTHETICS

Britsch, Gustaf: Theorie der bildenden Kunst.
F. Bruckmann: München 1930

Hildebrand, Adolf: Das Problem der Form in der
bildenden Kunst. J.H.E. Heitz: Straßburg 1914

Jodl, Friedrich: Ästhetik der bildenden Künste.
Cottasche Buchhandlung: Stuttgart 1920

Meumann, Ernst: System der Ästhetik. Quelle und
Meyer: Leipzig 1919

Meumann, Ernst: Einführung in die Ästhetik der
Gegenwart. Quelle und Meyer: Leipzig 1930

ANTHROPOLOGY

Bernaizik, Hugo Adolf: Der dunkle Erdteil. Atlantis-
Verlag: Berlin 1930

Grimm, Hans: Einführung in die Anthropologie. Gustav
Fischer Verlag: Jena 1961

Grimm, Hans: Plastik der vorderen Rumpfwand
als Kennzeichen des Kleinkindertyps, in Ärztliche
Jugendkunde, Jahrgang 52, Heft 1, 1959

Heberet, Gerhard, and *Kurth, Gottfried*: Anthropologie.
Fischer Lexikon A–Z, Band XV: Frankfurt am Main 1959

Klaus, Emil Jos.: Konstitution und Sport. Richard Tries
Verlag: Freibürg/Breisgau 1954

Kloos, Gerhard: Die Konstitutionslehre von Carl
Gustav Carus mit besonderer Berücksichtigung seiner
Physiognomik. Karger: Basel/New York 1951

Kretschmer, Ernst: Körperbau und Charakter.
Springer-Verlag: Berlin 1948

Lenz, Widukind: Wachstum, Körperbau und
Körperlänge. Proportionen. Habitus, in *Brock, Joachim*:
Biologische Daten für den Kinderarzt. Springer-Verlag:
Berlin/Göttingen/ Heidelberg 1954

Ranke, Johannes: Der Mensch, Band II.
Bibliographisches Institut: Leipzig/Wien 1911–1912

Stratz, Carl Heinrich: Der Körper des Kindes und
seine Pflege. Verlag F. Enke: Stuttgart 1923

Zeller, Wilfried: Konstitution und Entwicklung. Verlag
Psychologische Rundschau: Göttingen 1952

MEDICAL ANATOMY

Benninghoff, Alfred: Lehrbuch der Anatomie des
Menschen, Band I. J.F. Lehmanns Verlag: München
1939

Braus, Hermann: Anatomie des Menschen.
Springer-Verlag: Berlin 1929

Dobberstein, Johannes and *Koch, Tankred*: Lehrbuch
der vergleichenden Anatomie der Haustiere, Band I.
S. Hirzel Verlag: Leipzig 1953

Elfenberger, Wilhelm and *Baum, Hermann*:
Handbuch der vergleichenden Anatomie der
Haustiere. Springer-Verlag: Berlin 1932

Feneis, Heinz: Anatomisches Bildwörterbuch der
internationalen Nomenklatur. Georg Thieme Verlag:
Stuttgart 1972

Rauber, August and *Kopsch, Friedrich*: Lehrbuch
und Atlas der Anatomie des Menschen, Band I. Georg
Thieme: Leipzig 1951

Voß, Hermann and *Herrlinger, Robert*: Taschenbuch
der Anatomie. Band I. Verlag Gustav Fischer: Jena
1953

Waldeyer, Ant.: Anatomie des Menschen, Band II.
Teil. Walter de Gruyter: Berlin 1950

PSYCHOLOGY AND PHYSIOLOGY

Buser, Remo: Ausdruckspsychologie,
Problemgeschichte, Methodik und Systematik der
Ausdruckswissenschaft, Ernst Reinhardt Verlag:
München/Basel 1973

Leonhard, Karl: Der menschliche Ausdruck. Johann
Ambrosius Barth: Leipzig 1968

Lersch, Philipp: Gesicht und Seele, Grundlagen
einer mimischen Diagnostik. Ernst Reinhardt Verlag:
München/Basel 1971

Strehle, Hermann: Mienen, Gesten und Gebärden,
Analyse des Gebarens. Ernst Reinhardt Verlag:
München /Basel 1966

Wörterbuch der Psychologie. VFB Bibliographisches
Institut: Leipzig 1976

ANATOMY FOR ARTISTS AND FINE ARTS PAEDAGOGY

Bammes, Gottfried: Didaktische Hilfsmittel im Lehrfach Plastische Anatomie. Dissertation 1956

Bammes, Gottfried: Neue didaktische Hilfsmittel im Lehrfach Plastische Anatomie. Wissenschaftliche Zeitschrift der TH Dresden, Heft 4 (1956–1957)

Bammes, Gottfried: Neue Grundlagen einer Methodik des Lehrfaches Plastische Anatomie. Habilitation, 1958

Bammes, Gottfried: Die Gestalt des Menschen. Hand- und Lehrbuch der Anatomie für Künstler. Verlag der Kunst: Dresden 1964

Bammes, Gottfried: Lehrstuhl Künstleranatomie. Aus Lehre und Studium. Informationsheft 4/78 des Lehrstuhles für Künstleranatomie at the HfBK Dresden

Bammes, Gottfried: Das zeichnerische Akt-Studium, Seine Entwicklung in Werkstatt, Schule, Praxis und Theorie. VEB Verlag E.A. Seemann: Leipzig 1975, 2nd edition

Bammes, Gottfried: Die Gestalt des Tieres, Lehr- und Handbuch der Künstleranatomie typischer Landsäugetiere. VEB Verlag E.A. Seemann: Leipzig 1975

Bammes, Gottfried: Die Gestalt des Tieres, Lehr- und Handbuch der Anatomie für Künstler. E.A. Seemann: Leipzig 1975

Bammes, Gottfried: Der Akt in der Kunst. E.A. Seemann: Leipzig 1975

Bammes, Gottfried: Die Verarbeitung morphologischer Aspekte im Bereich der Künstleranatomie, in Verhandlungen der Anatomischen Gesellschaft. 71. 1977, 1491–1498

Bammes. Gottfried: Figürliches Gestalten. Ein Leitfaden für Lehrende und Lernende. Volk und Wissen: Berlin 1978

Bammes, Gottfried: Die Gestalt des Tieres. Eine Zeichenschule auf methodischen, künstlerischen und anatomischen Grundlagen. Ravensburger Buchverlag: Ravensburg 1986

Bammes, Gottfried: Die Gestalt des Tieres. Studienausgabe. Ravensburger Buchverlag: Ravensburg 1986

Bammes, Gottfried: Studien zur Gestalt des Menschen. Eine Zeichenschule mit Arbeiten von Laienkünstlern, Kunstpädagogen und Kunststudenten. Ravensburger Buchverlag: Ravensburg 1986

Bammes, Gottfried: Große Tieranatomie – Gestalt, Geschichte, Kunst. Ravensburger Buchverlag: Ravensburg 1986

Bammes, Gottfried: Arbeitsbuch zur Künstleranatomie – Grundinformationen – Lösungsangebote. Ravensburger Buchverlag: Ravensburg 1986

Bammes, Gottfried: Die Hand – ihre Darstcllungsaspekte in wissenschaftlicher und künstlerischer Durchdringung. Referat in Verhandlungen der anatomischen Gesellschaft 1987

Bammes, Gottfried: Sehen und Verstehen. Die menschlichen Formen in didaktischen Zeichnungen. Ravensburger Buchverlag: Ravensburg 1986 (also Volk und Wissen: Berlin 1988, 2nd edition)

Bammes, Gottfried: Wir zeichnen den Menschen. Eine Grundlegung. Volk und Wissen: Berlin 1989

Bammes, Gottfried: Der nackte Mensch. Hand- und Lehrbuch der Anatomie für Künstler. Verlag der Kunst: Dresden 1969 (1989, 6th edition)

Bammes, Gottfried: Akt – Das Menschenbild in Anatomie und Kunst. Belser Verlag: Stuttgart 1992

Bridgman, George C.: Constructive Anatomy. Dover Publications, lnc.: New York 1973

Camper, Peter: Abhandlungen über den natürlichen Unterschied der verschiedenen Gesichtszüge der Menschen verschiedener Gegenden und verschiedenen Alters. Voß: Berlin 1972

Farris, Edmond J.: Art Students' Anatomy, Dover Publications, Inc.: New York 1961

Fritsch, Gust.: Die Gestalt des Menschen. Mit Benutzung der Werke von E. Harless und C. Schmidt. Paul-Neff-Verlag: Stuttgart 1899

Geyer, Otto: Der Mensch. Union Deutsche Verlagsgesellschaft: Stuttgart/Berlin/Leipzig

Hatton, Richard G.: Figure Drawing. Dover Publications, lnc.: New York 1965

Hogarth, Burne: Dynamic Anatomy: Watson-Guptill Publications: New York 1958

Kollmann, Julius: Plastische Anatomie des menschlichen Körpers. Walter de Gruyter: Berlin 1928

Kramer, Jack: Human Anatomy and Figure Drawing, The Integration of Structure and Form. Van Nostrand Reinhold Comp. 1972

Le Clerc, Pierre Thomas: Principes des dessins d'après nature, around 1780

Macnab, lain: Figure Drawing. The Studio Publications: London and New York 1936

Marsh, Reginald: Anatomy for Artists. Dover Publications, lnc.: New York 1970

Mollier, Siegfried: Plastische Anatomie. Verlag J.F. Lehmann: München 1924

Richer, Paul: Anatomie für Künstler. W. Spemann Verlag: Stuttgart 1889

Rimmer, William: Art Anatomy. Dover Publications, lnc.: New York 1962

Seiler, Wilhelm Burkhard: Naturlehre des Menschen für Künstler und Kunstfreunde. Arnold: Leipzig 1826

Sheppard, Joseph: Anatomy. A Complete Guide for Artists. Watson-Guptill Publications: New York 1975

Tank, Wilhelm: Tieranatomie für Künstler. Otto-Maier-Verlag: Ravensburg 1939

Tank, Wilhelm: Form und Funktion. 5 Bände. Verlag der Kunst: Dresden 1953–1957

Tortebat, Francisco: Kurze Verfassung der Anatomie, 1668. Deutsche Ausgabe bei Joh. Andreas Rüdiger: Berlin 1706

Vanderpoel, John H.: The Human Figure, Life Drawing for Artisis. Dover Publications. lnc.: New York 1958

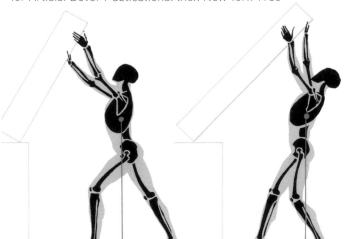

HISTORY AND SCIENCE OF ART

Albrecht Dürer – Die künstlerische Entwicklung eines Grossen Meisters. Deutsche Akademie der Künste: Berlin 1954

Bruck, Robert: Albrecht Dürer. Das Skizzenbuch in der königlichen öffentlichen Bibliothek zu Dresden. J.H.E. Heitz: Straßburg 1905

Grimm, Herman: Michelangelo. Safari-Verlag: Berlin 1949

Heydenreich, Ludwig-Heinrich: Leonardo. Rembrandt-Verlag: Berlin 1943

Hofmann, Werner: Bildende Kunst. I-III. Fischer Lexikon A–Z, Band XXI–XXIII: Frankfurt am Main 1960–1961

Hugelshofer, Walter: Ferdinand-Hodler-Monographie. Rascher-Verlag: Zürich 1962

Kuhn, Alfred: Die neuere Plastik von 1800 bis zur Gegenwart. Delphin-Verlag: München 1922

Kuhn, Alfred: Aristide Maillol. Landschaft, Werke, Gespräche. F. A. Seemann: Leipzig 1925

Leonardo da Vinci: Zur fünfhundertsten Wiederkehr seines Geburtstages 1452-1952. Deutsche Akademie der Künste: Berlin 1952

Lüdecke, Heinz: Leonardo da Vinci, Tagebücher und Aufzeichnungen. Paul List Verlag: Leipzig 1952

Nebbia, Ugo: Michelangelo Bildhauer, Maler, Architekt, Dichter. Asmus-Verlag: Leipzig 1941

Panofsky, Erwin: Dürers Kunsttheorie, vornehmlich in ihrem Verhältnis zur Kunsttheorie der Italiener. Vereinigung wissenschaftlicher Verleger: Berlin 1915

Panofsky, Erwin: Die Entwicklung der Proportionslehre als Abbild der Stilentwicklung, in Monatshefte für Kunstwissenschaft, Jahrgang 14, Heft 2, 1921

Seidlitz, Waldemar von: Leonardo da Vinci, Malerbuch. Verlag Julius Bard: Berlin 1919

Uhde-Bernays, Hermann: Aristide Malliol. Wolfgang Jeß Verlag: Dresden 1957

Vasari, Giorgio: Künstler der Renaissance. Transmare Verlag: Berlin 1948

Waldmann, Emil: Anselm Feuerbach. Rembrandt-Verlag: Berlin 1944

Waetzoldt, Wilhelm: Die Kunst des Porträts. Ferdinand Hirt und Sohn: Leipzig 1908

Waetzoldt, Wilhelm: Dürer und seine Zeit. Phaidon-Ausgabe. Georg Allen und Unwin Ltd.: London 1938

Wölfflin, Heinrich: Die Kunst Albrecht Dürers. Verlag Bruckmann: München 1943

MISCELLANEOUS

Apel, Max: Philosophisches Wörterbuch. Walter de Gruyter: Berlin 1930

Bargmann, Wolfgang: Anatomie und bildende Kunst. Karl Alber: Freiburg 1947

Bloemaert, Abraham: Zeichenschule. Vischer: Amsterdam 1611

Choulant, Ludwig: Geschichten und Bibliographie der anatomischen Abbildungen nach ihrer Beziehung auf anatomische Wissenschaft und bildende Kunst. R. Weigel: Leipzig 1857

Corinth, Lovis: Das Erlernen der Malerei. Paul Cassirer: Berlin 1920

Glaser, Hugo: Die Entdecker des Menschen. Schönbrunn-Verlag: Wien 1954

Goethe, Wolfgang: Morphologische Schriftcn. Eugen Diederichs: Jena 1926

Hoke, Ralph: Handbuch der Leichtathletik für Lehrer, Trainer und aktive Sportler. Globus-Verlag: Wien 1957 (Taschenbibliothck)

Kleine Enzyklopädie – Körperkultur und Sport. Verlag Enzyklopädie: Leipzig 1960

Loomis, Andrew: Figure Drawing for All It's Worth. Viking Press: New York 1946, 12th edition

Muybridge, Eadweard: The Human Figure in Motion. Dover Publications, Inc.: New York 1955

Preißler, Joh. D.: Gründlich verfaßte Regeln, derer man sich als einer Anleitung zu berühmter Künstler Zeichenwerken bestens bedienen kann. Nürnberg 1750

Schinnerer, Adolf: Aktzeichmmgcn aus fünf Jahrhunderten. R. Piper Verlag: München 1925

Schmidt, Ferdinand August and Kohlrausch, Wolfgang: Unser Körper. Handbuch der Anatomie, Physiologie und Hygiene der Leibesübungen. Voigtländers Verlag: Leipzig 1931

Schmitt, Johannes Ludwig: Atemheilkunst. Georg Müller: München/Berlin 1956

Wiessner, Moritz: Die Akademie der bildenden Künste zu Dresden, Festschrift zu der Feier des 100jährigen Bestehens. B.G.Teubner: Dresden 1864

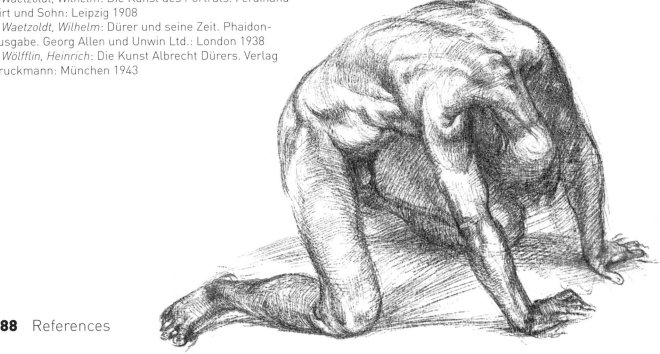

Index

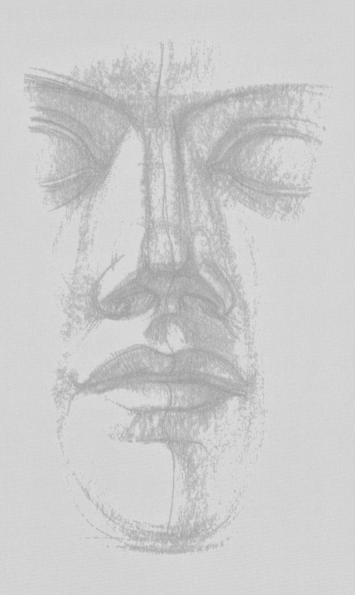

LIST OF ILLUSTRATIONS

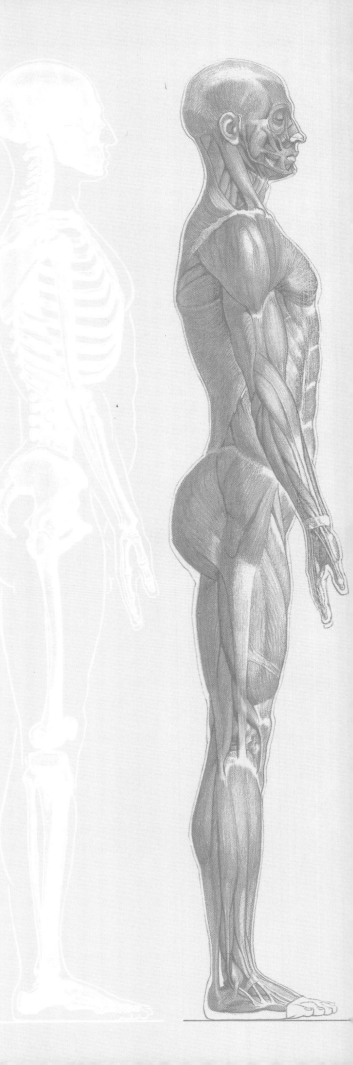

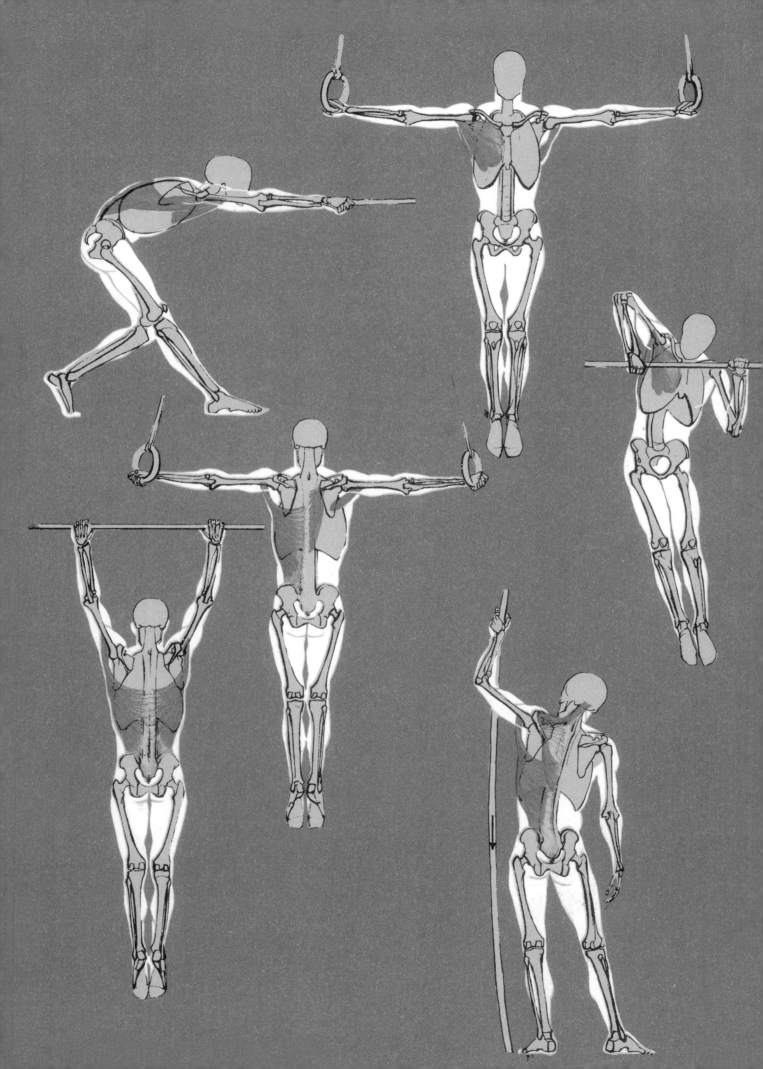